Mathematics in
Popular Culture

To Maeve —
From one math girl
to another! Hope you
enjoy the book — I
especially recommend
the Fair Division (p. 71),
Game Theory (p. 86) and
Mean Girls (p. 187)
essays!

Jessica R. Sklar

Mathematics in Popular Culture

Essays on Appearances in Film, Fiction, Games, Television and Other Media

Edited by JESSICA K. SKLAR *and* ELIZABETH S. SKLAR

Foreword by Keith Devlin

McFarland & Company, Inc., Publishers
Jefferson, North Carolina, and London

ALSO OF INTEREST

King Arthur in Popular Culture (edited by Elizabeth S. Sklar and Donald L. Hoffman; McFarland, 2002)

LIBRARY OF CONGRESS CATALOGUING-IN-PUBLICATION DATA

Mathematics in popular culture : essays on appearances in film, fiction, games, television and other media / edited by Jessica K. Sklar and Elizabeth S. Sklar ; foreword by Keith Devlin.
 p. cm.
 Includes bibliographical references and index.

ISBN 978-0-7864-4978-1
softcover : acid free paper ∞

 1. Mathematics in mass media. 2. Popular culture — United States. 3. Mass media and culture — United States. I. Sklar, Jessica K., 1973– II. Sklar, Elizabeth Sherr. P96.M395M38 2012
700'.46 — dc23 2012000543

BRITISH LIBRARY CATALOGUING DATA ARE AVAILABLE

On the cover: David Krumholtz as Charlie Eppes in *NUMB3RS* (CBS/Photofest)

Manufactured in the United States of America

McFarland & Company, Inc., Publishers
Box 611, Jefferson, North Carolina 28640
www.mcfarlandpub.com

For Rubby Sherr, pater familias
and for Frank Anderson, pater nonfamilias

Acknowledgments

We are deeply indebted to the many individuals who helped to bring this book to fruition. Our thanks to Daniel Heath for sharing with us his knowledge of projective geometry; Jonathan Melusky, Aaron Malver, and Roberta Davidson for serving as preliminary readers; Elliott Bangs for his wonderful work on our graphics; Janet Curtiss, for her indexing prowess; and Wilkie Collins IV, for rescuing us from some embarrassing gaucheries and creative spelling moments. Also due our thanks are Jessica's students and Facebook friends, who were liberal with their technical advice. Our authors have our abiding gratitude for their willingness to venture across disciplinary boundaries, for their intriguing essays (all but two of which are original to this collection)—and for enduring our fits of editorial zeal. We are grateful as well to math and pop culture maven Keith Devlin for his generous foreword, and to Alex Kasman, who allowed us to plunder his online database of mathematical fiction for our appendices and advised us on pertinent entries. Finally, we thank the periodicals department of the Mathematical Association of America for permission to reprint in this volume the two previously-published essays.

Table of Contents

Acknowledgments vi

Foreword by Keith Devlin 1

Introduction
 JESSICA K. SKLAR *and* ELIZABETH S. SKLAR 3

Part One: The Game

A Survey of Fictional Mathematics in Literature
 ALEX KASMAN 9

"You Never Said Anything about Math": Math Phobia and Math
 Fanaticism in the World of *Lost*
 KRISTINE LARSEN 27

What's in a Name? *The Matrix* as an Introduction to Mathematics
 KRIS GREEN 44

Mapping Contagion and Disease, Catastrophe and Destruction:
 Computer Modeling in the Epidemiological Disaster Narrative
 KATHLEEN COYNE KELLY *and* DOUGLAS WHITTINGTON 55

Fair and Unfair Division in Neal Stephenson's *Cryptonomicon*
 WILLIAM GOLDBLOOM BLOCH *and* MICHAEL D. C. DROUT 71

Game Theory in Popular Culture: Battles of Wits and Matters of Trust
 JENNIFER FIRKINS NORDSTROM 86

Coming Out of the Dungeon: Mathematics and Role-Playing Games
 KRIS GREEN 99

Playing *Moneyball*: Math and Baseball
 JEFF HILDEBRAND 114

A Mathematician Does the *New York Times* Sunday Crossword Puzzle
 GENE ABRAMS 123

Part Two: The Players

XKCD: A Web of Popular Culture
 KAREN BURNHAM 137

Counting with the Sharks: Math-Savvy Gamblers in Popular Culture
MATTHEW LANE 148

Stand and Deliver Twenty Years Later
KSENIJA SIMIC-MULLER, MAURA VARLEY GUTIÉRREZ *and*
RODRIGO JORGE GUTIÉRREZ 163

Smart Girls: The Uncanny Daughters of *Arcadia* and *Proof*
SHARON ALKER *and* ROBERTA DAVIDSON 172

Mean Girls: A Metamorphosis of the Female Math Nerd
KRISTIN ROWAN 187

The Mathematical Misanthrope and American Popular Culture
KENNETH FAULKNER 198

Alan Turing: Reflecting on the Life, Work, and Popular Representations
of a Queer Mathematician
K. G. VALENTE 219

Mat(t)h Anxiety: Math as Symptom in Gus Van Sant's *Good Will Hunting*
DONALD L. HOFFMAN 233

Part Three: Math + Metaphor

Thinking Outside the Box: Application Versus Discovery in *Saw* and *Cube*
JESSICA K. SKLAR 247

Tolstoy's Integration Metaphor from *War and Peace*
STEPHEN T. AHEARN 258

"We'll all change together": Mathematics as Metaphor in Greg Egan's Fiction
NEIL EASTERBROOK 265

Truth by the Numbers: Mysticism and Madness in Darren Aronofsky's π
LAURIE A. FINKE *and* MARTIN B. SHICHTMAN 274

Flatland in Popular Culture
LILA MARZ HARPER 288

Discovering a Higher Plane: Dimensionality and Enlightenment in
Flatland and *Diaspora*
CHRIS PAK 304

Projective Geometry in Early Twentieth-Century Esotericism: From the
Anthroposophical Society to the Thoth Tarot
RICHARD KACZYNSKI 314

Appendices

 A: *Mathematics in Performance Media* 333

 B: *Mathematics in Fiction and Poetry* 334

About the Contributors 337

Index 341

Foreword
by Keith Devlin

What is the connection between Lindsay Lohan, Tina Fey, and mathematics? This marvelous new book will tell you the answer, as its authors take you on a tour of some of the books, plays, films, television shows, and video games that weave mathematics into their stories.

The novella *Flatland*, the movies *Good Will Hunting*, *A Beautiful Mind*, *π*, and *Stand and Deliver*, the stage plays (and in two cases subsequently movies) *Arcadia*, *Breaking the Code* and *Proof*, and the hugely successful television crime series *NUMB3RS*—I suspect these are the most obvious examples of the appearance of mathematics in popular culture. But they are by no means unique, as a quick glance at Alex Kasman's *Mathematical Fiction Homepage* (http://kasmana.people.cofc.edu/MATHFICT) will indicate. In this compendium, editors Jessica K. Sklar and Elizabeth S. Sklar provide 24 in-depth analyses of portrayals of mathematics in popular culture.

The editors do not seek to provide a comprehensive survey of all works that contain or refer to mathematics. Instead, they have assembled what for the most part are analyses of examples where the marriage of mathematics and popular culture has real substance.

The mathematical connection is not always apparent until someone points it out. Who would think there are mathematical ideas behind the popular television series *Lost* or the disaster movie *Outbreak*? The cult comedy movie *The Princess Bride* contains an oft-quoted scene that provides an illustration of game-theoretic reasoning, and Tolstoy's *War and Peace* uses calculus as a metaphor. Science fiction novels sometimes have mathematical themes, of course, as do some video games and some cartoons. Sport appears too, though the compendium's focus on culture means it does so by way of a bestselling book, Michael Lewis's *Moneyball*.

Though many of the examples of popular culture discussed can be (and frequently are) dismissed as "shallow," the very fact that mathematics lies just beneath the surface indicates that even "mass entertainment" can have a hidden depth. Regardless of the cultural status of the examples chosen, the authors consistently deliver in-depth analyses, and the result is a unique volume that will surely fascinate.

Keith Devlin is a cofounder and executive director of Stanford University's Human-Sciences and Technologies Advanced Research Institute, a cofounder of the Stanford Media X research network, a senior researcher at Stanford's Center for the Study of Language and Information, and National Public Radio's "Math Guy." He wrote Mathematics Education for a New Era *(2011) and has published more than 80 research articles and 30 books.*

Introduction

JESSICA K. SKLAR *and* ELIZABETH S. SKLAR

"Just a few more touches to decode Saber's crypto system. To access the information on Darwin's PDA, I have to factor a univariate polynomial over a finite field."

— Speckles (*G-Force*)

"You being brought to this hospital isn't fate, John, it's probability!"
— Jack Shephard (*Lost*, "The Life and Death of Jeremy Bentham")

Mathematics has long been considered an arcane, inaccessible discipline. And from the Pythagorean cultists to modern-day Kabbalists and the reclusive genius Grigori Perelman, practitioners of mathematics have often either isolated themselves from or been excluded by the community at large. Despite the apparent mystique of both the discipline and its practitioners, however, mathematics has permeated popular genres and media for over a century. It is the "universal language" an alien culture employs to communicate with humans in Carl Sagan's *Contact* (1985), and a driving plot device in movies such as *The Bank* (2001) and *π* (1998) in which mathematicians attempt to derive ways of predicting stock market behavior; Penrose stairs allow a character to elude capture in the 2010 hit film *Inception*, and a presumed child prodigy struggles — hopelessly — to prove the Riemann Hypothesis in an episode of *Law & Order: Criminal Intent* ("Bright Boy").[1] Moreover, practitioners of mathematics — from Oxford professors to high school students to janitors to superheroes — feature in many novels, plays, and films that may or may not contain actual mathematics, ranging from character studies like *Good Will Hunting* (1997) and Tom Stoppard's elegant play *Arcadia* (1993), to genre works such as Guillermo Martínez's novel *The Oxford Murders* (2003) and Tina Fey's 2004 comedic film *Mean Girls*. The award-winning television series *NUMB3RS* (2005–2010) focuses on a collaboration between a mathematician and his FBI brother, while Marvel Comics' Mathemanic uses telepathy to alter his foes' perceptions of numerical quantities. This is in addition to the frequent appearance of mathematics and mathematicians in science fiction television series such as *Star Trek* and *Doctor Who* (in their various manifestations), and in the works of science fiction writers such as Greg Egan and Neal Stephenson, who employ mathematics not just as plot components but as metaphors or satirical devices.[2] Finally, we see mathematics celebrated, mocked, and explicated on our most popular of media outlets, the internet, in webcomics such as *xkcd*[3] and *Piled Higher and Deeper*, and in myriad YouTube music videos, for songs ranging from the abstract

3

algebra ditty "A Finite Simple Group (of Order Two)," performed by the Klein Four Group (a Northwestern University *a cappella* ensemble) to "Slope Intercept," a pedagogical rap about the slope-intercept form of equations for lines, performed by Lamar Queen, a Los Angelian eighth-grade math teacher. Even animated mole Speckles (quoted above), LOL-cats,[4] and nineteenth-century Russian novelist Leo Tolstoy[5] have gotten in on the mathematical action.

While there have been some significant publications in recent years on math in pop culture — particularly notable is Keith Devlin and Gary Lorden's *The Numbers Behind NUMB3RS: Solving Crime with Mathematics*,[6] which describes actual crime-solving uses of mathematics, using the television series as a launching pad[7] — the majority of them are written by and for mathematicians, and focus on a specific work or series of works. (See, for example, Melanie Bayley's article "Alice's Adventures in Algebra: Wonderland Solved," or Andrew Nestler's website *Guide to Mathematics and Mathematicians on* The Simpsons.) In our collection, we aim to extend the work of such studies by exploring a broad range of intersections between mathematics and mainstream culture. Our umbrella is capacious; because we conceive of this volume as an adventure in interdisciplinarity and aspire to topical breadth, we established minimal constraints for our authors with respect to choice of content, genre, methodology, or medium. In particular, we adopted a deliberately relaxed understanding of "popular culture,"[8] and refrained from setting chronological boundaries: while many of our essays discuss contemporary media artifacts that comfortably fall within the realm of "pop," our collection also includes essays on Tolstoy's *War and Peace* and on Edwin A. Abbott's Victorian novella *Flatland: A Romance in Many Dimensions.*

Our authors are as varied as their topics. We count among our contributors mathematicians, film theorists, and English professors, as well as experts in physics and astronomy, cultural studies, and the occult; in their essays, they consider everything from blockbuster films, baseball, crossword puzzles, fantasy role-playing games, and television shows to science fiction tales, award-winning plays, and a few classic works of literature. Authorial methodologies and perspectives are similarly diverse: for instance, the essays on *War and Peace* and *Flatland*, along with Richard Kaczynski's essay on the role of geometry in twentieth-century esotericism, adopt an historical orientation; film theory informs essays on π and *Good Will Hunting*; and Kenneth Faulkner's discussion ("The Mathematical Misanthrope") of Theodore Kaczynski (the Unabomber) and John Nash draws on cultural studies and psychology. Also displaying a socio-cultural approach are several essays — K. G. Valente's study of Alan Turing as a queer mathematician, Kristin Rowan's reading of *Mean Girls*, Sharon Alker and Roberta Davidson's analysis of the plays *Arcadia* and *Proof*, and Donald L. Hoffman's "Mat(t)h Anxiety" — that explore issues of gender and sexuality, and the essay *"Stand and Deliver* Twenty Years Later," which considers matters of race and class.

Because our book is designed for a multidisciplinary readership, all of its essays, regardless of subject matter, methodology, or authorial expertise, have been written and edited with an eye to accessibility for lay readers and specialists alike. So that readers can easily find the essays that will likely be the most interesting or useful to them, we have chosen to group our essays thematically, rather than chronologically or by medium or genre.

Our first section, *The Game*, focuses on mathematical content in literature, television, film, sports, and games. While essays in *The Game* may be most compelling to readers with some level of mathematical background, many are readily accessible to the lay reader. All

occupy familiar cultural territory as well. Alex Kasman opens the section with "A Survey of Fictional Mathematics in Literature," classifying the different types of invented mathematics — ranging from plausible, to bogus, to surreal — that punctuate our science fiction, classical literature, and film.[9] Kristine Larsen explores the various roles, such as unifier, polarizer, and apocalyptic predictor, that mathematics plays in the popular television series *Lost* (2004–2010), while Kris Green's "What's in a Name?" connects the *Matrix* movies to the use of matrices in creating computer graphics, predicting future events using Markov chains, and modeling group behavior using network theory.[10] In "Mapping Contagion and Disease, Catastrophe and Destruction," Kathleen Coyne Kelly and Douglas Whittington examine epidemiological computer modeling in disaster films such as *The Andromeda Strain* and *Outbreak*, and essays by Jennifer Firkins Nordstrom and by coauthors William Goldbloom Bloch and Michael D. C. Drout provide user-friendly introductions to the area of economic game theory, focusing on its role in television shows, films, and Stephenson's science fiction novel *Cryptonomicon*. Kris Green, Jeff Hildebrand, and Gene Abrams round out this section, discussing the mathematics in and behind role-playing games, baseball, and crossword puzzles.

The following two sections should appeal to mathematicians and non-mathematicians alike, and may be of particular interest to sociologists, psychologists, historians, and literary, film, and cultural theorists. *The Players* examines representations of mathematicians and the performance of mathematics in films and theater, as well as in the non-fiction genres of journalism and biography (Faulkner's "The Mathematical Misanthrope" and Valente's "Alan Turing"). Despite their disparate topics and authorial diversity — roughly half of the contributors to this section are in math or math-related fields, while the rest specialize in literary and cultural studies — most of the essays in *The Players* share a concern with misguided, negative, or demeaning public perceptions of mathematicians and the performance of mathematics, and analysis of the ways in which the works in question impact, reinforce, or attempt to run intervention with the associated stereotypes: the socially-inept nerd, the reclusive mad genius, the computational whiz kid, and the gauche, unattractive geek-girl.

A common refrain of this section is the argument that while some of the works under consideration manage to successfully challenge and reverse a common stereotype — particularly with respect to gender, as in *Mean Girls* (Kristin Rowan) or the plays *Arcadia* and *Proof* (Sharon Alker and Roberta Davidson) — others that purport to reinvent the public image of the mathematician or mathematical practice inadvertently perpetuate the very stereotypes they are attempting to subvert. For instance, in his essay "Counting with the Sharks," Matthew Lane posits that certain films and television shows featuring "math-savvy gamblers" succeed in severing the imagined link between mathematical ability and social ineptitude, but sustain a series of other mathematical myths, including the popular beliefs that "mathematical ability is a fluke of genetics," and that it is demonstrated solely through the performance of lightning-speed mental arithmetic. In a similar vein, although with a different stereotypical target in mind, Ksenija Simic-Muller, Maura Varley Gutiérrez, and Rodrigo Gutiérrez argue that the 1988 film *Stand and Deliver* not only advocates a non-productive strategy of math pedagogy, but also unwittingly replicates damaging social myths about Latino culture. Also addressing issues of marginalization is Donald L. Hoffman's essay on *Good Will Hunting*, which contemplates the ways in which a young math prodigy from the wrong side of the tracks is represented as an outsider trapped in an alien milieu. On a

lighter and happier note, Karen Burnham takes us on a romp through the popular webcomic *xkcd*, in which stick figures enthusiastically embrace their world of "hard-core math and science wonkery."

Our last section, *Math + Metaphor*, examines the ways in which literature, cinema, and occultism use mathematical metaphors to explain historical and cultural transformation and model the existence of extraphysical realms. Stephen T. Ahearn's "Tolstoy's Integration Metaphor from *War and Peace*" and Neil Easterbrook's essay on Egan's fiction consider literary mathematical metaphors for societal change, while Lila Marz Harper and Chris Pak illuminate parallels between the mathematical notion of higher-dimensionality and the human notion of higher consciousness as played out in Abbott's nineteenth-century *Flatland* (and the works it has inspired) and in Egan's late twentieth-century novel *Diaspora*. Connections between mathematics and the spiritual are also explored in Richard Kaczynski's discussion of the use of projective geometry in the design of the Thoth Tarot, and in "Truth by the Numbers," Laurie A. Finke and Martin B. Shichtman study the mystical significance of mathematical symbols in Darren Aronofsky's π. Finally, Jessica K. Sklar's "Thinking Outside the Box" turns the idea of "math as metaphor" on its head, suggesting that the twentieth-century horror films *Saw* and *Cube* can be viewed as metaphors for applied and pure mathematical research.

It is a well-worn maxim in pedagogical circles that mathematics can be found throughout the natural world.[11] What we celebrate here is that math also infuses our commercial, cultural, and imaginative worlds. It is sometimes superfluous (the presence of algebraic topology texts on a character's bookshelf in the 1998 Japanese film *Ringu*), sometimes absurd (a man folding his wife into the fourth dimension in the short film "Solid Geometry"), and sometimes deeply moving (Andrew Wiles discussing his proof of Fermat's Last Theorem in the *Nova* episode "The Proof"). But whatever shape it assumes, in whatever medium, it rarely fails to provide us with food for thought — or at the very least a good chuckle. In the spirit of the latter, we leave you with a wee mathematical riddle, courtesy of *The Big Bang Theory*'s Dr. Sheldon Cooper (Jim Parsons, "The Pants Alternative"):

Q: Why did the chicken cross the Möbius strip?
A: To get to the same side!

Notes

1. This is not the only depiction in popular culture of an attempt to prove a famous mathematical result inspiring criminal activity. For instance, both the series pilot for Masterpiece Mystery's *Inspector Lewis* (2005) and the 2007 Spanish horror film *Fermat's Room* (*La habitación de Fermat*) revolve around homicides prompted by lauded but erroneous proofs of Goldbach's Conjecture.

2. See Drout and Bloch's "Fair and Unfair Division in Neal Stephenson's *Cryptonomicon*," Easterbrook's "'We'll all change together': Mathematics as Metaphor in Greg Egan's Fiction," and Pak's "Discovering a Higher Plane: Dimensionality and Enlightenment in *Flatland* and *Diaspora*."

3. See Burnham's "*XKCD: A Web of Popular Culture*."

4. See the "math"-tagged entries at the website *I Can Has Cheezburger*.

5. See Ahearn's "Tolstoy's Integration Metaphor from *War and Peace*."

6. Both Devlin and Lorden are significant within the math and popular culture landscape: Devlin is National Public Radio's "Math Guy," while Lorden was a mathematical consultant for *NUMB3RS*.

7. *NUMB3RS* also inspired a slew of online pedagogical resources (e.g., the Cornell Mathematics Department's *Numb3rs Math Activities* site). Some of these resources were officially associated with the series. Beginning in September 2005, the National Council of Teachers of Mathematics, in association with Texas Instruments, created educational activities related to the mathematics presented in the television

show; these activities were posted on the show's official CBS website. Later, Wolfram Research developed a website, *The Math Behind NUMB3RS*, that was linked to from the show's website and provided animations and information related to the series' mathematical content.

8. While we choose not to comprehensively consider the definitions of "popular culture" and "mass culture" here, we direct interested readers to the essays "'Culture' and 'Masses'" (Raymond Williams) "Mass Civilization and Minority Culture" (F. R. Leavis) and "The Popular" (Morag Shiach) in *Popular Culture: A Reader*.

9. Kasman's site, *Mathematical Fiction Homepage*, provides a wealth of information for anyone interested in mathematics and popular culture.

10. Green's essay, "What's in a Name? *The Matrix* as an Introduction to Mathematics," originally appeared in the magazine *Math Horizons* in September 2008 (pp. 18–21).

11. See for instance, John A. Adam's book *Mathematics in Nature: Modeling Patterns in the Natural World*, or Michael Aaron Cohen's webpage on *Naturally Occurring Fractals*.

Works Consulted

Adam, John A. *Mathematics in Nature: Modeling Patterns in the Natural World*. Princeton: Princeton University Press, 2006.

Bayley, Melanie. "Alice's adventures in algebra: Wonderland solved." *New Scientist*, 16 Dec 2009.

Cohen, Michael Aaron. *Naturally Occurring Fractals*. Miqel, n.d. Web. 19 June 2011.

G-Force. Dir. Hoyt Yeatman. Walt Disney Pictures, 2009. Film.

Guide to Mathematics and Mathematicians on The Simpsons. Santa Monica College, 5 Dec 2010. Web. 5 May 2011.

Guins, Raiford, and Omayra Zaragoza Cruz, eds. *Popular Culture: A Reader*. London: Sage Publications, 2005.

Kasman, Alex. *Mathematical Fiction Homepage*. College of Charleston, n.d. Web. 16 June 2011.

"The Life and Death of Jeremy Bentham." *Lost: The Complete Collection*. Creators J. J. Abrams, Jeffrey Lieber, and Damon Lindelof. Walt Disney Studios Home Entertainment, 2010. DVD.

"The Pants Alternative." *Big Bang Theory: The Complete Third Season*. Creators Chuck Lorre and Bill Prady. Warner Home Video, 2010. DVD.

A Survey of Fictional Mathematics in Literature

Alex Kasman

A Serious Role for Science Fiction

> Few series can claim to have inspired more people to become scientists and engineers than *Star Trek*.
>
> — Sumit Paul-Choudhury, *New Scientist*, April 2009

Science fiction, called "sci-fi" by some but known as "SF" by its fans, does not have a great reputation. Regarded as light entertainment by many and as "genre fiction" in literary circles, few people take it seriously. However, in as much as we wish to ensure that sufficiently many students choose to study science, we must give it some serious consideration, as the opening quotation from *New Scientist* magazine indicates.

There are many factors affecting opinions about science among the general population, and young people in particular, including its presentation in school, documentaries, news stories, and science fiction. Among these, science fiction stands out precisely because of its defining characteristic: works of science fiction present hypothetical scientific advances beyond what is presently known or possible. Consider the transporter in *Star Trek*, the resurrection of dinosaurs in *Jurassic Park*, and the amiable droids from *Star Wars*. It is not difficult to see how these bits of "fictional science" could captivate audience members, some of whom then choose to become personally involved in turning the fantasy into reality and pursue careers in science. On the other hand, the presentation of scientists in works of fiction can also have the opposite effect. If their work is always shown as leading to unforeseen disasters or if they are presented as being failures in their social lives, then even if these stereotypes are untrue they may have the effect of convincing students to avoid careers in the sciences. Consequently, scientists and others interested in the advancement of science have reason to pay attention to trends in science fiction.

For similar reasons, since 1999 I have been interested in categorizing works of fiction that present images of mathematics or mathematicians. (The results of my efforts are publicly available at my *Mathematical Fiction Homepage*, an interactive web database.) In part, it must be admitted, this is simply an enjoyable hobby of mine, like collecting seashells. However, in collecting a list of (presently) more than 1010 works of "mathematical fiction," I

have learned quite a bit about how the general public views mathematics and how fiction shapes those opinions. Ideally, it would be nice to see works of fiction that could inspire people to become mathematicians just as *Star Trek* has inspired a generation of scientists. Therefore, this paper will consider the mathematical analogues of the transporter and those other scientific wonders acknowledged as having been inspirational. In other words, we will look at the fictional mathematics that appears in some works of fiction.

Fictional Math Versus Mathematical Fiction

> The mind can be stimulated by fancies as well as by rigorous thought, and I hope that many a high-school student who is legitimately bored to death by the mathematics taught in many of our classrooms will find himself seduced into genuine mathematical curiosity by the thought-provoking stories of Huxley and Capek, the whimsy of Russell Maloney, the humor of Martin Gardner, the troubling problems posed by Arthur C. Clarke.
> — Clifton Fadiman, Preface to *Fantasia Mathematica*

Most works of fiction appearing in my database are not really the mathematical analogues of the genre of science fiction. The film *Good Will Hunting* addresses the social pressures on a fictional mathematical prodigy from a poor neighborhood. The novel *Beyond the Limit* (Spicci) presents a fictionalized account of a small portion of the life of the real mathematician Sonia Kovalevskaya in nineteenth-century Europe. They appear on my list of mathematical fiction since each is a work of fiction that involves a great deal of mathematics and characters who are mathematicians. However, if these had involved physics or biology instead, they would not be what people normally consider to be "science fiction." The genre of science fiction is characterized not by the presence of scientists or discussions of real science, but by the presence of science which is itself fictional.

It is my impression, unsupported at this point by any statistical analysis, that fictional mathematics in literature is relatively rare. In particular, whereas a very large percentage of the works of fiction that significantly involve science include some fictitious scientific discoveries or applications (and are therefore science fiction, by definition), most of the works of fiction discussing mathematics seem to go to great lengths to avoid discussions of fictional math. Consider, for example David Auburn's play *Proof.* Despite the fact that the plot centers on the question of authorship of a mathematical proof, no hint is given in the script as to what it was that was proved. Of course, the success of the play (it won a Pulitzer Prize and was made into a film) attests to the fact that it was not necessary to state the relevant theorem or even to indicate in which branch of mathematics it resided. Nevertheless, I cannot help but feel that had the character of the father been an experimental scientist rather than a mathematician then more details regarding the nature of his exciting research would have been revealed.

Many other authors who discuss mathematics more directly than Auburn still avoid introducing any fictional mathematics by referring to some famous conjectures or results from the history of mathematics. The Riemann Hypothesis, fractals, the Four-Color Problem, and Gödel's Theorem are frequently mentioned in works of fiction. However, it is important to note that these are all real mathematics and, unless something additional is done with them to push them beyond what really is known, their inclusion is not really analogous to the fictional discoveries which characterize science fiction. For example, Tom

Stoppard's play *Arcadia* features a fictional prodigy, Thomasina, in the nineteenth century who goes well beyond the homework assigned by her tutor and makes startling mathematical discoveries. The discoveries she makes are described in great detail, but unlike the character, they are not fictional. Instead, Stoppard has Thomasina discover the connection between functional iteration and fractal geometry: this connection was one of the major discoveries in real mathematics during the second half of the twentieth century. This is an effective technique, simultaneously making the character appear undeniably brilliant to audience members who are familiar with this mathematics and introducing this interesting subject to those who are not. However, it does keep the play from being an example of the sort of fictional mathematics that this essay is intended to address.

So far as I know, what follows is the first formal survey of fictional mathematics in literature. It will offer a categorization scheme and examples of actual novels, short stories, plays, and films that fit into the designated categories. In the end, I hope to have a sufficiently representative view of this particular body of literature that we can determine whether fictional mathematics, like the fantastical scientific advances in the genre of science fiction, has the potential to benefit the field by generating interest and attracting students to mathematical careers.

Applied Math: The Magic Formula

> KLAATU: All you have to do now is substitute this expression at this point.
> BARNHARDT: Yes — that will reproduce the first-order terms. But what about the effect of the other terms?
> KLAATU: Almost negligible... With variation of parameters, this is the answer.
> BARNHARDT: How can you be so sure? Have you tested this theory?
> KLAATU: I find it works well enough to get me from one planet to another.
> — *The Day the Earth Stood Still*

In some works of mathematical fiction, a new formula or computation explains a character's ability to do something in the real world. According to the usual dichotomy, such discoveries lie in the realm of "applied mathematics" rather than "pure mathematics." Many mathematicians consider this distinction to be arbitrary, imaginary and indeed harmful. To those who agree with this view, there is no need for me to justify the inclusion of these sorts of fictional discoveries in this discussion. Others, however, exclude from the category "math research" any discovery which fails to advance our understanding of the abstract objects of mathematics themselves but instead only uses them to tell us something new about the real world. This is not my position, but even if it were, there are reasons to include in this survey a discussion of these "magical formulas" in fiction.

For one thing, whatever powers may be attributed to fictional formulas, whether the ability to predict the future, to destroy an opponent's nuclear weapons, or to travel through space (as in the scene above from the film *The Day the Earth Stood Still* [1951]), these applications may convince the reader of a work of fiction that mathematics research is valuable.

Moreover, although some of these applications may appear fantastical, the underlying idea that knowledge of a certain formula or equation could endow one with abilities in the real world is not entirely unrealistic. Consider some real examples. James Clerk Maxwell's equations describing the interaction between electrons and magnets suggested to him the

existence of electromagnetic waves, laying the theoretical foundation for the microwave ovens and cell phones that are used today. Paul Dirac predicted the existence of positrons (now used in hospital PET scans) from his formulas for relativistic quantum physics. Nancy Kopell was able to use a mathematical model to figure out how nematode swimming works at the neuronal level when experimental biologists could not. And Ed Belbruno's application of chaos theory to the trajectories of space craft has revolutionized the way space probes get to their destinations. Clearly, it is true that a formula can give one powers.

In fact, mathematical discoveries play a role in many scientific and technological advances, though they often contribute to the early stages and so may not receive the special recognition reserved for the final ones. Thus, the final reason that the fictional characters creating and applying new formulas may be of interest to us here is that it may reveal something about the way this role of mathematics is understood by the general public.

A good example of this category is the novel *Ground Zero Man* (1971) by Bob Shaw. The protagonist of this Cold War thriller discovers a way to simultaneously detonate every nuclear weapon on earth, and attempts to use this power for the benefit of mankind. The author could have chosen to make this character a physicist and explain the discovery in physical terms, or an expert in computer programming who can access the computer networks controlling the nuclear devices, or a hypnotist who had gained control of appropriate people inside the military structure of every nation in the "atomic club." However, the author chose to make him a mathematician who works on guidance systems. Just by playing around with formulas on a piece of paper, this self-described 'unimportant mathematician' makes a discovery that suddenly makes him one of the most powerful people on earth. Even though the mathematics involved is not described in detail (there are vague references to "Hermite polynomials" and "Legendre functions"), this demonstrates the power of applied mathematics, turning the manipulation of symbols representing abstract objects into something that can actually change the world. The story also probably benefits from the stereotype of mathematicians as quiet and unassuming, since that makes the hero's transition to a power player more interesting than if he had been a spy or political figure all along.

A similar theme is considered in the story "Nuremberg Joys" (2000) by Charles Sheffield. Here, a mathematician is on trial for war crimes because of a weapon built using equations he wrote in a paper that initially had no obvious military application. Again, the mathematics behind the discovery is not described in detail, but Sheffield knows quite a bit of mathematics. In fact, according to the author (in the notes of the anthology *The Lady Vanishes and Other Oddities of Nature*), the story was inspired by a real research paper that he had co-authored in the *Journal of Mathematical Physics* in 1973 and by the question of whether he would be culpable should the theorems it contained have horrible consequences that he had not foreseen.

It is true, in fact, that mathematical results often have real world applications that were not imagined by their discoverers. This was the subject of a famous paper by Eugene Wigner ("The Unreasonable Effectiveness of Mathematics in the Natural Sciences," CPAM 1960). In my own short story "Unreasonable Effectiveness" (2003), the protagonist's Ph.D. dissertation studies a class of manifolds with an unusual cohomological algebraic structure, which unexpectedly turns out to have medical applications. I revisited this idea in "On the Quantum Implications of Newton's Alchemy" (2007), in which the real mathematics of Riemann-Hilbert problems finds a fictional application in turning lead into gold.

A relatively common fictional application of mathematics is time travel. Perhaps this is not so unusual a concept. Certainly, as H.G. Wells explains in the classical example, *The Time Machine* (1895), in mathematical descriptions of physics time appears to be only a fourth dimension and it is not clear (from the mathematics) why it should not be possible to control motion in that direction as it is in the other three. (Although the mathematical aspects are not generally discussed in the film versions of Wells's story, the book does specifically discuss it, and attributes the time traveler's inspiration to a lecture on four-dimensional geometry by Simon Newcomb to the New York Mathematical Society.) In fact, by the early twentieth century, science had begun to catch up with this bit of fiction and physics, in the form of special relativity, did indeed describe reality as a four-dimensional Minkowski manifold in which time was not entirely distinguishable from space, even though "time travel" per se was not possible. And then, Kurt Gödel's "gift" to Einstein (a solution to the equations of general relativity in which time loops back on itself) justified the notion that time travel is mathematically (if not yet realistically) possible.

Other stories in which the ability to travel in time is specifically attributed to some applied mathematics are *The Janus Equation* (1980) by Steven G. Spruill, "Nanunculus" (2002) by Ian Watson, and "Ripples in the Dirac Sea" (1988) by Geoffrey Landis. Whereas the first two merely hint at the connections between math and time travel, the Landis story builds on real ideas in mathematical physics — near symmetry that reverses the direction of time and exchanges matter with antimatter using the same mathematics that Dirac used to discover antimatter in the first place — which almost makes sense when you read it.

A final common application of mathematics in fiction is prediction of human behavior. In fact, there are many non-fictional applications of mathematics in prediction. From the ability to predict the timing of celestial events like comets and eclipses to actuarial predictions of mortality rates of an insurer's clients, mathematics clearly does have predictive powers. However, the idea that a breakthrough in mathematical research might allow highly accurate and long-term predictions of human behavior and politics clearly appeals to readers.

One of the most famous applied mathematicians in fiction is Hari Seldon, the inventor of "psychohistory" in Isaac Asimov's *Foundation* series. Using the equations of psychohistory, Seldon is able to predict the future of humanity: wars, famine, political upheavals, and the like. His followers use this powerful mathematics to steer the course of history (presumably for the better). Although the idea that such things could be predicted mathematically seems quite unlikely to me (as sensitive dependence on initial conditions and a multitude of factors that cannot be sufficiently measured in advance would render any predictions inaccurate), this same concept was used not only in the *Foundation* series and its numerous official sequels, but also in other books such as the parody *The Dark Side of the Sun* by Terry Pratchett, *The Chimera Prophesies* by Elliot Ostler, *In the Country of the Blind* by Michael Flynn, and *Psychohistorical Crisis* by Donald Kingsbury.

The last two of these are notable for the extent to which they attempt to flesh out the vague mathematical justifications of Asimov's original concept, and hence contain the most fictional mathematics. *In the Country of the Blind* uses the term "cliology" for the science of using mathematics to predict future history, and goes so far as to include an appendix that explains the subject in detail, as if it were a chapter from a genuine textbook on the subject. (This raises fictional mathematics to a whole new level by not merely mentioning it in a story but actually simulating the mathematical texts that would accompany such a

discovery.) *Psychohistorical Crisis*, which more clearly attempts to capitalize on Asimov's famous oeuvre without mentioning Seldon by name, does not include a separate text on the mathematics, but its author, who taught mathematics at McGill University for many years, does a decent job of including interesting mathematical tidbits throughout the novel. In particular, the primary bit of fictional mathematics here is the protagonist's discovery of a new level of psychohistory, a sort of meta-psychohistory (like Kurt Gödel's meta-mathematics, which considers mathematics itself). In particular, while being trained to be one of the elite group of mathematicians who steer the course of human history based on the discoveries of "the Founder" (a veiled reference to Hari Seldon), the protagonist realizes that his teachers and mentors have failed to take into account the possibility that some other group might also know the equations of psychohistory and be using it for other goals. His discovery that this is indeed the case makes the "classical mathematics" that they were using obsolete, but as is often the case with such a scientific revolution, the accepted dogma is not easily overturned.

Verisimilitude

> "These are metagen expansions in an n-dimensional, configurational, degenerative series."
> "What are you saying? Didn't Skriabin prove that there are no metagens other than the variational?"
> "Yes. A very elegant proof. But this, you see, is transcontinuous."
> "Impossible! That would ... but it must have opened up a whole new world!"
> — Stanislaw Lem, *Return from the Stars*

To non-experts, practitioners of any advanced discipline discussing their area of expertise can sound as if they are speaking gibberish. The dialogue between doctors on medical dramas or scientists in fiction does not have to actually say anything, but only has to sound real enough to sound believable to the audience. (*Star Trek* script writer Ron Moore once admitted in response to an audience question that the writers often simply inserted the word "tech" into the dialogue in places where there character should be saying something seemingly scientific, and that experts would later go through the script and toss in appropriate-sounding words.)

Some authors of mathematical fiction have the ability to create fictional mathematics simply by producing dialogue or prose that sounds like the sorts of things real mathematicians say. Often, this can be done without actually providing any idea of what the words mean. I propose using the word "verisimilar" (which the dictionary defines as "having the appearance of truth") to describe this sort of fictional mathematics.

Consider, for example, the dialogue in the quote above. The speaker of the second and fourth lines is an astronaut who has returned to earth after a very long journey. Due to relativistic effects, the journey was even longer than it seemed to him and nearly everyone he knew is now dead. As he explains, he develops an interest in mathematics on the trip because he believes that mathematics has a permanence that makes it worth his time while other things he might learn or think about will become obsolete once he returns. At the emotional high point of the novel, he happens to meet an old mathematician (who as a young boy, coincidentally, met the astronaut before his flight) with whom he can discuss

his interests. The terms "metagen expansions" and "transcontinuous" are never defined. To my ears, at least, this does indeed sound like a real discussion between mathematicians. However, there is more to it than mere imitation. The author uses these meaningless words to communicate an important but sad point: that even in mathematics, where "New roads arise, but the old ones lead on ... [t]hey do not become overgrown" (Lem 86), the astronaut has been left behind. Although the things he learned may not be incorrect, as often happens with scientific results over time new definitions can expand the domain of the field to such a point that a person unfamiliar with these developments would be lost — as lost as Euclid would have been if he had suddenly appeared at a conference on Riemannian Geometry.

In Frank Herbert's classic SF novel *Children of Dune* (1976), the mathematician Palimbasha is sanctioned for his heretical lectures using mathematics to explain the seemingly mystical powers of religious leader Paul Muad'Dib. An excerpt from one of his lectures is provided:

> [F]irst we postulate any number of point-dimensions in space. (This is the classic n-fold extended aggregate of n dimensions.) With this framework, Time as commonly understood becomes an aggregate of one dimensional properties. Applying this to the Muad'Dib phenomenon, we find that we are either confronted by new properties of Time or (by reduction through the infinity calculus) we are dealing with separate systems which contain n body properties. For Muad'Dib, we assume the latter. As demonstrated by the reduction, the point dimensions of the n-fold can only have separate existence within different frameworks of Time. Separate dimensions of Time are thus demonstrated to coexist. This being the inescapable case, Muad'Dib's predictions required that he perceive the n-fold not as extended aggregate but as an operation within a single framework. In effect, he froze his universe into that one framework which was his view of Time [232].

Unlike the discussion of metagen expansions above, I do not think anything can be understood from this that really affects the reading of the book. Beyond knowing that there is some mathematics being discussed which explains Muad'Dib's predictive powers, this is just meaningless "tech," like the kind that the writers of *Star Trek* have inserted by others after the fact. Nevertheless, I am impressed by how successfully Herbert is able to imitate the sound of a mathematician talking about something even though the content is essentially meaningless. It leaves me wondering what experience the author had with real mathematicians.

Greg Egan is an author who clearly reads textbooks and current research, especially in mathematical physics, to find inspiration for his science fiction stories. Much of the math that appears in his writings is surprisingly advanced but non-fictional. For instance, the novel *Diaspora* (1998) contains a long passage in which a character (who happens to be an artificial intelligence) comes to understand the Gauss-Bonnet Theorem. Similarly, *Schild's Ladder* (2002) presents a future in which physics is done using quantum graph theory (QGT), which is a real subject of mathematical research today. However, Egan delves a little bit into the category of verisimilar mathematical fiction when the characters discuss what went wrong in a disastrous physics experiment. It comes down to a mathematical discussion of QGT which sounds so real that I (as a non-expert) can only assume the results they are discussing are fictional (as I am relatively certain the disastrous experiment is).

Surreal Fictional Math

> I was looking over Ephraim Cohen's latest paper *Nymphomaniac Nested Complexes with Rossian Irrelevancies* (old Ice Cream Cohen loves sexy titles), when the trouble started. We'd abstracted, and Goldwasser and Pearl had signaled me from the lab that they were ready for the first tests. I made the *Dold* invariant and shoved off through one of the passages that linked the isomorphomechanism and the lab.
> — Norman Kagan, "The Mathenauts"

We have already considered fictional math that sounds like real math but essentially says nothing (the "verisimilar" category) and will shortly address the fictional math that is so far from reality that it conveys a false impression of the discipline ("bogus"). The works that I wish to categorize as "surreal," in contrast, are quite obviously not real math and yet do not misrepresent it, either. Most of the examples I have chosen for this category are humorous, and so one might consider them to be parodies. However, the key feature is not so much that they are funny, as that they convey some deeper truth about mathematics.

Rudy Rucker has a Ph.D. in mathematics, worked as a math professor before becoming a successful author, and still maintains a connection to academia as a computer science professor at San Jose State University. Certainly, he knows more about mathematics than the authors of the works in the "bogus" category. So when he creates fictional mathematics, as he does in *Mathematicians in Love* (2006), it reflects his deeper understanding. The protagonists in that novel (who inhabit a universe somewhat mathematically simpler than ours) come up with a theorem that completely classifies dynamical systems. Knowing that dynamical systems are mathematical objects and that many important theorems in different branches of math classify the objects of study, this seems somewhat reasonable. On the other hand, Rucker is known for being bizarre, and hence it is not as straightforward as that. In fact, the classification scheme is organized around the objects being held by the Cat in the Hat while he balances on a ball in the classic Dr. Seuss book, resulting in discussions such as this:

> Rolling a die onto a hard surface is equivalent to a fish swimming inside a teapot, with a rake handle sticking in through the spout and the six tines of the rake resting on a dish. Morphically speaking, that is. It's a simple enough system that you don't need a cake [139].

Although he lacks Rucker's mathematical bona fides, Neal Stephenson presents a surreal fair division algorithm which I find similarly hilarious while also not "bogus." The classic fair division problem (in reality) involves cutting a cake to share between two people, and the "solution" comes in the statement that one person should cut the cake and the other select the piece s/he wants. As the number of people involved increases and the objects to be shared become more difficult to divide than an essentially continuous piece of cake, the algorithms also become more complicated. However, I have never encountered in a math textbook or article an algorithm like the one in Stephenson's novel *Cryptonomicon* (1999), which involves the beneficiaries of a will physically arranging on a playing field the objects to be inherited, according to their interest in owning them.

Colin Adams, who writes the "Mathematically Bent" column in *Mathematical Intelligencer* magazine, has also created some stories that arguably belong in this category. In his short story "A Proof of God" (2009), a math professor is approached by an amateur math-

ematician who claims to have a proof of the existence of a Supreme Being based on a mathematical technique known to every math major:

> "It is a proof by contradiction."
> "Yeah?" I said, flicking a glance at my computer, wondering if I had any new email.
> "Yes, I assume first of all that there is no God and then ultimately I derive a contradiction. Therefore there must be a God."
> "And what is the contradiction?"
> "That my first wife's name was Gladys."
> "That's ridiculous."
> "Yes, it is. My first wife's name was Elba. It was my second wife who was named Gladys" [32].

To fully appreciate the humor of this passage, it may be helpful to know that real mathematicians are frequently contacted by "cranks" claiming to have proved something they could not possibly have proved. But, if that were all that occurred, this would not be an instance of fictional math. As it turns out, however, in that fictional universe at least, the titular proof is valid! Another piece by Adams which may be classified as "surreal math" is "A Killer Theorem" (2009), in which a certain approach to resolving the famous (and fictional) Gauss' Last Lemma is so enticing that merely showing it to mathematicians results in their eventual deaths as they expend their last breaths trying to prove it.

Other examples of "surreal" fictional mathematics include the theory that allows mathematicians to move ships through space with their calculations in Norman Kagan's "The Mathenauts" (1964 — see this section's introductory quote) and the sexually inspired algebra of Jeff Noon's *Nymphomation* (2000).

Bogus Fictional Math Research

> My science is founded on astoundingly flimsy assumptions, it puts its trust in groping forward movements, and stumbles over every line of its conclusions. Cantor's Theory of Quantity and Peano's Spatial Curves no longer fit the foundations that were laid by Euclid and Newton. Modern mathematics is much closer to such things as Dadaism and Cubism, atonal music and the writings of Franz Kafka, which, thank God, I have never read. On our quest for absolute truth, despondency and defeat have been our constant companions, ever since Cantor and Peano.... Take it from someone who ought to know: there is nothing more calamitous in the world than failure. Stay away from mathematics!
> — Peter Stephan Jungk, *Tigor*

In the award-winning, Australian novel *Leaning Towards Infinity* (1996), Sue Woolfe presents just about the least appealing representation of research mathematics possible. The mathematicians who attend the conference in one of the key scenes are not there to learn from or collaborate with each other. Instead, their goal is to interrupt each other's talks, shouting out objections that they know are irrelevant merely to prevent each other from being able to say anything. The only female researcher there is humiliated by the overtly sexist audience until she defiantly bares her breasts to silence her colleagues' taunts. Of course, in reality there is some competitiveness among mathematicians. However, math conferences are actually usually very pleasant and cooperative affairs, with researchers speaking freely about their current research and generally trying to help each other. (Scientists and biology and physics conferences, in contrast, can be much more defensive and argu-

mentative. Two reasons for the relative peacefulness of mathematics may be that there is general agreement as to what constitutes "proof" and that relatively little money is at stake.) Also, although it must be admitted that the mathematics community is not entirely free of sexism, it is not now and has never been as horrible as what this story presents. I do honestly fear that young readers with mathematical talent who read this book before selecting a career would be steered away from a career in mathematics because of the image it creates, especially if those readers are female.

A similarly depressing representation of the field of mathematics is provided in the novel *Tigor* (1991) by Peter Stephan Jungk. As the quote at the opening of this section illustrates, *Tigor* gives the impression that mathematics is based on "flimsy assumptions" and is the scientific equivalent of Dadaism, an artistic movement whose goal was to emphasize the meaninglessness of existence. Rather than seeing mathematics as a source of truth, as a powerful tool for understanding and manipulating the world, or even as a glorious and enjoyable puzzle, works like *Tigor* and *Leaning Towards Infinity* see it as a pointless and cruel farce. (Of course, the authors of such books are free to say what they want. However, I also claim the same "free speech" right to criticize their misrepresentations as being both misleading and harmful.)

When authors with a misunderstanding of mathematics attempt to create fictional mathematics, the result may be offensively far from what constitutes actual math research. Let me (perhaps also offensively) use the term "bogus" for fictional mathematics of this slanderous variety. For example, the main character in *Tigor* is a geometer whose research consists of collecting and studying real snowflakes with the goal of demonstrating the superiority of Euclidean geometry over fractal geometry; his graduate student's doctoral thesis project deals with computing average tidal variations for Delaware Bay. The supposed conflict between Euclidean and fractal geometry is itself misleading, but the repetitive and pointless measurements that are considered "research" in this fictional universe are so unlike real math research that I might think it was funny if I were not afraid, as above, that this misrepresentation will scare talented students away from careers in mathematics.

Since my interest in mathematical fiction and the subject of my mathematical research are each shared by a relatively small group of people, it is somewhat ironic that the only discussion of this area of research in a major work of fiction falls into this, my least favorite category. As it does in *Tigor*, the literary role of the bogus mathematical research projects in *Sad Strains of a Gay Waltz* (Dische, 1997) serves to emphasize the depressive, antisocial, and nihilistic viewpoint of the fictional mathematician. To me, Soliton Theory, which studies nonlinear waves with surprising particle-like properties, is a beautiful and amazing subject that ties together seemingly unrelated areas of math and has applications from fundamental physics to communications. Although it is true that etymologically the "solit-" part of the name is derived from the word "solitary" (and J.S. Russell's nineteenth century investigation of solitary waves), solitons can in fact interact with each other in interesting ways, and the thousands of researchers in this field collaborate and meet at very enjoyable conferences around the world. Whereas the collision of solitons affects the dynamics in a subtle but theoretically important way (Benes, 2005), the hypothesis of Dr. Waller in Dische's book is that the novel's (fictional) "solitrons" are completely unaffected by collisions. While this may be a potent literary metaphor for Waller's lack of interaction with other people, the idea that his math research would consist of nothing other than repeating

the same numerical experiments over and over and failing to notice an effect is certainly *bogus.*

Other possible instances of bogus fictional mathematics include *Do the Math* (2008) by Philip Persinger, in which the mathematician's research involves "inevitability" in the context of a human life; the attempt of one mathematician to "penetrate zero" in the film *The Gold Cup* (2000); and the complete lack of order and uselessness of numbers demonstrated by the research of one character in John Banville's *Mefisto* (1986).

Note that it is not necessarily the case that I dislike books containing bogus fictional mathematics. In Robert Littell's *The Visiting Professor* (1994), the protagonist has become famous for looking for but being unable to find any pattern in finite sequences of digits from the decimal expansion of π. Like the results I list above, this one is more experimental and does not involve proof, which is really a fundamental aspect of math research. I would hate for anyone to think that this negative result really represents the epitome of mathematical achievement. On the other hand, this is one of the mathematical novels that I highly recommend to people when I am asked for such suggestions.

Plausible Fictional Math

> It was as beautiful and satisfying as Joan could have wished, merging six earlier, simpler theorems while extending the techniques used in their proofs.... It was not a matter of everything in mathematics collapsing in on itself, with one branch turning out to have been merely a recapitulation of another under a different guise. Rather, the principle was that every sufficiently beautiful mathematical system was rich enough to mirror in part — and sometimes in a complex and distorted fashion — every other sufficiently beautiful system. Nothing became sterile and redundant, nothing proved to have been a waste of time, but everything was shown to be magnificently intertwined.
>
> — Greg Egan, "Glory"

Perhaps the most intriguing category that will be considered here is the one containing results that sound the least remarkable. In particular, if an author is able to devise a bit of pure mathematics that is essentially plausible despite being entirely fictional, that is truly a remarkable achievement. In any research discipline, being able to come up with an open problem worth considering is difficult as one is frequently overwhelmed with all that is known and does not see room for new discoveries. In mathematics, this is even more difficult as many naive conjectures are easily shown to be false. Consequently, fictional mathematics that is not vacuous (as are the meaningless examples in the "verisimilar" category) and not entertainingly ridiculous (which I have put in the "surreal" category), and yet seems like real mathematics (unlike the "bogus" examples) is a rare treat.

Consider, for example, the "wild number problem" from Philibert Schogt's *The Wild Numbers* (2001):

> Beauregard had defined a number of deceptively simple operations, which, when applied to a whole number, at first resulted in fractions. But if the same steps were repeated often enough, the eventual outcome was once again a whole number. Or, as Beauregard cheerfully observed: "In all numbers lurks a wild number, guaranteed to emerge when you provoke them long enough." 0 yielded the wild number 11, 1 brought forth 67, 2 itself, 5 suddenly manifested itself as 4769, 4, surprisingly, brought forth 67 again. Beauregard himself had found fifty different

wild numbers; the prize money was now awarded to whoever found a new one.... This was not as easy as it looked: the higher the initial number, the more complicated the calculations became ... [a]nd when at last a wild number did reveal itself, it was usually one that had come up before, like 67 [34].

Although the author has not provided us with enough information about the "deceptively simple operations" to truly define the problem, the basic idea is both clear and realistic. This combination of a dynamical system on the rational numbers and the number theoretic problem of trying to identify the integers that will arise in each orbit — reminiscent of the Collatz problem — sounds like the sort of problem that can become famous as a challenge in pure mathematics, much as Fermat's Last Theorem was and Goldbach's Conjecture continues to be.

Although Fermat's Last Theorem and Goldbach's Conjecture are some of the best known mathematical statements among non-mathematicians, they are not especially useful. Some of the results most appreciated by mathematicians are those that relate the different branches of mathematics: for instance, Stokes' Theorem and the Atiyah-Singer Index theorem (each of which relate calculus to topology), Hilbert's Nullstellensatz (relating algebra and geometry), and the Langlands Program (relating representation theory and number theory). The opening quote from Greg Egan's *Glory* (2007) is a description of a grand result of this form discovered by an ancient alien species. When rediscovered by a human "xeno-mathematician," this fictional mathematical result unifies all of the branches of mathematics.

Richard Grant's short story "Drode's Equations" (1981) also involves the rediscovery of an old result. The equations of the title have been lost for so long that they have taken on an almost mythological significance when they are rediscovered by a historian in his own family library. These equations of mathematical physics are notable for one special feature: they provide a thoroughly accurate description of the physical universe without any variable representing time. This suggests that time, as we perceive it, is only an illusion and its use in mathematical physics (in the form of the variable t on which functions depend and with respect to which differentiation takes place) is unnecessary.

The search for a theory which would combine the presently separate (and essentially irreconcilable) theories of gravity and quantum mechanics is a goal of many real mathematical physicists today. So, having some character(s) discover such a theory is an obvious plot device for an author of mathematical fiction. Greg Egan is one of the few authors whose literary descriptions of such theories are detailed enough to constitute "fictional mathematics" (since I would not consider merely stating that such a theory has been discovered in itself to be sufficient). The quantum graph theory of *Schild's Ladder* has already been mentioned above. The act of discovery of such a theory is also the focus of his novel *Distress* (1995), which takes place at a conference under threat by terrorists who fear that a "theory of everything" will be disastrous. And Mark Alpert's 2008 novel *Final Theory* is based on the idea that, contrary to the popular belief that he spent his last decades of research on an unsuccessful attempt to discover a theory of quantum gravity, Albert Einstein did indeed find one and hid it because it was too dangerous.

Just as I would not consider mentioning that a "theory of everything" has been discovered without providing any mathematical details to be "fictional mathematics," proposing that a character has resolved some real, famous open problem of mathematics is only

"fictional mathematics" to me if the method of resolution is sufficiently discussed. As an example, please allow me to suggest my own short story "The Exception" (2005). In it, a college student participates in a research project to finally determine whether it is true, as is supposed in the famous Goldbach's Conjecture, that every even number greater than two is a sum of two prime numbers. A professor is able to prove that this is so for every even number greater than a certain very large number by decomposing even rank vector bundles over surfaces into a direct sum of two vector bundles of prime rank. (Certainly, if such a decomposition of vector bundles exists then that would indeed answer the question. However, I do not have any idea of how to prove that it does, which is why this is fiction.) The student is brought on to write a computer program to test the (finitely many) remaining even integers whose statuses in regards to the conjecture were not resolved by the professor's geometric approach. Surprisingly, he determines that there is in fact only one even integer greater than two which cannot be written as a sum of two primes, and it is later determined that this is not merely a mathematical oddity but a useful fact in mathematical physics. (Of course, it is most likely the case that the conjecture is true and that no such number exists, though we have no proof at the moment of that fact. If the conjecture is false, then it is probably the case that there are infinitely many counter-examples. However, in this fictional universe that was under my control, I chose to have there be exactly one exception, which seems like the most interesting possibility of all.)

Two very nice examples of plausible fictional mathematics build upon the work of Kurt Gödel. Gödel's Theorem tells us that any axiomatic system including the rules of arithmetic is either incomplete or inconsistent. Or, to put it another way, one of two unpleasant possibilities must be the case: either there are mathematical statements that can never be proved within the system to be true or false or there are contradictory statements both of which can be proved true. In *The Oxford Murders* (2004), Guillermo Martínez plays upon the analogy between the first possibility and Heisenberg's Uncertainty Principle in quantum physics by introducing a refinement, "Seldom's Theorem," that divides mathematical statements into a microscopic regime where Gödel's threat of unresolvability applies and a macroscopic regime where it does not. (In fact, no such enhancement of Gödel's Theorem has been proved. However, being a professional mathematician when not writing thought-provoking novels, Martínez knows that this is an intriguingly plausible idea.)

That some "true" mathematical statements cannot be proved from axioms is a weakness that many mathematicians find unpleasant. However, the other possibility, that math is actually inconsistent, is actually far worse. This is illustrated in Ted Chiang's "Division by Zero" (1991), a short story in which a great mathematician discovers a proof—a thoroughly valid proof—that any two numbers are indeed equal. Her husband, a non-mathematician, does not understand why this is so devastating to her, but to her suicide seems like the only option since mathematics was not only her career but really the basis of her worldview.

Meta-Math

"Yes, but he thought them in machine code," she says. "Or, to put it another way, in mathematics. Einstein was able to think relativity into existence because he could think it in to the very fabric of the universe. And, of course his theories

were plausible. They went with what had come before, even if they seemed coun-
terintuitive."

I make a little gasping noise. "Mathematics. Of course." That's what machine
code is made from. That's what makes the laws of physics.

— Scarlett Thomas, *The End of Mr. Y*

Another sort of "fictional math" is really fiction about mathematics and its relationship
to the universe rather than an imagined mathematical result itself. In particular, whereas
the stories containing "bogus" fictional math described earlier may portray math as an
obscure and useless discipline with no relationship to reality and the "magic formula" stories
show it to be a useful tool, those in this "meta-math" category suggest that reality really is
mathematics in a fundamental way.

For instance, as was already mentioned, "The Mathenauts" (1964) begins with the
premise that mathematical knowledge can allow one to travel from one part of the universe
to another. The conclusion of this same short story introduces the suggestion that this works
because mathematics is the real reality and that physical objects (including humans ourselves)
are simply specific mathematical objects.

One fundamental difference between the idea that math is a tool for studying the uni-
verse (which, I suspect, is what most people imagine it to be) as compared to this more dra-
matic idea that mathematics is the universe is that in these "meta-mathematical" stories,
mathematicians can actually change reality through their proofs and computations. This is
made explicit, for example, in the quote above from Scarlett Thomas' novel *The End of Mr.
Y* (2006), where the analogy is suggested that mathematics is to the universe as machine
code is to computers. Machine code is the very lowest level computer programming language,
the one directly understood by the chips and generally the most obscure. Whereas many
people are familiar with programming languages in which the commands look like words
and have a somewhat familiar syntax, in machine code even the commands look just like
numbers. Moreover, by directly altering specific memory locations in arbitrary ways, machine
code can change a computer in ways that ordinary computer languages will not normally
allow; the mind-blowing resolution of *The End of Mr. Y* suggests that math can do the same
for reality with Einstein's "creation" of relativity as an example. The same idea is (less explic-
itly) explored in the serial "Logopolis" of the BBC television show *Doctor Who* (the episode
is about a planet of mathematicians whose computations essentially create the universe) and
in the "pulp" sci-fi stories "The Living Equation" (Schachner, 1934) and "Mathematica"
(Fearn, 1936).

Greg Egan's sequence of short stories "Luminous" (1995) and "Dark Integers" (2007)
present another sort of meta-mathematics in which different mathematical truths apply in
different parts of the universe (or perhaps different universes) and in which the boundaries
between these different realities can be moved or altered by proofs and computations. (Hence,
as our reality comes under threat from a competing reality, the heroes have to do some
mathematics to fortify the border and protect us from being "proved" out of existence.)

Concluding Remarks

All of the fictional mathematics in literature that we have considered fits into the
following categories: plausible (good enough that it might be true), bogus (conveying an

offensively incorrect impression of mathematical results), verisimilar (sounding sensible but saying nothing), applied (citing some fictional mathematical result as the means to make something happen in the physical universe), surreal (revealing some truth about mathematics through a creatively twisted parody of it) and finally meta-mathematical (in which reality is nothing other than mathematics itself).

If our interest in fictional mathematics lies only in its ability to interest people in mathematics, then we can probably rule out the "verisimilar" and "bogus" categories from the start. The "verisimilar" category would not be likely to win many students over to a greater appreciation of mathematics. In fact, the vacuousness of it might reinforce a negative opinion of the subject as being overly complicated and not sufficiently useful or interesting. And, of course, the category I labeled as "bogus," by definition, contains works of fiction that would not be likely to interest people in becoming mathematicians. (In fact, if math research consisted of repeating the same meaningless numerical experiment ad infinitum, computing average tides, or failing to find a pattern in the decimal expansion of the number π, then I would not be interested in it either!)

The "surreal" and "plausible" categories are the two that are most likely to appeal to those who already know and appreciate mathematics. However, their similarity to real math (which is precisely what would appeal to this audience) also limits their power to attract those who have not yet become interested in the subject. In particular, if encountering real mathematics has not already interested a reader in it, then one may wonder why a fictional substitute might. In fact, there are some reasons that works in these categories are more effective than one might think. One thing is that students who are "math phobic" can approach the discipline from another direction when it is the subject of fiction. In this new context, they may see something in it that they have not previously appreciated. Moreover, the emotional aspects of fiction (the humor of the "surreal" or perhaps some non-mathematical plot development in a "plausible" story) also bring something to math that many people have not encountered before, as math is often taught as completely dry and emotionless in many lower-level courses. Finally, it must be admitted that much lower-level mathematical material is indeed relatively uninteresting, and that some of the most interesting ideas and objects are generally only introduced in advanced math courses. Yet, it is possible to introduce some of these objects and ideas in a less sophisticated way as part of a work of fiction.

The "applied" category appears to be surprisingly effective at interesting people in mathematics. In particular, if mathematics is presented in fiction as being able to achieve some goal that is clearly beyond our ability at this point (whether it is interstellar travel or curing disease), this seems to be able to capture the attention of someone who may not have considered math useful before and gives him or her an appreciation for mathematics. This is somewhat ironic, I think, since I certainly can point to many real situations in which math was useful in history (in creating cell phones, for instance). However, either because an old discovery seems less interesting or because people do not believe that the mathematical steps were really essential for it, fictional discoveries appear to be more effective.

Similarly, my experience with the students in my "Math in Fiction" class at the College of Charleston leads me to believe that "meta-mathematical" fiction is also more effective at changing the minds of those who have not previously expressed an interest in math than it should be. In particular, the claims of these stories are generally so far-fetched, it would

not really be logical to find them convincing evidence for the power of mathematics. Yet they do seem to work, and I think I know why. The fact is, most students have never thought about mathematics. They may do some thinking in mathematics, when challenged with a difficult problem, but they do not think much about mathematics itself. Reading these stories may not actually convince anyone that reality is nothing other than mathematics, but it may get people thinking about what math really is and recognizing that it is quite a bit more interesting than just a difficult subject to study in school.

So, to summarize the conclusions we reach from this analysis regarding how fictional mathematics may affect the public's appreciation of mathematics, it appears that some small subset (that in the "bogus" or "verisimilar" categories) may not help and may actually worsen the situation, but that most of it really can be very effective in interesting people in mathematics.

The next question to address is the rarity of fictional mathematics. Note that I have cited relatively few examples of works containing fictional mathematics (a rather small percentage of the over 880 works listed on my website and a tiny percentage of the total number of works of fiction). As I have said, I believe that fictional mathematics is quite rare, and that authors try to avoid it as much as possible either by saying nothing or by referring to some real math that they know.

Perhaps the rarity of fictional mathematics in literature is not mysterious. Two possible explanations present themselves immediately:

- Most mathematicians have been put in the situation of trying to answer the question, "What is it you do?" for a stranger at a party. Apparently, many people who can imagine what the job of a scientist entails are mystified as to what constitutes math research. "Is it like doing really huge long division problems which require months of calculation?" If this lack of familiarity with the activities of researchers in mathematics is shared by authors, then it is no longer mysterious that they feel that they are unable to come up with reasonable-sounding but novel research activities for their mathematician characters, resorting instead to describing real math research that they have read about or simply avoiding the subject entirely.
- Even those who understand the idea that math research involves proving theorems about abstract mathematical objects may be stymied in trying to imagine fictional mathematical results by their lack of familiarity with those objects. As compared with the objects of study of biologists, chemists, and physicists, the things studied by mathematicians (such as vector bundles, p-adic numbers, non-commutative geometry, etc.) are difficult to think about. Being able to understand what has been done with them already is sufficiently challenging, and speculating about possibilities beyond what is known is simply too difficult.

Ironically, in either case, these causes of the scarcity of fictional mathematics could both be at least partially alleviated by mathematical fiction itself. That is, instances of fictional mathematics appearing in literature could increase awareness of mathematical research and familiarity with mathematical objects, thereby leading to further increases in the frequency of mathematical research in literature in a positive feedback loop that would be beneficial for the mathematical community. In fact, there has been quite a lot of mathematical fiction published in the past two decades. If this hypothesis is correct, then it may be part of a

trend that leads to a greater understanding and appreciation of this important academic discipline.

Works Consulted

Adams, Colin. "A Killer Theorem." *Riot at the Calc Exam and Other Mathematically Bent Stories*. Providence: American Mathematical Society, 2009. 179–88.

_____. "A Proof of God." *Riot at the Calc Exam and Other Mathematically Bent Stories*. Providence: American Mathematical Society, 2009. 31–40.

Alpert, Mark. *Final Theory: A Novel*. New York City: Pocket Star, 2009.

Asimov, Isaac. *The Foundation Trilogy*. New York: Bantam, 2004.

Auburn, David. *Proof: A Play*. New York: Faber, 2001.

Banville, John. *Mefisto*. New York: Godine, 1989.

Benes, N., A. Kasman, and K. Young. "On Decompositions of the KdV 2-soliton." *Journal of Nonlinear Science* 16.2 (2006): 179–200.

Chiang, Ted. "Division by Zero." *Full Spectrum 3*. Ed. Lou Aronica, Amy Stout, and Betsy Mitchell. New York City: Broadway, 1991. 196–211.

The Day the Earth Stood Still. Dir. Robert Wise. 20th Century–Fox, 1951. Film.

Dische, Irene. *Sad Strains of a Gay Waltz*. Holt, 1993.

Egan, Greg. "Dark Integers." *Asimov's Science Fiction Magazine* Oct./Nov. 2007: 20–51.

_____. *Diaspora*. New York: Eos, 1999.

_____. "Glory." *The New Space Opera*. Ed. Gardner Dozois and Jonathan Strahan. New York: Eos, 2007. 88–112.

_____. "Luminous." *Asimov's Science Fiction Magazine* Sept. 1995: 20–56.

_____. *Schild's Ladder: A Novel*. New York: Eos, 2004.

Fadiman, Clifton, comp. and ed. *Fantasia Mathematica: Being a Set of Stories, Together with a Group of Oddments and Diversions, All Drawn from the Universe of Mathematics*. New York: Springer-Verlag, 1997.

Fearn, John Russell. "Mathematica." *Astounding Stories* Feb. 1936. 64–87.

Flynn, Michael. *In the Country of the Blind*. New York: Tor, 2003.

Grant, Richard. "Drode's Equations." *The Ascent of Wonder: The Evolution of Hard SF*. Ed. David G. Hartwell and Kathryn Cramer. Akron: Orb, 1997. 278–87.

Good Will Hunting. Dir. Gus Van Sant. Perf. Matt Damon, Robin Williams, and Ben Affleck. Miramax, 1998. Film.

Herbert, Frank. *Children of Dune*. New York: Ace Books, 1987.

Jungk, Peter Stephan. *Tigor*. Handsel, 2003.

Kagan, Norman. "Mathenauts." *Mathenauts: Tales of Mathematical Wonder*. New York: Arbor, 1987. 286–300.

Kasman, Alex. "The Exception." *Reality Conditions: Short Mathematical Fiction*. Washington, DC: The MAA, 2005. 101–10.

_____. *Mathematical Fiction Homepage*. College of Charleston, n.d. Web. 23 Sept. 2010. http://kasman. people.cofc.edu/MATHFICT.

_____. "On the Quantum Theoretic Implications of Newton's Alchemy." *Analog Science Fiction and Fact* Oct. 2007. 74–83.

_____. "Unreasonable Effectiveness." *Math Horizons* Apr. 2003: 29–31.

Kingsbury, Donald. *Psychohistorical Crisis*. New York: Tor, 2002.

Landis, Geoffrey. "Nuremberg Joys." *Asimov's Science Fiction* Mar. 2000: 41–53.

Lem, Stanislaw. *Return from the Stars*. Chicago: Harcourt, 1989.

Littell, Robert. *The Visiting Professor: A Novel*. 1994. Boston: Penguin (Non-Classics), 2009.

"Logopolis." 4 episodes. *Doctor Who*. BBC. 28 Feb.–21 Mar. 1981. Television.

Martínez, Guillermo. *The Oxford Murders*. London: Penguin, 2005.

Noon, Jeff. *Nymphomation*. New York: Anchor, 2000.

Ostler, Elliot. *The Chimera Prophesies*. W. Conshohocken, PA : Infinity, 2007.

Persinger, Philip. *Do the Math: A Novel of the Inevitable*. New York: iUniverse, 2008.

Pratchett, Terry. *The Dark Side of the Sun*. New York: St Martin's, 1976.

"Ron Moore Calls *Star Trek*'s Tech 'Meaningless.'" *Blastr*. Syfy, 12 Oct. 2009. Web. 14 Feb. 2010.

Rucker, Rudy. *Mathematicians in Love*. New York: Tor, 2008.

Schachner, Nathan. "The Living Equation." *Astounding* Sept. 1934. 6–19.

Schogt, Philibert. *The Wild Numbers*. New York: Plume, 2001.

Shaw, Bob. *Ground Zero Man*. New York: Avon, 1971.

Sheffield, Charles. *The Lady Vanishes and Other Oddities of Nature (Five Star First Edition Science Fiction and Fantasy Series)*. Barcelona: Five Star, 2002.

_____. "Ripples in the Dirac Sea." *Asimov's Science Fiction* Oct. 1988. 86–97.

Spicci, Joan. *Beyond the Limit*. New York: Forge, 2002.

Spruill, Steven G. *Binary Star #4: Legacy/The Janus Equation*. New York: Dell, 1980.

Stephenson, Neal. *Cryptonomicon*. New York: Avon, 2002.

Stoppard, Tom. *Arcadia*. Oxford: Faber, 1994.

Thomas, Scarlett. *The End of Mr Y*. Edinburgh: Canongate, 2007.

Watson, Ian. "Nanunculus." *The Great Escape*. Urbana: Golden Gryphon, 2002. 120–34.

Wells, H.G. *The Time Machine*. London: Heinemann, 1895.

Wigner, Eugene. "The Unreasonable Effectiveness of Mathematics in the Natural Sciences." *Communications in Pure and Applied Mathematics* 13.1 (1960): 1–14.

Woolfe, Sue. *Leaning Towards Infinity*. Boston: Faber, 1996.

"You Never Said Anything about Math"

Math Phobia and Math Fanaticism in the World of Lost

Kristine Larsen

Introduction

Four, eight, fifteen, sixteen, twenty-three, forty-two: these six numbers permeate the universe of the hit science fiction television series *Lost* (2004–10). From the flight number of the castaways' plane (Oceanic 815) to the seat numbers of various characters on that ill-fated flight, the viewers and writers of the series were involved in a constant game to find as many instances of these seemingly magical numerals as possible. As the series drew to the conclusion of its sixth and final season, the "Numbers" (as they are termed) continued to fascinate and confound the show's legions of loyal and detail-oriented fans. But even casual viewers could not ignore myriad other mathematical references contained within the series. Horace Goodspeed (Doug Hutchison), the one-time leader of the Island's DHARMA Initiative, was a mathematician (his role proudly embroidered on his Initiative-issued work clothes), as was Dr. Daniel Faraday[1] (Jeremy Davies), the brilliant but troubled theoretical physicist and mathematician who experimented with time travel at the expense of his own (and others') mental health. In Season 5's "The Variable," a young Daniel is easily able to keep track of the total number of metronome counts (864) that occur while he is playing a Chopin piece on the piano. Though Daniel has a passion for music, his mother, Eloise Hawking (Fionnula Flanagan), tells him that he must focus on science, setting him on the path which eventually leads him to master the physics and mathematics of time travel. It is a path she knows will ultimately result in Daniel's untimely death on the Island (in a past timeline, at her own hands while she is pregnant with him).

Equations adorn maps, blast doors, and blackboards, serving as tantalizing clues for dedicated *Lost*-heads. These same formulae simultaneously speak to the general public's unease with math, which typically ranges from simple superstitions (such as a fear of the number 13) to a deep-rooted aversion or even phobia often rooted in experiences in elementary or middle school math courses. To paraphrase Winston Churchill, *Lost* is a riddle,

wrapped in a mystery, inside an enigma, topped with the bow of equations, and in equipping the show with mathematical intrigue its writers have added an additional layer of complexity to the series' already legendary mystique. Indeed, the ultimate origin and meaning of the Numbers were rumored to be among the secrets which the series took to its grave, with the exception of what was revealed in ancillary media to the series: that they represent six factors of the Valenzetti Equation, a doomsday equation which has the power to predict the means and timing of the ultimate demise of humanity.

The Valenzetti Equation has its roots in mathematical "crystal balls" created by nonfictional statisticians and soothsayers. One need look no further than the current (rather pessimistic) obsession of a segment of the population with the supposed ending of the Mayan calendar on December 21, 2012, and its alleged connections to a multitude of end-of-the-world scenarios, to understand the power of mathematics in society today. This paper will explore the complex numerology of *Lost* through the bifocals of science and society, with the goal of illuminating the carefully crafted mathematical themes which thread through the very core of the series.

Binary Bodies

One of the most important numbers in *Lost* is 2, or as represented in binary code, the dichotomy of 0 and 1. The so-called "Lostiverse" (as the *Lost* universe is known by its fans) is fundamentally based on the tension between the opposites of black and white, good and evil, science and religion, "us" and "them." Characters routinely self-identify as members of opposing groups, such as the Oceanic 815 survivors versus the "Others"; the DHARMA Initiative versus the "Hostiles"; survivors from the fuselage versus the "tailies"; and the Island itself versus the outside world. This opposition also occurs on a more individual level: for example, the series consistently explores the friction between Jack Shephard (Matthew Fox) and John Locke (Terry O'Quinn) as, respectively, a "man of science" and a "man of faith." Characters are also divided into dead and alive (this happens increasingly as the series progresses), and the fundamental division between writer and viewer (or sender and receiver) also plays an important role in the Lostiverse: the writers played a carefully crafted game of cat and mouse with their most loyal fans, sowing small bites (bytes?) of information about the show's mythos throughout the internet. The result of this accentuation of differences between groups of people and individuals has predictably been tension, mistrust, and open hostility, not only in the Lostiverse, but, as is evidenced on web boards whenever *Lost* is mentioned, also between *Lost* fans and other internet users.

In the series' pilot episode, Jin Kwon (Daniel Dae Kim) tells his wife Sun (Yunjin Kim), in Korean, that they do not need the "others" (meaning, in this case, the other survivors of the Oceanic 815 crash) and should rely solely on each other. But as Jin and the other survivors come to understand during the course of the series, isolation is deadly on the Island. As Jack explains to his fellow survivors in the show's fifth episode ("White Rabbit"), if "we can't live together, we're going to die alone." The line becomes a mantra of sorts throughout the entire series, as echoed in the title of Season 2's finale "Live Together, Die Alone," which is also the verbatim reply of Juliet (Elizabeth Mitchell) when asked in Season 5's finale, "The Incident," if she and Sawyer (Josh Holloway) should help Jack in

his seemingly insane mission to explode an atomic bomb and "reset" the timeline of the Island.

The division into "us" and "them" becomes blurred over the course of the series, further exploring the futility of rigid dichotomous labels. For example, Benjamin Linus (Michael Emerson) arrives on the Island as a child member of the DHARMA Initiative, a scientific community set up on the Island to study its unique properties and, according to the Initiative's charter, work for the benefit of humanity. As a young man, Ben betrays his father and the other members of the Initiative by killing them in a poisonous gas attack in order to join the Hostiles (who we are led to believe at that point are indigenous inhabitants of the Island).[2] Following this massacre, the Hostiles take over the DHARMA Initiative homestead and laboratories and in fact become another form of the DHARMA Initiative, although they appear to be working not for the "benefit of humanity" but for their own benefit—or, more precisely, for the Island's benefit, as defined by Jacob (Mark Pellegrino), the Island's mysterious "protector." When several of the Oceanic 815 survivors travel back in time to the 1970s, they join the DHARMA Initiative (under the pretence of being new recruits brought to the Island by submarine) in order to survive. Finally, we must recall that "us" versus "them" is inherently subjective. In Season 2's "One of Them," Jack tells Locke that Danielle Rousseau (Mira Furlan), a solitary survivor of an earlier shipwreck on the Island, tortured their friend Sayid Jarrah (Naveen Andrews) because she thought he was one of the "Others" (her term for the long-time inhabitants of the Island). Locke agrees, saying that Sayid "is one of them. To Rousseau, we're all others. I guess it's all relative, huh."

One of the dichotomies stressed in the series was between the scientific and spiritual spheres of human experience. Although the division is initially (and perhaps most obviously) introduced through the ongoing tension between John Locke ("man of faith") and Jack Shephard ("man of science") in Season 1, it became a central theme throughout the series. However, as with many aspects of the Lostiverse, this dichotomy between science and faith, which was so firmly ingrained into the series' canon from the pilot episode, also evolved as the show steamed towards its dramatic conclusion. For just as Locke lost his faith along the way—both in his belief that his life has a purpose, and more generally in the Island itself, Jack became less shackled by the confines of the scientific method and has, interestingly, become a man of faith. For example, he agrees to follow Hurley on a seeming suicide mission without question in Season 6's twelfth episode, "Everybody Loves Hugo," admitting that he has finally learned the hardest lesson of all for a scientist: that he cannot always lead the way, and that there are some things which science cannot fix.

In his famous essay "The Two Cultures," C.P. Snow warns against the expanding divide between the sciences and the humanities more generally, writing that "the number two is a very dangerous number: that is why the dialectic is a dangerous process. Attempts to divide anything into two ought to be regarded with much suspicion" (15).

Earlier in the same essay, he voiced a warning which resonates with the Lostiverse and Jack's often-uttered mantra, reminding us "each of us is alone: sometimes we escape from solitariness, through love or affection or perhaps creative moments, but those triumphs of life are pools of light we make for ourselves while the edge of the road is black: each of us dies alone" (13).

The dichotomy of "white versus black" is also demonstrated literally throughout the series, from Walt (Malcolm David Kelley) and Locke's playing of backgammon in Season 1,

to the white and black stones seen on a balance scale in Jacob's cliffside cave in Season 6. As viewers of the later seasons of the series have come to understand, the tension between white and black represents the battle between the mysterious figures of Jacob (who is presumed to represent the forces of good), and the unnamed and presumably evil "Man in Black," who can manifest himself as a monstrous column of black smoke (the "Smoke Monster") and who eventually took the form of the then-deceased John Locke. One of the earliest symbolic representations of the binary nature of black/white was in Season 1's "House of the Rising Sun," in which Jack and company find a cave which contains not only a source of fresh water, but the wreckage of a small airplane and the desiccated/mummified bodies of a man and a woman, dubbed "Adam and Eve" by *Lost* fans online. Jack finds a small pouch next to one of the bodies, which contains a white stone and black one, and pockets it without showing it to his friends. The stones appear to be a form of numerical divination dating back to the Old Testament called *urim* and *thummim* (sometimes written *thummin*) and translated as "doctrine and truth" (Driscoll). Exodus 28.1–43 details the exact vestments which were to be created for Aaron, with Exodus 28.30 explaining that "thou shalt put in the breastplate of judgment the Urim and the Thummim; and they shall be upon Aaron's heart, when he goeth in before the Lord: and Aaron shall bear the judgment of the children of Israel upon his heart before the Lord continually." Biblical scholars have interpreted this and similar passages as referring to a system of divination where yes/no answers to questions can be ascertained using black and white stones. In some versions of the system, one stone of each color is used, while in others three stones of each are used. In this second system, stones are randomly drawn out of a container, and only in the case of three stones of the same color being drawn was it said that the answer was definitive. Otherwise, it was said that God was not amenable to answering the question on that occasion (Milton 211).

Safety in Numbers

As noted in Jack's oft-repeated plea for his peers to live together or risk dying alone,[3] there is definitely "safety in numbers" on the Island. In "Homecoming," Charlie Pace (Dominic Monaghan) says precisely that to Jin as he decides to join those who are taking refuge in the caves, as opposed to remaining on the beach. But there are also other ways in which numbers or mathematical ideas help protect the characters of the Lostiverse.

Coordinate Knowledge

Numbers also provide safety (and answers) in the form of coordinates. On the Island, compasses do not work correctly, and as revealed in Season 5, the Island is in constant motion through time and space relative to the planet, so anyone traveling to and from the Island must possess exact coordinates in order to safely arrive and depart. In "Live Together, Die Alone," Michael Dawson (Harold Perrineau) is given a strict compass heading of 325 degrees (a northwest bearing) in order to safely sail away from the Island. In the same episode, Desmond Hume (Henry Ian Cusick) attempts to leave the Island by boat and ends up sailing right back to the Island's shore, presumably because he does not have the necessary numerical information.

In Season 4, physicist Daniel Faraday arrives on the Island along with mercenaries whose stated task is to capture Ben Linus. Daniel is responsible for calculating the proper space-time coordinates of the Island and directs his pilot, and others flying between the Island and their ship, to always keep to a precise heading of 305. Only the physicist and his mathematics can assure the safety of those traveling between the Island and the rest of the world. This is also seen in Season 5's "The Lie," when it is revealed that Daniel's mother, the enigmatic Eloise Hawking, is working in a DHARMA station called the Lamp Post (named for the marker where worlds come together in C.S. Lewis' *Chronicles of Narnia* series). Located under a church in Los Angeles, the Lamp Post engages a Foucault Pendulum–like apparatus to calculate the predicted position of the Island at a given time.

Constants and Variables[4]

Not only does the Island spontaneously travel in space-time, but, as a last resort, the Island can be purposefully moved. In the Season 4 finale "There's No Place Like Home," Ben Linus moves the Island in order to protect it and its inhabitants from the mercenaries and their boss, Charles Widmore (Alan Dale). However, this results in the Island and many of the show's main characters becoming "unstuck" in time and time-traveling seemingly at random. As it turns out, this can be damaging, and even fatal, for the unstuck time-travelers. Aware of the deleterious effects of time travel due to his previous experiments at Oxford, Daniel is careful to assign himself a "constant" — that is, an anchor which exists in all the time periods to which his consciousness time travels.[5] Desmond is selected as Daniel's constant, both because the two cross paths at several points in the series' convoluted timeline, and, more importantly, because Desmond seems able to bend the "normal" rules of causality and time travel: his consciousness begins uncontrollably time traveling in and out of his body once he leaves the Island and arrives on the mercenaries' freighter, presumably because his pilot strayed from the 305 setting to avoid a thunderstorm. In turn, Daniel becomes Desmond's constant, in that he is able to follow Daniel's directive to visit the past-self of the scientist in Oxford in order to learn how to stop the time-shifting. As evidence of his knowledge of the "future Daniel," Desmond is told to tell the "past Daniel" that his time-travel device needs to be turned to a setting of 2.342 and oscillate at 11 Hz.

After convincing "past Daniel" of the truth of his predicament, Desmond is told he must find his own constant in order to anchor himself in the future on the mercenaries' freighter. He chooses his ex-girlfriend (and love of his life), Penelope Widmore (Sonya Walger), and telephones her while in the year 1996, begging her to keep her current phone number until he makes a life-saving phone call eight years later. This maintained phone number provides yet another example of numbers representing a lifeline.

The stress placed on the numerical concept of a constant is interesting in its juxtaposition to the title and message of Season 5's "The Variable," in which Daniel explains to his fellow characters who have been trapped in the Island's past (1977) that even though he had previously warned them that they could not change the future, he now realizes that he had not taken into account all the variables — namely, human behavior and free will. Daniel sets into motion the plan to detonate an atomic bomb in order to "reset" the Island's timeline (with the hopes of preventing Oceanic 815 from having crashed in the first place), a plan which results in the apparent alternative time line featured in Season 6. Ironically, Daniel

does not change his own self-consistent timeline, and is still killed by his own mother. Another example of the play of variables can be found in the Season 6 opener "LA X," which is a play on the official aviation code for the Los Angeles airport (to which Oceanic 815 was bound when it crashed). In Season 6 we are introduced to the possibility of multiple timelines/parallel universes, which diverge from the point of whether or not the detonation occurred. This possible event plays the role of a variable, leading to several possible universes in which various characters are alive or dead, or otherwise have different lives than they did in the main Lostiverse.[6]

Countdowns

Numbers also aid the show's main characters via the commonly used trope of a countdown. In episodes too numerous to name, various characters use a traditional 1-2-3 or 3-2-1 countdown before attempting an action (such as lifting a heavy object, posing for a photograph, or pushing to deliver a baby), or as a warning before firing a shot. More interesting is a seemingly innocent story which Jack tells Kate Austen (Evangeline Lilly) during the pilot episode as she stitches up a wound in Jack's side using a regular needle and thread. He explains that in an earlier incident in his life, when he was faced with paralyzing fear, he was able to regain control by using a simple countdown. A spinal surgeon, Jack tells Kate that during his residency he was concluding a thirteen-hour spinal surgery when he accidentally cut the patient's dural sac. As nerves came spilling out, he was gripped by terror. Embracing free will (another key concept on the Island), Jack "made a choice. I'd let the fear in, let it take over, let it do its thing, but only for five seconds. That's all I was going to give it. So I started to count. 1. 2. 3. 4. 5. Then it was gone. I went back to work, sewed her up, and she was fine."[7]

Kate takes the lesson to heart, and later in the same episode, while running from the Smoke Monster, finds herself separated from Jack and tries to compose herself by counting to five. In Season 2's "Man of Science, Man of Faith," Kate conquers her fear once again using the countdown method when she climbs down into the mysterious Swan Station (a.k.a., "The Hatch"). In the episode "Not in Portland," a season later, Jack brokers Kate and Sawyer's escape from the Others by intentionally interrupting his surgery to remove Ben's spinal tumor, and instructs Kate to signal that she and Sawyer have reached safety by radioing back and retelling the story he had told her when they first met. Countdowns, and stories surrounding them, provide structure, safety, and a means of communication for Lostiverse inhabitants.

"The Numbers"

Nowhere else in Lostiverse is the power of mathematics more clear than in case of the Numbers, the six-numeral sequence 4, 8, 15, 16, 23, and 42. Instances of these individual numbers infest the series like a virus. The numbers 8 and 15 appear in the flight number of the crashed Oceanic plane and are painted on lab rabbits in "Every Man for Himself" and "There's No Place Like Home, Pt. 2." Oceanic 815's pilot was discovered by the flight's survivors in the remains of the cockpit 16 hours after the crash, and Hurley's hotel room in Sydney before the ill-fated flight departed was 2342. The show's writers and viewers have

engaged in an obsessive game of embedding and uncovering myriad examples of these numbers within the text of the show, from obvious examples such as the entire series of numbers being stamped onto the side of the newly-completed Swan Station as its serial number ("Some Like It Hoth") to the more subtle example of the decorations at Hurley's birthday party in "There's No Place Like Home." Here, careful viewers can identify 4 artificial palm trees, 8 birthday balloons, 15 presents, 16 party hats, and the numbers 23 and 42 printed on children's shirts.

Why these particular numbers? What do they mean? As previously noted, it has been suggested that the Island took at least parts of these answers to its watery grave. At least one of the numbers — 42 — plays a seminal role in Douglas Adams's classic work *The Hitchhiker's Guide to the Galaxy*, in which it is the "ultimate answer." It has been confirmed that this numeral choice was an homage to Adams (*Lostpedia* "Interview"). The number 23 appears in the 2007 film of the same name, in which Jim Carrey plays a character whose obsession with occurrences of that number in his life, and possible connections to a fictional novel of the same name, drive him to madness. Current interest in the number is generally attributed to psychologist, author, and former *Playboy* editor Robert Anton Wilson. His popular *Illuminatus* trilogy poked fun at various conspiracy theories involving the occult, and introduced the idea that there is some deep cosmic importance to the number 23, as recounted in his book *Cosmic Triggers*. However, Wilson is careful to point out that the number of occurrences of 23 which he found in his life was due to the fact that he was *looking* for occurrences (Wilson 45). It would be interesting to know how many occurrences of other numbers (such as 5 or 21) might likewise be found by *Lost* viewers if they were not distracted by six specific numbers. However, such rational thinking does not prevent 46 percent of Europeans and 32 percent of Americans from believing that some numbers are particularly lucky for certain people (National Science Board 2004: 7–22). The same can be said of those numbers considered unlucky.

The Numbers in *Lost* are clearly tied to ideas of luck, or lack thereof. Although the specific meaning of all six of the numbers themselves might never be revealed, their effect on one specific character's life has been explored since the show's first season. In "Numbers," it is revealed that Hugo "Hurley" Reyes (Jorge Garcia) spent some time in a mental hospital in order to deal with the collapse of a deck which caused people's deaths, and which he believed was caused by his obesity. A fellow patient, Lenny (Ron Bottitta), repeated the six numbers over and over again; upon release, Hurley played the numbers in the lottery and won a record prize of 114 million dollars. However, to Hurley's horror the numbers seemed cursed, and his good fortune soon turned into a string of bad luck. Within a short time after he won the lottery, Hurley's grandfather dies of a sudden heart attack, his priest is struck by lightning at his grandfather's funeral, his brother's wife leaves him, his best friend steals his would-be girlfriend, the house he buys for his mother burns to the ground, and he is falsely arrested. To top it off, he buys Mr. Clucks, the former fast food restaurant he suffered through working for as a low-level employee, only to have the building destroyed by the fall of a large meteorite ("Tricia Tanaka Is Dead"). Neither Hurley's deeply religious mother nor his well-meaning prodigal father can break him of his obsessive fear that he has been cursed by the Numbers. His accountant readily admits that as an accountant, he "believe[s] in numbers" ("Numbers") but dismisses the idea of a curse out of hand. In fact, he explains, some of the presumed bad luck actually worked in Hurley's favor (including

bestowing upon him large insurance settlements), which led to Hurley nearly doubling his winnings in only a few months. Hurley isn't convinced, especially when a man is seen falling to his death from an upper story window in his accountant's office building.

A visit with Lenny back at the asylum only bolsters Hurley's conviction that the Numbers will continue to plague him and ruin the lives of those around him. It is this obsession that ultimately leads him to travel to Australia, to visit the widow of Sam Toomey, the man who had told the Numbers to Lenny, and whose own obsession with the alleged curse had only ended when he had taken his own life with a shotgun. But to Hurley's surprise, Martha Toomey (Jayne Taini) isn't convinced there is a curse, and in fact emphatically argues that "You make your own luck, Mr. Reyes. Don't blame it on the damn numbers. You're looking for an excuse that doesn't exist" ("Numbers"). Interestingly, in the alternate "flash sideways" afterlife of Season 6, Hurley (still a lottery winner) explains to Sawyer that "Nothing bad ever happens to me. I'm the luckiest guy alive" ("LA X").

Hurley's obsession with the Numbers mirrors the widespread superstition of triskaidekaphobia, the fear of the number 13. The proposed sources of the superstition are many, including the contrast between the 13 lunar months in each 12-month solar year, and the perceived "perfection" of 12, including the 12 signs of the zodiac, the 12 tribes of Israel, the 12 Apostles, and the 12 chief gods of Olympus in Greek mythology. It is estimated that more than 80 percent of all tall buildings lack a 13th floor, and airports, hotels, and hospitals often omit 13 from their numbering systems (Roach 2004). Combine this deep-seated fear of the number 13 with a negative connotation for Fridays (which was, after all, the day of Christ's crucifixion) and one arrives at paraskavedekatriaphobia — the irrational fear of Friday the 13th. Reactions of individuals to Friday the 13th range from mild anxiety to full-fledged panic attacks, and people may actually change their daily routine or cancel events due to this fear. For example, a study published in the British Medical Journal found a 1.4 percent reduction in traffic on the M25 in England on Friday the 13th (Scanlon et al. 1585).

"No One Said Anything about Math"

A fear and avoidance of specific numbers in one's everyday life can certainly lead to minor obsessive-compulsive behavior; a fear of mathematics in general is more crippling, and unfortunately very widespread in our culture today. In its use of mathematics, *Lost* also highlights this unfortunate circumstance, and in the process further separates the viewers into the binary mode of casual viewer versus diehard "Lostaways." Mathematics, not just numbers, plays a significant role in *Lost*. Sayid, a former Communications Officer for the Iraqi Republican Guard, succeeds in repairing the plane's transceiver in the pilot episode, and picks up a mysterious radio broadcast emanating from the Island: a repeating distress call in French. Each time the call is iterated, it is preceded by a spoken number that identifies the total number of times — including the current instance — that it's been broadcast. Sayid quickly does the math in his head (taking into account the length of each iteration), and determines that the signal has been broadcasting for "sixteen years and five months" ("Pilot, Pt. 2").

As with many aspects of *Lost* canon, the shortwave radio transmission of the numbers walks the line between science fact and science fiction. So-called "numbers stations" are

mechanisms for one-way communications between governments and classified agencies and personnel in the field — that is, they enable "spy talk." Many of these enigmatic communications are repeating series of numbers or letters, done in a number of languages. For example, at least two numbers stations have come online since the beginning of the Iraq war, one broadcasting from England and the other from Egypt. One of the strangest stations, 30 km outside of Moscow, has broadcast the same buzzing tone, repeated at a rate of 25 times a minute, for two decades. On only two occasions were voice messages heard (Walsh 2004). Interest in these broadcasts led to the Conet Project, which produced four CDs of 150 different signals.[8]

While Sayid is clearly proficient and confident in his ability to translate the foreign language of mathematics, he is unable to understand French, and must rely on others for this piece of the puzzle. Shannon Rutherford (Maggie Grace), until this point painted as a stereotypical "blonde bimbo," steps up to the challenge and translates the message, despite her lack of confidence in her own ability. Later in the first season, when Sayid returns from a self-imposed exile after torturing Sawyer under the mistaken belief that the con man was hoarding Shannon's asthma medicine, he brings with him maps which he had taken from Rousseau's camp. These maps not only provided valuable plot points, but were among the first exercises given by *Lost*'s writers to allow fans to actively participate in unraveling the mysteries of the Island.

The methodical and calculating (quite literally) Sayid struggles with the various mathematical notations on Rousseau's maps, trying to discern whether or not they are coordinates (as he suspects) or some other quantitative indicator. As he explains to Jack, although he is "good at mathematics and decryptions" the maps' equations confound him, as do the accompanying notations written in French ("Whatever the Case May Be"). He asks Shannon for help, but she is initially reluctant, again lacking confidence in her abilities. When she does relent and begins examining the documents, she is quickly repulsed by the sight of the equations, proclaiming, "You never said anything about math." Sayid assures her that he will take care of the mathematics, and Shannon begins working on the French translation. Her translations seem like gibberish to Sayid, who is expecting "something about latitude or longitude, something about the stars" (in other words, a mathematical clue as to the Island's location), and he calls their collaboration "a mistake." Shannon is immediately consumed by her self-doubt: "Haven't you heard? I'm completely useless." Shannon later figures out the origins of the French phrases: while Shannon's translation was correct, the revealed citations had no obvious connection to anything mathematical, but instead were the lyrics to the song "La Mer" repeated over and over again (*la mer* being French for "the sea"). Several episodes later, in "Special," Sayid explains to Jack that when the maps are overlapped onto each other they form a triangle which pinpoints a location on the Island, rather than the Island's position.

In "Whatever the Case May Be," Sayid and Shannon fall into all-too-common stereotypes concerning mathematics and gender. As a man, Sayid is assumed to be mathematically proficient and as a woman, Shannon is assumed to be both mathematically inept and mathphobic. Research has shown that women avoid mathematics and disciplines which involve mathematics to a much greater degree than men, which can severely limit their choices of majors in college and eventual career paths. This is especially significant in the case of elementary school teachers, who have been reported to suffer from a higher than average level

of mathphobia or anxiety (Tobias 61; Trujillo and Hadfield 220). This author has found that among students enrolled in basic-level college astronomy courses, 39 percent of males and 44 percent of females reported some level of mathphobia in 1994. The 2005 figures were 47 percent of males and 50 percent of females, respectively (Larsen 2006). What is possibly most curious (and most troubling) about mathphobia (as opposed to a lack of confidence in other skill areas such as reading and writing) is that mathphobia is often considered normal and even expected in our society (Chinn 61). In playing into these gender stereotypes concerning mathematics (as well as painting mathematicians Horace Goodspeed and Daniel Faraday as "nerds"), the writers of *Lost* have done a disservice to their audience.

It should also be noted here that the two women who are directly connected to mathematics within the series — Danielle Rousseau and Eloise Hawking — are both portrayed in a negative light, furthering stereotypes of women in science and mathematics as not only unfeminine but abnormal. Rousseau is the only surviving member of a scientific expedition whose ship was stranded on the Island during a storm. She felt forced to kill the other members of her team — including Robert, the father of her then unborn daughter, Alex — because she felt they were "infected" (after entering the mysterious temple and presumably being exposed to the influence of the Smoke Monster). The loss of her infant daughter (who was kidnapped and raised by Benjamin Linus) and subsequent sixteen years of living alone in fear of the other inhabitants of the Island proved too much for her sanity, and she is often referred to by the other inhabitants of the Island (and by series fans) as the "crazy French woman." She has lost all social graces — one might say she has come dangerously close to losing her very humanity — and tortures Sayid with a home-made electrical device when he stumbles into one of her traps ("Solitary").

Eloise Hawking was a leader of the "Others" on the Island in the 1970s. After accidentally killing her future son (and discovering this fact by reading his journal during one of the time slips), she moved to the United States during the early months of her pregnancy and devoted her life to making sure Daniel would follow the exact path to becoming a physicist and mathematician that would ensure he would die at her hands. What is one to think of a mother who would put an Island over her own flesh and blood? If the viewer is meant to consider Benjamin Linus a monster for choosing the Island over the life of his adopted daughter Alex (who is shot and killed by mercenaries who had arrived on the Island to capture him), then there are hardly words to describe the heartless Eloise. Clearly neither woman is depicted as a positive female role model in the Lostiverse.

Rousseau's maps are just some of many examples of artifacts in *Lost* which depict mathematics. Other examples include the Blast Door Map, Daniel's Oxford laboratory chalkboard, and the blackboard in the Lamp Post station. In each such case of displayed mathematics, viewers have devoted many hours to identifying the equations (when they correspond to real-world mathematics) and conjecturing about their possible significance in the greater series mythos. As in the case of Rousseau's maps, these visual props offer clues to the avid viewer who wishes to dig deeply into the hidden meaning behind the series. The Blast Door Map is featured in Season 2's "Lockdown" and "Live Together, Die Alone," and was painted on a blast door in the Swan Station by Stuart Radzinsky (Eric Lange), the DHARMA Initiative's Head of Research. It was Radzinsky's obsessive drive to harness the electromagnetic energy buried beneath the Swan Station which led to the infamous Incident, which necessitated the subsequent degaussing[9] of the station every 108 minutes (through

the entering of the Numbers into a computer terminal, 108 being the sum of the Numbers).

Radzinsky was one of the original team members of the Swan Station, and began painting in detergent a map, referred to by fans as the Blast Door Map, of the Island and its facilities. After Radzinsky committed suicide, his partner continued creating the map, which could only be seen under ultraviolet light. The map consisted of the layout of the Island and the location of the other DHARMA stations, along with various equations and comments. *Lost* viewers have identified a number of these notations as trigonometric relations, electromagnetic equations, and measurements of magnetic field strength (*Lostpedia* "Blast Door Map Equations").

Another set of equations and calculations are seen in Season 4's "The Constant," when Desmond visits Daniel in his Oxford laboratory. Once again, mathematically and scientifically astute *Lost* viewers researched the equations and identified a number of them as being related to general relativity and time travel (such as the Kerr metric). In addition, the blackboard contains a famous mathematical error, an expression for the fine structure constant seen in a photograph of physicist Enrico Fermi (*Lostpedia* "Daniel Faraday").

Finally, in Season 5's "The Lie" and "316," Eloise Hawking, Daniel's mother, is seen working out mathematics on a blackboard in the Lamp Post Station, trying to calculate the upcoming coordinates of the Island's location. As she explains, the station utilizes "a series of equations which tell us, with a high degree of probability, where [the Island] is going to be at a certain point in time." The Lamp Post's blackboard[10] does feature statistical calculations, another "Easter egg" for the mathematically astute, detail-oriented viewer, but yet another instance of how *Lost* sometimes celebrates duality and dichotomy at the expense of a segment of its (potential) viewership, for as demonstrated by many anonymous posts on myriad online bulletin boards, it's not easy being a *Lost* viewer without quite literally becoming lost. In some ways, these mathematical additions, rather than being seen as enhancements to the viewing experience, instead further promulgate the opinion that *Lost* is utterly incomprehensible at best, and hopelessly disjointed and nonsensical at worst. The same details which might engage some viewers and prompt them to search out further information might cause other viewers to give up on the series.

The Doomsday Equation

Of all the equations associated with *Lost*, one fictional example stands out in particular: an equation which includes Hurley's infamous lottery-winning Numbers. As we learned in "Numbers," Rousseau and her scientific party were brought to the Island when their ship's radio picked up the transmission of these numbers, and Hurley heard the numerical series from fellow mental hospital inmate Lenny. Sam Toomey, Lenny's partner at a U.S. Navy Pacific listening post, apparently heard the same transmission as Rousseau and used the numbers to correctly guess the number of beans in a huge jar at a fair. Although he won a hefty prize, right after that there was a traffic accident in which Sam's wife lost her leg, and some time afterwards Sam committed suicide. That apparently began Lenny's obsession with the numbers, and the alleged curse which accompanied them. On the Island, Hurley risks his life to track down Rousseau in order to obtain some validation of his obsession

after seeing the Numbers written on one of her maps. When she agrees that the Numbers do indeed seem to be cursed (since they were at least partially responsible for her being stranded on the Island, for the death of her colleagues, and for the kidnapping of her infant daughter), Hurley embraces her with the fervor of one who has had his faith reaffirmed.

Between the end of Season 2 and the start of Season 3, the most fervent *Lost* fans were able to whet their appetite for new *Lost* content and explanations of the Island's mysteries by participating in the *Lost* Experience, an alternate reality game (or ARG) developed by the *Lost* writers and released piecemeal fashion on the internet. Among the clues presented was the explanation that the numbers represent "core factors" in the fictional *Valenzetti Equation*, supposedly developed by the equally fictional mathematician Enzo Valenzetti after the Cuban Missile Crisis in order to predict the exact timing of the end of the human race. The core factors represent different methods of destruction, such as nuclear war, pandemic, overpopulation, and chemical and biological warfare (*Lostpedia* "The Valenzetti Equation"). According to the "Sri Lanka Video" (also part of the *Lost* Experience), Alvar Hanso (Ian Patrick Williams) and his Hanso Foundation took on the task of trying to alter one of the factors, thus hopefully changing the fate of humanity.

According to Hanso, this was the true mission of the DHARMA Initiative, which was funded by his Foundation at least through 1987. The broadcast of the Numbers from the Island was to continue until they had succeeded in changing one of the factors. This became the clandestine primary function of the Hanso Foundation's Mathematical Forecasting Initiative, who took over the task from the failed DHARMA Initiative. As explained by Hanso Foundation President and Chief Technologist Thomas Mittelwerk (Robert Greygrass) in the so-called Sri Lanka Video,

> we are gripped in the tyranny of those six numbers. We have tried to change those values by manipulating the environment in many, many ways. We have done our level best, and yet this inscrutable equation keeps bringing us back to the numbers [Pandora, "DHARMA and the Sri Lanka Video"].

However, the manner in which the Hanso Foundation carried out its research was less than ethical. For example, the Mathematical Forecasting Initiative was essentially a front for the imprisoning of mathematicians in a secret ward of the Vik Institute in Iceland under the guise of treatment for "idiot savants." Here they were forced to work with the Valenzetti Equation and discovered that manufacturing a virus with a mortality rate of 30 percent was "optimum" for Valenzetti-related research (Pandora, "DHARMA and the Sri Lanka Video"). Mittlewerk became convinced that unleashing a genetically engineered virus with such a death rate upon two unsuspecting villages would be a valid test of their mathematical model, and might ultimately lead to their being able to change one of the Valenzetti factors (and hence altering the timing of the end of the world). *Lost* fans who only viewed the televised episodes are unaware of this important parallel storyline.

Is it possible for a single equation to quantify the destruction of the earth, or of the human species? Another instance of the *Lost* alternative reality texts, the novel *Bad Twin*[11] (published in 2006 and supposedly penned by one of the casualties of Oceanic 815, Gary Troup) seems to ridicule this idea. Manny Weissman, the mentor of the lead character, a private detective named Paul Artisan, argues that "life is complicated. That's the point. It isn't like a string of numbers, you add them up there's only one solution. Any number of possible outcomes can emerge from a single set of facts" (Troup 130). However, real-life

scientists and mathematicians have tried to construct such a doomsday equation. For example, in 1993 astrophysicist J. Richard Gott III estimated the long-term survival of humans to be 2000 centuries, and in his 2009 book *Apocalypse When?*, physicist and mathematician Willard Wells derived a formula for human survivability based on both natural and manmade catastrophes. He estimates the long-term survivability of humanity over many centuries to be about 70 percent.

Also in the real-world, public interest in doomsday scenarios and the perceived power of numerical cycles have conjoined in an unholy alliance with widespread misrepresentations of ancient cultures and their scientific knowledge to create the current 2012 craze. If the hundreds of books and thousands of websites are to be believed, the Maya somehow crafted a supposed end to their calendar to occur on December 21, 2012, in order to warn future generations of an impending catastrophe. The nature of this catastrophe ranges from the improbable flipping of the Earth's rotational poles and the collision of the Earth with a supposed tenth planet (sometimes named Nibiru) to the melting of the Earth's surface and/or core through the influence of solar flares the likes of which have never been seen emitted from any star. While numerous scientists (this author included) have spoken loudly and widely against this foundationless pseudoscience, the general public continues to be sucked into this vacuum of reasoning, in part due to their lack of understanding of mathematics. For example, in *How to Survive 2012*, Patrick Geryl promises to give a mathematical proof of the 12/21/12 apocalypse date (191) and instead utilizes seventeen pages of arithmetic gymnastics (the adding, subtracting, multiplying, and dividing of "sacred numbers," astronomical cycles, and other miscellaneous numbers) to finally end up with the sought-after date. To the average reader, the calculations certainly could appear legitimate. It would be interesting to suggest to the *Lost* fandom that, now that the series is completed, they could serve the public good by lending their mathematical muscles to the public debunking of the 2012 hysteria.[12]

"I Am Not a Number"

To a scientist, mathematics is an indispensable tool, a means to model the laws of nature and to check the consistency and applicability of scientific theories. However, the majority of Americans see mathematics as a rather mysterious, almost mystical enterprise, seemingly disconnected from their daily routine beyond the price of their morning coffee or monthly mortgage payment. It is therefore understandable that ancient pseudosciences involving numbers still permeate parts of our culture. Number mysticism — the concept that numbers have some special, mystical connection to the greater universe — is generally traced back to Pythagoras and his followers (circa 572 BCE), who posited a connection between mathematics, the musical scale, and the "harmony of the spheres." Various terms, such as numerology and *gematria* (the process of assigning numerical values to individual letters of the alphabet, and then adding up the values for a given name's letters in order to ascertain some divine meaning or reading of a person's personality or fate) are used (rather inconsistently) to describe various pseudoscientific applications of numbers. For example, gematria plays a role in the mystical Jewish tradition of the Kabbalah.

In simpler versions of numerology, individual numbers are assigned special significance

(good or evil), and appearances of these numbers are noted with special interest. For example, the number 7 appears quite frequently throughout ancient texts, including the Bible. There are seven days in the week, seven sacraments in Catholicism, seven deadly sins, and seven wonders of the world. Hurley considers all of the six Numbers to be cursed, and if they do indeed represent the destruction of humanity, it may be reasonable to consider them to be at least a symbol of evil, if not evil in and of themselves.

One of the most infamous numbers in Western Culture is certainly 666, the well-known "Number of the Beast" in the Book of Revelation. What is less well-understood by the general public is the true meaning of the number, and its origin. According to many biblical scholars, it is not a trio of 6's, but rather the mathematical sum of the numerical values of the consonants in the Hebrew form of Nero Caesar's name (Gentry Jr. et al. 159). To the Hebrews of the time, Nero would undoubtedly been thought of as a "beast," consistent with the allegorical nature of Revelation.

In modern literature, characters are also sometimes referred to by a number, as in the case of James Bond, Agent 007. In the 1967–68 British television series *The Prisoner*, Patrick McGoohan starred as a British government agent who finds himself in a mysterious place known as "the Village," where all inhabitants are known by numbers rather than by names. In the premier episode, "Arrival," McGoohan's character protests being referred to as Number Six, proclaiming "I am not a number, I am a *person*."[13] The writers of *Lost* extensively explored this theme. For example, in a flashback in the Season 1 finale "Exodus," Jack and Ana Lucia (Michelle Rodriguez) share a drink at an airport bar, compare their seat numbers, and plan to meet up on the plane. When Jack tries to get Rose to open up about her husband after crashing on the Island, he introduces himself as "Seat 23A. I'm the guy that told you not to worry about the turbulence" ("Walkabout"). During the same episode, casualties from the crash are also referred to by their seat number during the memorial service, and in a flashback Locke and a coworker refer to each other by code names while playing an army game — the coworker's code name involves the number 12. In the previous episode, "Tabula Rasa," Kate is seen in a mug shot, where she is identified as prisoner number 961136. Even non-humans are referred to by numbers, such as the lab rabbits 8 and 15. Six people — Kate, Jack, Sayid, Hurley, and Sun from Oceanic 815, along with Jack's nephew Aaron, born on the Island to Oceanic passenger Claire Littleton (Emilie de Ravin) — escape from the Island and return to civilization (after 108 days), becoming known as the "Oceanic Six."

However the most interesting identification of individuals (or collections of individuals) with numbers in *Lost* occurs in Season 6. The Man in Black, masquerading as John Locke — and henceforth known as Man in Locke when in this form — attempts to recruit Sawyer to his side in the war of good versus evil.[14] He takes Sawyer (whose real name is James Ford) to a cliffside cave in which Jacob had written on the cave's ceiling and walls a series of names prefaced by numbers ("The Substitute"). Most of the names have been crossed out, with the following exceptions:

4 — Locke	15 — Ford	23 — Shephard
8 — Reyes	16 — Jarrah	42 — Kwon[15]

Man in Locke explains that "Jacob has a thing for numbers," and that the names represent candidates to replace Jacob as the protector of the Island. Among the crossed-out names

are a number of the show's deceased characters, including Charlie (195), Daniel (761) and Shannon (21). As Man in Locke crosses out Locke's name on the wall, he explains to Sawyer that he can refuse to be considered a candidate (that is, reject his number) and they can escape from the Island together.

In the next episode, "Lighthouse," Hurley, who has the ability to see and communicate with dead people, is told by Jacob to bring Jack to an old stone lighthouse on the coastline in order to help an unidentified character find the Island. Within the lighthouse's tower is a large horizontal wheel/gear which has individual degrees marked (presumably as a mechanism for setting the lighthouse's mirrors and hence channeling signal light in the correct direction). Hurley pulls on a chain connected to a series of gears and pulleys and instructs Jack to tell him when the marker is aligned to 108 degrees, in conjunction with Jacob's instructions. Jack notes that written next to each of the 360 degree markers is a name; most of the names are crossed out. However, a few are not stricken, including the name Kwon next to the 42-degree mark, and the name Shephard next to the 23-degree mark. (Note that these are the same numbers that refer to Kwon and Shephard in the cliffside cave writings.) When the gear passes 23 degrees, Jack sees his childhood home reflected in the mirrors and realizes that Jacob has been manipulating people throughout their entire lives in order to get them to the Island, presumably to undergo his candidacy process. Predictably, Jack rebels against being a mere cog in the machine, and uses a small spyglass to smash the mirrors in a futile attempt to regain his free will. Fans of the show were not surprised when Jack took on the role of the "next Jacob" and protector of the Island, albeit only long enough to defeat the Man in Black and pass the torch to Hurley.

Conclusion

In crafting a detailed, self-consistent universe in which the viewer can become completely immersed, the writers and producers of *Lost* have utilized mathematics to a degree which far surpasses the majority of science fiction programming. *Lost* fans have responded by researching the mathematical and scientific allusions in the story line, and have developed myriad websites and blogs with which to educate fellow viewers on these intricacies of the Lostiverse. The characters of *Lost* also reflect our real world, including the superstitions and anxieties which affect a large segment of the general public, as well the possible abuses of mathematics and statistics in the name of fraudulent pseudoscience. It is therefore true that *Lost* is arguably one of the most complex shows ever to be created. As fans continue to digest and dissect the series, whose final episode aired in May 2010, there is no doubt that mathematics will be an integral part of their analysis. After all, hindsight is 20/20.

Notes

1. The writers of *Lost* have gone out of their way to name characters after famous scientists, philosophers, and writers, with characters named Hume, Locke, Hawking, Faraday, Kelvin, and C.S. Lewis (among others).

2. One of the major themes of the later seasons of *Lost* is that people are specifically brought to the Island for a reason; in particular, some are brought there to be tested as candidates for the role of new protector of the Island.

3. The phrase is so often repeated that in "Through the Looking Glass," Rose Nadler (L. Scott Caldwell) warns, "If you say 'live together, die alone' to me, Jack, I'm gonna punch you in your face."

4. In mathematics, a constant is a value which does not change. For example, 2 is always the square root of 4. A variable can change its value. For example, your grocery bill is a variable, because you do not buy the exact same amount of food each week (and the food prices change).

5. As if the series were not confusing enough, in Daniel's experiments (and on the mercenaries' ship) it is only the consciousness which time travels, not the body, while when the Island is moved by Ben, it appears that both body and mind time travel together.

6. Although space does not allow for a discussion in this essay, the reader is invited to ponder connections between the "sideways" flashes of the parallel universe and the infamous thought experiment in quantum mechanics known as Schrödinger's Cat.

7. Interestingly, as with many things about Jack Shephard, the infamous countdown story is not what we originally led to believe. In the Season 5 finale ("The Incident"), the viewer is shown the actual surgery in a flashback, and it is revealed that rather than being Jack's self-sufficient, reasoned response to his error, the countdown was the brainchild of his father, a surgeon in his own right who was attending the surgery and who threatened to "fix her for you" if his son failed. The tension between Jack and his father (and Jack's search for his father's approval) is one of the underlying themes throughout the series, and seeing the countdown in this light proves yet again the power which Jack's father (and numbers) has had over Jack's life.

8. See the website *The Conet Project—Recordings of Shortwave Numbers Stations*.

9. "Degaussing" is a method used in electronics to reverse the effects of an external magnetic field.

10. A screen capture of this blackboard can be found in the 20 Feb. 2009 entry of the *Some Other Lost Screenshots* weblog.

11. The novel appears in the televised series in the episodes "The Long Con" and "Two for the Road" in which Sawyer reads the manuscript.

12. For more on the 2012 phenomenon and efforts to debunk its more sensational claims, see the website *2012: Debunking the "2012 Doomsday."*

13. The reduction of a person to a mere numeric designation has certainly been used by those in power to suppress the humanity of others, as in the case of concentration camps and prisons. Science fiction series prior to *Lost* have exploited the dehumanizing power of numbers in naming certain characters, from *Star Trek Voyager*'s "Seven of Nine" to the mass-produced humanoid models of Cylons in the recent series remake of *Battlestar Galactica*. (It is telling that the individual Cylons who are passed off as humans [fooling even themselves in some cases] are given actual names, such as "Ellen Tigh.")

14. By the airing of the fifth episode of the season it was suggested that Claire and Sayid are already under Man in Locke's control.

15. "Ford" is Sawyer's real surname. Also, it is unknown whether Kwon here refers to Sun or to Jin.

Works Consulted

"Blast Door Map Equations." *Lostpedia*. Wikia, 12 Mar. 2008. Web. 21 Feb. 2010.

Chinn, Steve. "Mathematics Anxiety in Secondary Students in England." *Dyslexia* 15 (2009): 61–68.

The Conet Project—Recordings of Shortwave Numbers Stations. Irdialani Limited, n.d. Web. 24 Sept. 2010.

"Daniel Faraday." *Lostpedia*. Wikia, 1 Sept. 2010. Web. 1 Sept. 2010.

Driscoll, James F. "Urim and Thummim." *The Catholic Encyclopedia*. Vol. 15. New York: Robert Appleton Company, 1912. 21 Feb. 2010.

Gentry, Kenneth L., Jr., et al. *Four Views on the Book of Revelation*. Grand Rapids, MI: Zondervan, 1998.

Geryl, Patrick. *How to Survive 2012*. Kempton, IL: Adventures Unlimited, 2007.

Gott, J. Richard, III. "Implications of the Copernican Principle for Our Future Prospects." *Nature* 363 (1993): 315–19.

Larsen, Kristine. "Results of an Astronomy Literacy Survey." *Dr. Kristine Larsen*. Central Connecticut State U, n.d. Web. 21 Feb. 2010.

Lost: The Complete Collection. Creators J. J. Abrams, Jeffrey Lieber, and Damon Lindelof. Walt Disney Studios Home Entertainment, 2010. DVD.

"The *Lostpedia* Interview: David Fury." *Lostpedia*. Wikia, 28 Apr. 2009. Web. 26 Feb. 2010.

Milton, Janet S. "Probability in Ancient times." *Mathematics Teacher* 82.3 (1989): 211–13.

National Science Board. *Science and Engineering Indicators 2004*. Washington, DC: NSF, 2004.

Pandora. "DHARMA and the Sri Lanka Video." *Sledgeweb's Lost Stuff*. 27 Sept. 2006. Web. 21 Feb. 2010.

Roach, John. "Friday the 13th Phobia Rooted in Ancient History." *National Geographic News*. National Geographic Society, 12 Aug. 2004. Web. 21 Feb. 2010.

Scanlon, T. J., et al. "Is Friday the 13th Bad for Your Health?" *British Medical Journal* 307 (1993): 1584–86.

Snow, C. P. *The Two Cultures: and a Second Look.* New York: Cambridge University Press, 1963.
Some Other Lost *Screens: Eloise Hawking Explains the Lamp Post Station.* N.p., 20 Feb. 2009. Web. 25 Sept. 2010.
Tobias, Sheila. "Math Anxiety and Physics: Some Thoughts on Learning 'Difficult' Subjects." *Physics Today* 38.6 (1985): 61–68.
Troup, Gary. *Bad Twin.* New York: Hyperion, 2006.
Trujillo, Karen M. and Oakley D. Hadfield. "Tracing the Roots of Mathematics Anxiety through In-Depth Interviews with Preservice Elementary Teachers." *College Student Journal* 33.2 (1999): 219–33.
2012: Debunking the "2012 Doomsday." N.p., 29 June 2010. Web. 24 Sept. 2010.
"The Valenzetti Equation" (book). *Lostpedia.* Wikia, 20 Feb. 2010. Web. 21 Feb. 2010.
Walsh, Jason. "Dark Side of the Band." *Wired.* Condé Nast Digital, 15 Nov. 2004. Web. 21 Feb. 2010.
Wells, Willard. *Apocalypse When?* Berlin: Springer, 2009.
Wilson, Robert Anton. *Cosmic Trigger.* Las Vegas: Falcon, 1989.

What's in a Name?
The Matrix *as an Introduction to Mathematics*[1]
KRIS GREEN

In my classes on the nature of scientific thought, I have often used the movie *The Matrix* (1999) to illustrate how evidence shapes the reality we perceive (or think we perceive). As a mathematician and self-confessed science fiction fan, I usually field questions related to the movie whenever the subject of linear algebra arises, since this field is the study of matrices and their properties. So it is natural to ask, why does the movie title reference a mathematical object?

Of course, there are many possible explanations for this, each of which probably contributed a little to the naming decision. First off, it sounds cool and mysterious. That much is clear, and it may be that this reason is the most heavily weighted of them all. However, a quick look at the definitions of the word reveals deeper possibilities for the meaning of the movie's title. Consider the following definitions related to different fields of study taken from Wikipedia on January 4, 2010:

- Matrix (mathematics), a mathematical object generally represented as an array of numbers.
- Matrix (biology), with numerous meanings, often referring to a biological material where specialized structures are formed or embedded.
- Matrix (archeology), the soil or sediment surrounding a dig site.
- Matrix (geology), the fine grains between larger grains in igneous or sedimentary rocks.
- Matrix (chemistry), a continuous solid phase in which particles (atoms, molecules, ions, etc.) are embedded.

All of these point to an essential commonality: a matrix is an underlying structure in which other objects are embedded. This is to be expected, I suppose, given that the word is derived from the Latin word referring to the womb — something in which all of us are embedded at the beginning of our existence. And so mathematicians, being the Latin scholars we are, have adapted the term: a mathematical matrix has quantities (usually numbers, but they could be almost anything) embedded in it. A biological matrix has cell components embed-

ded in it. A geological matrix has grains of rock embedded in it. And so on. So a second reason for the cool name is that we are talking, in the movie, about a computer system generating a virtual reality in which human beings are embedded (literally, since they are lying down in pods). Thus, the computer program forms a literal matrix, one that bears an intentional likeness to a womb.

However, there are other ways to connect the idea of a matrix to the film's premise. These explanations operate on a higher level and are explicitly relevant to the mathematical definition of a matrix as well as to the events in the trilogy of *Matrix* movies. They are related to computer graphics, Markov chains, and network theory. This essay will explore each of these in turn, and discuss their application to either the events in the film's storyline or to the making of the movie itself.

Computer Graphics and The Matrix

Formally in mathematics, a *matrix* is an arrangement of information, usually numerical, into rows and columns. The objects within the matrix are called its *entries*. For instance, the following is an example of matrix with numerical entries:

$$\begin{pmatrix} 2 & -1 & 3 & 4 \\ 5 & 2 & 0 & -9 \end{pmatrix}.$$

Matrices can sometimes be added to each other and sometimes multiplied together.[2] They have many special properties that help characterize the information they contain, and they relate to many different physical and social phenomena. One of their most common current applications is in computer graphics, and the reasons for this can be easily understood.

First of all, a computer screen is itself a matrix. It is, quite literally, a collection of rows and columns of *pixels*, each of which can be thought of as a single "dot" of color. In many Windows-based computers, the screen can be set to a variety of settings for both the resolution (the number of pixels in each direction) and the number of colors or states for each pixel. Consider a fairly typical arrangement of pixels into 800 rows and 1,280 columns, with 32-bit color. In this case, at any given time, each of the $800 \times 1,280 = 1,024,000$ pixels can be in any of 2^{32} states. To put these numbers in perspective, imagine that every particle of matter in the universe is capable of displaying just one of these pixel arrangements per second. Then, since the moment of the Big Bang, the entire universe would have displayed far less than 1 percent of the possible computer screen configurations. (Perhaps this is why we should expect more from Hollywood than remaking old movies!) Of course, the preceding counting argument ignores some important facts: many of these configurations will be related. Some will be rotations or reflections of others, and some will be the same configuration, only color-shifted. Accounting for these symmetries vastly reduces the number of distinct screens that a modern computer can display, but it's still far more than could be explored in the lifetime of the universe.

However, this approach to representing images (called a *bitmap*) is not very efficient. For starters, it requires a tremendous amount of memory to store many different bitmaps, such as would be needed for a movie. In addition, it treats each pixel as separate and provides no information on how pixels are grouped into objects or how those objects are organized

spatially in relation to one another. Thus, if an object in a bitmap moves in front of another object, there is no easy way to determine which parts of each object are obscured relative to a particular perspective or to determine how the lighting should shade the object as it moves. Instead, vector-based graphics are typically used. In this method, representing an object on a computer screen (or a movie screen, or on the mind of an enslaved human embedded in the Matrix) involves defining the coordinates of each point on the object. However, in the case of simulating a three-dimensional object, different viewpoints will result in the object taking on different appearances in terms of shape, lighting, texture, and so forth. By representing these points in a matrix, we have the necessary tool for determining how the shape of an object varies with different viewpoints.

The essential idea can be understood from a two-dimensional problem. Suppose we have a triangle with its vertices (labeled A, B, and C) at the coordinates $(-1,-2)$, $(0,6)$, and $(3,4)$, respectively, and we wish to know the coordinates of the shape after it is rotated counterclockwise by 30 degrees around the origin, $O = (0,0)$. If we write each point on the triangle as a vertical column of numbers — a matrix with two rows and one column — we can perform a matrix calculation that outputs the coordinates of the point after the rotation. For example, take point C. As a matrix, point C looks like

$$C = \begin{pmatrix} 3 \\ 4 \end{pmatrix}.$$

To compute the coordinates of the image, C', of point C under a counterclockwise rotation by θ degrees, we multiply C by the following rotation matrix, R_θ:

$$R_\theta = \begin{pmatrix} \cos\theta & -\sin\theta \\ \sin\theta & \cos\theta \end{pmatrix}.$$

For example, if we rotate the triangle 30 degrees counterclockwise, we have

$$R_\theta = \begin{pmatrix} \cos 30° & -\sin 30° \\ \sin 30° & \cos 30° \end{pmatrix} = \begin{pmatrix} \sqrt{3}/2 & -1/2 \\ 1/2 & \sqrt{3}/2 \end{pmatrix};$$

multiplying this matrix by the coordinates of point C gives the coordinates of C'.

$$C' = R_\theta C = \begin{pmatrix} \sqrt{3}/2 & -1/2 \\ 1/2 & \sqrt{3}/2 \end{pmatrix} \begin{pmatrix} 3 \\ 4 \end{pmatrix} \approx \begin{pmatrix} 0.598 \\ 4.964 \end{pmatrix}.$$

If we repeat this process for each point of the object, its new coordinates can be determined and the object redrawn to appear as it would from another perspective; see Figure 1. This is surely an important function of the computer program in the movie, since it must continually construct a shared reality among many different viewpoints and allow each person to perceive the virtual world correctly as he or she interacts with it.

Markov Chains and The Matrix

But it is the use of matrices to represent an object called a Markov chain that allows us to see how the *Matrix* trilogy uses the idea of a mathematical matrix in order to deal

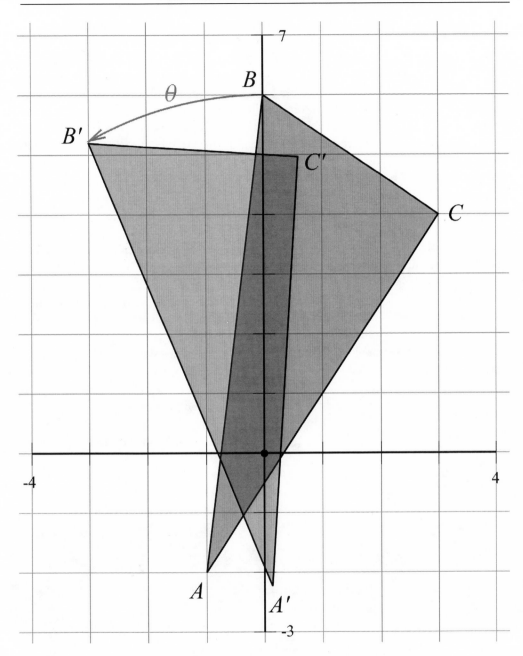

Figure 1. The original triangle *ABC* and the rotated triangle *A'B'C'*.

with the ages-old debate of free will versus predestination. In other words, the mathematical concept of a matrix can help us understand how, in a computer-generated world such as that depicted in the *Matrix* trilogy, a human mind — or any "mind" — can possibly know the future the way Neo (Keanu Reeves) appears to in the second movie of the trilogy.

The key lies in thinking about the future as a series of events, each with its own probability of occurring, and each of which is selected from a large but finite number of choices.

But it goes even further. If you think about an event that occurs as defining the current "state" of the future, the chance of transitioning into a different state may be different depending on your starting state. For example, if you go to use a photocopier at the office, it will be in one of two states, working (W) or broken (B). Now, past experience might tell you that when you need to copy something and have no prior information, you expect the copier to be in state W about 80 percent of the time and state B 20 percent of the time. But, once it is in state B, the probability of the copier working in the near future changes. The chance of a broken copier remaining broken the next day might be 55 percent, while the chance that it is really fixed (and thus back to state W) is 45 percent. Thus, we have probabilities, called *transition probabilities*, for how the future states of the machine will unfold, given its current and previous states. If we have a sequence of states leading up to the present, we can use these probabilities to predict the future states of the machine.

This chain of events determined by transition probabilities is called a *Markov chain*, and the transition probabilities between states can be written as the elements of a *transition matrix*, T. By raising T to the nth power we can study the likelihood of the system (in this case, the copier) being in a particular state after n time steps.

Thus, the use of a matrix in a Markov chain process can help us determine the probabilities for future events, but it cannot tell us for certain (a) how we get there (the chain of states we pass through) or (b) in which state we will definitely be at a given future time. This is physically illustrated in the final scenes of the second matrix movie (*The Matrix Reloaded*) as Neo sits in front of the Architect (Helmut Bakaitis) discussing the reality of the matrix. He is surrounded by hundreds of television screens, each of which depicts different possible reactions Neo might have to the information he is receiving (see Figure 2).

As Neo starts to make a decision and act, more and more of the screens depict the same resulting action, neatly illustrating the increased probability of transitioning from his current state to a particular future action.

This idea of a Markov chain also explains the insistence of the Oracle (Gloria Foster) that Neo already knows the future and has made his choice but does not understand it.

Figure 2. Neo's possible reactions. (Film still from *The Matrix Reloaded*, courtesy Warner Bros. Entertainment, Inc.)

Essentially, this means that the set of states and the transition probabilities Neo has been using to predict the future is no longer sufficient, since some of the realizable states of the system are not included in his current mental collection. Until he understands the radical events surrounding him and constructs a new mental picture — taking into account recent events and new states — of the possible future states, he cannot predict events past this discrepancy between what he can predict and what is actually possible: his list of current states and transitions is not up to the task. The copier example can be used to illustrate this idea. Suppose that after a week we have gone through a succession of states like *W-W-B-W-W-B-X* and arrived at a new state *X* that means the copier is in a permanently broken state. This new state was not part of our original list of states. It is not accounted for in our transition matrix, thus we could never have predicted this outcome. Until we revise our set of states from {*W, B*} to {*W, B, X*}, we can never represent the chain of possible futures. Philosophically, this means that our assumptions about the copier were wrong; we assumed that it could always be fixed. Neo's assumptions about the future fall apart after Trinity (Carrie-Anne Moss) nearly dies as a result of the new information he has received. Until he processes this and understands it, his mind cannot make further predictions about the future.

A further application of Markov chains connects the movie trilogy's exciting fight scenes with mathematics. When one is involved in a physical fight, predicting the actions of the opponent will allow you to react more quickly and to respond more effectively. This is why, in the opening moments of many fights — boxing, martial arts, wrestling — there is a period of "feeling each other out" while the opponents get a sense of how each other moves and what signs will give away his or her actions. But one can go much deeper. Each style of fighting has distinct characteristics. A taekwondo stylist tends to use a lot of fast, far-reaching kicks. Kung fu stylists use circular motions. Karateka tend to rely on more linear movements with powerful punches. And it goes even deeper than this. Regardless of training, everyone has a unique physique and a unique training history. This contributes to some movements and some combinations of movements feeling more natural. And the more natural a sequence of moves, the faster and more accurately one can reproduce them.

This means that each fighter will tend to have "favorite combinations" of techniques that he or she uses more often than others. And if you can identify those combinations, you are more likely to be able to accurately predict your opponent's actions. One way to do this — a way that lends itself nicely to creating computerized opponents — is to use transition matrices. If each of the states is a fighting technique (uppercut, reverse punch, back-leg roundhouse kick, etc.) then one can analyze a fighter by counting the number of times each technique is followed by each other technique. After a little data collection and analysis, one will have a pretty good idea of what moves are more likely to follow each of your opponent's moves.

Clearly, this would require collecting a large amount of data. And clearly during a fight one is not going to be computing transition probabilities. But over the course of many fights, one will naturally adjust and "get comfortable" with an opponent. In the *Matrix* movies, however, rather than generating a matrix from an opponent's moves, the fictional computer system controlling the Agents and the environment needs to create multiple and varied opponents to deal with the rebels. By creating slightly different transition matrices, it can develop different fighting styles to challenge Neo and his cohorts. And since we are talking about a massively parallel computer system, the Matrix itself can analyze Neo,

Trinity, and Morpheus (Laurence Fishburne) to determine their likely strategies and develop optimal opponents to confront them. This gives the computer a powerful tool to deal with human intuition.

This type of analysis is used frequently in computer games to generate opponents with different styles. For example, a chess game could create different opponents by having a different likelihood of using a particular opening, then having slightly different likelihoods for responding to each type of move. Of course, in doing this, one must carefully determine the allowable states in the system. Simply using "punch," "kick," and "move" as options in a fight gives one very little predictive ability since there are many different punches, kicks and movements possible. But it allows one to build a rough idea of style quickly, because the data is coarser grained. On the other hand, defining states by every possible stance, body part, and technique combination (like "left-hand reverse uppercut from a right-foot-forward Seisan stance") results in too few opportunities to observe and collect data, but allows, after sufficient data is available, very precise predictions. Thus, one might choose to adopt a mixture of analysis tools beginning with a coarse-grained approach and refining each category as further information becomes available.

Network Theory and The Matrix

A final connection between the movies and linear algebra comes from the emerging science of network theory. This is the study of how interconnected agents (in this case, we are referring to the people trapped in the Matrix, not the Agents in the movies) share and pass information along through a network. One can represent the interconnections with a matrix and by exploring the properties of the matrix come to understand how various phenomena (usually called "epiphenomena" or "emergent phenomena") come about purely as a result of these interactions. A typical example is the way crickets in a field will initially chirp independently, but as a result of the feedback from hearing each other, will quickly synchronize their chirps. The emergent phenomena — synchronized chirping — is not the result of a central dictatorial cricket demanding harmony, but rather an emergent property of the way each individual cricket responds to its surroundings. For more details on this field of study — albeit without the technical features — one should consult Duncan Watts's volume *Six Degrees* or *Nexus* by Mark Buchanan.

Basically, in a network model, one can represent the connections as a graph or in the form of one of several different matrices, one of which is called the *adjacency matrix*. Visualizing a matrix as a two-dimensional array of numbers, the adjacency matrix simply lists all the individual components next to the left side of the matrix and above the top row of the matrix. If two components of the network are connected, then there is a 1 in the corresponding entry of the matrix. If they are not connected, there is a 0 in that entry. Using this approach, one-way connections can also be represented. For example, if our network of interest is a food web, the individual components (agents, nodes, or whatever term is your favorite) are the types of organisms in the food web. The connections might represent who eats whom. Thus, in the matrix entry representing the interaction between the row containing a shark and the column containing a small fish, there would be a 1. However, since the fish does not prey upon the shark, the entry in the row containing the fish and

the column containing the shark would be a 0. Such matrices lack the property of symmetry: that is, we may have $T_{ij} \neq T_{ji}$, where T_{ij} indicates the element in row i and column j of the matrix T. In this way, one can study various properties of the food web by computing quantities related to the adjacency matrix representing this web.

A critical component of making the network aspect function, though, is that each agent in the system (e.g., the people in the pods) can influence each other and cause real changes in each other's behavior. This is illustrated at several points in the trilogy. One of the most graphic illustrations of this is the use of food. The Merovingian (Lambert Wilson) claims to have written a program — in the form of a piece of cake — which influences a young woman's behavior. The Oracle gives Neo a cookie she baked herself, claiming that he will feel "right as rain" when he finishes it. And at their second meeting, Neo comes away full of candy. After each of these food-related encounters, Neo undergoes a significant change. Without this ability to explicitly affect each other, information could not pass through the connected network of individuals, as it would exist only within the computer-generated construct and not within the individual minds connected to the system.

The third movie of the trilogy provides a superb example of network theory and emergent phenomena in action. And in this example, it applies to both the fictional action on screen and the methods for creating the imagery of the movie. In the climactic battle at the docks, millions of sentinel-machines emerge from the tunnels to swarm the defenses of Zion. These objects are all independent "entities" but seem to cohere into huge "meta-creatures" that attack the dock. This behavior is seen in swarms of bees, colonies of ants, flocks of birds, and schools of fish: some sort of local behavioral rules lead to an emergent behavior of the collective. Although the machines seem capable of tremendous computational complexity, trying to create a central unit to coordinate the movements of millions of sentinels

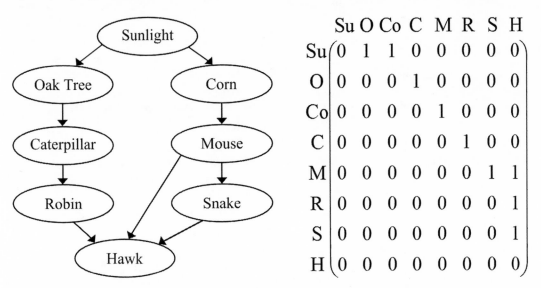

Figure 3. A simple ecosystem and its adjacency matrix. Prey/resources are located at the tails of the arrows and predators/consumers are located at the heads of arrows. Each organism is represented in the matrix by its first letter, except for Sunlight (Su) and Corn (Co). (Ecosystem taken from the Trends in International Mathematics and Science StudyScience Test, Eighth Grade, 1999.)

would be nearly impossible, given the number of variables involved. For example, if one sentinel is destroyed, which one takes its place? What we have learned recently, through simulations of bird flocking behavior (see Craig Reynolds's *Boids*), is that no central coordinator is needed. By simply defining the relationships — usually by nearest neighbor, which frequently changes — and local rules for acting, one can generate large-scale behavior. The sentinels utilize this very effectively. Notice how easily the defenders hold the dock before the collective forms. And then take note of how quickly the defenders lose control after the collective coheres.

In the same way, movie special effects houses would be overwhelmed trying to produce such epic battles if they had to rely on programming and moving each object by itself. Instead, they create agents and rules of behavior and simulate the movements of the objects. This allows efficient creation of huge armies, such as those in the final battles of the *Matrix* films and the *Lord of the Rings* trilogy. Such particle simulations can be used at a variety of scales, from generating armies to schooling fish to clouds of vapor moving across the screen. By giving each agent or particle rules for how to behave when a collision occurs (like when a smoke particle runs into a wall or when a soldier from one large army meets a soldier from another) each agent can behave independently according to reasonable rules (like the laws of Newtonian physics) and the appropriate large-scale behavior emerges from tweaking certain parameters that are shared by all agents of a particular type.

Further Thoughts

On a related note, the sequels to *The Matrix* (*The Matrix Reloaded* and *The Matrix Revolutions*) take the nature of network connections to the next logical step. Starting in the second movie, Agent Smith (Hugo Weaving) begins to download his code into the brains of humans plugged into the system, effectively copying himself. At one point, he even copies himself into the brain of an individual who has been freed from the system, thereby releasing his program from the system. Eventually, Smith copies himself onto every individual plugged into the Matrix (an excellent example of exponential growth, I might add). Although this may seem impossible, it is merely an extension of the mechanisms already at work in the computer system. For example, the rebels can easily download information from cartridges into a person's mind in order to teach them kung fu or how to fly a helicopter. This surely involves changes in the real brain of the individual, for they must remember, at the very least, that they have this knowledge in the computer world in order to make use of it the next time they "plug in." Thus, programming in the computer world can have effects in the real world. Without these reciprocal effects, information — about people and places and abilities — would never pass through the system of interconnected people, and the rebellion would be doomed to failure.

If one thinks of a human brain as a network of electrical connections, then the matrix of an individual's brain is surely changed by his or her interactions with the computer-simulated reality of the Matrix. And so each individual represents a matrix as well. So we have a more complicated structure: a computer-simulated reality supported by a matrix of people connected together, each of whom is him- or herself a complex matrix of ideas. It really seems that the machines must have some other purpose for humanity than simply extracting

power from them, if they are willing to put up with all the complexity and hassle of such a system, rather than simply snipping a few nerves in the brain and having vegetative bio-batteries without a need for all these shenanigans.

If we are willing to stretch our analogy a little beyond the obvious, we can find still other examples of the relationship between mathematical matrices and the movies. One, in particular, harkens back to the situation leading to the trilogy's climax. Agent Smith has copied himself onto every mind that is plugged in, and is close to crashing the system. At the same time, humanity is in desperate trouble in their last city, Zion, as the machines physically assault them with an unbelievably massive army. But how did this come to pass?

Earlier I mentioned that one can multiply a square matrix of probabilities by itself to determine likelihoods of events happening later. If one multiplies a typical transition matrix by itself sufficiently many times, though, an interesting thing happens. For instance, if we start with the following simple transition matrix

$$M = \begin{pmatrix} 0.2 & 0.9 \\ 0.8 & 0.1 \end{pmatrix}$$

and multiply it by itself repeatedly, we obtain, for instance, the following matrices as its fourth and sixty-fourth powers:

$$M^4 \approx \begin{pmatrix} 0.6424 & 0.4023 \\ 0.3576 & 0.5977 \end{pmatrix}, \qquad M^{64} \approx \begin{pmatrix} 0.52941 & 0.52941 \\ 0.47058 & 0.47058 \end{pmatrix}.$$

Notice that as M is multiplied by itself many times, the entries converge so that each row's entries all look the same after a relatively small number of iterations. Technically speaking, a normal transition matrix for a Markov chain is a matrix with a dominant eigenvalue of 1. Multiplying the matrix by itself many times eventually leads to a matrix with the same column repeated over and over; the column is the eigenvector associated with the dominant eigenvalue and scaled so that the elements of the vector add to a total of 1. This vector then defines the steady-state distribution of the Markov chain, showing the likelihood that the long-term state of the system will be in each of the possible states. The matrix, M, above, results in a steady-state distribution with approximately a 52.941 percent chance of being in the first state and a 47.058 percent chance of being in the second state.

In the case of the network in the *Matrix* movies, the Architect explains that there is an inevitability to the matrix: eventually it will crash and lead to potentially disastrous consequences for humanity. In the movie, this crash is related to the copying of Agent Smith over and over until every person in the matrix is a copy of Smith. Thus, there must be something about the particulars of the matrix — and the connections between the elements of the network — such that after many iterations, the Markov chain is almost 100 percent guaranteed to be in a particular state — one with all individuals replaced by Agent Smith.

Conclusion

In the end, we are left with not only popular reasons for the movie title, but also mathematical reasons. The notational power of matrices and the mathematical sophistication of the related field of linear algebra provide tools that can be used to model transformations

of images, to examine the relationships among interconnected people in a network, and to analyze the likelihood of various future events. Thus, the title of the film opens our eyes to ideas that are critical to the movie's plot, themes, and special effects.

Shakespeare's Juliet asks, "What's in a name?" She concludes that the object to which the name refers would be identical, regardless of its label. But in the case of a movie, which interacts with us on intellectual and emotional levels, its name has power. It suggests relationships and concepts. It provides us a framework for attaching events and ideas. It provides a lens through which we view its plot and characters. To see how important the words used to describe a narrative can be, consider the thirty other titles Hemingway considered for his novel *A Farewell to Arms* (Oldsey 14–16). Imagine how differently *The Matrix* might have been received had it been called "Our Machine Masters" or "Ghosts in the Machine." The former suggests a rebellion against oppression, while the latter hints at mystical significance related to the soul; the chosen title, however, evokes an enigma and connections to mathematics. The alternate titles fail to capture the mathematical and scientific connections that fascinate many viewers. As it stands, we'll be watching and re-watching the film for many years, looking for the instances of mathematics hidden within.

Notes

1. A shorter version of this essay originally appeared in *Math Horizons* Sept. 2008: 18–21; I thank the editor(s) of *Horizons* for permission to reprint it in its present form.

2. Specifically, if A and B are matrices, then we can form the sum $A+B$ exactly when A and B share the same number of rows and the same number of columns, and the product AB exactly when the number of columns of matrix A is the same as the number of rows of matrix B.

Works Consulted

Buchanan, Mark. *Nexus: Small Worlds and the Groundbreaking Science of Networks*. New York: Norton, 2002.

Foley, J. D., and A. Van Dam. *Fundamentals of Interactive Computer Graphics*. Reading, MA: Addison-Wesley, 1984.

The Matrix. Dir. Andy and Lana Wachowski. Perf. Keanu Reeves, Laurence Fishburne, Carrie-Anne Moss. Warner Bros., 1999. Film.

"Matrix." *Wikipedia*. Wikimedia Foundation, 15 Dec. 2009. Web. 4 Jan. 2010.

The Matrix Reloaded. Dir. Andy and Lana Wachowski. Perf. Keanu Reeves, Laurence Fishburne, Carrie-Anne Moss. Warner Bros., 2003. Film.

The Matrix Revolutions. Dir. Andy and Lana Wachowski. Perf. Keanu Reeves, Laurence Fishburne, Carrie-Anne Moss. Warner Bros., 2003. Film.

Oldsey, Bernard Stanley. *Hemingway's Hidden Craft: The Writing of* A Farewell to Arms. University Park: Pennsylvania State University Press, 1979.

Paz-y-Miño C., Guillermo. "Predicting Kumite Strategies: A Quantitative Approach to Karate." *Journal of Asian Martial Arts* 9.4 (2000): 22–35.

Reynolds, Craig. *Boids (Flocks, Herds, and Schools: A Distributed Behavioral Model)*. Reynolds Engineering and Design, 30 July 2007. Web. 5 May 2010.

Watts, Duncan J. *Small Worlds: The Dynamics of Networks between Order and Randomness*. Princeton: Princeton University Press, 1999.

Mapping Contagion and Disease, Catastrophe and Destruction

Computer Modeling in the Epidemiological Disaster Narrative

KATHLEEN COYNE KELLY *and* DOUGLAS WHITTINGTON

MAJ. CASEY SCHULER: I hate this bug.
COL. SAM DANIELS: C'mon, you have to love its simplicity.
MAJ. CASEY SCHULER: So, what do you want to do, take it to dinner?
COL. SAM DANIELS: No.
MAJ. CASEY SCHULER: What, then?
COL. SAM DANIELS: Kill it.

— *Outbreak* (1995)

Restate my assumptions. One: Mathematics is the language of Nature. Two: Everything around us can be represented and understood through numbers. Three: If you graph the numbers of any system, patterns emerge. Therefore, there are patterns everywhere in nature. Evidence: The cycling of disease epidemics, the wax and wane of caribou populations, sun spot cycles, the rise and fall of the Nile.

— Maximillian Cohen in *π* (1998)

We live in a knowledge society: alas, one in which useful knowledge and perniciously fake knowledge is intertwined.

— Darko Suvin, "Circumstances and Stances"

Introduction

Science fiction films have changed enormously since Susan Sontag wrote "The Imagination of Disaster" in 1965. Still, as she famously observed, film — and now, of course, television and video games — offers the "fantasy of living through one's death and more, the death of cities, the destruction of humanity itself" (212). Sontag describes the fear of depersonalization that underwrites many 50s and 60s science fiction films, as in, for the most famous example, *The Invasion of the Body Snatchers* (1956). In this instance, one might experience death not as destruction, but as *replacement*. In such films, one at least retains one's outward appearance, even if one's soul or self has been consumed or extinguished. Zombie films, which have become an especially popular subgenre in the past forty years, also offer

55

the vicarious experience of living through the death of the self and of humanity, but in a much more immediate, graphic way: one does not remain intact; instead, one's flesh subsides into decay and, ultimately, deliquescence. Flesh replaces flesh in the economy of the gluttonous undead.

Another subgenre of science fiction that is driven by the same sort of disintegration of flesh as is the zombie film is the so-called epidemiological science fiction or disaster film: that is, a film in which the enemy is not aliens from outer space, but the viruses or bacteria that invade our inner space. Bodily boundaries disappear as living flesh rots from the inside out: in fact, the person dying from an RNA virus looks very much like a reanimated zombie.[1] In Wolfgang Peterson's *Outbreak* (1995), for example, Major Salt (Cuba Gooding Jr.) and Major Casey Schuler (Kevin Spacey) describe the effects of viruses in this way:

> SCHULER: When the patient first gets the virus, he complains of flu-like symptoms, then in two or three days pink lesions begin to appear all over his body, along with small pustules that soon erupt with blood and pus, a kind of milky substance —
> SALT [interrupts]: When these particular lesions become full-blown, they feel like mush to the touch. There is vomiting, diarrhea, bleeding in the nose, ears, gums; the eyes hemorrhage; the internal organs shut down. They liquefy.[2]

Part of the awful fascination of *Outbreak* involves watching people progress through the stages of the Motaba virus until they do indeed finally liquefy. Yet as powerful as the visual effects are throughout *Outbreak*, in this scene, between Schuler and Salt, the film depends upon dialogue, upon narrativizing the human body in the most graphic terms. It is a kind of verbal mapping in which the body itself is the terrain. The narrative of the body's disintegration intensifies the horror and provides a map for what we shall soon see for ourselves.

Outbreak has its antecedents, including Elia Kazan's Oscar-winning film *Panic in the Streets* (1950); Alistair MacLean's novel *The Satan Bug* (1962), made into a film of the same name by John Sturges in 1965; and Michael Crichton's book *The Andromeda Strain* (1969), made into a film by Robert Wise in 1971. In these fictions and films, the virus or bacteria is a threat to the entire species; it is the threat of *replacement*: microbes are powerful enough to take over the planet, rendering the human race extinct. In fact, *Outbreak* begins with a chilling epigraph, a quotation from Nobel Laureate Joshua Lederberg: "The single biggest threat to man's continued dominance on the planet is the virus."[3]

We are interested in exploring how the epidemiological science fiction film achieves its emotional impact through the portrayal of mathematical computer mapping, particularly in the context of real-life viruses, such as AIDS, Avian Flu (H5N1), Ebola, and most recently, though far less lethally, Swine Flu, or H1N1. As we write in the winter of 2010, H1N1 makes television, radio, and Internet news almost daily. Moreover, one can find dozens of descriptions and discussions of, and diatribes on, H1N1 on the net, running the gamut from a video made by the Centers for Disease Control and Prevention to crackpot conspiracy theories about the virus.[4] Several websites also offer computer simulations of the progress of H1N1 as it either has or might spread across the United States. That contagion and disease is so graphically represented as an inevitable, inexorable geographical expansion ramps up the stakes and the *frisson* of the fear of infection. One watches "the destruction of humanity" figured as a map.

Mapping as a heuristic has a long history: tracking and/or collecting data has been

done, and is still done, through simple schematic geographies, such as drawings, or with pushpins or a pen on a two-dimensional paper map. In this respect, mapping serves as a mode of investigation in a variety of fields and endeavors: one can map linguistic data, or sales markets, or migrations of animals, for instance.[5] Since Jane Addams and her colleagues first published the book *Hull-House Maps and Papers* in 1895,[6] maps have underwritten sociological studies. Moreover, one can map, say, burglaries or murders on a map as a way to discover a pattern, which helps investigators determine the identity of the crimes' perpetrator(s). Such a map may even be used to predict where and when she or he may strike again. Such maps are a staple of detective fiction, films, and television dramas. Thriller and espionage films are full of war rooms in which digital maps of the world dominate; science-fiction films go even further, and offer maps of the universe. In fact, the cinematic computer simulation of the spread of disease has its most immediate antecedent in Hollywoodized representations, such as *Dr. Strangelove, Or How I Learned to Stop Worrying and Love the Bomb* (1964), of another, equally devastating mode of destruction: the atomic bomb.[7]

However, real (not reel) mapping simulations depend not upon special effects, but upon mathematical models; therefore, any simulation is only as good as its theorized mathematics. A simulation is just that: a visual representation of an idea, a projection. There is always a gap between the model and the real world, yet this gap is often ignored or suppressed — or not even understood as such by those who view and/or use simulated mappings. In what follows, we hope to explore this gap by focusing on disaster films in which computer modeling or mapping of the spread of disease is a feature. We want to explore how a cinematic computer simulation may take on a dangerous materiality and facticity. Is the cinematic simulation a simulation of a simulation, or does it have any real science behind it? What is the difference, if any, between a real-life mapping and a fictional one?

Finally, because the medieval Plague — the Black Death — is such an ubiquitous trope in contemporary discourses on contagion and disease, we conclude this study of computer modeling in the epidemiological disaster narrative by considering how modern historians map the Plague — in effect, how they map the past. Since the power of the trope of the Plague figures so prominently in the popular imagination, and, in fact, films set in the Middle Ages, if not directly about the Plague, invariably include references to it,[8] we also offer an example of movie medievalism in which the mapping of disease is plotted upon the physical body. The Black Death, even more than the Influenza Pandemic of 1918 — which at least is in within reach of living memory — serves as the sign *par excellence* of contagion and death. One might argue that modern pandemics are always already medieval, in a perverse version of Umberto Eco's argument that "our age is neomedieval" (73).

Mathematical Modeling of Disease

Any contemporary discussion of the representation of a deadly, infectious disease is haunted by the cultural and historical trauma of the Black Death, also known as the Bubonic Plague, of the late Middle Ages. During the cholera and influenza epidemics of the nineteenth and twentieth centuries, for example, the Plague was constantly invoked by analogy. And, as we know, the idea of the Plague circulates in contemporary culture as a pernicious analogy to AIDS. In the Middle Ages, the Plague (which itself has its cultural antecedent

in the biblical Ten Plagues of Egypt) was often described as having been visited upon humanity because of the anger of a righteous God; AIDS in the hands of the fundamentalist right is also often so figured.[9] Because the Plague persists as a powerful, generative trope in contemporary culture, it is worth considering how historians — who, granted, look backward, not forward, compared to most modern epidemiologists — map the Plague and arrive at their conclusions with respect to how, and how fast, the Plague traveled from Asia to Western Europe.

But first, a lesson in mathematics — specifically, in the mathematical formulae that are used to model certain phenomena that fall under the rubric of physics — may be helpful. There are different ways to make a computer map or simulation, and we cannot do justice to all of them here. However, many simulations are variations on or extensions of theories having to do with what physicists call a "traveling wave," which is a way to conceptualize the transference of energy from one site to another. As is true of most scientific concepts, a traveling wave is best explained through a metaphor, and a quite familiar one at that: a ripple spreading out from a stone dropped in water. The peak of the ripple moves through space (that is, propagates), even though the individual water molecules (for the most part) do not go anywhere. The traveling wave (or waves; there are several different kinds) is an abstract idea that can be expressed as a mathematical equation, which can then be applied to any given real system; in this case, to the spread of disease. By analogy, think of humans as the water molecules and the disease as the energy. The humans move over short distances and (for the most part) do not go anywhere, while the disease propagates. However, there is another, more complex, way to model the spread of disease: that is, through diffusion, wherein individual humans *do* actually traverse significant distances, in a more or less orderly manner. In this case, any carried disease moves at the speed of human travel — including walking, running, driving, or flying — and hence spreads at greatly increased rate.

Here, we focus on the work of theoretical physicist Dirk Brockmann, in part because his work supersedes the traveling wave model, and also because he uses the Plague to illustrate his mathematical model of the spread of disease.[10] Brockmann uses models based on the mathematics of fractional diffusion (which we discuss below), and works in the interdisciplinary field known as "computational epidemiology" (comprised of computer science, mathematics, geographic information science, and public health), which develops tools and models for tracking the spread of diseases. Brockmann's initial research focused on human mobility and transportation networks. He and colleague Lars Hufnagel theorized that one way to track human mobility was to track the circulation of money, and used a website called *Where's George?* to collect data. The site invites people to log on and register where and when a certain dollar bill came into their hands. Brockmann and Hufnagel then analyzed the data — the movement of over one million dollar bills — and created a set of "scaling laws" for human mobility, based on the geographical circulation of money. Brockmann is now extrapolating from this research to theorize and develop a model for the spread of epidemics.[11]

Of course, the circulation of disease is far more complex than the circulation of money. For example, in Brockmann and Hufnagel's money experiment, the marked dollars, unlike pathogens, don't reproduce. If the dollars *did* act like pathogens, then if, say, at an airport McDonald's you obtained a marked bill as change and put it into your wallet, by the time your flight from New York landed in Los Angeles you would be a millionaire. Further, the

bills would have overflowed your wallet and the people sitting near you would also be on the road to wealth as well. Thus there are other factors — such as mode of transmission, incubation time, and mutation — that one must take into account when attempting to track or predict the spread of disease. If an airplane starts its trip with just one passenger infected with AIDS, it most likely lands with one infected passenger. Not so with influenza; everybody on board could easily become a carrier by the time they start hailing cabs at their destination. Disease incubation time is also important. People with AIDS can move around for years before it is clear they are infected. On the other hand, a Plague carrier is incapacitated or dead in short order and stops being a mobile carrier. Finally, diseases mutate, and mutation is very hard to model mathematically.

It is not surprising that Brockmann uses the Plague as his historical example when demonstrating how one might differentiate between the spread of disease in the past and the spread of disease today. As he argues using his simulations (see, e.g., "Spatial Dynamics of Epidemics: Computer Simulation for Germany," currently available on Brockmann's website, *Research on Complex Systems*, on February 2, 2012), in the fourteenth century the Plague spread over short distances like a traveling wave, while today, epidemics spread over long distances much more quickly, and in "jumps." The pattern is commonsensical: in the Middle Ages, people walked or rode horses or traveled on ships; today, people drive cars, take trains, travel on faster ships, and fly.

Let us consider how mathematicians model the spread of modern epidemics. First, we consider simple, or classical, diffusion: imagine an open handkerchief with a drop of ink placed in its center. Over time, the ink diffuses outward, spreading evenly in all directions. After a while we see an intense spot of ink in the handkerchief's center, with the ink splotch decreasing in intensity as it extends radially from that center. If we wait long enough, the handkerchief's entire surface will take on a uniform pale stain of ink. Diseases, however, don't just diffuse; they reproduce themselves and die off. So what we see in the case of disease is diffusion in which the leading edge of the "stain" is reinforced while its trailing edge dissipates. This mimics the behavior of a traveling wave spreading out from the original point of infection. Such a model approximates the spread of disease when the rate of travel is the same for all infected people in all directions (as in the case of the spread of the Plague).

But suppose the handkerchief's constitution is not uniform; suppose some parts of it absorb ink much better than others. Perhaps it has a design woven into it, consisting of long stripes of very absorbent material, surrounded by less absorbent material. In this case, the ink might travel quickly along the stripes and diffuse slowly out from the edges of the stripes. Analogously, we can consider the spread of a disease (ink) which more or less "jumps" from place to place when people travel by plane (by analogy, along the stripes) and spreads locally when they travel by foot (outside of the stripes). In such a situation, mathematicians use a *fractional diffusion* model to predict the resulting disease pattern (ink stain) over time.[12] With this approach, we see the development of a discontinuous, fractal, pattern of disease with new foci of infection which are not adjacent to the previously infected areas. In short, fractional diffusion conveniently models a disease that both jumps from place to place, and spreads evenly in all directions from any landing spot.

In his simulation, "Spatial Dynamics of Epidemics: Computer Simulations for the United States," Brockmann creates a simulation of the "historical" spread of disease and compares it to a "modern" model.[13] In the "historic scenario," the epidemic begins in New

York City as people travel short distances; it moves, we are told, as a "traveling wave ... as in the spread of Bubonic Plague in the fourteenth century." The disease spreads relentlessly west until it reaches Texas. At this point, it spreads more quickly into New Mexico and Arizona, and turns north, heading into Colorado and Utah, at the same time that it spreads west into California. In the model for the modern period, which Brockmann prefaces by telling us that "modern emergent infectious diseases will spread in this fashion," the epidemic again begins in New York, but in addition to diffusing into areas such as Florida, Texas, Arizona, and California, it jumps to other locations, such as Utah, Colorado, South Dakota, North Dakota, and Washington. Specifically, it jumps to airports in those states, and from those locations the disease spreads out isotropically.

In spring 2009, Brockmann developed a worst-case scenario for the spread of H1N1—one in which "no measures have been taken to combat the spread of disease" (Ayshford). He says of his scenario: "With our projections, we correctly identified hot spots and the overall geographical pattern of the novel virus in the United States. We proportionately estimated the number of cases that would be detected for each county of the continental U.S."[14] The mathematics able to generate such projections is indeed quite powerful — and invisible. One must turn to scholarly journals to understand how such projections are made — if one can follow the math, that is. Moreover, Brockmann's map is not the only one available to the public. Maps simulating the spread of H1N1 proliferate on YouTube. No context, no bona fides, no explanation — and, after watching several in succession, we have concluded that, even when bona fides are given, it is sometimes not clear if the bona fides are real. We would like to think that the use of urgent, scary music would be a clue to a lack of veracity. One video, for example, uses the theme music from the zombie film, *Resident Evil* (Paul W. S. Anderson, 2002).[15] When is a given map generated by actual mathematical equations, and when is its content merely speculative, or even fictitious? It can be difficult, if not impossible, for a lay person to distinguish between the two, since mathematically-derived simulations and fictional animations can "look" almost the same. We would argue that each has the same rhetorical effect on the viewer.[16] We would add that the visual rhetoric that describes an unstoppable, inescapable virus has itself mutated and proliferated in contemporary discourse.

Mapping Disease in Literature and Film

A fictional verbal description of the trajectory of disease, a precursor to visual mapping, can be found in *Panic in the Streets*, Elia Kazan's experiment in film noir. The film has been productively read as a Cold War anti–Communist allegory. Walter Metz, for one, notes "the slippage between disease and Communism in 1950s cinema": that is, how Communist ideas were easily figured as germs infecting the body politic (27). In *Panic in the Streets* , the disease — the rare but almost one-hundred-percent fatal pneumonic form of Bubonic Plague that is transmitted directly from human to human — is brought into the country via a "foreigner" through the port of New Orleans. By analogy, Communism, like disease, threatens American capitalism and democracy from outside its too-permeable borders. The hero of *Panic in the Streets*, epidemiologist Dr. Clint Reed (Richard Widmark), at one point rebuts the notion that the Plague will remain within the confines of the local community:

Anyone leaving here with plague endangers the entire country.... Do you think that you're living in the Middle Ages? Anybody that leaves here can be in any city in the country in ten hours. I could leave here today and be within Africa tomorrow. And whatever disease I had would go right with me.

This narrative has both spatial and temporal dimensions: the listener travels backward and then forward in time and also travels around the world. There is nothing scarier to invoke than the Plague, whose Bubonic and pneumonic forms wiped out millions from Asia to Western Europe in just a few years. It is the perfect disease to strike terror (not necessarily an unpleasurable emotion) into a movie audience: it is both a trope and a reality, and it is here, now, in New Orleans. Reed's fierce anger is, on one level, generated by the fear of the Plague and the ease with which it can spread; however, and following Metz, his speech might also be read as anxiety about the rapid spread of un–American ideas. Keeping traveling wave theory and fractional diffusion mathematics in mind (that handkerchief with a stain), let us imagine two maps based on what Reed says: one is of the Middle Ages, when people traveled slowly and communities were much smaller; the other is of a modern world in which people can travel anywhere in the world in a day. Now imagine what the spread of disease would look like in comparison. This sort of comparative projection is precisely what Brockmann did in his initial simulations, as we shall see.

Both the terror of the Plague and the smallness of the modern world are invoked in MacLean's novel, *The Satan Bug*.[17] Here, the virus is man-made; it is intended to be used as a biological weapon. The good guys must find the bad guys who have stolen the vials of the "Satan Bug" (a derivative of the polio virus) before it is too late. We read:

I take a saltspoon of this powder, go outside into the grounds of Mordon [a biological warfare facility] and turn the saltspoon upside down. What happens? Every person in Mordon would be dead within the hour, the whole of Wiltshire would be an open tomb by dawn. In a week, ten days, all life would have ceased to exist in Britain. I mean all life. The Plague, the Black Death—as nothing compared with this. Long before the last man died in agony, ships or planes or birds or just the waters of the North Sea would have carried the Satan Bug to Europe. We can conceive of no obstacle that can stop its eventual world-wide spread. Two months, I would say two months at the very most.... The Lapp in the far north of Sweden. The Chinese peasant tilling his rice fields in the Yangtze valley. The cattle rancher on his station in the Australian outback, the shopper on Fifth Avenue, the primitive in Tierra del Fuego. All dead. Because I turned a saltspoon upside down.... Who would be the last to go? I cannot say. Perhaps the great albatross forever winging its way round the bottom of the world. Perhaps a handful of Eskimos deep in the Arctic basin. But the seas travel the world over, and so also do the winds; one day, one day soon, they too would die [48–49].

Note that the Plague is alluded to so that it may be dismissed as nothing; the Satan Bug is far more lethal. We are given a narrative, a verbal map in which the spread of the disease is easily plotted from England to the Arctic.[18]

The map is one strategy of many that Michael Crichton deploys to establish verisimilitude in his 1969 novel *The Andromeda Strain*. Crichton works within a specialized subgenre sometimes called "docu-fiction"; he is a master of the false document and the pseudo-testimony.[19] One begins reading *The Andromeda Strain*, for example, by working through a series of so-called government documents; the novel begins with the words, "THIS FILE IS CLASSIFIED TOP SECRET" (n.p.). Crichton, in his acknowledgments (placed strategically in the front of the book), writes as if his book were a historical account, not a fiction: "This

book recounts the five-day history of a major American scientific crisis" (n.p.). Crichton also appends an ersatz bibliography at the end of the book. Briefly, scientists discover that a lethal alien virus, which they name the "Andromeda Strain," has attached itself to a space probe which crashed in Arizona, wiping out everyone — including the entire population of a small town — who comes in contact with it. Dr. Jeremy Stone has had the foresight to secure funding for a secret military base designed to cope with such an event. He assembles a team (aptly named "Wildfire") to study and neutralize the virus; in the course of their research, the other members of the team learn that the military has been preparing for biological warfare and thus is interested in determining if they can use the Andromeda Strain as such a weapon. As in *Panic in the Streets*, *The Andromeda Strain* exploits the fear of contagion — this time, from outer space. And, if Communism is the enemy from without in *Panic in the Streets*, in *The Andromeda Strain* government — funding dangerous and secret initiatives as biological warfare — is the enemy within.

Crichton furnishes maps in the book, which are actually back-formations from computer simulations. He writes:

A NOTE ON THE OUTPUT MAPS: these three maps are intended as examples of the staging of computerbase output mapping. The first one is relatively standard, with the addition of computer coordinates around population centers and other important areas.

The second map has been weighted to account for wind and population factors, and is consequently distorted.

The third map is a computer projection of the effects of wind and population and is a "scenario."

None of these output maps is from the Wildfire Project. They are similar, but represent output from a [Chemical and Biological Weapons] scenario, not the actual Wildfire work

(*courtesy General Autonomics Corporation*) [64–66].

We see simple drawings and schematics of Arizona, California, Colorado, Nevada, New Mexico, and Utah. Crichton mimics the moves of a careful scholar by making it clear that he does not have the "real" maps from the Wildfire project in his possession; far scarier, he uses a substitute, an available and "real" Chemical and Biological Weapons scenario — which is, of course, also fake. Crichton tells us that he made (simulated) the computer simulations in the book on an IBM Selectric by manually typing. Crichton, who was in medical school at the time that he wrote the book, says that he used what he was learning in his classes, and adds, "I didn't do any research at all, actually" ("Portrait").

Director Robert Wise admired the pseudo-documentary conceit of *The Andromeda Strain*, and adopted it in his film version of the book so that the movie could also be experienced as a non-fiction documentary (this is one reason that, Wise says, he cast relative unknowns in starring roles; see "The Making of the Andromeda Strain"). The maps in the book become integral to the drama of the film.

At one point in the film version, scientists Stone (Arthur Hill), Dutton (David Wayne), and Leavitt (Kate Reid) try to determine if they can predict the spread of the virus. They stare at a computer screen:

DUTTON: We've got to get a biomap mapping its new growth potential and spread.
[Stone then punches a few keys, and maps appear on the screen]
LEAVITT: These are biological warfare maps!
STONE: Yes, so they are. Simulations. Defensive. Just a scenario.

In its preoccupation with computers and simulations and wondrously-designed labs, *The Andromeda Strain* is also invested in technology as a subject in itself. For example, in both

book and film, the scientists' attempt to model how the deadly Andromeda virus functions crashes the computer. In the film, the virus is displayed against an old DOS screen as it rapidly multiplies and mutates — that is, as not the virus, but a *simulation* of the virus, spreads. Stone cries, "Too much data coming in too fast!" Then "601," a code for a system error, appears on the screen and the camera zooms in so that the number fills the frame of the film (a screen within a screen). In 1970, such a moment was thrilling — so much so that it is recreated at the end of the film when, the Andromeda crisis averted, we watch as another virus multiplies, and "601" again fills the computer/film screen (as is the case at the end of many sci-fi and horror films, we are led to conclude that, while this particular monster has been defeated, another one is about to rise). The battle is really being waged between the powerful computer, which can crunch vast quantities of data at a tremendous speed, and the virus, which multiplies so quickly that it seems that the computer cannot keep up. However, to watch *The Andromeda Strain* forty years later (especially after seeing, say, James Cameron's *Avatar*, 2009) is to view its love affair with technology with some amusement, for special effects technology in 1970 can hardly be compared to the digitized effects used today. Douglas Trumbull and James Shourt (a computer engineer) were responsible for the "special photographic effects" in the film; in fact, as Trumbull says, "we didn't have any computer graphics," so what we see is a simulation of a computer executing a simulation ("The Making"). In the end, while both Crichton and Wise are keenly interested in representing advanced technology as an idealized shiny new toy, we must remember that advanced technology is double-edged: recall that it was a space probe that brought the Andromeda virus to Earth in the first place.

Laurence Dworet, who wrote the screenplay (with Robert Ray Pool) for *Outbreak*, was, like Crichton, trained as a physician, and actually still practices medicine. In *Outbreak*, as in *The Satan Bug*, the virus was initially designed as a biological weapon. And, as in *The Andromeda Strain*, the guys the audience is taught to distrust are the members of the U.S. military. *Outbreak* tells the story of how the fictional deadly Motaba virus is found rampaging in the bucolic town Cedar Creek, California, leading to a quarantine of the entire town. At one point in the film, at a military briefing, Major General Donald McClintock (Donald Sutherland) points to a map of the United States, on which the virus is represented as a red stain spreading inward from both coasts. "The most optimistic projection is this: twenty-four hours ... thirty-six hours ... forty-eight hours." The map of the U.S. goes completely red at forty-eight hours.[20]

Maps figure at other points in the film as well. As the team attempts to identify the original host of the virus (a monkey whose blood will contain antibodies that they can use to cure the disease), Schuler maps with a magic marker on a whiteboard the path of disease as it jumps from individual to individual. In another scene, Colonel Sam Daniels (Dustin Hoffman), concerned about containment of the virus, shouts at Brigadier General Billy Ford (Morgan Freeman): "I just drove through a hundred people. And if one of them has got it, then ten of them have got it, and if one them gets out of Cedar Creek...." Here, Daniels invokes Colonel Reed in *Panic in the Streets* by narrating a map that might have been generated by fractional diffusion mathematics. And when we see Robby Keough (Rene Russo) at the Center for Disease Control in Atlanta, the CDC Epidemic Control Center — which looks very much like a war room — has a large map of the United States on one wall, that maps, with statistics, chicken pox, measles, and tuberculosis. Finally, in one scene, as

Ford and McClintock discuss the Influenza Pandemic of 1918, a map of Cedar Creek is projected on a monitor behind them, with the words "704 PERSONNEL INFECTED 321 PERSONNEL DEAD" blazoned across the top in terminal font (pun coincidental).[21] What we find particularly disturbing about this last is the reduction of the citizens of Cedar Creek to "personnel"; apparently the military's software cannot account for those outside its ranks. In addition, we are struck by how the two military "personnel" responsible for the Motaba virus can sit so calmly in front of such appalling statistics while McClintock argues for a cover-up.[22]

Still, and perhaps because of— rather than in spite of— McClintock's villainous behavior, we would like to argue that the computer models in *Outbreak* offer some degree of comfort and security for viewers, however perverse. A high-concept map suggests that a particular government or power or corporation has access to superior knowledge, resources, and technology. A government arrogates to itself the responsibility for mapping boundaries and patrolling those boundaries; taking censuses and then creating public policy based on those censuses; and compiling and interpreting (or manipulating) statistics. When the military or the CDC generates the outlines of the United States in order to represent the spread of disease, those very outlines and the mapping of disease within them suggest containment and control— if not at the moment, then very soon. These maps, in effect, describe and therefore reinforce the body politic. In comparison to such maps, Schuler's whiteboard, while sufficiently useful as a tool for creating a map of contagion, is provisional, subject to change, because it is intended to capture the present moment, the *now* of the disease. The whiteboard with its squiggles and arrows represents what the doctors have hypothesized about the Motaba virus; as such, it maps the doctors' questions and puzzlements and frustrations. On the other hand, the hypothesis offered by McClintock's map— a projection of an unthinkable catastrophe, presented by a man of unwavering conviction — feels more like a foregone conclusion than a hypothesis. And we use the word "feel" deliberately, for the movie audience is invited to experience vicariously fear and despair. We would agree to anything to stop that inexorable spread of red, and certainly those who can produce such slick graphics have the ability to stem its tide? In the end, McClintock does persuade the President to bomb Cedar Creek, in part because of the power of a map produced by a military force that has something to hide.[23]

Mapping the Plague

So far, we have been considering both narratives and visual representations of disease in fiction and film, sometimes suggesting how the verbal and the visual may work together to heighten that *frisson* of fear that can be so perversely pleasurable for a spectator. We have also described how applied mathematics— a mathematics that is far from visible in our novels and films — is capable of generating computer models. At this point, we would like to look backwards, at the medieval Plague and how it has been mapped. The Black Death was a fourteenth-century pandemic that began in Asia (at least, this is where the Plague's presence was first recorded) and spread west to Europe by the 1340s, peaking in 1347–51. The progress of the Plague followed the extant caravan routes from China (or Central Asia) to southeastern Europe and then to Western Europe and North Africa. Most modern books

on the medieval Plague include some version of a map (and frequently, graphs) that show the routes we have just narrated. These maps are generated by modern historians based exclusively on medieval narratives and eye-witness accounts; no one made maps of the Plague in the Middle Ages. Historians who reconstruct the progress of the Plague depend upon contemporary records and first-person accounts to generate maps. For example, one of the most gruesome Plague narratives makes the thirteenth-century Genoan city of Kaffa (on the Black Sea; now Feodosija, Ukraine) a crucial feature of any map of the Plague. In 1345, the Khan of the Golden Horde, Jani Beg, began a siege of the port city; in 1347, according to one Gabriele de' Mussi, as his army succumbed to the Plague, they threw the infected corpses over the battlements. A group of Genoese merchants escaped, but they were also infected, and carried the Plague to Sicily (Wheelis 972ff.).

In addition to maps published in scholarly books and encyclopedias, several maps and computer simulations that illustrate the spread of the Plague can be found on the internet (e.g., Melissa Snell's maps associated with her article "The Spread of the Black Death through Europe" on *About.com*.) Many of these maps are based not on mathematical equations, but on narratives that historians have reconstructed; the maps vary in their details depending upon how those narratives have been read.

In other cases, maps on the internet — mathematically-generated and otherwise — have no value as historical representations.[24] As previously noted, Brockmann offers us one such simulation ("Spatial Dynamics of Epidemics: Computer Simulation for Germany"), illustrating the spread of the Plague using the traveling wave model. But when we look at his model for the disease's spread, Brockmann has got it all wrong. The run of the Plague in Germany in the Middle Ages did not originate in Munich, as his simulation indicates. Indeed, here is historian O. J. Benedictow's account of the Plague in Germany:

> In 1349, the armies of the Black Death closed in on the present-day Federal Republic of Germany from several quarters — from the south across Austria and Switzerland; from the west by forces that in the summer and the autumn were moving up along the R. Rhine in Alsace in north-eastern France; and from the north by armies of the Black Death engaged in the murderous conquest of England and Norway... [185].

We'd like to point out that Brockmann and Benedictow are working within the same realm of the figural: Benedictow personifies the Plague as a military force (unnecessarily, in our view — the Plague was horrendous enough), while Brockmann offers us a simple visual *metaphor* designed to show the difference between the (pre-modern, medieval) traveling wave pattern and the (modern) fractional diffusion model. The latter attempts to account for technologically-advanced modes of transportation, but does so at the expense of history. This ought to remind us of the power of figurative language to reify, to make present that which defies materiality. In one of his interviews, Brockmann says that tracking money is a "proxy" for understanding the spread of disease.[25] He is careful to use the words "simulation" and "scenario" in his prefaces to his simulations; he is quite aware of what a simulation is and the rhetorical effects of using one.

To be fair, we should add that Brockmann's comparative simulations have been supplanted by more complex models. Brockmann no longer compares the fractional diffusion and traveling wave models to make his arguments; instead, he has developed more sophisticated maps, ropy with red arcs everywhere. Instead of using creeping spots of color in his simulations, Brockmann now uses a globe with routes plotted out, shown as red curved lines

connecting points. They remind one of the maps of routes that airlines offer in the front pocket of every seat on an airplane (see Ayshford).

Bodies as Maps, Diseases as Spots

We conclude on a lighter note — if measles can be considered so — by looking at two cartoons in which the body itself provides the terrain for the mapping of the spread of disease. Measles (rubeola) was first described by physicians in the seventh century; it is a disease that is characterized by a red spotty rash all over the body. A vaccine was manufactured in 1963, but not generally distributed in the U.S. until the early seventies. Prior to 1963, measles underwent epidemic cycles every few years; it is estimated that ninety percent of adolescents had had a bout with measles in the United States before the vaccine was made available.[26] Given the extent of the measles epidemic of the first half of the twentieth century, the threat of measles may well have been a familiar and quite scary trope for the viewers of our chosen cartoons: Hanna-Barbera's Tom and Jerry feature "Polka-Dot Puss" (1949) and Disney's *The Sword in the Stone* (1963).

In *Outbreak*, the Motaba virus comes to Cedar Creek via a monkey who bites a pet store owner; the owner's blood is then splattered accidentally on a medical technician, who goes to a movie theatre — and coughs. We see the deadly viral particles up close as they are expelled from the technician's mouth and float through the air, finally and fatally to be inhaled by everyone else in the theatre. The movie audience is thus drawn into a *mis en abîme*, a nested narrative: it watches as a movie audience is infected with the virus (see Metz 28). And to heighten the effect of an endless regression, what is on the theater's screen is "Polka-Dot Puss."[27] Jerry (the mouse) paints red dots on Tom (the cat), tricking him into thinking that he has caught the measles. Jerry points to a newspaper headline: "Measles Epidemic Hits Nation!" Reading from a book by a "Dr. Quack," Jerry subjects Tom to numerous torturous diagnostics and so-called remedies before Tom catches on. When Jerry himself really pops out in red spots — first one, then another, then a whole batch — a panicked Tom rushes to the medicine cabinet and swallows everything that he can find. He catches the measles, and both cat and mouse are quarantined. We're most interested in the moment in which Jerry helpfully holds up a mirror for Tom to see his (painted-on) spots. It is a moment of Lacanian recognition in which Tom acknowledges himself as diseased; because of this (mis)identification, he submits to Jerry's torments. Tom reads his face in the mirror and accepts the evidence as it has been literally, though falsely, drawn on his body. The cartoon ends with Tom and Jerry, covered in red spots, looking glumly out of the window, a transparent "mirror" into which those on the outside can peer in, thankful that they have escaped the measles — for the moment.

We find an analogue to "Polka-Dot Puss" in the pseudo-medieval world of director Wolfgang Reitherman's *The Sword in the Stone*. Merlin (voiced by Karl Swenson) and Madam Mim (voiced by Martha Wentworth) engage in a wizard's shape-shifting duel. When Mim turns herself into a huge dragon, Merlin, in the form of a mouse, is put in danger, until he shifts shape again:

> MERLIN: Madam ... I am very tiny. I am a germ. A rare disease. I am called "malignalitaloptereosis"[28] ... and you've caught me, Madam!

MADAM MIM: What!
MERLIN: First you break out into spots [red spots pop out all over Mim's dragon belly], followed by hot and cold flashes and violent sneezing [Mim sweats, shivers, and sneezes].[29]

This is a kind of justice, since at a point earlier in the film, Mim says: "Sounds like someone's sick. How lovely. I do hope it's serious. Something dreadful." As a medieval, Merlin, of course, should not have known about germs. But Merlin lives backwards; in the book on which this episode is based, the original *The Sword in the Stone* (1938), T. H. White writes that Merlin turned himself "into the microbes, not yet discovered, of hiccoughs, scarlet fever, mumps, whooping cough, measles and hot spots" (82). As Merlin names the features of the terrain — that is, as he verbalizes the symptoms — the spots are mapped onto Mim's body in the same way that Tom and Jerry's are: first one spot, then another, then large clusters of spots.[30] In the intertext we're creating here, Tom and Jerry's measles might be said to anticipate the red spots that pop out all over Mim; Mim's spots similarly anticipate the red dots on McClintock's map. However, what might be described as a rather whimsical trope takes on much more menace in *Outbreak*, in part because of generic differences (cartoon versus feature film); the map and its red dots are persuasive because they are technologically realistic. We trust the map without thinking about what generated it and the facticity of its representation.

Conclusion

Unlike the authors of some of the other essays in this volume, we haven't discussed mathematics as itself the ostensible subject of a text or film. Rather, the mathematics surrounding our topic is invisible to audiences, residing behind the dramatic effects that consumers of pop culture so eagerly absorb. Surely it is a rare reader or viewer who reflects upon fractional diffusion when confronted with a real or simulated computer simulation; instead, most viewers/readers accept the digital map as simply contributing to the *mise-en-scène*. We think it's important to note that literary theorist and science fiction critic Darko Suvin uses not the word "false," but "fake" in his dystopian view of post-industrial capitalism in which knowledge is the product (536). How does one determine the difference between the real and the phony? Perhaps, to pursue Suvin's argument (and Jean Baudrillard's, when he declares that "sign-objects are all equivalent and may multiply infinitely" [224]), not being able to discern between the real and the fake is as comforting for consumers as it is advantageous for the cultural systems in which those consumers are enmeshed. Images such as that map going red in *Outbreak* serve as an overdetermined yet powerful trope for visualizing disease, contagion, destruction and death and, to return to Sontag, the (un)pleasures therein. To attain such (un)pleasures, much of the audience must willingly suspend its math disbelief, or resign itself to its own innumeracy — or worse, fail to make any calculation at all. Subsequent feelings of helplessness and despair and fear — again, which is not to say that such feelings are unpleasurable in the movie theatre — serve to reinforce the truth-value of computer simulations and the ideologies that create them.

Finally, we'd like to observe that, in a way, the digital map of the spread of disease functions as a metonymy in reverse: the whole (country, world) is an abstract substitute for what one is really most anxious about, and that is the part that is one's own singular body.

Someday, one of those red dots on the epidemiological landscape blurring into thousands of others might stand in for oneself.

Notes

1. Comparing the slack, staring face of those dying from a lethal RNA virus to a zombie is, in fact, the simile that Richard Preston uses repeatedly in his sensational book on Ebola, *The Hot Zone* (1994). But see Laurie Garrett, *The Coming Plague: Newly Emerging Diseases in a World Out of Balance* (1995), for a more somber look at the possibility of pandemic.

2. In the original screenplay, but cut from the film, another character adds:

But say you're unlucky. And you get one of those filoviruses we don't have an antiserum for, which is most of them. There's no medicine, no cure, nothing we can do to help you. Your body gets so hot, your liver, your kidneys, all your vital organs melt, and your skin turns into tapioca pudding.

3. Lederberg actually said "a," not "the" virus.

4. H1N1 has already affected the habits of millions of Americans: many people have invested in bacterial soap and changed the way they wash, cough, and opens doors. Most public spaces now have hand-washing stations, and coughing in public can elicit strong negative reactions.

5. Consider the following two examples of mapping with two very different purposes: first, in the HBO drama series *The Wire* (2002–08), the group of detectives investigating the drug organization led by Avon Barksdale uses a map of the city of Baltimore, pinning up photographs of known suspects in their neighborhoods. Second, the store where Kathleen bought her platform bed, Bedworks, in Cambridge, MA, displays a map of all Bedworks customers in the Cambridge-Boston area. The store is "ground zero," as it were, and blue dots, concentrated heavily in Cambridge, spread outward from Central Square in all directions.

6. The book includes two maps of the distribution of the immigrants who lived around Hull-House.

7. Computer simulations predicting the reach or spread of other kinds of disasters figure in such films as director Roland Emmerich's *The Day After Tomorrow* (2004) and *2012* (2009).

8. Perhaps the most famous examples of films involving the Plague are *The Seventh Seal* (1957) and *Monty Python and the Holy Grail* (1975). See also *The Navigator* (1988).

9. Samuel Kline Cohn, in his introduction to David Herlihy's *The Black Death and the Transformation of the West* (1997), writes:

Perhaps stemming from the utter mystery of these two epidemics in contrast to syphilis in the sixteenth, cholera in the nineteenth, and tuberculosis in the late nineteenth and twentieth centuries — all highly contagious diseases — AIDS and the Black Death heighten popular distrust of expert opinion, particularly of the medical profession, and have led more forcefully to the suspicions, fears, and hatreds of the alien. In the fourteenth century the plague gave rise to the spread of anti–Semitism ... today [AIDS] has reinvigorated fears and hatred of homosexuals and the poor [5].

Also see Cohn, "The Black Death: The End of a Paradigm" (June 2002).

10. Research groups at Indiana and Ohio State Universities also use computer simulations to model the spread of infectious diseases. Examples of projections based on the traveling wave model alone can be found in Grenfell, Bjørnstad, and Kappey's "Traveling Waves and Spatial Hierarchies in Measles Epidemics" (2001) and in Cummings, Irizarry, Huang, Endy, Nisalak, Ungchusak, and Burke's "Traveling Waves in the Occurrence of Dengue Haemorrhagic Fever in Thailand" (2004).

11. See the video "The Scaling Laws of Human Travel" (accessed on Brockmann's website, *Research on Complex Systems*, on February 12, 2012). In this popularized overview of Brockmann and Hufnagel's work, we are told that currency "provide[s] data about how and where people travel, [which is] the key to revealing routes for infectious agents as they spread through a population." Once one accounts for "travel patterns, the speed at which a virus is transmitted, [and] how long it takes for symptoms to appear," then "realistic descriptions of routes taken" and thus predictions of the future "spread of dangerous viruses" can be made, the idea being that "being able to predict which regions are likely to be hit first could help save lives."

12. A useful visual description of the difference between classical diffusion and fractional diffusion can be found in Brockmann, David, and Morales Gallardo, "Human Mobility and Spatial Disease Dynamics," 77–78.

13. This video was previously available on YouTube.

14. See the projection applet associated with the report "Computational quantitative projections for H1N1 flu dynamics in the United States." Because these are computational forecasts, the page has not been updated since June 2009.

15. Compare actual data from Rhiza Labs ("Tracking the spread of H1N1 swine flu in the U.S.—

Rhiza FluTracker," currently available on YouTube) to other, specious H1N1-spread simulations found online.

16. In a video for "Killer-Disease," a song by the Melody Stars, AIDS is represented on a cartoon map of the world; the point is that it cannot be mapped, because it is everywhere.

17. Priscilla Wald, in *Contagious: Cultures, Carriers, and the Outbreak Narrative* (2008), coins the term "outbreak narrative," a major characteristic of which is, she argues, "a fascination not just with the novelty and danger of the microbes but also with the changing social formations of a shrinking world … as epidemiologists trace the routes of the microbes, they catalog the spaces and interactions of global modernity" (2). In her discussion of *Outbreak*, Wald focuses on the idea of the American and "Americanism" (60ff.). In *The Coming Plague* (1995), Garrett, like Wald, emphasizes the swift global reach of any given virus.

18. The film version of *The Satan Bug* (1965) is a proto–Bond noirish flick; we hear a shorter version of this narrative, but we do not see gruesome depictions of death. Since the emphasis is on espionage, bodies hardly figure in the book and the film.

19. See Gary D. Rhodes and John Parris Springer, *Docufictions: Essays on the Intersection of Documentary and Fictional Filmmaking* (2006). Orson Welles' production of H.G. Wells' *War of the Worlds*, broadcast on CBS radio in 1938, is perhaps the most famous example; other examples include *Take the Money and Run* (1969); *This Is Spinal Tap* (1984); *Borat* (2006); and the British sitcom *The Office* (2001–03), as well as its American, et al., versions.

20. The map is featured in a trailer for the film. While *Outbreak* can be placed in the thriller genre, it borrows a trick from documentaries in its practice of projecting place names (Motaba Valley, Zaire; Boston Municipal Hospital) at points at which the location of the scene changes.

21. Terminal font is one of the names for the original DOS font (also known as VT-100).

22. Walter Metz observes that AIDS is "the obvious ideological 'ghost' of *Outbreak*"; however, his main argument about the film is that it is "downright possessed by the Cold War" (29). He writes:

In the post–Cold War action cinema, the Communist (and to a large extent, nuclear) threat has been lost, so new threats need to be manufactured. The viral threat seems particularly useful, since the same maps [as in post–World War II nuclear scare films] can be used to predict the gloom [36].

23. *Outbreak*, like *Panic in the Streets*, could be described as a film about the U.S. being attacked by a "foreign" disease, and therefore concerned with constructing what can only be a false sense of security; see Wald, who argues that it is impossible to achieve anything like closed borders (58ff.) — a point that Brockmann makes clear in his projections.

24. See "Black Death Strikes Europe," *Spread of the Black Death* — which contains an interactive map that one can click on by year to follow the progress of the disease — and *The Black Death*, whose map, based on a 1998 article in *National Geographic*, was created by a first-year college student.

25. See Brockmann's "Money Circulation Science" (currently available on YouTube).

26. See "History of Measles" and "Measles (Rubeola)."

27. "Polka-Dot Puss" is currently available on YouTube.

28. There are many other fictional, cinematic, and video-game viruses and diseases in addition to the few discussed here; see, for example, Edgar Allan Poe, "The Masque of the Red Death" (1842), Stephen King's *The Stand* (1990), and J. K. Rowling's *Harry Potter and the Order of the Phoenix* (2003) and *Harry Potter and the Deathly Hallows* (2007). In addition, there is an entire subcategory of works featuring viruses that create zombies or vampires, such as Richard Matheson's *I Am Legend* (1954; films 1964, 1971, 2007) and Max Brooks' *The Zombie Survival Guide* (2003). And let us not forget that other fictional disease, the "Hippy Hippy Shake," as first mapped by Chan Romero, then by the Beatles, and then by the Swinging Blue Jeans. Finally, H. G. Wells gave us a *reverse* virus in *The War of the Worlds* (1898): Terran microbes, harmless to humans, are deadly to Earth's invading aliens.

29. The scene dissolves to a red-spotted Mim in bed, under the care of Merlin, who says: "Oh it's not too serious madam, you should recover in a few weeks and be as good, uh … he-he, I mean, as bad as ever. But I would suggest plenty of rest, and lots and lots of sunshine." Madam Mim responds: "I hate sunshine! I hate horrible, wholesome sunshine! I hate it! I hate it! I hate, hate, hate…"

30. Mim actually dies in the book, an event that was cut from the American edition. And Mim is cut altogether from the *Sword in the Stone* section of *The Once and Future King*.

Works Consulted

The Andromeda Strain. Dir. Robert Wise. Universal Pictures, 1971. Film.

Ayshford, Emily. "Professor's Computer Simulations Show Worst-Case Swine Flu Scenario." *McCormick News*. Robert R. McCormick School of Engineering and Applied Science, Northwestern University, 29 Apr. 2009. Web. 28 Aug. 2010.

Baudrillard, Jean. *The System of Objects*. 1968. Trans. James Benedict. London: Verso, 1996.

Benedictow, Ole J. *The Black Death 1346–1353: The Complete History*. Woodbridge, Suffolk: Boydell & Brewer, 2006.

"Black Death Strikes Europe: 1347–1353." *Blackdeath2.gif*. Wikimedia Commons, 4 Dec. 2009. Web. 14 Oct. 2010.

Brockmann, Dirk. *Research on Complex Systems*. Engineering Sciences and Applied Mathematics, Northwestern University, n.d. Web. 2 Feb. 2012.

_____, Vincent David, and Alejandro Morales Gallardo. "Human Mobility and Spatial Disease Dynamics." *Diffusion Fundamentals III*. Ed. C. Chmelik, N. Kanellopoulos, J. Kärger, D. Theodorou. Leipzig: Leipziger Universitätsverlag, 2009. 55–81.

Cohn, Samuel Kline, Jr.. "The Black Death: The End of a Paradigm." *The American Historical Review* 107.3 (June 2002): 703–39.

"Computational quantitative projections for H1N1 flu dynamics in the United States." *Research on Complex Systems: Engineering Sciences and Applied Mathematics, Northwestern University*. Brockmann Group, 3 June 2009. Web. 10 Nov. 2010.

Crichton, Michael. *The Andromeda Strain*. New York: Harper, 2008.

_____. "A Portrait of Michael Crichton." *The Andromeda Strain*. Dir. Robert Wise. Universal Studios, 2003. DVD.

Cummings, Derek A. T., Rafael A. Irizarry, Norden E. Huang, Timothy P. Endy, Ananda Nisalak, Kumnuan Ungchusak, and Donald S. Burke. "Traveling Waves in the Occurrence of Dengue Haemorrhagic Fever in Thailand." *Nature* 427 (2004): 344–47.

Dr. Strangelove: Or How I Learned to Stop Worrying and Love the Bomb. Dir. Stanley Kubrick. Columbia Pictures, 1964. Film.

Eco, Umberto. "Living in the New Middle Ages." Trans. William Weaver. *Travels in Hyperreality*. 1973. New York: Harcourt, 1986. 73–85.

Garrett, Laurie. *The Coming Plague: Newly Emerging Diseases in a World Out of Balance*. New York: Farrar, 1995.

Grenfell, B.T., O. N. Bjørnstad, and J. Kappey. "Traveling Waves and Spatial Hierarchies in Measles Epidemics." *Nature* 414 (2001): 716–23.

Herlihy, David. *The Black Death and the Transformation of the West*. Cambridge: Harvard University Press, 1997.

"History of Measles." *eMedTV*. Clinaero, n.d. Web. 14 Oct. 2010.

MacLean, Alistair (as Ian Stuart). *The Satan Bug*. New York: Scribner's, 1962.

"The Making of *The Andromeda Strain*." *The Andromeda Strain*. Dir. Robert Wise. Universal Studios, 2003. DVD.

"Measles (Rubeola)." *MedicineNet.com*. MedicineNet, n.d. Web. 14 Oct. 2010.

Metz, Walter. *Engaging Film Criticism: Film History and Contemporary American Cinema*. New York: Peter Lang, 2004.

Outbreak. Dir. Wolfgang Petersen. Warner Brothers, 1995. Film.

"*Outbreak* Script-Dialogue Transcript." *Drew's Script-O-Rama*. N.p., n.d. Web. 14 Oct. 2010.

Panic in the Streets. Dir. Elia Kazan. 20th Century–Fox, 1950. Film.

π. Dir. Darren Aronofsky. Artisan Entertainment, 1998. Film.

"Polka-Dot Puss." Dir. William Hanna and Joseph Barbera. Anim. Kenneth Muse, Ed Barge, Ray Patterson, and Irven Spence. MGM, 26 Feb. 1949. Film.

Preston, Richard. *The Hot Zone*. New York: Random, 1994.

Rhodes, Gary D., and John Parris Springer, eds. *Docufictions: Essays on the Intersection of Documentary and Fictional Filmmaking*. Jefferson, NC: McFarland, 2006.

Snell, Melissa. "The Spread of the Black Death through Europe." *About.com: Medieval History*. About.com, n.d. Web. 28 Aug 2010.

Sontag, Susan. "The Imagination of Disaster." *Against Interpretation and Other Essays*. New York: Farrar, 1966. 209–25.

Spread of the Black Death. Cengage Learning, n.d. Web. 14 Oct. 2010.

Suvin, Darko. "Circumstances and Stances." *PMLA* 119.4 (2004): 535–38.

Svendsen, Lyle. *The Black Death*. University of Minnesota, 3 Feb. 1997. Web. 14 Oct. 2010.

The Sword in the Stone. Dir. Wolfgang Reitherman. Disney Studios, 1963. Film.

Wald, Priscilla. *Contagious: Cultures, Carriers, and the Outbreak Narrative*. Durham: Duke University Press, 2008.

Wheelis, Mark. "Biological Warfare at the 1346 Siege of Caffa. (Historical Review)." *Emerging Infectious Diseases* 8.9 (2002): 971–75.

White, T. H. *The Sword in the Stone*. London: Collins, 1938.

Fair and Unfair Division
in Neal Stephenson's
Cryptonomicon

WILLIAM GOLDBLOOM BLOCH *and*
MICHAEL D. C. DROUT

In what at first glance appears to be a throwaway scene in his massive novel *Crypto-nomicon*, Neal Stephenson introduces the problem of *fair division*: how can a group of ran-corous siblings divide up a beloved grandmother's furniture and other possessions without violent infighting? "The question reduces," says one character, "to a mathematical one: how do you divide up an inhomogeneous set of *n* objects among *m* people (or couples actually); i.e., how do you partition the set into *m* subsets (S_1, S_2, \ldots, S_m) such that the value of each subset is as close to possible to being equal?" (625).

The way Stephenson "solves" this problem of fair division — unfairly, it turns out — encapsulates some of the most important themes of the novel. In *Cryptonomicon*, there is more than one question that "reduces to a mathematical one," but, as becomes evident upon a close and mathematically-informed reading of this scene, the reduction of complex questions of personalities and social relations to mathematics does not always lead to satisfactory results, precisely because there are people involved, and some of them will not be satisfied even if the system is "mathematically provable as fair" (*Cryptonomicon* 627).

The fair division scene in *Cryptonomicon* is an obvious satire of family politics and a less-obvious satire of the difficulty (and perhaps folly) of applying advanced mathematical ideas to situations where they are not (obviously) necessary. There is a deeper level of satire as well, one only visible to mathematicians. The method Stephenson dramatizes, although it might have worked if one of the family members had not cheated and secretly programmed a supercomputer to give him the result he wanted, is not the optimal one for this situation, and anyone sufficiently schooled in the subject of fair division (as Stephenson obviously is) would know this.

In the 1930s, mathematician Bronisław Knaster created a straightforward system that allows for an optimal distribution of inhomogeneous goods, which is exactly the scenario confronting the Waterhouse clan in *Cryptonomicon*. In contrast to the complexities of Stephenson's solution — which involves a supercomputer, the shuffling of objects around

x- and *y*-axes in a parking lot, and the possibility of the computer's programmer cheating — the Knaster Method of Sealed Bids relies on simple computations that are quickly and easily performed with paper and pencil. But you only get this deeper layer of the joke if you are a mathematician (or if one explains the joke to you). This is a small scene in a huge novel, and only marginally important to the plot, but, we will argue, it represents *in micro* much of what Stephenson is accomplishing in *Cryptonomicon*. First, he turns readers — readers of a *New York Times* bestseller — into nominal insiders in the technological and mathematical worlds. Then he undercuts that very insider-hood by creating another layer of "coded" reference that only "true insiders" (viz. real mathematicians) can recognize — a fitting gesture for a book that is essentially a meditation on encoding and decoding, information and disinformation.

The Problem of Fair Division

There are two major plotlines in *Cryptonomicon*, one set during World War II and the other in the 1990s. Lawrence Waterhouse, a major player in the World War II plotline, is "one of the dozen or so figures, mostly departed now, who compete for the essentially bogus title of 'inventor of the digital computer'" (623). Extremely mathematically skilled but not particularly worldly, Lawrence works to break Axis code systems. Lawrence's grandson, Randy Waterhouse, is the protagonist of the 1990s plot. A self-trained computer scientist, Randy builds computer networks as part of a project to create a data haven in the fictional Sultanate of Kinakuta. He soon gets caught up in a complex plot involving gold hidden in the Philippines — gold whose location his grandfather had discovered by breaking the (also fictional) Arethusa cryptosystem, one of the most sophisticated cryptological systems of the Second World War.

Randy has come to believe that a key to finding the hidden gold might be in a trunk in the attic where his grandfather stored stacks of old computer punch cards. But that trunk has now become entangled in family relationships and politics: Randy's grandmother needs to go into an assisted living facility, and so her children and their spouses have gathered to divide her possessions. To avoid the situation of "ten or twelve emotionally fraught people clambering around a packed-to-the-ceiling U-Stor-It locker with flashlights, sniping at each other from behind the armoires" (630), the Waterhouse family has decided to take a non-traditional approach to the division of the family treasures: they have developed "a booty division system that is mathematically provable as fair" (627).

Understanding the nature of Stephenson's inside joke involves moving beyond our intuitive ideas about fair division to looking at different ways of formalizing the process in such a manner as to optimize as many desirable outcomes as possible.[1] The most basic fair division question asks how two people can cut, say, a cake into two pieces so that both individuals are as satisfied as possible with their respective portions. A time-honored method might be called "You cut and I'll choose." The basic notion of this method is that whoever cuts the cake will make a very strong effort to cut it exactly in half; thus, the person who chooses will perceive no real difference between the pieces. Contentment is maximized!

Unfortunately, it is rarely this simple to solve a fair-division problem in the real world. For example, creating a "good" method of dividing a cake into three portions for three people is surprisingly difficult. Many math papers and several books have been published

on cake-cutting algorithms for three or more people. Even without worrying about generalizations to higher numbers of cake-consumers, the simple method described above has some inherent problems. A few moments of thought shows that "happiness" is a mutable concept, varying across the spectrum of humanity, and it may be difficult to guarantee happiness for participants such as *Cryptonomicon*'s Aunt Nina, who is willing to commit physical violence to defend her ownership of a piece of furniture (the Gomer Bolstrood console[2]) and Rachel, an in-law whom the Waterhouse clan fears will somehow manage to walk away with all of Grandmother Waterhouse's worldly goods. Consider the following problems with the "You cut and I'll choose" method. (These are *not* taken from Stephenson's book; we made them up.)

Inhomogeneous Cakes: Suppose that Aunt Nina loves frosting — especially those frosted flowers on birthday cakes. If she's the one cutting, she'll cut a corner piece loaded with frosted flowers smaller than the rest, because she hopes that Rachel will choose the larger, less frosted piece. Aunt Nina might get burned by her cut — perhaps Rachel also is a lover of frosting — but with so many people watching their weight these days, Aunt Nina is probably safe. Is this a fair division? The goods were not divided equally, but it appears that if Rachel simply wants the biggest piece, both will end up happy.

Spite: Suppose the situation is as above — that is, Aunt Nina prefers frosting and Rachel prefers as much moist rich cake as she can get. But Rachel is annoyed with Aunt Nina: Rachel thinks that Aunt Nina is being overly clever, and resents the way she rigs things for her own benefit. Consequently, Rachel takes the frosted piece, suspecting that that's the one that Aunt Nina really wants.

Information: Suppose again the situation is as above, except that in this scenario, Aunt Nina knows that Rachel *loves* frosting, whereas Aunt Nina likes a robust combination of frosting and cake. This time, Aunt Nina makes the cut so that a significantly smaller piece has just enough extra frosting that she surmises that Rachel will take it. If Aunt Nina is correct, she ends up with a significantly bigger portion that includes a goodly amount of frosting. Of course Rachel can always choose to spite Aunt Nina, but in so doing, she's spiting herself, too.

Envy: Continue to suppose that everything is as in the inhomogeneous example. Rachel takes the larger piece of cake, and Aunt Nina gets the corner piece loaded with frosting. Even though Rachel got a bigger piece, Rachel may worry that somehow Aunt Nina has gotten the better end of the deal. Consequently, Rachel feels envy, and it eats away at her like skrrghs[3] gnawing at her intestines. She most definitely is not happy with this so-called fair division — despite the fact that she feels (correctly) that she got more cake!

Buyer's Remorse: This concept usually applies to expensive purchases, such as homes or cars. The idea is that after completing the purchase, the buyer deeply regrets it. One can easily imagine this with a cake-slice choice: even though Rachel might not feel envious of Aunt Nina, she may nevertheless regret her choice.

Over-Anticipation and Boredom: In a multiple-player version, by the time the cake is actually divided by a fair-division method, everyone may have lost interest in the "fairness," because each participant just wants a piece of cake as soon as possible! Consequently, as the turns come up, each selector simply takes the first available piece.[4]

It's easy to imagine how these cake-cutting examples might apply to a pair of siblings who inherit a large estate. If the land is homogenous, say all woods or all farmland, it would be easy to equitably cut it into pieces. But if it's part farm, part woods, and has shoreline on a lake, it might be very difficult to find a division of the land that the co-heirs feel is optimal. (Imagine how much worse the problem would be with, say, five brothers and sisters.) Even trickier is the situation in which a good simply cannot be divided without essentially destroying it.

Indivisible Goods: This time, let's suppose that rather than dividing a cake or even different types of land, we are trying to determine what to do with an indivisible good, such as a house. We could always sell it and split the profits, but perhaps the house has tremendous sentimental value, or the market is down, or it has been in the family for 160 years and we can't bear to give it up. We might try time-sharing, but unless we're merely treating it as a vacation home, that would be a recipe for disaster.

The rest of this essay will deal with the problem of indivisible goods, as that is the problem confronting the Waterhouse clan in *Cryptonomicon*.

The Waterhouse Method

Randy and his uncles (all mathematically sophisticated) have arrived at a solution to the problem of the division of the indivisible heirlooms of Grandmother Waterhouse. Each sibling will record a set of preferences for the various items. A supercomputer will then be used to calculate the fair distribution of Grandmother Waterhouse's bequest. For many writers, the above description would be enough and the magic of the supercomputer plus some hand-waving would move readers through this particular plot point. But Stephenson is mathematically sophisticated, and therefore makes his satire work in a richer and more complex fashion.

First, the various siblings must express their valuation of the items. To facilitate this, an empty parking lot at the local university has been set up as a coordinate plane: the x-axis represents the items' perceived economic values and the y-axis their perceived emotional values. Each sibling then takes a turn arranging the items on this plane as a means of expressing his or her preferences and valuations. For example, an ugly, smelly blanket of Qwlghmian wool has negative economic and emotional value, and so any sibling would place it in the $(-x,-y)$ quadrant. But the Gomer Bolstrood console — which sat in Aunt Nina's room from the time she was born until she left for college — has significant economic and emotional value for her, and would therefore be placed by her in the $(+x, +y)$ quadrant. The Waterhouse family decides to express these values by shuffling furniture and boxes of china around in a parking lot in subzero temperatures not for mathematical reasons, but because of what engineers would call "human factors": they think that moving the items themselves around rather than working out the rankings on paper will give them "a direct physical analog of the value-assertions that they [are] making" and also allow them to see the heirlooms in daylight rather than by flashlight in a storage locker (629).

For each of the m people (or couples) in the family

there exists an n-element value vector,[5] V, where V_1 [the vector's first entry] is the value that that particular couple would place on item number 1 ... and V_2 [the vector's second entry] is the value they would place on item number 2 and so on all the way up to item number n. These m vectors, taken together, form a value matrix [625].

$$\begin{bmatrix} V_{1_1} & V_{1_2} & \cdots & V_{1_n} \\ V_{2_1} & V_{2_2} & \cdots & V_{2_n} \\ \vdots & \vdots & \ddots & \vdots \\ V_{m_1} & V_{m_2} & \cdots & V_{m_n} \end{bmatrix}$$

Once the combined preferences and valuations by all the siblings for all the grand-mother's worldly goods have been recorded, all the choices will be mathematically scaled "so that they add up to the same total values on both the emotional and financial scales" (628).[6]

In his novel, Stephenson alleges that this problem of fair division is so complex that one of the fastest computers in the world will be necessary to solve it. Here the question arises of whether Stephenson is unaware of some methods of solving fair division problems, or is, rather, deliberately avoiding mentioning such methods in accordance with narrative strategies he's employing for dramatic effect. Anyone researching the problem of fair division of indivisible goods is likely to learn of Knaster's Method (which we discuss below) and it seems reasonable to assume that Stephenson did research the problem. We can assume this because he sensibly describes the problem as being how to partition the items into m subsets (S_1, S_2, \ldots , S_m) such that the values of the subsets are as close as possible to being equal, and also because he invokes the "knapsack problem"[7] (more on this below).

It's easy to quibble with the system Stephenson sketches. First, having an emotional-value axis and a financial-value axis is striking but unnecessary. Ultimately, what will matter is the distance an item is placed from the origin, so the heirlooms could instead be rated using simply a number line, rather than a full coordinate plane. Second, Stephenson's set-up allows for negative values, and since the infamous Qwlghmian blanket is worse than worthless (both financially and emotionally), a canny Waterhouse — that is, any of them — would assign the blanket the most negative emotional and financial values possible, in effect jacking up the value of the cared-for items. Even if the Waterhouse clan is wed to doing the rating in two dimensions, the process would be equivalent and arguably more simple if only nonnegative ratings were allowed. Finally, the system used is so computationally intensive that working with it necessarily requires a computer program that for the siblings is a "black box" (see below), allowing the algorithm and its workings to be easily gamed by programmer Randy.

So, despite all the efforts by the brainy, mathematically sophisticated Waterhouses to devise a system that will be mathematically provable as fair, the siblings are undone by simple human factors. Aunt Nina, who cares only that she gets the Gomer Bolstrood console, identifies the weak link: because the calculations cannot be done in the open, with pencil and paper, the family must rely on the supercomputer and, more significantly, the programmer of the computer, to get the correct result. When the underlying mathematics is so computationally intensive, the computer program is, for all the participants, a black box, and it is not possible to make a good guesstimate or back-of-the-envelope calculation to make sure that something has not gone wrong with the program (or the programmer). "I guess I'm just worried," Aunt Nina says, "about having my preferences mediated by this super-computer. I have tried to make it clear what I want. But will the computer understand that?" She realizes that now that the actual workings of the math have become opaque to the participants, the computer programmer — Randy — becomes very important for the fair working of the system. Aunt Nina then asks Randy if there is anything that he wants from the inheritance. "Then like an almost perfect moron — like an organism genetically engi-neered to be a total, stupid, idiot," Randy glances directly at the trunk of code books and punch cards, letting Aunt Nina know what he wants. It is then a simple matter for her to put the Gomer Bolstrood console and the old trunk (which no one else wants) at exactly

the same place on the coordinate plane (631). Her (coded) communication with Randy is straightforward: if she gets the console, he'll get what he wants. And so Randy sabotages the computer program to "ensure that Aunt Nina gets what she wants, so that she'll give him what is rightfully his" (633).

A Better Way: Knaster's Method of Sealed Bids

Bronisław Knaster's Method of Sealed Bids[8] is slightly over sixty years old, is not very complicated, and guarantees equitable distributions of indivisible goods — although it doesn't guard against envy, spite, or inside information. As such, it's a reasonable method to use; however, in the example below, at least one of its shortcomings will be obvious.

We'll begin our analysis with the simplest possible case: two people and one indivisible good. Fanny and Alexander[9] are two children who have to decide how to divide their parents' giant sterling silver samovar that was a happy fixture of many family celebrations. Each of them submits a sealed bid of how much the samovar is worth to them. To use the technical term, they each give a *valuation* of the samovar. (All numbers in tables are in dollars, rather than kronor, though it doesn't really matter.)

	Fanny	Alexander
Valuation of samovar	2,000	1,000

Fanny values the samovar more than Alexander, and so she is awarded the samovar. Now, we must make some restitution to Alexander. Here's how it goes:

	Fanny	Alexander
Valuation of samovar	2,000	1,000
Value received	2,000	0

We compute an *initial fair share* for each person to remedy the inequity. It's called "initial" because we will modify it later. A person's initial fair share is his or her valuation of the samovar, divided by the total number of people sharing the goods — in this case, two people. Thus, we add another row to the table:

	Fanny	Alexander
Valuation of samovar	2,000	1,000
Value received	2,000	0
Initial fair share	1,000	500

Next, we compute the *differences*

$$\text{(value received)} - \text{(initial fair share)} = \text{difference}$$

for Fanny and Alexander. Note that a difference may be either positive or negative.

	Fanny	Alexander
Valuation of samovar	2,000	1,000
Value received	2,000	0
Initial fair share	1,000	500
Difference	1,000	−500

Based on initial fair shares, Fanny perceives herself to be $1,000 ahead of her "fair half" of the samovar, and Alexander sees himself as down the $500 of his "fair half." We now sum

the differences of the players (noting that since Alexander's difference is negative, adding it to Fanny's difference actually involves subtracting one positive number from another):

$$\$1,000 \text{ (Fanny)} - \$500 \text{ (Alexander)} = \$500.$$

This amount is called the *surplus*. Next, we divide the surplus into equal shares for each participant: $500/2 = $250. Adding these equal shares of the surplus to the initial fair shares, we obtain the *adjusted fair shares* for Fanny and Alexander.

	Fanny	Alexander
Valuation of samovar	2,000	1,000
Value received	2,000	0
Initial fair share	1,000	500
Difference	1,000	−500
Share of surplus	250	250
Adjusted fair share	1,250	750

Now we calculate the *final excess* for each person. This number is the

$$\text{(value received)} - \text{(adjusted fair share)} = \text{final excess};$$

in other words, it's the amount received "over" each person's estimation of his or her fair share. Note that a participant's final excess can be negative, indicating that he or she has actually received *less* than his or her fair share. Thus Fanny's final excess is $2,000 − $1,250 = $750; she's ahead of the game by $750. On the other hand, Alexander has a final "excess" of $0 − $750 = −$750; he's down by $750.

	Fanny	Alexander
Valuation of samovar	2,000	1,000
Value received	2,000	0
Initial fair share	1,000	500
Difference	1,000	−500
Share of surplus	250	250
Adjusted fair share	1,250	750
Final excess	750	−750

Now, Fanny gives Alexander her final excess, which exactly matches his deficit. These paid-out and received amounts are called *cash settlements*. Fanny's cash settlement is negative, because she must pay Alexander $750; Alexander's is positive, because he is receiving $750.

	Fanny	Alexander
Valuation of samovar	2,000	1,000
Value received	2,000	0
Initial fair share	1,000	500
Difference	1,000	−500
Share of surplus	250	250
Adjusted fair share	1,250	750
Final excess	750	−750
Cash settlement	−750	750

If we sum up the total value received by the participants, both from the samovar and the cash settlement, we calculate that Fanny received a samovar she values at $2,000 and pays out $750. So, in her eyes, she receives a final value of

$$\$2,000 - \$750 = \$1,250,$$

which constitutes (in her eyes) 62.5 percent of the samovar. On the other hand, Alexander doesn't get the samovar, but does get a cash settlement of $750. Thus, from his perspective, he gets

$$\$0 + \$750 = \$750,$$

which constitutes 75 percent of his assessment of the value of the samovar. Both Fanny and Alexander believe they are getting more than half the estate! Knaster's Method guarantees that participants will receive at least their fair share (in their minds) of the samovar. (Notice that each person's final value received is his or her adjusted fair share.)

	Fanny	Alexander
Valuation of samovar	2,000	1,000
Value received	2,000	0
Initial fair share	1,000	500
Difference	1,000	−500
Share of surplus	250	250
Adjusted fair share	1,250	750
Final excess	750	−750
Cash settlement	−750	750
Final value received	1,250	750

Now let's consider some potential issues that may arise.

Is envy a problem? In this example, it's not: from Fanny's perspective, Alexander got $750, which is only 37.5 percent of the value of the samovar, while she got 62.5 percent of its value. From Alexander's perspective, he got 75 percent of the value of the samovar, while Fanny received only 25 percent of its value. Both the heirs think that they came out significantly ahead of the other.

Is spite a problem? Not really. It's true that Alexander could bid a ludicrous amount of money to spite Fanny and get the samovar. But if he does, he'll have to pay her a proportionally huge cash settlement at the end, and ultimately hurt himself more than her.

Is money a problem? Yes: if Fanny doesn't have any money to spare, she might not have the means to make the cash settlement to Alexander. This is the major weakness of the Knaster Method, although there are ways around it, especially in the multi-object, multi-heir version.

Is having extra information a problem? Definitely. There are two ways in which it can cause trouble.

 First way: If, say, Alexander knows what Fanny is going to bid, he can submit a bid that is only $1 less than hers if he doesn't want the samovar. Such a move would alter his final value received to $999.75, which is significantly larger than the $750 from the example above. Similarly, if Fanny knows Alexander is going to bid $1000, she can lower her bid to $1001. Then her cash settlement to him will be only $500.25, which is, in turn, considerably less than her "real" bid would have led her to pay.

 Second way: If, after the cash settlements, either Fanny or Alexander learns what the other bid, she or he will become envious. Alexander will feel shorted by $250, because half of Fanny's valuation of the samovar is $1000 and he only received $750. On the other hand, Fanny will feel she overpaid by $250, since half of Alexander's valuation is only $500.

Multi-Player Knaster's Method

Here is a multi-player version of Knaster's Method, based on the characters and heir-looms in *Cryptonomicon*.

Participants: Uncle Geoff and Aunt Anne
Aunt Nina and Uncle Red
Uncle Tom and Aunt Rachel
Randy's Parents
Unnamed fifth Waterhouse sibling[10]

Items: Gomer Bolstrood console
Grand piano
Silver tea service
Royal Albert china set
Gomer Bolstrood dining set
Trunk filled with code books and punch cards
Suite of armoires
(We're ignoring the overstuffed chair and Qwlghmian blanket)

Because we couldn't determine the name of one of the Waterhouse siblings, we'll run an example involving four participating couples who have seven items to divide. Some of the goods, such as the tea service, could theoretically be split up between the Waterhouses, but we'll maintain the integrity of the heirlooms. We also assume that each participant is either financially solvent or willing to sell a received item in order to be able to cover any cash settlement he or she owes. Let's apply Knaster's Method of Sealed Bids to this; no supercomputers need apply.

Each team of participants makes a sealed bid valuation of each of the seven objects (all table values are again in dollars, not kronor, and it still doesn't matter).

	Geoff/Anne	Nina/Red	Tom/Rachel	Parents
Gomer Bolstrood console	400	10,000	1,000	500
Grand piano	4,000	1,000	7,000	5,000
Silver tea service	4,000	2,000	3,000	1,000
Royal Albert china set	1,000	0	2,500	3,000
Gomer Bolstrood dining set	9,000	1,000	15,000	8,000
Trunk of Arethusa intercepts on punch cards	0	5,000	0	0
Suite of armoires	4,000	1,000	3,000	500

Notice that the team of Aunt Nina and Uncle Red has placed absurdly high values on the Gomer Bolstrood console and the trunk containing the code books and punch cards in order to ensure they will get them both. On the other hand, Rachel and Tom's team, status-conscious, has bid high on the dining set and the grand piano.

The next step is to find each team's total valuation: that is, the total amount they assign to the estate. This is easily done by adding up the columns.

	Geoff/Anne	Nina/Red	Tom/Rachel	Parents
Gomer Bolstrood console	400	10,000	1,000	500
Grand piano	4,000	1,000	7,000	5,000

	Geoff/Anne	Nina/Red	Tom/Rachel	Parents
Silver tea service	4,000	2,000	3,000	1,000
Royal Albert china set	1,000	0	2,500	3,000
Gomer Bolstrood dining set	9,000	1,000	15,000	8,000
Trunk of Arethusa intercepts on punch cards	0	5,000	0	0
Suite of armoires	4,000	1,000	3,000	500
Total valuation	22,400	20,000	31,500	18,000

Based on the sealed valuations, each item is assigned to whosoever bid highest on it. Thus, in our scenario

- Geoff and Anne get the silver tea service and the armoires.
- Nina and Red get the console and the trunk.
- Tom and Rachel get the grand piano and the dining set.
- Randy's parents get the china set.

Based on this, we now calculate the value of the items received by each team *as perceived by each team*.

	Geoff/Anne	Nina/Red	Tom/Rachel	Parents
Gomer Bolstrood console	400	10,000	1,000	500
Grand piano	4,000	1,000	7,000	5,000
Silver tea service	4,000	2,000	3,000	1,000
Royal Albert china set	1,000	0	2,500	3,000
Gomer Bolstrood dining set	9,000	1,000	15,000	8,000
Trunk of Arethusa intercepts on punch cards	0	5,000	0	0
Suite of armoires	4,000	1,000	3,000	500
Total valuation	22,400	20,000	31,500	18,000
Value of items received	8,000	15,000	22,000	3,000

Now we calculate the initial fair shares. In this case, a team's initial fair share is its total valuation divided by four — that is, it's what each team perceives a fair share (one quarter of the estate) to be. In the interest of saving space, we'll omit the estate valuations henceforth.

	Geoff/Anne	Nina/Red	Tom/Rachel	Parents
Total valuation	22,400	20,000	31,500	18,000
Value of items received	8,000	15,000	22,000	3,000
Initial fair share	5,600	5,000	7,875	4,500

Now we calculate the difference between the value of items received and the initial fair share:

	Geoff/Anne	Nina/Red	Tom/Rachel	Parents
Total valuation	22,400	20,000	31,500	18,000
Value of items received	8,000	15,000	22,000	3,000
Initial fair share	5,600	5,000	7,875	4,500
Difference	2,400	10,000	14,125	−1,500

Add the differences to determine the surplus:

$2,400 (G/A) + $10,000 (N/R) + $14,125 (T/R) − $1,500 (Parents) = $25,025.

Each team is assigned an equal share of the surplus, so we round this amount

$$\frac{\$25,025}{4} = \$6,256.25 \approx \$6,256$$

to the nearest dollar, and add it to each team's initial fair share. This sum is the adjusted fair share.

	Geoff/Anne	Nina/Red	Tom/Rachel	Parents
Total valuation	22,400	20,000	31,500	18,000
Value of items received	8,000	15,000	22,000	3,000
Initial fair share	5,600	5,000	7,875	4,500
Difference	2,400	10,000	14,125	−1,500
Share of surplus	6,256	6,256	6,256	6,256
Adjusted fair share	11,856	11,256	14,131	10,756

Here's the important calculation for the cash settlement: we find the difference between the value of items received and the adjusted fair share for each team. If a team received more value than its adjusted fair share, it has an initial excess and must pay that money into the cash settlement (so its cash settlement will be negative). If, on the other hand, it has received less value than its adjusted fair share, then it will receive a positive cash settlement.

	Geoff/Anne	Nina/Red	Tom/Rachel	Parents
Total valuation	22,400	20,000	31,500	18,000
Value of items received	8,000	15,000	22,000	3,000
Initial fair share	5,600	5,000	7,875	4,500
Difference	2,400	10,000	14,125	−1,500
Share of surplus	6,256	6,256	6,256	6,256
Adjusted fair share	11,856	11,256	14,131	10,756
Final excess	−3,856	3,744	7,869	−7,756
Cash settlement	3,856	−3,744	−7,869	7,756

Finally, we calculate the total value that each team received and that value's percent of the estate (from the team's perspective). Note that each perceived percent should be at least 25 percent in order for each team to be happy. Notice also that, again, each team's final value received is the same as its adjusted fair share. (If you are eagle-eyed, you will notice that the teams of Nina/Red and Tom/Rachel together pay out a total of $11,613 while the other two couples, Geoff/Anne and Randy's parents, receive a total of only $11,612. This is due to our rounding when computing each couple's surplus; the referee for Knaster's Method pockets the extra $1.)

	Geoff/Anne	Nina/Red	Tom/Rachel	Parents
Total valuation	22,400	20,000	31,500	18,000
Value of items received	8,000	15,000	22,000	3,000
Initial fair share	5,600	5,000	7,875	4,500
Difference	2,400	10,000	14,125	−1,500
Share of surplus	6,256	6,256	6,256	6,256
Adjusted fair share	11,856	11,256	14,131	10,756
Final excess	−3,856	3,744	7,869	−7,756
Cash settlement	3,856	−3,744	−7,869	7,756
Final value received	11,856	11,256	14,131	10,756
Approx. perceived % of estate received	53%	56%	45%	60%

Using Knaster's Method of Sealed Bids, each team feels they have done spectacularly well — far exceeding in each team's take the 25 percent that would be its "fair share."

The method cannot solve all problems, however. For example, if Rachel wants to spite Aunt Nina, she could bid a tremendous amount to guarantee that she'll get the console. This entails, again, that she'd have to make a large cash payment, and perhaps not get the other objects she wants. And if one of the heirs is very rich, and wants all the objects, that heir can bid very high for all of them and then make cash restitution to the remaining heirs. That would certainly invite unpleasant relations, at least, and unfortunately Knaster's Method will not solve deep-seated problems of sibling rivalry or borderline personality disorder.

On the positive side, among the many benefits of Knaster's Method is the simplicity of the mathematics, particularly in contrast to the Waterhouse method. Stephenson has Randy justify the valuations of the furniture and the necessity of the supercomputer as an essential tool in the fair division by drawing an analogy between the method the Waterhouse clan has agreed upon and the previously-mentioned knapsack problem.[11] Briefly, this problem involves a hiker carrying a knapsack; imagine Randy backpacking through Philippine jungles in search of Nazi gold. Suppose there are n different objects he might take in his knapsack, and they won't all fit at the same time. Consequently, Randy rates the desirability of each object: for example, a water bottle would presumably rate very highly, as would a sleeping bag. On the other hand, the unabridged twenty-volume edition of the Oxford English Dictionary would likely rate very low — it would possibly be assigned a value of negative infinity.

There are 2^n possible subsets that can be taken from a set of n objects.[12] The value of a subset of Randy's set of n items is found by adding up the ratings of all the objects in the subset. Randy decides to find the values of all possible subsets of objects. Once all those values are computed, he will take with him a subset of objects with a maximal value (that is, a subset whose value is not exceeded by the value of any other subset). If there are, for example, only 7 items that Randy can take with him, then that entails that only $2^7 = 128$ different subset-values need to be calculated, which is easy for a computer to do.

But if the knapsack is large, and Randy plans on being in the jungle for ten days, then he might have as many as 50 or 60 objects to choose from. This means that the number of subsets whose values must be computed is

$$2^{60} \approx 10^{18} = 1,000,000,000,000,000,000.$$

If Randy's computer were able to perform one million ($= 10^6$) calculations per second, it would take about 10^{12} seconds — that is, over 30,000 years — to compute the values for all the subsets! Furthermore, he would have to be careful in rating the items, because it's conceivable an optimally-ranked subset might lack an absolutely necessary piece of equipment.

We conjecture that Stephenson must be imagining that the Waterhouse offspring will each give their valuations of the many pieces of the estate, and then the values for all possible subsets will be computed and compared. Moreover, in this case, there'd be the additional complexity that the estate must be subdivided into five shares that each team perceives to be equal. If one adopts a brute force approach, à la the knapsack problem, one would quickly encounter preposterously large numbers requiring insidiously clever algorithms and state-of-the-art supercomputers to run them. Or, one could just use the Knaster Method of Sealed Bids.

Geeks and Mundanes

One of the reasons we repeatedly teach *Cryptonomicon*[13] is the way Stephenson demonstrates and celebrates the great utility (and pleasure!) of mathematical thinking:

> The basic problem for Lawrence [Randy's grandfather] was that he was lazy. He had figured out that everything was much simpler if, like Superman with his X-ray vision, you just stared through the cosmetic distractions and saw the underlying mathematical skeleton. Once you found the math in a thing, you knew everything about it, and you could manipulate it to your heart's content with nothing more than a pencil and a napkin [8].

Cutting through the cosmetic distractions and solving a problem by working the underlying math is, in our opinion, not a skill that is taught (or appreciated) enough. One of the great strengths of *Cryptonomicon* is that Stephenson not only dramatizes his characters' abilities to solve problems this way, but also, rather than simply invoking mathematics, illustrates *how it works.*[14] By having his readers "do the math"—at least vicariously, as they read over formulae—Stephenson is turning them into insiders, people possessed of esoteric knowledge that enables them to do things that other people cannot do. He thus gives a mathematician's perspective on how the magic of the math works. The main point of view in Stephenson's pre–*Baroque Cycle* science fiction novels (*Snow Crash*, *The Diamond Age*, and *Cryptonomicon*) is that of the mathematically-knowledgeable, technologically-savvy individual who is not fully integrated into the socio-cultural mainstream: in other words, it's that of the geek. Hiro Protagonist (*Snow Crash*), Nell (*The Diamond Age*), and both Lawrence and Randy Waterhouse (*Cryptonomicon*) are geeks who eventually raise their individual abilities to even higher, supra-geek levels by blending their powers of abstract mathematical and scientific thinking with newly acquired social and cultural skills. The geeks learn how to interact with "mundanes," people more concerned about, say, fashion, popular culture, or interpersonal relationships than about number theory and efficient algorithms. In the process, the geeks discover that some of the things that they used to think mundanes cared too much about actually are significant. Because such large portions of the plots of the novels are mediated through these geek characters' points of view, readers are unwittingly made into scientific, mathematical, and technological insiders. After working through *Cryptonomicon*, careful readers have some reasonably detailed general knowledge about cryptology, computer networking, and, after page 633, a system for fair division: they have become geeks themselves.

Readers are therefore mapped onto one side of the geek/mundane dyad set up by Stephenson.[15] They are geeks and can chuckle knowingly at the mundanes who are unable to do or uninterested in doing the math. Part of Stephenson's genius is this ability to transform mundane readers into believing that they are geeks (or that they are even better, because now they have the geek knowledge but also retain their social abilities). But by deliberately crippling his fair division system in a way that is only evident to people with even more mathematical knowledge than one gains by reading *Cryptonomicon*, Stephenson turns the tables on these readers. This dynamic undercuts geek readers' (and transformed-into-geeks-by–*Cryptonomicon* readers') pretensions to superior knowledge. You might be a knowledgeable enough geek to think you understand everything that is going on in the fair division scene, but a real mathematician knows more. You may have a set of powerful role-

playing-game cards, including a devastatingly effective troll or wizard, but Randy's friend Chester has tucked away in his vest THE THERMONUCLEAR ARSENAL OF THE UNION OF SOVIET SOCIALIST REPUBLICS, or YHWH (647–49). You may be a stupendous badass who wields samurai swords, but mercenary Raven (the primary antagonist in *Snow Crash*) has a hydrogen bomb in the sidecar of his motorcycle (*Snow Crash* 271–72). No matter how much you know, no matter how extreme your geek cred, there is always someone else who knows more.

This dynamic fits well with an important theme that runs throughout Stephenson's work. Esoteric knowledge and superior mathematical thinking, while great desiderata, are not enough. We live in a social world and it is not always sufficient to just cut through cosmetic distractions and see the math underneath: sometimes the heart of the problem really lies in the apparent cosmetic "distraction." Stephenson's non-geek protagonists (Y. T. in *Snow Crash*, Bobby Shaftoe in *Cryptonomicon*) augment the geek characters by being able to accomplish things using social interactions and even brute force. Part of the conclusion of a Stephenson novel is the development of synergy between approaches: the geek character develops social skills and physical bravery, and the partnership between geek and mundane accomplishes a goal larger than that which could be accomplished by either character working alone. This is one of the real strengths of Stephenson's work: rather than uncritically celebrating his geek characters, he dramatizes both the strengths and weaknesses of approaching the world solely through abstract reasoning. Aunt Nina can look through the cosmetic distraction of complex formulae and supercomputers and realize that the key to getting what she wants is through the manipulation of *social* reality: sophisticated knowledge of human behavior can be a sufficiently powerful tool for achieving one's ends. Similarly, Lawrence and Randy both learn to become socially adaptable and to pay attention to social behavior; Lawrence shows he has become socially savvy when he breaks the Arethusa cryptosystem by tricking a character into transmitting the word "crocodile" in a message (883), and Randy learns to perform social niceties — for example, he accepts a cigarette even though he does not smoke (867).

Unlike many science fiction writers, who end up defending "their" side in the strongest terms,[16] Stephenson has the remarkable ability to look at both sides, depicting the fun, excitement, and freedom of a libertarian future while also dramatizing its weaknesses and inherent problems. For example, the future in *Snow Crash* is not quite utopian or dystopian, and the extreme libertarian freedom celebrated (to a degree) in that novel is shown to be as problematic as the more regimented, state-focused society of the Vickies in *The Diamond Age*.[17] Further, Stephenson does not promulgate the view that if only everyone in the world thought like geeks then things would work out; rather, he shows characters with different approaches learning from one another. Thus Stephenson celebrates mathematical sophistication and general geekiness — as he should! — but also critiques it, demonstrating that an integrated approach (albeit with a higher component of geekiness than is standard) to problem solving is the most fruitful. By making his readers first into insider geeks and then (to the mathematically initiated) revealing them to be outsider mundanes, Stephenson has his cake, and eats it, too. Hardly a fair division!

Notes

1. See Hugo Steinhaus' "The Problem of Fair Division."
2. Gomer Bolstrood is a legendary New England furniture maker invented by Stephenson.

3. Pronounced something like "skerries," these are "the frisky, bright-eyed, long-tailed mammals" — remarkably vicious and destructive beasts — "that are the mascot of ... [Stephenson's fictional] islands" of Qwghlm (234).

4. This actually happened in our class one year when we brought in a cake for the students to cut into slices using a fair division method.

5. We can think of such a vector as an ordered array of *n* values, or *entries*. There are many sophisticated theories from mathematics and physics that allow for operations on vectors, and vectors are especially well-suited for manipulation by computers.

6. We note that Stephenson's mathematics here is at best vague and at worst specious. He appears to have the Waterhouses summing vectors to obtain numbers; in standard algebraic structures, vectors sum to vectors.

7. See Lester E. Dubins, "Group Decision Devices."

8. Bronisław Knaster, "Sur le problème du partage pragmatique de H. Steinhaus."

9. From Ingmar Bergman's film *Fanny and Alexander*.

10. At least, we were unable to find his or her name in the novel.

11. Randy also alludes to the fact that the knapsack problem is sufficiently complex that there are code schemes based on it; it goes unmentioned that the code schemes suck and aren't used by professionals, though surely Stephenson must know this.

12. There is a lovely combinatorial proof of this. Given a subset of a set *S*, there are two possible states for each element of *S*: each element is either *in* the subset, or *not in* the subset. The total number of subsets of *S* is thus found by multiplying together the numbers of possible states for each element:

$$\underbrace{2 \cdot 2 \cdot 2 \cdots 2}_{n \text{ of these}} = 2^n .$$

13. We have taught *Cryptonomicon* many times in our paired mathematics and English courses, "The Edge of Reason" and "Science Fiction." We would like to thank President Dale Marshall and Provost Susanne Woods for supporting us in the development of these courses as a pioneering part of Wheaton's "Connections" curriculum, which provides students with thematically-linked courses. And we would like especially to thank our students who were willing to experiment and who with sharp questions and good humor helped us to improve the courses significantly.

14. Compare the glamorization of mathematics in Robert A. Heinlein's *Starman Jones*: the scene of round-robin astrogation under extreme time pressure is very exciting and obviously a dramatization of the importance of mathematical knowledge (see also Heinlein's *The Rolling Stones*), but Heinlein does not require his readers to engage in the actual math. Similarly, Heinlein famously spent days working out the correct trajectories for his spaceships for a section of *Space Cadet*, but, again, readers are not asked to *do* any math.

15. Whether this dynamic is really dichotomous is beyond the scope of this essay. See Stephenson's *Lord of the Rings* metaphor in *Cryptonomicon*, in which he equates engineers and technical people with dwarves, true mundanes with hobbits, and people fluent in both worlds with elves (80–81).

16. Among these we would include Heinlein, Frank Herbert, and Isaac Asimov.

17. Compare the Lunar society in Heinlein's *The Moon Is a Harsh Mistress*, which is a libertarian utopia; Heinlein never dramatizes what would happen if an extremely powerful and socially disruptive character like *Snow Crash*'s Raven appeared in Luna City.

Works Consulted

Dubins, Lester E. "Group Decision Devices." *The American Mathematical Monthly* 84.5 (May 1977): 350–56.

Heinlein, Robert A. *The Moon Is a Harsh Mistress*. 1966. New York: Doherty, 1996.

_____. *The Rolling Stones*. New York: Scribner's, 1952.

_____. *Space Cadet*. 1948. New York: Doherty, 2006.

_____. *Starman Jones*. New York: Scribner's, 1953.

Knaster, Bronisław. "Sur le problème du partage pragmatique de H. Steinhaus." *Annales de la Societé Polonaise de Mathematique* 19 (1946): 228–30.

Steinhaus, Hugo. "The Problem of Fair Division." *Econometrica* 16 (1948): 101–04.

Stephenson, Neal. *Cryptonomicon*. New York: Avon, 1999.

_____. *The Diamond Age: Or, A Young Lady's Illustrated Primer*. New York: Spectra, 1995.

_____. *Snow Crash*. New York: Bantam, 1992.

Game Theory in Popular Culture
Battles of Wits and Matters of Trust
JENNIFER FIRKINS NORDSTROM

Fundamental concepts from game theory appear in a variety of films. For instance, in 1987's *The Princess Bride*, two characters engage in an intellectual battle in which one tries to outwit the other by untangling the latter's strategy, while in the 2008 Batman movie *The Dark Knight*, the Joker pits two ferryboats against each other so that one's passengers can only save themselves by choosing to destroy the other boat. Competitive situations often add drama to a film, as they elicit fundamental psychological conflicts between characters. In particular, game-theoretic scenarios develop themes of trust, selfishness, and altruism. They can also be used to demonstrate characters' intellectual prowess or fearlessness. In contrast to the scripted fictional setting of film, some game shows provide an opportunity to see how people might truly behave in classic game-theoretical settings; for example, in *Survivor*, contestants form alliances with their competitors in order to further their positions in the game. In all of these cases, it is interesting to see not just how examples of theoretical games and assumptions appear in our media, but also how their outcomes in practice may differ from those in traditional mathematical models.

An Introduction to Game Theory

The mathematical theories behind game theory are traditionally used to model competitive situations among *players*. These players can represent corporations, governments, political candidates, or any competitors. In order to analyze such games mathematically, several assumptions must be made. The most fundamental assumptions are that the players have some amount of common knowledge about the game, that all players will play to the best of their ability, and that each player's goal is to maximize his or her *payoff*. A payoff is often presented numerically, but could represent a psychological reward as much as a financial reward. Players have a choice of strategies. Once the players choose their individual strategy, the payoff to each player is determined. When analyzing games mathematically, it is desirable to be able to determine which strategy each player should choose, and, thus, predict the outcome of the game.

One of the most common scenarios analyzed in economic game theory is the *two-player competitive game*. Each player has a choice of strategies, and goal of each player is to maximize his or her own payoff. As an example, consider the game of Rock-Paper-Scissors. Each player chooses to play "Rock," "Paper," or "Scissors." They make their choice simultaneously. Then the winner is determined by the rule that Rock beats Scissors, Scissors beats Paper, and Paper beats Rock. Thus if Player 1 plays Scissors and Player 2 plays Paper, then Player 1 wins. Since the payoff to Player 1 is "winning," the payoff to Player 2 is "losing." If both players play the same thing, then they tie.

In order to think of this game more mathematically, we could give values to "winning" and "losing." For example, "winning" could be given a value of 1, and "losing" a value of –1. We can represent the payoff to each player as an ordered pair with Player 1's payoff listed first, Player 2's second: for instance, the case of Player 1 winning and Player 2 losing would be represented by (1, –1). Now this game's potential outcomes can be easily depicted with a table or *payoff matrix* showing the possible strategies and the corresponding payoffs to each player. Player 1 is the "row" player, meaning that she chooses from among the strategies represented by the rows in the matrix (she chooses from the three options listed in its first column); Player 2 is the "column" player, meaning he chooses from the strategies represented by the columns of the matrix (he chooses from the three options listed in its first row).

Rock-Paper-Scissors, for instance, has the following payoff matrix:

		Player 2 Options		
		Rock	Paper	Scissors
	Rock	(0, 0)	(–1, 1)	(1, –1)
Player 1 Options	**Paper**	(1, –1)	(0, 0)	(–1, 1)
	Scissors	(–1, 1)	(1, –1)	(0, 0)

(Note that in this example, Player 1 and Player 2 have the same choices of strategy; this is not always the case.) Once both players have made a choice of strategy, the payoff to each player is determined by the corresponding pair in the matrix, with the first value going to Player 1, and the second going to Player 2. For example, if Player 1 chooses Scissors and Player 2 chooses Paper, this results in the payoff (1, –1), where, again, we can think of getting 1 as winning, getting –1 as losing, and getting 0 as tying. Although we will not analyze this game here, understanding what a payoff matrix represents will allow us to better understand some key ideas from game theory and see how those ideas have been used in film and television.

Perfect Knowledge

In order to analyze a game using game theory, it is important for each player to have information about not only his or her own choices, but also the choices of his or her opponent. In other words, both players must have some common knowledge. In the context of game theory, we often make the assumption that not only do the players have common knowledge, but that they both *know* that this is common knowledge (as opposed to, say, each player being provided some information, but neither player knowing that the other player has that same information). In particular, players know their own possible strategies,

the strategies of the other players, and the payoffs for each combination of strategies. But they also know that their opponent has this same knowledge. In trying to determine one player's best strategy, it is crucial to understand what his or her opponent is likely to do.

For example, consider the following theoretical game in which both players have two choices with the following payoff matrix. Note that since the first column's entries are A and B, these are the choices for Player 1, and since the first row's entries are C and D, these are the choices for Player 2. Also, remember that in each ordered pair, the first number is Player 1's payoff and the second is Player 2's payoff.

Player 2 Options

Player 1 Options		C	D
	A	(5, −5)	(−5, 5)
	B	(10, −10)	(−10, 10)

At first glance, we see that Player 1 gains the most if she chooses B while Player 2 chooses C. Thus, it might be tempting for Player 1 to choose B. However, we can see that Player 2 should never choose C, since regardless of what Player 1 chooses to do, choosing C would lead to a negative Player 2 payoff while choosing D would lead to a positive Player 2 payoff. So Player 1 should assume that Player 2 will choose option D. Then Player 1 wants to minimize her losses by choosing A. So in a mathematical model of this game, we determine that Player 1 will choose A and Player 2 will choose D, leading to a payoff of −5 and 5 for Players 1 and 2, respectively. In doing this analysis, note that it was important that Player 1 knew not only what her own options and payoffs were, but also those of Player 2.

In the last example, Player 2 did not really use any information about Player 1, so let us consider a more complicated example.

Player 2 Options

Player 1 Options		D	E	F
	A	(−5, 5)	(−15, 15)	(10, −10)
	B	(−1, 1)	(1, −1)	(0, 0)
	C	(−10, 10)	(5, −5)	(15, −15)

Again, at first glance, we can see that Player 1 would most like to be able to have a payoff of 15, by choosing C. Player 2 would most like to have a payoff of 15 by choosing E. But as we saw before, Player 1 cannot expect Player 2 to choose F, and Player 2 cannot expect Player 1 to choose A; in fact, if Player 1 plays C and Player 2 plays E, we have the resulting payoff of (5,−5), disappointing both players. So what *can* each player expect? First, Player 2 should never play F, since he always does better (no matter what Player 1 does) by choosing D instead of F. So Player 1 can assume that Player 2 will never choose F. Next, Player 1 should not choose A since she does better to play B instead of A, regardless of whether Player 2 plays D or E (remember, he won't play F). Player 2 knows that Player 1 knows that he will never play F, so he knows that Player 1 will now never play A. Both players can now just consider the game without A and F.

		Player 2 Options	
		D	E
Player 1 Options	**B**	(–1, 1)	(1, –1)
	C	(–10, 10)	(5, –5)

We now can see that Player 2 should never choose E. Player 1 knows this; hence, she will choose to play B, knowing that Player 2 will play D. In the end, Players 1 and 2 will obtain payoffs of –1 and 1, respectively. Again, all of this works because each player knows that his or her opponent will go through exactly the same analysis.

We can summarize the process just described in this way:

- Player 1 knows that Player 2 will not play F. Thus, Player 1 will not play A.
- Player 2 knows that Player 1 knows that he will not play F, and so he knows that Player 1 will not play A. Hence, Player 2 will play D.
- Player 1 knows that Player 2 knows that she knows that he will not play F and hence Player 1 knows that Player 2 knows that she will not play A. Therefore, Player 1 knows that Player 2 will play D; thus, Player 1 plays B.

In this manner, both players can determine this outcome of the game. Needless to say, this last analysis is rather confusing, but sheds some light on the idea of *perfect knowledge*, that is, the idea that players can understand the consequences of their own decisions, the decisions of their opponents, and how all of those decisions affect the game. They also know that any logical analysis that they can do, their opponents can do as well. Each player uses his or her perfect knowledge of the game to avoid the greatest loss.

Applications of Perfect Knowledge: Mystery Men, The Princess Bride, *and* Dr. Strangelove

We've seen that the idea of perfect knowledge can be rather complicated. This complexity is often used as a means of "intellectual battle" between characters in films. For example, in *Mystery Men* (1999), the hero, Captain Amazing (Greg Kinnear), and the villain, Casanova Frankenstein (Geoffrey Rush), face off. Prior to Captain Amazing's arrival, Casanova Frankenstein tells his guests that he is expecting a visit "from a very old friend."

> CASANOVA FRANKENSTEIN: Captain Amazing, what a surprise.
> CAPTAIN AMAZING: Really? I'm not so sure about that. Your first night of freedom, and you blow up the asylum. Interesting choice. I knew you couldn't change.
> CASANOVA FRANKENSTEIN: I knew you'd know that.
> CAPTAIN AMAZING: Oh, I knew that, and I knew you'd know I knew you'd know I'd know you knew.
> CASANOVA FRANKENSTEIN: But I didn't. I only knew that you'd know that I knew. Did you know that?
> CAPTAIN AMAZING [pausing, hesitantly]: Of course.

Here Captain Amazing gets lost in the cycle of logic, showing his confusion. His nemesis then denies that he did have that much knowledge. Captain Amazing is trying to sound smarter by "knowing" more. However, Casanova's control of the logic demonstrates his

intellectual prowess. This comic scenario is a common play on the purely theoretical notion of perfect knowledge. Mathematically, we can assume all players are equally adept at applying logic, but the reality may be quite different.

A more involved version of a two-player game involving a demonstration of perfect knowledge is in *The Princess Bride*. Here the two players are Vizzini (Wallace Shawn) and Dread Pirate Roberts (Cary Elwes). Vizzini boasts of his intellectual prowess, and Dread Pirate Roberts challenges him to a battle of wits. Dread Pirate Roberts secretly places some poison into a goblet of wine. Vizzini is to deduce which goblet contains the poison.

DREAD PIRATE ROBERTS: All right. Where is the poison? The battle of wits has begun. It ends when you decide and we both drink, and find out who is right ... and who is dead.

VIZZINI: But it's so simple. All I have to do is divine from what I know of you, are you the sort of man who would put the poison into his own goblet or his enemy's? Now, a clever man would put the poison into his own goblet, because he would know that only a great fool would reach for what he was given. I am not a great fool, so I can clearly not choose the wine in front of you. But you must have known I was not a great fool, you would have counted on it, so I can clearly not choose the wine in front of me.

DREAD PIRATE ROBERTS: You've made your decision then?

VIZZINI: Not remotely. Because iocane comes from Australia, as everyone knows, and Australia is entirely peopled with criminals, and criminals are used to having people not trust them, as you are not trusted by me, so I can clearly not choose the wine in front of you.

DREAD PIRATE ROBERTS: Truly, you have a dizzying intellect.

VIZZINI: Wait till I get going! Where was I?

DREAD PIRATE ROBERTS: Australia.

VIZZINI: Yes, Australia. And you must have suspected I would have known the powder's origin, so I can clearly not choose the wine in front of me.

DREAD PIRATE ROBERTS: You're just stalling now.

VIZZINI: You'd like to think that, wouldn't you? You've beaten my giant, which means you're exceptionally strong, so you could've put the poison in your own goblet, trusting on your strength to save you, so I can clearly not choose the wine in front of you. But, you've also bested my Spaniard, which means you must have studied, and in studying you must have learned that man is mortal, so you would have put the poison as far from yourself as possible, so I can clearly not choose the wine in front of me.

DREAD PIRATE ROBERTS: You're trying to trick me into giving away something. It won't work.

VIZZINI: It has worked! You've given everything away! I know where the poison is!

Ultimately both characters rely on trickery outside the "rules" of the game, resulting in Vizzini's loss and Dread Pirate Roberts's win, but the dialogue demonstrates the concept of perfect knowledge in that Vizzini points out that anything that he can deduce, Dread Pirate Roberts can also deduce. Vizzini can then use that knowledge to make a further deduction, and so on, until he ultimately claims he knows the solution. As in *Mystery Men*, the idea of perfect knowledge is used to establish the intellectual superiority of the characters. But also as in *Mystery Men*, the ultimate winner of the battle of wits is not the one flaunting his use of perfect knowledge. Vizzini loses since Dread Pirate Roberts employs a strategy unknown to Vizzini (specifically, Dread Pirate Roberts has put iocane powder in both goblets, having built up a tolerance to the poison during his time in Australia); this again mocks the idea that players can truly have perfect knowledge of the game.

In contrast, *Dr. Strangelove* (1964) demonstrates how game-theoretic solutions can no longer be predicted when both players do not have common knowledge. In this film, the Soviet Union has built a "doomsday machine" that will automatically render the entire earth

uninhabitable for 93 years if the Soviet Union is attacked. The purpose of the machine is to be a deterrent to attack since there is no means of disarming it. This is seen as the ultimate defensive weapon since it is believed no one would attack the Soviet Union if it meant certain annihilation of the world. We witness the following exchange between President Muffley and Dr. Strangelove (both played by Peter Sellers).

> PRESIDENT MUFFLEY: But, how is it possible for this thing to be triggered automatically, and at the same time impossible to untrigger?
> DR. STRANGELOVE: Mr. President, it is not only possible, it is essential. That is the whole idea of this machine, you know. Deterrence is the art of producing in the mind of the enemy ... the *fear* to attack. And so, because of the automated and irrevocable decision making process which rules out human meddling, the doomsday machine is terrifying. It's simple to understand. And completely credible, and convincing.

However, as Dr. Strangelove also points out, "Yes, but the whole point of the doomsday machine is lost if you keep it a secret! Why didn't you tell the world, eh?" Since no one knew of the doomsday machine, it was not an effective deterrent: without one's enemy having shared knowledge of the possible outcome, the strategy is likely to fail.

In sum, the ability to apply mathematical reasoning to determine the outcome of a game-theoretic scenario relies on some key assumptions, one of which is the idea that the players have common knowledge of the possible strategies of their opponents. Moreover, the players must have an even deeper understanding, perfect knowledge, of how their strategy choices and the strategy choices of their opponents affect the game. We now work within this logical structure, applying mathematical techniques to determine outcomes of such games.

The Prisoner's Dilemma: The Dark Knight, Murder by Numbers, Return to Paradise, *and* Friend or Foe?

One of the best-known game theoretical dilemmas is the classic Prisoner's Dilemma. In the traditional scenario, two accomplice prisoners are taken to separate rooms with no chance to communicate with one another. Each is given two options: to "confess" or "not confess." If one player confesses while his accomplice does not, the confessor receives a minimal sentence of a quarter of a year, while the nonconfessor receives the maximum sentence of 10 years. (The idea here is that the confessor is able to provide evidence to convict his partner, and in return receives a much lighter sentence.) If both prisoners confess, they receive 5 years each, since they are able to provide evidence against each other. If both stay silent, they each receive only 1 year, as there is not enough evidence to convict either of them of the full crime. We can depict the prisoners' options in the following payoff matrix. The "row" player receives the first parenthetical number of years in prison, while the "column" player receives the second parenthetical number of years.

	Player 2 Options	
	Confess	**Stay Silent**
Confess	(5, 5)	(0.25, 10)
Stay Silent	(10, 0.25)	(1, 1)

Player 1 Options

Now the prisoners need to decide what to do. At first glance this may not seem like much of a dilemma. If you consider the situation from an individual prisoner's point of view, no matter what his accomplice does, the prisoner always does better by confessing. Since he has no knowledge of what his partner will do, he should do what is in his own interest, that is, confess. However, and here is the dilemma, if both players confess then they each get 5 years. Clearly *both* then would have done better to not confess. But once either player decides to not confess, then his partner is *much* better off confessing. And now we are back to both players confessing.

This game can be analyzed on another level. If both players have perfect knowledge of the game and are "perfect" players, and each knows the other is a "perfect" player, then both players should reason that they will come to the same decision as to what to do. Hence, either both players confess or both players do not confess. Clearly, if they are going to make the same choice, the best choice is to not confess. But this requires both players to trust in the ability of the other player to come to the same conclusion. This is probably a tall order, especially for criminals.

The Prisoner's Dilemma has many variations, but all share a few key criteria. First, there must be two players, and the players must have no ability to communicate with each other. Each player has two options, to "cooperate" or "defect." Here we consider "cooperating" to mean that the player chooses to do what is best for *both* players while "defecting" means choosing the option that is best only for him- or herself, regardless of what the other player does. Hence, in our above scenario, not confessing would be choosing to cooperate (think of this as implicitly cooperating with the partner in crime) while confessing would be choosing to defect (defecting on or "selling out" the partner in crime). The payoffs must be comparable in the following ways: each player must individually be better off by choosing to defect — there must be a significant reward for choosing to defect (such as a lighter prison sentence) — yet, both players must do better by choosing to *both* cooperate than choosing to *both* defect.

This idea of pitting two players against each other, requiring players to choose between the common good and individual reward, is used in film both for social commentary and as a dramatic plot device. The boat scene in *The Dark Knight* (2008) is a classic example. In this scene, two ferryboats have been wired with explosives. One boat carries prisoners and the other carries non-prisoners, whom we will refer to as "civilians." Each boat is given a detonator for the explosives on the other boat. If one boat blows up the other boat, then the remaining boat's passengers survive. If neither boat pushes its detonator then the Joker (Heath Ledger) will explode both boats.

The Joker comments that this is a "social experiment." How is this "social experiment" related to the Prisoner's Dilemma? Well, if we think of "detonating" as "defecting," then we can see that choosing to detonate the other boat gives the people on a boat the greatest chance at survival. Thus, individually, each boat "does better" by choosing to blow up the other boat. However, if both boats choose to defect, then each would have had a greater chance at survival by *not* choosing to defect, since someone — Batman (Christian Bale) — might have been able to stop the Joker from detonating the boats. In this scenario, the fact that one boat carries prisoners adds to the social pressure for the civilian boat to activate its detonator. First, the prisoners are seen as less valuable to society, encouraging the civilians to save themselves. Further, the prisoners are considered to be untrustworthy: if the civilians

believe that a boat full of murderers will have no hesitation to defect, then they should themselves defect first, possibly saving their own lives. This removes any potential civilian boat psychological "reward" for self-sacrifice. This is deliberate on the Joker's part: he has set up the ferryboat situation to show that given the choice, people will choose self-interest (defection), even if this means hurting many others. But the Joker's prediction is belied: neither boat chooses to defect and all passengers are ultimately saved, demonstrating the reward of cooperation.

A more literal version of the Prisoner's Dilemma occurs in *Murder by Numbers* (2002). The police suspect two students of collaborating in a murder. The police know that they do not have enough evidence to convict the suspects if neither of them confesses, and place the students in separate rooms in order to try to elicit confessions from them. Each student is told that the one who did the murder will be executed (or, at a minimum, go to jail for the rest of his life), while the other one, if he "cooperates" (by fingering the other), will "have a chance at a real life." A detective explicitly states: "Just think of it as a game. The one who talks first is the winner." But the two students have developed a strong loyalty to each other, and are not likely to confess. The police then try to exploit a sense of distrust between the partners, by suggesting that one of them has already betrayed the other. The "game" ends with the entrance of a lawyer; neither has confessed, so both students are able to walk away with no penalty. However, the psychological battle over who will ultimately betray the other carries through the remainder of the film. Ultimately, the more "selfish" of the students confesses. (Interestingly, this "defection" is foreshadowed at the beginning of the film with a quote from one of the students: "Indeed, freedom is crime, because it thinks first of itself and not of the group.")

The entire plot of *Return to Paradise* (1998) is based on a variation of the Prisoner's Dilemma. Lewis (Joaquin Phoenix) is incarcerated, on drug charges, in a Malaysian prison and will be sentenced to death if his two friends, Tony and Sheriff (David Conrad and Vince Vaughn), don't return from the United States to confess to their part in the crime. If both return, each of the two will receive a sentence of three years in a Malaysian prison. If only one returns, he gets six years in prison, while the other gets to live his normal life in the States. If neither returns, Lewis will die. This scenario has two of the key characteristics of the Prisoner's Dilemma. Tony and Sheriff individually have the best outcome by remaining in the States (individuals do best by defecting). However, if neither goes back to Malaysia, then their friend dies. Both characters feel that three years in prison is preferable to their friend dying, since they may be able to resume their lives after three years, but six years in a Malaysian prison seems unthinkable to both Tony and Sheriff (both players cooperating is preferable to both players defecting). However, one key feature of Prisoner's Dilemma is missing in this film, as the characters are able to communicate with one another. In this case, this is only a moderate variation since a major theme of the film is based on whether the characters actually *trust* what the others say they will do: communication in a Prisoner's Dilemma is meaningless if neither player actually trusts what the other player says. Although the best scenario for all of the characters is for both friends to return and save Lewis' life, the battle between self-interest and the good of the entire group plays out throughout the film.

In the game show *Friend or Foe?* (GSN, 2002–03), contestants play yet another version of the Prisoner's Dilemma. Contestants first work in pairs to win money that is placed in

a "trust fund." The two contestants then decide whether to play "friend" or "foe." If both choose to play "friend," they spilt the money. If both choose "foe," they receive nothing. If one plays "friend" while the other plays "foe," then "foe" receives all the money while "friend" receives nothing. We can see that no matter what a contestant's opponent does, he or she always does at least as well choosing "foe." However, if both choose "foe," both would have done better to choose "friend." Players are allowed to communicate with each other prior to deciding which strategy to choose. Then the strategy choice is secretly "locked in" before being revealed. Ultimately, the choice to cooperate and mutually choose "friend" depends largely on whether the two strangers are able to trust each other.

Chicken: Rebel Without a Cause *and* Footloose

Chicken is a two-player game similar to the Prisoner's Dilemma. In the classic Chicken scenario, two players drive straight towards each other. The first to swerve is the "chicken" and the other player is the winner. Here, the players each have two options: to swerve or to drive straight. If both players swerve, neither wins. If both players drive straight, they crash; certainly there is no winner if that happens, either. We can create a possible payoff matrix for the game of Chicken.

		Player 2 Options	
		Swerve	Straight
Player 1 Options	Swerve	(0, 0)	(−1, 10)
	Straight	(10, −1)	(−100, −100)

The value of −100 represents the risk of injury or death (and certain damage to one's vehicle), while the value 10 represents the bragging rights of being the winner, and −1 represents the shame of being the chicken. This is similar to the Prisoner's Dilemma in that both players prefer to swerve (cooperate) rather than to both drive straight (defect). In the Prisoner's Dilemma, if either player chooses to defect, then the other player does better by defecting as well. This is not the case with Chicken. If one player chooses to drive straight, then the other player does better to swerve.

We call an outcome of a game an *equilibrium point* if neither player would have chosen to act differently having known his or her opponent's choice of action; in other words, if neither player regrets his or her choice of strategy. In many games, equilibrium points determine optimal payoffs for both players; thus, it is often advisable for players to aim for an equilibrium point. It turns out that the game of Chicken has two equilibrium points, while the Prisoner's Dilemma has only one. The equilibrium points of Chicken are the two outcomes in which one player drives straight (defects) while the other one swerves (cooperates). The Prisoner's Dilemma's equilibrium point, on the other hand, is the outcome in which both players defect, since if his or her opponent defects, a player would not want to switch and now cooperate. Now, the big question in Chicken is which equilibrium point will actually be the outcome, or will the game even result in one of the equilibrium points? In the Prisoner's Dilemma it was easy to reason that if both players simply played selfishly, they would both defect. In Chicken, in order to end up at an equilibrium point the two players must play *differently* from each other.

It is this tension in how characters will play differently from each other that makes Chicken an interesting scenario in films. The cinematic depiction of Chicken is often used to highlight the characters' struggles to face risk and to show courage, and to pit an underdog against a bully. The game is interesting from mathematical and social points of view only if both players are willing to try to play for one of the equilibrium points. As with the Prisoner's Dilemma, the game is simple, but very dramatic as the viewer anticipates which character will swerve and which will drive straight.

One of the best-known depictions of Chicken occurs in *Rebel Without a Cause*. In this game of Chicken, two drivers speed towards a cliff; the first to jump out of his car is the "chicken" or loser. In this game it is expected that both drivers will eventually jump out from their cars before reaching the cliff, but each player wants to be the last to jump. The commitment to playing this dangerous game is, as the film's protagonist, Jim (James Dean), describes it, "a matter of honor." Throughout the film, Jim is trying to prove that he can stand up to others, that he isn't a "chicken." Although Jim is able to jump out of the car, his opponent gets stuck in his car and goes over the cliff; this twist makes Jim the "winner" as he is the only survivor.

Another classic version of Chicken is a race with tractors in *Footloose* (1984). Both players drive towards each other; the first to swerve is the "chicken." For the characters, the game is meant to determine who has the most courage: who is willing to face his fears, and who is really willing to risk his life. Even the soundtrack for the tractor scene is "Holding Out for a Hero," implying that the one who wins the game is the most "heroic." As in *Rebel Without a Cause,* the competitors are the classic "underdog" and "bully." The race is used to demonstrate the ability of the underdog to defeat the bully. The irony in this scene, however, is that Ren (Kevin Bacon), the underdog, wins by being unable to competently drive a tractor, and by getting his shoelace caught. Thus, although he wins the race, he has not really met the "hero" ideal by being the most courageous.

Bargaining Games with More Than Two Players: Survivor

Not all games require opponents to independently choose their strategies. Games in which players can work together to determine the outcome are called *cooperative* or *bargaining games*. If a player can get the largest payoff in such a game by acting alone, then he or she should always choose to do so, and our game theoretic analysis would not differ from that of games in which the players cannot work together. Therefore, in the case that there are three or more players, we will assume that a single player needs the cooperation of some of the other players in order to obtain the largest possible payoff.

Consider an example in which three people, A, B, and C, with different skills, are interested in forming a business. We make the following assumptions.

- At least two people are needed to form the business.
- If A and B form the business together, they can make $1,000 per week total, but C will be unable to form a separate business to compete, and hence will make nothing.
- If A and C form the business together they can make $800 per week total, but B will make nothing.

- If B and C form the business together, they can make $600 per week total, but A will make nothing.
- If all three form the business together, they can make $1,200 per week total.

In analyzing this game we want to conclude which players form the business, and how its profits are distributed. The actual analysis is somewhat complex, but it should be reasonably clear that the three players are not in equal positions. Indeed, if all the players were in equal positions, they might expect to divide the profits into three equal shares. However, if C demands more than $200 of the weekly profit to join with A and B, then A and B lose no money by forming the business by themselves, leaving C with nothing. Thus, C should be willing to settle for a mere $200 of the weekly $1,200 profits that would result from a joint business venture with A and B; this is significantly less than one third (namely, $400) of those profits. Similarly, if B is not willing to give A more than 60 percent of the profit they would make by forming their own company, then A can join with C, offering C $200 and taking $600 for herself, leaving B with nothing.

In the popular reality game show *Survivor* (CBS, 2000–present), eighteen contestants spend up to forty days in a remote location (such as a tropical island), trying to survive with very few provisions, and ultimately win a million-dollar prize. The mechanics of the game are as follows. At the beginning of the game, the contestants are placed into two teams, or "tribes"; tribe members must work together to provide the tribe with food and shelter. (Some seasons begin with more than two tribes of contestants, but we focus simply on the two-tribe case here.) Moreover, every three days one contestant will be voted out of the game by other contestants in a ceremony called a "Tribal Council." The tribes compete in a variety of "Immunity Challenges"; a tribe losing an Immunity Challenge must attend a Tribal Council and vote one of their tribemates out of the game, while the winning tribe gets to keep all of its members. Eventually, the two tribes "merge." At this point, the players live together as a single tribe, and now compete in challenges individually, hoping to win "individual immunity." A player with individual immunity cannot be voted out of the game at the next Tribal Council. The game continues in this manner, with one contestant leaving the game every three days, until there are only two or three remaining contestants (the number varies in different seasons). A collection of the most recently-eliminated contestants returns to vote for one of the remaining players to win the game and the million-dollar prize.

In order to remain in the game, contestants form coalitions that act as voting blocks. A coalition containing a majority of tribe members can guarantee that its participants will not be voted out. Although only one player ultimately wins the prize of a million dollars, contestants are motivated to remain in the game as long as possible in order to continue to have a chance at receiving that prize. *Survivor* provides an interesting example of how coalitions or "alliances" form and how different players have different levels of bargaining power. One challenge in actually applying game theory to *Survivor* is determining the payoffs for possible coalitions. In order to mathematically analyze the game, a potential coalition payoff needs to be assigned a numerical value. Since players cannot share the million-dollar prize, a coalition does not have naturally-assigned monetary payoffs; rather, its payoffs lie in how long the coalition's power allows its members to stay in the game. Although it can be difficult to predetermine how long a coalition will remain in action, we could try to quantify its

durability based on factors such as the ability of its members to win challenges and the like-lihood of their remaining loyal to the coalition. For example, during the portion of the game in which there are two tribes, an individual's physical strength and stamina are valuable tribe assets, helping tribes win immunity (and hence not have to vote off their members). The ability to provide food for others is also important, since food provides players with both comfort and energy, and trustworthiness is highly valued by fellow coalition members, as players' actions in the game are not legally bound by their words.

For example, consider a physically strong player who can help a tribe win challenges, and hence allow the tribe members to stay in the game. Other players may feel it's important to keep this player in the game; hence, players might expect higher payoffs by colluding with strong players rather than with physically weaker ones. It might be difficult to assign such payoffs specific numerical values, but we can certainly use numbers to represent payoffs relative to one another. As the game progresses, the relative values of attributes such as strength may change, but theoretically each coalition has a certain chance of progressing in the game, and thus players can determine varied expectations of how long they will remain in the game depending on their choice of allies.

One common event in *Survivor* is the increase in a player's importance to a coalition when the coalition needs an additional vote to ensure its safety. For example, suppose there are seven members of a tribe that is going to Tribal Council. Members A, B, and C want to vote out member D, and members, D, E, and F want to vote out member A. The coalition of A, B, and C needs an additional vote to eliminate D in order to ensure that A remains in the game (and, thus, that their coalition remains in the game); similarly, the coalition of D, E, and F needs an additional vote to eliminate A. Now the vote of the seventh player, G (who really only wants to guarantee his own safety, and hence has no initial preference as to whether he votes out A or D), is extremely important to both coalitions. Such "swing votes" are often wooed by the two coalitions. The coalition that offers the greatest promise of safety (from being voted off) to the wooed voter often wins the swing vote.

Admittedly, even if payoffs were known and explicit, most *Survivor* contestants have not studied bargaining games and do not have the mathematical tools to do a thorough analysis of the situation. Thus, the actual coalitions that form and the relative positions of their constituents may not coincide with those predicted by mathematical theory. However, *Survivor* provides an interesting example of how players work to determine the value of other players and how they can bargain to form coalitions that will ultimately get them further in the game.

Conclusion

The assumption of perfect knowledge, the games of the Prisoner's Dilemma and Chicken, and the theory of bargaining games are but a few ideas from the field of game theory. They provide some insight into the complexities of the mathematical analysis of economic games, and establish connections between the mathematics of such games and the social and psychological nature of these scenarios. The Prisoner's Dilemma, for instance, provides a forum for exploring the tension between self-interest and the desire to do what is best for society, and can be used to delve deeply into themes of trust among players in

film, fiction, or actual game scenarios. The game of Chicken, on the other hand, is often used in films to exemplify a character's struggle to face risk, to show his or her courage, and to pit an underdog against a bully. Both games, though fairly simple from a mathematical viewpoint, are psychologically complex for actual players.

If cinematic scenarios can provide a matrix for studying and understanding game theory, applying mathematical knowledge of game-theoretic concepts to fictionalized games allows us to understand the impact of characters' choices. Although characters in films and contestants on game shows rarely employ rigorous mathematics to win their games, bringing an understanding of the mathematical nature of the games can provide a broader context in which to analyze the intentions of filmmakers or the mistakes of contestants. Thus, recognizing game theory in popular culture helps develop our understanding of mathematical concepts, and, conversely, understanding mathematics helps us develop insight into human behavior.

Works Consulted

The Dark Knight. Dir. Christopher Nolan. Perf. Christian Bale, Michael Caine, Heath Ledger. Warner Bros., 2008. Film.

Dr. Strangelove or: How I Learned to Stop Worrying and Love the Bomb. Dir. Stanley Kubrick. Peter Sellers, George C. Scott. Columbia Pictures, 1964. Film.

Footloose. Dir. Herbert Ross. Perf. Kevin Bacon, Chris Penn, Lori Singer. Paramount Pictures, 1984. Film.

Friend or Foe? Varied producers. GSN. 3 June 2002–1 Apr. 2003. Television.

Murder by Numbers. Dir. Barbet Schroeder. Perf. Sandra Bullock, Ben Chaplin, Ryan Gosling, Michael Pitt. Warner Bros., 2002. Film.

Mystery Men. Dir. Kinka Usher. Writ. Neil Cuthbert. Perf. Greg Kinnear, Geoffrey Rush. Universal Pictures, 1999. Film.

The Princess Bride. Dir. Rob Reiner. Writ. William Goldman. Perf. Carey Elwes, Wallace Shawn, Robyn Wright. 20th Century–Fox, 1987. Film.

Rebel Without a Cause. Dir. Nicholas Ray. Perf. James Dean, Natalie Wood. Warner Bros., 1955. Film.

Return to Paradise. Dir. Joseph Ruben. Perf. Anne Heche, Joaquin Phoenix, Vince Vaughn. Universal Pictures, 1998. Film.

Survivor. Prod. Mark Burnett. CBS. 31 May 2000–present. Television.

Coming Out of the Dungeon
Mathematics and Role-Playing Games

KRIS GREEN

Introduction

After hiding it for many years, I have a confession to make.

Throughout middle school and high school my friends and I would gather almost every weekend, spending hours using numbers, probability, and optimization to build models that we could use to simulate almost anything.

That's right. My big secret is simple. I was a high school mathematical modeler.

Of course, our weekend mathematical models didn't bear any direct relationship to the models we explored in our mathematics and science classes. You would probably not even recognize our regular gatherings as mathematical exercises. If you looked into the room, you'd see a group of us gathered around a table, scribbling on sheets of paper, rolling dice, eating pizza, and talking about dragons, magical spells, and sword fighting. So while I claim we were engaged in mathematical modeling, I suspect that very few math classes built models like ours. After all, how many math teachers have constructed or had their students construct a mathematical representation of a dragon, a magical spell, or a swordfight? And yet, our role-playing games (RPGs) were very much mathematical models of reality — certainly not the reality of our everyday experience, but a reality nonetheless, one intended to simulate a particular kind of world. Most often for us this was the medieval, high-fantasy world of *Dungeons & Dragons* (*D&D*), but we also played games with science fiction or modern-day espionage settings. We learned a lot about math, mythology, medieval history, teamwork, storytelling, and imagination in the process. And, when existing games were inadequate vehicles for our imagination, we modified them or created new ones. In doing so, we learned even more about math.

Now that I am a mathematics professor, I find myself reflecting on those days as a "fantasy modeler" and considering various questions. What is the relationship between my two interests of fantasy games and mathematics? Does having been a gamer make me a better mathematician or modeler? Does my mathematical experience make me a better gamer? These different aspects of my life may seem mostly unconnected; indeed, the "nerd" stereotype is associated with both activities, but despite public perception, the community

of role-players includes many people who are not scientifically-minded. So we cannot say that role-players like math, or math-lovers role-play, because "that is simply what nerds do." To get at the deeper question of how mathematics and role-playing are related, we first need to look at the processes of gaming, game designing, and modeling.

What Do Gamers Do?

Throughout this paper, by *gamer* we will mean someone who participates in RPGs. What, however, does this participation entail? An RPG such as *D&D*—sometimes referred to as a "gaming system"—engages players in many different activities at many different levels. In general, the gaming system provides a set of rules that guide game play, as well as the background and flavor necessary to flesh out an imaginary world. Within this framework, one player — usually called the *gamemaster*, or GM — designs a "campaign" in which the other players' *characters* (avatars) participate, growing and developing throughout the process. A *campaign* is a collection of linked *adventures* (storylines) situated within a specific place and time, and focused on particular characters and artifacts. An adventure might have a fairly simple plot, like rescuing a captive, rooting out a traitor, raiding a treasure trove, or protecting a village from destruction.[1] A small adventure might be played out in one night through a series of encounters; a larger adventure might take many nights of gaming, while an overall campaign may last for several years.

The tasks of the GM and of the players are as follows. The GM constructs the background, history, non-player characters, setting, and mood of a campaign. She also plays the parts of all the non-player-controlled characters, and adjudicates any conflicts that occur, resolving them according to the rules of the game as agreed upon by the players (which might differ slightly from those in the officially published game guides). The players use the rules and the GM's work to create characters who will explore the campaign world. They may design their characters together, engineering a cohesive group, or they may develop them in private consultation with the GM.[2]

An important part of playing the game focuses on the development of the characters over the course of a campaign. Players generally keep written records of their characters' skills and traits. Characters from different gaming systems have different abilities; these tend to center on what is important in the settings and encounters likely to occur in a particular game. For instance, the game *Call of Cthulhu*, based on the horror writings of H. P. Lovecraft, requires that characters track their sanity as they run afoul of strange things that "go bump in the night" and defy all logic; if events cause a character to question reality too much, he is usually locked away in an asylum, effectively removing his player from the game.

In most games, a character's traits are described using combinations of numbers and verbal phrases. Verbal phrases cover a character's abilities, motivations, and attitudes, while numbers represent her chances of success at various activities. For example, in *D&D* when a character is created, her intrinsic abilities are determined by six numbers, ranging from 3 to 18. These values represent the character's strength (physical ability to lift heavy objects), dexterity (agility and quickness), constitution (general hardiness and toughness), intelligence (ability to remember facts and solve complex problems), wisdom (insight into people and situations), and charisma (charm and attractiveness), and can change over time as the char-

acter gains new abilities or suffers from illness or injury. *D&D* also uses a myriad of secondary characteristics (hit points, armor class, feats, special abilities, equipment, alignment, and skills) to round out a character's abilities.[3]

In many game systems, a character is further defined by the selection of a class or profession representing his training; for instance, a character may be a fighter, a rogue, or a wizard. Usually characters also have a host of other abilities, ranging from skills in which they train, such as animal riding, stealth, or diplomacy, to the ability to perform learned feats in special circumstances, such as casting spells, wielding combinations of weapons, or manipulating people through song. Each of these abilities is assigned some number or description, usually representing a combination of the training, natural talent, equipment, and magic that a character has. This number is then used to determine the character's success or failure each time he attempts to use the ability to accomplish a task.

Instead of explaining how this works in the abstract, we here give a concrete example. Generally, when a character attempts some action, the results of the attempt are determined by some combination of randomness — such as rolling one or more dice — and the abilities of the character. For instance, suppose that we have a *D&D* character, Bob the Barbarian, who has devoted some of his training to handling animals, and has 4 ranks in the skill "handle animal" (more ranks in a skill indicates more time devoted to its learning and practice). Bob also has a charisma score of 13, which adds a score of 1 to each of his charisma-related skills (such as animal-handling); so Bob has a total *bonus* of 5 when working with animals. Now, if he wants to teach a tame dog to defend him in combat, the *Player's Handbook* (the rulebook of *D&D*) tells us that Bob must roll a 20-sided die and add the yielded number to his bonus (5); if the resulting sum is greater than a *target number* of 20, then he succeeds in training the dog. Different events and circumstances alter the required target number that a player must "beat."

This process of determining bonuses, identifying target numbers, and rolling dice gets repeated during every significant action a character attempts in an adventure, whether it is swinging a sword, climbing a rock face, or impressing an audience with musical talent. The GM describes the situation, the characters describe their attempted actions, and the game system's rules determine how likely it is that the characters succeed in their attempts, and what the consequences of success (or failure) are. Different games vary in their rules, so an action outcome requiring multiple rolls in one game may be resolved with a single roll in another.

Throughout the campaign, players engage in many role-playing activities that are essentially exercises in gaining skills and abilities that give their characters greater chances of success in achieving game-related goals. A great deal of arithmetic is involved in determining the probabilities that govern their characters' successes or failures. These probabilities are introduced so that event outcomes are somewhat randomly determined; this adds an element of risk to the decisions players make. Different games use very different mechanisms to generate randomness, depending on whether they are modeling worlds in which all events are essentially independent, in which case actions are typically resolved by the roll of a die, or worlds in which characters have a finite amount of "good luck," in which case actions may be resolved by drawing from a 52-card deck without replacement. More exotic methods can also used to generate randomness, create more suspense, allow characters to perform more heroic actions, or have events follow more of a normal (a.k.a. "bell curve") distribution so that extreme events rarely occur and "average" scenarios are common.

What Do Modelers Do?

A common description of mathematical modeling involves the modeler navigating between two different worlds. The first is the real-world situation that is being modeled; the second is the model world, a representation of the real-world. The modeler actually works within the model world, and then extrapolates to apply her results to the real world. According to Maaß (62), in negotiating between these worlds, modelers must carry out the following activities:

1. Simplify, structure, idealize.
2. Mathematize.
3. Work within mathematics.
4. Interpret.
5. Validate.

To see the parallels with gaming, though, it helps to think of these steps as *simplification and abstraction*, *quantification*, *analysis*, and *interpretation* (absorbing the validation step into the interpretation step).

Simplification involves reducing the real-world situation down to the fewest elements (be they variables, constants, or relationships) necessary to capture the phenomenon being studied. In practice, this requires several repetitions of the processes of development, testing, and evaluating to find the right amount of detail. Insufficient simplification leaves the modeler working with so many variables that her mathematics becomes unwieldy, if not downright impossible to manage; on the other hand, simplifying too much loses so much information about the situation that obtained mathematical results are meaningless. (Many mathematical modeling jokes poke fun at mathematicians' potential oversimplification of real-world situations, involving punch lines to the effect of "assume a perfectly spherical cow.") Some attempts to model the motion of objects begin by assuming that the object behaves as if all of its mass is located at a single point (rather than being distributed throughout space) or that air resistance is insignificant in comparison to the other forces in the situation. If one is modeling the way a population of deer changes over time, one may reasonably focus on births and deaths due to natural causes or predation while ignoring minor changes in population size due to animals moving in and out of the relevant area. The process of simplification reduces the number of variables and amount of information needed to obtain a reasonable solution to the problem.

Closely related to simplification is the process of *abstraction*, which requires that the modeler combine elements of and ignore specific details about the relevant real-world relationships. In population modeling, one may abstract all the ways that an animal might die into a single measure of the population's death rate. One may attempt to study the population as a whole, rather than track the circumstances of specific individual animals. Even more abstractly, one might represent the population as a percentage of its ecosystem's maximum sustainable population (often referred to as its *carrying capacity*). Both simplification and abstraction require that the modeler engage in assumption-making to translate the real world into a mathematical one.

Once the modeler has simplified and abstracted the real world in conjunction with the features that are important to the model, she *quantifies* the relevant objects and relationships:

in other words, she represents the objects and relationships in the model world using mathematical language. She can then manipulate these objects using mathematical rules and processes.

Quantifying requires thinking about the scale of and the units for each of the quantities involved. When considering a model that involves variations in spatial dimensions, do we need to scale our variables so that we can see what is happening on the level of meters, kilometers, or centimeters? Does the system have any sort of "natural scale" to which everything can be easily compared, with a rating of 1 indicating average size or strength? If so, should the values scale linearly, so that a rating of 2 indicates twice that average size or strength, or should they scale logarithmically, so that 2 indicates a strength that is, say, 10 times that indicated by a rating of 1, 3 indicates a strength that is 10 times that indicated by a rating of 2 (hence 100 times that indicated by a rating of 1), and so forth? If time is a component of our situation, do we want to measure time in continuous or discrete units? If we choose discrete units, then what should each time unit or "tick of the clock" represent: a day, an hour, a month, a year? Do we need to examine the effects of a disease separately on males and females? On the young versus the old? Tracking any additional data characteristics necessitates the assignment of a new variable, so the process of quantification requires determining how many quantities and what type of quantities will be involved in the model.

The abstract, simplified, quantified model can then be *analyzed* using mathematical tools (e.g., solving algebraic or differential equations, integrating, working with matrices, etc.). The results of this analysis then must be *interpreted* by moving back from the model world to the real world and determining what the solutions of the mathematical analysis imply about the original situation under consideration. One must carefully consider the reasonableness and accuracy of the results to determine whether or not one has oversimplified the model (leaving out too much important information) or abstracted too much.

As an example, consider the task of modeling the way someone learns new information. One approach might be to treat the information to be learned in the abstract: instead of trying to model each of its specific elements, we could treat it as a single quantity, "amount to be learned." We can keep the situation simple by ignoring the various distractions the learner might experience and treating the rate of change of the amount he knows as a function of some intrinsic "ability to learn" and the amount remaining to be learned. This would result in a differential equation much like Newton's Law of Cooling,[4] but with the quantities reinterpreted to represent the various aspects of the particular situation. Making different choices about how to simplify, abstract, and quantify would lead to other models of the situation.

Designing Games as Mathematical Modeling

In the case of role-playing games, the "real world" is the fantasy scenario existing in a shared imagination among the players, the GM, and the game designers. It could be a dungeon filled with treasure, a town with complex political and social hierarchies, or a planet with a sophisticated ecosystem that makes it "alive." The "model world" is the set of rules that provide the system for deciding whether certain events happen and whether characters succeed at attempted tasks. When creating the set of rules for a game, the game's designers translate between these worlds repeatedly, constantly evaluating and revising the models

they create while searching for the right balance between accuracy and usability. (All modelers struggle with balancing some factors. For instance, engineers know how to make planes much safer, but the incurred expense would make plane-construction impractical or would lead to many people not being able to afford air travel, potentially leading to more deaths on our roads.)

Each of the modeling processes is inherent in the design of RPGs. *D&D* designers simplified by using a mere six values to quantify characters' traits (strength, dexterity, and so forth). (Other games may further reduce these traits to simply "Physical," "Social," and "Mental" statistics, or expand them to include separate statistics for memory, learning ability, appearance, coordination, endurance, and others.) Reality is much more complex: we would never try to describe a friend completely using only six numbers. Some gamers argue that *D&D*'s designers have oversimplified, debating, for instance, the notion of "dexterity" as a valid simplification, since the designers have incorporated both a character's agility and balance, as well as her fine motor coordination, into a single number. Indeed, rarely does a week pass without someone questioning this particular simplification on one of the many online *D&D* message boards.

The game universes themselves are also full of simplifying assumptions. What can be ignored in order to achieve the desired game flavor? Is the designer trying to create a setting and system with historical accuracy, mythological accuracy, cinematic accuracy, or realistic combat models? Does he want the game characters to be omniscient about the world around them, or have the characters know exactly and only what the players know?

Abstraction appears in multiple places in role-playing game design. For example, rather than representing a character's defensive capability with 30 different places where a person can be hit, each having its own armor and damage-absorbing characteristics, *D&D* designers chose to describe defensive capability with a single descriptor, called "armor class." This is an abstraction that incorporates both a character's ability to dodge and parry blows and her ability to resist impacts and take damage. Another excellent example of abstraction is given by the *d20 Modern* rules for dealing with a character's wealth. In the real world, a person's wealth is a complex combination of available cash, savings accounts, retirement funds, and other investment accounts, non-monetary assets, and loans. Rather than force players to keep detailed records of every purchase a character makes and bank record he accesses, the *d20 Modern* designers of created a single abstract quantity called "Wealth" that determines how easy it is for a character to acquire equipment and resources. Players roll against the difficulty (which incorporates cost and availability as well as legality) of acquiring a good, and their wealth may change as a result of the roll, representing in the abstract a loss of assets.

Quantification is nearly omnipresent in RPG design: it is the process by which the abstracted and simplified events in the game world are described. Rather than a character simply being said to be "strong" or "fast," in most games character traits are identified by a collection of numbers having mathematical relationships with one another. For example, in *D&D*, the number representing your dexterity helps to determine how easy it is for your character to hit targets with ranged weapons (like bows); your character's strength helps determine the amount of damage he can inflict in hand-to-hand combat; and his intelligence determines the potential he has for learning new skills. (Even in games with more descriptive statistics, the likelihood of an action's success is eventually quantified in some way to avoid

the potential for bias and to promote fairness among the players.) In mathematical terms, game designers want the sets of numbers describing a character's skills to be *orthogonal* : that is, we want each number to represent a distinct concept, so that it is clear which number should be used in any given situation. For example, we could describe a person's coordination with one number and her "fine motor skills" with another number, but there are situations, such as performing surgery in a moving ambulance, in which she would need to make use of both of these skills. On the other hand, having one number representing a person's *agility* and another representing her fine motor skills would make it clearer that the former applies when she attempts an action involving whole body movements (like dodging a thrown rock) and the latter applies to smaller scale actions (like picking a lock). Many games use an additional abstract number, a character's *level*, to provide a rough measure of the overall skill and ability of the character. This allows the GM to easily tailor the conflicts in the game so that characters are not easily outmatched by or always vastly superior to opponents they encounter.[5]

Interpretation occurs when outcomes in the "real world" of the game universe are determined via the rolling of dice. Each gaming action involves an array of possible outcomes. For instance, if the action is an attempt to hit an opponent with a weapon, the outcomes could involve a successful hit (for some amount of damage), a miss, or even a fumble (which leaves the attacker off-balance and more vulnerable to a counteract). If the action is an attempt to climb a sheer cliff face, then the possible outcomes might include making some progress up the cliff, holding steady without making progress, or losing ground. It could even involve falling down the cliff and getting injured.

The outcome of each action has a different likelihood, or probability of occurrence; relevant abilities (such as the above example of Bob's skill in animal-handling) influence the probability of a character being successful in a particular attempted action.[6] The game designers' rules set the framework for interpreting "model world" results (often outcomes of die rolls) in the game's "real world": for instance, in comparing a rolled number with the relevant characters' numeric descriptors, one is using "model world" rules to determine the action's outcome.

Is This Modeling Really Mathematical?

Clearly then, game designers create models that players use to simulate events. This leaves us with an important question: why is RPG designing an example of *mathematical* modeling rather than of modeling in general? What distinguishes the two? Mooney and Swift define mathematical models as "models built using the tools and substance of mathematics" (1), which leaves a lot of room for interpretation. Other definitions in the literature are equally (im)precise. Furthermore, Mooney and Swift point out that all models must have a *purpose* and that simplification makes extensive use of Occam's Razor.[7] To what extent is this true of RPGs?

Well, certainly RPGs use mathematics to quantify characters' skills and to determine the outcomes of events through probability. They also have a purpose, which is typically for the players to have fun participating in a game in a particular genre (such as fantasy or horror) and involving a particular style of play (e.g., for a serious interstellar gaming

experience with a gritty, realistic feel, you might play *d20 Future*, while for a more relaxed, campy, space-opera feel in the same setting you might choose to play *Adventures in Space*). And game designers do indeed use Occam's Razor to capture the elements they feel are critical to the flavor of the game they are creating, while ignoring any details that would complicate the experience or deviate from the intended style of play. So it seems that RPGs are indeed mathematical models.

Different Choices Lead to Different Games (Models)

Game designers can perform their modeling processes in a variety of ways. The manner in which the processes are carried out determines the type of model world, and hence, the type of game, in which the players will participate. For *D&D*, the game designers realized that combat will likely occur on a frequent basis. Thus, they designed the combat system to capture some realism, but abstracted much of it in order to not have it consume too much time, and to avoid complex tracking of spatial relationships accounting for each and every movement of each body part of each entity involved in a combat situation. Specifically, for *D&D* combat, time is broken into discrete units, called *rounds*, lasting six seconds each. During a round, characters can attempt certain movements or combined movements. Chances for success are not based on specific actions (such as "swinging a sword at the monster's head") but rather on an abstracted notion of these actions ("attacking the monster for this round"). Thus, the associated die roll determines not whether a single swing of a sword results in damage to the opponent, but rather whether any of the abstract actions involved in attacking during the round result in injury to the target.

On the other hand, most computer-based role-playing games like *World of Warcraft*, for which recordkeeping and arithmetic can be handled efficiently by the computer, actually model each individual action — swinging a sword, climbing a few feet up a steep hill, picking a single lock, etc. Thus, these games have rules for determining the success or failure of small-scale events; these small-scale events then combine into a larger encounter with each opponent or obstacle.

Still other games, notably the independently-created games available online for free, tend to have much more abstract notions of encounters than even *D&D* does. For example, in the game *Resourceful*, characters have a mere eight values that determine their abilities, and the outcome of an entire situation is obtained by rolling three 10-sided dice exactly once. In comparison, a straight-up fight in *D&D* may require hundreds of dice to be rolled, as each combat is broken into myriad rounds during which characters are able to perform multiple actions which require separate success/failure rolls and degree of success rolls.

Thus, we see how different levels of abstraction result in very different game-play experiences.

Using RPGs to Learn Mathematics

While designers use mathematical modeling in their creation of games, simply playing an RPG doesn't necessarily mean one is actively or consciously engaging in mathematical

modeling. Certainly, players encounter arithmetic, probability and expected values,[8] and unit conversions. But more mathematics can be brought to light through reflection on the game as a model. For instance, players often seek to optimize their characters, setting out future paths of development so that there is no wasted effort in moving from a beginning character to a more powerful character; this requires a great deal of planning and design up front so that when a character gains abilities and powers, they lead to the next step in the intended path. This and other aspects, like strategic planning by groups, are important, but still leave most of the mathematical modeling in the hands of the game designers. However, many players move past this passive game play into a more obviously mathematical realm. For instance, a GM may attempt to "reverse engineer" a game: that is, work out the details of how the game designers built the game's tables, charts, and mechanics, in order to design new elements that have a similar feel and maintain some sort of balance with the elements already in the game world. For example, many games have a list of professions or classes of which characters can be members; one's chosen profession or class determines which abilities one can gain as one's power increases. One look at the discussion boards for any such game makes it immediately obvious that many gamers spend a great deal of time inventing their own classes; however, this is a delicate process that could easily result in a class that would be too powerful or too weak to match well with pre-existing classes. Maintaining a balance between classes — so that are all useful and allow characters of that class to "take center stage" equally often and equally well — is one of the hardest aspects of game mechanics. As a GM, one thus experiences these explicit modeling elements more frequently, but that still excludes the majority of those involved in RPGs from have a genuine modeling experience. What can be done to change this?

Well, learning mathematics and mathematical modeling through role-playing games can occur at three different stages. First, players can learn about basic probability, scale, and the concept of quantification through playing a game. (Clearly, though, during game play, much of the calculation of probabilities occurs behind the scenes so as not to interfere with players' enjoyment of the game. In order for players to gain an explicit appreciation for such mathematics, or for how modeling aspects are enacted in a game's design, they must reflect on and analyze game sessions.) Second, players can more actively practice modeling by taking on the role of the GM of a game or of a series of gaming sessions. Finally, players can engage even more intensively in the modeling process by creating their own RPGs. These different stages mimic the different levels of inquiry common in science education (Fay and Bretz), as students and teachers negotiate roles regarding who is designing learning activities and making the plans for carrying them out. In the remainder of this section, we detail the ways in which these stages of learning can take place.

Learning as a Player

There is a great deal of computation involved in playing pencil-and-paper RPGs, and most RPGs involve some sort of randomness. Thus, players can learn about probability and arithmetic through gaming. They are encouraged to consider the components of a mathematical model (simplification and abstraction, quantification, analysis, and interpretation); they learn about selecting optimal paths to develop their character's abilities and about creating the "best mix" of characters to accomplish certain tasks. They learn about trade-offs

and constraints through selecting features of characters and following varied paths, and they meet various mathematical relationships and must engage with them in order to play effectively. Players develop a broad range of problem-solving skills and regularly practice visualization in order to picture their environment and the actions in that space (this is especially important during moments of intense action, like those during combat). Almost all RPGs also engage players in economic models through the use of exchange rates and units. Further, players experience and develop other aspects of understanding necessary for participation as professional mathematicians, such as teamwork, communication, and time management (Nyman and Berry 35).

Players use mathematical ideas even in computer-based RPGs where much of the arithmetic is handled automatically. Consider, for instance, the online RPG *World of Warcraft*. Since in this game success heavily depends on coming out ahead in confrontations with other players or with computer-controlled elements, players must make a variety of decisions about which skills to develop and which pieces of equipment to gather, pursue, and build. These choices are not at all obvious. Should a character focus on developing skills with a single, slow weapon that deals massive damage each time it hits? Should he develop the use of a smaller weapon, along with the use of a shield? Should he focus on smaller, faster weapons that allow many attacks? Or would using a weapon that deals a small amount of recurring damage over time be better? Answering these questions has led many players to carry out computational tasks that balance competing factors such as the number of attempts a weapon offers per round of combat, the likelihood of each attack being successful, and the expected value of the damage done per hit to one's opponent. Thus, players are using basic ideas in probability and statistics in determining their strategies.

Finally, some RPGs are specifically designed to teach math and science (see Ahmad, Shafie, and Latif, as well as Riegle and Fansler). Certainly video games can be based on real-world physics (see *World of Goo* for an example using mechanics, the original *Star Trek* RPG for a detailed model of how starship combat takes place based on the laws of physics, and the original *Traveller* for a detailed model for the generation of realistic solar systems) or can involve mathematical puzzles (for example, solving a Knight's Tour problem was a component of *The 7th Guest*). However, many of these games set up arbitrary scenarios that do not have much relation to real gaming environments. For example, players may need to solve mathematical equations or perform a sequence of computations in order to win a challenge, rather than winning it "authentically" by swinging a sword or escaping a trap. On the other hand, some designers, like Keith Devlin, are finally starting to create math-focused RPGs in which the mathematics occurs naturally and must be worked with, in context, to solve genuine problems (Bergeron).

Learning as a GM

Eventually, like Hollywood actors, most players of RPGs want more control of the action, and take on the role of GM. GMs must consider issues of scale (as they design maps to organize and guide gaming sessions), of probability (as they set difficulty levels and determine random events), and of fairness (as they try to design an adventure that allows every player a chance to succeed in her endeavors). They also play with statistics and modeling of the world at large when they engage in urban planning in order to develop a realistic

setting for the game. This might, for example, involve figuring out the distribution of different types and levels of characters in a town, laying out the town's architecture, or designing an entire economy based on local goods and services.

Learning as a Game Designer

At the highest level, players designing their own RPGs encounter many more aspects of modeling as they consider the balance of accuracy in their models with the models' reasonableness and playability (usability). Indeed, accuracy can be achieved by including many details and designing games to model particular events with realism, but often these details reduce the usefulness and playability of the game, slowing it down and requiring more time to adjudicate game events. For example, suppose a designer wishes to create a contemporary economically-focused game. Does she create a model that requires detailed tracking of every asset, loan, and expense in a character's life? While this would enable players to practice valuable real-world skills, it would interfere with game play and require players to spend most of their time managing resources rather than actually exploring the game's world. It may be better for her to use the process of abstraction, and represent a character's monetary situation by a single measure that goes up or down as players attempt to acquire additional material resources. (This, for instance, is how the wealth system in *d20 Modern* is managed.)

As designers, they also need to consider "game balance." An RPG is considered "balanced" if its design ensures a sense of "fairness" among the different possible character roles and among the paths that a character can follow. Discussions of game balance in *D&D* often center on making sure that the character classes have equivalent options and actions in which to engage and that the characters themselves have similar levels of power. But how does one determine these equivalences? Character abilities differ wildly; choices of class or profession open up some possibilities for a character's future development and close off other paths. How does a game designer go about balancing these issues to ensure that all players will have opportunities to participate and be important during adventures? To create this balance, a designer could use, for instance, a detailed multivariable regression model;[9] in fact, some players have attempted to reverse engineer existing characters to build an idea of how the game designers balanced different factors.

Even more intriguing is that what seem to be purely qualitative aspects of a gaming world, such as style and mood, can also be modeled quantitatively. For example, the card-based RPG *The Wizards* (based on the *Lord of the Rings* novels by Tolkien) includes a mechanism to account for corruption, so that characters with too many powerful items and effects can be "lost" to the "darkness." Each character has a score that controls how pure he is, and thus not only power, but goodness, must be balanced in solving the problems encountered in the games.

Game designers can also challenge and alter real-world math and science by incorporating magic, time travel, and alternate realities into their games, playing with serious "what if" questions. Suppose we do allow magic. Does it follow the law of conservation of energy? If so, does the energy used in practicing magic drain the user, or can he draw the energy from a source outside himself? Does the magic's strength dissipate with distance and area covered? (For one interesting exploration of these issues, see the independent RPG *Circe*,

which requires detailed mathematical calculations to determine the amount of energy used by a magical spell.)

RPGs in Education

There is little doubt that mathematical modeling, by itself, is a powerful tool for learning, and for altering perceptions of, mathematics. Falsetti and Rodriguez show that mathematical modeling experiences can improve students' attitudes toward mathematics, and Nyman and Berry show that general, transferable competences such as interpersonal skills, time management, organization, independent study, personal research, library skills, and computing skills can also be developed by focusing attention on modeling. Furthermore, mathematical modeling can be used as a vehicle for students to learn new mathematics, rather than simply apply previously-learned mathematics in new ways (Boaler 126).

These and many other studies point to a single conclusion: contextualizing mathematics by using it to solve realistic problems creates positive mathematical learning experiences for students and helps them gain other skills and understandings. The National Council of Teachers of Mathematics and most state- and district-level education standards recognize this and include applications and modeling as an integral part of their curricula. Further, most college-level mathematics programs include opportunities for students to use mathematics to build real-world models, and the Consortium for Mathematics and Its Applications recognizes the challenges and rewards of this activity, sponsoring an annual national Mathematical Modeling Contest.

At the same time, we have available a powerful tool for engaging students: the RPG. The availability and widespread appeal of RPGs is well-documented (see Riegle and Fansler, for example). As proof of their appeal, consider that, in the last decade, the lone RPG *World of Warcraft* went from nonexistence to having over ten million subscribers worldwide; during the same time period, only 450,000 STEM (Science, Technology, Engineering, and Mathematics) degrees were conferred in the United States (Mayo). I suspect that if we consider the hours that people spend on gaming versus the hours they spend on reading, studying, and participating in STEM-related educational activities, we might see an even more significant difference.

Incorporating RPGs into mathematics curricula could thus engage students while teaching them valuable mathematical skills. Educational RPGs already exist, primarily as computer-based or online experiences. The use of such games is showing promise at promoting positive learning outcomes (Mayo). As an example, consider *Revolution* (developed and sponsored by the Education Arcade), which focuses on the people and places that were important at the start of the American Revolution. Rather than reading about Paul Revere's ride, players interact with historical figures and ultimately are forced to decide how to proceed, working either on the behalf of the colonists or on behalf of the Crown. Players can take on a variety of personae that cover the gamut of social roles in the colonies. Through playing the game, students are both learning about historical facts and developing facets of understanding such as perspective, empathy, and interpretation (Wiggins and McTighe, ch. 4). Similar results are achieved by students playing *Descartes' Cove* (Wallace), which requires players solve mathematical problems to complete challenges.

As we've seen, playing games can be mathematically educational, and by designing games, one can learn even more. Add to this the fact that games are just plain fun! Imagine if students always approached learning the same way they approach games. How would the work of educators be transformed? Shaffer points to some of these possibilities in his study of "epistemic games." His work indicates that allowing students to engage in realistic roles, under the physical, social, and economic constraints and expectations of those roles, can help them develop knowledge, skills, values, and identity. Well-designed RPGs provide these benefits since they are really models and simulations of different realities, placing players in situations requiring them to work with each other and within the game world's constraints in order to accomplish their goals. Including RPG playing and design in mathematics curricula could teach students important skills — mathematical and otherwise — while capturing their interest.

Conclusion

In short, many of us would like our students to learn the valuable skills required for doing mathematics, and specifically, for performing mathematical modeling. We also possess a platform that engages students: that of the RPG. The experience of gaming, with embedded reflection and systematic stages of development from player, to GM, to game creator, can provide an ideal platform to help students experience mathematics in a new way, and might get students to see that mathematics offers a way of thinking that has considerable value. At the same time, students get to have fun.

After all of this, I find that my modeling and gaming identities are deeply interconnected. Certainly, my interest in understanding how various games worked led me to use mathematics to reverse engineer game mechanics. Further, in attempting to design my own games, I learned a great deal of math. Thus, mathematics has influenced the way I play and think about designing games. On the other hand, as a researcher, I find myself "playing the game" of mathematics in attempting to quantify and describe relationships that others might not see quantitatively — a skill I learned as a gamer. So in that sense, gaming has taught me some of the behaviors and ways of thinking required of mathematicians. In sum, I am neither wholly a mathematician nor wholly a gamer, but rather a symbiotic blending of those two entities that mutually reinforce (and occasionally mutually distract) one another.

Notes

1. A campaign often links its adventures in ways that go beyond characters and context; usually this connection is slowly discovered by the players over time. For example, it may eventually be revealed that the region the characters inhabit is being invaded by a powerful force that is working in secret to steal the life energy of every living being. In an early adventure within a campaign, the characters may simply be looking for treasure, and in raiding an ancient ruin overrun by monsters might discover a device that lets them see distant events. This reveals that one of the local officials has been funneling resources into his own private army. They root out this individual in a second adventure. At this adventure's conclusion, the traitor suggests that there are stronger enemies coming. Through additional adventures, the characters learn more, develop skills, and eventually gain what they need to defend the region from onslaught, thus resolving the larger campaign.

2. The GM makes sure that they are not violating the game system's rules or deviating too far from the plot she has in mind — for example, a GM may not let a player create an evil character in a campaign

in which the other characters are good, since this would, if the players accurately portray their characters, result in tremendous friction in the game, diminishing its players' enjoyment.

3. Gaming involves favoring those aspects that one wants to make the focus of the game. In *D&D*, characters often find themselves in physical combat, so much of the game system is devoted to combat and many of a character's abilities are related to the skills, equipment, and other abilities needed for fighting. In some games, however, combat is not important, so less of the game requires characters be strong or fast or have a good sword. For instance, in a game such as *Chronicles of the Drenai*, it is more important for players to focus on their characters' motivations, interests, and addictions, relative to other characters, in order to resolve inter-character conflicts rather than conflicts between the characters and the environment established by the GM. Some games eschew the numerical system of ranking abilities altogether, focusing on narrative descriptions and storytelling rather than on the resolution of conflict via randomness.

4. An (ordinary) differential equation is an equation that involves the rates at which various quantities are changing. One of the most commonly encountered examples of this is Newton's (yes, *that* Newton's) Law of Cooling, which says that the rate of change of the temperature of an object is proportional to the difference between its current temperature and the temperature of its surroundings. Thus, the greater the difference between these two temperatures, the faster the object's temperature changes. One application of this is to predict the amount of cold water one will have to add to a bathtub of hot water in order to obtain just the right temperature for a good soak.

5. Allowing characters to have different levels helps to keep a game interesting and unpredictable, but introduces the difficulty of ensuring that different types of characters and different combinations of abilities are roughly equivalent. Thus, elements of the mathematics of fairness come into play. When certain abilities are more useful than others, players quickly learn the mathematical skill of optimization, ignoring "flavor" abilities in favor of those abilities that are most useful in the game world, as experienced by the players. Thus, one may find a number of *D&D* characters who are very good at climbing and at swinging sharp swords but have no skills pertinent to earning a living in their barter economy, since such skills can only be developed at the expense of their sword-swinging skills.

6. Hierarchies of achievement and ability often lead players to seek ways to improve their characters, either through training or through the acquisition of equipment.

7. Occam's Razor is also known as the *principle of parsimony*: "Things should not be multiplied without cause." The modern version of this is known as the K.I.S.S. principle: "Keep It Simple, Silly." The goal is to make the model as simple as possible in order to describe and capture what you want, without making it so simple that it fails to be accurate.

8. An *expected value* is the most likely result of a random event. For example, if you play a game in which you flip a coin and a result of heads wins you $3 but a result of tails costs you $1, you might want to know how much you would expect to gain on average (if you played this game many times). Since each result is equally likely, and hence has probability 1/2, the expected value of a single flip of the coin is $(1/2)(\$3) - (1/2)(\$1) = \$1$. This indicates that after playing the game many times, you would be likely to be up $1 per game played, so the game is in your favor.

9. *Multivariate regression modeling* involves attempting to find an equation that describes a large amount of data, so that one can predict how each individual variable in the data influences a single dependent variable. In gaming, such modeling arises when players attempt to determine the "hidden costs" assigned to the various features of a character class, so that they can create a new class that remains roughly equivalent to existing ones in power and progression.

Works Consulted

Ahmad, Wan, Afza Shafie, and Mohd Latif. "Role-Playing Game-Based Learning in Mathematics." *Electronic Proceedings of the Fourteenth Asian Technology Conference in Mathematics*. Mathematics and Technology, Dec. 2009. Web. 7 June 2010.

Bergeron, Louis. "In Reality, Simulation Is Key to Math Education, Says Stanford Mathematician." *Stanford News Service*. Stanford U, 18 Feb. 2010. Web. 7 June 2010.

Boaler, Jo. "Mathematical Modeling and New Theories of Learning." *Teaching Mathematics and Its Applications* 20(3) (2001): 121–27.

Cook, Monte. *Dungeons and Dragons Dungeon Master's Guide: Core Rulebook II*. v. 3.5. Reston, WA: Wizards of the Coast, 2003.

Edwards, Ron. "GNS and Other Matters of Role-Playing Theory." *The Forge*. Adept, 14 Oct. 2001. Web. 7 June 2010.

Falsetti, Marcela C., and Mabel A. Rodriquiez. "A Proposal for Improving Students' Mathematical Attitude Based on Mathematical Modeling." *Teaching Mathematics and Its Applications* 24(1) (2005): 14–28.

Fay, M. E., and S. L. Bretz. "Structuring the Level of Inquiry in Your Classroom." *The Science Teacher* (July 2008): 38–42.

Gee, James Paul. *What Video Games Have to Teach Us About Learning and Literacy*. Revised and updated edition. New York: Palgrave, 2007.

Kestrel, Gwendolyn F.M. "Working Hard at Play." *New Horizons for Learning: Teaching and Learning Strategies*. New Horizons for Learning. Mar. 2005. Web. 7 June 2010.

Kirk, Whitson John, III. "Design Patterns of Successful Role-Playing Games." *Legendary Quest Downloads*. Loreweaver, 13 Sept. 2009. Web. 1 Sept. 2010.

Maaß, Katja. "Barriers and Opportunities for the Integration of Modeling in Mathematics Classes: Results of an Empirical Study." *Teaching Mathematics and Its Applications* 24(2–3) (2005): 61–74.

Mayo, Merrilea J. "Video Games: A Route to Large-Scale STEM Education?" *Science* 323 (2009): 79–82.

McComas, W. E. "The Nature of the Laboratory Experience: A Guide for Describing, Classifying and Enhancing Hands-on Activities." *CSTA Journal* (Spring 1997): 6–9.

Mooney, Douglas D., and Randall J. Swift. *A Course in Mathematical Modeling*. Washington, DC: MAA, 1999.

Nyman, Melvin A., and John Berry. "Developing Transferable Skills in Undergraduate Mathematics Students through Mathematical Modeling." *Teaching Mathematics and Its Applications* 21(1) (2002): 29–45.

Riegle, Rodney P., and Kenneth W. Fansler. "The ABCs of Online RPCs (Role-Playing Courses)." *Annual Conference on Distance Teaching and Learning Resource Library*. University of Wisconsin, 2005. Web. 24 June 2010.

Shaffer, David W. *How Computer Games Help Children Learn*. New York: Palgrave, 2006.

Wallace, Patricia. "Blending Instructional Design Principles with Computer Game Design: The Development of Descartes' Cove." *Proceedings of the World Conference on Educational Multimedia, Hypermedia and Telecommunications 2005*. Ed. P. Kommers and G. Richards. Chesapeake, VA: AACE, 2005: 402–07.

Wiggins, Grant, and Jay McTighe. *Understanding by Design*. 2nd ed. Upper Saddle River, NJ: Pearson, 2005.

Wizards of the Coast Team. *Dungeons & Dragons Players' Handbook: Core Rulebook I*. v. 3.5. Reston, WA: Wizards of the Coast, 2003.

Playing *Moneyball*
Math and Baseball
JEFF HILDEBRAND

In 2003, journalist Michael Lewis published *Moneyball: The Art of Winning an Unfair Game*, a study of the Oakland Athletics (A's) baseball team. In it, he described how, starting in the late 1990s, the A's used unconventional techniques to achieve success, despite having a budget that was vastly smaller than their competitors'; this culminated in the A's making four straight postseason appearances between 2000 and 2003. Although it was not the main focus of the book, the fact that the A's were heavily invested in using statistical and numerical analysis was what garnered the most reader attention.[1] In very short order "Moneyball" became shorthand for the use of quantitative tools in analyzing baseball, a field known as *sabermetrics*.[2]

Despite their notoriety after the publication of *Moneyball*, the A's were hardly pioneers in sabermetrics; numerical analysis had been done for decades prior to the A's embrace of the concept. In 1954, the famous baseball executive Branch Rickey[3] published an article in *Life* magazine that considered measures of a player's performance other than batting average, runs batted in, and other traditional statistics. While the article addressed themes and ideas that would recur in the decades to come, it did not make much of an impact at the time. In fact, one of the conclusions of the article — that on-base percentage tells us more about a player's offensive performance than batting average does — was presented in *Moneyball* as if it were a radical new idea (Lewis 59).

In 1964, mechanical engineering professor Earnshaw Cook published *Percentage Baseball*, which generated headlines with its sensational claims about how teams could improve their performance by making extensive use of probability and statistics. Its most surprising suggestion was that a team could increase their scoring by about a third simply by changing its batting order (Deford). While the book received considerable attention at the time, most of that was negative, due to Cook's poor writing — described by Lewis as "prose crafted to alienate converts" (71) — and sloppy mathematics. Indeed, reviewer George Lindsey, a statistician and baseball researcher himself, stated that the book "should be ... carefully kept out of the sight of students of the theory of probability" (1090).

His sarcastic reviewing style notwithstanding, Lindsey is a significant figure in the history of sabermetrics. In particular, he was the first person to systematically introduce the

concept of conditional probability to the study of baseball. A *conditional probability* tells us the chances of a particular event happening, given that a particular set of circumstances is known. Even the most casual baseball fans know that the chances of a team scoring can vary quite a bit, depending on the circumstances. For instance, a team with the bases loaded and no outs is expected to score at least one run and likely get more, while a team batting with two outs and no base runners is likely not to not score at all. Lindsey's great contribution to the study of sabermetrics was to quantify such conditional probabilities.

Lindsey's initial work faced the same difficulty many early sabermetric researchers faced: namely, a lack of data. At the time, the play-by-play data that is needed for estimating the needed conditional probabilities was not available to anyone not directly involved with Major League Baseball. So Lindsey enlisted his father to record play-by-play data from over 350 games during the years 1959 and 1960. While Lindsey acknowledges that this was an approach with some problems ("Investigation" 484), it did yield at least reasonable approximations of the actual conditional probabilities. Lindsey published his results in 1963 ("Investigation" 485).

Knowing these conditional probabilities allowed quite a few questions to be answered. Leaving baseball for the moment, we look at an important probabilistic concept. The *expected value* of a quantitative variable (that is, a variable that takes on numeric values) is found by first multiplying the probability of each possible value the variable can take on by the probability that it takes on that value, and then summing up the resulting products. This expected value gives us an idea of what we can expect the outcome of an event to be. For example, suppose you roll a fair six-sided die. The yielded result could be any value between 1 and 6, inclusive, and the probability of any one of these values being yielded is exactly $\frac{1}{6}$. So the expected value of your die roll is

$$(\frac{1}{6} \times 1) + (\frac{1}{6} \times 2) + (\frac{1}{6} \times 3) + (\frac{1}{6} \times 4) + (\frac{1}{6} \times 5) + (\frac{1}{6} \times 6) = \frac{21}{6} = 3.5.$$

Returning to baseball: a table containing the conditional probabilities of a team achieving particular numbers of runs, under a specific set of circumstances, is called a *run expectations chart*. This chart can be used to determine the team's *run expectation value*— that is, the expected number of additional runs the team will achieve — given a particular set of circumstances. For example, the following is taken from a conditional probability table created using data from 1998 to 2002, and shows the probabilities of an average team scoring different additional numbers of runs when it has two outs and no one on base (Tango).[4]

Number of additional runs scored	0	1	2	3	4	5 or more
Probability	0.923	0.051	0.017	0.005	0.002	0.001

This means that a team would have a 92.3 percent chance of scoring no more runs, a 5.1 percent chance of scoring one more run, a 1.7 percent chance of scoring two more runs, and so on. So the run expectation value for this situation would be:

$$(0.923 \times 0) + (0.051 \times 1) + (0.017 \times 2) + (0.005 \times 3) + (0.002 \times 4) + (0.001 \times 5) = 0.113.[5]$$

In other words, over the long run, in an inning in which a team has two outs and no one on base, we should expect the team to score, on average, about 0.113 additional runs.

In the late 1960s and 1970s, such run expectation charts were used by both Lindsey and another researcher, Pete Palmer, to answer a question that Rickey had tried to address

back in the 1950s: namely, how much extra do extra base hits (doubles, triples, and homers) add to the value of a player? Is a double twice as valuable as a single? More than twice as valuable? Less? Again, some basic tools of probability are essential in answering this. Computing run expectations is an important step in assessing the value of each type of hit, but it is only a single step. One also needs to determine how likely each base or out scenario is to happen in the first place, given that every inning starts with no outs and no one on base. Fortunately, the theory of Markov chains applies to exactly such a scenario.[6] Using this theory it is possible to compute the probability of each possible outcome resulting from a player's time at bat, and create what has become known as a *linear weights formula*. The most widely-known linear weights formula is the Batting Runs formula, developed by Pete Palmer over a number of years and published in various places, including the influential book *The Hidden Game of Baseball* (1984). Because run expectation charts can vary over time due to rule changes, changes in the ballparks being used, and other factors, there have been multiple Batting Runs formulas used over the years. One example (Albert 200) shows a player's Batting Runs (BR) given by the formula

$$BR = (0.46 \times 1B) + (0.80 \times 2B) + (1.02 \times 3B) + (1.40 \times HR) + (0.33 \times (BB + HBP)) + (0.30 \times SB) + (-0.60 \times CS) + (-0.25 \times (AB - H)).^{7}$$

A player's Batting Runs value is a measure of how many more runs one should expect him to produce over the course of a season, compared to an average player. For example, each double (*2B*) adds about 0.80 runs to the player's BR value, while each out (*AB – H*) reduces that value by a quarter of a run. The introduction of linear weights formulas brought into discussions some concrete data, such as how much batting average is worth sacrificing for a batter who can hit many home runs, and which is more valuable to a team: doubles hitters, or speedy singles hitters who can steal a lot of bases?

While much of the work of Lindsey and Palmer was crucial for laying the groundwork of sabermetrics, it did not attract a lot of attention, since much of it was written in fairly technical language and Lindsey published in academic journals that were never seen by most baseball fans. The most important step in popularizing these ideas came in the late 1970s from a very unusual source: Bill James. James was not a mathematician or even in a career that had anything to do with numerical work. He graduated from college with degrees in English and Education and had thought about being a high school English teacher; however, a couple years after graduating, he was working as a security guard at a local food packaging plant, and researching baseball statistics during his breaks. Like previous researchers, such as Lindsey, his research was so unusual that no commercial publisher was interested in it, so in 1977 he self-published the first of his twelve *Baseball Abstracts*. Virtually everything that has been done since then in the field of baseball statistics has been influenced to some degree by James's work. In fact, even the name of the field is due to James: one of his early *Baseball Abstracts* included the first appearance of the term "sabermetrics." The value of James's work lies in the fact that despite not being a mathematician, James has a good intuitive feel for mathematical and statistical concepts, and combines that with a writing style that is very accessible even to those without a technical background. Indeed, James has been held up as a model for those who want to write about statistics for a popular audience (Branson).

One of James's earliest, and still most important, contributions to sabermetrics was

the introduction of the concept of *normalizing data*: that is, placing raw numbers in context. It was well-known at the time that certain ballparks were more conducive than others to scoring runs; for instance, before its demolition in 1997, Atlanta's Fulton County Stadium was frequently referred to as "The Launching Pad" because of the high number of home runs hit there. But there had so far been no real effort to quantify those differences, known as *park factors*. In his 1978 *Baseball Abstract*, James began attacking that issue, stating that the previous season's home run leader, George Foster, would have hit sixty-five home runs and set the single season home run record had he played for a team with a "normal" home ballpark instead of one that suppressed offense (quoted in Gray 34).

Taking park factors into account when computing probabilities may involve simple or fairly complex mathematical computation. For example, there was a lot of discussion in 2009 about the new Yankees Stadium, and how it seemed to be very easy to hit home runs there. A look at the 2009 year-end statistics reveals that in the 81 games played at Yankees Stadium, there were 237 homers hit (136 by the Yankees and 101 by their opponents), while there were only 188 homers hit in the 81 Yankee road games Therefore, the simple park factor[8] for homers in new Yankees Stadium is $^{237}/_{188}$ = 1.261, which means that there were about 26 percent more home runs hit in Yankee home games than in away games; this turned out to be the highest park factor for the year for homers in the major leagues. At the other extreme, in the Cleveland stadium, players were about 33 percent *less* likely to hit a home run than they were in Cleveland's road games.

Once you have determined park factors you can start to do some normalization of the stats. For example, in 2009, at first glance a player in New York who hits 36 home runs for the Yankees would seem to have more power than a player who hits 30 homers for Cleveland. However, the above statistics tell us that if the Yankee had played all his games in an average ballpark we should estimate he would have hit 32 homers; in contrast, the Cleveland player would be expected to have hit 36 homers in an average ballpark. Thus, the raw numbers in this example are not necessarily leading us to the correct conclusions. By taking park factors into account, we strip away some of the noise that could be leading us astray.

This example is somewhat overly simplistic. There are many additional factors which should be considered, such as the quirks caused by game schedules and the fact that there is usually a benefit to playing at home. More recent work has taken into account these and other factors, but although the computations are more difficult, the basic idea is still essentially the same: to ascertain the true value of a player, any raw statistics should be adjusted for context.

These are just a few of the areas in sabermetrics for which James provided vital foundational work. Very rarely are James's conclusions the final word on the subject, but time and time again, they have proven to be the first such word, or an early one of great importance. In addition, James succeeded, where earlier researchers such as Lindsey had failed, in getting the attention of and, in some cases, the agreement of, a wide audience. After five years of self-publishing the *Baseball Abstract* books, the series was picked up by a commercial publisher, and it continued to run for seven more years, finally ending because James felt he had done all that he could with the format and was getting burned out on the work.

If James set a lot of ideas in motion, it was the advent of the Internet that provided a valuable forum in which others could advance those ideas. During the early 1990s, the online discussion group *rec.sport.baseball* was home to numerous writers and researchers

advancing sabermetric ideas.[9] In 1996, a handful of those writers followed in James's footsteps and self-published the first edition of *Baseball Prospectus* (BP). Unlike the *Baseball Abstract* series, BP gained publishers' attention very quickly and was only self-published for one year. By the end of the decade, BP's empire had expanded: it now includes a website (*baseballprospectus.com*), and has featured the work of roughly a dozen different writers with a variety of backgrounds, including journalists, lawyers, historians, engineers, meteorologists, statisticians, and mathematicians (this author among them).

One of the earliest and most important contributors to BP was Clay Davenport. In the interest of having "every single player ... held to the exact same standard" (Davenport et al. 5), Davenport considered multiple factors when normalizing data in order to compare players. Building on previous work by Lindsey, James, and others, his Davenport Translations (DTs) took into account, for instance, not just a player's home ballpark, but also the league and era in which he was playing. Among other things, the DTs helped one predict how well young players' results in the minor leagues would translate to the major leagues. In addition, Davenport took a somewhat different approach to questions that had previously been addressed with the linear weights formulas: he incorporated these performance-affecting factors into his computations of the importance of each possible outcome of a player's time at bat, and created a statistic called Equivalent Runs. While the results are similar in most cases to those previously obtained, the addition of these factors improves the accuracy "[a]t the extremes of performance-players or teams who are either far above or far below the league average" (Davenport et al. 9).

Three years later, in *Baseball Prospectus: 1999 Edition*, Rany Jazayerli focused attention on a completely different area of baseball: namely, injuries to pitchers. Ten years previously, Craig Wright had speculated in his book *The Diamond Appraised* (cowritten with Tom House, 1989) that a starting pitcher who faced more than thirty batters per game was running an increased risk of injury. However, Wright faced the same problem that researchers had faced for decades: namely, getting enough data to test his theory. In the Internet age, however, data became far more widely available. Five years before Wright published, James proposed "Project Scoresheet"[10] as a method for independently gathering data for baseball research (*1984* 250–51). The idea languished for five years, but in 1989 it was reborn in spirit when a group of researchers began working on a project called "Retrosheet." In the twenty years during which their project has been in existence, they have succeeded in finding play-by-play data for virtually every major league game ever played, and have made it available free of charge on the website *retrosheet.org*. By the late 1990s, websites, freed from the space constraints of daily newspapers, were not only listing play-by-play but also pitch-by-pitch data.

It was this availability of information down to the pitch level that allowed Jazayerli to suggest a new way of looking at whether pitchers were being put at excessive risk of injury. In 1999, he proposed a system he called Pitcher Abuse Points (PAP), which assigned points based on the number of pitches a starting pitcher threw. The number of points assigned was essentially a quadratic function on the number of pitches thrown over 100, although it was not presented that way. The theory was that over the course of a season, a high number of points would correlate to an increased risk of injury. Jazayerli admitted in his description of the statistic that it "is an arbitrary, empirical system" (16); in particular, the choice of the number 100 was more or less random. However, it was merely intended to offer a starting point for study to see if this sort of approach could have any predictive value.

In 2001, Jazayerli joined with another BP author, Keith Woolner, to analyze the two years of Pitcher Abuse Points data. While there was not sufficient data to determine whether or not the system could predict injuries, it was possible to look at whether high pitch counts affected a pitcher's performance in the next few games in which he was the starting pitcher. What they found was that the system did have some predictive value, but the original PAP formulation wasn't ideal. A cubic function (which they labeled PAP³) was more useful than a quadratic one, and in fact it did quite a good job of predicting future events. Jazayerli and Woolner were able to offer a simple rule of thumb for pitcher usage: "starting pitchers should, in general, be held to 121 or fewer pitches" (511). If a starting pitcher was allowed to throw more than 121 pitches in a start, chances were high that he would not perform as well in his next few starts.

BP has also addressed an issue which has very little to do with how the game is actually played, but is a popular topic with fans of the game: namely, what the chances are that a team will win their division and make the playoffs. In the World Series, in which only two teams play a maximum of seven games, it's quite straightforward to figure out a team's chance of winning given certain conditions.[11] However, during the regular season there are hundreds of games featuring dozens of teams and computing the necessary odds using that method is difficult to the point of impossibility.

For years, various attempts have been made to perform such computations. In 1964, at the request of a local radio station, a Franklin Institute statistician, Al Polaneczky Sr., started computing the Philadelphia Phillies' chances of making it to the World Series. At the time, they had a six-and-a-half game lead with twelve games left to play, and, unsurprisingly, he found their chances were extremely high. Unfortunately for Polaneczky, the Phillies then proceeded to lose ten straight games and he was stuck providing updates to the radio station that showed the odds dropping rapidly day after day. When the team failed to make the playoffs, he stopped making those computations.

Polaneczky's actual computations were never publicized; the public only knew that they made use of what was then a state-of-the-art computer. More recently, computer technology has allowed the use of a mathematical modeling technique known as *Monte Carlo simulation*. Monte Carlo simulations use random numbers to simulate events; in sabermetrics, they are used to simulate the outcomes of games over the course of a season, and then repeat that simulation process a very large number of times, keeping track of how frequently certain results occur. The first BP mention of Monte Carlo simulations occurred in the 2002 edition, when this author used them to study the effect of changes in how frequently teams play one another during the regular season, and whether that frequency influences which teams make the playoffs. Then, late in the 2004 season, they began to be used to generate a daily report on the BP website (Davenport, "Return").

In order to perform those simulations, two important problems had to be solved: first, there needed to be some way of evaluating the true talent levels of the teams in a given game, and, second, those talent levels had to be turned into a measure of how likely each team was to win the game. Once again, Bill James had done the initial research for this. In fact, he had addressed both of these issues in a single article, "Pythagoras and the Logarithms." Many people would assume that using the percentage of games that a team has won would be a reasonable measure of that team's strength, but James felt that this could be misleading because a team could wind up being either very lucky, winning a lot of very

close games, or very unlucky, losing a lot of close games. Instead, he created what he called the "Pythagorean Theorem of Baseball" (so called because the right-hand expression's denominator reminded James of geometry's well-known Pythagorean Theorem). His theorem proposed that the true expected winning percentage of a team could be predicted by the formula

$$Win\% = \frac{(RunsScored)^2}{(RunsScored)^2 + (RunsAllowed)^2},$$

where RunsScored is the total number of runs a team has scored, and RunsAllowed the total number of runs their opponents have scored, in their games over the course of the season. When tested, it was found that this *expected winning percentage*, *Win%*, rather than its actual current winning percentage, better predicted a team's results going forward. Over the years, refinements have been made to the basic idea, and for the playoff odds reports on the BP website, Davenport incorporates many of the earlier-discussed DTs: the expected winning percentage of a team is based not only on runs scored and runs allowed, but also on, among other things, which other teams a team has played and in which ballparks its runs were scored.

In "Pythagoras and the Logarithms," James also introduced what he called the "log5 formula" (so named because James felt there was a similarity between this formula and a logarithm, although that connection is not really clear to others). James's lack of mathematical background shows somewhat here because he was, to a certain degree, reinventing the wheel. The same formula could be derived from Bayes' Theorem, an important, commonly-known result used for computing conditional probabilities. The form James proposed was

$$W\%(Avs.B) = \frac{W\%(A) \times (1 - W\%(B))}{W\%(A) \times (1 - W\%(B)) + (1 - W\%(A)) \times W\%(B)},$$

where $W\%(A)$ is the expected winning percentage for Team A, $W\%(B)$ is the expected winning percentage for Team B, and $W\%(Avs.B)$ is the percentage of games between Team A and Team B that we should expect Team A to win.

These elements were put together to create, mainly for the amusement of the authors, a daily "state of the pennant race" report on the BP website. As Davenport stated a few weeks after its inception, "I thought I was running a fun little toy ... one which hardly anyone would notice or take very seriously" ("Playoff"). Instead, it became one of the most popular features on the website, and at times (usually near the end of the regular season) has been very prominently located on the site's front page. Over the years there have been many tweaks to James's log5 formula—new versions take into account additional data—but the basic concept of Monte Carlo simulation is still used to this day.

While the amount of attention paid to sabermetrics has grown steadily over the years, there were two events that really earned the field wider recognition. The first was the aforementioned publication of *Moneyball*. The attention the book garnered was not always the most positive. Some commentators who had been around baseball for a long time were not impressed, and took every opportunity possible to disparage the book; national television announcer Joe Morgan, who had a long, distinguished playing career, was particularly vocal on the subject. Critics were frequently able to shift the topic of discussion away from the issue of whether or not sabermetric techniques were effective. Instead, they would focus on

some of the personalities in the Oakland front office, implying that the entire field was nothing more than an attempt to feed the egos of a few individuals.

The second event was much harder to ignore. In 2004, the Boston Red Sox won the World Series for the first time since 1918. The significance of the Red Sox win lies in the fact that the team owner, and most of those responsible for putting together the roster of players, were major advocates of sabermetric tools for evaluating performance, and, a mere two years earlier, James had been hired to serve as an advisor for the team. The 2004 World Series win by the underdog Red Sox showed that sabermetric approaches to baseball analysis have real-world applications.

By the end of the decade, sabermetric ideas had penetrated baseball coverage to the point of becoming routine. The play-by-play pages for games on ESPN's website now feature real-time calculations — based on the same sort of probabilities used by Lindsey half a century earlier — of each team's chance of winning its current game. The ideas on pitcher usage that had been so controversial in 2000 are now widely accepted, to the point that less than 10 percent of all major league pitchers passed the 121 pitch mark more than once in the 2009 season, as compared to the roughly 40 percent that did so during the 1999 season. When a player changes teams, discussions in forums ranging from sports talk radio to major newspapers to fan-run blogs frequently include comments about the effect that changing home ballparks or leagues will have on team performance, and instead of blindly dismissing sabermetric results, national broadcasters are figuring out the best way to incorporate them into their broadcasts (Sciambi). While the exact numbers and equations used in the underlying research may not regularly come up in public debate, sabermetric ideas and general approaches are now commonplace.

Meanwhile, research in the field continues to move forward. Of the thirty major league teams, twenty-nine currently have full-time employees whose jobs are to work on sabermetric research, and the thirtieth team uses outside consultants for the same purpose. There are also multiple "think tanks" set up online (with names such as Baseball Think Factory, Beyond the Box Score, and the Hardball Times), all devoted to looking for new ways to apply numerical and statistical analysis to the game. Sabermetrics has changed the way the game of baseball is thought about and enjoyed, but perhaps its biggest triumph is that its ideas have become so widely accepted that it is now just another part of the game.

Notes

1. The actual focus of the book was on the A's skill at detecting talented players that other teams overlooked; the use of analytical tools was only meant as an example of one of the many ways in which the A's sussed out talent. However, this use was so intriguing to the public that it inspired a critically-acclaimed film, *Moneyball*, in 2011.

2. The term *sabermetrics* was inspired by the acronym for the Society for American Baseball Research (SABR). At the time, some members of SABR were not happy about the name since they viewed the organization as a historical research organization, and felt the term "sabermetrics" implied that the organization existed solely to promote statistical research.

3. Rickey is best known for signing Jackie Robinson in 1946, breaking baseball's color barrier.

4. These values will differ from team to team, but the convention has been to use league-wide averages when computing these probabilities.

5. The probability of a team getting more than 5 additional runs under the circumstances is so small that we can essentially ignore this possibility: its contribution to the expected runs total is within the rounding error of the computation.

6. A *Markov chain* is a mathematical object that can be used to compute the probability of an outcome's

occurrence, given known probabilities of preceding events. Further details can be found in most under-graduate-level probability textbooks (see, for example, Chapter 11 in Grinstead and Snell).

7. $1B$ represents the number of singles a player hits, $2B$ the number of doubles, $3B$ the number of triples, HR the number of home runs, BB the number of walks, HBP the number of times a batter is hit by a pitch, SB the number of stolen bases, CS the number of times caught stealing, and $AB - H$ the number of at bats minus the number of hits, or, in other words, the number of outs achieved.

8. One can consider more complicated park factor measurements: for example, one could take into account the fact that in 2009 the New York Yankees played the Chicago White Sox four times in Chicago, but only three times in New York. However, usually the resulting difference in factor measurements is extremely small.

9. It was also home to numerous critics, who would deride the researchers as "statheads" if they were being relatively polite or "stat drunk computer nerds" if they weren't (Davenport et al. 3).

10. The original proposal involved readers sending to some central location photocopies of game scoresheets they had kept.

11. In fact, this is frequently an exercise in undergraduate probability courses.

Works Consulted

Albert, Jim, and Bennett, Jay. *Curve Ball: Baseball, Statistics, and the Role of Chance in the Game*. New York: Copernicus, 2001.

Branson, William. "Bill James as an Exemplar of Statistical Writing." 2006 AMS/MAA Joint Mathematics Meetings. San Antonio. 13 Jan. 2006. Presentation.

Cook, Earnshaw. *Percentage Baseball*. Cambridge: MIT Press, 1964.

Davenport, Clay. "Playoff Odds Report, Redux." *Baseball Prospectus*. Prospective Entertainment Ventures, 23 Sept. 2004. Web. 28 Feb. 2010.

_____. "Return of the Playoff Odds Report." *Baseball Prospectus*. Prospective Entertainment Ventures, 2 Sept. 2004. Web. 28 Feb. 2010.

Davenport, Clay, et al. *Baseball Prospectus '96*. Self-published, 1996.

Deford, Frank. "Baseball Is Played All Wrong." *Sports Illustrated* 23 Mar. 1964.

Gray, Scott. *The Mind of Bill James: How a Complete Outsider Changed Baseball*. New York: Doubleday, 2006.

Grinstead, Charles M., and J. Laurie Snell. *Introduction to Probability*. 2nd revised edition. Providence: American Mathematical Society, 1997.

Hildebrand, Jeff. "Fairness in Scheduling." *Baseball Prospectus: 2002 Edition*. Ed. Joseph Sheehan. Washington, DC: Brassey's, 2002. 479–83.

James, Bill. *1984 Bill James Baseball Abstract*. New York: Ballantine Books, 1984.

_____. "Pythagorus and the Logarithms." *1981 Baseball Abstract: The 5th Annual Edition*. Self-published, 1981. 104–17.

_____. *1977 Baseball Abstract: Featuring 18 Categories of Statistical Information That You Just Can't Find Anywhere Else*. Self-published, 1977.

Jazayerli, Rany. "Pitcher Abuse Points." *Baseball Prospectus: 1999 Edition*. Ed. Joseph Sheehan. Washington, DC: Batsford Brassey, 1999. 14–18.

Lewis, Michael. *Moneyball: The Art of Winning an Unfair Game*. New York: Norton, 2003.

Lindsey, George. "An Investigation of Strategies in Baseball." *Operations Research* 11.4 (1963): 477–501.

_____. "The Analyst's Bookshelf." Rev. of *Percentage Baseball*, 2nd ed., by Earnshaw Cook. *Operations Research* 16.5 (1968): 1089–90.

Polaneczky, Ronnie. "Dear Dad: To Avoid Phold, Do Not Touch Your PC." *Philadelphia Daily News* 23 Oct. 2008: 10.

Rickey, Branch. "Goodbye to Some Old Baseball Ideas." *Life* 2 Aug. 1954. 81–85.

Sciambi, Jon. "Guest Column: Building a Better Broadcast." *Baseball Prospectus*. Prospective Entertainment Ventures, 23 Feb. 2010. Web. 28 Feb. 2010

Tango, Tom. "Sabermetrics 101: Run Frequency Matrix, 1999–2002." *Tango on Baseball*. Tom Tango, n.d. Web. 27 Feb. 2010.

Thorn, John, Pete Palmer, and David Reuther. *The Hidden Game of Baseball: A Revolutionary Approach to Baseball and Its Statistics*. Garden City, NY: Doubleday, 1984.

Woolner, Keith, and Rany Jazayerli. "Analyzing PAP." *Baseball Prospectus: 2001 Edition*. Ed. Joseph Sheehan. Washington, DC: Brassey's, 2001. 505–16.

Wright, Craig, and Tom House. *The Diamond Appraised*. New York: Simon and Schuster, 1989.

A Mathematician Does the *New York Times* Sunday Crossword Puzzle[1]

GENE ABRAMS

Introduction

A Fourier series function is a deep mathematical concept. The subject of graduate courses. The heart of Ph.D. theses. The gist of research seminars. And the 84-Across clue in the July 5, 2009 *New York Times* Sunday Crossword Puzzle.

I've been an avid crossword puzzle solver for more than thirty years, having initially become afflicted during my (limited) downtime in math graduate school. For me, crossword puzzles, especially the (generally acknowledged gold-standard) *New York Times* Sunday Crossword Puzzle, provide a nice change of pace from my duties as a math professor, as well as an entertaining way to stay in touch with both historical subjects and popular culture. But until July 5, 2009, it had never occurred to me that mathematics might in fact constitute an integral part of the crossword ethos. Just how pervasive are mathematically-oriented clues and solutions in the puzzlers' world? In this essay we examine the ubiquity of math in the *New York Times* Sunday Crossword Puzzles.[2]

The structure of this essay loosely mimics the framework used to structure the collection in which it appears. In *The Game* we provide examples of mathematically-oriented clues and solutions appearing in the 2009 *New York Times* Sunday puzzles, and in *The Players* we explore responses from a survey of puzzle constructors regarding their backgrounds and interests in mathematics. Finally, we provide two appropriately-themed crossword puzzles which the reader is invited to solve.

The Game

In this section we describe some of the many examples of mathematics and mathematically-oriented constructs arising in the 2009 *New York Times* Sunday Crosswords (NYTSXs). First, we offer a quick primer on various aspects of the NYTSX, and on cross-

word-puzzling in general. A *cruciverbalist* is a person who constructs crosswords. We identify "across" clues using an "A" and "down" clues using a "D": for instance, 3A would indicate the clue corresponding to 3-Across. If a clue contains an abbreviation, then the corresponding solution will as well. It is not uncommon for some of the squares in a puzzle to include inscribed circles, typically indicating that the letter (or letters) which go into such squares are related to each other in some (usually-not-initially-obvious) way (see, for example, the puzzle *Perpetual Motion*, discussed below). Every NYTSX puzzle has both a title and a theme: the theme of a puzzle is usually its most entertaining, creative attribute. The title of a puzzle typically contains a hint as to what the puzzle's theme might be. We offer here two examples of themes and corresponding titles which we hope will provide the reader with some context for various observations which will be made later in the essay. These, and all subsequently-mentioned puzzles, are 2009 NYTSXs.

Example 1. The January 25 NYTSX is titled *Fiddle Dee Dee*. Its theme: each solution occurrence of "TT" is replaced with "DD." E.g., the clue "Dairy frivolity?" (22A) yields the solution UDDERNONSENSE.

Example 2. The April 26 NYTSX is titled *Roughly Speaking*. Its theme: some single squares hold the strings "um" or "er." E.g., the clue "Wall Street newsmakers" (93D) yields the five-square solution M E/R G E/R S (er, get it?).

It's Really Math

Some of the clues and solutions used in various NYTSXs might well have come straight out of a math textbook or math history book. Here are some examples (including my previously-mentioned favorite).

Date	Placement	Clue	Solution
March 1	9D	Some operators in Boolean logic	ANDS
March 15	109D	Arithmetic series symbol	SIGMA
April 19	119A	Like most primes	ODD
April 26	103D	Kind of power	NTH
May 24	76D	Trig ratios	SINES
May 24	86D	Common thing to count in	BASETEN*
June 14	77A	Mathematician Turing	ALAN
June 21	30A	Pair in an ellipse	FOCI
June 21	44A	Mathematician de Fermat	PIERRE
July 5	84A	Fourier series function	SINE
July 12	109A	Lead-in to calculus	PRE
August 2	63D	Enigma machine	CODER
October 11	26A	Prove it	THEOREM
November 29	58D	French mathematician who pioneered in the theory of probability	FERMAT
November 29	67A	Many curves, in math	LOCI
December 13	92D	Low point	MINIMUM

*That is, "base 10."

Not only does mathematics arise in individual clues and solutions, it may actually provide the theme of a puzzle. For instance, the theme of the May 24 puzzle, *Perpetual Motion*, centers on the notion of infinity. In this particular puzzle there are two sets of eight squares containing inscribed circles; each of these sets forms (roughly) an oval shape, and the two sets are (roughly) side-by-side in the puzzle. Once the solutions from the germane clues are entered, if one reads the letters in order around the first oval, the words SYMBOLOF are

formed; around the second oval, the word INFINITY appears. Of course, the two ovals side-by-side form the infinity symbol! The five themed clues produce solutions related to infinity: for instance, the 25A clue "Bond film that's a real gem?" yields the solution DIA-MONDSAREFOREVER. The mathematical pièce-de-résistance follows from the puzzle's accompanying note, in which the cruciverbalist indicates that the solver should "connect the circles in one continuous line to identify a figure invented by 29-Down" (the solution to 29-Down is seventeenth-century English mathematician JOHNWALLIS, and the figure is the aforementioned infinity symbol).

As another example of mathematics lying at the heart of a crossword, the grid of the October 18 puzzle looks (roughly) like a spiral. The theme centers around Frank Lloyd Wright's design of the Guggenheim Museum, and includes the solution SPIRALSHAPE to the 120A clue "Controversial form that 43-Down used for 23-/29-Across."

It's Really Math-y

In addition to the standard mathematics words and phrases described in the previous subsection, there are also a number of NYTSX clues, solutions, and themes which give a nod to mathematics. For instance, the May 10 clue "Tendency to throw one's club after sinking a short stroke?" (40A) yields the solution PUTTERFLYEFFECT (a pun on "butterfly effect"); the July 19 clue "Greeting from Smokey the Bear?" (72A) yields the solution URSINEWAVE (a pun on "sine wave"); and the November 8 clue "Resident of a military installation?" (25A) yields the solution BASETENANT (a pun on "base 10"—which was the solution to a clue in the May 24 puzzle earlier in the year!).

In the June 7 puzzle, themed answers include the ordinals 1ST, 2ND, 3RD, 4TH, 5TH, and 6TH (written using numerals) in six squares containing inscribed circles. For instance, 1ST is the one-square entry at the intersection of the solution for clue "Witnessed" and the solution for clue "Teacher's question at the start of show-and-tell" (that is, the intersection of the solutions SEEN1STHAND and WHOS1ST). These six circles are laid out on the grid in a manner that evokes the image of the manual transmission pattern in a stick-shift car. There is a seventh inscribed circle in the middle of the pattern, with NEUTRAL the one-square answer. The title of this puzzle? *Shifty Business*, of course.

To solve the August 2 puzzle, a solid knowledge of the Greek alphabet (an alphabet regularly tapped by mathematicians) is essential. Each of the themed solutions is a sequence of three Greek letters. For instance, the 79D clue "Group formed at Trinity College in 1895" yields the straightforward 3-square solution $\alpha \chi \rho$. But the 91A clue "Engine attachment," whose 5-square solution intersects the 79D solution at both solutions' third square, yields the tricky AIρSE (ρ = RHO, so AIρSE is read as "airhose").

It's "Real World" Math

The mathematical words most frequently occurring in everyday life are usually associated with magnitudes, sizes, geometric shapes, and Roman numerals, to name a few. There are numerous appearances of such words in the NYTSXs, including those in the following list. Of course I'm especially fond of situations in which the cruciverbalist has chosen to use a math-oriented clue, rather than an obvious non-math choice. (See, e.g., the March 8, March 22, and April 19 clues.)

Date	Placement	Clue	Solution
February 15	98D	It's nice when checks have lots of them	ZEROES
February 15	90A	Rocket's path	ARC
February 22	31A	Geometric fig.	CIR
March 8	115D	Kind of graph	BAR
March 22	44D	"x" in an equation	VALUE
March 29	78D	Circle makers	COMPASSES
April 5	86D	Abacus, e.g.	ADDER
April 19	106D	Algorithm part	STEP
April 19	120A	15%, maybe	TIP
April 19	103A	90-degree turn	ELL
April 26	21A	Two lines may make one	ANGLE
May 10	91D	Highest point	APOGEE
June 14	71D	Tithe amount	TENTH
June 21	74D	Eight: Prefix	OCTA
August 23	50D	Having digits	NUMERIC
August 30	13D	1,111	MCXI
September 6	81D	Year the mathematician Pierre de Fermat was born	MDCI
October 25	14D	Draws a parallel between	EQUATES
December 6	41D	Galaxy shape	SPIRAL
December 13	49D	Amphitheater shape	OVAL
December 13	97D	Numerical comparison	RATIO
December 13	105D	Three more than quadri-	SEPTI
December 20	12D	Geom. measure	DIAM

Really?

In this final subsection of *The Game*, we start by singling out two types of math-related clues and solutions which appeared in the 2009 NYTSXs. First, those words which are so uncommon that they left me wondering, despite nearly forty years in the math business, "Is that *really* a word?"

Date	Placement	Clue	Solution
February 15	51D	Quintillionth: Prefix	ATTO
May 3	66A	Duodecim	XII
August 30	10A	Four-sided figure	RHOMB

Second, those solutions which left me thinking, because of my nearly forty years in the math business, "Doesn't this *really* scream for a math clue?" (Here we first give the *solution*, followed by its corresponding clue.) Admittedly, the knowledge base required to interpret the given solution mathematically may not be acquired until graduate-level math studies.

Date	Placement	Solution	Clue
January 11	91D	RADII	Parts of forearms
May 31	112A	ERAT	Quod _____ faciendum
June 21	98A	PLUS	Anode indicator
July 19	59A	IDEALS	Topic in transcendentalism
July 26	27A	OLMOS	Actor Edward James _____*
August 9	37D	AMS	Pro _____
August 9	71D	ABACI	Summers
September 13	88D	HESSIAN	German mercenary
September 13	44A	EIGEN	Manfred _____, 1967 Chemistry Nobelist
October 11	1A	ANGLE	Fish
November 15	75A	TREFOIL	Girl Scout symbol
December 13	121A	DELTA	Mouth feature
December 20	26D	FALSE	Like some starts
December 27	63D	TEN	Big _____

*It would have been nice to see OLMOS clued as "*Stand and Deliver* star."[3]

We finish this section with some miscellaneous observations. It's not uncommon for a solution to be a number expressed in a foreign language in a NYTSX: for instance, ACHT (German for "eight") and SIETE (Spanish for "seven") each appeared in 2009. I learned some math history trivia in 2009: on March 29 it came to my attention that the Greek mathematician/philosopher Zeno hailed from ELEA, while on May 24 I came to find out that a painter named HALS produced a portrait of mathematician/philosopher René Descartes. And I became aware on January 11 of a (punning) interpretation of "numbers" which had never before crossed my mind: "Numbers?" (84D) OPIATES.

Think about it.[4]

The Players

Each year, thousands of puzzles are submitted to *The New York Times* by cruciverbalists (both seasoned veterans and first-timers) for review by puzzle editor Will Shortz and his staff. From among these, the 52 puzzles which are selected to appear in the Sunday *New York Times* are chosen on the basis of creativity, degree of difficulty, and breadth of included topics.

In 2009 there were 41 different individuals whose names appeared as an author or coauthor of a NYTSX. Will Shortz is the editor of each of the 52 puzzles. Some puzzles have just one author, others have two coauthors. (Since 52 puzzles were created by 41 people, the mathematical Pigeon Hole Principle implies that some cruciverbalists authored more than one 2009 puzzle. Indeed, one constructor can claim credit for five 2009 puzzles!)

In order to get a better sense of what exactly is driving the pervasiveness of math-oriented content in the NYTSXs, I put together a list of questions to ask each cruciverbalist about her/his connection to mathematics. Through the gracious assistance of Patrick Merrell, co-writer of *Wordplay: The Crossword Blog of The New York Times*, the following set of questions was emailed to thirty-seven of the forty-one 2009 puzzle constructors during the first week of January 2010. (Mr. Merrell included an introduction and context for these three questions, noting that potential responses would possibly be used to build the current essay.)

1. Describe your "relationship with mathematics." (For instance: Do you love it? Hate it? Did you take a lot of it in school? Or did you perhaps avoid it at all possible cost? Do you read general audience books about mathematics and mathematicians?)

2. If appropriate, describe any mathematically-oriented decisions you had to make when constructing your puzzle. For instance: Tony Orbach and Amy Reynaldo in the July 5 puzzle chose to use the clue Fourier series function to produce the answer SINE. *Be still my heart!* There are certainly more standard ways of getting SINE as an answer, e.g. _____ qua non, or Elementary trig function. Heck, Fourier series aren't typically presented in a math curriculum until graduate school.... For instance: There are Alans (resp., Pierres) other than Turing (resp., Fermat). See the June 14 (resp., June 21) puzzle.

3. Over the past twenty years or so, do you think there has been any change in the profile of mathematics in popular culture? If so, do you think that the amount of mathematics which is included as part of *New York Times* Sunday Crosswords has changed as a result?

Twenty of the thirty-seven constructors generously provided responses! (A 54 percent return rate on a voluntary survey? Are you kidding me? Heck, I've given *required* homework assignments which have yielded smaller return percentages.) These twenty respondents were responsible for twenty-eight of the fifty-two NYTSXs put out in 2009. As I'll describe below, the responses indicate that the connection between mathematics and cruciverbalism runs quite deep.

1. **Relationship with mathematics.** For many of the respondents, their "relationship with mathematics" is close and ongoing. The twenty respondents include a D. Phil. in mathematics (from Oxford); a holder of both a B.S. in mathematics and an M.S. in applied statistics; a high school math teacher with more than forty years experience in the classroom; and a consulting actuary who minored in math in college. Add to these a number of people with strong science and/or high tech connections: a family practice doctor; an M.B.A. holder in information systems; a veterinarian; and Ph.D. holders in operations research (more info on this respondent appears below) and chemical engineering. The vet mentioned that he loved math in high school and college, and even went so far as to contact his high school math teacher "45 years after graduation — just to tell her what a great teacher she was." The M.D. modestly described himself as "capable, but not a whiz" at math, although the author has learned that this respondent did complete a year of calculus at an Ivy League school. One 2009 puzzle constructor, currently a high school junior(!), indicated that he was indifferent to math during his freshman and sophomore years, but, now that he's taking calculus, he "...absolutely love[s] it."

For some respondents mathematics is an interest or pastime, but nonetheless has been relegated to bridesmaid status in their studies or life pursuits. One, currently a college student, notes that "If I weren't studying linguistics, there's a good chance I'd be studying math." Another writes: "I started violin studies at nine years old, and so math is an integral part of my life. I loved math class, especially geometry. I opted for music studies instead of calculus. The mathematics of a musical score are highly ordered, as are relationships between notes in the musical scale."

Only one of the twenty respondents admits to being "...decidedly NOT a math person." The remaining respondents all indicated at least some degree of comfort or ability with mathematics: "[I received a grade of] A in calc in college"; "[I did] much better on math SAT and GRE scores than verbal, but didn't like math and majored in English"; "[I] loved math until Calculus kicked my butt in my senior year of high school"; "I went to a math/science HS — I like math, but don't love it."

A number of respondents commented on the connection between puzzles and mathematics. One notes that he "loved junior high school plane geometry ... figuring out proofs was literally akin to solving a puzzle." He went on to comment: "...I've been surprised to find over the years that a lot of constructors have math-oriented or music-oriented careers.... Maybe there's more to the math angle [and its relationship to crosswords] than meets the eye."

To appreciate what is clearly the most compelling "relationship with math" response I received, some historical background is in order. When the mathematical prodigy Ramanujan was in the early stages of his career in India, he shared some of his mathematical writings with various mentors in his Madras community. One such important mentor to Ramanujan was the respected mathematician S. Narayana Aiyar, in whose office the *wunderkind* was

employed as a clerk. Narayana Aiyar recognized the sheer genius demonstrated by Ramanujan's work, prompting him to recommend Ramanujan to the world's leading number theorist at the time, the British mathematician G. H. Hardy. The eventual collaboration between Hardy and Ramanujan born of this recommendation is now the stuff of legend. (Kanigel 95–98, 102–06; n.b.: "Aiyar" is spelled "Iyer" therein.)

Wrote one respondent:

> I know this is going to sound bizarre at first, but my association with math predates my birth. I'm named after my great-grandfather, Narayana Aiyar.... Since the day I was named after him [he was my grandmother's father], my grandmother's only requirement was that I live up to his reputation (quite an awful burden for a kid, don't you think?). I've always loved math — being grandma's favorite must have helped! — so I ended up [in a very math-intensive field, eventually] earning a Ph.D. in industrial engineering/operations research. I guess you could say that I took a lot of math. As a matter of fact, I make my living applying math.

2. **Mathematically-oriented decisions.** When I crafted this second survey question, what I expected to receive as responses to it were explanations as to why a cruciverbalist might use a math-oriented clue in a situation in which other clue options exist. (I've mentioned specific such examples previously. Indeed, the "Fourier series function" clue provided the original motivation for this essay.) As it turns out, many of the responses did in fact address this question directly. But at least as many discussed more general relationships between mathematics and puzzle construction.

Here are the responses of the type I expected. One respondent suggested that he would "...prefer to use science/math clues if possible when a word has different contexts," while another, conversely, said that he will "...oftentimes discount mathematical and scientific answers / clues because they typically are not considered to be of relatively general enough knowledge by puzzle editors." A third "...doesn't deliberately try to include math answers." (This respondent indicated that he actually doesn't deliberately try to include answers relating to *any* specific subject too often, even those subjects that he personally likes, in order to avoid alienating those puzzlers who don't share his taste for those subjects.) A fourth suggested that his familiarity with math and computers is a "hindrance" much of the time, since things that he might find familiar might be totally unfamiliar to the average solver. A fifth remarked that he considers "...math and the sciences [to be] an absolute necessity in puzzles in terms of clues and answers, because they are an integral part of the broad spectrum of human knowledge and accomplishment." Our previously-mentioned high schooler wrote that his clue "Produce some combinations, say," with solution BOX was "...purposely intended to misdirect any math people."[5]

Here are the responses which, to me, were completely unexpected. One respondent suggested that "[Puzzle construction] is often a degree-of-freedom problem. Basically, filling the grid [once the themed solutions have been set] is like solving, semi-simultaneously, a set of 70+ equations (i.e., words)." In the same vein, another response noted that "Constructing a crossword involves solving a constraint satisfaction problem." The first constructor continues:

> On top of the degree-of-freedom analysis, there's an optimization that takes place in every constructor's mind. It is not uncommon for a constructor to have to choose between using, say, A) two fun words and two bland words, and B) three really fun words and one terrible abbreviation. As a solver, what would you prefer? Obviously, this is a rhetorical question.

A third constructor wrote, "All puzzlemaking is based on specific mathematical principles of symmetry and percentages. We observe strict rules for black / white square percentages, and word limits." Disagreements can arise among co-constructors regarding which clue to use for a particular solution; a fourth respondent described a numerically-based system for trying to resolve such issues. Narayana Aiyar's great-grandson waxed poetic about the relationship between cryptic clues (ones which require additional levels of interpretation on the solver's part)[6] and mathematics. "In a broader sense, cryptic clues have a sense of mathematical completeness that make[s] you want to write QED after you've solved them.... You know you have the answer the moment you solve the clue: there is really no need to solve the intersection clues for confirmation."

Ironically, although I learned a great deal about the decision-making processes which go into the selection of clues, in the end I did not achieve closure vis-à-vis the motivating question. The July 5 puzzle was constructed by Tony Orbach, Amy Reynaldo, and editor Will Shortz. Amy Reynaldo wrote: "We submitted two clues for SINE: 'Trig function' and 'Fourier series function.' I know nothing about Fourier series functions ... I have no idea where that [clue] came from!" Tony Orbach wrote: "I would love to say that Amy or I had been champing at the bit to get that SINE clue in — I don't think so." Both Orbach and Reynaldo, however, offered enlightening follow-up comments.

> In general, though, I think most crossword constructors would like to use a less common clue for a given word whenever possible. We also strive to limit use of fill-in-the-blank clues, so that was most likely the reason to decide to look beyond "____ qua non." Armed with a computer and reference books and being in search of an interesting clue, you never know where you might end up — looking at the Fourier series, perhaps! [Orbach].

> Maybe a *Diary of a Crossword Fiend* blog commenter suggested [the clue] around the time Tony and I were working on the clues [Reynaldo (italics added)].

So, in the end, an unnamed blog commenter may in fact be the one to thank for creating the "Fourier series function" clue. And to thank, as well, for inspiring this essay.

3. Profile of mathematics in popular culture. As to the question of whether or not the profile of mathematics in popular culture has changed over the past twenty years, the vast majority of responses can be collectively paraphrased as "not much, if at all."

A few of the respondents mentioned that the depiction of math in popular culture, other than in the TV series *NUMB3RS*, was at best unflattering; they wrote that mathematicians are made out to be "eccentric, mentally unbalanced geniuses" and that "...math and science is viewed as something nerds would be interested in." One stated: "I don't see that we've moved a great deal beyond the stereotypical portrait of nerds with pocket protectors."[7]

As to the specific question of the appearance of mathematically-related items in the NYTSXs, one respondent noted that there are certainly more "hi tech" clues than there used to be, while another noted that "...allusions to math in the past were minimal compared to now."

One contributor commented that creative, geometric shapes are now often used in the grid itself (e.g., in the previously-mentioned October 18 spiral puzzle). A handful of respondents remarked that the amount of mathematically-oriented content appearing in NYTSXs has increased during Will Shortz's tenure as editor (which began in 1993).

Conclusion ... and Puzzles!

As one survey respondent put it, "crossword puzzles ... wind up reflecting a fair amount of pop culture." We hope that this essay has brought to light an interface between mathematics and popular culture, reflected in the *New York Times* Sunday Crossword Puzzles. We also hope the reader will try her/his hand at solving the two puzzles given below. Our intention in presenting these puzzles is to give the reader topic-appropriate examples of how title, theme, and clue choice combine to produce challenging, informative, and (hopefully) entertaining puzzles.

The first puzzle, *MATH and Popular Culture*, should be accessible to the crosswording novice. (We note that this puzzle, at grid size 15 × 15, is smaller than the standard 21 × 21 grid size used in most *New York Times* Sunday Crosswords.) The second puzzle, titled *Do the Math*, is more representative of the type of puzzle which would actually appear as a NYTSX. (A short *mea culpa* is warranted here: *Do the Math*, constructed by the author of this essay, admittedly violates some of the aforementioned common guidelines of good cruciverbalism.)

Notes

1. This essay is dedicated to the memory of Stan Abrams; a puzzle and pen were his constant companions.

The author is extremely grateful to each of the twenty respondents to the survey of 2009 NYTSX puzzle constructors. They are, in alphabetical order by surname: Alan Arbesfeld, Michael Ashley, Eric Berlin, Daniel Finan, Victor Fleming, Matt Ginsberg, Elizabeth C. Gorski, David J. Kahn, Lynn Lempel, Caleb Madison, Patrick Merrell, Andrea Carla Michaels, Will Nediger, Tony Orbach, Amy Reynaldo, Phil Ruzbarsky, Barry Silk, Michael Torch, Narayan Venkatasubramanyan, and Robert H. Wolfe. Special thanks to Patrick Merrell for agreeing to email the survey questions to the 2009 constructors. Very special thanks to Victor Fleming, who through a series of email correspondences taught me some of the do's and don'ts of cruciverbalism; this e-discussion provided the impetus for the construction of the first of the two puzzles which appear in this essay. The author acknowledges John Allen Paulos, whose numerous books about mathematics' role in society include *A Mathematician Reads the Newspaper* and *A Mathematician Plays the Stock Market*; the title of the current essay derives from these.

2. That the *New York Times* Sunday Crosswords should provide a reflection of popular culture is indicated by puzzle editor Will Shortz, on the *Times*' Crossword Submission Guidelines website. Shortz writes that the Sunday puzzles provide "...well-balanced test[s] of vocabulary and knowledge, ranging from classical subjects like literature, art, classical music, mythology, history, geography, etc., to modern subjects like movies, TV, popular music, sports and names in the news."

3. *Stand and Deliver* is a 1988 film which tells the true-life story of Jaime Escalante, a math teacher in a longtime-underachieving urban Los Angeles high school who helps a group of students prepare for, and ultimately pass, the AP calculus exam. The film stars Edward James Olmos as Escalante, and features Lou Diamond Phillips in a supporting role as one of the students. Olmos' portrayal of Escalante earned him a 1989 Oscar nomination for Best Actor in a Leading Role, and the film was hugely popular upon release.

4. Hint: Opiates are things that numb...

5. The word "combination" has a precise interpretation to a mathematician as "subset." For instance, if we start with the set $S = \{a, b, c, d\}$, the subset $\{a, c\}$ is a *combination chosen from S*. Specifically, in a "combination," elements are not repeated, and the order in which the elements are presented does not matter. E.g., the combination $\{a, c\}$ is the same as the combination $\{c, a\}$. The word "combination" is contrasted to the word "permutation," a related concept in which the order of the elements does play a role.

6. For instance, in the August 30 puzzle *Literally So*, the 121A clue "W--THL-SS R-AD-TER" looks like the words "worthless roadster," but without the letters "OREOS." The solution should therefore be some sort of response which can be interpreted as a bad car from which sweets have been removed. Answer? LEMONDROPCOOKIES.

MATH and Popular Culture

Gene Abrams / Victor Fleming

ACROSS

1 Finished the cake
5 Scam with a fake Web page
10 Hawaiian four-stringers
14 Alaskan city 1,161 16-Acrosses from where the Iditarod starts
15 "Shucks!"
16 1,760 yards
17 Like Plato and Socrates, say
19 ___ mater
20 Traveling, as a road show
21 Repetitive toy train sound
23 Ham on ___
24 ___ TURN (turnpike sign)
26 Babe in baseball
27 Arkansas or Colorado
29 Store-bought hair
33 Farm-related prefix
36 Of sound mind
38 Suave competitor
39 Trudge
40 Person, place or ___

42 ___ Diner (establishment on "Alice")
43 Latin profession?
45 19-country grp.
46 Downwind, on deck
47 Cloverleaf component
49 Coin worth five shillings
51 Polynesian food
53 Author Le Shan
54 ___ de Cologne
57 Kind of district where landlords may flourish
61 Prepares burgers, perhaps
63 Port of Pennsylvania
64 Promos touting the nonexistence of positive integer solutions to $x^n + y^n = z^n$ for $n>2$?
66 "Mad" cartoonist Drucker
67 First-string players
68 Agcy. that inspects workplaces
69 "To Live and Die ___" (1985 film)
70 Peter of "Young Frankenstein"
71 Green veggies

DOWN

1 ___ it (about to experience trouble)
2 Like many a bad one-liner
3 Overdo the stage directions
4 Trial version
5 Traditional Sunday fare
6 1968 election monogram
7 "___ Around" (Beach Boys hit)
8 Mexican mister
9 Baseball sportscaster's cry
10 "Pulp Fiction" acress who tells a joke that starts, "Three tomatoes are walking down the street ..."
11 Start to meter?
12 Ticklish doll
13 Chair
18 Female relative
22 Car roof variety
25 Salt Lake City native
27 In meteorology, expression used to denote the standard deviation of wind direction
28 Computer of the '40s
30 Banana covering
31 Magazine that gives Style awards
32 Last term in many a threat
33 Concerning, in a memo
34 Isolated valley
35 Sound of a crows
37 ___ nous (confidentially)
41 Words of congrats to an athlete, often
44 Actor Sharif
48 House that goes up quickly
50 Bit of Halloween makeup
52 "Takes ___ know ..."
54 Alex's mom on Family Ties
55 Word before male or particle
56 "___ directed"
57 Half up front?
58 Its atomic weight is 55.845
59 Tomorrow's woman
60 Deuce topper
62 Flapjack chain
65 Practice starter?

Do the Math

Gene Abrams

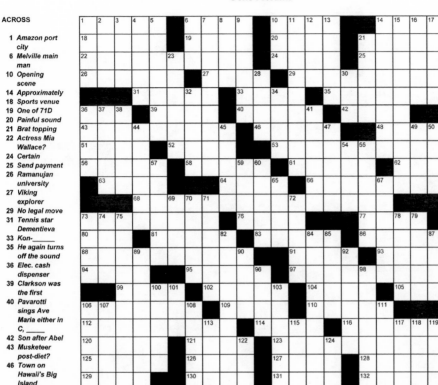

ACROSS

1 Amazon port city
6 Melville main man
10 Opening scene
14 Approximately
18 Sports venue
19 One of 71D
20 Painful sound
21 Brat topping
22 Actress Mia Wallace?
24 Certain
25 Send payment
26 Ramanujan university
27 Viking explorer
29 No legal move
31 Tennis star Dementieva
33 Kon-____
35 He again turns off the sound
36 Elec. cash dispenser
39 Clarkson was the first
40 Pavarotti sings Ave Maria either in C, ____
42 Son after Abel
43 Musketeer post-diet?
46 Town on Hawaii's Big Island
48 Unhappy utterance
51 Sweater Girl Turner
52 Charlie's wife
53 Rescuer after chem. explosion?
56 School on the Seine
58 Sculpts with steel
61 St. Petersberg sister city
62 Bygone can material
63 Emerald Isle
64 Part of Q.E.D.
66 Imelda's narrow stilettos
68 Blues singer Willie Mae?
73 Displaced persons
76 Grape residue
77 Utah mountain bike mecca
80 Blood doping hormone
81 Paper used in

artwork
83 Plumb loco
86 Sound
88 For n>2, $x^n + y^n = z^n$ has no positive integer solutions! ?
91 Country Slaughter
93 Afghanistan province
94 Tractor and trailer
95 Internet gossip
97 Umpire Hallion calling balls and strikes?
99 Med. school course
102 Sedgwick and others
104 Ladies' lanes lg.
105 Cartoon drawing
106 Lake and

province
109 Bruins' sch.
110 Biblical lady-led land
112 Hall of Fame 2nd Baseman Charlie
114 Coup d'____
116 Jefferson place
120 Families have them
121 Money for a month
123 Departing Venizelos International?
125 Danish town near Odense
126 Author Stanley Gardner
127 Mean man
128 Reddish dye
129 Paranormal abilities
130 Ascent
131 Tomato type

132 On the plus side

DOWN

1 Oz creator
2 Humorist Bombeck
3 "____. or get out of the way!"
4 Between in Barcelona
5 Gospel singer Jackson
6 Penn. Stn. sign
7 Christmas movie
8 Winglike
9 Adolf's ally
10 Puzzle-appropriate prof. org.
11 Teddy's 3rd child, to Jon Jon
12 Sour

13 Type of hearing aid
14 City south of Salt Lake
15 Colorado State NCAA participant?
16 Large hotel room
17 Playful mammal
21 Krispy ____ donuts
23 Had in the past
28 Enterprise captain
30 Guitarist Paul
32 "____, no way!"
34 Australian girl's name
36 Norwegian Fields Medalist Selberg
37 Outline in pencil

38 Secondary area of study
41 Marketplace
44 Pepperdine home
45 Oregon capital
47 Jordan capital
49 Seed cover
50 Tevye had none
54 ____ on the back
55 Town on Lake Tahoe
57 WWII code machine
59 Unit of volume
60 Devil
65 Finished, in a text message
67 Sufficient
69 Beowulf tribesman
70 Royals pitcher Gil
71 Fredric March, both as Jekyll and ____

72 Eight at music
73 Umps
74 Olympic sword
75 Assistance from an editor?
78 Not generalizable
79 Climactic region
82 Childbirth pain blockers
84 Blizzard
85 Exertion sound
87 Pitcher Hershiser
89 Mosque features
90 Anglicized 27A
92 Former Belgian airline
96 At a distance
98 Bewitched girl
100 Get up
101 Bygone can material
103 Took 119D, as an example
106 Amorite king ____ Giant
107 Roman fiddler and others
108 One who stares
111 Often paired with pains
113 One-letter prefix connoting high-tech
115 Jason's ship
117 Lay and Kesey
118 Feminine suffix
119 Ref. to 103D
122 Birth surname
124 "____ culpa!"

Solution to *Math and Popular Culture*

I	C	E	D	■	P	H	I	S	H	■	U	K	E	S
N	O	M	E	■	O	H	G	E	E	■	M	I	L	E
F	R	O	M	A	T	H	E	N	S	■	A	L	M	A
O	N	T	O	U	R	■	T	O	O	T	T	O	O	T
R	Y	E	■	N	O	U	■	R	U	T	H	■	■	■
■	■	S	T	A	T	E	■	T	O	U	P	E	E	
A	G	R	I	■	S	A	N	E	■	P	R	E	L	L
S	L	O	G	■	T	H	I	N	G	■	M	E	L	S
T	E	A	M	O	■	N	A	T	O	■	A	L	E	E
O	N	R	A	M	P	■	C	R	O	W	N	■	■	
■	■	T	A	R	O	■	E	D	A	■	E	A	U	
H	I	G	H	R	E	N	T	■	G	R	I	L	L	S
E	R	I	E	■	F	E	R	M	A	T	H	Y	P	E
M	O	R	T	■	A	T	E	A	M	■	O	S	H	A
I	N	L	A	■	B	O	Y	L	E	■	P	E	A	S

Solution to *Do the Math*

```
B E L E M ■ A H A B ■ A C T I ■ ■ O R S O
A R E N A ■ R O L E ■ M O A N ■ K R A U T
U M A T H U R M A N ■ S U R E ■ R E M I T
M A D R A S ■ E R I K ■ S T A L E M A T E
■ E L E N A ■ T I K I ■ R E M U T E R ■
A T M ■ I D O L ■ O R I N B ■ S E T H ■
T R I M A T H O S ■ K A P A A ■ A L A S
L A N A ■ O O N A ■ H A Z M A T H E R O
E C O L E ■ W E L D S ■ T A M P A ■ T I N
■ E R I N ■ E R A T ■ A A A H E E L S
■ B I G M A M A T H O R N T O N ■
R E F U G E E S ■ M A R C ■ M O A B ■
E P O ■ M A C H E ■ N U T S O ■ A U D I O
F E R M A T H Y P E ■ E N O S ■ G H O R
S E M I ■ E D I R T ■ T O M A T H O M E
■ A N A T ■ E D I E S ■ W P B A ■ C E L
O N T A R I O ■ U C L A ■ S H E B A ■
G E H R I N G E R ■ E T A T ■ N I C K E L
T R E E S ■ L O A N ■ F R O M A T H E N S
H O L T E ■ E R L E ■ O G R E ■ H E N N A
E S P S ■ R I S E ■ R O M A ■ A S S E T
```

7. Many in the mathematics community have been working hard over the past few decades to increase the profile of mathematics in popular culture. So I was admittedly somewhat discouraged by the overall tone of these responses.

Works Consulted

Fisher, Dave. "Crossword Submission Guidelines — The New York Times." *About.com: Puzzles.* About.com, n.d. Web. 7 June 2010.

Kanigel, Robert. *The Man Who Knew Infinity: A Life of the Genius Ramanujan.* New York: Washington Square, 1991.

The New York Times Premium Crosswords Crossword Puzzle Archive. New York Times, n.d. Web. 8 June 2010.

Paulos, John Allen. *A Mathematician Plays the Stock Market.* New York: Basic, 2003.

_____. *A Mathematician Reads the Newspaper.* New York: Anchor, 1996.

Stand and Deliver. Dir. Ramón Menéndez. Perf. Edward James Olmos, Lou Diamond Phillips. Warner Bros., 1988. Film.

Wordplay. Dir. Patrick Creadon. IFC Films, 2006. Film.

XKCD: A Web of Popular Culture

KAREN BURNHAM

Mathematics is perhaps the most pure and abstract branch of the natural sciences (see Figure 1). Computer science takes the stuff of raw mathematics and makes (mostly) useful things: programs, spreadsheets, algorithms, and Second Life. Programming computers can give one godlike powers: making something out of nothing, coming up with something completely new, having a whole microcosm that obeys your every command. However, when you wake up out of your Mountain Dew–fueled coding trance (we'll be talking about geek stereotypes later), you'll find out that your office, apartment, friends and girlfriend are not microcosms over which you have godlike powers. This may make you very sad. To cheer yourself up, you'll probably make sure to read the webcomic *xkcd*[1] every Monday, Wednesday, and Friday, on which days it has been reliably posting new content for over four years and seven hundred strips — each one complete with "mouseover text," an extra little tidbit or punch line you see when you hover your mouse over the strip. You'll be amused by the dissonance between the world we have and the world geeks may want to have (see Figure 2). And sometimes you'll be enlightened by the way that even in the real world, people can still make something out of nothing (about which more later).

Figure 1. *XKCD*#435 "Purity." Mouseover text: "On the other hand, physicists like to say physics is to math like sex is to masturbation." (Reproduced with permission from xkcd.com.)

As you can see, *xkcd* goes in for minimalist art — read "stick figures." It didn't start out like that. When creator Randall Munroe first posted *xkcd* content in September of 2005, it consisted of art from his sketch books. It was rather more elaborate and less joke-oriented. The art included colored and shaded sketches of landscapes, sailing ships, red spiders navigating a cube world, people, and animals. Some pieces seem like idle doodles, others the epic products of interminably pointless meetings (an *@Google Talks* interview with Munroe informs us that he worked as a NASA contractor before making a full-time living from the comic strip). There were also a few pieces formatted like "normal" comic strips that included stick figures and dialog. By the fiftieth entry, the strip more or less settled into its current format, focusing on the stick figures.

Figure 2. *XKCD*#149 "Sandwich." Mouseover text: "Proper User Policy apparently means Simon Says.?" (Reproduced with permission from xkcd.com.)

Let me make clear that "xkcd" is not an acronym. According to the "About" page of Munroe's *xkcd* website: "It's not actually an acronym. It's just a word with no phonetic pronunciation — a treasured and carefully-guarded point in the space of four-character strings."

The strip is published every Monday, Wednesday, and Friday for free on the Internet. Munroe and a few others make a living by selling merchandise, and there's also been one physical collection of strips into a book so far. Munroe is also sometimes invited to speaking engagements at places like MIT and Google. Each individual strip has artwork, a title, and alternate text that appears when the reader hovers their mouse over the comic strip image. The mouseover text is never critical to the meaning of the strip, but it often includes an extra punch line or commentary. It's there as a (not very secret) Easter egg for the fans (and the internet-savvy) who know where to look, and is a testament to the level of tech-knowledge that the strip expects of its readers. Along with just reading, fans can discuss the strip (and other associated topics such as math, science, history, and politics) on the *xkcd* forum, talk with other fans on the *xkcd* IRC (Internet Relay Chat) channel, and read Munroe's blog. There's also a communally-created *xkcd* wiki online.

Although there are no "main" characters and almost none of the characters have names, there are two recurring characters, distinguished by their sartorial choices. The man in the black hat, or "hat guy," is a normal stick figure except for the addition of a black hat.[3] See Figure 3 for a typical appearance. He first appears in Strip #12, puncturing the joy of another character who claims to be a Poisson distribution[4] (the mouseover text reads, "Poisson distributions have no value over negative numbers"). He is a sociopath who has no problem

wreaking violence on the world around him — and sometimes the reader cheers for him. He's the one to take an EMP cannon to the computer of an Internet guy who heckles women online (Strip #322). On the other hand, he also ships live bobcats to people who bid for innocuous eBay items (Strip #325). He is not to be trusted. Of him, Munroe explains:

> Well, I decided early on that I sometimes wanted to be an asshole and sometimes I wanted to be sappy and romantic. And unlike the nerdiness and the romance, the asshole seemed harder to reconcile in one character and make that believable. I started putting the man in the hat, when I just wanted to say the most absurd thing. A lot of the time, I'm in a real life situation and I think what's the most hurtful thing, what's the worst way this can go, and have someone do that gleefully. That's just a recipe for comedy right there. Then I have the guy in the hat so I'd put all that on him and then say "but that's not the main guy, he's much nicer than that" [Munroe, Interview].

The other be-hatted character is the guy in a beret. His first appearance can be seen in Figure 4. He is a joyful but not terribly bright character who loves bakeries, adventures, and toys, and never lets the sarcasm of the other characters get him down.

Figure 3. *XKCD*#163 "Donald Knuth." Mouseover text: "His books were kinda intimidating; rappelling down through his skylight seemed like the best option." (Reproduced with permission from xkcd.com.)

Stick-figure art aside, *xkcd* sometimes revels in more complicated scenarios. One of the marvels of its popularity is that it contains so much hard-hitting math and science content. Many of its strips consist of pure graphs, often making math jokes. This has been core to *xkcd* since Strip #5, which shows a numeral 70 being blown into its prime number components (7, 5, and 2) by a mail bomb. Another early iconic strip is shown in Figure 5. In the mouseover text, the narrator challenges the reader to guess which graph this is. In fact, it's the graph showing the amazingly close agreement between the predicted and measured values for the energy density of the cosmic background radiation.

Above: Figure 4. *XKCD*#167 "Nihilism." Mouseover text: "Why can't you have normal existential angst like all the other boys?" *Below:* Figure 5. *XKCD*#54 "Science." Mouseover text: "Bonus points if you can identify the science in question." (Both figures reproduced with permission from xkcd.com.)

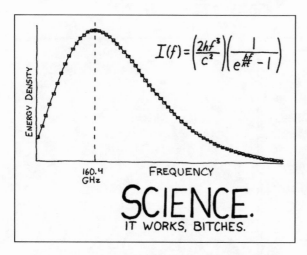

Other epic strips (several of which have since been turned into posters) include one that illustrates the relative height of everything from us (approximately 1–2 meters) to the top of the universe (46 Billion Light Years) on a logarithmic scale (Strip #482). Another takes the same approach for depth (Strip #485), going from human scale to the size of a proton (ending with a doodle labeled "Brian Greene knitting furiously").[5] Yet another illustrates the relative depth of all the gravitational wells in the solar system (including a side doodle labeled "Your Mom," Strip #685).

That's not to say that it's all math and science. There's also history and language, as well as pop culture references. A recurring joke is the hat man's fear of velociraptor attacks à la the *Jurassic Park* movies. *XKCD* revels in puns, as in Strip #282, in which one character, riffing on the concept of biofuels, states: "Mussolini made the trains run on thyme" (to which the other stick figure replies, "…We are no longer friends"). A tribute to Munroe's eclectic interests can be seen on his blog, as when he translates the complete text of George Washington's Farewell address into contemporary informal speech (e.g., "Elections are coming up, and it's time to figure out who we wanna give the keys to. I figure it might clear things up if I take a sec to explain why I'm not running"). This counters a geek stereotype (that is, that geeks are people who only care about what happens in computers) but lines up well with the modern American geek experience of very intelligent people with many and varied wide-ranging interests.

Of course, Munroe's joy in mathematics and puzzles appears in concentrated form in the *xkcd* book, *xkcd: volume 0*. Perhaps all that needs to be said is that the pages are numbered in skew binary.[6] Likewise, the margin notes are full of mathematical and cryptographic

puzzles, which have so far provided fans with months of entertainment trying to decode them all. They include altering the images and text of some of the comic strips to point to clues, having keys embedded in cryptic poem-riddles, and embedding codes in red-and-white pixel images that themselves encode binary information. To be fair, the margins also include some additional stick-figure doodles and plain text comments, but they're rather outweighed by the math puzzles.

Despite this hard-core math and science wonkery, the subject that comes up more than any other in the comic strip is relationships. This counters the geek stereotype of loners living in their parents' basements and instead hits on the reality of geeks somehow finding each other and pairing off. In *xkcd*, the slant given to portrayals of relationships has changed over time. In the early days of the strip, there were more strips dealing with breakups and pain, and how geek couples can harrass each other using sysadmin powers. There have always been strips showing how staying immature (with "yo momma" and "your sister" jokes and others) can really impede forming healthy relationships. Over time there's been a bit less of that, and in more recent strips there's even been a few dealing with the joys of geek parenthood. As discussed below, it's dangerous to entirely conflate Randall Munroe and the narrator of the comic strip — certainly there's no public indication that Munroe has children. However, the comic does seem to track the growth curve of the core demographic of the strip: people who came of age in the mid– to late 1990s, and thus are most comfortable with pop culture references from *Star Wars* (1977) onward (the strips contain many references to *Firefly*, *Ender's Game*, Nintendo games, etc). Presumably these readers finished college before Munroe started the strip, have been navigating early adulthood since, and are starting to settle down into families about now. True for all readers? Of course not. But probably true for a good number of them.

XKCD has a romantic streak a mile wide, especially when it comes to geek guys and geek girls finding each other. There's romance in the Fibonacci sequence, in GPS coordinate algorithms, and in angular momentum when both partners understand how cool they are. Even the mostly-evil hat guy finds his ideal mate in an unusual sequence of linked strips: the couple now occasionally shows up jointly disposing of bodies. When the matches found each other (Strip #433), the woman said, "There's still time to leave and find a non-crazy girl." He replied: "Not even *slightly* interested."

Now, this isn't to say that relationships aren't darn complicated. Possibly the most iconic *xkcd* strip is #55 (Figure 6). You can't take the cosine of love, or its square root, or a derivative. Occasionally the characters try to apply mathematical logic to human relationships, but it usually goes tragically, comically wrong. It is a universal truth, very painful for many geeks to learn, that just because you're smart doesn't mean you're mature. If you're still making "yo momma" jokes when your girlfriend is trying to talk to you seriously, things might not work out so well. And if you try to take the drama out of sex by simply changing the social rules by fiat ... well, a chart shows "Drama vs. Time" increasing exponentially after the rule change (Strip #592). Because, really, people are complicated. Even geeks are more complicated than people think. There's much more to geekdom than Trekkies and Unix, and *xkcd* explores that complex space.

XKCD taps into the insecurity at the heart of many people, geeks and otherwise. In Strip #616, one of the characters is leasing a house. He says: "I'm concerned that we're sitting here like I'm a responsible adult. I'm pretty sure I stopped growing up in my teens

and have been faking it ever since. For god's sake, you're entrusting me with a *building*. I still make Lego buildings sometimes." What does it mean that the demographic that reads *xkcd* (primarily geeky members of Gen Y) has graduated from college, gotten jobs, gotten married and had children now? Well, it means that we make jokes about conducting genetic experiments on our offspring and remember that all females are sort of Von Neumann machines: "It's neat how you contain a factory for making more of you," says a man kneeling curiously in front of a woman in Strip #387.

$$\sqrt{\heartsuit} = ?\qquad \cos\heartsuit = ?$$

$$\frac{d}{dt}\heartsuit = ?\qquad \begin{bmatrix}1 & 0\\ 0 & 1\end{bmatrix}\heartsuit = ?$$

$$\mathcal{L}\{\heartsuit_t\} = \int_{0^-}^{\infty} e^{-st}\heartsuit_t\, dt = ?$$

MY NORMAL APPROACH IS USELESS HERE.

Figure 6. *XKCD*#55 "Useless." Mouseover text: "Even the identity matrix doesn't work normally."

And really, that's the key to *xkcd*'s romance: it encourages people to face the adult world without giving up the loves and dreams of their childhood. People don't have to abandon playpen balls, or cryptanalysis, or a love of science just because they grow up. If they have the right friends, partners, and attitudes, they can make their life as fun as they want to and still be functional. You don't have to abandon science for romance or vice versa. After all, as it says on the top of the website, *xkcd* is "A webcomic of romance, sarcasm, math and language," and it can be all that at once.

The default world of *xkcd* is undeniably male. However, women, specifically geeky women, show up in at least half of the strips so far (and not just as love interests, although that's frequently the case). Munroe has certainly been able to distill some of the challenges geek girls face. Strip #385, shown in Figure 7, is often referenced on the Internet. Similarly, in Strip #322, the hat guy lectures to an IRC user:

When someone with a feminine username joins your community, and you say "OMG a woman on the Internet" and "jokingly" ask for naked pics, you are being an asshole. You are not being ironic. You are not cracking everybody up. You are the number one reason women are so rare on the Internet. At least, the parts of it *you* frequent.

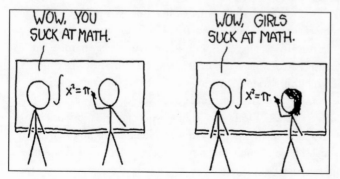

Figure 7. *XKCD*#385 "How It Works." Mouseover text: "It's pi plus C, of course." (Both figures reproduced with permission from xkcd.com.)

He then introduces a woman with an EMP cannon to melt any computer the guy uses to try to go online, physically banning him from the Internet.

XKCD is a creature of the

Internet, and it's no surprise that much of its humor comes from Internet situations. Characters have gone to Rick Astley's house to physically "rickroll" him by hacking his cable feed (Strip #351). Strip #355 shows a couple in bed, and the guy asks, "So, is this it? Are we a couple now?" The girl replies, "I don't know. I like this. I just … I don't know." After a beat, the guy asks, "Well, will you be my 'It's Complicated' on Facebook?" There is also at least one example of *xkcd* causing effects in the outside world: Strip #481 suggested that if YouTube commenters had to listen to their comments before posting them, they'd finally realize how moronic they sound. A few months after that strip debuted, YouTube rolled out an "Audio Preview" feature on their comment sections.

Munroe has a B.S. in physics from Christopher Newport University and worked for several years as a NASA contractor at Langley Research Center. As he puts it in the introduction to the first *xkcd* book, "In late 2006, my contract ended and wasn't renewed. (My lack of enthusiasm for working probably contributed to management's lack of enthusiasm for paying me)" (ii). He had also already reached the point where *xkcd* could provide a modest living. Other than that, he doesn't put much about his personal life or information out in public. He has a blog, but only updates it at most a couple of times a month. From it, one can discern that he likes kite photography, cryptography, and the interesting spontaneous creations that spring from the minds and workshops of *xkcd* readers. This makes the narrative "I" that shows up in *xkcd* a bit problematic. If the narrator in the strip, either through dialogue, fourth wall statements to the reader, or mouseover text also indicates a love of kite photography or cryptography, is it fair to conflate the narrator with Munroe? When the strip says "My hobby is…" (a running theme of several strips), how much is that Munroe speaking? Strip #37 reads, "My hobby: Whenever anyone calls something an [adjective]-ass [noun], I mentally move the hyphen one word to the right." Then one character says, "Man, that's a sweet ass-car." OK, that's amusing and you could see someone making that mental adjustment. However, in Strip #53 we get: "My hobby: When the police bust drug hideouts, I sneak in and hide. Then I jump out and startle them into shooting me so they lose points." So, maybe Munroe cannot completely be conflated with the strip's "I."

Confusion increases with the conflations between *xkcd* and real life. One example is Strip #150 (Figure 8), where a woman fills her apartment with playpen balls: "Because we're grown-ups now, and it's our turn to decide what that means." Afterwards, a fan decided to

Figure 8. *XKCD* #150 "Grownups." Mouseover text: "I've looked into this, and I can't figure out a way to do it cheaply. And I guess it wouldn't be sanitary." (Reproduced with permission from xkcd.com.)

do this in his apartment, and wrote to Munroe about it. Then Munroe and his roommates decided to do the same thing on a smaller scale instead of buying a new couch set. The results are photographically documented on Munroe's blog, *xkcd: The blag of the webcomic.*

So Munroe resembles the narrator of *xkcd*, but isn't exactly coincident with him. In this, he's probably like every author that ever lived. However, the above-mentioned leakage from the borders of *xkcd* into the real world makes the question feel more relevant. Those fuzzy boundaries constitute what may be the central theme of the strip. As mentioned in the introduction, computer programmers have complete control and godlike powers over their digital domains. They sometimes may feel comparatively helpless when faced with the physical realm and its more arbitrary physical and social rules. *XKCD*, on the other hand, has shown all sorts of things and events being pulled out of thin air into the real world.

The most famous example comes from Strip #240, "Dream Girl" (Figure 9). A man hears GPS coordinates and a date in a dream. When the strip first appeared online, the date mentioned was six months in the future. In the strip, the man goes to the coordinates and finds nothing there. In the real world, the coordinates are for a small park in Cambridge, Massachusetts. Munroe maintained strict silence when questioned about what would really be there on that day. So when the day came, hundreds of *xkcd* fans showed up to throw themselves a day-long celebration. Munroe was also there, talking with fans, signing things, and giving fans a chance to draw new concluding panels for the strip — obviously it had to be changed, since something really did happen, just by someone wanting it to.

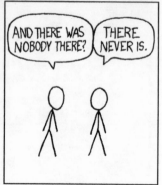

Figure 9. *XKCD*#240 "Dream Girl." **Mouseover text: "No matter how elaborately you fool yourself." (Reproduced with permission from xkcd.com.)**

Likewise, Strip #249 shows a guy gluing chess pieces to a chess board. He wants to get his picture taken on a roller coaster in such a way that it looks like he's thoughtfully working on a chess problem during the big drop action shot. After so many fans sent in similar staged shots, Munroe set up on his website a gallery—"Chesscoaster"—for them. Chess, checkers, Go, and even Jenga have now been featured on amusement park rides across the world.

Even when it comes to producing a book, the project spills over to the wider world. A portion of the proceeds from the sale of *xkcd: volume 0* (a collection of *xkcd* strips), combined with some money raised at fund-raising events, went to the charity Room to Read to build a school in Laos (copyright page of *xkcd: volume 0*). When the fundraising was complete, Munroe posted to his blog (Munroe, "School"):

> Just a note: thank you to everyone who made it to the events. We raised enough money to build a school! It'll be in the Salavan Province, on Road No. 13 South. We're not going to torment the kids' ability to learn phonetics by calling it The XKCD School, but we will be writing a dedication which will go on a plaque. You guys made this happen—does anyone have any suggestions for what it should say?

After much deliberation, it was decided that the plaque will read:

> "Do not train children to learning by force and harshness, but direct them to it by what amuses their minds, so that you may be better able to discover with accuracy the peculiar bent of the genius of each."—Plato.
>
> This school is a gift from the readers of XKCD, an internet comic strip. The world is full of exciting things to discover. We hope you find some of them [Munroe, "Books"].

When it comes to making imaginary things happen in the real world, Munroe has been trying to use his powers for good. In the introduction to the *xkcd* book, he says: "(Friends suggested I try writing a comic entitled Everyone Mails Randall Twenty Bucks, but I resisted the urge)" (ii–iii). He also says:

> My fans have been acting out my comics and I was making them weird and the fans were still acting them out. So I was just like, I'm going to make one that is impossible for you to make happen and then that can be the standing challenge. If someone can do that then I can start worrying about this again. And so I had Janeane Garofalo jumping a motorcycle off of a crashing space station towards a volcanic island with dinosaurs while she is armed with a tranquilizer gun. I figured that would be good [Munroe, Interview].

Again countering geek stereotypes, *xkcd* encourages people to leave their computers and head out into the real world. Munroe introduced geohashing to his fan base, starting in Strip #426. Geohashing involves using an algorithm to randomly generate a set of GPS coordinates for a given day. A typical algorithm is limited to a certain geographical region and uses the day's stock market results. On that day, anyone can find out the day's coordinates and travel there by any means necessary, including driving, boating, biking, and hiking. If a few people decide to go out on the same day, it turns into a fun way to not only see a new place that you'd have no reason to visit otherwise, but also meet like-minded geeks. The wiki page inspired by *xkcd* calls it "A Spontaneous Adventure Generator." The site suggests Saturday at 4 pm as the ideal meet-up time. In fact, this idea of getting out and away from the computer has been present from the early days of the strip. In Strip #77, a guy and the man in the hat decide to leave the Internet and walk around the world. They walk through beautiful landscapes (drawn mostly in grayscale pencil shading), stopping to revel in the

natural beauty. In the end, the guy remarks to the hat guy: "And yet, all I can think is, 'This will make a great Livejournal entry.'" The mouseover text adds: "I used to do this all time."

Through *xkcd*, Munroe has been urging geeks to grow into their lives on their own terms. Very few of the strips are set in the traditional geek domains of school and work, and instead present the characters in their own lives on their own time, following their own bliss. Although stereotypically math and science geeks lead inward-focused lives, in realms of concrete laws and controlled mutability, *xkcd* shows geeks turning outward, at least a little bit, and using their intellect and creativity to make their worlds more interesting places in which to live.

Notes

1. On the capitalization of *xkcd*:

Well, the first thing is, it started off as a screename and an irc nick, where I'm very used to seeing it all lowercase. There are a lot of trendy things, from e.e. cummings, the poet, up through businesses that take that sort of thing. It is a big problem for starting sentences. If you want to start a sentence with "xkcd" it seems very wrong not to capitalize it. But I really grew to dislike capital X, lower case "kcd" because that made it seem like a word or a name more than a string of letters. The whole purpose is that it is a really abstract string. Capitalizing it is sort of saying something about it. If you're used to treating abstract strings in programming, changing case is not a trivial thing. It's changing what the string is. So when it is in its canonical form, that's the real xkcd, the other forms look wrong to me. So but on the other hand, I try not to make things too hard on people so I say "ok, all lower case is preferred if you want to capitalize, I prefer all caps. Mixed case is my third and least favorite choice." But to some extent that's just style. Not for any particularly important reason [Munroe, Interview].

2. "Sudo" is a Unix command. An abbreviation of "superuser do," it allows a user to take on the privileges of another user, usually the root or admin, and command the computer to do things that it usually wouldn't do for the original user.

3. According to Monroe in his interview with Joshua Zelinsky, the "hat guy" was inspired by the character of Aram in the Aaron Farber webcomic, *Men in Hats*.

4. A Poisson distribution is a statistical distribution. Unlike Gaussian (normal) distributions (whose graphs are the commonly-known "bell curves"), a Poisson distribution exists only for nonnegative numbers. This allows black-hat guy to invalidate Poisson guy by being "negative."

5. Brian Greene is a science popularizer who has helped to bring knowledge of string theory into the public consciousness. However, string theory is currently a theoretical model that has not yet been validated by experiment, and several *xkcd* strips have expressed skepticism about its widespread popularity.

6. Skew binary is a form of numbering that uses the digits 0, 1 and 2. This differs from (non-skew) binary, which uses only 0 and 1. Also, in binary, the weight of the kth digit (reading from right to left) in a number's representation is 2^k: thus, from right to left, the digits' weights are 1, 2, 4, 8, etc. For example, the string 101 in binary represents the number $1(4) + 0(2) + 1(1)$, or 5. In skew binary, the weight of the kth digit (again reading from right to left) in a number's representation is $2^{k+1} - 1$: thus, from right to left, the digits' weights are 1, 3, 7, 15, 31, etc. Therefore, the string 101 in skew binary instead represents the number $1(7) + 0(3) + 1(1)$, or 8.

Works Consulted

"Authors@Google: Randall Munroe." Online video clip. *YouTube*. 11 Dec 2007. Web. 28 Feb. 2010.

"Geohashing." *XKCD Wiki*. MediaWiki, n.d. 28 Aug. 2010. Web. 1 Sept. 2010.

Munroe, Randall. "About." *XKCD*. Randall Munroe, n.d. Web. 28 Feb. 2010.

_____. "Books and Laptops and Bugs." *XKCD: The Blag of the Webcomic*. Randall Munroe, 14 Dec. 2009. Web. 28 Feb. 2010.

_____. "Chesscoaster." *XKCD*. Randall Munroe, n.d. Web. 28 Feb. 2010.

_____. "Growing Up." *XKCD: The Blag of the Webcomic*. Randall Munroe, 19 Nov. 2007. Web. 28 Feb. 2010.

_____. Interview by Joshua Zelinsky. "Randall Munroe, Writer of *XCKD*, Talks about the Comic, Politics and the Internet." *Wikinews.* Wikimedia Foundation, 4 Mar. 2008. Web. 28 Feb. 2010.

_____. "School." *XKCD: The Blag of the Webcomic.* Randall Munroe, 11 Oct. 2009. Web. 28 Feb. 2010.

_____. "Washington's Farewell Address Translated into Everyday Speech." *XKCD: The Blag of the Webcomic.* Randall Munroe, 29 Jan. 2007. Web. 28 Feb. 2010.

_____. *xkcd: volume 0.* San Francisco: Bread Pig, 2009.

"Randall Munroe." *Wikipedia.* Wikimedia Foundation, 21 Aug. 2010. Web. 1 Sept. 2010.

Counting with the Sharks
Math-Savvy Gamblers in Popular Culture
Matthew Lane

Introduction

The portrayal of people who study mathematics in television and film typically falls into one of a few categories. There is the savant whose mathematical ability is explained away as a natural gift (*Rain Man, Cube*), and the misanthropic genius whose obsessions drive him (and in rare cases, her) to the brink of insanity (*A Beautiful Mind, Proof*). Also, who could forget the brilliant young mathematician who races to complete his Ph.D. before finishing puberty (*NUMB3RS*, π)?[1] While there are certainly real world examples of people who fall into these categories, in general things are not so simple: as with any other group of people, the personality types of those who study mathematics fall along a continuous spectrum. It is therefore unfortunate that so many negative stereotypes about mathematicians persist in popular films and television. Contrary to popular opinion, not all mathematicians are borderline insane, nor are they all chronically unable to form healthy and long-lasting relationships. Mathematicians go to parties, get married, and tell jokes just like everyone else. Most of them shower regularly, too.

Of course, not all the stereotypes are negative, but even the positive ones often miss the mark. For example, being a mathematician does not mean that you are really good at multiplying large numbers together in your head — in fact, many mathematicians stay away from computations of any kind. In spite of this, whenever characters in film or on television are supposed to be good at math, there are invariably scenes in which they do some extremely complicated calculations in their heads.

Recently, however, a new breed of math whiz has emerged on both the large and small screen, which differs from the traditional breed in several ways. I will refer to this archetype as the *math-savvy gambler*. Math-savvy gamblers are much more social creatures, due in no small part to the substantial earnings gained from their deep understanding of games of chance. Like the traditional portrayal of mathematicians, they often have obsessive personalities, but for the math-savvy gambler, the obsession is as much with gambling as it is with mathematics. Moreover, as a consequence of their success, they appear to clean themselves up better than the classical mathematicians — they wear the finest clothes, and their high-roller status allows them to attend parties with rock stars and supermodels.

On the face of it, this modern portrayal of the mathematically inclined seems to have its advantages over the more traditional one. While a stereotype is still a stereotype, it's much more flattering to be stereotyped as someone who is charismatic and wealthy as opposed to socially awkward and oblivious to much of the outside world. If we dig a little deeper, though, we are forced to ask: to what extent is the math-savvy gambler an improvement over the more traditional stereotype? For example, while the math-savvy gambler may be more outgoing, in general, than *A Beautiful Mind*'s John Nash or π's Max Cohen, this does not mean that he is immune to eccentric behavior. By analyzing such gamblers in film (*Rain Man, 21*, and *The Hangover*) and television (*NUMB3RS* and *2 Months. 2 Million*), we will see that in the end, this archetype has its own share of flaws. In fact, often the math-savvy gambler represents some of the same stereotypes found in other portrayals of mathematicians in popular culture, only modified slightly or viewed from a different perspective. Moreover, when this image begins to deviate from the more classical image, the result is sometimes an even less flattering characterization. In the quest for normalcy in the portrayal of people who study mathematics, the math-savvy gambler simply comes up short.

The Math-Savvy Gambler in Film: Rain Man

By far, the preferred game for the math-savvy gambler is blackjack. The most commonly cited reason is that with the right strategy, blackjack is the only game that will give the player an advantage over the house. In other words, it is the only game where a skilled player has a significant chance of netting a profit when playing against the house over an extended period of time. How much of an advantage a player has depends on the strategy employed, but it is important to strike a balance between advantage and ease of use: while a more complicated system may yield better theoretical returns, if that system is too complicated for the player to use without making mistakes, it may be better to take a simpler but more conservative approach.

For the interested reader, we here provide a brief introduction to some mathematical gambling strategy. A *card-counting strategy* or *card-counting technique* is any strategy whereby a player gains an advantage by somehow keeping track of information garnered from the preceding play of cards. Card-counting techniques first became widely popular with the publication of the book *Beat the Dealer* in 1962.[2] In this book, mathematician and author Edward O. Thorp outlined several strategies one could use to shift the advantage in blackjack from the dealer to the player. Thorp's book was the first to stress techniques of card counting in addition to an underlying strategy, called a *basic strategy*, that tells the player when to stand, when to draw, when to double down, and so on. The book was a tremendous success: it made a brief appearance on the *New York Times* best-seller list, and Thorp was profiled in *Life* magazine (Humble and Cooper 5).

For purposes of illustration, let us briefly mention one such strategy: the *simple point-count system*. This system is inspired by the observation that when there are many high cards (tens, face cards, and aces) in the deck, the player's advantage is larger than the house's. Conversely, when the deck contains many low cards (with a value of two through six), the player's advantage is significantly less than that of the house. (This is a consequence of the rules of blackjack; for details, see Thorp 44–55.) As a player, you are free to take a card at

any time, provided the sum of the values of the cards in your hand is less than 21. You draw cards until you are satisfied with your score, or until that score is greater than 21, in which case you lose (this is called *busting*). The dealer, on the other hand, is more restricted, because she must *always* draw a card if her total is under 17, and *cannot* draw a card if her total is over 16. This means that when the deck is poor in low cards, there is a greater chance for the dealer to bust and for you to get dealt a pair of cards with a very high value. The converse is true when the deck is poor in high cards.

The simple point-count system exploits this fact by assigning a value of –1 to each high-valued card that appears and a value of +1 to each low-valued card that appears as cards are dealt from the deck. At any given time during the game, the sum of these numbers, called *the count*, indicates the nature of the remaining cards in the deck. For example, if there are only a few cards left in the deck and you know the count is very high, this means there are very few cards of low value remaining in the deck. This, in turn, means that the player has a large advantage, and so should increase her bet because of this advantage. While the simple point-count system has some flaws,[3] it's straightforward to understand and gives some of the flavor of card-counting techniques in general. Also, perhaps because it is so easy to explain, the simple point-count system is often the system on display when card-counting techniques are discussed in film and television (*21* and *NUMB3RS* both give explanations of this technique).

Due to the success of Thorp's book, and of the many other books on the subject that sprang up afterwards, it is safe to say that card counting had seeped into American cultural consciousness by the time the film *Rain Man* was released in 1988. The film's plot revolves around Charlie Babbitt (Tom Cruise) discovering a brother named Raymond (Dustin Hoffman) when their father dies and leaves Raymond a three million dollar inheritance. Charlie learns that the inheritance is to pay for Raymond's fees at a mental institution, where he has lived for most of his life, but feeling entitled to his share, Charlie kidnaps Raymond and the two set off for California. Dustin Hoffman's portrayal of autistic savant Raymond Babbitt not only won him an Oscar the following year, but has also become a well-known pop culture reference, parodied by the likes of the Jim Henson Company and *The Simpsons*.[4] More importantly for our purposes, Hoffman's performance gives us our first example of the math-savvy gambler.

From the outset, Charlie is portrayed as materialistic and driven by a singular desire: to accumulate wealth. This desire is what motivates him to sell luxury cars, and it is certainly what motivates him to kidnap his autistic brother when he feels like he's been shortchanged by their father's inheritance. Therefore, when Charlie discovers that Raymond has an eidetic memory, it is no surprise that he thinks of card counting as a way to turn Raymond's illness into something profitable. A detour to Las Vegas becomes an opportunity to test Raymond's potential.

The card counting on display in this film does not follow any strategy you'll find in a book on blackjack. This is because Raymond doesn't employ any strategy. Instead, he simply keeps a mental count of every card that has been played, so that he knows what cards are remaining. This brute-force method is not discussed in books on blackjack strategy for the simple reason that such a method would be impossible to implement effectively for most people. The average person would have a hard enough time trying to keep track of all the cards in one deck, but many casinos use several decks (called a *shoe*) simultaneously in an

effort to thwart card counters. In the film, however, Raymond is able to accurately keep a running count of the cards even though the shoe is quite large. The one benefit to this method lies in its novelty: the casino has no idea how Raymond and Charlie are winning, but security insists that "there's no one in the world that can count into a six deck shoe."

While Raymond keeps track of the count, Charlie makes the money. Before entering Las Vegas, Charlie teaches Raymond a very simple rule so that they can communicate at the table: if the cards in the shoe are bad, Raymond is to bet one chip, and if they are good (meaning many tens and face cards) he is to bet two chips. This small distinction lets Charlie know when the deck is skewed in favor of the player, and he uses this advantage to win big. By the end of the night, Charlie's corner of the table is swarming with casino chips totaling $90,000.

It's a fun scene to watch, but the portrayal of the math-savvy gambler does no favors to the mathematically inclined. As mentioned before, aside from a great deal of counting, Raymond isn't actually doing any mathematics. While it's certainly helpful if you can keep track of 312 cards as they're being played, most people, including most mathematicians, would find such a task impossible. That is why mathematicians have developed strategies to give the player an advantage over the house that do not require special abilities. Card counting strategies are not easy to master, and require practice like any other technique. In *Rain Man*, however, card counting is presented as an unattainable goal, one achievable only by true savants.

This speaks to a popular misconception featured in many films with a mathematical bent, including *Rain Man*: the idea that mathematical ability is a fluke of genetics, rather than something that evolves through hard work and discipline. There are individuals who seem to have a natural proclivity for mathematics, and are able to grasp concepts extremely quickly or perform calculations with ease. For the majority of working mathematicians, however, even those with exceptional gifts, mathematics requires hard work. It is challenging and sometimes frustrating, but it is only by overcoming its challenges that beautiful results emerge. Portraying people who are good at mathematics as being gifted rather than driven only helps perpetuate the stereotype that being good at mathematics is out of one's control.

In addition to being pre-determined, one's mathematical ability is usually portrayed as having a high social cost. More specifically, people who are good at mathematics in film tend not to be socially well-adjusted. Sometimes this phenomenon manifests itself in characters that are painfully awkward (see Max Cohen in π or John Nash in *A Beautiful Mind*), while other times characters may initially seem fine, although it's soon revealed that they have significant trouble functioning within the larger society (see Will Hunting in *Good Will Hunting* or John Giving in *Revolutionary Road*). In the case of *Rain Man*, due to his autism Raymond lacks the ability to handle most everyday tasks. While he is socially awkward, here that awkwardness is one of the core features of his disability, rather than a byproduct of mathematical acuity. Unfortunately, in later incarnations of the math-savvy gambler, this will not always be the case.

It's important to note that the character of Raymond Babbitt is based loosely on real-life savant Kim Peek, a savant known more for his abilities with memory recall than for his mathematical talent. Therefore, it may seem a bit unfair to critique Raymond Babbitt as a math-savvy gambler, especially since Babbitt's card counting technique doesn't really use

mathematics. Regardless of its original intent, however, a consequence of *Rain Man*'s success is its influence in the card counting movies that followed. Although more recent portrayals of the math-savvy gambler differ significantly from that of Raymond Babbitt, the misconceptions present in *Rain Man* have a ripple effect in later films. For this reason it's important to discuss this prototype of the math-savvy gambler, even though it turns out that he's not so math-savvy after all.

The Math-Savvy Gambler in Film: 21

Throughout the 1960s and 1970s, blackjack experienced spikes in popularity, due in large part to the publication of card-counting books such as Thorp's. But as blackjack popularity grew, so too did the level of sophistication required to make it profitable. Fearful that a better understanding of blackjack would lead to a hemorrhage of cash into players' hands, casinos began to alter the rules of the game to tip the scales back into their favor. At the same time, casinos were forced to strike a balance between modifying the rules of the game to chip away at the player's advantage, and changing the rules so much that players became indignant and stopped playing.

Luckily for the casinos, they soon found that even with the increased interest in blackjack strategy, their profits at the tables only increased. In the words of Humble and Cooper in *The World's Greatest Blackjack Book*, "Most players who had purchased [Thorp's] book could not understand the difficult Ten Count it explained, and those few who could, did not take the time to master it. The Casinos saw their Blackjack profits skyrocketing" (5–6). Thorp's readers' inability to put his methods into practice, combined with casino measures such as the introduction of the card shoe, helped to keep blackjack a lucrative game for casinos. Even so, the casinos were unprepared for a new loophole exploited famously by Ken Uston in the mid–1970s: team play.

The basic principle behind playing blackjack in teams is quite simple. First, the team is divided into two groups. The *spotters* sit at the tables and make the minimum bet every hand. Their purpose is not to make money, but to keep track of the count (using some particular card counting method) so that they know when the deck is favorable for a player. When the deck is favorable, the spotters call the *big players* to make large wagers. The big players are the ones who bring in the money for the team. When the deck becomes less favorable, another signal is given by the spotters, and the big players move on to a different table.

The point here is that it is very difficult for a single card-counting person to alter his/her bets based on fluctuations in the count and not get caught. If a person bets the minimum bet whenever the deck is unfavorable, and suddenly switches to the maximum bet whenever the deck becomes favorable, the casino will quickly infer that the player is counting cards. By having the spotter and the big player always bet the same amount, the card counting is more difficult to trace. In fact, this method went unnoticed by Nevada casinos for several years.[5]

The film *21* (2008) focuses on a team of MIT undergraduates who moonlight as blackjack players. It is based on Ben Mezrich's book *Bringing Down the House*, which itself is based on the real-life story of former MIT student Jeff Ma. The existence of a whole team

of math-savvy gamblers, headed by professor Mickey Rosa (Kevin Spacey), would seem to be the perfect opportunity to show a broad spectrum of people with strong skills in mathematics. Unfortunately, the film wastes this opportunity by painting in broad brushstrokes, invoking a number of negative stereotypes, including those displayed in *Rain Man*.

The main character of the film is Ben Campbell (Jim Sturgess), an MIT undergraduate whose lifelong dream, for reasons unbeknownst to the viewer, has been to attend Harvard medical school. He's an exceptional student with a 4.0 GPA, and sits as the current president of the "American Legion Math League." Faced with the hefty price of admission to medical school, Ben reluctantly agrees to join professor Rosa's blackjack team. He masters the team's card-counting techniques and strategies, and before long he is spending his weekends traveling to Las Vegas to help the team earn tens of thousands of dollars. Mickey Rosa recognizes Ben's skill, and soon promotes him from a spotter to a big player.

While Ben does have some certain traits that are stereotypically associated with people who are good at math, on the whole he is portrayed as relatively normal. Perhaps the most glaring stereotype in the film is the insistence that having mathematical ability is roughly equivalent to being a human calculator. Consider the answer Ben gives at his part-time job when a customer asks how much a certain outfit will cost: "Oh, well, let's see, the belt's $49.95, minus 15%. The jacket's $589.99, the pants, $285.99, minus 10% for both. Unfortunately, the shirt's not on sale, but I can knock off 5% from the $69.99. The shoes were just marked down from $155, so you're looking at $1,042.68." That he could give such an exact answer without using a calculator or even pausing to think is highly implausible. Nevertheless, this is a common fallback for lazy writers who want to impress upon the audience that the character in question is good at math. Nobody mentions, however, that one can be good at calculations and bad at math in general, and conversely one can be a strong mathematics student who always makes mistakes with calculations. While there may be a correlation between the two, portraying all mathematicians as calculating machines does a disservice to all the wonderful mathematics that exists apart from basic arithmetic, and furthers the popular misunderstandings about what it is exactly that mathematicians do (hint: it doesn't involve mentally multiplying really big numbers together).

Ben is also socially awkward around women, although this stereotype fades as the movie progresses. At the opening of the film, Ben is working on "a robotic wheel that can navigate itself using a proprietary GPS system" with two friends; collectively, they have no luck with women. While this affords them more time to work on their project, it's clear that all three wish they could get a date. Later on, when love interest Jill (Kate Bosworth) stops by Ben's work, we get to witness firsthand his powers of seduction. After Ben turns aside to compose himself when he sees her, the following conversation ensues.

JILL: Hey.
BEN: Hey.
JILL: Could you help me?
BEN: Oh, yeah. Yeah, sure.
JILL: Uh, I'm looking for a tie.
BEN: Oh, well, we're having a 15% sale on the ties. And, if you want, I could, uh, probably get you and additional 10% with my, uh, employee discount.
JILL: This one's nice.
BEN: Yeah, oh yeah. Um, this one's, uh, actually been treated with our patented Nano-Tex fabric protection, you know, to repel liquids, stains...

JILL: Oh, that's ... really functional.
BEN: Yeah, yeah, it's, it's pretty functional.

This inability to talk with members of the opposite sex is fairly typical of characters with mathematical talent. To the film's credit, however, Ben does overcome his awkwardness around Jill mid-way through the film, for once he begins to win money on the blackjack team, his confidence grows in conjunction with his wallet.

While Ben's growth into a more confident young man may sound like a boon for the portrayal of mathematicians in popular culture, the film never lets you forget that despite Ben's credentials, he is not (nor does he aspire to be) a mathematician. His one goal is to go to Harvard and become a doctor, and because of this, blackjack is only a means to an end. In contrast, Ben's friends who are working with him on his science project are portrayed as more conventional nerds. These supporting characters have little depth, and only further some of the negative stereotypes associated with people who are good at math. In this way, Ben's passion for medicine places him a few degrees removed from the traditional nerdy role, so that his evolution, while welcome, is in a sense overshadowed by a lack of evolution in the characters filling more stereotypical roles.

It's also worth pointing out that Jeff Ma, the person on whom the character Ben is based, never had such ambitions to become a doctor. In the book *Bringing Down the House*, author Ben Mezrich describes Jeff as being quite unsure about his future:

> [He] had just turned twenty a month before and he was old enough to make his own decisions about the direction of his life. But like most twenty-year-olds, he had no idea where he was heading. He knew only where he *didn't* want to end up.... Medicine, academia, science for science's sake — these were not compelling choices in the tornado of options swirling around a campus such as MIT [12].

Not only did Jeff have no aspirations to study at Harvard, but the book makes the claim that Jeff had no interest in medicine whatsoever. Ben's dream of becoming a doctor is a purely fictional point, one which allows blackjack to serve as a necessary stepping stone in order for Ben to be able to afford his dreams, rather than what it actually was: a fun diversion that required some mathematical talent. Had medical ambitions been absent from Ben's character, the film would have necessarily needed to focus more on his mathematical ability, which in turn could have done more to advance the portrayal of people who are good at math as Ben's character evolved.

The film also sends a mixed message when it comes to the conflict between natural mathematical ability and hard work. At the beginning of the film, Ben explains in a voiceover that "not everyone can do it [count cards]. Just those with gifted minds. I have a gifted mind." His brilliance is further reinforced by Mickey Rosa, who describes him as "being on cruise control" at MIT. Nevertheless, it's also clear that Ben works extremely hard: his mother even chastises him for it, when he tells her that he's going to go home and get some work done on his birthday. There are also several scenes of Ben practicing his card counting technique and working with the team to perfect their rhythm. So while the film doesn't totally abandon the idea that mathematics ability is a gift from the heavens, at least it shows that natural talent in mathematics, just as in anything else, must be nurtured through hard work in order to produce results. In addition, the fact that the math-savvy gamblers here are actually shown doing math is a vast improvement over the portrayal in *Rain Man*.

In summary, this film doesn't rock the boat too much when it comes to the portrayals of those who study math. While Ben himself is a bit more of an everyman than one often finds, this is counterbalanced by supporting characters that fill stereotypical roles, and moreover, the film makes it abundantly clear that Ben's first passion is for medicine, not mathematics. Even so, Ben is unquestionably a math-savvy gambler, and the film's approach to combining math and gambling is much sharper than the methods used in *Rain Man*.

The Math-Savvy Gambler in Film: The Hangover

Although critical response to *21* was far from enthusiastic,[6] the film was undeniably a financial success, and set the tone for the math-savvy gambler in the twenty-first century. The baton was passed to another film involving Las Vegas and card counting a year later: *The Hangover* (2009). This film met with much greater success than *21*, both critically and commercially, and is currently the domestically top-grossing R-rated comedy of all time.[7]

The film centers on four friends who go to Las Vegas for a bachelor party. When Doug Billings (Justin Bartha), the groom-to-be, goes missing after a night of heavy partying, the three remaining men scramble to find him, and, as expected, hilarity ensues. One of the three men is Doug's future brother-in-law Alan Garner (Zach Galifianakis), who towards the end of the film uses card counting to win enough money to pay a ransom that he hopes will lead him and his compatriots to Doug.

From the audience's first introduction to Alan, it's clear that he's a bit of an outcast. After Doug and Alan are fitted for their tuxedos, Doug's fiancée, Tracy (Sasha Barrese), takes him aside and thanks him for taking Alan along for the bachelor party:

> TRACY: Thanks again for bringing him, by the way.
> DOUG: You don't need to thank me, it's nothing. He's a cool guy.
> TRACY: It's not nothing and he's not a cool guy ... so thank you. Thank you. Thank you.[8]

Being called uncool in his very first scene certainly sets the tone for what we can expect from this character. To really drive home the point, just a minute later Doug's future father-in-law gives Doug the keys to his Mercedes to take to Las Vegas, but cautions him, saying, "Don't let Allen drive, there's something wrong with him." At this point, the film cuts to a shot of Alan tongue kissing the family dog.

All of this firmly establishes within the first eight minutes of the film that Alan is extremely socially awkward. It doesn't take much longer to establish that he is also interested in card counting. By the fifteen minute mark, we see Alan studying card counting techniques out of *The World's Greatest Blackjack Book*, and soon afterwards he asks for volunteers to be his spotter. When Doug suggests that Alan shouldn't be doing too much gambling, the following exchange takes place:

> ALAN: Gambling? Who said anything about gambling? It's not gambling when you know you're gonna win. Counting cards is a fool-proof system.
> STU: It's also illegal.
> ALAN: It's not illegal, it's frowned upon, like masturbating on an airplane.
> PHIL: I'm pretty sure that's illegal too.
> ALAN: Yeah, maybe after 9/11 where everybody got so sensitive. Thanks a lot Bin Laden.
> DOUG: Either way, you've gotta be super smart to count cards buddy, okay? It's not easy.

ALAN: Oh really? Ok, well maybe we should tell that to Rain Man, because he practically bankrupted the casino and he was a retard.

The above exchange does a few things. First, it shows Alan's potential as a math-savvy gambler — even though he's exceedingly awkward, he also seems to understand the fundamentals of blackjack and how it can be won. Secondly, Doug's comment about being "super smart" rather than something like "super motivated" reinforces the common misconception that mathematical ability is a gift that comes from birth, rather than a skill that needs to be developed through practice. Finally, the overt reference to *Rain Man* further illustrates the influence of that film on the portrayal of the math-savvy gambler.

In fact, *Rain Man*'s influence is felt later on as well, when Alan puts his studies to the test at the blackjack table. At a certain point in the film, Alan, Phil (Bradley Cooper), and Stu (Ed Helms) believe that in order to find Doug they have to pay off a ransom of $80,000. With less than a day to acquire this sum, Alan decides that the best course of action is to count cards. The shot of Alan and Phil riding the escalator down to the casino floor is a clear homage to the gambling scene in *Rain Man* — Alan is even wearing the same suit that Raymond Babbitt wore when he entered the casino.

But if Alan is meant to be a more modern twist on the math-savvy gambler presented in *Rain Man*, he has two essential differences: his awkwardness is not the result of any documented handicap, and, like Ben in *21*, he actually uses mathematics. Whereas Raymond Babbitt's severe form of autism plays a central role in *Rain Man*, no explanation is given for Alan's strange behavior. Instead, Alan simply becomes the latest in a long list of characters whose strangeness is portrayed as necessary in order to have a degree of mathematical aptitude. And, as the gambling scene shows, Alan certainly does have some mathematical aptitude. While he is gambling, numbers and equations flash by on the screen, many of them irrelevant for card counting. Nevertheless, the intended effect is clear: the audience is meant to believe that somehow this chubby, awkward, borderline-incompetent man is actually a math whiz.

This is in sharp contrast to Ben from *21*, who from the outset is shown to be good at math, and its effect simultaneously reinforces and breaks down stereotypes about good math students. On the one hand, for much of the film Alan seems fairly stupid; when they check in to their hotel room at Caesar's Palace, for example, he asks whether the hotel is actually the palace where Caesar lived. In fact, at one point Stu tells Alan that he is "literally too stupid to insult." Yet despite this perception of Alan, when motivated he is still able to master some mathematics and use it to his advantage. This helps to dispel the notion that to understand mathematics you must be some kind of genius. However, on the other hand, even though Alan is shown reading *The World's Greatest Blackjack Book* a few times early on in the film, there is little screen time devoted to the actual study and practice of card counting that would be necessary to make Alan a skilled blackjack player. By omitting this piece of Alan's development, the true nature of mathematics as a discipline that requires hard work and practice over natural talent is once again obscured. Instead, Alan's mathematical ability becomes a sort of *deus ex machina* to help bring the film to a satisfying conclusion.

In the end, *The Hangover*'s portrayal of the math-savvy gambler fails to live up to its potential, much like in *21*. Alan further perpetuates the stereotype that mathematical ability

and social awkwardness go hand in hand, as well as the stereotype that mathematical ability is something that comes naturally, rather than being the product of many hours of focused study. It's not a total loss, however, as Alan's character shows that you don't need to be considered stereotypically smart to be good at math. But if you're not socially awkward, all bets are off.

The Math-Savvy Gambler on Television: NUMB3RS

Centering on the exploits of mathematician Charlie Eppes (David Krumholtz) and his FBI agent brother, Don (Rob Morrow), the television show *NUMB3RS* (CBS, 2005–2010) has mathematics as a central feature, and is the first procedural drama to put such a heavy focus on the subject. Charlie's back-story is a bit stereotypical — he graduated from Princeton with his Ph.D. at the age of sixteen — but in spite of this, his character is given a significant amount of dimension. He is friendly and socially well-adjusted, he has a girlfriend,[9] and he has as much of a passion for mathematics as he does for helping his brother fight crime, although these two activities are usually not mutually exclusive. But while Charlie is many things, he is not a gambler. Therefore, to see how this show interprets the math-savvy gambler, we must consider a specific episode, rather than the series as a whole.

In the second season episode "Double Down," Don is sent to investigate a murder outside of a casino. The victim, who in the opening scene is shown winning big money at the blackjack table, is soon revealed by the notebooks of equations found in his car to be a math-savvy gambler. As the story progresses, we encounter a few of his math-savvy compatriots; unlike the films we've discussed, however, this episode of *NUMB3RS* gives an unconventional, yet surprisingly dark interpretation of the archetype.

The deceased gambler, Yuri Chernov (Dean Chekvala), is a different breed of math-savvy gambler. To begin with, he had a girlfriend, although when questioned by the FBI, his ex admits that they broke up over Yuri's obsessive gambling habits. Like most math-savvy gamblers, Yuri was able to use his mathematical skills to reap huge rewards; unlike the characters we've already encountered, however, Yuri was incapable of separating his personality in the casino from his personality outside of it. As his ex-girlfriend put it, "Yuri got into this whole player vibe, dressing differently, [and] acting differently." Unlike Ben in *21*, whose true personality was quite different from the personas he adopted as a big player, Yuri blurred the lines between fantasy and reality.

In other respects, though, Yuri is not so different from Ben. After checking with the college Yuri attended, the FBI finds that he was a "straight A student" and "a total math geek." The same is true of Yuri's two classmates and fellow card counters, who are revealed as the story develops. On the surface, then, there is little to distinguish these three young men from the math-savvy gamblers we have already encountered. Indeed, even Yuri's girlfriend seems like a bit of a fluke: later on, we learn that the female member of their counting team isn't a math major at all, but instead is a stripper that the three of them hired as arm candy so that their big players would have more credibility. The fact that these three math students had to hire a stripper in order to find an attractive girl to hang out with them while they gambled suggests that, at the very least, their ability to talk to with women may not be so different from those of the stereotypical math nerd.

What, then, is the catalyst that drives these young men into a sequence of violent situations? The key is that the math-savvy gamblers portrayed in *NUMB3RS* are the first ones to actually break the law.[10] Through the course of their investigation, the FBI learns that these players are not necessarily winning because they are good at counting cards. Instead, it is discovered that the players worked with a man who designed the algorithm used in the card-shuffling machines at the casinos. With knowledge of the algorithm, the players were better able to predict what cards would be dealt to them and to the other players. This slippery slope led them to a money-laundering scheme, and this in turn eventually caused one of the students to murder the other two.

While the fundamental traits of the math-savvy gambler are still present, this episode of *NUMB3RS* takes the audience to a much darker place than has been explored in film. The episode could therefore be seen as a cautionary tale about the dangers of greed (or perhaps the dangers of mathematics), a noble sentiment that is echoed a bit in the film *21*, but less so in *Rain Man* or *The Hangover*. While *21* does feature scenes of violence against card counters, any such violence is by the casino in retaliation for simply card counting, an act which, by itself, is not illegal; this makes it easier to sympathize with the characters on the receiving end of such violence. In *NUMB3RS*, however, it is clear that the math-savvy gamblers are breaking the law.

Certainly, this is not a very flattering portrayal of people who study mathematics, but it is tempered by the presence of Charlie Eppes and his colleague Larry Fleinhardt (Peter MacNicol), who in the episode is revealed to have once been a math-savvy gambler himself. Unlike the three men at the center of the story, however, Larry never broke the law, and becomes indignant whenever anyone suggests he did. "Card counting is not cheating," Larry insists, when Charlie's father implies otherwise, "it is the application of probability theory to a game." Moreover, Larry never let his card counting obsession get the best of him, and even shows remorse for how much he got caught up in blackjack, after seeing the ill effects it had on some of his contemporaries.

These two distinct types of math-savvy gambler come to a head at the end of the episode, when Larry confronts an old colleague named Leonard Philbrick (Ethan Phillips), the man who had mentored the three students and helped design the auto-shuffler whose mechanism they exploited. Their conversation at the FBI office offers two very distinct takes on the math-savvy gambler:

> LARRY: How could you do it? You know what the game did to us. How could you visit such a fate upon young, gifted minds?
> LEONARD: Those kids came to me.
> LARRY: And instead of sharing your wisdom, two are dead and another's going to prison.
> LEONARD: These kids were a second chance for me. Come on, don't tell me you don't remember what it felt like, to beat the house at their own game. You were the best I ever saw, Fleinhardt, and you just walked away.
> LARRY: That's right, I never looked back. When the numbers are running you instead of you running the numbers, it's time to take your money off the table, Leonard.
> LEONARD: Men make choices they have to live with.
> LARRY: Well, you know, I know two who will never get that chance.

Larry's castigation of Leonard, and by extension the actions of the three younger students, gives a layer of depth to the math-savvy gambler not present in any of the portrayals on film. While it may be hard to believe that math students could turn to money laundering

and murder, especially when they showed such academic promise, Larry gives a dose of reality, and serves as an important contrast to the more violent portrayal of the math-savvy gambler in the episode. Even though the characters on screen here (Larry included) do have a few stereotypical traits of the math-savvy gambler, they interact with a depth not seen in big screen portrayals.

The Math-Savvy Gambler on Television: 2 Months. 2 Million

At the very end of the *NUMB3RS* episode, Charlie, Don, their father, and Larry are all at Charlie's house discussing the case. Eventually the father suggests they sit down to a game of poker, a game in which he claims that "all the math in the world is useless against a good read and steady nerves." And in a sense, he is correct: poker is as much a game of psychology as it is a game of chance. Unlike blackjack, where basic strategy determines the optimal move in any possible situation, to win at poker you have to have an understanding of your opponents. Nevertheless, it's unfair to say that math has no place in poker, as a basic understanding of the underlying odds certainly has advantages. And while all of the math-savvy gamblers we've encountered so far have favored blackjack, the show *2 Months. 2 Million* bucked this trend by featuring four poker players instead.

Debuting in August 2009 on G4TV, *2 Months. 2 Million* was a reality show featuring four friends and successful online poker players named Dani, Brian, Emil, and Jay. The show chronicled their attempt to, as the name suggests, win two million dollars in two months by playing online poker. They set up their headquarters in a rented Las Vegas mansion, complete with a room full of computers, and were filmed as they gambled and partied.

From the outset, it's suggested that these four are no slouches when it comes to mathematics. Every episode begins with the following introduction:

> Welcome to Las Vegas, where fortunes are made on the flip of a card. These former high school math whizzes are four of the best online poker players in the world. They've pooled their money, and for one high stakes summer, they'll live and play together. Their goal: two months, $2 million.

It's clear that we are meant to think these guys are good at poker in part because they're good at math. Each member of the group even comes with his own stereotypical trait. Dani, at twenty-two, is the youngest member of the group (or as twenty-six-year-old Brian calls him, "a member of the younger generation"), and represents the young prodigy seen in characters like Charlie Eppes from *NUMB3RS*. Brian is cocky and very sure of himself, a trait shared by many mathematicians portrayed in film (most notably, John Nash in *A Beautiful Mind*). Emil is the most eccentric of the group: he sticks mainly to a white food diet, and his interactions with girls can be socially awkward. On one episode, for example, he tries to explain to a girl why he has green eyes even though he's Indian by discussing Punnett squares from biology class.

Lastly there's Jay, who serves as an example of the commonly held belief that mathematics is a young man's game. Even though he's only twenty-five, Jay comes to the show with his reputation in question. Emil tells us that "back in 2007, Jay was one of the top no

limit players in the world. And when he went on a downswing in late 2008, there was a perception that maybe he's not as good as some of these new up and coming players." Similarly, in popular culture there is a misconception that to have a career in mathematics, you must be quite young — this is a misconception that is promoted by characters like Charlie Eppes. The truth is much less dramatic, of course: working mathematicians come in all different ages, and just because a mathematician is older does not mean he or she is incapable of contributing good, original work. Similarly, Jay is out to show everyone that he can still compete with the best players in the world.

Unfortunately, beyond these tropes, the show does little to advance the portrayal of the math-savvy gambler. In fact, it's not even clear how skilled these players are with mathematics. Despite the words in the introduction, the guys never discuss math, and most of their discussions about poker are in regard to psychological strategies, such as discovering their opponents' "tells," than probabilistic strategies. Even the words in the introduction are a bit murky — the modifier "high school" in "high school math whizzes" is a bit of a backhanded compliment when all of them are in their twenties, with their high school days far behind them.

Instead, the show focuses more on their lavish Las Vegas lifestyle. There are parties in every episode, money is thrown around casually, and their house is littered with empty bottles. They hire a personal chef and a personal assistant, and eat at expensive restaurants. Dani, after winning a large sum of money in one day, rewards himself by buying a $2,000 pair of sneakers. The net effect of all of this is to leave one wondering whether it wouldn't have been more economical for them to simply attempt this challenge from home, since most of their time spent playing poker in Las Vegas is still on the computer.

On a positive note, the show does manage to do one thing better than any of its competitors: illustrate the law of large numbers. Earlier portrayals of the math-savvy gambler always show him winning. In *Rain Man*, after an early misstep Charlie and Raymond are never shown losing a hand, and their stack of chips increases monotonically. The same is true of Alan in *The Hangover*; Phil becomes so excited by Alan's success that at one point he exclaims, "Hey, come on! He can't lose! He can't lose!" In *21*, Ben is only shown losing once, and even then he's accused of losing simply because he was too emotionally involved at the time.

The truth, of course, is much less exciting. Even with a winning strategy, losses will be frequent. The difference is that *over time*, the wins should outpace the losses. Because of the fact that it's a reality show, *2 Months. 2 Million* actually illustrates this principle. The guys on this show lose large sums of money, and they do so often. Luckily for them, they are also able to win, although they end the show approximately $1.3 million short of their goal. So while the show doesn't do anything to shatter stereotypes about the math-savvy gambler, at least it manages to inadvertently showcase some mathematical truths better than the fictionalized stories discussed above.

Conclusion

The math-savvy gambler is a bit of a double-edged sword for those who actually study mathematics. On the one hand, these films and television shows do show that people who

are good at math aren't always hopeless losers or misanthropic crazies. In fact, sometimes it does even more than that, by showing people who are both good at math and stylish and sociable. On the other hand, the "big player" persona employed by the math-savvy gambler is often just that: a persona. Ben Campbell was awkward around girls despite his skill at the table, and Alan Garner only passed for a high roller because he kept his mouth shut while he was gambling. The three students in *NUMB3RS* learned to adapt to the big player persona, but to such an extent that they were then corrupted by it.

At its foundation, the math-savvy gambler still relies on many of the stereotypes associated with people who study math. Many of them are socially awkward, especially around women. For many, their talents are never shown to be the product of hard work, except in the case of the men in *2 Months. 2 Million*, whose talents are far removed from mathematics. Any trait that goes against convention, such as the perception that Alan is both stupid and good at math, or the fact that Yuri had a girlfriend, is dwarfed by the larger categories into which these characters fit. While one character may make strides towards dispelling a certain stereotype, usually another character will reinforce it.

Taken as a whole, this new portrayal of the mathematically talented is still more flattering than the image of the math nerd with coke-bottle glasses, hiked-up pants, and a pocket protector. Unfortunately, the latter characterization's effects can still be felt, to varying degrees, in this more modern one. Even so, at least the math-savvy gambler has been able to show different facets of an archetype that was once completely predictable. It remains to be seen, however, whether future portrayals of the math-savvy gambler will lead to revealing explorations of the mathematical mind, or whether they will be nothing more than modern interpretations of the same clichéd conventions.

Notes

1. Charlie Eppes, the protagonist in *NUMB3RS*, finished his Ph.D. by the time he was sixteen. Max Cohen, the protagonist in π, did not finish his Ph.D. until the age of twenty, but was published by the time he was sixteen.

2. Thorp's book was not the first to provide a study of the game of blackjack, but it was the most popular. For an earlier study of the game, see Baldwin et al.

3. Here is one potential problem with the simple point-count system. Suppose you are playing blackjack against a dealer who is using a large shoe, say six or eight decks. If the count is very high after one hand, e.g., +6, this tells you very little, because there are still a large number of cards left in the deck, many of which will have a low value. If, on the other hand, the count is +6 with only half a deck remaining undealt, this indicates a much more significant advantage for the player.

This example suggests that a better measure of the advantage can be obtained by dividing the count by the number of decks remaining in play. As expected, this leads to a refinement of the simple point-count system, which Thorp calls the *complete point-count system.*

4. Episode 201 of the television series *Muppets Tonight* (ABC, 13 Sept. 1997); *The Simpsons* episode "$pringfield (Or, How I Learned to Stop Worrying and Love Legalized Gambling)" (*The Simpsons—The Complete Fifth Season*, Fox Home Entertainment, 2004, DVD).

5. In fact, most casinos didn't know about team strategy until Ken Uston revealed the strategy in his 1977 book *The Big Player.*

6. According to review aggregator Rotten Tomatoes, as of September 25, 2010, only approximately 35 percent of 161 linked-to critic reviews were positive (see "*21* [2008]").

7. As of December 17, 2009, *The Hangover* had grossed $277,322,503 in the United States and Canada (see "*The Hangover* [2009]").

8. It should be noted that this exchange was cut from the theatrical release of the film, and appears only in the unrated version.

9. Although Charlie does have a girlfriend, it should be noted that their courtship began while he

was her Ph.D. advisor. So while the writers earn points for giving a mathematician a relationship, they lose points for the inappropriateness of the relationship's origins.

10. Despite examples to the contrary in popular culture media, card counting without the aid of technology is legal. In fact, in the case *Uston v. Resorts International Hotel Inc.*, the New Jersey Supreme Court ruled that casinos in Atlantic City did not have the right to ban players simply because they are skilled (Rose).

Works Consulted

Baldwin, R., W. Cantey, H. Maisel, and J. McDermott. "The Optimum Strategy in Blackjack." *Journal of the American Statistical Association* 51 (1956), pp. 429–39.

A Beautiful Mind. Dir. Ron Howard. Perf. Russell Crowe, Ed Harris, and Jennifer Connelly. Universal Studios, 2001. Film.

"Double Down." *NUMB3RS—The Complete Second Season.* Paramount, 2006. DVD.

Good Will Hunting. Dir. Gus Van Sant. Perf. Matt Damon, Robin Williams, and Ben Affleck. Miramax, 1998. Film.

The Hangover. Dir. Todd Phillips. Perf. Bradley Cooper, Ed Helms, and Zach Galifianakis. Warner Bros., 2009. Film.

"*The Hangover* (2009)." *Box Office Mojo.* IMDb.com, n.d. Web. 1 Sept. 2010.

Humble, Lance, and Carl Cooper. *The World's Greatest Blackjack Book.* New York: Broadway, 1980.

Mezrich, Ben. *Bringing Down the House: The Inside Story of Six M.I.T. Students Who Took Vegas for Millions.* New York: Free Press, 2002.

O'Neil, Paul. "The Professor Who Breaks the Bank." *Life* 27 (May 1964): 80–91.

π. Dir. Darren Aronofsky. Perf. Sean Gullette, Mark Margolis, and Ben Shenkman. Artisan Entertainment, 1998. Film.

Rain Man. Dir. Barry Levinson. Perf. Dustin Hoffman, Tom Cruise, and Valeria Golino. United Artists, 1988. Film.

Revolutionary Road. Dir. Sam Mendes. Perf. Leonardo DiCaprio, Kate Winslet, and Michael Shannon. DreamWorks, 2008. Film.

Rose, I. Nelson. "#149: Dealing with Card-Counters." *Gambling and the Law.* Whittier Law School, 2002. Web. 25 Sept. 2010.

"$pringfield (Or, How I Learned to Stop Worrying and Love Legalized Gambling)." *The Simpsons—The Complete Fifth Season.* Fox Home Entertainment, 2004. DVD.

Thorp, Edward O. *Beat the Dealer.* New York: Vintage, 1966.

21. Dir. Robert Luketic. Perf. Jim Sturgess, Kevin Spacey, and Kate Bosworth. Columbia Pictures, 2008. Film.

"21 (2008)." *Rotten Tomatoes.* Flixter, n.d. Web. 25 Sept. 2010.

2 Months. 2 Million. G4TV. 16 Aug. 2009–21 Oct. 2009. Television.

Uston, Ken, and Roger Rapoport. *The Big Player: How a Team of Blackjack Players Made a Million Dollars.* New York: Holt, 1977.

Stand and Deliver
Twenty Years Later

KSENIJA SIMIC-MULLER,
MAURA VARLEY GUTIÉRREZ *and*
RODRIGO JORGE GUTIÉRREZ

From classics such as *Blackboard Jungle, Goodbye Mr. Chips* and *To Sir with Love* to the more recent *Dead Poets Society, Mr. Holland's Opus, The Emperor's Club, Dangerous Minds,* and *Freedom Writers,* numerous films targeting adolescent audiences have offered stories of gifted teachers inspiring students to transcend personal limitations or overcome cultural constraints. Films about mathematics are also common, as this volume clearly shows. However, to our knowledge, there is only one film whose subject is the mathematics education of Latinos: namely, *Stand and Deliver*, which depicts the true story of Jaime Escalante, a high school mathematics teacher famous for creating a tremendously successful advanced placement (AP) calculus program in an East Los Angeles school whose students had previously been failing basic math.

Directed by Ramón Menéndez, *Stand and Deliver* was released in March 1988 to a lukewarm box office reception: it garnered only $412,000 during its opening weekend. It was a low-budget film, which some reviewers judged better-suited for television than for the big screen — more after-school-special than commercial film. Observed Washington Post reviewer Rita Kempley in 1988: "[T]here's nothing rich and pervasive in the movie's atmosphere.... The language, yes. But you can't sense the salsa. It's all math anxiety, and no milieu."

Yet the movie received considerable critical acclaim. It won multiple awards — including six Independent Spirit awards — and was included in the American Film Institute's 2006 list of 100 most inspiring movies of all time ("AFI's 100 Years ... 100 Cheers"). It also propelled Jaime Escalante — portrayed by Edward James Olmos, who was nominated for an Academy Award for the role[1] — to fame. The Los Angeles Times claimed: "After his story was told on film, Escalante became legendary." Anecdotal evidence and internet forums suggest that the movie remains popular among educators to this day; indeed, we have come across many people who encountered this movie in a math class while a student or presented it in a math class as a teacher.

The film's plot, for the most part, follows actual events of Escalante's life. The real Jaime Escalante taught mathematics between 1974 and 1991 at East Los Angeles' James A. Garfield High School. During this time, he transformed the school's mathematics program into a nationally renowned success. In 1987, at the peak of the program, close to ninety Garfield students, the majority of them Latinos, passed an AP calculus exam (Jesness).[2] A few years later, Escalante left the school due to conflict with its administration, and ultimately returned to his native Bolivia. Escalante received numerous honors, including five honorary doctorates, a presidential medal for excellence in education in 1988, and a "Best Teacher in North America" award from the Freedom Forum in 2005. He is credited for the rise in popularity of AP calculus programs across the country:

> Nationally, there is no denying that the Escalante experience was a factor in the growth of Advanced Placement courses during the last decade and a half. The number of schools that offer A.P. classes has more than doubled since 1983, and the number of A.P. tests taken has increased almost sixfold. This is a far cry from the Zeitgeist of two decades ago, when A.P. was considered appropriate only for students in elite private and wealthy suburban public schools [Jesness].

In 2009, Escalante became ill with bladder cancer. Shortly before he died in 2010, many of his former students came forward to proclaim his influence on their lives.

We now turn to the film version of Escalante. Like the real Escalante, Olmos's character teaches at Garfield High School, positioned in a neighborhood boasting a predominantly Latino population. Escalante finds that his students lack even the most basic of math skills, and that their other teachers have all but given up on them. Believing that obtaining a strong mathematics education could open doors for his students, Escalante is unwilling to accept the status quo, and adopts unusual teaching practices in order to motivate his students to learn. Amidst vehement protests from his fellow teachers, Escalante creates an AP calculus course. Determined that its students will pass the standardized AP calculus exam, Escalante meets with them on Saturdays, after school, and during the summer, neglecting both his family and his health; his perseverance and personal sacrifice pay off when every one of the students passes the exam. Unfortunately, this unanimous passing by a group of students of color raises suspicions at the exam-administrating Educational Testing Service (ETS), whose representatives, claiming that the students' errors were too similar to one another to be accidental, accuse the students of cheating on the exam. Escalante, in turn, accuses the ETS of racism, declaring that the results never would have been questioned had the students not been of color and poor. Eventually, he convinces his students to retake the test, which they again pass.

As is inevitable with Hollywood films, some details of Escalante's story were changed to increase dramatic impact (for instance, what took ten years to accomplish in real life took approximately one year in the movie). And while, according to Escalante, 90 percent of the film's story is true (Jesness), certain choices made by its filmmakers undercut its positive messages about race and class. Without question, *Stand and Deliver* boldly addressed racism at a time when the marginalized position of Latinos in our society was not as visible a topic as it is today, and the film was certainly unique in its portrayal of not just Latino students, but an inspiring Latino teacher; at the same time, however, the film perpetuates demeaning myths and stereotypes about Latinos. Given the sustained popularity and uniqueness of *Stand and Deliver*, we pose the following question: If this is the only movie

people will see about the mathematics education of Latinos, what kind of messages does it send about math pedagogy and about race?

Pedagogy

On the surface, *Stand and Deliver*'s portrayal of a high school class compares positively to those in films such as *Fast Times at Ridgemont High*, in which students are sleeping, chewing gum, or throwing notes across the room, while their teachers unsuccessfully — and often half-heartedly — attempt to capture their attention (consider, for instance, Ben Stein's classic droning economics teacher in *Ferris Bueller's Day Off*). Olmos's Escalante, in contrast, shows a deep-seated passion for teaching. He engages his students using unconventional means, such as coming to class dressed as a short-order cook and posing word problems involving gigolos. More importantly, he motivates his students to succeed by promising them a better future — and threatening a dismal one, if they don't succeed: "If the only thing you know how to do is add and subtract, then you will only be prepared to do one thing: pump gas." Moreover, he doesn't avoid the sometimes delicate subject of race. "You already have two strikes against you," he tells his primarily Latino students. "There are some people in the world who will assume that you know less than you do because of your name and your complexion, but math is the great equalizer." He assumes that strength in mathematics will allow his students to overcome the discrimination still applied to people of color, and he has faith that his students will in fact succeed.[3]

Escalante's faith in his students withstands both the general prejudice of his fellow teachers and the common temptation to judge students based on statistical data. When his colleagues complain about the poor quality of their students, he counters, "Students will rise to the level of expectations. All you need is *ganas* (desire)." And when the school administration laughs at him for wanting to teach calculus, he threatens to quit: "I want to teach calculus next year. I teach calculus or have a good day." Even when his students are accused of cheating on the AP exam, he remains convinced of their talents and integrity.

Yet, for all his pedagogical skill and mentorship, this film version of Escalante is not an ideal teacher. Though exemplary in his creation of a challenging curriculum, he fails to show how mathematics is relevant to his students' lives, and though revolutionary in his endeavor to teach calculus at Garfield High, he fails to provide his students with an empowering classroom environment.

When am I ever going to need this?" is a refrain frequently heard in math classes. Educational researchers and major teacher organizations, such as the National Council of Teachers of Mathematics (NCTM), assert that it is important for students to have an answer to this question, and recommend that students be encouraged to create meaning in mathematics, to see connections between different areas and concepts, and to relate the material to the real world: "The opportunity to experience mathematics in context is important. Mathematics is used in science, the social sciences, medicine, and commerce" (NCTM 66).

When the question is posed by students who have previously been let down by the system, such as inner-city children, recent immigrants, children living in high poverty areas, and those belonging to marginalized ethnic groups, it can provide a special challenge for the teacher to tie what is often considered to be arcane material to his or her students' day-

to-day lives. Some reviewers of *Stand and Deliver* believe that Menéndez's Escalante succeeded in creating this bridge; for instance, film critic Roger Ebert asserts in his review of the movie that Escalante uses "examples out of the everyday lives of his students." While this is partially true, we believe that Ebert's assertion isn't fully supported. For example, when Escalante introduces a word problem involving gigolos, student Pancho (Will Gotay) remarks that the material does not make sense unless they understand how it relates to the real world. Instead of coming up with a more pertinent example, Escalante makes a joke out of this question and asks if gigolos can be brought to class for a demonstration, thus perpetuating the stereotype that gigolos are somehow relevant to his students' lives.

In the next scene, we see Escalante and his students visiting a lab at which Escalante formerly worked as an engineer. Here, the students get to wear lab coats and see calculus on a computer screen. This trip, despite providing students with a snapshot of math being applied in the real world, actually perpetuates one of the most common myths about mathematics: that it is an esoteric body of knowledge reserved for a select few. After all, the men in the lab wear white, important-looking coats; they do not look like the students. And the obtuse mathematics that the computer churns out says nothing about the students' lives. Recent trends in mathematics education reject such mystification. NCTM proposes that for the student and the layperson alike, mathematics is an integral part of our daily lives:

> Knowing mathematics can be personally satisfying and empowering. The underpinnings of everyday life are increasingly mathematical and technological. For instance, making purchasing decisions, choosing insurance or health plans, and voting knowledgeably all call for quantitative sophistication [NCTM 4].

Perhaps Escalante could have found a way of showing his students how math was actually relevant to *their* lives, rather than implicitly reinforcing the belief that while mathematics may be useful, it lives in an esoteric world far removed from his students' neighborhoods.

Of course, making mathematics seem relevant to students' lives is only part of the equation for encouraging student learning. Teachers and mathematics education researches are constantly looking for better ways imparting knowledge to students. In addition to lecturing, teachers can provide their students with collaborative learning experiences (e.g., small group work) and experiential learning using *manipulatives* (real-world objects that can be touched and moved by students to enhance mathematics learning).

Though *Stand and Deliver* is a movie about teaching mathematics, we actually see very little math being taught in the film. We do see an integral that is solved using integration by parts, as well as a sine function, some algebra, and fractions. And we poetically learn the origins of zero: "It was your ancestors, the Mayas, who first contemplated the zero, the absence of value, true story, you burros have math in your blood," Escalante says. But if we really pay attention, we see that the movie's approach to mathematics is less than ideal. All of the students' math tasks are decontextualized; problem solutions rely on memorization of facts and "tricks"; and there are no "whys" or explanations — Escalante's focus is on mere skill acquisition. His students chant, "Negative times a negative equals a positive" and "parentheses always mean multiply"; integration by parts is done using the "tic-tac-toe" method — a convenient but non-enlightening mathematical device.

While in order to pass the AP exam it is indeed important for Escalante's students to learn such mathematical algorithms, we find it unfortunate that there is no room left in the

movie to portray mathematics as a creative endeavor, one that exists beyond applying mere procedural knowledge. We never see students discuss the meanings of derivatives and integrals, or apply calculus to the real-world (by, for instance, solving an optimization problem). The goal of Escalante's students is to pass the AP test, rather than to learn how to engage in mathematical practices in the context of real problems. This is eerily similar to the stated goal of mathematics education in the U.S. today: since the No Child Left Behind act was instituted in 2001, teaching to a test has become common practice in mathematics classrooms (Darling-Hammond, 1049).

One revealing scene in *Stand and* Deliver shows Escalante teaching English to English Language Learners (ELLs). The class consists of his saying a word, and his students repeating it in unison. If we compare this to the scenes taking place in his calculus classroom, we see that Escalante teaches math much in the same way as he teaches English: he gives his students a formula, and they repeat it after him. He does not ask his students to figure things out on their own. The implicit assumption is that the teacher is the one who possesses all the knowledge within his or her discipline and that he or she "pours" it into students. This is known as the "banking concept" of education, a term coined by Brazilian educator and theorist Paulo Freire, who argued for education as a liberating practice for the oppressed (44). In banking education, the teacher "deposits" the knowledge and the students are "depositories" of this knowledge, passively receiving it. In Jaime Escalante's classroom, the hierarchy is clear; students are not being taught to access knowledge that they already possess. Rather, their teacher *stands* at the front of the classroom and *delivers* this knowledge. When Garfield's principal visits Escalante's class, the latter tells him "It's not that they're stupid, it's just they don't know anything"; Escalante apparently views his students as "empty vessels." By suppressing the process of investigation and discovery that makes for an engaging and engaged classroom dynamic, Escalante reflexively prevents more profound student empowerment.

Race

Popular media provide few examples of students of color succeeding academically. When such students are portrayed, their successes are typically explained by natural ability, in conjunction with a little luck. *Stand and Deliver* is one of the rare films that suggest that a dedicated teacher is, if not essential, at least invaluable in enabling everyday students of color — no more or less gifted than anyone else — to academically succeed. The movie has, understandably, then, been heralded as a shining example of what Latino students can do when provided the appropriate academic opportunities.[4] However, we argue that many negative ethnic stereotypes are reinforced in the film, and that the messages viewers walk away with may perpetuate racialized ideas of who students of color are and how they should be educated.

Films that deal with education and people of color tend to center on the "savior" white teacher who breaks through to the tough, inner-city students of color, changing their lives for the better (e.g., *Dangerous Minds*, *Freedom Writers*); this is a reflection, no doubt, of the fact that the overwhelming majority of the teaching force in the U.S. is white (Cochran-Smith 5). Seldom do we hear of the work of adults of color in communities of color. *Stand and Deliver* refreshingly provides a story of a teacher of color in that role. It should be

noted, however, that although Escalante is Latino, there still exists a cultural mismatch between the middle class, middle-aged, South American teacher whose roots are not Mexican, and his students, who hail from the Los Angeles barrios. This difference in background complicates the idea that this teacher is an authentic member of his students' community. Nonetheless, he does try to connect with class members outside of the confines of the school. For instance, he pleads with one student's father to allow her to stay in school rather than wait tables at the family's restaurant. Additionally, when a student and his grandmother arrive at his door during Christmas dinner, Escalante warmly greets them and invites them to stay, even engaging the grandmother in Spanish. We applaud the fictional Escalante for these efforts, since teacher connection and communication with parents is an essential component of an approach to education that seeks to reverse current exclusionary trends toward students of color.

However, one of the most pernicious myths the movie perpetuates is the idea that people of color need "saving" from their own communities, and in particular from their own families. It is not uncommon even amongst educators today to contend that Latino parents simply do not value education. From our personal experience, interactions with teachers, and research (see Thompson 48), we find that where there are students of color, you are likely to overhear statements about parental lack of investment in their children's education. Parents are blamed for the low achievement of their children, while educators ignore systemic barriers to parent participation in education and exclusionary practices of schools, which often prevent meaningful family involvement; for instance, parents are asked to be involved solely by contributing money — which they may not have available — or by helping with homework that might not be in the family's home language. In *Stand and Deliver*, we see a number of scenes that serve to reinforce the message that parents are discouraging the academic success of their children. In one case, Escalante attempts to convince a student's father, who insists that she drop out of school to help out at the family restaurant, that she is better off studying calculus. The father adamantly challenges this idea, asserting that the family tradition of children working at the restaurant is more important than the daughter's education. In another scene, a tired mother returning from work asks her daughter to turn off the light so she can rest, implying that she does not value her daughter's attempts to finish her homework. In a third scene, one of Escalante's students asks her mother to sign a permission form for her to put in extra time in her calculus class. The mother is coloring her hair when her daughter brings up the topic, and responds by declaring, "Boys don't like it if you're too smart." The scene implies that doing your hair and appealing to men are what should matter most to a Latina, and perpetuates an additional myth: that Latinas are expected to fulfill stereotypical gender roles, and are not necessarily expected to achieve academically.

Racial stereotypes perhaps come into play most prominently — both explicitly and implicitly — in the film when Escalante's students' AP calculus test scores are questioned. In recent years, there have been numerous challenges to the myth that assessments (in particular, standardized tests) are blind to race and are therefore a valid measure of student performance (see, for instance, Jencks 56–58). An over-reliance on test score data and over-focus on the so-called achievement gap (demonstrated by students of color falling behind white students on test scores) all too often lead to the assumption that students of color are deficient in both learned skills and inherent capability (Gutiérrez 358–62). *Stand and Deliver*

directly confronts such issues of standardized testing and bias, as the ETS officials' challenge of Escalante's students' scores is presented as inexcusable racism: "Those scores would have never been questioned if my kids did not have Spanish surnames and come from barrio schools," Escalante declares. But even as it draws attention to such discrimination, the film reinforces the inherently problematic and often discriminatory idea that passing a standardized test should be a primary stepping-stone towards upward advancement and mobility.

Twenty Years Later

Most mathematicians would agree that the mathematics seen in the movie is not representative of what it means to do mathematics (a sorry comment, perhaps, on the United States' focus on test-driven pedagogy). In addition, most Latinos would agree that the stereotypical portrayals of Latinos in the movie are not representative of what it means to be Latino. Moreover, the film's message is that if we simply staff schools like Garfield with more teachers who "stand and deliver," and fewer under-qualified, burned-out teachers (like Escalante's colleagues in the film), then that is sufficient. But though the Olmos's Escalante raises the level of expectation for his students and demands more time and commitment from them than their other teachers have, this additional time is not used for varied curricular and pedagogical approaches; it merely allows for more disempowering banking instruction.

In our educational system, societal myths such as those about mathematics and Latinos need to be challenged and transformed rather than reproduced and reinforced. Perhaps the movie that should be made is one that challenges stereotypes of students of color and demonstrates how schools can partner with communities to identify and access funds of knowledge for teaching — a movie that makes its viewers question their beliefs while interrogating the role of societal forces on education. Interestingly, Anne McCall claims that, contrary to what we see portrayed in the movie,

> Escalante used past graduates to come back to talk to current students and to serve as models of achievement. He also depended heavily upon parent involvement, claiming that "To succeed, a program as intense as mine must have 100 percent support from the parents" (Escalante, 1990, p. 418). Other important elements of his program were community resources and donations and the use of quality textbooks with lots of interesting practice problems and linkages between math principles and their real-world applications.[5]

It is a shame that we do not see this in the film: we see no parent support and no real-world applications. Instead, the movie seems to perpetuate many of the mainstream perspectives on what constitutes mathematics education and also on what is needed in terms of mathematics education for Latinos in particular. Maybe we should not expect more from popular media — after all, it is all too often an uncritical reflection of society. Perhaps, therefore, it is our duty to use popular media as an opportunity to examine what myths our society perpetuates and to begin to question the way our society is structured. There are elements of the movie that we feel successfully bring to light topics that deserve more attention, and others that we hope serve as a reminder for us to always critique that which we see.

Notes

1. The Academy Award eventually went to Dustin Hoffman for *Rain Man*, a film that amassed $14,000,000 on its opening weekend, as much as *Stand and Deliver* during its entire run. Interestingly, *Rain Man* also contained mathematical themes.

2. The AP calculus exams are standardized tests which, like the SAT and PSAT, are administered by the United States's Educational Testing Service (ETS). A high school student who takes an AP calculus exam may, based on his or her score, be granted college credit for calculus prior to actually attending college.

3. This faith, it turns out, is less common in schools than one might hope. It is well-documented (see Valenzuela or Oakes) that schools at which the majority of students are of color are often lacking in academic rigor and high expectations for their students. And despite Olmos's assertion that "Jaime exposed one of the most dangerous myths of our time — that inner city students can't be expected to perform at the highest levels. Because of him, that destructive idea has been shattered forever" (Breslow), current data suggests Latinos, in particular, are still being let down by our educational system. Latinos at present have a higher high school dropout rate than any other ethnic group in the U.S.; according to the Population Reference Bureau, "In 2006, 50 percent of Latino males and 41 percent of Latino females did not graduate from high school on time with a regular diploma" (Mather and Kent), and the National Center for Education Statistics states that "[c]ompletion rates for Hispanics have fluctuated over the past two and one-half decades, showing no consistent trend" (Llagas and Snyder).

4. One reviewer, Pat Collins, dubbed *Stand and Deliver* "*Rocky* of the classroom."

5. The reference within this quote is to the following article: "Jaime Escalante Math Program." *Journal of Negro Education* 59.3 (1990): 407–23.

Works Consulted

"AFI's 100 Years … 100 Cheers." *Afi.com*. American Film Institute, 2006. Web. 29 Nov. 2010.

Breslow, Jason M. "Jaime Escalante, Inspiration for 'Stand and Deliver,' Dies at 79." *PBS NewsHour's The Rundown: A Blog of News and Insight*. MacNeil/Lehrer Productions, 31 Mar. 2010. Web. 30 Nov. 2010.

Cochran Smith, Marilyn. *Walking the Road: Race, Diversity, and Social Justice in Teacher Education*. New York: Teachers College, 2004.

Darling-Hammond, Linda. "Standards, Accountability and School Reform." *Teachers College Record* 106.6, (2004): 1047–85.

Ebert, Roger. "*Stand and Deliver* (PG-13)." *Rogerebert.com: Movie Reviews*. 15 Apr. 1988. Web. 14 Dec. 2010.

Freire, Paulo. *Pedagogy of the Oppressed*. New York: Continuum, 2000. Print.

Gutiérrez, Rochelle. "A 'Gap-Gazing' Fetish in Mathematics Education: Problematizing Research on the Achievement Gap." *Journal for Research in Mathematics Education* 39.4 (2008): 357–64.

Jencks, Christopher. "Racial Bias in Testing." *The Black-White Test Score Gap*. Ed. Christopher Jencks and Meredith Phillips. Washington: Brookings Institution, 1998. 55–85.

Jesness, Jerry. "Stand and Deliver Revisited." *Reason.com*. Reason Magazine. July 2002.Web. 28 Feb. 2010.

Kempley, Rita. "*Stand and Deliver* (PG)." *The Washington Post*. The Washington Post Company, 15 Apr. 1988. Web. 30 Nov. 2010.

Llagas, Charmaine, and Thomas D. Snyder. "Status and Trends in the Education of Hispanics." *National Center for Education Statistics*. National Center for Education Statistics, Apr. 2003. Web. 28 Feb. 2010.

Mather, Mark, and Mary Mederios Kent. "U.S. Latino Children Fare Poorly on Many Social Indicators." *Population Reference Bureau*. Population Reference Bureau, Nov. 2009. Web. 28 Feb. 2010.

McCall, Anne. "Motivational Strategies for Underachieving Math Students." *MSTE*. University of Illinois, n.d. Web. 28 Feb. 2010.

National Council of Teachers of Mathematics. *Principles and Standards for School Mathematics*. Reston: National Council of Teachers of Mathematics, 2000.

Oakes, Jeannie. *Keeping Track: How Schools Structure Inequality*. 2nd ed. New Haven: Yale University Press, 2005.

_____, et al. *Multiplying Inequalities: The Effects of Race, Social Class, and Tracking on Opportunities to Learn Mathematics and Science*. Santa Monica: RAND Corporation, 1990.

Stand and Deliver. Dir. Ramón Menéndez. Perf. Edward James Olmos, and Lou Diamond Phillips. Warner Bros., 1988. Film.

Thompson, Gail. *What African American Parents Want Educators to Know*. Westport: Praeger, 2003.

Valencia, R., and M. Black. "'Mexican Americans Don't Value Education!' On the Basis of the Myth, Mythmaking, and Debunking." *Journal of Latinos and Education* 1.2 (2002): 81–103.

Valenzuela, Angela. *Subtractive Schooling: U.S.-Mexican Youth and the Politics of Caring*. Albany: State University of New York, 1999.

Smart Girls
The Uncanny Daughters of Arcadia *and* Proof
SHARON ALKER *and* ROBERTA DAVIDSON

Introduction

When two mathematically-challenged English professors were asked to explore the relationship between literature and math, our first response was an experience of strangeness bordering on the uncanny. The uncanny, after all, is linked to a sense of strangeness or mystery that is simultaneously deeply familiar, and few things are stranger to professors of literature than the mysteries of mathematics, or more familiar to both English and math majors than the perceived intrinsic gulf between our disciplines. However, the experience of working outside our usual boundaries ultimately led us to a surprising discovery. As we began to study two plays that link mathematical principles with the artistic imagination, our unfamiliarity with mathematics in fact facilitated our recognition of the persistent presence of the uncanny in those works.

Often associated with gothic narratives and ghost stories, the uncanny seems distant from the objective, empirical methodology of mathematics or science. Nonetheless, in *Arcadia* (1993) and *Proof* (2001), the playwrights, Tom Stoppard and David Auburn, respectively, harness mathematics for two distinct but related purposes. First, they foreground the importance of the uncanny experience to revolutionary mathematical thought. And second, they challenge women's exclusion from and subordination within the male-dominated mathematical disciplines by suggesting that the marginalization of women, through historically limiting their access to education, or by expecting them to assume extensive travails of domesticity, paradoxically may have encouraged them to disrupt and recreate old mathematical models. *Arcadia*'s Thomasina and *Proof*'s Catherine possess unlikely and extraordinary mathematical gifts that defamiliarize both the familiar and the familial and plunge both characters and audience alike into an experience of the uncanny.

As Nicholas Royle has noted, the idea of the uncanny is complex and fragmentary. In a discussion of Freud's essay "The Uncanny," he remarks, "[t]o write about the uncanny, as Freud's essay makes admirably clear, is to lose one's bearings, to find oneself immersed in the maddening logic of the supplement, to engage with a hydra" (8). Commenting on Freud's attempt to draw up an inventory of what is uncanny, Royle adds:

[I]t is as if he thinks, or is willing to pretend that we might think, that the uncanny can be col-
lated, classified, taxonomized. But one uncanny thing keeps leading on to another. Every
attempt to isolate and analyze a specific case of the uncanny seems to generate an at least minor
epidemic. It becomes, at moments, irresistibly comical, verging on the endlessly supplementary
'chief weapons' in Monty Python's "Nobody Expects the Spanish Inquisition" [13].

In this essay, therefore, while we seek to isolate and analyze specific cases of the uncanny,
we recognize that both plays in fact are uncanny in multiple ways. Stoppard's *Arcadia* evokes
numerous haunting moments of intersection between past and present as he slowly brings
his audience towards an understanding of a particular historical moment only to confound
them, while Auburn's *Proof* explores very different kinds of intersections — between madness
and genius, the analytical and the inspirational.

Our analysis of the uncanny is centered on epiphany and creativity. M.H. Abrams has
described the epiphany as "a sudden sense of radiance and revelation that one may feel when
perceiving a commonplace object," surely an intersection of the familiar and the strange.
He locates such moments in the Romantic period, the very moment where *Arcadia* takes
place, where they were described as "moments of revelation" or, as Wordsworth would have
it, "spots of time" (81). Of course in the early nineteenth century and arguably in the twen-
tieth century, such moments were generally associated with men, rather than women, and
with poetry, rather than mathematics.

However, an analogy between mathematics and the Romantic idea of the epiphany is
not hard to uncover. Mathematicians have traditionally made the claim that "mathematics
is the language of nature," a tropological expression of the interconnectedness between num-
bers and the patterns of the real world (Klaver 7). By implication, therefore, mathematicians
are continually engaged in acts of defamiliarizing the known, natural world to discover its
hidden meanings. This allies those innovative mathematicians who see the furthest, and
unearth "truths," with the figure of the Wordsworthian mystic, who can "see into the secret
life of things." Mathematics itself, therefore, is already positioned on the borders of the
uncanny, particularly for those who observe its workings from the outside.

Stoppard's Arcadia

Epiphanies: New Patterns in Inherited Knowledge

Arcadia tells two simultaneous stories, both of which occur on the same English estate,
Sidley Park, at different moments in time. The first, set in the Romantic period, is centered
on a rakish tutor, Septimus, and his brilliant young pupil, Thomasina. The witty drama
focuses on the young girl's intellectual awakening to the aesthetics and power of mathematics
and science as her tutor deals with the problematic aftermath of a series of passionate illicit
encounters. The garden of the stately home echoes this dichotomy between mathematical
order and wild desire. Thomasina's mother, Lady Croom, is renovating the classical garden,
changing it into a Romantic wilderness, hermit and all. At one point in the drama, Lord
Byron visits the house, though the audience never sees him directly. The second narrative
foregrounds present-day scholars who are researching the history of the house and its past
inhabitants. Bernard Nightingale, a pompous university professor, is convinced that Byron
once visited the house and killed the husband of one of Septimus's conquests in a duel. His

research is marked by an unbounded imagination unconstrained by a limited knowledge of facts. Hannah, an independent scholar whose work has previously focused on feminist history, is researching the life and writings of the mad hermit who lived on the grounds of Lady Croom's stately home. Her research tends to be cautious and, for the most part, grounded in painstakingly nuanced evidence. The two researchers interact with members of the household, including Valentine Coverly (a son of the present-day owner of the house), who happens to be a mathematician working on his own research project, studying the historical patterns of grouse on the estate.

Stoppard, having thoroughly introduced us in Scene One of the first Act to the Sidley Park ongoings in April 1809, immediately shifts, in the second scene, to the home as it is refashioned in a much later era. Such time transitions continue throughout the play. As the scenes shift back and forth in time, the audience becomes accustomed to the dissonance, and to the emerging pattern of connections between past and present that exist uneasily alongside multiple moments of interpretative failure. The culmination of the pattern is the double dance that concludes the final act. Two characters from the past, Septimus and Thomasina, alongside two characters from the present, Hannah and the silent Gus, awkwardly dance a waltz, an act that refuses to illustrate or expound on the discomfort of the uncanny in any logical sense, but rather invites the audience or reader to find knowledge, perhaps patterns, in its mystery. This work, then, is deeply saturated in the uncanny throughout.

In centering his play on mathematical knowledge, Stoppard links the uncanny nature of the journey toward epiphany to mathematics in particular. Valentine, in a discussion of his research on grouse, describes the process when he attempts to sort through the "noise" in his data and discover a numerical pattern. He complains of the

> Distortions. Interference. Real data is messy.... It's all very, very noisy out there. Very hard to spot the tune. Like a piano in the next room, it's playing your song, but unfortunately it's out of whack, some of the strings are missing, and the pianist is tone deaf and drunk — I mean the *noise*! Impossible! ... You start guessing what the tune might be. You try to pick it out of the noise [46].

Creating new mathematical knowledge, Stoppard suggests, is an uncanny experience, particularly during the period (whether it be minutes or decades) when a pattern is partially clear, but not quite. Such moments of epiphany are grounded in familiar knowledge but organized in a new way, an emergent pattern which is not yet quite understood; responding to these insights involves a delicate and vulnerable act of interpretation and creation that is often associated more with Romantic poetry than with mathematics.

Terry Hodgson has pointed out that Stoppard's source material, James Gleick's *Chaos*, also directly associates science with art and the uncanny. Gleick argues that

> the twentieth century's best expression of ... flow needed the language of poetry. Wallace Stevens, for example, asserted a feeling about the world that stepped ahead of the knowledge available to physicists. He has an uncanny suspicion about flow, how it repeated itself while changing [151].

Uncanny suspicions, then, are at the center of new creations that derive from but transform old knowledge; they involve "stepping ahead" to see the unfamiliar from within the familiar, to deploy the memory of accumulated knowledge alongside the creative authority of the imagination which can invent the new.[1]

Alongside associating the uncanny with creative reason and fractal geometry, Stoppard also firmly connects the uncanny to issues of gender and sexuality. This is not a new alliance. The intersection between intimacy and the uncanny has a history. As Terry Castle has noted in relation to desire,

> [t]he eroticized female body — in life and death, in relation to other bodies, in relation to the phantasmatic — has been a recurrent motif.... ([There is] no more *unheimlich* [uncanny] place, says Freud, than the female genitals — that entrance to the former *Heim* [Home] of all human beings, to the place where everyone dwelt once upon time and in the beginning) [19].

From Thomasina's initial question about the meaning of carnal embrace in the play's opening scene to the final dance between Septimus and Thomasina, *Arcadia* is saturated with questions of sexual fulfillment. And Hannah's feminist historical research, which has previously centered on the complexity of Byron's cast off (and under-studied) lover Caroline Lamb, brings broader gender issues to the fore. Thus *Arcadia*'s assessment of the relationship between the uncanny and gender goes far beyond mere carnal embrace to disturb conventional patterns that have been imposed on the accumulation of knowledge. While Valentine suggests that "[i]t doesn't *matter* [who developed an idea first]. Personalities. What matters is the calculus. Scientific progress. Knowledge" (61), the play itself resists that idea, revealing that the elision of women from scientific and mathematical history, not to mention literary tradition, or the inability of institutions of knowledge to accept and celebrate female discoveries, has stymied the development of new knowledge. Placing women back at the center of scholarship and uncannily disturbing tradition will fruitfully disrupt conventional narratives of intellectual history. Thomasina, a young woman on the verge of adulthood, is at the center of the disruption and destabilization of the primarily masculine scholarly world of mathematics.

From the beginning of the play, Thomasina and Septimus encounter knowledge, particularly mathematical knowledge, differently. Septimus aligns knowledge, in relation to his pupil, either with banal busy work or with wit and language play. He translates Shakespeare's *Antony and Cleopatra* into Latin, for example, only to have his pupil translate it back again. Translation here is a repetitive task, designed to build aptitude in certain skills. His teaching methodology, of course, may well be influenced by the opinion of his employer, Thomasina's mother, who at one point claims that "ignorance should be like an empty vessel waiting to be filled at the well of truth — not a cabinet of vulgar curiosities" (11). The double play on the word "curiosity" and its alignment with vulgarity suggests that creativity and play have no place in educational development, particularly that of a young woman. Lady Croom's anxiety about curiosity and the disturbing uncertainty that might follow it is revealed in her concern that the gardener, Noakes, may have been reading "too many novels" of the gothic variety (13). Keats's celebration of a mind that is "capable of being in uncertainties, mysteries, doubts, without any irritable reaching after fact & reason" (539) is most unappealing to the taste of Lady Croom. On the other hand, Septimus himself is immensely creative in his own interaction with the literary arts; he writes witty, caustic book reviews and much of the play surrounds his ability to rapidly produce a series of hilarious quips that play with the doubleness, the uncanniness, of language. For example, he reassures Ezra Chater, a hopeful poet who is sadly lacking in talent, about his recent book, "'The Maid of Turkey'! I have it by my bedside! When I cannot sleep I take up 'The Maid of Turkey' like an old friend" (8). Thomasina, on the other hand, specifically sees *mathematics* as creative and complains:

Each week I plot your equations dot for dot, *x*s against *y*s in all manner of algebraical relation, and every week they draw themselves as commonplace geometry, as if the world of forms were nothing but arcs and angles. God's truth, Septimus, if there is an equation for a curve like a bell, there must be an equation for one like a bluebell, and if a bluebell, why not a rose? [37].

Septimus humorously rebuts such rebellious acts of exploration. Early in the play, Septimus tells Thomasina an anecdote commonly known to mathematicians: Fermat had made a notation in the margins of one of his mathematical works stating that he had "discovered a wonderful proof of his theorem" (referring to the infamous Fermat's Last Theorem), but that the margins were too narrow to contain it (6).[2] As he finishes, Thomasina remarks, "Oh! I see now! The answer is perfectly obvious," assuming that the notation is a joke (6); Septimus responds, "you may have overreached yourself," implying that she is claiming to have proven the theorem. Such exchanges frequently recur — Thomasina seeks the "true meaning of things" (3), and Septimus provides evasive or witty answers to prevent her from "overreaching" herself. Yet overreaching oneself is a vital state, an uncanny stage, in the process of revolutionizing knowledge. Indeed, one must overreach oneself to the point of unlearning, moving outside conventional norms. Valentine describes this when he comments, "It makes me so happy. To be at the beginning again, knowing almost nothing" (47). The word "almost" is key here for it is moving uncannily between inherited tradition and strange, untested ideas that produces progress.

Gender and the Destabilization of Mathematical Knowledge

In the modern scenes in Stoppard's play, the two primary scholars represent different configurations of imagination and knowledge in different, and perhaps gendered, ways. Bernard privileges imagination, though he undoubtedly brings some factual evidence to the table (literally, in this case, as a large table occupies a central position on stage in every scene of the play), but it is insufficient to allow him to access new knowledge, because, caught up with ambition, he is unwilling to step far enough away from old paradigms that privilege the work and ideas of great men, in this case Byron. His approach is validated by the academy in which he holds a position. Hannah, however, has no problem stepping away from inherited canons, and, as a careful researcher who pays attention to detail, her imagination does not simply wildly create history from nothing. Hannah's character and her research, which is centered on Caroline Lamb and a disorderly hermit at Sidley Park rather than on Byron, reveals that women often have different ways of seeing than do men, not because of some intrinsic natural difference but due to their distinct and different position in society. Hannah's condition as an independent scholar outside of the academic establishment reveals that her way of seeing has neither been privileged nor accepted as the norm. If this is the case in literary studies, it is even more so with mathematics. Claudia Henrion has recently pointed out that even now "women continue to be significantly underrepresented in mathematics, particularly at the highest levels of accomplishment" and that even "those who have already made it by standard measures of success ... often continue to feel (to varying degrees) like outsiders in the mathematics community" (xvii–xviii). The position of outsider, though, can actually be a powerful one.

William S. Haney II recognizes this subversive authority when he notes that in *Arcadia* "Thomasina rebels against ... repressive authority." Haney concludes that she may do so

because, in the words of Chris Clarke, "[b]elow the rulers of the power/knowledge hierarchy there persisted what Foucault termed, 'subjugated ways of knowing.'" Both Clarke and Haney, however, connect these subjugated ways to "emotion[al] and associative ways of knowing" (87–88). While acknowledging that Thomasina values both emotion and the power of associative thinking, we would also suggest that power of rational thought is crucial to Thomasina, who far prefers the rational, productive Queen Elizabeth to the emotional Cleopatra, whom she calls an "Egyptian noodle [who] made carnal embrace with the enemy who burned the great library of Alexandria" (38) (in itself a poignant reminder that while we may think we understand the past, as the two twentieth-century scholars in *Arcadia* are confident they do, our reconstruction of events is based upon those records that have survived to be recovered, while other contradictory narratives may be lost). Rational thought, Stoppard suggests, can be uncanny under certain circumstances. Paradoxically, what makes Thomasina's reason different from that of the better-educated men in the play is its very marginalization, its limits, which in fact ultimately empower her and allow her to fruitfully imagine outside the boundaries of contemporary thought. Women's exclusion in the Romantic era from institutional educations that would provide a prolonged exposure to accepted bodies of knowledge certainly ensures that they have less power in society, but that very lack also prevents them from being co-opted into outdated paradigms and can come to accepted models, whether they be mathematical or literary, technological or poetic, from a different, unexpected direction, seeing the world through different lenses. Their exclusion, in that case, may actually enhance women's ability to see the unfamiliar in the familiar, to access the uncanny and defamiliarize old models, making them open to change. Thomasina recognizes the limits of Septimus' models, asking him why his equations only "describe the shapes of manufacture" rather than exploring how "nature is written in numbers" (37); her ability to see what he has left out, and perhaps does not even perceive, leads her to revolutionary mathematical conclusions. Valentine, reading the young woman's work over a century later, realizes that in asking new questions, in creating new figurative points of comparison, she has been creating something new, an "iterated algorithm" (43). He explains to Hannah that "the maths isn't difficult" but what is remarkable is that "every time she works out a value for y, she's using *that* as her next value for x. And so on. Like a feedback. She's feeding the solution back into the equation, and then solving it again," a technique that "hasn't been around for much longer than, well, call it twenty years" (44).

The overturning of an accepted body of knowledge can have far reaching effects on an entire discipline. For instance, replacing an established literary canon made up of European male writers with a plethora of works with multiple points of cultural and gendered origin has brought literary scholars through moments of unease and uncanniness to new perceptions — which will likely be challenged again in the future. The reframing of history and literary studies over the past few decades has revitalized the humanities and social sciences, but while mathematics and science has certainly been radically recast by new theories (Einstein's theory of relativity and the introduction of non–Euclidean geometries, for example), there has been less urgency about basing future developments on the reassessment of previously ignored material from the past, looking in particular at the ideas of the disenfranchised. As George Gheverghese Joseph has noted of the relationship between multiculturalism and mathematics in the classroom, "[t]here is a view prevalent among mathematics

teachers that the universal character of the language and reasoning of mathematics is sufficient evidence of its lack of cultural specificity" (6). Mathematics and the sciences, therefore, have been slower to acknowledge the revolutionary effects, the creative uncanniness, that can emerge from the decentering of inherited histories of a discipline by the exploration of excised histories, by exploring the works of those excluded from authorized traditions. Valentine is a key figure in describing how such decentering works. In a long, pompous lecture, Bernard claims that "the drama of life and death at Sidley Park was not about pigeons but about sex and literature" (54). Valentine responds "Unless you were the pigeon" (55). This is more than just a witty remark. Looking at the same sequence of events Bernard is researching through the "game book" (a somewhat banal historical record of hunting on the estate) changes everything, proving, for example, that Byron actually had visited Sidley Park. And it is Valentine who recognizes that Thomasina is also potentially capable of disturbing existing systems when he says:

> When your Thomasina was doing maths it had been the same maths for a couple of thousand years. Classical. And for a century after Thomasina. Then maths left the real world behind, just like modern art, really. Nature was classical, maths was suddenly Picassos. But now nature is having the last laugh. The freaky stuff is turning out to be the mathematics of the natural world [44–45].

Thomasina is a creative revolutionary in mathematics whose (brief) life experience and different view of the world might have changed the entire field had she lived in a later era with advanced technology. On the one hand, it might seem as if her influence does not come to fruition because of her unfortunate death, but it is also the case that she would have faced substantial institutional resistance had she lived. Even Valentine, who, living in a post-feminist world, is certainly no oppressive force, cannot believe that Thomasina could have held such knowledge about the "behavior of numbers" (45) so many generations ahead of her time. He at one point insists she "was just playing with the numbers ... [she was d]oodling. Nothing she understood" (47). His dismissal of her abilities echoes her tutor's admonitions not to overreach herself.

Septimus, however, ultimately recognizes the worth of Thomasina's work. At the end of the play we (along with Hannah) realize that he is the hermit that Hannah has been researching. Whereas Hannah had claimed that the hermit of Sidley Park was her "epiphany" (27), we discover that the hermit himself was existing in a prolonged state of epiphany, of the uncanny. Having lost his earlier belief that "[w]e shed as we pick up, like travelers who must carry everything in their arms, and what we let fall will be picked up by those left behind," a belief system that seems to give little credence either to individual achievements or personal revelations, Septimus has entered the uncanniness of Thomasina's mathematics, unrealizable in the period because "[t]here wasn't enough time," in a pre-digital age, to map out all the iterations of the formula. A discovered letter notes that "[t]he testament of the [hermit] serves as a caution against French fashion ... for it was Frenchified mathematick that brought him to the melancholy certitude of a world without light or life" (65). But the letter writer is wrong. Thomasina's mathematics, indeed, has brought Septimus into a state that transcends the material world, but it has also provided a powerful revelation that goes beyond existing mathematics. As Valentine puts it in regard to Thomasina's diagram of heat exchange, "she didn't have the maths, not remotely. She saw what things meant, way ahead, like seeing a picture" (93). Septimus spends the remainder of his life engaging with

that picture, the art of mathematics, Thomasina's former teacher transformed through the experience of epiphany into her student and disciple.

It has been said that Byron haunts the play, though his presence is never explicit. But there is surely another historical figure who haunts this play, one who makes Thomasina's character more than a mere fictional construction. George Gordon, Lord Byron, had a daughter, Ada Byron, who was known for her brilliant mathematical mind, even in her own time. Writing to his estranged wife when his daughter was young, Byron commented, "I hope the Gods have made her anything save poetical — it is enough to have one such fool in the family." His wife responded, "Her prevailing characteristic is cheerfulness and good temper. Observation. Not devoid of imagination, but it is chiefly exercised in connection with her mechanical ingenuity — the manufacture of ships, boats, etc." (Angulin 60). Ada Byron, like Thomasina, was tutored in mathematics, and she also died relatively young, in her mid-thirties. Unlike Thomasina, Ada's genius had the opportunity to reach fruition during her work with the mathematician and inventor Charles Babbage, who had created an "Analytical Engine ... that would not merely tabulate polynomials of some fixed maximum degree, but which would be able to execute *any* analytical calculation" (63). Ada Byron collaborated with him in imagining this new creation, and translated into English, annotated, and published Italian mathematician Luigi F. Menabrea's "The Sketch of the Analytical Engine Invented by Charles Babbage" (65). As Anguluin comments, the memoir and Ada's notes outline "a century before its time ... the concept of a general-purpose digital computer, developed to an amazing degree of sophistication" (65). While Ada's mother may have commented on her childhood obsession with mechanical matters, Ada also clearly imagined mathematics as aligned with nature. Ada writes, "the Analytical Engine weaves algebraical patterns just as the Jacquard loom weaves flowers and leaves" (Manovich 22). Ada's haunting, uncanny presence draws our attention to Valentine's computer, which ultimately helps to solve the riddle of the past, and grounds this imaginative work firmly in the actual history of mathematics and women's long underrepresented position within its tradition. Moreover, Ada's analogy between math, mechanics, and representing the natural world is not only reflected in Thomasina's belief that nature is written in numbers but also points us ahead to Auburn's *Proof* and that play's similar exploration of mathematics as a language that expresses nature.

Auburn's Proof

Proof is even more focused than *Arcadia* on the figure of a young woman with extraordinary mathematical talent. The central character is Catherine, a twenty-five-year-old woman who has sacrificed her own academic aspirations to look after her father, Robert, a brilliant mathematician and retired professor of the University of Chicago. Robert's early retirement, we learn, was due to mental illness, patterned on the mental breakdown of real-life mathematician John Nash (whose life was also the subject of the film of *A Beautiful Mind*). Robert, we learn, was obsessed with the patterns to be discovered in randomness and, even more significantly, in nature itself. Like Thomasina, he believes that mathematics is the language of nature (Klaver 7). Unlike, Thomasina, however, he is deluded in his belief that he has discovered an equation that was hitherto concealed in the natural world.

Persistently, the play explores the difference between what things appear to be and what they are, via a champagne-shaped bottle that turns out not to contain champagne; via Robert's specious mathematical breakthrough regarding temperature and the seasons; and via Catherine herself, who is not what she appears to be to her friends and family — nor, possibly, to herself.

When *Proof* begins, Catherine's father is dead and his former protégé, Hal, is sorting through Robert's notebooks. Catherine has warned Hal that her father suffered from graphomania in his last years and there is nothing to be found in the notebooks except "bullshit." Hal, however, is convinced that a mathematical gem may lie hidden in them, and wishes to persevere in his search. Meanwhile, Catherine's sister, Claire, a currency analyst and a compulsively organized individual, arrives for their father's funeral. John Madden, director of the London stage version and the film of *Proof* has suggested that the character of Claire "deals with math as the creation of order rather than the explanation of disorder and infinity which is what the other sister is involved with" (Madden). Claire pressures Catherine to return home with her, and, although she couches her offer in terms of the greater social and educational opportunities available to Catherine in New York City, it is quickly apparent that Claire's true motive is concern about what she perceives to be Catherine's mental instability.

Catherine and Hal make love the night of Robert's funeral, and, the next morning, Catherine gives Hal a key to the locked drawer of a desk in her father's study. There he discovers a notebook of the same kind as those filled with Robert's ramblings, but containing a revolutionary mathematical theorem about prime numbers. When Hal expresses his amazement that Robert was able to construct such a theorem at the very time when the world considered him insane, Catherine informs him that the theorem is hers. Both Claire and Hal express skepticism — Claire because she assumes this is a sign of Catherine's encroaching madness and Hal because he is aware of Catherine's limited formal mathematical training and cannot conceive of how such sophisticated thinking could exist outside the confines of academia. Catherine is deeply hurt and angered by Hal's skepticism. Subsequently, however, she begins to doubt her own memory of constructing the proof, and allows Claire to talk her into returning with her to New York, where, it is made clear, Claire will lovingly put Catherine under the care of psychiatrists, ensuring her permanent dependant status. Claire is saved from this fate at the last minute, however, when Hal returns and recants his original disbelief, recognizing — based on various points of circumstantial evidence — that Catherine and not her father must have written the theorem.

Throughout, the play is structured as a series of episodes set in the present spanning a week, interspersed with episodes from the past covering roughly four years, showing the closeness of the relationship between Catherine and Robert and gradually revealing Robert's psychological deterioration. We are shown Catherine's attempt to leave her father during one of his periods of remission in order to attend school at Northwestern, and her return to care for him when he relapses. We observe Robert's inability to tell the difference between his genuine discoveries and his obsessive delusions. Although the play shows little of Catherine's own private work on her theorem, Robert's demonstrated confusion "proves" that he could not have been the work's author.

When *Proof* was first performed in 2001, questions were inevitably raised concerning *Arcadia*'s influence on the play. It was pointed out that in both plays "there is a very clever

young woman who has remarkable insights into mathematics and is 'mentored,' in a way, by a slightly older man who is well-trained in mathematics but much less original in his thinking" (Alexanderson 2). Auburn, however, claimed to be unaware of the parallels between his work and Stoppard's, although acknowledging himself an admirer of Stoppard's work. Despite the many surface similarities of the plays, this denial has some merit. Where Stoppard draws clear analogies between the productive uncanniness of the mathematician's creative imagination and that of the Romantic Poet, Auburn's more unstable mathematicians, far from demonstrating any kind of controlling intelligence, veer from madness to epiphany, sibyl-like victims of the vagaries of inspiration. Uncanniness is present in the play in multiple ways, from the production of a ground-breaking mathematical formula by a young woman with little formal education, to the association of math with madness, and, once again, the uncanny nature of mathematics itself.

Mathematics and Madness

Proof essentially divides mathematicians into two groups: those who approach problems in a linear, sequential, and logical manner — who are sane — and those whose work is so original as to appear nearly supernatural — who are sometimes delusional. That the latter's mathematical abilities are not truly supernatural is emphasized in Catherine's explanation to Hal of Robert's analytical process: "He'd attack a question from the side, from some weird angle, sneak up on it, grind away at it. He was slogging. He was just so much faster than anyone else that from the outside it looked magical" (37).

However, later in the play, Catherine describes her own process in a way that reaffirms the epiphanic necessity underlying the "slogging": "It was just connecting the dots. Some nights I could connect three or four. Some nights they'd be really far apart, I'd have no idea how to get to the next one, if there was a next one" (82). Descriptively, therefore, Auburn differentiates the abilities of mathematical geniuses from those employing purely logical processes: Catherine's epiphany lies not so much in the straightforward connection of dots as it does in her sudden awareness of the existence of a new dot. Auburn places genius squarely in the realm of the Uncanny, constructing it in similar fashion to the "original" definition of the uncanny as something "...*suggestive of*—'associated with' or 'seeming' to have a basis in the supernatural" (Royle 10). In fact, Auburn's depiction of mathematical genius resembles the stereotype of the artistic genius. Transplanting a typically "left-brained" activity into a "right-brained" context is, in itself, enough to defamiliarize what Catherine and her father do, giving them an aura of uncanniness. The play involves, to use one definition of the uncanny, a "mixing of what is at once old and long-familiar with what is strangely 'fresh' and new; a pervasive linking of death, mourning and spectrality, especially in terms of storytelling, transgenerational inheritance and knowledge" (Royle 12), all of which could serve as a synopsis for the major themes and narrative strategies of *Proof*.

Auburn's interest in madness, and in mathematicians as non-normative, increases the play's associations with the uncanny, and, like *Arcadia*, strengthens the association of math and art. Here, however, the uncomfortable nature of mental illness comes much more to the fore, becoming not only a metaphorical trope or a misunderstanding of genius (Septimus ending his life in a heightened state of awareness which is perceived as madness by others) but also a potentially literal condition. The playwright revealed in an interview two days

after the opening of his play that he had not planned, from the beginning, to write a play about mathematics. His initial interest had been in the question of whether or not mental illness, as well as talent, can be inherited, and the mathematical connections came after (Alexanderson 1). His interviewer, Robert Osserman, a mathematician himself, responded by citing a study that ranked various professions by the numbers of adherents to the field who have also suffered from mental illness. Poets ranked at the top of the list. People in the creative arts are two or three times as likely to suffer from psychosis as scientists (mathematicians were not cited separately), according to K. R. Jamison in *Touched with Fire* (Alexanderson 2). Auburn said he had read of enough cases to justify writing his play about mathematicians. Besides, people are used to hearing about mad scientists. Who would want to read about a perfectly sane scientist? Osserman responded by saying they might want to read about mad poets (Alexanderson 2). It is possible to argue that, in *Proof*, we see the lunatic, the scientist, *and* the poet. Auburn's idea of the mathematician as "the solitary worker in an attic somewhere ... working on a problem and coming up with something entirely original ... edgy personalities that make leaps of the mind that most people just cannot make" (Alexanderson 2) is interchangeable with the image of the Romantic poet in his garret. (It is notable that Andrew Wiles, the mathematician who finally proved Fermat's Last Theorem, spent years working on it in, literally, his attic.)[3] It seems appropriate, therefore, that Catherine does not use a computer, but composes her proof in a notebook, which she then conceals in a locked drawer, like a mathematical Emily Dickinson.

The hiddenness of the notebook itself reflects one more aspect of the uncanny, "...an apprehension, however fleeting, that something that should have remained secret and hidden ... has come to light" (Royle 2). Certainly, the initial response to the notebook's revelation is damaging to Catherine. Carol Schafer, in her reading of the play notes:

> Gaston Bachelard in *The Poetics of Space* claims that drawers, particularly drawers in desks and filing cabinets, are metaphors for repositories of rational thought. Catherine's father, according to Hal, "invented mathematical techniques for studying rational behavior" (Auburn 17). What Catherine has hidden in the drawer of her father's desk is a mysterious proof of great significance. She offers Hal her rational mind, not her heart, as the innermost treasure that she had kept hidden from all others [7–8].

Schafer's reading suggests that, like *Arcadia's* Thomasina, Catherine's mathematical uncanniness, her artistic ability, is deeply immersed in reason as well as imagination. Ultimately, it is Catherine's reason, in both senses of the word, that is subsequently questioned and attacked when not only her ability to have written the proof is denied, but her very sanity is called into question. Ironically, this attack on Catherine illustrates the way in which her ability to reason beyond normal limits is perceived as tantamount to irrationality.

It may be that the resonances Auburn constructs between artistic and mathematical creativity in the play are sustained, in part, because the audience does not see much actual math. Even Catherine's knowledge of prime numbers ostensibly can be dismissed as "basic knowledge we all learned in grade school" (Klaver 6).

> [W]e are supposed to feel awestruck in the presence of innate genius (if there is such a thing); and, unfortunately, we probably go on to assume that only mathematical prodigies can reach such heights. Truthfully, though, anyone can memorize the largest-known Germain prime, including the actress playing Catherine [7].

The use of mathematics in *Proof,* therefore, seems to have less to do with mathematics itself, and more with Auburn's harnessing of it as a metaphorical vehicle. The trope of mathematical thought is used to signify insights into concealed patterns in nature perceivable only through the destabilization of the familiar; these insights, however, when taken to an extreme, can also threaten to deceive its practitioners into delusional belief in the objective reality of patterns existing only in their own minds. Catherine's mathematical abilities are linked to ways of thinking beyond comfort and common sense, potentially more profound and dangerous to herself and to the comfort of others than those of ordinary beings. Of necessity, in order to function in the world as we experience it, we retreat from the revealed truths of mathematics back into the mundane conventions of linear time and space. Indeed, advanced mathematics may only be communally acceptable when represented in literature and theater or when domesticated by academia.

Gender and Mathematics

Auburn, like Stoppard, reiterates that women mathematicians have traditionally existed outside the academic mainstream, and so, potentially represent the dangers of wildness and unmediation, bringing the uncanny qualities of mathematics once again to the foreground. Indeed, even today, when there has been significant improvement in the recruitment and retention of women in math and the sciences at universities and colleges, there is still the sense that these are not always fields that are woman-friendly. This may, at times, be inadvertent. "…[M]athematicians are not widely known for their social skills," Rob Corless, a mathematician at the University of Western Ontario, noted ruefully in a 2009 article addressed to creating a warmer environment for women in the sciences.

> To be sure, there are many [male mathematicians] who are competent, and some who are not just competent but even charming. But we have to acknowledge that there are also many who are socially backward. Others are downright unpleasant and some may even be misogynistic…. Among those men who are not misogynistic, one way to account for their cold or awkward behavior is fear. Male academics, especially men in the sciences, may not have spent very much time around women and may not be that comfortable in their presence. To such men the best advice we can offer is relax [Brennan and Corless 59].

Perhaps it is true, as Freud suggested,

> Whenever primitive man institutes a taboo, there he fears a danger … and it cannot be disputed that the general principle underlying all of these regulations and ordinances is a dread of women. Perhaps the fear is founded on the difference of woman from man, on her eternally inexplicable, mysterious, strange nature which thus seems hostile [66].

While Robert, as Catherine's father, mentor, and friend does not experience this particular form of male paranoia concerning her, Hal — who self-identifies as a "geek, nerd, wonk, dweeb, dilbert, paste-eater" (16) — and who is also sexually attracted to Catherine, very much resembles Corless' uncomfortable academic man, relatively inexperienced with women, who is forced through his acquaintance with Catherine into an accelerated learning curve. It can, perhaps, be seen as an optimistic note for the future of academia that his acceptance, even advocacy, only takes him a week.

Moreover, in that week's time, Hal's character had a lot to accept. Catherine's ability to do math is triply uncanny. First, as a woman, she already intrudes upon the predominantly

male mathematical community trailing clouds of the "inexplicable" and "mysterious." Turning once again to Klaver's categorization of the ways in which the "uncanny" is experienced (1), Catherine is both "something familiar unexpectedly arising in a strange and unfamiliar context" (academia, while accustomed to mathematical genius, does not expect it to appear in a comparatively uneducated young woman) and "something strange and unfamiliar unexpectedly arising in a familiar context" (her sister and lover are shocked to learn of her prodigious mathematical talents — she is no longer the person they thought she was). Indeed, as previously mentioned, Catherine, faced with Claire and Hal's skepticism, experiences the uncanny in relation to herself—"feelings of uncertainty, in particular regarding the reality of who one is and what is being experienced" (1) — when she begins to doubt her own memories. In fact, in the film version of *Proof*, the director deliberately heightened the audience's own uncertainty concerning Catherine's sanity, not letting them know for certain until the very end of the film that her father was no longer capable of the kind of mathematics that the notebook contained. It is particularly interesting, in light of the perceived outsider role of women in mathematics, that despite Catherine's sympathetic portrayal as rational, albeit depressed and somewhat neurotic, half the audience of the film reported not believing Catherine had written the proof when she first claims to have done so (Madden). Equally significant as a reflection of the association of familiarity, context, and acceptance, is that when a similar question was asked of two classes of students in a "Mathematics in Fiction" course, nearly everyone was reported as having felt it was obvious Catherine wrote the proof. "People at the [Proof and Prejudice] conference were just left wondering why these confusing lines were thrown in when it was obvious to them at every instant who had really written the proof" (Kasman 4).

Echoing, albeit more explicitly, the haunting presence of Ada Byron in *Arcadia*, *Proof* also points to a tradition of women mathematicians. Catherine asks Hal at one point if he knows of Sophie Germain. Hal mistakenly believes Germain is a contemporary, but Catherine reveals she lived during the French Revolution, and corresponded with the leading mathematicians of her time, disguised initially as a man. Germain's ground-breaking achievements were in the study of prime numbers, and, appropriately, Catherine first learned about Germain from a book given her by her father, the one person in the play who recognizes Catherine's own abilities as potentially on a par with his own. Clearly, Catherine's own work in prime numbers is as much an inspirational inheritance from Germain as her biological inheritance of her abilities from her father. Germain is Catherine's symbolic "mother" (one clearly more sympathetic to young women's specialized education than Thomasina's mother), a female role-model who balances the ambiguous influence of her father, and perhaps indicates a more hopeful outcome for Catherine's own sanity.

Schafer compares Catherine to Katharina in *The Taming of the Shrew*: she is "a shrew who, in the end, willingly submits to patriarchal dominance [in the form of Hal's mediation between Catherine and the mathematical world] in order to become a fairy-tale princess." She argues that "[o]n its surface, *Proof* deceptively claims to challenge perceptions of women as incapable of authority in fields that have been traditionally dominated by men; however, the familiar affirmation of patriarchal hegemony lurks beneath the surface" (13). To an extent, however, Hal's mediation between Catherine and the academic world reflects the actual historical experience of women mathematicians, including Germain. Her acceptance by the French Academy of Sciences was facilitated by the efforts of various contemporary

male mathematicians, including Carl Frederick Gauss, one of her earliest mentors, who convinced the University of Göttingen to give Germain an honorary award, although she died of breast cancer before she could receive it. Catherine's need for Hal to introduce her to the mathematical world, therefore, may reflect Auburn's perception that for a woman without any formal educational credentials, in whatever field, the world of academia remains a closed community (and, as the son of a college professor and dean, Auburn presumably knows whereof he speaks). When Catherine questions why Hal changed his mind about her authorship, he reveals:

> I spent this week reading the proof. I think I understand it, more or less. It uses a lot of newer mathematical techniques, things that were developed in the last decade. Elliptical curves. Modular forms. I think I learned more mathematics this week than I did in four years of grad school [79].

Hal's encounter with Catherine's genius, like Septimus' with Thomasina's, allows him to experience epiphany for himself. Catherine, therefore, may be the sibyl—a visionary who sees that which cannot be seen by ordinary mortals and who, through painstaking mathematical reason, makes knowable that which was not known—but it is ordinary, admiring, male Hal who henceforward will be her prophet.

In both *Arcadia* and *Proof,* then, mathematics, like literature, is revealed to thrive and revel in moments of uncanniness, and women scholars, in particular, are able to disrupt static and conventional methods in part because they have traditionally had limited access to knowledge. Both plays seem to suggest that revolutionary mathematics can often come from outsiders, who reach beyond inherited methods. With this in mind, it might be worth considering that neither play was written by a mathematician. Both Stoppard and Auburn, creative artists themselves, construct an analogy between creativity in the arts and inspiration in mathematics and in doing so create a new, decentered perception of the latter. In a reworking of the idea that mathematics is the language of nature, artistic metaphor is employed as the language of mathematics, associating the invisible principles of the mathematical theories used in each play with the visible language of performance—making the unseen seen, and the unknown knowable. In this way, the artist and the critic, by approaching mathematics "from the side," transpose the familiar onto the uncanny, and come to terms with what is strange by transforming it into something over which they feel a greater sense of control.

How much actual math is left by the end of this literary metamorphosis is debatable. As the plays draw to a close, however, we think we understand "mathematicians" because, secretly, they are just like us. We in the audience, like Septimus and Hal, are able to see what was obscure to us before due to the illuminating analogies of playwrights. And now we—the playwright and the professor alike—know we *can* write about math, because, thanks to the mediating and epiphanic alchemy of art, we are no longer writing about the uncanny, but about the known.

Notes

1. William S. Haney II has connected this experience to death and described transcendence as "the transformation to a higher stage of development through the notion of Thanatos and Eros" (83).

2. As Dov M. Gabbay and John Woods note, Fermat's Last Theorem was eventually proven in the twentieth century by Princeton mathematician Andrew Wiles. Gabbay and Woods comment that "there is now ample reason to conclude that Fermat was mistaken in his claim to have found a proof, but this

was not apparent to Wiles at the beginning of his long journey towards the demonstration he would achieve in 1995" (294).

3. We would like to thank Jessica Sklar for bringing this historical information to our attention.

Works Consulted

Abrams, M. H. *A Glossary of Literary Terms*. 7th ed. Boston: Heinle, 1999.

Alexanderson, Gerald L. "Osserman Interviews David Auburn, author of *Proof*." *The Mathematical Association of America*. MAA, n.d. Web. 21 Jan. 2010.

Angluin, Dana. "Ada Byron Lovelace." *Complexities: Women in Mathematics*. Ed. Bettye Anne Case and Anne M Leggett. Princeton: Princeton University Press, 2005. 60–67.

Auburn, David. *Proof: A Play*. New York: Faber, 2001.

Brennan, Samantha, and Rob Corless. "Creating a Warmer Environment for Women in the Mathematical Sciences and in Philosophy." *Atlantis* 33.2 (2009). 54–61.

Castle, Terry. *The Female Thermometer: Eighteenth-Century Culture and the Invention of the Uncanny*. Oxford University Press, 1995.

Freud, Sigmund. "The Taboo of Virginity." *Sexuality and the Psychology of Love*. Ed. Philip Rieff. New York: Touchstone, 1997. 60–76.

Haney, William S., II. *Integral Drama: Culture, Consciousness, and Identity*. Amsterdam: Rodopi, 2008.

Henrion, Claudia. *Women in Mathematics: The Addition of Difference*. Bloomington: Indiana University Press, 1997.

Hodgson, Terry. *The Plays of Tom Stoppard for Stage, Radio, TV and Film: A Reader's Guide to Essential Criticism*. Cambridge: Icon, 2001.

Kasman, Alex. "*Proof* (2000)." *Mathematical Fiction Homepage*. College of Charleston, n.d. Web. 21 Jan. 2010.

Keats, John. *The Complete Poems*. Ed. John Barnard. 3rd ed. London: Penguin, 1988.

Klaver, Elizabeth. "Proof, Pi, and Happy Days: The Performance of Mathematics." *The Journal of the Midwest Modern Language Association* 38.1 (2005): 5–22.

Madden, John. "Director's Commentary." *Proof*. Miramax, 2006. DVD.

Manovich, Lev. *The Language of the New Media*. Cambridge, MA: MIT, 2001.

Royle, Nicolas. *The Uncanny*. New York: Routledge, 2003.

Schafer, Carol. "David Auburn's *Proof*: Taming Cinderella." *American Drama* 15.1 (2006): 1–16.

Stoppard, Tom. *Arcadia*. London: Faber, 1993.

Mean Girls
A Metamorphosis of the Female Math Nerd
KRISTIN ROWAN

The more our female math students are exposed to women role models — role models who can show them not only that women can "do math" but also that their feminine identities need not be viewed as a liability — the more they are likely to view math environments as places where they can belong and succeed.
— Emily Pronin

Math class is tough!

— *Teen Talk Barbie*

Introduction

For many people, describing someone as a "nerd" conjures up images of such pop culture characters from the 80s as Arthur Poindexter from *Revenge of the Nerds*, Brian Johnson from *The Breakfast Club*, the nameless "geek girl" from *Sixteen Candles*, and Patty Greene from *Square Pegs*. What physical traits do these characters have in common? Glasses, pockets filled with pens, faces with freckles or acne, greasy or frizzy hair, and dowdy clothes. Personality-wise, they're reflected as shy, insecure, and socially inept. These nerds are smart, though — they get good grades, and have academic prowess that should, by all rights, be seen as enviable — yet they're represented as undesirable outcasts who exist on the lowest level of social hierarchy. It's this stereotype that set the tone for how nerds would be represented in film from that point onward.

Fast-forward to 2004 and the under-the-radar movie *Mean Girls*, penned by comedienne Tina Fey and based on Rosalind Wiseman's non-fiction parental self-help guide *Queen Bees & Wannabes*, an investigation of the nasty underbelly of the world of teenage girls. Fey's protagonist, Cady Heron (Lindsay Lohan), represents a modern-day take on the female "math nerd." Cady doesn't look or act the type fostered by pop culture to date. She's a new breed of nerd: pretty, with long flowing red hair and hip clothes, she exudes self-confidence, is socially adept, and is unafraid to approach new people and situations. Thus, *Mean Girls* attempts to shift societal perception and provide girls with a positive female role model who successfully embraces her "inner nerd" and blossoms as a result.

Since role models don't typically come into being without some form of a struggle, Fey places Cady in the very complicated and, at times, brutal world of teenage politics, and

187

shows us how challenging it can be to be an individual amid intense pressure to conform. Cady may look like the stereotypical popular, pretty girl on the outside, but she's also a smart math girl on the inside. She quickly realizes that people — particularly girls — who excel at math are not seen in a positive light; in fact, her peers inform her that any association with math is actually "social suicide." The articulation of this belief in a modern day movie shows us that the nerd stereotype has, unfortunately, lived on. Cady's exposing herself as a nerd would be akin to her wearing a socially-stigmatizing scarlet letter "N." Moreover, Cady has another prejudice that she must battle as a female: namely, the widespread belief that girls aren't "good" at math like their male counterparts — especially not *pretty* girls who are supposed to be known for their looks and *not* for their intelligence. Many people believe that one must sacrifice femininity in favor of demonstrating more gender-neutral or masculine traits in order to be accepted and garner respect in what has been a predominantly male field for many years; this belief contributed to the birth of the cliché female nerd who is deemed unattractive and socially undesirable.

In 1992, Mattel released their line of *Teen Talk Barbie* and stirred up controversy when, as one of her 270 phrases, Barbie lamented "Math class is tough!" (Other notable and seemingly vacuous phrases Barbie exclaimed included "Will we ever have enough clothes?"; "I love shopping!"; and "Wanna have a pizza party?") In response, the American Association of University Women protested that the math lamentation was demeaning to women and that it exacerbated the already-present lack of female mathematical confidence that has led to lower representation in the field. Mattel responded by stating that each doll was programmed to say four out of 270 possible phrases, so no two dolls were likely to be the same, and offered to exchange the doll if customers desired. Three months later, the doll was permanently pulled from the shelves as a result of the controversy.

Cady is faced with a choice that serves as the impetus for her journey to self-discovery: should she downplay the "girly girl" so she can be the math nerd, or should she forego the math nerd role and embrace *Teen Talk Barbie* mentality, thereby locking in acceptance and popularity with boys and girls alike? Her self-discovery is only achieved though the realization that she actually doesn't need to hide or sacrifice being either the math nerd *or* the girly girl in order to be accepted and respected by both her fellow math nerds and the high school's "popular crowd." Enter Cady, the Female Math Role Model. The reality is that girls can be feminine and pretty *and* excel at math; there is no need to make a choice when these characteristics can harmoniously co-exist.

The Departure

At the start of the movie, we see Cady preparing for her first day in a public high school after having been home-schooled while living in Africa. We're presented with a wholesome and attractive teenage girl who appears unaffected by first-day jitters and proceeds nonchalantly into her day — that is, until she walks into her calculus class, where she cheerily greets a fellow student and receives a blunt, "Talk to me again and I'll kick your ass!" Such is Cady's introduction to the high school social scene. From this point forward, she endeavors to acclimate to an environment that's foreign to her and that erodes her self-confidence. We observe Cady's bewilderment as she tries to make sense of social cliques' territories within the cafeteria, and ultimately ends up eating her lunch in a bathroom stall.

On her second day in school, much to her relief, she finally finds friends in Janis (Lizzy Caplan) and Damian (Daniel Franzese). It is no accident that she makes these friends in math class, nor that a great deal of the film's later plot unfolds there: math is Cady's world, and she seems most comfortable when she can approach day-to-day problems in a very logical, analytical fashion. Math is how she thinks and who she is. When a puzzled Damian asks her why she likes math so much, she replies: "Because it's the same in every language." To which a visibly impressed Damian says, "That's beautiful. This girl is deep!" It's clear that while he may not understand her way of thinking, Damian is in awe of Cady and respects her. While her life outside of math class is fraught with turmoil and confusion, Cady's world makes sense and becomes stable as soon as she walks through the classroom door. She says, "By eighth period, I was so happy to get to math class. I mean, I'm good at math. I understand math. Nothing in math class could mess me up."

The people she meets in math class become her truest friends. Janis and Damian, "art freaks," are outsiders themselves; they embrace their individuality and, seeing Cady as a fellow outsider (a "math freak," if you will), take her under their wings. Cady's math teacher, Ms. Norbury (Tina Fey), on the other hand, is the epitome of a positive female role model in mathematics; she is essentially the adult version of the teenaged role model that Cady becomes by the end of the movie. Like Cady, she's pretty, with dark hair, a trim figure, and smart-but-sexy glasses; she has a confident ease about her. We learn that she has successfully navigated through a divorce and its accompanying hardships, and are encouraged to see her as both strong and resilient. As Cady's first few school days progress, we also discover that Ms. Norbury has a warm, almost maternal relationship with her students. She zeroes in immediately on Cady, both sensing the latter's vulnerability as a new student, and recognizing her as a mathematical talent. She encourages Cady to join the "Mathletes" (the school's math team), and Cady happily complies; it's clear that mathematics provides a safe haven for her, a comforting place in which she feels stable, confident, and happy.

The Meeting with the Goddess

Cady is introduced to the environment outside of this safe "math class world" when she catches a glimpse of the "Plastics" for the first time. As Cady watches three pretty girls make their way outside for gym class, Damian informs her that "they're teen royalty ... if North Shore were *Us Weekly*, they would always be on the cover." The Plastics are comprised of Karen Smith (Amanda Seyfried), whom Damian laughingly describes as "one of the dumbest girls you will ever meet ... she asked me how to spell 'orange'"; Gretchen Wieners (Lacey Chabert), who "knows everything about everyone ... that's why her hair is so big, it's full of secrets"; and most importantly, the Plastics' fearless leader, Regina George (Rachel McAdams). When we see Regina for the first time, she's carried onto the football field by a retinue of cute guys, smiling sweetly and blowing a kiss to them as they gently place her on the ground. As Damian wistfully tells Cady, "Evil takes a human form in Regina George. Don't be fooled, because she may seem like your typical selfish, backstabbing, slut-faced ho-bag. But in reality, she's so much more than that. She's the queen bee. Those other two are just her little workers." (The savvy reader might note that Regina lives up to her name, which means "queen" in Latin, Italian, and Romanian.)

Just as Damian was impressed with Cady's "deepness" earlier in the movie, Cady is visibly in awe of these three girls. And she's not alone: it's clear that Regina's fellow classmates both revere and fear her. She features prominently in student gossip: "I hear her hair is insured for $10,000"; "I hear she does car commercials — in *Japan*"; and disturbingly enough "one time, she punched me in the face — it was *awesome!*" As Cady gazes at the Plastics from afar, Janis tells her not to worry because "you'll get socialized all right, a little slice like you." Cady seems puzzled by this statement, so Janis clarifies by telling her she's a "regulation hottie." At this point, we may rightly ponder when we last heard of a math nerd described in these terms; where are her glasses, her acne, her frizzy hair and dowdy clothes? Is it possible that a nerd might actually be *attractive?* It is clear from Cady's response that the idea of being a "hottie" hadn't even occurred to her; she is still a wholesome, clean-cut girl who has been unaffected by such stimuli outside of mathematics ... until now.

Cady's education in high school politics continues as Janis presents her with a map illustrating the division of North Shore's cafeteria into social cliques' turfs. (We have an immediate flashback to Cady's first day and recall how ill at ease she was while trying to figure out where to eat lunch.) Who you *are*, apparently, is *where you sit*, as Janis explains, enumerating the student body's various cliques: "Freshmen; ROTC guys; preps; JV jocks; Asian nerds; cool Asians; varsity jocks; unfriendly black hotties; girls who eat their feelings; girls who don't eat anything; desperate wannabes; burnouts; and sexually active band geeks." In this scene, the line between what constitutes "nerd" and "cool" is firmly drawn: the boundary is absolute. The Plastics, recognized as the ruling class in North Shore hierarchy, have their own table from which they survey their domain.

When Cady, on her way to sit with Janis and Damian at the "art freak" table, is harassed by a teenage boy (who is clearly attracted to the pretty new girl from Africa), she finds herself unexpectedly rescued by Regina George. Cady is relieved and impressed as she watches Regina serve up the verbal equivalent of a body slam: "You do *not* come to a party at my house with Gretchen and then scam on some poor, innocent girl in front of us three days later ... she's *not* interested ... so you can go shave your back now." As the boy slinks off, Regina smiles sweetly at Cady and the viewer — though Cady is oblivious to it at this point — gets the sense that while Regina's exterior is attractive, her interior is not.

When Regina offers Cady a coveted seat at the Plastics table, Cady is baffled by the invitation — it's clear to her that most people would not be welcome there. Flattered, she accepts, after only a moment's hesitation. As introductions are made, Regina tells Cady, "You're, like, *really* pretty." Cady blushes and thanks Regina, who smiles at her and says, "So you agree?" Cady finds herself in an unfamiliar lose-lose scenario: if Cady says yes, she might be seen as snobbish and overly confident; if she says no, she might be seen as insecure and unworthy of such attention from the Plastics — not to mention that she'd be disagreeing with their ruler. Confused by this double-edged maneuver, she tries to make sense of a situation that she's not able to logically reason her way through. She may *look* like a Plastic, but she's really a math nerd under her Plastic-approved exterior.

After lunch, it's evident that Cady has passed her first test with the Plastics; she's displayed the right balance of self-confidence (showing that she is Plastic-worthy), and wide-eyed reverence (implying that she is not a threat). Cady is seen as a malleable girl whom the Plastics can reshape in their own image. They invite her to eat lunch with them for the rest of the week. Janis, amused, urges her to accept the Plastics' invitation and to report

back to her all of the supposed hilarious, juicy details of Plastic life. Cady agrees to go along with Janis' scheme; her transformation has begun.

As Cady becomes immersed in the Plastics' world, she seems overwhelmed by its details and nuance; she observes that, "Having lunch with the Plastics was like leaving the actual world and entering 'girl world.' And 'girl world' had a lot of rules." She senses that if she doesn't conform to the Plastic's fashion rules (Gretchen solemnly tells her, "If I were wearing jeans today, I'd be sitting over there with the art freaks!"), she will be exiled from the Plastics' table. It appears that pretty, all-powerful Regina George has the ability to make or break her peers' social standings.

The subject of math unexpectedly comes up one day at lunch. Regina is about to eat a nutrition bar and wants to know what percentage of its calories come from fat. Knowing that the bar contains 120 calories, 48 of which are from fat, she asks her coterie for help:

> GRETCHEN: Well, 48 into 120?
> CADY: It's 40 percent. 48 over 120 equals x over 100 and then you cross-multiply and get the value of x.
> REGINA [staring at Cady with a strange look of mild shock and disgust]: Whatever. I'm getting cheese fries.

Without realizing that it may have social ramifications, Cady has revealed her math ability—and been summarily dismissed. Regina's negative reaction is, in itself, a stereotypical knee-jerk response to mathematics and to the people who are good at it. In the Plastics' world, "cool people" don't go around rattling off mathematical equations; they chitchat about cute boys and about what color clothing they should wear on a given day of the week. Cady's pretty exterior wins out, though; Regina appears to quickly dismiss any suspicions of Cady because the latter's appearance has her convinced that she's *one of them*.

The Road of Trials

As Cady becomes more assimilated into the Plastics, she begins living two lives: one in which she is popular and pretty, the other in which she is a math nerd. At North Shore, the Plastics represent all that is pretty and feminine and the Mathletes represent all that is intelligent and logical: what we have is a classic case of beauty (cool) vs. brains (nerd). The cool and nerd types simply do not mix, and it becomes clearer as the movie progresses that trying to unite them or establish a middle ground may have negative consequences. To be accepted into the Plastics, Cady is expected to adopt *Teen Talk Barbie*'s mindset: "regulation hotties" just don't do *math*—in fact, they opt for cheese fries when presented with a basic mathematical problem. When Cady informs the Plastics that she's joined the Mathletes, she receives horrified looks from all three girls: "You *cannot* do that! That is *social suicide*! Damn, you are so lucky you have us to guide you!" Cady is torn over how to handle the negative feedback: her love for math fights against the pull of the glittery, feminine Plastic world.

But, not surprisingly, there's a dark underbelly just beneath that glitter. The Plastics introduce her to their "Burn Book," a pretty, pink book they've created in which they write down nasty rumors about their peers. (Interestingly, most of the rumors are about *female* classmates.) As the girls flip through the book, Cady sees Janis' picture; underneath it is

written: "Janis Ian — dyke!" Cady chooses to preserve her social standing and not defend Janis. And when the Plastics ask about the guy in the background of Janis' picture, Cady identifies him as Damian, jokingly repeating the teasing description Janis used when introducing them: "He's almost too gay to function!" Regina laughs and tells them to write that down in the book, and Cady thinks to herself, "Oh no, maybe that was only funny when *Janis* said it?!" She has been presented with an opportunity to pick a side, but remains silent, not wanting to alienate herself from the Plastics by aligning herself with her nerd friends.

Cady successfully manages to straddle the line between both worlds ... at least until she finally talks to the oh-so-cute and popular Aaron Samuels (Jonathan Bennett) in math class. She's gazed at the back of his head since her first day in class, and she's in full-on teenage crush mode by the time she gets up the nerve to speak to him. Her confidence is visibly bolstered by her new feminine Plastic-styled clothes, accessorized with fluttering eyelashes and pouting lips bathed in lip gloss. She purposely dumbs herself down in an attempt to get Aaron's attention (the parenthetical remarks are in Cady's internal dialogue).

CADY: (So I followed my instincts.) Hey, I'm totally lost. Can you help me? (But I wasn't lost.)
AARON: Yeah.
CADY: (I knew exactly what Ms. Norbury was saying.)
AARON: It's a factorial, so you multiply each one by n.
CADY: (Wrong!) Is that the summation?
AARON: Yeah, they're the same thing.
CADY: (Wrong! He was so wrong!) Thanks, I get it now.

Cady not only represses her math nerd side, she also lies in pretending she doesn't know the answer when she really does. She believes that the helpless, "dumb" female has more appeal with males than smart but nerdy girls, and she is not alone in this belief. Danica McKellar, a well-known actress[1] who has since become an author and mathematical education advocate (*Math Doesn't Suck, Kiss My Math*), observes: "The message [girls] are getting ... is: It's really cool to be dumb. Look at Jessica Simpson. She's famous for being dumb. I guess it started with Marilyn Monroe, and she actually wasn't that dumb, but that's how she was perceived — and that's what got popular" (Rowe 1).

Unfortunately, Cady finds out from Gretchen and Karen that Aaron is Regina's exboyfriend — and in girl world, it's against "girl rules" to date your friend's ex-boyfriend (or as Gretchen exclaims, "It's, like, against the rules of *feminism*!"). Still, Cady finds it hard to resist flirting with Aaron, and is thrilled when Aaron invites her to his house for a Halloween party (a sure sign that she's part of the "in-crowd"). In a telling move, Cady ditches a Mathletes meeting to go home and make a costume for the party.

We get our last glimpse of Math Nerd Cady when she shows up for Aaron's party as a self-described "ex-wife zombie bride"; she admits that she didn't understand that Halloween is an opportunity for girls to freely "dress like ... slut[s]." She walks uneasily through the party, watching the Plastics work their feminine magic on the mostly male party crowd. During the course of the night, Regina finds out that Cady has a crush on Aaron, and promises to put in a good word for her with him; however, her real intent is to re-claim him for herself. When Cady discovers Regina's true game plan, she becomes infuriated. The queen of the Plastics has used her looks and her femininity to trump the nerdy girl. From this point forward, what started out as a lark with Janis turns into a full-fledged plot to

destroy Regina. Whether she consciously realizes it or not, Cady has essentially "gone to the dark side" by determining to out–Regina even Regina herself.

Conferring with Janis on the perfect revenge, they concoct a plan to sabotage Regina's re-established relationship with Aaron. Determined to lure Aaron away, Cady continues to play dumb in math class, but realizes it will be hard to convince him that she's not good at math if she continues to get high test scores. So Cady decides to step it up a notch: "If I was going to keep this going, I was *really* going to have to commit." She purposely bombs her next test, and plays the exasperated flirt when Aaron asks her how she did, batting her eyelashes and suggesting to him that, *perhaps*, she might need a tutor. (As Barbie says, "Math class is tough!") Ms. Norbury becomes increasingly concerned with Cady's declining performance in class, recognizing its root cause. In handing Cady her test back with a big, red D on it, Ms. Norbury frowns and sighs heavily, "*Not your best!*"

Cady is soon beyond the point of no return, unable to extract herself from her Plastic persona, and consequently loses sight of herself. Her classmates speak of her with the same awe and admiration with which they used to gift Regina: "That Cady girl is hot. She might even be hotter than Regina George!" Even Cady herself seems aware of her transformation; she points out in her internal narrative, "I had learned how to control everyone around me." Determined to become the pretty Plastic girl, she begins to purposely fail her math tests; then, in response to Ms. Norbury's proffered help — she tells Cady, "I'm going to push you because I know you're smarter than this" — Cady becomes angry and makes an entry in the Burn Book that twists Ms. Norbury's words, implying that she is a drug-dealer. No longer appealing or admirable, Cady seems to have lost her ethical center.

As Cady's ethical status sinks, her social status continues to rise, and she decides to throw a party at her house while her parents are out of town. But underneath her shiny exterior, the true Cady still resides. During the party, she drunkenly "comes clean" with Aaron about her real math ability:

CADY: I pretended to be bad at math so that you'd help me, but the thing is ... I'm not really bad at math. I'm actually really good at math. You're bad at math! Anyway, so now I'm failing!

AARON: Wait, so you're failing on purpose? That's stupid!

Cady immediately begins to backtrack, sensing even in her drunken state that she may have taken her Plastic persona just a bit too far; Aaron is not impressed by a smart girl pretending to be dumb. By the end of the night, Cady loses Aaron, Regina discovers part of Cady's sabotage plan, and Janis finds out that Cady ditched her art show to host her party. Cady is exposed as a phony and a fraud, and her ultimate descent into the role of social outcast has begun.

The next day at school, Regina exacts her own form of revenge against Cady by exposing the Burn Book to the school principal, making it look as if Cady, Karen, and Gretchen are its sole authors because their pictures are the only ones *not* in the book: Regina has set them up by pasting her own picture in the book, with the caption "fugly bitch." When Regina posts copies of the Burn Book's pages throughout the school, all hell breaks loose amongst the junior girls, causing the principal and Ms. Norbury to stage an intervention. When in the midst of other confessions of girl-on-girl crime Janis exposes her and Cady's plot against Regina, Regina storms out of the school, and Cady follows her, apologizing, prompting Regina to retaliate with, "You know what people say about *you*? They say you're a less hot

version of *me*!" It is intended as a put-down, but to Cady it is an epiphany: she has been recreating herself in Regina's image, rather than being true to her own nature. She's been pretending to be someone else all along.

Master of the Two Worlds

The next day, Cady endures a particularly painful freeze-out from her classmates; in her efforts to fit in she has alienated herself and become a social pariah. Thus, Cady is forced to recognize what she has become in sacrificing her individual identity in order to fit in — Regina. This marks a turning point for Cady as she begins to realize that she must shed her Plastic persona if she is going to reclaim her individuality and rehabilitate herself. Her redemption begins when, in front of her math classmates, she finally owns up to the drug pusher allegation from the Burn Book, clearing Ms. Norbury's name. As Cady turns in a math quiz, Ms. Norbury announces that she knows the perfect way for Cady to make it up to her: she should participate in an upcoming Mathletes competition. She earns an A on the quiz, and Aaron teasingly tells her, "Welcome back nerd!"

As the majority of the junior class prepares for their annual Spring Fling dance, we see Cady donning her math competition outfit, which includes a customized Mathletes prep shirt. Gone are her Plastic-approved short skirts, tight tops, perfectly-coifed hair, and loads of lip gloss; Cady looks like herself again. As the North Shore Mathletes go head-to-head with competitors from rival high school Marymount, both teams solve math problems quickly and confidently, leading to a tie. Each team then chooses the sole girl on the opposing team — supposing her to be its weakest link — to compete in the tie-breaking challenge. Cady goes up against Marymount's Carolyn Krafft (Clare Preuss), who is a stereotypical female math nerd: "Miss Carolyn Krafft seriously needed to pluck her eyebrows. Her outfit looked like it was picked out by a blind Sunday school teacher ... and she had some 99¢ lip gloss on her snaggletooth." But as the tie-breaking question is revealed,[2] Cady realizes that making fun of Carolyn's appearance wouldn't stop the latter from beating her in the competition. As Cady says: "Calling somebody else fat won't make you any skinnier. Calling someone stupid doesn't make you any smarter. And ruining Regina George's life definitely didn't make me any happier. All you can do in life is to try to solve the problem in front of you." "Try to solve the problem in front of you" ... an approach to which someone with mathematical abilities would certainly relate. With this realization, Cady re-establishes herself *as* herself, someone finally comfortable in her own skin, but with a level of humility and wisdom earned during her journey towards self-realization. Carolyn ends up incorrectly answering the tie-breaking question; Cady gives the correct answer and wins the competition for North Shore.

Although Cady's inner transformation is complete, in the eyes of her peers she is still a Plastic. As she enters the dance at North Shore, the principal announces that her peers have elected her, the new Regina, to be the Spring Fling Queen — she's the school's new golden calf. In order to truly redeem herself, Cady must broadcast her self-realization to the wider community and, in effect, transform that community's perceptions — not just of her, but of itself. She publicly apologizes, stepping down from her social pedestal and redirecting the audience's attention to its own members:

> To all the people whose feelings got hurt by the Burn Book, I'm really sorry. You know, I've never been to one of these things before and when I think of all the people who wanted this [crown] and how many people cried over it and stuff ... I mean, I think everybody looks like royalty tonight.... Look at Jessica Lopez. That dress is amazing. And Emma Gerber, I mean, that hairdo must have taken hours, and you look really pretty.

She even attempts to restore a measure of human dignity to Regina George — who has been, in one of the movie's most startling moments, hit by a bus — stating: "She fractured her spine, and she still looks like a rock star."

As Cady makes these observations, she begins to break up her crown and distribute pieces of it to the audience in a gesture that is clearly meant to unite them all in the sharing of an object that is ordinarily divisive; she's figuratively leveling the social playing field.

In watching this scene, we may well wonder when we last saw a math nerd actually being the belle of the ball; nerdy girls are the wallflowers standing in the corner with their ill-fitting dresses and bad makeup, waiting for a guy — any guy — to ask them to dance. Here stands Cady, beautiful in her Mathletes prep shirt, not only graciously accepting the Spring Fling crown, but sincerely apologizing to her classmates for her past behavior. The real Cady Heron has finally stood up. As she puts it: "[She] had gone from home-schooled jungle freak to shiny Plastic to most hated person in the world to actual human being."

The message this sends is a simple and positive one: be true to who you are and know that you are a valuable, worthwhile person, regardless of how you're perceived by others and of the social group to which you belong. By ultimately choosing her own path as an individual rather than remaining a clone of the type of girl she thought was desirable, Cady has established herself as a positive female role model; like Ms. Norbury, Cady is now confident in her ability to be simultaneously nerdy and feminine.

The Ultimate Boon

This is something with which Tina Fey, herself, has had personal experience, having garnered public popularity and respect by not downplaying her intelligence just because she happens to also be pretty: "I think, in terms of [*Mean Girls*], I was somewhere in between the characters of Janis and the Mathletes. I was just kind of a, well, not a Mathlete, I was sort of an AP nerd and just hung out with my own nerd friends" (Otto 1). While her long-running role as a fake newscaster on *Saturday Night Live* launched her into the spotlight, it was writing the screenplay for and starring in *Mean Girls* that propelled Fey into movie stardom. Other role models in Hollywood who embody the new breed of female nerd are finally starting to make their way into the public eye.

> [O]ver the past few years, there's been a quiet feminist revolution on television. The female nerd has arrived, and she's not interested in a makeover. It started with Willow on *Buffy the Vampire Slayer*, a computer geek who bagged a musician boyfriend without giving up computer hacking. Hollywood must have taken note of her popularity, because in the years since, the female nerd has taken off [Marcotte].

Examples of this new breed of Hollywood female nerd include Hermione (Emma Watson) from the *Harry Potter* film series, and Chloe O'Brian (Mary Lynn Rajskub) and Pam Beesly (Jenna Fischer) from the respective television series *24* and *The Office* (the American version). But progress has been slow: "If you want an indication of how much Hollywood fears female

characters that step (even slightly) outside of gender norms, look at the dearth of female nerds on the big screen.... We can hope that Hollywood will get over this skittishness" (Marcotte).

This reflects a greater issue: the pressure which faces many real girls in typically male-dominated "nerd" fields, such as mathematics. In particular, girls often either don't believe that they're innately capable of doing well at math because they're female, or, if they excel at math, they feel they need to pick sides, so to speak, and either be a girl or be a nerd. Recent studies have shown that having a positive female role model, like Ms. Norbury, as a math teacher helps bolster girls' confidence, and the lack of such a teacher hurts them:

> Young students tend to model themselves after adults of the same sex, and having a female teacher who is anxious about math may reinforce the stereotype that boys are better at math than girls, explained Sian L. Beilock, an associate professor in psychology at the University of Chicago ["Girls' Math"].

McKellar emphasizes the importance of encouraging girls at an early age to succeed in mathematics:

> I had done quite a bit of research about math education when I spoke before Congress in 2000 about the importance of women in mathematics. The session of Congress was all about raising more scholarships for girls (in math) in college. I told them I felt that it's too late by (the time they get to) college. If you look at the stats, girls start losing interest in math and grades start dropping in middle school. That's where you have to put the money [quoted in Rowe 1].

When women enter college, the challenge continues:

> Studying undergraduates enrolled in an introductory calculus course, the researchers discovered women possessing strong implicit gender stereotypes and likely to identify themselves as feminine performed worse relative to their female counterparts who did not possess such stereotypes and who were less likely to identify with traditionally female characteristics. The same under-performing females were also the least inclined to pursue a math-based career ["Stereotypes May"].

Once they leave the university environment, women have similar issues to face in the workplace:

> A recent Center for Work-Life Policy study found that 52 percent of women leave [science and engineering] jobs, with 63 percent saying they experienced workplace harassment and more than half believing they needed to "act like a man" in order to succeed. In the past, women dealt with that reality in two ways: some buried their femininity, while others simply gave up their techie interests to appear more feminine [Bennett 2].

And even women who pursue mathematics in an academic setting don't seem to be exempt. In 2005, Harvard President Dr. Lawrence Summers suggested that innate differences between men and women might be one reason fewer women succeed in science and math careers:

> It does appear that on many, many different human attributes — height, weight, propensity for criminality, overall IQ, mathematical ability, scientific ability — there is relatively clear evidence that whatever the difference in means — which can be debated — there is a difference in the standard deviation, and variability of a male and a female population [Perry].

Like *Teen Talk Barbie*, Summers' remarks inspired public controversy:

> Melissa Franklin, a physics professor, said she wished that Harvard had "a president who can add something positive rather than something negative." And while she didn't call for Summers to resign, she said his remarks constituted "a resignable thing."

"The biggest problem with female science students is confidence," Franklin said. "When they are sitting there constantly saying, 'Am I smart enough? Am I smart enough?' it doesn't really help when the president of the university says, 'Maybe you're not'" [Bombardieri].

Perhaps the good news in all of this is that these issues have finally found their way to the surface. As a result, we are starting to see more of the new generation of female nerds:

Society's pressures have created a new ideal female. Nerdiness — caring about school — is now mandatory for the cool female, along with the typical desired traits of attractiveness and sociability. Instead of the movies' airhead cheerleader as the popular campus queen, in the modern day, the admired female is smart, concerned about school and active in achieving her success [Theis].

Moving forward, female role models — be they in Hollywood or in the real world — will continue to play a key role in breaking down stereotypes. Today, there is increasing optimism that the motto adopted by the "Nerd Girls," a group of female Tufts University engineering students, will eventually become the societal norm:

"Brains are beautiful. Geek is Chic. Smart is sexy. Not either/or."

Notes

1. McKellar is most famous for her role of Winnie Cooper on the popular television series *The Wonder Years* (1988–93).

2. This question actually contains a specifically mathematical linguistic error. The Mathletes are asked to find "the limit of [an] equation," but in fact they are meant to find the limit of an *expression*. Equations involve equals signs, and it is clear that no equals sign is present in the displayed mathematics. The concepts of "equation" and "expression" are often conflated by those unfamiliar with or new to the study of mathematics.

Works Consulted

"About the Nerd Girls." *The Nerd Girls*. Nerd Girls, Inc., n.d. Web. 1 Oct. 2010.

Bennett, Jessica. "Revenge of the Nerdette." *Newsweek*. Harmon-Newsweek, 7 June 2008. Web. 1 Oct. 2010.

Bombardieri, Marcella. "Harvard Women's Group Rips Summers." *Boston.com*. NY Times Co., 19 Jan. 2005. Web. 1 Oct. 2010.

"Girls' Math Fears May Start with Female Teachers." *MSNBC.com*. MSNBC.com, 25 Jan. 2010. Web. 1 Oct. 2010.

Marcotte, Amanda. "Rise of the Female Nerds." *The American Prospect*. The American Prospect, Inc., 13 Apr. 2010. Web. 1 Oct. 2010.

Mean Girls. Dir. Mark Waters. Perf. Lindsay Lohan, Rachel McAdams, Tina Fey. Paramount Pictures, 2004. DVD.

Otto, Jeff. "IGN Interviews Tina Fey." *IGN.com*. IGN Entertainment, 23 Apr. 2004. Web. 1 Oct. 2010.

Perry, Mark J. "Greater Male Variability: It's a Fact, But It Can Sometimes Be Deadly." *The American: The Enterprise Blog*. The American Enterprise Institute, 6 Jul. 2010. Web. 1 Oct. 2010.

Pronin, Emily. "Women and Mathematics: Stereotypes, Identity, and Achievement." *College Board AP Central*. The College Board, n.d. Web. 1 Oct. 2010.

Rowe, Aaron. "Math Book Helps Girls Embrace Their Inner Mathematician." *Wired.com*. Condé Nast Digital, 2 Aug. 2007. Web. 1 Oct. 2010.

"Stereotypes May Affect Female Math Ability." *PhysOrg.com*. PhysOrg.com, 24 Jan. 2007. Web. 1 Oct. 2010.

Theis, Sophie. "The New Female Nerd and the 'Gender Gap.'" *WireTap*. WireTapMag.org, 22 Jul. 2006. Web. 1 Oct. 2010.

The Mathematical Misanthrope and American Popular Culture

Kenneth Faulkner

> The problem with stereotypes is not that they are untrue, but that they are incomplete. They make one story become the entire story.
>
> — Chimamanda Adichie, Nigerian Novelist
>
> You *never* understand everything. When one understands everything, one has gone crazy.
>
> — Philip Anderson, 1977 Nobel Laureate, Physics

We all know that stereotypes are notoriously unreliable. Yet even the most liberal and open-minded among us still often cling, unthinkingly, to borrowed and shallow portrayals or fuzzy notions of particular "types" of people as we encounter various individuals in our day-to-day lives. For it remains true that, just as civilization requires at least some modicum of efficiency if it is to maintain social order, as individuals in a crowded, fast-paced world we often rely on our own private, internal, shorthand "readings" of others so as not to be burdened and slowed down by the thinking and insight that would be required were we to truly get to know every person we meet.

This leaves us with a sobering and unavoidable reality: each of us walks through the world, every day, subconsciously assuming that we know much more about the people around us than we actually do. Although stereotyping is usually thought of in terms of race, religion, nationality, or sexuality, it has historically also been applied in relation to occupation (with its obvious, inherent link to class). And no other profession has been stereotyped in quite the same way as that of the mathematician.

My purpose in this essay is twofold: first, I will briefly review some of the supposed characteristics of the stereotypical "mathematical" personality — which, for the sake of convenience and consistency, I will refer to as the "Mathematical Misanthrope" — by taking a cursory look at some of those characteristics as reported in the behaviors of several prominent mathematicians throughout history. Doing so will provide an opportunity to briefly speculate as to how the stereotype may have evolved and why it persists. Second, I will examine how that stereotype was inflected through the lens of American popular culture via the media's portrayal of two recent mathematicians whose fame has spread well beyond the boundaries of the academy, for reasons that have little to do with mathematics.

There have always been some individuals, no matter what their occupational calling,

who exhibit eccentric characteristics or behavior that is outside of the mainstream. But for some reason the perception has long been that mathematicians are particularly prone to such eccentricities. Granted, there is plenty of evidence to support this perception. History, both ancient and modern, is rife with examples of bizarre behavior exhibited by mathematicians. Archimedes, who is generally considered the greatest mathematician of the ancient world, famously did his most brilliant work in the bath. During the Roman invasion of his home city of Syracuse, he "told the Roman soldier who killed him while he was pondering geometry: 'Do not disturb my circles'" (Matthews and Lobastova 2). The nineteenth-century French mathematician Évariste Galois was a prodigy in his chosen field. At the age of fifteen he developed an insatiable interest in mathematics, and those around him began to notice a change in his personality "from being serious, open, and loving to taciturn and peculiar," "eccentric," and "bizarre" (Fitzgerald and James 92); he was arrested and imprisoned twice by the government for his opposition to the Crown. His brief and melodramatic life ended at the age of twenty in a duel, the exact circumstances of which remain a mystery to this day because the police records about it "were destroyed in the Paris Commune of 1871" (95).

One of Galois' predecessors and fellow countrymen, Augustin-Louis Cauchy, at times "forgot about something he had written earlier and published the same paper twice" (79). The twentieth-century American mathematician Norbert Wiener, one of the fathers of modern cybernetics, was so well-known for his absent-mindedness that the following joke became a staple among his mathematical peers: "It is said he once lost his way walking home from the Massachusetts Institute of Technology. He came across a small girl in the street and asked if she could give him directions. 'Yes, daddy,' she replied, 'I'll take you home'" ("Count" 604).

A variation of the same story was often told by those at Princeton University about Albert Einstein:

Someone once called the dean's office for directions. "How do I get to Albert Einstein's home?" the caller asked. When the man at the dean's office said he couldn't give out those directions, there was a pause on the other end. Then, a sigh, and a response: "This is Albert Einstein. I got lost walking home from the campus" [Blackwell].

And then there was the Austro-Hungarian Kurt Gödel, whose only close friend was Einstein. In fact, Einstein once said that he went to Princeton's Institute for Advanced Study every day "just to have the privilege of walking home with Kurt Gödel" (quoted in Fitzgerald and James 161). "They didn't want to speak to anyone else, explained a colleague; they only wanted to speak to each other" (162). Toward everyone else, Gödel was notoriously antisocial: "Gödel ... was a noted misanthrope, who shunned human contact at the Institute for Advanced Study in Princeton, preferring all colleagues to communicate via pieces of paper stuffed through the crack beneath the door of his office" ("Count" 604).

Throughout his life, Gödel suffered several mental breakdowns as well as two psychotic episodes that required hospitalization in a sanitarium. He was also a hypochondriac who made his wife taste his food before he ate it and who was so afraid of being poisoned by, for instance, gases escaping from his refrigerator that toward the end of his life he was sometimes in a state of semi-starvation (Fitzgerald and James 160–61). "When certain foreign visitors came to Princeton, he would not leave home, for fear that they might try to kill him" (161). He had a "prodigious intellect," yet "often exhibited a childlike naivety.... His favorite film was Walt Disney's *Snow White and the Seven Dwarfs*" (162).

More recent examples of the Mathematical Misanthrope can be seen in the attitude toward life and work demonstrated by German-Russian mathematician Alexandre Grothendieck, who once conducted a series of lectures in the forests around Hanoi while the United States was bombing the city as a protest against the Vietnam War (Pragacz 839n6), and by the Russian Grigori Perelman, who became the first person in history to decline the Fields Medal, the most prestigious honor in mathematics. Together, in fact, they have declined well over a million dollars in prize money for their various mathematical achievements.

Prudence dictates, of course, that we treat at least some of the many anecdotes about quirky mathematicians as apocryphal. And there have been thousands of lesser-known mathematicians, as well as quite a few famous ones, who have never displayed such eccentricities. But true or not, the persistence of such stories about mathematicians and the mathematically gifted points to the general public's underlying assumption that these individuals are somehow "different" from the rest of us, or, less generously, "weird." As the journal *Nature* put it in 2005:

> Despite — or perhaps, because of — such behaviour, the history of mathematics is probably more colourful than that of any other scientific discipline.... These tales are popular not just for their panache, but because they celebrate mathematicians as pure intellectuals who, unlike physicists, biologists or chemists, are untainted by applications of their work. For even though mathematics is eminently useful, its application barely features in its public reputation.... [M]athematics, this most theoretical of disciplines, has haplessly bungled its way into people's hearts ["Count" 604].

Indeed, by the middle of the first decade of the twenty-first century, even mathematicians themselves were willing to publicly recognize that their way of communicating with the rest of the world, and with each other, could use a little work. On July 12, 2005, "a select group of about 30 mathematicians, playwrights, historians, philosophers, novelists and artists descended on the Greek island of Mykonos" for a three-day "Mathematics and Narrative" conference, in order to discuss how "narrative approaches" — that is, storytelling — might "help the increasingly esoteric sub-fields of mathematics communicate with one another, ... help mathematicians frame the abstract problems that fill their working lives," and, in general, help mathematicians do a better job of explaining to the public exactly what it is that they do (Tomlin 622).

It is perhaps telling that in elucidating its aims within the wider cultural context, the organization behind the conference — called "Thales and Friends" after Thales, the legendary father of ancient Greek mathematics and philosophy — makes overt reference to the Mathematical Misanthrope in, ironically, the "Who We Are" section of its website:

> ...the rift between mathematics and the culture at large is there; it becomes glaringly obvious if we look at the huge distance between the work of contemporary frontier-of-knowledge mathematics and public understanding of the field. The caricature of the "absent-minded mathematician" is unfortunately not too far from the general culture's actual conception of mathematics as the realm of otherworldly solitary geniuses who alone have access to its esoteric secrets, secrets of little or no interest to the rest of the world ["Who We Are"].

"Caricature" is indeed an apt description of the picture "the general culture" draws of brilliant mathematicians when its sole source of information is popular media portrayals of such figures. Somewhere along the way, the Mathematical Misanthrope became so ingrained in America's (and the industrialized world's) collective consciousness that it devolved even

from stereotype to caricature, and became a trope which popular culture has been all too happy to exploit in news accounts, books, theater, and cinema.

Before proceeding further I should explain a little more specifically what I have in mind when I discuss the "Mathematical Misanthrope." This label denotes a very specific stereotype — that of the brilliant, but socially inept and eccentric, mathematician. It is far from scientifically derived; rather, it is simply shorthand for a ubiquitous — and often inaccurate — cultural perception. Our typical Mathematical Misanthrope is distinguished by the first, plus at least two of the following four, salient characteristics:

1. Mathematically brilliant (at the "genius" level).
2. Disdainful of— or oblivious to — authority, and most, if not all, authority figures and institutions.
3. Misanthropic. I should note here that by "misanthropic" I do not strictly mean the "dictionary" definition of the *misanthrope* as someone who hates or dislikes his fellow man. Not all Mathematical Misanthropes are "misanthropic" in this strict sense of the word; many get along quite well with other people when they want to, and most do not possess any kind of general, latent "hatred" of the human race. While some Mathematical Misanthropes do appear to intensely dislike their fellow human beings, I choose to give the word "misanthropic" a broader valence, meaning someone who is solitary; someone who does not like to be around other people (or is uncomfortable around other people); or someone who is simply lacking in conventional social skills (in other words, someone who is deficient in what might be more colloquially called "the social graces").
4. Somewhat disconnected or detached from what others think of as "reality" or "everyday reality."
5. Eccentric. The Mathematical Misanthrope's eccentricities typically manifest in a number of odd, unconventional behaviors, such as Gödel's periodic immaturity or childishness, Grothendieck's overt rebelliousness, Perelman's apathy toward others' opinions of him, or Wiener's and Einstein's ability to become so deeply lost in thought that they completely forget where they are for extended periods of time. One eccentricity that appears to be universal among Mathematical Misanthropes is hyper-rationality. They are often so hyper-rational that to others they appear to be *irrational*. The Mathematical Misanthrope's eccentricities may or may not be attributable to psychological or mental illness.

It would be difficult to define the Mathematical Misanthrope more specifically than that, for, like all stereotypes, it is a concept that is not rooted entirely in fact; rather, it is an amalgamation of behavioral tendencies and personality characteristics which can manifest in an infinite variety of combinations from individual to individual. Ultimately, the Mathematical Misanthrope is a loosely constructed signifier that has held together well enough over time to achieve the density or "critical mass" of meaning necessary to become a widely held cross-cultural concept which, when simplified, morphs into a global trope.

The roots of this conception of the mathematician as misanthrope are undoubtedly many and varied, as well as difficult (if not impossible) to trace, disentangle, and completely isolate, for they emanate from a cultural field of discrete, topical rhizomes that co-exist in close proximity to one another within the social sciences: the history of science, the evolution of human culture, and the creation and evolution of the modern consumer of popular media in industrial and post-industrial societies, to name a few. But one could probably safely argue that their origins may, at least in part, have something to do with the simple fact that throughout history, most people have had to scratch out their living with their hands — via some form of manual, physical labor — and mathematicians, whose vocation exists entirely within the realm of ideas and abstract thought, are, in *their* everyday pursuits, about as far

away from manual laborers as one can get. As Oxford University professor Marcus du Sautoy says, "You need a little bit of craziness to do mathematics, because [the world of mathematics] is such a weird world" (quoted in Matthews and Lobastova 2). It's an even weirder world, of course, to someone who has never had the inclination, opportunity, privilege, or ability to occupy such rarefied conceptual air. Thus the invention of the Mathematical Misanthrope also, one might presume, became a way for the rest of us mere mortals to cut these geniuses — who were and still are a bit frightening in their seeming ability to, as Einstein put it, "read the mind of God"— down to size: "Sure, he can think in four, or seven, or eleven dimensions, but he can barely dress himself and he doesn't know how to talk to anybody!"

At the same time, however, one can't help but think that something odd is afoot when so many leading lights in the same discipline consistently exhibit such apparently atypical behavior. The few relevant, reputable psychological studies that have been conducted do not yield conclusive results. One, conducted in 2006 by the biological anthropologist David Nettle, attempted to measure "schizotypy and mental health among poets, visual artists, and mathematicians, including twenty-six research mathematicians" (Fitzgerald and James 9). Simply put, *schizotypy* is a kind of "sliding scale" (as opposed to categorical) method used in assessing mental health. Rather than being put into a discrete, conceptual, categorical "box" with a label, each subject is placed on a continuum in accordance with his or her "propensity to loose and unusual thought"[1] (9). In the study, "Poets ... scored more highly than the general population, mathematicians less highly. As Nettle observes, this is consistent with a more autistic profile for mathematicians — strong and narrow interests and a high degree of focus. The mathematicians also came out as more introverted and less emotionally labile..." (9).

In another study, released in 1998, psychologist Simon Baron-Cohen and his colleagues surveyed 641 "science" (physics, engineering, mathematics) students and 652 English and French Literature students at Cambridge University regarding

> ... the incidence of a range of psychiatric conditions in their families [rather than] about their own mental health. Among the relatives of the science students, six cases of autism were reported; among the replies of the literature students, there was just one case. Twice as many cases of bipolar disorder were reported in the families of students studying literature; one hundred cases versus fifty in the families of science students. For other conditions there was not much difference [9].

This finding coincides with observations made by other psychologists indicating that in general, the incidence of autism and Asperger's syndrome is higher than average amongst gifted mathematicians and scientists, while the incidence of bipolar disorder is higher than average amongst writers and artists (xii).

But whatever the ultimate causes of the behaviors displayed throughout history by gifted mathematicians — and they likely involve a complex mixture of factors ranging from the purely biological to the socially conditioned — the fact remains that the Mathematical Misanthrope-turned-caricature-turned-pop-culture-trope morphed into its present form after a long historical presence in the global public consciousness. Let us now examine two recent examples of how popular culture in the late-twentieth and early twenty-first centuries employed that trope in its commoditization of the lives, experiences, crimes, and achievements of two mathematicians who took very similar journeys to very different destinations.

Born only fourteen years apart, both men were mathematical prodigies in their teens. One is from a working-class background, the other from a more middle-class one, but both

came from homes where books and learning were revered, respected and encouraged. One was born in the heart of urban America, in downtown Chicago; the other, in Bluefield, West Virginia, a railroad town nestled in the Blue Ridge Mountains that straddles the border between Virginia and West Virginia. Each, by his mid-twenties, was granted a Ph.D. from a top-ranking mathematics program (at the University of Michigan and Princeton, respectively). Both became tenure-track professors of mathematics at top-tier universities (Berkeley and MIT) by their late twenties, and each resigned his professorship in anger by the time he was thirty years of age (one at twenty-seven, the other at thirty). After resigning these posts, the one born in the city moved to the Montana wilderness, where he spent most of the next twenty-five years before losing his freedom; the one born in the mountains stayed in an urban setting, within an hour's drive of both Philadelphia and New York City, and spent most of the next twenty-five years in a much different kind of wilderness before *regaining* his freedom. One deliberately tried to destroy the techno-industrial society in which he lived, and ultimately landed in a federal penitentiary; there, he will end his days as a convicted murderer and domestic terrorist. The other inadvertently contributed to the perpetuation of the techno-industrial social order,[2] and after spending nearly half his life in a much different kind of prison — that of severe mental illness — miraculously managed to escape it. He will end his days as a respected genius, who overcame overwhelming odds in a long and lonely struggle to reclaim his professional reputation and win one of the world's most prestigious honors (the Nobel Prize).

Both men were notorious early in life for eccentric, misanthropic behavior that was later publicized and used by the popular media as a lens through which to attempt to gain a better understanding of their motivations and their brilliance; and finally and perhaps most significantly, each has been professionally diagnosed as a "paranoid schizophrenic."

Who are these men? They are two individuals who have become iconic for reasons that extend far beyond their respective reputations for mathematical genius: the serial killer and confessed "Unabomber" Theodore (Ted) J. Kaczynski, whose early promise as a brilliant mathematician and scholar was overcome by his hatred for behavioral psychology and technological society; and Nobel Prize Laureate John Forbes Nash, Jr., whose portrayal in Ron Howard's biopic *A Beautiful Mind* (2001) brought renewed attention to debates about how the popular media's depictions of psychiatric disorders (such as paranoid schizophrenia) influence and mediate our understanding of both mental illness and genius.

How do such seemingly similar, parallel lives diverge so drastically? What connections might we make between the extraordinary mathematical insight of these two figures, their eccentric behavior, and their respective journeys to "pop icon" status? And what role has the popular media played in making them larger-than-life celebrities? Answers to such questions are, of course, always going to be somewhat speculative. But they are worth seeking, since examining such questions within the context of current cultural mores and critical theory may help us gain some insight into the ways in which popular culture's depictions of the Mathematical Misanthrope both inform and misinform our reading of "genius."

The self-confessed Unabomber, Theodore J. Kaczynski, fit to a "T" the stereotype of the Mathematical Misanthrope from a very young age — and it worked against him at every turn. In his 2003 book, *Harvard and the Unabomber: The Education of an American Terrorist* (not simply a biography of Kaczynski, but a thoroughly researched, comprehensive, and thoughtful study of the familial, personal, and cultural forces that shaped him as a young

man and helped turn him into the Unabomber), Alston Chase paints a fascinating and detailed picture of the Cold War, 1940s and 1950s American culture in which Kaczynski grew to adulthood; of his blue collar upbringing; of his astonishing, early gift for mathematics; of his distant and demanding father (who, terminally ill with cancer, committed suicide in 1990); and of his vitriol and resentment toward his mother and brother.

As a boy, Kaczynski was just another "normal kid" in his neighborhood, until some of his friends started to get into trouble (Chase 161). Trying to be a "good boy," he separated himself from them and retreated into books and a life of the mind, becoming increasingly isolated and introverted. Not much later, his advanced intellect, quantified on a fifth-grade IQ test, reinforced adults' (and, in particular, his parents') notions of him as a "boy genius," the result being that what little attention and affection he *did* receive came from his excelling in pursuits (such as mathematical ones) that require, for success, isolation and solitude. It became a vicious spiral. In order to continue to do well intellectually and receive continued attention and praise as a "prodigy," Kaczynski found that he had to spend more and more time alone in study. This continued throughout high school — where he was the youngest in his class, having been promoted two grades ahead of his peers — and on into his undergraduate years at Harvard.

At Harvard, Kaczynski encountered a burgeoning "culture of despair" (Chase's term), thanks to the advent of the philosophy of positivism at American universities. Also, according to Chase, there were two specific incidents in Kaczynski's life that shaped the dark forces that ultimately drove him to murder; the first of these occurred at Harvard. At seventeen, Kaczynski manifested, in his attitude and behavior, the characteristics of the Mathematical Misanthrope to an extreme. Due to this, he was chosen to be a subject in a psychological study conducted by legendary Harvard psychologist Harold Murray — a study using human test subjects which, even by 1950s standards, was patently unethical. The study made such an impact on Kaczynski that among his papers, many of which were found in his cabin by the FBI at the time of his arrest, are copies of Murray's initial questionnaire and a scholarly paper that Murray ultimately wrote about his findings. Reading Chase's account of the incredible depth to which Murray probed each of his subjects — over three years, they were subjected to dozens of intense psychiatric tests, some of which were conducted under false pretenses and designed to induce high levels of stress — one gets the feeling that this was not an experiment, but a psychological rape.

This experience apparently left Kaczynski with indelible emotional and psychological wounds. He graduated Harvard as an alienated and angry young man and brought his rage to Ann Arbor, where he enrolled in the University of Michigan's prestigious doctoral program in mathematics. It was there that his second transformative experience occurred. One morning in the fall of 1966, having spent the previous night listening to a couple having sex in a neighboring apartment, Kaczynski briefly entertained the idea of having a sex-change operation, believing that only by becoming a woman could he ever touch one. He made an appointment at the university's health center, hoping to con a psychiatrist into approving the procedure. But while waiting for the consultation, "he suddenly realized what a self-destructive act he was contemplating" (Chase 305). Chase explains Kaczynski's subsequent epiphany:

> He had sought too hard to please others. Pressure from his parents, school authorities, and math department professors had brought him to the point of contemplating, literally, an act of self-

emasculation. The realization filled him with self-loathing. How he hated "the system" that had pushed him to this brink [305].

Kaczynski himself admits that this moment was a turning point in his life, for it was then that he pieced together the chain of reasoning by which he would justify to himself the act of murder.[3] Chase summarizes his thinking neatly:

> If trying hard to be good drove him to despair, his salvation lay in being bad! By obeying society's ethical standards, that positivism had taught him were subjective anyway, he had created a prison for himself. Freedom lay in throwing the rules away and not caring what other people thought. And throwing off the yoke of these moral scruples would allow him to do what he really wanted, namely, to take revenge on all those who had built this cage around him [306].

By the time Kaczynski left Michigan, he had decided to earn a professor's salary just long enough to make the money he needed to buy some land and move into semi-isolation. Then he would exact his revenge on the system that had treated him so poorly, packaging up his rage in boxes and mailing it across the country to some of the people he blamed for his misery. The Mathematical Misanthrope had resolved to become a murderer.

On January 22, 1998, after a long, intense, and controversial legal battle, Kaczynski confessed to being the infamous "Unabomber" who, during the seventeen years between 1978 and 1995, was responsible for sixteen bombs that killed three people and injured twenty-three others. His actions ensured that, first and foremost, he will always be remembered as a serial murderer. For anyone writing about Kaczynski, it is important to emphasize this point. Once one becomes familiar with the particulars of Kaczynski's life and his legal case, it is easy to understand why writers such as Chase and Vermont law professor and attorney Michael Mello — who have written what I believe to be the two best books about Kaczynski and the Unabomber case[4] — write as if they consider it their moral responsibility to point out the barbaric nature of Kaczynski's crimes and their personal repugnance toward them before delving into particulars: the allure of Kaczynski's intellect is so powerful, and the nature of his criminal activities so unique for their time, that it is easy to overlook just how chilling and vile the murders he committed and injuries he inflicted really were.

Kaczynski eluded the best minds and the most sophisticated technology that the most powerful government in the world was capable of employing, and he did so "right under the nose" of that government for seventeen consecutive years. The manhunt conducted to locate and capture him was the most extensive and expensive in the history of the FBI, and for the last three years of it the federal government's Unabomb Task Force offered a million-dollar reward for information leading to his capture and conviction (45). Just as stunning as his ability to avoid detection was his skill at manipulating and exploiting the popular media as a means of disseminating his message that "the industrial-technological system" that defines so-called "advanced" societies in the modern world cannot be reformed, and therefore must be destroyed before it completely enslaves humanity and human behavior (Kaczynski 5–6).

The relationship between Kaczynski and the media, and the media's haphazard and mostly inaccurate attempts to "capture" Kaczynski's personality and psyche for its mass audience, are instructive in any consideration of the Mathematical Misanthrope's ubiquity across American culture and power as an instrument of persuasion. On September 19, 1995, Kaczynski convinced two of the nation's most respected "establishment" newspapers (the *New York Times* and the *Washington Post*) to print, as a special supplement, his fifty-six-

page "manifesto" *Industrial Society and its Future*, written and published under his pseudonym "FC" (for "Freedom Club"). He did so by promising to halt his bombing campaign immediately if they complied. The manifesto's opening sentence (and premise) — "The Industrial Revolution and its consequences have been a disaster for the human race" (5) — slammed head-on into the developed world's cultural conversation with such force that Kirkpatrick Sale wrote in *The Nation* that Kaczynski's argument "is absolutely crucial for the American public to understand and ought to be on the forefront of the nation's political agenda" (quoted in Chase 87). The international reaction to the essay was immediate and, while some criticized it as, for example, "a long, tedious screed" and "a diatribe" (quoted in Chase 88), many others were surprisingly sympathetic: "'I've never seen the likes of this,' observed Michael Rustigan, a criminologist specializing in serial killers. 'Numbers of people … seem to identify in some way with him'" (quoted in Chase 87).

For many people at the time, the manifesto further enhanced a popular perception of the Unabomber — largely generated and perpetuated by the mainstream media — as a modern-day, romantic outlaw or folk hero, a mysterious enigma with a world-saving agenda. As Robert Wright wrote in *Time* magazine in 1995, "There's a little bit of the Unabomber in most of us" (quoted in Chase 32). This only added to the public shock once the Unabomber was finally arrested and identified as a fifty-four-year-old, unkempt and dirty recluse who lived in an area of the country that most people considered to be remote wilderness. Once America realized that the Unabomber had been acting alone all along, that he had been a brilliant mathematician, and that he lived in primitive conditions, its perception of him shifted — even before he ever stood in front of a judge — to the belief that he was a man suffering from mental illness who had simply "gone off the deep end" in waging his own private, personal vendetta against "the system." He instantly became the Mathematical Misanthrope, and that impression among the general public remains largely intact to this day.

Indeed, it was the popular media's portrayal of Kaczynski and his crimes — and the resultant image of him in the popular psyche — that made me want to see the man's papers for myself. And although I am not a psychologist, after spending approximately eight hours poring over and through them[5] — a very brief amount of time, even for such a relatively small collection (fourteen file boxes) of documents — two things became clear to me: first, Ted Kaczynski is far from "crazy" or "insane." As Chase notes, "Although clearly neurotic, the best clinical evidence suggests he is quite sane" (Chase 362). Mello concurs, writing, "…the claim that Theodore Kaczynski was a paranoid schizophrenic must be qualified … I do not believe the existing public record supports the conclusion that Kaczynski suffers from any serious or organic mental illness." (Mello 22). Second, the Mathematical Misanthrope is an extremely fecund content-generator for mainstream media.[6]

Kaczynski's private writings reveal, as most people's would, multiple facets of a personality ranging from angry to humorous, from annoyed and impetuous to thoughtful and patient, from businesslike to philosophical and poetic. But in this case, especially in correspondences and private writings composed during the 1970s and 1980s, they also betray three characteristics of Kaczynski's that, when mixed together in the same psyche, create the potential for catastrophe: a great deal of underlying, seething rage at certain aspects of his own personality, and at the "industrial-technological system" which is run by "scientists," "technophiles," and "bureaucrats"; a Herculean intellect with a facility for manipulating

concepts and ideas and marshalling them into a systematic, purely rational point of view that is devoid of any middle ground; and extraordinary patience.

Chase goes into much greater detail than this brief synopsis can convey to explain the origins of, and influences upon, Kaczynski's rage and impulse to murder. None of it, of course, excuses what Kaczynski did or the way he did it. After all, millions of other people throughout history who have gone through similar, or even worse, tribulations than Theodore Kaczynski never killed anyone. The same is even true for millions of his generation who share his ideological views. So why did *he* decide to take murderous revenge on "the system?"

No definitive answer to that question will ever be found, but the general point can be made that for the unfortunate Kaczynski, the trope of the Mathematical Misanthrope played a large role in creating the person who would ultimately become the Unabomber. Manifesting several of the traits of the Mathematical Misanthrope at an early age (brilliance, detachment, eccentricity) quickly isolated him from his peers and created a pattern of intellectual achievement and reward that propelled him to Harvard at an accelerated rate. At Harvard, those same traits, now more pronounced than ever, brought him to the attention of Murray as a perfect human specimen upon whom to conduct his experiments. (Significantly, Kaczynski would later refer to his murderous bombings as "experiments" in his journals.) Murray's project further deepened Kaczynski's sense of isolation and detachment, making these classic characteristics of the Mathematical Misanthrope even more pronounced in his personality. It also did something far more dangerous: it created within him a deep hatred for and resentment toward the techno-industrial institutions that fund and carry out such experiments on human subjects. Kaczynski came to view these institutions and the technocrats within them as destructive and controlling forces in the modern world that must be destroyed. He then acted on these emotions and beliefs, conducting his seventeen-year bombing campaign.

In his book, Chase reviews Kaczynski's premeditated crimes vividly enough to make it clear that the project is by no means meant to be an excuse for the Unabomber's actions. The book details the FBI manhunt for Kaczynski, his subsequent arrest, and the turbulence of the pre-trial maneuvering that ended in his controversial confession of guilt, a confession that he later tried, unsuccessfully, to have revoked. Kaczynski was furious at his legal team's portrayal of him as a paranoid schizophrenic and at the "mental defect" defense it tried to put forth to the court on his behalf. Chase explains that while Kaczynski was apparently unaware that such a plea was being prepared as his defense strategy, his family was giving interviews to media outlets around the world and portraying him as mentally ill in an effort to save him from the death penalty (Chase 134–35). Ultimately, Chase demonstrates, the court-appointed forensic psychiatrist, Sally C. Johnson, would render a "provisional" diagnosis of "schizophrenia, paranoid type" that was now in "remission" (quoted in Chase 146), while at the same time also judging Kaczynski to be competent to stand trial and even "assist in his own defense" (quoted in Chase 147). Despite this diagnosis, in a bizarre and inconsistent ruling that legal scholars still scratch their heads over, the court refused to let Kaczynski represent himself when he petitioned to do so after expressing his displeasure about how his defense team intended to portray his psychological state. "I believe," Mello writes,

> that Kaczynski pleaded guilty in exchange for life imprisonment without the possibility of parole, not because he feared the death penalty, but because he simply had no other choice. It

was the only way he could prevent his lawyers from portraying him as crazy and his manifesto as the ravings of a madman [Mello 128].

Mello also writes that "Dr. Johnson's analysis reveals more about the values, blind spots and cultural and intellectual biases of her profession than it reveals about Theodore Kaczynski's mental health" (33). Kaczynski wanted a trial so he could air his ideas in an international, public forum, and he stated on several occasions over a period of years that he was more than willing to die for those ideas. According to Chase, "Kaczynski, the ideologue, wanted his ideas to be taken seriously more than he valued his own life. Instead, his own attorneys planned to portray them as symptoms of mental illness" (Chase 144). Mello agrees, stating flatly that "like the defense experts, Dr. Johnson's findings were based on her conclusion that Kaczynski's political ideology was a delusion rather than a philosophy" (Mello 33). Many still regard the judge's denial of Kaczynski's request to represent himself, whatever the reasons for it, as a direct violation of one of the central tenets of the American jury system — that any mentally competent client has the right to defend himself if he so chooses. As Mello puts it, "The point is that it's *his* defense. It's *his* life. It's his day in court. And the choice of the grounds upon which to stake that life ought to be his and his alone" (153; emphases Mello's).

The popular media's handling of both Johnson's diagnosis and the judge's refusal to let Kaczynski represent himself in court demonstrates the malleability of the Mathematical Misanthrope trope in American popular culture, for at this point during the Kaczynski case it morphed once again in the mainstream press. This time it became the basis for an inaccurately represented psychiatric diagnosis. Kaczynski was no longer just an eccentric "hermit" whom authorities had tracked down in the Montana wilderness; now he was also certified as crazy. Chase writes, "The national news media, however, noticed neither the specious reasoning that lay behind Johnson's tentative diagnosis nor her explicit caveat that it was 'provisional' only. Instead, they hailed the report as proving Kaczynski insane" (Chase 147). This is also noted by Mello, who writes, "The daily press and others missed the fact that Dr. Johnson's diagnosis was provisional" (Mello 33).

I would argue, however, that "the daily press" didn't exactly "[miss] the fact"; rather, I believe it chose to use Johnson's provisional diagnosis as a shortcut to getting to the portrayal of Kaczynski that it ultimately wanted to promote, because it knew that such a portrayal would better capture the public's attention and thus "sell" better: Kaczynski as an extreme (that is, insane) version of the Mathematical Misanthrope was a hot press commodity. Like Murray, the media exploited the trope for its own purposes: for Murray, the desired end was research data and professional prestige; for the media, the desired end was profit. Rather than reporting the nuanced facts about Johnson's provisional diagnosis and thus presenting Kaczynski and his case within the proper medical and legal contexts, the media simultaneously fell back on its representation of Kaczynski as the Mathematical Misanthrope *and* ratcheted up the trope's eccentricity by telling the world that he was "insane." Examples abound, in fact, of how the popular media reverted to this stereotype in its "reporting" instead of investing the time and effort required to dig out actual facts:

To *Time* magazine (April 15, 1996), Kaczynski was "the hermit on the hill" (even though his cabin lay in the Canyon Creek bottom) and "you could smell him coming." The *New York Times* (May 26, 1996) described him as "usually unwashed," *Newsweek* (April 15, 1996) as "pathologically reclusive."

In dubbing Kaczynski a hermit, the media confused misanthropy — dislike of people — with primitivism — antipathy toward civilization. One can abhor society, yet like company. Just so, Kaczynski sought to reject modern life, not avoid people....

Reportage at the time of Kaczynski's arrest had exhibited a feature of pack journalism: It was wide but shallow [Chase 124].

As one of Kaczynski's former classmates, Russell Mosny, told Chase, "I probably knew Ted better than anyone else, and most of what [the] media says about him is baloney" (quoted in Chase 175).

This kind of coverage stemmed from the nature of the investigation itself. "Most investigators kept looking for psychological and physical associations," Chase writes. "So they missed the major point: that Kaczynski's crimes not only had a psychological component but an intellectual one as well" (39). He adds:

To federal agencies awash with psychologists, every criminal fits a predetermined personality profile. And in a therapeutic society such as ours, every kind of cruel or unusual behavior is seen as a symptom of mental illness. By relying so heavily on profiling as an investigative tool, federal officials would reduce their quarry to a psychological artifact. And the media would do likewise [44].

Kaczynski's mindset — purely rational, binary, uncomfortable with ambiguity and uncertainty — seems to have evolved both out of his mathematical "bent" and the "culture of despair" articulated by Chase. Although Kaczynski's "deepest interests lay, to judge from his reading, in history and literature" (40), he doesn't seem to have taken from them what would normally be intended in the teaching of the typical humanities curriculum: the ability to deal with ambiguity and uncertainty, the ability to negotiate the "gray middle" rather than take up extremes. He loved to read Conrad — Chase makes the point that *The Secret Agent* "is practically a Unabomber instruction manual" (62) — but seems to have *mis*read him on several crucial points. "*The Secret Agent* is written with great irony and a strong moral tone, both of which Kaczynski seemingly missed. The theme is moral decay, not anarchism or the evils of science" (62).

Having been reduced to an abstraction throughout his life by the likes of Murray and school administrators at institution after institution, Kaczynski learned to turn his perceived enemies into abstractions, as well:

The real story of Ted Kaczynski and contemporary terrorism is one of the nature of modern evil — evil that results from the corrosive powers of intellect itself, and its arrogant tendency to put ideas above common humanity. It stems from our capacity to conceive theories or philosophies that promote violence or murder in order to avert supposed injustices or catastrophes, to acquiesce to historical necessity, or to find the final solution to the world's problems — and by this process of abstraction to dehumanize our enemies [369].

Thus, the story of Ted Kaczynski is not only one of murder and thwarted revolution; it is also a tragedy, because someone who could have contributed so much took so much instead in the name of "reason." It is a cautionary tale about the value of the humanities — and proper instruction in them — even in today's increasingly technological society. Lionel Trilling made the point years ago:

Certain parts of the enterprise of education need little or no theoretical justification. Science is nowadays justified out of hand, if only by its connection with technology.... But the study of literature is not justified by practical and professional considerations.... Our rationalization must be wider; it must include the aims of education in its largest sense, or, as we say, its real

sense. We must make reference to what in America we call — or used to call until we got sick of the phrase — the whole man [Trilling 183].

Ironically, in his incarnation as the Unabomber, Kaczynski mirrored the very all-or-nothing, no-compromise, binary, by-any-means-necessary culture he was seeking to destroy. Chase points out that Kaczynski never seems to have learned the crucial lesson (also missed by Kurtz in Conrad's novella *Heart of Darkness*) that "strength does not come through intelligence but through faith" (Chase 199). Kaczynski's is a modern-day Frankenstein tale, the ugly monster — created by men who value only "science" and its "method" — who turns on those men and tries to destroy them using their own philosophies and tools. In doing so, he made himself the most tragic of all Mathematical Misanthropes in modern times.

The story of John Forbes Nash, Jr., another Mathematical Misanthrope, is as inspiring as Kaczynski's is tragic, not just because of what he endured to become a Nobel Laureate (who is still doing mathematics and lecturing about it around the world) but also because of what some of the people around him endured to help him get to that point. If the story of Theodore Kaczynski is that of the Mathematical Misanthrope abandoned to the vicissitudes of a merciless culture, the story of John Nash is that of the Mathematical Misanthrope rescued — not just once, but time and time again.

Nash's life story reads like a twentieth-century *Odyssey*, and no one has done a better job of chronicling it than former *New York Times* economics correspondent Sylvia Nasar in her 1998 biography of Nash, *A Beautiful Mind*. Like Chase's book about Kaczynski, Nasar's project is extensively researched, though its compass is somewhat smaller. By 1994 — the year he won the Nobel Prize in Economics — Nash had been so completely forgotten that just "[g]etting a picture of the life required some 1,000 interviews, letters and e-mails with people who had known Nash at different points" (Nasar, Interview I). Nasar's illuminating portrayal resurrected Nash's remarkable story for the general public in much the same way that the gradual and unlikely remission of Nash's schizophrenia resurrected his life and his career.

Nash's achievements as a mathematician are by now legendary and, for the sake of accuracy and fairness, I must point out that they dwarf those of Theodore Kaczynski. Kaczynski never completely fulfilled the tantalizing and prodigious academic promise of his early years; Nash, on the other hand, seemed naturally endowed with stupendous, unworldly mathematical superpowers, and became a giant in the field of mathematics almost from the moment he entered it.

I will only deal with the bare outline of the Nash story here because, compared with Kaczynski's, its through line is much more straightforward and familiar. Whereas popular media distorted the truth about Kaczynski by reflexively falling back on the trope of the Mathematical Misanthrope — because, in a sense, doing so protected American popular culture from having to look at itself in the mirror and see Kaczynski staring back — no such manipulation was necessary in the case of Nash, for here was the Mathematical Misanthrope straight from central casting. And unlike Kaczynski, he really *was* mentally ill, and severely so. Whereas Ted Kaczynski was and is much more like the rest of us than most of us would like to admit, John Nash has never been like the rest of us in many important respects.

In one sense, Nash's story is the oldest story in Western culture, echoing the "Hero's Journey" about which the late mythologist Joseph Campbell wrote so eloquently. It is the story of great and prodigious achievement early in life, followed by a great fall, and culmi-

nating in an unexpected, even miraculous "awakening." That Nash's story is such a cliché makes it especially remarkable, as it is an actual manifestation of one of our most persistent cultural myths. Nasar recognized this appeal and made the most of it. In a lecture given at MIT on October 28, 2002, she recalled that it was, in fact, this characteristic of Nash's story that first drew her to it as a subject for biography:

> Before I studied economics, I majored in literature. Literature abounds with stories about mete-oric rises followed by catastrophic falls. There are very *few* stories, much less *true* stories, with a genuine third act. But John Nash's life had such a third act. In fact it was that amazing third act that drew me to his story in the first place.... To me, the notion that someone, that someone who had been lost for so long could be found again, that someone who had fallen as far as John Nash had fallen could come back, to me that seemed extraordinary. It sounded like a Greek myth or a fairy tale. Extraordinary lives have this unique power [Nasar, "Genius"].

Nicknamed "Big Brains" by his childhood friends in Bluefield (Nasar, *Mind* 36), Nash, like Kaczynski, has demonstrated many of the quintessential characteristics of the Mathematical Misanthrope throughout his life. Peculiar and solitary as a child, Nash displayed eccentric but brilliant behavior from the very beginning. Supremely confident even as a boy and at times obnoxiously arrogant as an adult, he could be so hyper-rational that he came across as cruel and insensitive (which, at times, he was). But his approach to problem-solving when he was in his prime became the stuff of legend. Nasar writes:

> Nash's genius was of that mysterious variety more often associated with music and art than with [mathematics], the oldest of all sciences. It wasn't merely that his mind worked faster, that his memory was more retentive, or that his power of concentration was greater. The flashes of intu-ition were non-rational.... Nash saw the vision first, constructing the laborious proofs long afterward. But even after he'd try to explain some astonishing result, the actual route he had taken remained a mystery to others who tried to follow his reasoning [*Mind* 12].

Nash's contributions and their technical complexities have been elaborated elsewhere, and for the purposes of this essay are of only tangential importance. It is sufficient to note that Nash greatly expanded and improved upon mathematician John von Neumann's work in game theory so that it could be applied to real-world scenarios, especially in areas such as economics, political science, and, more recently, population genetics and evolutionary biology. In May of 1950, at the age of only twenty-one, Nash published his doctoral thesis, "Non-Cooperative Games," and became an instant legend. The key to the thesis — the work for which he would win the Nobel Prize in Economics forty-four years later — is Nash's fundamental concept of an "equilibrium point," known simply as the "Nash Equilibrium." Nash managed to prove that at least one such point exists in every non-cooperative game. (Incredibly, to those mathematicians who practice on the same stratospheric plane as Nash, his doctoral thesis is actually less impressive than his later work.)

For all of his mathematical genius, however, it was Nash's extraordinary, thirty-year descent into madness and his astonishing recovery that vaulted him back into the limelight[7] and expanded his fame beyond a small circle of mathematical "geeks and nerds" to the larger culture beyond. The popular media's literary and cinematic portrayals of Nash, and American audiences' overwhelmingly positive responses to those portrayals, demonstrated, yet again, the general public's ongoing fascination with the Mathematical Misanthrope.

Nasar's biography delves behind the scenes of Nash's life during his best and worst moments, presenting a believable and balanced picture of his complex and unconventional

personality. Given Nash's bizarre behavior and the many peculiar episodes throughout his life for which it served as a catalyst, this is no mean achievement, for he so thoroughly personifies the idea of the Mathematical Misanthrope that it probably would have been much easier for Nasar to fall back on the pop culture caricature. The biography was unauthorized, and Nash, who, like Kaczynski, is still alive, made no attempt to influence Nasar's work. She dedicates *A Beautiful Mind* to Nash's wife, Alicia, because of all the individuals who have helped to rescue Nash from the abyss over the last half century (and there are many), she has been the one who has done the most to save him.

Alicia first met Nash at MIT, where he was a young professor with a reputation for strange behavior coupled with brilliance, and she was one of only two undergraduate female physics majors in her class. Two years later, in February 1957, they married — even though Alicia knew that he already had a three-year-old son by a woman whom he had known for four years and was still occasionally seeing. As Nasar reveals, Nash's personal life at this time was a tangled mess:

> In those first years at MIT ... between the ages of twenty-four and twenty-nine, Nash became emotionally involved with at least three other men. He acquired and then abandoned a secret mistress who bore his child. And he courted — or rather was courted by — a woman who became his wife [*Mind* 167].

The question of whether or not Nash ever truly was homosexual is a vexed one, and became a popular topic of media discussion soon after the release of the motion picture based on Nasar's biography.[8] But Nasar insists that Nash is not homosexual and never has been:

> ... nobody's taking it seriously. Nash had several emotionally intense relationships with other men in his early twenties. In the homophobic, McCarthyite 1950s, that made him vulnerable. But he wasn't gay. Nobody who knew him thought he was gay. The biography never portrayed him as gay [Interview II].

We see highlighted here the perennial divide between the popular media's approximation of truth (or, in this case, speculation presented as truth) and the more thorough — and thus, more nuanced and less easily consumed — approaches to a subject that come from writers like Nasar. It reminds us again of the fact that the commercial nature of the popular media means it is always looking for a saleable story, and in the case of the Mathematical Misanthrope, anything that can be tagged onto the trope and promoted and sold as "abnormal" qualifies. Homosexuality, even as late as 2001, when the cinematic version of *A Beautiful Mind* was released, was not nearly as accepted in mainstream culture as it is now.

Nasar writes that "the first visible signs of Nash's slide from eccentricity into madness appeared when he was thirty and was about to be made a full professor at MIT" (*Mind* 16). This was in 1959, and the next thirty years of Nash's life would be an odyssey during which he alternated between periods of lucidity and calm, and episodes of disturbing and even dangerous behavior attributable to his mental illness. Nasar goes on to describe the devastation wrought by paranoid schizophrenia:

> At thirty years of age, Nash suffered the first shattering episode of paranoid schizophrenia, the most catastrophic, protean, and mysterious of mental illnesses. For the next three decades, Nash suffered from severe delusions, hallucinations, disordered thought and feeling, and a broken will.... [He] ... finally became a sad phantom who haunted the Princeton University cam-

pus where he had once been a brilliant graduate student, oddly dressed, muttering to himself, writing mysterious messages on blackboards, year after year....

Schizophrenia contradicts popular but incorrect views of madness as consisting solely of wild gyrations of mood, or fevered delirium. Someone with schizophrenia is not permanently disoriented or confused, for example, the way that an individual with a brain injury or Alzheimer's might be. He may have, indeed usually does have, a firm grip on certain aspects of present reality. While he was ill, Nash traveled all over Europe and America, got legal help, and learned to write sophisticated computer programs [16–18].

In the 1960s Nash would lose everything to the disease: "family, career, the ability to think about mathematics" (169). But by the early 1980s he had begun to make recognizable progress and was even talking to and informally tutoring students again at Princeton, where for more than a decade he had made almost daily visits to campus, writing those mysterious messages on classroom blackboards, ruminating in the library, conversing with old colleagues, and continually attempting to work on new problems. (To the students on campus, he became a local curiosity known as "The Phantom of Fine Hall.") By 1990, it was apparent to everyone who interacted with him that John Nash's schizophrenia was in remission. Slowly, as word spread about his miraculous recovery, and people who thought he had been long dead learned that he was actually still alive and walking Princeton's campus every day, he began to again garner the attention of the mathematical community. In addition, due to the fact that new and exciting applications of the "Nash equilibrium" were being discovered in other fields (particularly in economics), the scope of his fame in the scholarly community began to increase.

It is instructive to compare the popular press' ham-handed, bungling employment of the Mathematical Misanthrope trope in its coverage of Kaczynski to Nasar's skillfulness in deftly navigating *through* the trope in her biography of Nash. Whereas the press used the Mathematical Misanthrope story frame to create a caricature out of Kaczynski, Nasar succeeds in the far more difficult task of transforming a caricature into a human being. Nasar ends her biography of Nash just after he has accepted the 1994 Nobel Prize in Economics, providing a glimpse of Nash and Alicia — still living together in Princeton, New Jersey — and their daily life together. They worry about Nash's son and are constantly helping him with his own battle with schizophrenia. There are some days when Nash still finds it difficult to work, but he walks to his office on the Princeton campus nearly every day to try. Nasar writes:

> The extraordinary journey of this American genius, this man who surprises people, continues.... In deed, if not always in word, Nash has come to a life in which thought and emotion are more closely entwined, where getting and giving are central, and relationships are more symmetrical. He may be less than he was intellectually, he may never achieve another breakthrough, but he has become a great deal more than he ever was — "a very fine person," as Alicia put it once [*Mind* 388].

In the intervening fourteen years since the release of Nasar's biography, Nash has enjoyed the kind of iconic status that allows him to do what he pleases. He continues to teach, travel the world giving lectures and speeches, and work on new problems. He has, he says, learned to control, somewhat, the delusional thinking that used to plunge him back into schizophrenic episodes. It is that ability to know and control his own mind — learned after decades of hard experience — that has helped to give John Nash his life back.

The motion picture version of *A Beautiful Mind*, while faithful to the essence of Nash's life and experience, is by no means a factual account. True to Hollywood's "blockbuster"

mentality, the cinematic portrayal, though based on Nasar's book, takes liberties with the facts of Nash's life in order to communicate its greater truth.[9] Not surprisingly, given that the film was also created to make a blockbuster profit, it heavily emphasizes the Mathematical Misanthrope trope in its portrayal of Nash, relying on the audience to respond sympathetically to the on-screen manifestation of one of American culture's most recognizable stereotypes.

The bare outline of Nash's life and a few of the salient facts about his personality — his competitive nature, his early mathematical genius, his desire for achievement and recognition, his lifelong love affair with Alicia, and of course, the onset of his schizophrenia — form the central ingredients in the filmmakers' creation of a mainstream-oriented, "studio system" picture designed to appeal to the general public. Though not exactly as clichéd as many Hollywood movies, two essential components of the typical Hollywood formula are prominent in the film: the protagonist/hero (played by Russell Crowe) who overcomes great obstacles and ultimately triumphs in the end, and the love interest (played by Jennifer Connelly, who won the 2001 Best Supporting Actress Academy Award for the role). In defense of producer Brian Grazer and director Ron Howard, however, it must be pointed out that these two aspects of the formula so closely resemble the truth of Nash's story that it would have been impossible not to include them in its film rendition

This mainstream approach to conveying the story of Nash's life onscreen accomplishes three things that Grazer and Howard surely intended: it delivers the essence of Nash's journey within the parameters of typical Hollywood storytelling convention; it created a commercially successful Hollywood blockbuster; and it created a drama that garnered enough critical acclaim to be considered Oscar-worthy. In fact, *A Beautiful Mind* won four Academy Awards: Best Picture, Best Director, Connelly's Best Supporting Actress nod, and Best Adapted Screenplay. The picture also won four Golden Globes, including Best Motion Picture Drama, and the Broadcast Film Critics Association's Critics Choice Award for Best Picture (*Mind* DVD production notes).

The movie's hopeful conclusion mirrors the optimism of the last twenty years of the real John Nash's life, and it is perhaps summed up best by some remarks made by the fictional Nash toward the end of the biopic, as he explains how he deals with his schizophrenic hallucinations: "No, they're not gone, and maybe they never will be. But I've gotten used to ignoring them and I think as a result they've kind of given up on me. I think that's what it's like with all our dreams and our nightmares ... you've gotta keep feeding them for them to stay alive."

It is interesting to note that the popular media's representations of Kaczynski (in the press) and Nash (in the cinema) were both largely factually inaccurate. Yet the cinematic portrayal of Nash managed to capture the truth — the essence and spirit, if you will — of his life's trials and his triumphs, whereas, as already noted, the popular press' portrayal of Kaczynski generally missed the mark when it came to capturing the truth about the man. Of course, mainstream journalism is not meant to be an artistic genre, whereas the cinema *is*. And all great art is, as Pablo Picasso said, "a lie that tells the truth." Nevertheless, while it is entirely possible to enjoy the cinematic representation of the Mathematical Misanthrope in the film version of *A Beautiful Mind* without having read its namesake biography, it is impossible to fully understand and appreciate its details and nuance without prior knowledge of Nasar's well-calibrated and sensitive treatment of the trope.

The absent-minded professor; the math whiz; the geek; the nerd; the reclusive genius; "Einstein": each is a popular colloquialism that has been used at one time or another to describe those in American society who demonstrate extraordinary brilliance in the field of mathematics. The Mathematical Misanthrope, with its intimations of both eccentricity and perceived intellectual superiority, has become so prevalent that it has become a stock character in American popular culture. What can we learn, if anything, from the brief, comparative glance we have just taken at our popular culture's use of the Mathematical Misanthrope via the case studies of Ted Kaczynski and John Nash?

Perhaps the first and most obvious lesson is an awareness of just how deeply embedded the trope is in our collective cultural consciousness. Like all stereotypes, it is imbued with tremendous cultural and persuasive power, and is easily employed as a kind of shorthand signifier, the sum of which is much greater than its parts, because it is already accepted by most people as "true," even if only at the subconscious level. Truth based on established and consistent facts must often overcome ingrained cultural bias to be accepted; stereotypes, being part of that cultural bias, do not have such hurdles to overcome.

The second lesson is that the Mathematical Misanthrope is an extremely malleable trope which can be, and often is, manipulated in order to serve a particular purpose. In Kaczynski's legal case, it was used by both the prosecution and the defense to create a profile of the accused that they hoped would achieve one of two polar opposite goals: a sentence of capital punishment or a reprieve from it. In Nash's case, it was used by the motion picture industry to create entertainment with a redeeming message of social justice: namely, that the mentally ill deserve compassion and understanding, not ostracism and judgment.

In the realm of academic cultural and critical theory, interesting connections might also be discovered or made between Felix Guattari's and Gilles Deleuze's ideas about "schizo-analytic modeling" and the Mathematical Misanthrope as manifested in the personalities of Kaczynski and Nash. Deleuze and Guattari saw in the schizophrenic personality a model for resistance to authority and the inherent pressures of social convention. It could be argued that Kaczynski and Nash (or, at least, aspects of their respective personalities) can be seen as real-life "prototypes" or examples of the kind of schizophrenic "desiring machines" who challenge and try to undermine society's "rational order," as described and implied in Deleuze and Guattari's 1972 text, *Anti-Oedipus*.

More than anything, however, popular culture's employment of the Mathematical Misanthrope trope in its respective representations of Kaczynski and Nash, if read properly against the real backgrounds of both men, is capable of telling us something profound about the human heart and the importance of human relationships. Ted Kaczynski's rage stemmed not only from the fact that the answers he was seeking about his place in the world could never be captured within the confines of a mathematical equation (however sophisticated, complex, or elegantly conceived), but also from the simple fact that he was alone; and this was due in large part because, for most of his life, he seemed to others to fall so neatly within the parameters of the Mathematical Misanthrope stereotype. Institutional psychology, which ultimately helped to rescue and partially "heal" Nash, ultimately damaged and failed Kaczynski. Nash, on the other hand, though he was the very definition of the Mathematical Misanthrope in so many ways, was from a very young age surrounded by a cohort of academic and professional colleagues who, despite his eccentricities and personality flaws, respected and cared for him. And finally, Nash was lucky enough to have the companionship

and loyalty of a woman who truly loved him for more than fifty years, and who still does to this day, because she is able to see past his imperfections to the real man underneath.

Such facts give one pause, for it is Nash, not Kaczynski, who by clinical standards was the "crazy" one. Kaczynski was never able to escape the binary trap that society imposes on each of us, to realize that the unity that lies beyond and behind that duality may be intuitively understood and felt but never, ever captured in the cage of an inflexible mathematical proof. It was a task at which even Einstein failed, and Nash himself undoubtedly helped to trigger and exacerbate many of his schizophrenic episodes by attempting to use mathematics to rein in reality. In fact, it was Nash's attempt

> to address Einstein's famous critique of Heisenberg's uncertainty principle ... that Nash would blame, decades later in a lecture to psychiatrists, for triggering his mental illness — calling his attempt to resolve the contradictions in quantum theory, on which he embarked in the summer of 1957, "possibly overreaching and psychologically destabilizing" [Nasar, *Mind* 221].

But he learned — slowly, gradually, painfully — to accept the impossibility of finding mathematical and logical "proof" of that unity while also learning that to continue to attempt the seemingly impossible could be a rewarding way to exercise one's talents and spend one's life. In a sense, Nash has come as close as anyone to proving the existence of an alternative to the simple, binary conceptual construct through which most people perceive reality, for his theory of non-cooperative games and their equilibrium points provided groundbreaking new insights into how complex human interactions affect real-world outcomes. Nash has given us a way of understanding and seeing the great gray, middle space that inhabits most of our daily lives beneath the illusory surface of "either/or."

Or perhaps it was simply a generational matter, this difference between Nash and Kaczynski. When Nash was born, logical positivism — which taught Kaczynski that "there was no logical justification for morality," as he wrote in one of his journals (Chase 293) — had yet to cross the Atlantic from continental Europe, and when Nash entered Carnegie Mellon as an undergraduate, exactly thirteen years before Kaczynski entered Harvard, no one was conducting harmful psychological tests on students in the service of the federal government.

Whatever the reason or reasons, in the end, John Nash acquiesced to the complexities of the world around him and accepted the fact that he would never fully understand or explain them. Ted Kaczynski was unable to do so and made war on the world instead. Nowhere has Nash's acceptance been better articulated than in his cinematic version's speech at the Nobel Prize Award ceremony in Stockholm[10]:

> I've always believed in numbers, in the equations and logics that lead to reason. But after a lifetime of such pursuits, I asked, "What truly *is* logic? Who decides reason?" My quest has taken me through the physical, metaphysical, the delusional, and back. And I have made the most important discovery of my career. The most important discovery of my life: it is only in the mysterious equations of love that any logic or reason can be found.

Though this sentiment is purely fictional, it expresses what is perceived by many as a real and fundamental truth: namely, that the most essential and powerful aspects of our existence can never be fully explained by the brain because they reside in the enigmatic universe of the heart. This truth eluded one Mathematical Misanthrope, but saved another—

in the end, *A Beautiful Mind* suggests, Alicia's humanity is as powerful a gift as Nash's mathematical brilliance.

Notes

1. Schizotypy is only one methodology among many that are routinely used in attempting to make mental health assessments.

2. Today, when governments desire to sell scarce public resources such as oil leases and radio spectrum bandwidth, they do so in carefully constructed public auctions that have been designed by economists using the principles of economic game theory. The practice began in 1994, when the Federal Communications Commission sold public licenses for commercial bandwidth at an auction designed to maximize fairness (and government profits) using theories originally developed by John Nash and subsequent game theorists. The essential core of all such auctions — and of modern game theory itself— is the concept of the "Nash equilibrium." Before 1994, such licenses were simply given away by federal regulators for free, a process that was subject to political manipulation and one which greatly enriched companies while those companies paid nothing in return for the use of public assets. See Nasar, *Mind*, pp. 374–78.

3. Kaczynski later wrote in his psychiatric competency report:

As I walked away from the building afterwards, I felt disgusted about what my uncontrolled sexual cravings had almost led me to do and I felt humiliated, and I violently hated the psychiatrist. Just then there came a major turning point in my life. Like a Phoenix, I burst from the ashes of my despair to a glorious new hope. I wanted to kill that psychiatrist because the future looked utterly empty to me. I felt I wouldn't care if I died.... And so I said to myself why not really kill the psychiatrist and anyone else whom I hate? What is important is not the words that ran through my mind but the way I felt about them. What was entirely new was the fact that I really felt I could kill someone. My very hopelessness had liberated me because I no longer cared about death [quoted in Chase 305–06].

4. Mello's perceptive 1999 critique of the legal aspects of the Unabomber case, *The United States of America versus Theodore John Kaczynski: Ethics, Power and the Invention of the Unabomber*, and Chase's study (which was republished in paperback in 2004 under the title *A Mind for Murder: The Education of the Unabomber and the Origins of American Terrorism*) are the most comprehensive analyses to date of Kaczynski, his life, his crimes, and his criminal motivations. Mello — who served as an informal advisor to Kaczynski's defense team — considers the Unabomber case in its historical context and provides an excellent analysis of the controversies surrounding the court's attempts to evaluate Kaczynski's psychological condition. Chase, on the other hand, traces the cultural forces that helped shape Kaczynski and the ideologies he used to justify mass murder. Mello and Chase consulted with each other as they were writing their respective books.

5. Kaczynski's papers are housed in a special collection called "The Labadie Collection on anarchy and social movements" at the University of Michigan's Hatcher Graduate Library in Ann Arbor, Michigan. My great thanks to the Labadie Collection's Curator, Julie Herrada, and Reference Assistant Kate Hutchins for their assistance with the research for this paper.

6. All of the popular mainstream media outlets, news programs, talk shows, and publications of the time, as well as smaller, non-mainstream media such as *SECONDS Magazine* and *RANT Magazine*, wrote letters to Kaczynski requesting interviews. In 2003, the *Smoking Gun* website displayed copies of a smattering of the Labadie Collection's Kaczynski archive (provided to the website by the Hatcher Library).

7. Nash had earlier, and very briefly, enjoyed mainstream popularity when he was recognized in the July, 1958 issue of *Fortune* magazine as one of the world's brightest young mathematicians.

8. There are certainly indications that Nash may have had homosexual tendencies: for instance, in 1954 he was quietly and discreetly released from his job as a consultant to the RAND Corporation, after four summers with the think tank, because of an arrest for solicitation in Palisades Park near California's Santa Monica beaches (*Mind* 184).

9. The screenwriter for the project, Hollywood veteran Akiva Goldsman, had "strong ideas about structuring the flow of the narrative. 'It's not a literal telling of Nash's life.... I tried to take the architecture of his life — the genius, the schizophrenic break, the Nobel Prize — and from that constructed a semi-fictional story'" (*Mind* DVD production notes).

10. Nobel Prize laureates do not give acceptance speeches. According to a FAQ published on the website of the Seeley G. Mudd Manuscript Library at Princeton:

At the Nobel Prize Award ceremony, His Majesty the King of Sweden hands each Laureate a diploma, a medal, and a document confirming the Prize amount. The Laureates do not give acceptance speeches. The scene in the movie *A Beautiful Mind* in which Nash thanks his wife Alicia for her continued support during his illness is fictional.

Laureates are each invited to give an hour-long lecture; however, the Nobel committee did not ask Nash to do so, due to concerns over his mental health.

Works Consulted

A Beautiful Mind. Dir. Ron Howard. Perf. Russell Crowe, Jennifer Connelly, Ed Harris. Dreamworks Pictures; Universal Studios, 2006. DVD.

Blackwell, Jon. "1933: The Genius Next Door." *The Capital Century: 1900–1999.* N.p., n.d. Web. 8 Feb. 2010.

Chase, Alston. *A Mind for Murder: The Education of the Unabomber and the Origins of Modern Terrorism.* New York: Norton, 2004. Originally published as *Harvard and the Unabomber: The Education of an American Terrorist.* New York: Norton, 2003.

"Count Themselves Lucky." Editorial. *Nature.* Nature Publishing Group, 4 Aug. 2005. Web. 8 Feb. 2010.

Fitzgerald, Michael, and Ioan James. *The Mind of the Mathematician.* Baltimore: Johns Hopkins University Press, 2007.

John Nash FAQ. Princeton University Seeley J. Mudd Manuscript Library, University, 6 Nov. 2007. Web. 7 June 2010.

Kaczynski, Theodore J. *The Unabomber Manifesto: Industrial Society and Its Future.* Livermore, CA: WingSpan, 2009.

Matthews, Robert, and Nadejda Lobastova. "Mathematics, Where Nothing Is Ever as Simple as It Seems." *Telegraph.co.uk.* Telegraph Media Group, 20 Aug. 2006. Web. 16 Feb. 2010.

Mello, Michael. *The United States of America versus Theodore John Kaczynski: Ethics, Power and the Invention of the Unabomber.* New York: Context, 1999.

Nasar, Sylvia. *A Beautiful Mind.* New York: Simon and Schuster, 1998.

_____. "Genius, Madness, Reawakening." *Applied Mathematics Colloquium.* MIT Department of Mathematics, Boston. 28 Oct. 2002. Guest Lecture.

_____. Interview Parts I–II. *Maximum Russell Crowe.* Maximum Crowe, n.d.; 10 Jan. 2002. Web. 3 Mar. 2010.

Pragacz, Piotr. "The Life and Work of Alexander Grothendieck." *The American Mathematical Monthly* 113.9 (2006): 831–46.

Tomlin, Sarah. "What's the Plot?" *Nature.* Nature Publishing Group, 4 Aug. 2005. Web. 8 Feb. 2010.

Trilling, Lionel. "The Two Environments: Reflections on the Study of English." *Beyond Culture.* New York: Harcourt Brace Jovanovich, 1965. 181–202.

"Who We Are." *Thales and Friends.* Thales and Friends, n.d. Web. 20 Feb. 2010.

Alan Turing

Reflecting on the Life, Work, and Popular Representations of a Queer Mathematician[1]

K. G. VALENTE

Surely there is something queer about this.
—Ludwig Wittgenstein, *Lectures on the Foundations of Mathematics*[2]

Heads of government do not often make public apologies. Yet this is precisely what British Prime Minister Gordon Brown did on 10 September 2009. Writing in the *Daily Telegraph*, Brown expressed regret for the injustices suffered by and persecution of the mathematician Alan Mathison Turing (1912–54). This act of remorse contributes to a continuing effort to reclaim Turing as one of the most inventive minds of the twentieth century. That his legacy requires reclaiming owes much to the nature of his contributions to codebreaking during World War II, work that demanded he carry the secrets of his service to his grave. The other crucial aspect of Turing's life that complicates his recognition — and one made a matter of public record before his untimely death — was his homosexuality and conviction for gross indecency in 1952.

Though some have reason to disagree with particulars of Prime Minister Brown's apology, there is no question that Turing deserves to be recognized.[3] His name may be well known by mathematicians, computer scientists, philosophers, and psychologists; still, it struggles to occupy a prominent place in the public consciousness. He should be remembered, if for no other reason, as the man who both set the stage for and helped usher in the age of computing technology, forever changing our perception of intelligence in the process. There is, nevertheless, a plausible explanation for the extent of our collective disregard, for as a mathematician and homosexual Turing was doubly queer.

In common usage the word "queer" typically marks subjects, experiences, or situations that are in some way out of the ordinary. It is safe to say that mathematicians are by this definition often perceived in the popular imagination as queer. Their intellectual abilities and esoteric pursuits prominently signal their otherness, people out of step with social conventions that interpret a life of the mind as a form of exoticism. Indeed, the cultural unease with those who spend their lives in the rarified pursuit of knowledge is apparent in a variety

219

of familiar tropes: dysfunctional loners, detached savants, mad scientists, and absent-minded professors. It is little wonder, then, that Turing represents such a challenging persona. In his case, the mind of the eccentric and otherworldly "Prof," as colleagues knew him, occupied a body tainted by a persistent public disdain for homosexuality.

"Queer" takes on a richer texture within the critical vernacular of queer theory. Here, among other things, it signifies disruptions that serve to expose the multiple ways *subjectivities* are constructed (that is, the ways subjects are culturally constituted and understood), experiences are imbued with meaning, and situations are interpreted. As much as the popular, the academic connotations of "queer" are relevant to this examination of Turing as it considers three phases of his work: solving the Decidability Problem, serving as a wartime codebreaker for the British government, and modeling morphogenesis. In each of these we find material that lends itself to queer analytics. Contemporary popular representations and appropriations of Turing, like his mathematical accomplishments and interests, invite readings that are similarly attuned to the construction of subjectivities. Acknowledging their cultural significance, this essay considers books, plays, films, and public commemorations as essential points of reference for reflecting on Turing as a queer mathematician.

This examination would not be possible without a wealth of material already available on Turing. Anyone looking for a full account of his life should consult Andrew Hodges' unsurpassed biography, *Alan Turing: The Enigma* (1983). Indeed, at least two other works have made use of Hodges' extensive and thought-provoking research: Hugh Whitemore's play *Breaking the Code* (1987) and David Leavitt's *The Man Who Knew Too Much: Alan Turing and the Invention of the Computer* (2006). Hodges effectively integrates Turing's (homo)sexuality among the central themes of a narrative that presents his life and work, and this understandably influenced both Whitemore and Leavitt. To a significant degree, this approach has undoubtedly served to reclaim and recuperate Turing as an historical subject. By employing queer analytics as its framework, this essay enlarges the scope of these undertakings so as to include opportunities for critical reorientations: that is, shifts of attention away from Turing and toward cultural constructions related to his life, work, and popular representations. Even so, several notable dichotomies identified by Hodges and others are essential to any reflection on Turing: the body and the mind; the conventional and the innovative; and the adherence to and deviation from established rules.

Reflecting on the Queer Aspects of Turing's Work

The Decidability Problem

Turing first earned a place in the annals of mathematical history with his solution to the Decidability Problem, work that also prepared the ground for the contributions to computing machinery and commentary on intelligence that he made throughout his career.[4] The problem, or *Entscheidungsproblem*, was the last hope for the foundational project of Formalism championed by David Hilbert.[5] In the aftermath of Kurt Gödel's stunning Incompleteness Theorem (1931), those seeking to secure mathematical knowledge on the firm foundation of a combinatorial system of formal symbols and manipulations confronted a devastating fact. Specifically, no such system rich enough to account for arithmetic is

simultaneously complete (in its ability to prove or disprove all possible statements the system might generate) and consistent (by virtue of its inability to produce contradictory statements). With this realization, the continued viability of Formalism hinged entirely on the Decidability Problem, which sought a definite means of identifying — within the system — those statements that could be proved by the system.

Turing learned of the Decidability Problem in 1935 while completing his dissertation at King's College, Cambridge, and eventually proved that no identifying procedure exists. If the failure of the Formalist project can be considered surprising, then Turing's approach to solving the problem added another unexpected twist. His argument, which is contained in the 1937 paper "On Computable Numbers, with an Application to the *Entscheidungsproblem*," deployed theoretical "computing machines" instructed to perform specific tasks (Turing 231, 241). Further, his argument envisions a universal computing machine that would, when provided with a properly encoded set of instructions, emulate the function of any specific machine. As Hodges points out, Turing's solution very much reflects the mechanical nature of the decidability process that the problem demanded (Hodges 93).[6] Still, his was a novel approach that represents a disruption of the type central to queer discourse.

As Charles Babbage's nineteenth century endeavors on his difference and analytic engines signify, the idea of mechanized computing certainly predated Turing. What makes Turing's conception radically different is the degree to which he blurs the boundaries between mind and body as well as the human and the mechanical. In "Computable Numbers," he raises questions about the scope of the human mind, while simultaneously suggesting that mental processes can be isolated and simulated outside of the body. That is, through his solution to the Decidability Problem, Turing effectively began deconstructing and challenging assumptions regarding human thought. Extending beyond the content to the form of his argument, we see another way in which his work destabilized conventions. The paper's presentation, as Leavitt points out, defies the structure of rigorous argumentation expected of mathematical publications of the time (Leavitt 56–58). By eschewing accepted professional and social conventions, Turing's work lays claim to more than solving a problem regarding the foundations of mathematics.[7]

Later in his career — and after the wartime experiences that so influenced him — Turing returned to the themes central to his solution to the Decidability Problem. His most notable work in this regard is a 1950 essay, "Computing Machinery and Intelligence," that appeared in the prestigious journal *Mind* (Hodges 415–26; Leavitt 240–59). The paper's famous opening sentence, "I propose to consider the question, 'Can machines think?'" only begins to signal the disruptive nature of his continuing interests (433). For Turing, ever the iconoclast, the question required consideration within an innovative paradigm that exposed humanistic, moralistic, and sentimental biases. The imitation game proposed in the *Mind* essay, which has come to be known as the Turing Test, provides this paradigm. Not persuaded by the claims being made in connection with the nascent development of electronic computing technology, others insisted that machines could never be considered intelligent until they could undertake creative acts. Turing's responses to such ongoing criticism extended beyond the pages of "Computing Machinery and Intelligence." Indeed, he appeared with one of his most ardent opponents, the neuroscientist Geoffrey Jefferson, in a discussion televised by the BBC in 1952 which explored the topic further (Hodges 450–55), and his unorthodox opinions had already made their way into several newspapers, including a 1949

article for *The (London) Times* (Hodges 405–06). It was the decidedly queer notions Turing expounded upon in *Mind* that made him something of a public figure.

Cryptography and Codebreaking at Bletchley Park

The public attention garnered by Turing's commentary on machine intelligence stands in stark contrast to the secrecy that necessarily surrounded his work on cryptography.[8] He was, in 1938, the first mathematician recruited to work with Britain's Government Code and Cypher School. Having returned from a two-year stay at Princeton, during which he earned a Ph.D. under the thesis direction of Alonzo Church, Turing soon took up his post at Bletchley Park in Oxfordshire (Hodges 145). There he joined in a concerted effort to decipher messages related to the German Navy, coded messages produced using the notoriously complex Enigma machines. Turing's experiences at Bletchley represent a link between the theoretical machines that underpinned his solution to the *Entscheidungsproblem* and his later involvement with their realization as electronic computing machines.

To some extent, Enigma machines were an open secret. They were developed in Germany in 1918 for the secure transmission of banking information. Commercially manufactured models could be found across Europe and America in the late 1920s. By that time, however, the German Navy had begun secretly adapting Enigma machines, and these were used for military encryption through the early 1940s. Without access to a military machine, the Enigma's structural adaptations had to be reconstructed by codebreakers using information gleaned from messages encoded by them. Revealing the internal logic secreted within a machine's body required an attack coordinated by disciplined minds, and early efforts at reconstructing the machines were undertaken by Polish mathematicians (Hodges 170–76; Rakus-Andersson). The knowledge obtained was passed on to the British government in 1939, when further changes to the Enigma machines and their use increased their complexity by several orders of magnitude.

Turing was well suited to assist in the mathematical attack on the Enigma code. This attack required an innovative mind, one comfortable with the possibilities as much as the limitations of mechanical processes. While there were certainly setbacks (indeed, there were periods of serious concern when the task seemed beyond the scope of those involved), by 1942 German messages sent using the naval Enigma protocols were being decoded with considerable regularity. As much as this is a testimonial to the dedication of the hundreds of men and women working at Bletchley, all of whom swore not to speak of their mission in accordance with Britain's Official Secrets Act, Turing was instrumental to these efforts. Indeed, he was a leader in developing, among many other things, the machines installed at Bletchley that mechanized the search for the keys that could unlock the coded transmissions produced by the Enigma. It seems altogether fitting that Turing should seek a mechanical surrogate to expose the weaknesses of another machine.

Yet during this time Turing was more than an eccentric boffin — the Prof— working on a problem of immensely significant proportions.[9] As chief analyst at Bletchley Park, he twice undertook perilous trans–Atlantic voyages to share information with officials in Washington, D.C., and New York. By 1943, however, the effective mechanization of the Enigma decryption process left Turing with little to occupy his mind. He was aware of, though took no real part in, perhaps the most prolific work undertaken at Bletchley: the development

of the Colossus in 1944–45. This electronic cryptanalytic machine was designed to respond to another mechanical coding scheme employed by the German Navy and represents one of the first tangible steps on the path to realizing the computing technology with which we are intimately familiar today.

It is difficult to assess the extent to which Turing fully understood the transformative nature of the years he spent at Bletchley Park, a period that set the stage for significant social and personal disruptions to come. He certainly believed that the time was right for turning the theoretical universal computing machine envisioned in his seminal essay "On Computable Numbers" into a reality. Though thwarted in his own ambitions, he eventually joined Manchester University in 1948 in order to work with the Baby, the world's first stored-program electronic digital computer.[10] On another level, he very likely relished the broader implication, suggested by his codebreaking experiences, that minds are capable of engendering new forms of power.[11] After all, the geese laying the golden eggs that Winston Churchill so heartily acknowledged were part of Bletchley Park's "intellectual armoury" (Hodges 205; Whitemore 24). It is, however, much less certain that Turing was conscious of the "closet" that he would occupy for the few remaining years of his life. While it did not exist in his day, the metaphor of the closet is appropriate insofar as it has come to represent constraints that inhibit people from living their lives authentically. As much as the bodily desires of this homosexuality, it was the exceptional character of his mind, itself the object of Bletchley Park's interest as well as the custodian of its many secrets, that eventually closeted both Turing and his legacy.

Morphogenesis

Turing's final years in Manchester not only provided an opportunity to pursue long-standing interests; they also gave rise to his last notable intellectual project. There can be little doubt that his post–Bletchley efforts to develop technology and his access to the Baby in Manchester — as well as its 1951 successor, the Mark I — underpinned his return to the ideas that infuse "Computing Machinery and Intelligence." It was, however, the physiological problem of *morphogenesis* — that is, the process by which matter takes on form and pattern — that competed for his attention (Hodges 429–37). Turing sought to use mathematical models as a means of exploring such processes. While others adopted different paradigms for considering the etiology of such processes, Turing was convinced that morphogenesis was "defined by some variation of chemical concentrations" and focused on systems of equations that modeled chemical reactions (Hodges 431). Ultimately, he believed that the creation of standing waves could trigger the development of particular physiological attributes. The real difficulty in adopting such an approach lies in the mathematical complexity inherent in the equations that model the chemical reactions considered, and the Mark I promised the computational power that Turing's approach required.[12] As Hodges justly observes, Turing's work on morphogenesis — a project showing the kind of innovation and independence of mind that were hallmarks of his entire career — constitutes an exercise in "numerical analysis *par excellence*" (434).

As mathematically impressive as his ideas are, Turing's research into morphogenesis can be considered queer with respect to both the nature and the context of the undertaking. Here, his attention was squarely focused on the disruptive consequences of alterations in

chemical concentrations. Yet, in essence, Turing addressed questions having fundamental significance well beyond physiology: for example, how can deviation (that is, the establishment of new attributes) be accounted for in the context of adhering to specific rules? And whence the rules that prescribe, as well as the environments that accommodate, such deviations?

Noting these questions is not meant to suggest that Turing was attracted to morphogenesis because of his sexuality. However, it must be remembered that he was undergoing "chemical castration" at the time this work was unfolding. The intertwining of these episodes of Turing's life is compelling, if primarily in a queer and somewhat speculative context. Turing was arrested for gross indecency in 1952, and his case went to trial some months later. The precipitating and undisputed event, which took place in the privacy of his own home, involved engaging in consensual sex with another man. Turing himself, through a complicated turn of events, admitted this to the police. Found guilty of the charge, he chose to receive estrogen treatments rather than serve time in prison. Hormones, by this time, were understood to affect the development of male and female genitalia as well as other attributes typically associated with gender. By the 1950s, hormonal theories provided a basis for the essentialism of sexual inversion and the therapies meant to address these. Since the nineteenth century, homosexuality had been typically understood as an inversion by virtue of which anatomical sex fails to align with psychosexual expression. The disruption, incorrect distribution, or inefficacy of hormones within the system could, it was believed, account for such inversions. In essence, and echoing some aspects of morphogenesis, medical authorities at the time adopted a chemical perspective that identified hormones as one source of Turing's deviance (Murphy 510–13).

The therapy Turing chose to endure was intended to reduce his libido, thereby reducing the intensity rather than the direction of his homosexual cravings and, thus, his inclination to satisfy them. This raises an interesting question: Were such interventions meant to cure or to control the subject? In shifting our attention to popular representations, this distinction continues to be relevant, though in a slightly different form. In what ways and to what extent do these representations seek to recuperate or to otherwise shape our perceptions of Alan Turing and his legacy?

Reflecting on Representations of Turing as a Queer Mathematician

Many maintain that Turing was airbrushed from history after his death. Be that as it may, various representations of his life and work have been directed at popular audiences since the 1980s.[13] Such is their number that the relevant concern is now not the ways by which Turing remains hidden from the public consciousness; instead, it is how his life as a queer mathematician has been constructed or reconstituted for public consumption. The central challenge inherent in such representations is undoubtedly one of helping audiences to appreciate two subjectivities that many find problematic: the mathematician and the queer. To explore the challenges presented by the latter, it is necessary to consider first the extent to which Turing constituted a queer subject during his lifetime.

Recent scholarship that reflects upon social histories in both England and America

provides a richly nuanced picture of homosexuality in the twentieth century (Chauncey, Cook, Higgins). Social codes associated with the sexual or romantic relationships men pursued with other men, although somewhat fluid during the Victorian era, became more restrictive over time. Indeed, in the early 1900s, it was entirely possible for men to seek and have sex with men, yet not be explicitly identified as homosexual as they might be today. The homosexual label — and much of the public's distain — typically applied only those who presented the kind of gender inversion that was understood to mark psychosexual inversion. Those queer men who presented a masculine persona occupied a more liminal cultural position during the first part of the century.

That inclinations could be obfuscated by otherwise convincingly performing accepted codes of masculinity contributed to the tensions that eventually resulted in the emergence of new sexual identities and regimes, as well as a virulent backlash against those who engaged in homosexual acts. Twentieth century wartime concerns only exacerbated attitudes.[14] On one hand, that queer men were adept at negotiating double lives suggested their susceptibility to being seduced by foreign influences so that they might betray national interests. On the other, the more overt and public expressions of homosexuality indicated the degree to which wartime destabilized established social norms, especially those related to gender. While historians have pointed out that Britain typically did not succumb to the witch-hunt mentality that gripped the U.S. during this period, in England the 1950s marked a time of particular hostility towards queers, witnessing several high-profile prosecutions (Cook 153, 167–71; Higgins ch. 10–12).

Turing, by almost all accounts, projected the kind of masculinity that sheltered him from public suspicion. This self-image might also account for the fact that, although undoubtedly aware of them, he did not move comfortably within queer subcultures, such as the one that flourished at Cambridge during his years there (Cook 158–59; Hodges 78; Leavitt 18–20). This is not to suggest that Turing was in denial — or in the closet — regarding his sexuality, for this is certainly not the case. Indeed, as is evident from his experiences in Manchester, he learned well enough the codes and signals that could be employed to find willing partners.[15] Further, it is difficult to imagine someone living a closeted life so freely acknowledging, as he did to the police, his relationship with another man. Turing, while fully accepting of his sexual inclinations, would not have identified as a homosexual as the term was primarily understood in the first half of the twentieth century. Rather, he was a man who had sex with men and who, until his arrest, negotiated this identity with discretion and honesty, if not approbation.

Serious efforts to reclaim and recuperate Turing as a queer mathematician begin with Andrew Hodges. His extensively-researched biographical study, *Alan Turing: The Enigma*, provides the first detailed account of all aspects of Turing's life and work, including the Bletchley Park years. Of equal importance, it embeds these in a richly detailed socio-historical context. While certainly sympathetic, Hodges' work does not concern itself with cynicism or conspiracy. This is most evident in its consideration of Turing's suicide: he died from eating an apple contaminated by cyanide. It is tempting to imagine a scenario in which powerful institutions wishing to insulate themselves from the scandal associated with Turing after his conviction sought to eliminate the concern. Instead, fully acknowledging the unanticipated nature of the suicide, Hodges chooses to evoke the frustration Turing must have felt being bound by rules that engendered contradictions (487–527). "The confusion and

conflicts that underlay his apparently single-minded homosexual identity," as Hodges astutely observes, "reflected the fact that the world did not allow a gay man to be 'ordinary' or indeed 'authentic'" (518). Given this, Turing may well have seen suicide as the inevitable deviation ordained by the rules then in play.

Among its many accomplishments, Hodges' biography inspired Hugh Whitemore to adapt Turing's story for the stage. *Breaking the Code* premiered in London in 1986, opened in New York the following year, and was adapted for television by the BBC in 1996, with Derek Jacobi playing the lead role in all three productions. Whereas Hodges' development largely sustains its narrative momentum by speculating on Turing's lifelong affection for Christopher Morcom, a childhood friend who died during his adolescence, Whitemore renders Turing's life by imaginatively reflecting on his arrest and conviction for gross indecency. The drama that unfolds through flashbacks and soliloquies allows for the juxtaposition of transformative events and ideas. For example, a scene in which Turing expresses to Morcom his wish that they could share a home and life together (16) immediately precedes one that has him inviting Ron Miller, the character representing the young man with whom his sexual liaison led to prosecution, to come home with him (19). Amid such temporal shifts, the character of Detective Sergeant Ross constitutes a focal point, and dialogues involving him provide much of the play's structure. In the play, Ross projects an "everyman" persona and serves as a foil for Turing. Where the latter understands the complicated and necessarily limited nature of systems governed by rules, the former cannot accept the practical significance of this theoretical observation in the context of social regulation (64).

One of the closing scenes of *Breaking the Code* reflects Turing's final days and provides the play's most memorable line. After his estrogen treatments ended, Turing traveled to Corfu, where he undoubtedly enjoyed the benefits of a homosocial environment very different from 1950s England (Hodges 486). The scene, which conjures up the intellectual and sexual relationships between boys and men of stature long associated with Greek antiquity, is largely devoted to Turing recounting his work on the Enigma code in the presence of his young paramour, Nikos. After imagining the immense pleasure associated with actualizing the "deeply satisfying relationship between the theoretical and the practical," Whitemore gives voice to a moral that can be drawn from Turing's life: "In the long run … it's not breaking the code that matters — it's where you go from there" (78). Through this scene, the play transforms the iconoclastic Turing into a tragic queer icon, one who seemingly anticipated a spirit of gay liberation that required serious rehabilitation in an AIDS-afflicted world.[16]

David Leavitt, like Whitemore, acknowledges a debt to Hodges' biography for the information it provided for his retelling of Turing's involvement with computing technology (301). Best known for works of fiction, most notably the queer classic *The Lost Language of Cranes*, Leavitt contributes to a series of books that undertake innovative examinations of scientific enterprises for popular audiences.[17] His work, *The Man Who Knew Too Much*, adopts new perspectives that are most notable in his reading of "Computing Machinery and Intelligence" and — as the title suggests — in his reconfiguration of Turing as a persecuted subject. Regarding the former, the imitation game presented by Turing as a means of assessing a machine's ability to think involves correctly ascertaining the gender of two subjects, one man and one woman, based solely on interrogation. Leavitt, unlike Hodges, literally interprets Turing's idea that the subject instructed to deceive the interrogator (the man) be replaced by a machine: "the game should now be played between [the interrogator] *and a*

computer pretending to be a man pretending to be a woman" (243, with original emphasis). The subversive nature of this interpretation is the basis upon which Leavitt asserts "Turing's preoccupation with [performing] gender" in the imitation game (245). This allows him to speculate on ways that Turing may have been signaling his queer identity through his "most perverse paper" (240–53, esp. 240).

Additionally, Turing's final years take on more desperate and sinister hues in Leavitt's rendering, according to which he was "'hounded out of the world' by forces that viewed him as a danger" (4). Alongside the disruptive aspects of his speculations on intelligence, Leavitt points out the extent to which Turing made people think about homosexuality as an identity, undoubtedly in uncomfortable ways (195–97). Social pressures may well have influenced the "anxiety concerning gender" that Leavitt observes in relation to "Computing Machinery and Intelligence," as well as the pathological notion of arrested development that appears in a short story Turing was writing near the time of his death (272). Further, both the story and another letter from the same time employ the *double entendres* and argot long used by queer men as a sub-cultural code (270–71). Their apparently unusual appearance in Turing's later writings suggests that Leavitt is justified in claiming that Turing was desperately reassessing his place in society after his conviction, with the resilience of valor giving way to the despair of victimization (279).

As its title reflects, Robert Harris' 1995 novel *Enigma* is set against the backdrop of Bletchley Park. This popular thriller and work of historical fiction follows the heroic efforts of Tom Jericho, a talented Cambridge mathematician recruited to join the ranks of British codebreakers, as he seeks to uncover the truth behind the mysterious disappearance of Claire Romilly, a Bletchley recruit with whom he has become romantically involved. Harris provides appropriate overviews of the Enigma machine and of the extreme difficulties it presented to cryptographers, acknowledging the help of many who had first-hand experience (452). His story grounds the mathematical nature of the work, as well as Jericho's intellectual suitability for it, through references to Carl Gauss, David Hilbert, Ernst Kummer, and Bernhard Riemann (12–15). G. H. Hardy's *Mathematician's Apology* also makes notable appearances, which allows for commentary on the relationships between mathematics and warfare (120–21, 317).[18]

Turing occupies an interesting position in Harris' story, but one that keeps him on the margins of the narrative. To establish the protagonist's — as much as the author's — credibility, Jericho is recruited to work at Bletchley on Turing's recommendation (15). Indeed, the early supervisory relationship Turing has over Jericho's mathematical research at Cambridge becomes one that later extends to their cryptographic endeavors (12–15, 51–54). Harris acknowledges Turing's work on the Decidability Problem and "On Computable Numbers" so that Jericho can reflect on the use of machines in the cryptographic work at Bletchley (193, 280). Turing's mentorship of Jericho also relates to an important moment in the plot, when Romilly asks Jericho to explain a reference to the *Entscheidungsproblem* that she finds in a paper among his books. The narrative carefully contextualizes the dialogue and clearly identifies Turing as the person who solved the problem (158–59). Ultimately, Harris provides a portrait of Turing that represents the actual subject to the extent that it serves his literary purposes. There is, for instance, no explicit reference to Turing's homosexuality, and his spirit inhabits the book much like a doppelganger for Jericho, who engages in more physical approaches to problem solving.[19]

Harris' wartime thriller, like many such books, soon underwent cinematic treatment. The film version of *Enigma* was released in 2001, with a screenplay written by Tom Stoppard. While not to suggest that film adaptations necessarily need to remain absolutely faithful to either literary sources or historical contexts, it is interesting that Turing is written out of the film. If he was a doppelganger in Harris' book, then the real and fictional subjects of Turing and Jericho are completely — and problematically — fused in the film. To note this requires attention to the short, yet pivotal, scene roughly 40 minutes into the film, in which Romilly asks Jericho about the paper she finds among his books. In contrast to the book's more accurate development, which appropriately and explicitly evokes Turing, the film's dialogue is subtly obscure:

ROMILLY: What's the *Entscheidungsproblem* when it's at home?
JERICHO: It's just something I was working on at Cambridge. It's a theoretical machine that...
ROMILLY: Theoretical, so it doesn't exist? ... Well, this will do. I want something of yours to keep.
JERICHO: Give it back!
ROMILLY: Why?
JERICHO: Because it means nothing to you and a lot to me.

Only knowledge of mathematical history can alert the viewer to what has transpired in this exchange. Turing has not only been removed as a subject of any consequence, his work on the Decidability Problem has been effectively appropriated by the fictitious Jericho, who undertakes swashbuckling and (decidedly) heterosexual exploits. This act of cinematic reconstitution is made even more suspect given the physical resemblance Dougray Scott, who plays Jericho, bears to Turing. In one sense Jericho represents Turing in the film. Certainly rendering the intellectual heroism of Bletchley Park for popular consumption presents a challenge for storytellers. In the case of *Enigma*, this is most immediately apparent in the cinematic conceit of following the transformation of Jericho from a talented mathematician committing his mind to the service of his country to an action figure risking life and limb in a shoot-out with Nazis. Sadly, Turing's legacy, the one Prime Minster Brown justly acknowledged in his recent apology, is given little — indeed, no — opportunity to speak for itself.[20]

Fortunately, Turing's intellectual and wartime contributions are remembered through various commemorative designations. Many people may admit an acquaintance with the Turing Test by virtue of its status as the holy grail of machine intelligence. Some claim that the now ubiquitous (bitten) Apple logo, once replete with a rainbow motif similar to that adopted by queer communities, was developed as an homage to Turing (Leavitt 280). Although the designer denies this, the cultural association persists as a potent myth. Signifying a greater awareness of him in Britain, his birthplace in London, as well as his house in Wilmslow, the town south of Manchester where he spent his final years, both bear English Heritage Blue Plaques.[21] Turing's legacy is also vividly recounted for visitors to Bletchley Park. Among professionals, the Association for Computing Machinery offers the $250,000 Turing Award as its "most prestigious technical" recognition ("ACM Awards"). In academic settings, buildings and facilities on campuses in England, Denmark, and the United States carry his name. Of particular note, the University of Manchester School of Mathematics now occupies the Alan Turing Building, which was completed in 2007 and is located only a short distance from where its namesake would have spent time minding the Baby (the *Manchester Institute* website).

Undeniably proud of its adopted son, as well as of the spirit of radicalism that permeates its heritage, the city of Manchester is home to several other public acknowledgements of Turing. Fittingly, two of these highlight the difficult nature of commemorating the life and work of a queer mathematician. Alan Turing Way skirts the eastern margin of the conurbation as part of its inner ring road system. Established in 1994 as part of Manchester's effort to pay tribute to many noteworthy citizens, the road accommodates a great deal of traffic making its way to industrial parks, superstores, and the new Sportcity complex. While certainly not meaning to repudiate the intentions of such civic efforts, and notwithstanding reports that attended renaming the road, it is difficult to imagine the typical commuter associating their experience with Turing in any meaningful way. The road is several miles from either the University of Manchester or Turing's home in Wilmslow, and it offers little by way of fostering the kind of reflection that a figure like Turing warrants. Ultimately, Alan Turing Way, like many such road-naming efforts, acknowledges a life out of context, a subject disassociated from both mind and being.

A more appropriate commemoration is found in a quiet, green space in the city's center. Manchester City Council selected Sackville Park as the site for Glyn Hughes' bronze statue of Alan Turing, which was commissioned and situated in time to mark the 2001 anniversary of Turing's birth.[22] The statue features a contemplative Turing sitting alone on a park bench, an apple held in his hand. This is a memorial on a human scale and one that invites passers-by to reflect on — or at least question — the plaque placed at his feet: "Alan Mathison Turing … Father of Computer Science, Mathematician, Logician, Wartime Codebreaker, Victim of Prejudice" ("Alan Turing"). The plaque ends with words from Bertrand Russell: "Mathematics, rightly viewed, possesses not only truth but supreme beauty, a beauty cold and austere like that of a sculpture." One of the most compelling features of this statue, however, is its location. A few paces, taken in one of opposite directions, lead either to academic buildings that Turing would have recognized or to Manchester's now very visible Gay Village.

Conclusion

As these popular portrayals and public commemorations make clear, Prime Minister Brown's posthumous apology merely continues the work of reclaiming and recuperating the legacy of Alan Turing. That a project undertaken with such a seriousness of purpose in the 1980s maintains its relevance more than twenty years on only hints at the considerable challenges involved in honoring a gifted mathematician and persecuted homosexual in a cultural milieu that renders both identities unusual. Indeed, acts that seek to reposition Turing in the popular consciousness — including those with limited ambitions — provide a rich context in which to consider queer analytics, since the subjectivities being (re)constructed speak to a variety of normative disruptions. Inasmuch as they allow us to interrogate conventions regarding human intelligence, Turing's intellectual pursuits encourage us to consider the ways in which his sexuality reveals cultural anxieties that, in their day, played a role in sanctioning medical interventions. At the same time, Turing's homosexuality signals an otherness expansive enough to circumscribe his identity as a mathematician. Ultimately, this is an otherness that offers both problems and possibilities for authentic representations of his genius and spirit.

It is certainly fitting that this essay is included in this collection under a section entitled "Players." To be considered such suggests numerous associations, including "games" and "performances." Turing was certainly a "player," one whose life and work permeates a complex network of connotations.[23] Yet he was much more: by choosing to disregard accepted rules and conventions, he exposed and subverted both the "games" and "performances" in which he participated. As challenging as it may be to convey this to popular audiences, it is difficult to imagine a more fitting legacy for a queer mathematician.

Notes

1. I would like to thank John Townsend for his longstanding interest in Turing's legacy, for countless insightful conversations on this subject over the years, and for critically reading earlier drafts of this essay.

2. Wittgenstein's famous Cambridge lectures gave rise to this apropos observation during an exchange with Turing, who was included in the lectures' very select audience (96).

3. Perhaps the most potent criticism asks why the Prime Minister failed to take the opportunity to apologize for the systematic persecution of countless queer men and women less well-known than Turing.

4. The thematic grouping of activities in this section provides a structure for this intentionally brief overview of Turing's many accomplishments. It belies, however, the extent to which it is effectively impossible to compartmentalize various aspects of his work.

5. The Decidability Problem is also known as the Decision Problem. Hodges employs the former title, while Leavitt prefers the latter. For further discussion of the Decidability Problem, its history, and possible "loopholes" to its 1930s solutions, see Beeson (92).

6. Turing learned of the Decidability Problem from the Oxford mathematician Max Newman, who described it in terms of a mechanical process; Newman's emphasis on the mechanical nature of the problem, although likely serendipitous, inspired Turing's work (Hodges 93–94). Alonzo Church's independent solution involving lambda-calculus takes an approach more in keeping with the expectations of mathematical logic (Hodges 112).

7. In a similar vein, Imre Lakatos drew attention to the penchant of some mathematicians, particularly in the modern age, to disrupt the universalizing inclinations of others. These disruptions to normative perspectives, which emphasize the significance of the "abnormal" in interrogating the "normal," might be read in the context of today's queer analytics (19n3, 22–23, esp. 23).

8. For a detailed account of the work undertaken at Bletchley Park and Turing's numerous contributions to this work, see Hodges (esp. ch. 4–5) and Sale.

9. One of many colorful stories of Turing at Bletchley has him wearing a gas mask while bicycling in order to avoid the effects of hay fever (Hodges 209; Leavitt 187).

10. Recruited in 1945, Turing worked for the National Physical Laboratory (NPL) for three years. Although unable to persuade officials at the NPL to produce the kind of machine he envisioned, Turing's 1945 project report on the Automatic Computing Engine (ACE) represents thoughts bookended by "On Computable Numbers" and "Computing Machinery and Intelligence" (Hodges 307–77).

11. Daniela Cerqui notes two trends concomitant with the emergence of today's information society: "an increasing valorization of the mind ... over body and matter" and "a strong tendency to replace everything human with artificial elements" (60). She argues that Turing's work and life from the 1940s exemplifies the extent to which these tendencies can be considered complementary rather than contradictory (60–65).

12. Turing's model is challenging in that it constitutes a nonlinear system of differential equations rather than a more manageable linear system. Finding a solution to a linear system of differential equations can be achieved by the method of superposition. This involves establishing solutions to particular components of the linear system and piecing these solutions together to generate the desired result. Nonlinear systems are not amenable to this reductive approach; consequently, solving such systems requires more holistic and computationally demanding analyses.

13. One recent work worthy of note is *A Madman Dreams of Turing Machines* (2006). In this, Janna Levin juxtaposes the troubled lives of Kurt Gödel and Alan Turing for an elegantly imagined novel that reflects on the notion of free will.

14. Ironically, many queer men fondly remember their lives during wartime, noting the sexual freedoms it provided (Cook 148–50).

15. He also acknowledged his homosexuality while at Bletchley Park, at least to one of those colleagues closest to him (Hodges 206, 216).

16. Another notable feature of the scene is the way in which the sexual freedom offered by Turing's

holiday in Greece is juxtaposed with a freedom to speak openly about the work undertaken at Bletchley Park.

17. The "Great Discoveries" series is published by W. W. Norton. Leavitt has recently returned to mathematical themes in *The Indian Clerk* (2007), which explores the life of Srinivasa Ramanujan.

18. As Harris justly observes through his characters, Hardy's perceptions of mathematical purity were sadly nostalgic.

19. Regarding Turing's relationship with Alonzo Church at Cambridge, Leavitt notes the extent to which "reputation trumps talent" (126). Interestingly, Turing's intellectual talents trump his homosexual reputation in Harris' *Enigma*. One can argue that this is entirely appropriate given Turing's discretion regarding his (homo)sexuality. However, the extent to which the book mingles cryptographic and romantic intrigue means that Turing would be a problematic central character.

20. Leavitt comments on Turing's absence in the film version of *Enigma*, but apparently fails to appreciate his appropriation by Jericho (158).

21. Awareness of Turing in Britain has increased considerably since the 1980s. Indeed, Turing was voted to an eclectic list of "100 Great British Heroes" in a nationwide poll conducted by the BBC in 2002.

22. Derek Jacobi, who played Turing in *Breaking the Code* on stage and in film, was patron of the Alan Turing Memorial Fund that paid for and sought permission to erect the statue (Jacobi). As a queer academic who, like Turing, has adopted Manchester as his home, I was honored to be among those invited to and present at the statue's dedication ceremony.

23. Cognizant of another popular connotation, I do not want to suggest any association of the word "player" with one who engages in cavalier or indiscriminate sexual activity. To do so here would run the risk of reinforcing, albeit implicitly, a stereotypical linkage between homosexuality and promiscuity. Such an association is certainly problematic in Turing's case. Moreover, the disruption of unquestioned assumptions, such as those that give rise to the notion of homosexual promiscuity, is an essential aspect of queer theory.

Works Consulted

"Alan Turing." *Wikipedia*. Wikimedia Foundation, n.d. Web. 25 Jan. 2010.

Beeson, Michael J. "The Mechanization of Mathematics." *Alan Turing: Life and Legacy of a Great Thinker*. Ed. Christof Teuscher. Berlin: Springer-Verlag, 2004. 77–134.

Brown, Gordon. "Gordon Brown: I'm Proud to Say Sorry to a Real War Hero." *Telegraph.co.uk*. Telegraph Media Group, 10 Sept. 2009. Web. 1 Sept. 2010.

Cerqui, Daniela. "From Turing to the Information Society." *Alan Turing: Life and Legacy of a Great Thinker*. Ed. Christof Teuscher. Berlin: Springer-Verlag, 2004. 59–74.

"Charles P. Thacker Named Recipient of 2009 ACM A.M. Turing Award." *Association for Computing Machinery*. Association for Computing Machinery, n.d. Web. 25 Jan. 2010.

Chauncey, George. *Gay New York: The Making of the Gay Male World, 1890–1940*. New York: Basic, 1994.

Cook, Matt. "Queer Conflicts: Love, Sex and War, 1914–1967." *A Gay History of Britain: Love and Sex Between Men Since the Middle Ages*. Ed. Matt Cook, with H. G. Cocks, Robert Mills, and Randolph Trumbach. Oxford: Greenwood, 2007. 143–77.

Enigma. Dir. Michael Apted. Perf. Dougray Scott, Kate Winslet, Saffron Burrows. Miramax, 2001. Film.

Harris, Robert. *Enigma*. London: Arrow, 2009.

Higgins, Patrick. *Heterosexual Dictatorship: Male Homosexuality in Post-War Britain*. London: Fourth Estate, 1996.

Hodges, Andrew. *Alan Turing: The Enigma*. London: Vintage, 1992.

Jacobi, Derek. Letter to J. Staniforth, Director of Parks. 9 Sept. 1998. Manchester City Council, Manchester.

Lakatos, Imre. *Proofs and Refutations*. Ed. John Worrall and Elie Zahar. Cambridge: Cambridge University Press, 1976.

Leavitt, David. *The Indian Clerk*. New York: Bloomsbury, 2007.

_____. *The Man Who Knew Too Much: Alan Turing and the Invention of the Computer*. New York: Norton, 2006.

Levin, Janna. *A Madman Dreams of Turing Machines*. New York: Knopf, 2006.

Manchester Institute for Mathematical Sciences. University of Manchester, 1 Jan. 2009. Web. 25 Jan. 2010.

Murphy, Timothy F. "Redirecting Sexual Orientations: Techniques and Justifications." *Journal of Sex Research* 29 (1992): 501–23.

"100 Great British Heroes." *BBC*. BBC, 21 Aug 2002. Web. 25 Jan. 2010.

Rakus-Andersson, Elisabeth. "The Polish Brains behind the Breaking of the Enigma Code Before and

During the Second World War." *Alan Turing: Life and Legacy of a Great Thinker*. Ed. Christof Teuscher. Berlin: Springer-Verlag, 2004. 419–40.

Sale, Tony. "Alan Turing at Bletchley Park in World War II." *Alan Turing: Life and Legacy of a Great Thinker*. Ed. Christof Teuscher. Berlin: Springer-Verlag, 2004. 441–62.

Turing, Alan. "Computing Machinery and Intelligence." *Mind* 59 (1950): 433–60.

_____. "On Computable Numbers, with an Application to the *Entscheidungsproblem*." *Proceedings of the London Mathematical Society*. 2nd ser. 42 (1937): 230–65.

Whitemore, Hugh. *Breaking the Code*. Oxford: Amber Lane, 1987.

Wittgenstein, Ludwig. *Lectures on the Foundations of Mathematics: From the Notes of R. G. Bosanquet, Norman Malcolm, Rush Rhees, and Yorick Smythies*. Ed. Cora Diamond. Ithaca, NY: Cornell University Press, 1976.

Mat(t)h Anxiety
Math as Symptom in Gus Van Sant's Good Will Hunting

Donald L. Hoffman

My boy's wicked smart.
— Morgan in *Good Will Hunting*

The notorious *Cahiers du Cinéma* theory of the *auteur* has been profoundly critiqued, and in recent years seems all but discredited. It is certainly true that any film that manages to get made and displayed is a collaborative production, involving unknown quantities of interference, hostility, tempers and tensions, and innumerable squabbles over details, to say nothing of trampled egos and libidos, which affect the final product. Despite all this there are certain directors with a vision (or a tic) that stamps their work with a unique personal vision. Hitchcock, or course, is the most prominent exemplar of this control, and Douglas Sirk one of the most miraculous, managing to impose a personal style on a body of mediocre melodramas assigned to him by the studio, and creating an estimable body of work within a (deservedly) much-maligned genre. Among those who manage to impose a style on their projects, despite the increasing dominance of a complex Byzantine structure of corporate production demands, Gus Van Sant may claim to be one of today's most original, recognizable, and impressive *auteurs*. He was able to achieve this status, in part, by his roots in the indie movement, which allowed him to pursue his themes and obsessions unencumbered — or, at least, considerably less encumbered than he would have been in corporate Hollywood. To his studies at the Rhode Island School of Design, he owes the opportunity to develop his own style, while to Portland, Oregon, he owes his early freedom from Hollywood and the ability to explore his own themes.

In the great corpus of Van Sant's work from the 1985 indie masterpiece, *Mala Noche* (a haunting and funny film about a charming, racist druggie and his obsession with a mysterious, stunningly photographed, Mexican street boy) to his first mainstream success, the relatively early *Good Will Hunting* (1997), and to his most recent hit, *Milk* (2008), certain themes and images remain constant. Above all, Van Sant is the chronicler of the outsider, particularly the adolescent male outsider, from the "illegal" Mexicans in *Mala Noche* to the junkies in *Drugstore Cowboy* (1989) and the Portland hustlers in *My Own Private Idaho* (1991), to the more mainstream (?) activists in *Milk*. Beginning with *Good Will Hunting*,

233

Van Sant spent a number of films investigating the position of a newly-identified outsider: the young man trapped in an academic institution. In addition to Will Hunting (Matt Damon) at MIT, we have Rob Brown (Jamal Wallace), the "ghetto genius" of 2000's *Finding Forrester* (who is nearly destroyed by winning a scholarship to an elite east coast prep school) and the children trapped in the endlessly oppressive corridors of Watt High School — a fictional version of Colorado's Columbine High School — as imagined in *Elephant* (2003).

As is probably obvious from the above list, a fairly large number of Van Sant's "outsiders" are gay. This is certainly true of *Mala Noche*'s Walt (Tim Streeter) who obsesses over Johnny (Doug Cooeyate), of at least some of the hustlers in *My Own Private Idaho* (in which River Phoenix's Mike falls poignantly in love with his protector and betrayer, Scott Favor, played by Keanu Reeves), and, of course, of most of the cast of *Milk*.[1] Even those films that do not explicitly deal with gay themes maintain a gay sensibility, and a gay subtext — not necessarily played as a consistent throughline — often recurs in Van Sant's films, sometimes in disturbing or off-putting ways (such as the brief, fumbling, and furtive sex scene between the high-school snipers in *Elephant*). *Good Will Hunting* may be one of Van Sant's most mainstream films, but its obsession with marginalized youth remains strong, and gay themes are prominent, if not always overt. Indeed, insofar as there are gay themes in *Good Will Hunting*, they are found less in the script than in the treatment — in gestures, hints, and images that are found on the screen in the interstices of the text. These interventions, which bear the distinct impress of Van Sant's direction, mark Van Sant as a contemporary *auteur*.

Matt Damon and Ben Affleck devised the basic plot of *Good Will Hunting* as a vehicle to further their ambitions to become movie stars. Although both young actors had respectable resumes for their ages, the film eventually made from their thousand-page script provided a major boost to their careers.[2] Drastically reduced in size, the script led to a successful film which is quite accurately described by Bouquet and Lalanne as a traditional *conte* or folktale (94) in which a rejected orphan suddenly displays amazing talents and wins the hand of the princess and, in conjunction, her kingdom (or, in this case, her inheritance). Will even has the aid of what in the olden days would have been his fairy godfathers, here translated, in good late twentieth-century fashion, into mentors and social workers.

Van Sant's intervention in this simple fable complicates things in interesting ways. From the very first shot of the film, there is a discrepancy between the published screenplay (Damon and Affleck, 1997) and the completed project.[3] The screenplay opens with shots of Boston's Saint Patrick's day parade,[4] which would significantly establish Will's racial and social milieu, both of which link Will with the outsiders who have attracted Van Sant from the beginning of his career. Van Sant's opening of the film, however, creates a more complicated context for Will and his story. Instead of the simple social documentary style implied in the screenplay, Van Sant brings us immediately into the mysterious world of Math and Academe. While the credits are rolling, we see a highly stylized montage consisting of shots of myriad textbooks and close-ups of dizzying quantities of inscrutable (to most viewers) mathematical formulas; the images resemble those seen through a kaleidoscope, perhaps emphasizing the division between Will's two worlds. Finally, we are given a crane shot of Will alone in his room, immersed in books. Only after this, as the narrative proper begins, do we see Chuckie (Affleck) approaching a fairly ramshackle house in a clearly non-affluent neighborhood, from which Will emerges and joins his friend.[5]

This opening is clearly more complex than the one described in the screenplay. The screenplay's images immediately establish Will and his friends as Irish and as "Southeys" (a popular term for residents of Boston's South End, a traditionally Irish Catholic working-class neighborhood). Van Sant's opening, on the other hand, focuses not on Will's solidarity with this marginalized group, but with his marginalization *within* this group as a party of one, a solitary autodidact reading voluminously and relentlessly. Only after Will is established in his place as out of place does Van Sant take us into the South End itself, an area victimized by economic deprivations, as evidenced by houses ruined or unbuilt. It is a fairly devastated neighborhood and situates Will in his environment far more immediately than the parade would have done. (It also focuses on the wearisome routine of daily life in the South End rather than on a moment of celebration that would distract the viewer from the daily, more dismal lives of the Southeys.[6]) The close-up of the house, in addition, sets up the "happy" ending of the film in which Will escapes from the house and from the South End. Finally, images of iconographic houses, such as Dorothy's house (the one that falls on the Wicked Witch of the East) and the Bates' residence in *Psycho* (Alfred Hitchcock, 1960), recur in Van Sant's films: for instance, the former home appears significantly in *My Own Private Idaho* and in *Drugstore Cowboy*, and the latter in Van Sant's 1998 remake of *Psycho*, his first project completed after *Good Will Hunting*). Insofar as Will's house echoes that of Norman Bates, it reminds us how different Good Will is from Mad Norman, and that for the orphaned/abandoned Will, the house was never a maternal one.

The contrast between Will's two worlds is made clear as we move from the dilapidation of the South End to the manicured lawns and classic architecture of the MIT campus, where Will works as a janitor. These drastically different settings establish Will's divided worlds and the distance between them, a distance that grows even greater as the camera enters the classroom of Professor Lambeau (Stellan Skarsgård) and the mystery of math is reprised from the shot of formulas that opens the film. In his introduction to Damon and Affleck's screenplay, Van Sant himself identifies the math in the film as a *maguffin*, which he defines as "the thing that all the characters in our story desperately care about but we as an audience don't care about, at least not directly" (ix).[7] The "thing" is usually thought of as an object. A classic example is the money that Marion Crane (Janet Leigh) steals in *Psycho*, but, in effect, Marion herself is a maguffin, as the search for her is really a distraction from what becomes the search for the true *objet petit a* of the film, Norman Bates — or even more truly his mother, the *objet petit a* within the "screen" *objet petit a*.[8] Though Van Sant asserts that *Good Will Hunting*'s math is a maguffin, it may, in fact, turn out to be more significant than it seems, as Van Sant hints when he adds to the assumption that the "the audience [doesn't] care" the suggestive qualifier, "at least not directly," hinting, to follow up Hitchcock's metaphor, that, if we are clever enough, we might actually find lions in Scotland.

When we enter Lambeau's classroom, we are greeted with a plethora of maguffins. The screenplay's "stage" directions read, "The chalkboard behind him is covered with theorems" (5). All these theorems are maguffins in the purest sense, since their proofs are irrelevant to everyone but the mathematicians in the narrative (and perhaps a few in the audience). They do, however, set up a more complicated problem, when Lambeau, in the film, tells his students that he's "put an advanced Fourier system on the main hallway chalkboard"[9] and that he's "hoping that one of [them] might prove it by the end of the semester."[10] Lambeau promises "fame and fortune" to whoever is able to provide such a proof. In the next scene,

we see Will, mop in hand, discover Lambeau's posed problem.[11] Van Sant then alternately shows the two sides of Will: Will the Southey hangs out with Chuckie at a bar; Will the Academic returns home to work on Lambeau's problem, and, returning to MIT, writes his solution on the hallway chalkboard; Will the Southey hangs out with Chuckie at some batting cages, where Chuckie suggests they "fuck up some smart kids." Then we are back at MIT with a student approaching Lambeau, eager to find out "who proved the theorem." Maguffin upon maguffin. Within the film's world, the problem now is not to solve the problem but to solve the problem of who solved the problem. As is typical of the *conte*, a trap is set to identify the mysterious hero. Lambeau poses another problem, intent on "unmasking" the "Mystery Math Magician," who he still assumes to be one of his students. Later that evening, Lambeau solves the problem of who solved the problem when he happens upon Will yet again writing on the hallway blackboard. Lambeau, with his elitist assumptions, accuses Will—who flees upon being discovered—of defacing the blackboard with graffiti before he notices that the problem has been solved.

But then the maguffin shifts again and brings us closer to the heart of the narrative. Lambeau having solved the problem involving the problem-solver's identity, the problem now is for the viewer to solve Will; he is his own *Kindersurprise,* concealing the *objet petit a*, the subject of the *conte*, and the problem that turns the *conte* into a modern narrative.[12] As the search for the solver ends, the search for/battle for Will begins. Van Sant, however, has already defined the core of the problem, namely, Will's divided self, split between the worlds of the South End and of academe. The film chronicles, as Van Sant puts it, the "fight over Will's good will" (ix). Or, to put it another way, we are in process of hunting for Good Will, which obliges us to also acknowledge the presence of Bad Will.

Bad Will is sort of the proverbial elephant in the room. Once one actually looks at Will's badness, it is abundantly present. Both Damon and Affleck's writing and Damon's acting create a character practically awash in charm, who attracts our sympathy almost as soon as we see his straw-colored mop of Dennis-the-Menace hair in the opening credits. Damon's charismatic performance, then, convinces us to overlook Will's badness, and even to encourage it. How can we not root for the disadvantaged boy scorned by the academic community, when he—let's admit it—mean-spiritedly attacks academe with its own weapons? The audience either fails to notice or actively supports Will's badness.

While in the film it is the (presumably) Good Will that we first meet, studying voraciously alone in his room, in the original screenplay it is the Bad Will to whom we are first introduced, as he joins with his rough chums in enjoying the fairly brutal tale of Chuckie's cousin beating a cat to death.[13] More dramatically, in the film the scenes of Lambeau putting the theorems on the board are intercut with scenes of Will and his chums commenting on the "nice ass" of a girl as she talks to "fucking guinea" Carmine Scarpaglia (Rob Lyons), leading to what, in the age of *West Side Story*, would have been called a "rumble," and ultimately landing Will in jail. Describing the fight, the screenplay indicates that "whatever demons must be raging inside Will, he is taking them out on Carmine Scarpaglia" (16). While it is unlikely that either Damon and Affleck or Van Sant literally thought of Will as possessed by demons, this offhand extradiegetic comment leaves no doubt that there is a bad side to Will.

One fight combining homosocial bonding and juvenile jealousies with a bit of neighborhood racial rivalries may make Will an occasionally bad guy, but it does not make him

a demon. Nor, in fact, does it make him particularly interesting. What begins to make him interesting is that Bad Will Hunting is a genius and is as lethal with his brains as he is with his fists. The first example of his Bad Boy Brains shows up in the elitist atmosphere of a Harvard bar where Chuckie thought "there'd be equations and shit on the wall" (23). Will is immediately attracted to Skylar (Minnie Driver) who is talking to Clark (Scott William Winters), a stereotypical grad student. As Clark tries to put down the Southey, Will responds to Clark's remarks about "the evolution of the market economy in the southern colonies" with

> Of course that's your contention, you're a first year grad student. You just got finished reading some Marxian historian ... you're going to be convinced of that until next month, when you get to James Lemon, then you're going to be talking about how the economies of Virginia and Pennsylvania were entrepreneurial and capitalist way back in 1740.

Will ends his schooling of Clark by mentioning Gordon Wood's comments on "the pre–Revolutionary utopia and the capital-forming effects of military mobilization." When Clark responds, Will points out that his response is straight out of Vicker's *Work in Essex County*, page 98. Clark slinks away, defeated, as Morgan (Casey Affleck) gloats, "My boy's wicked smart."

Earlier Will has been seen studying alone, but, after the fight scene, we become aware that Will's "smarts" are also a weapon, and that he battles fiercely, and sometimes unfairly, with both his brains and his fists. He is in this case definitely a Bad Will, but a Bad Will who wins us over because we are instantly alienated from the pompous grad student and ally ourselves with the scorned Southey. And we are also inclined to like him because he is coming on to Skylar and our history of movie-going has trained us to recognize that we have just witnessed one of the infinite variations on the "meet cute"; the film has triggered our sympathies for the characters we can tell are meant to be lovers. All our Hollywood schooling in both class and romance direct us to appreciate Will.[14] Despite there clearly being a lot of good in Will Hunting, we get to really know Bad Will first. And we like him. We are also encouraged by the film's direction, of course, since this is just the kind of under-class hero that Van Sant has made his reputation portraying. Will sells neither drugs nor his body, but he is nevertheless, as a marginalized Southey, a member of one of Van Sant's numerous bad boy gangs.

The job of turning Bad Will into Good Will falls first on the shoulders of Lambeau. Having solved for Will (that is, discovered Will's identity as the blackboard problem-solver), he is the first to undertake the job of "solving Will," of saving him from a life in the under-class and grooming him to become a young man fit for the privileges and rewards of a successful well-paying academic career; the professor is rife with good will and determined to turn Will into an idealized young and beautiful version of himself, to coax him into becoming the prize-winning genius that he, himself, almost became. As part of this project, he sends Will to a series of therapists, where Will has the opportunity to further show his "bad" side by using his intelligence to beat the therapists at their own games. Once again, Will is playing by street, bad kid rules. And once again, we love him for it. The series of encounters may be unfair to the psychiatric profession, but it continues to be a pleasure to see the underdog win; deconstructing the aridity of psychoanalytical theory and the platitudes of therapy,[15] bad boy Will triumphs again.

When the respected therapists fail, Lambeau turns Will over to his friend, Sean Maguire

(Robin Williams), who, although meant to solve problems, raises a huge number of his own. As something of a dropout, having given up a brilliant career to teach at a community college, Sean is the least convincing and most problematic character in the film. He is something of an outsider (which accounts for his ability to connect with Will), but he is also compromised and diminished, redeemed mainly (and only in a bathetic Hollywood ethic) by his love for his wife, who died, tragically young, after a spontaneous, whirlwind courtship. This narrative of doomed romance is a pivotal model for Will's redefinition of himself as he becomes more open to emotion.

With the entrance of Sean into the narrative, Will's *conte* begins to explore the conflict between his "fairy godfathers" in their battle for his soul. On the basic diegetic level, the conflict is a simple one. Lambeau is a successful academic, a touch disappointed in his aspirations, but quite a respectable success; however, he also represents success within academia, which, essentially, in Hollywood terms, means capitulation to the demands of a system that values conformity over individuality and tradition over experimentation — that is, to the demands of a system that requires you be a "good" boy. This is exactly the sort of system that Van Sant's heroes have always rejected;[16] Lambeau may be a good man, but he is also a "company man." Sean, on the other hand, seems to be a more typical kind of Van Sant hero. He shares notable similarities with Will: he is Irish, he is a dropout (of sorts), and while he, too, operates within an academic setting, academia is not an institution that defines him, and is one that he can relatively easily reject. It seems a simple opposition, if not quite between success and failure, then between freedom and constraint, and, if not quite a struggle between good and evil, at least something like the ancient struggle between the heart and the head: brainy, "safe" Lambeau vs. intuitive, romantic, "dangerous" Sean.

This is not an entirely erroneous reading of the contest between the two professors, but in one significant scene Van Sant complicates and undercuts this simple binary. It is a small moment, but it has no counterpart in the published screenplay. Will and Lambeau are bonding over mathematics. They sit next to each other on two office chairs, which Van Sant shoots from behind. During a moment of silence and unspoken affection, Lambeau slowly begins raising his left arm, leans towards Will, reaches up to put his arm around Will in an almost-embrace, and tousles his hair. It is not exactly a seduction, but it certainly approaches an intimacy beyond that of an appropriate teacher-student relationship, and is far more tender than the homosocial bonding of Will and his Southey friends, who would unhesitatingly find a suitably common and derogatory label for that gesture. Will's reaction is hard to read, though we do know that he does not remove Lambeau's arm and does not get up to leave. If Lambeau's gesture is unambiguous, Will's response is not.

However great or small the erotic charge the gesture may carry, it does compromise Lambeau's intervention in Will's life. His motives do not seem entirely pure. It also introduces a gay-straight binary into the series of oppositions between Lambeau and Sean, and, most importantly and oddly, it interpolates mathematics into a nexus of queerness and, for Will, introduces the possibility that, like the bad boy brothers in other Van Sant films, Will too might be gay. While this is never an issue that is addressed directly, it does establish additional reasons why Will might begin to withdraw from the life plan that Lambeau seems to have prepared for him.[17]

This moment lends a particular intensity to a resonant scene in the film that, like the furtive embrace, finds no precedent in the published text. The *Good Will Hunting* DVD

offers as part of its supplementary materials a deleted scene that is perhaps an alternate version of one that is actually included in the film. In the deleted version, Will writes mathematical formulas on a vertical board with the intensity of Orlando carving the name of Rosalind into all the trees of Arden. In the brilliant image that Van Sant invents and apparently uses to replace this moment, Will writes mathematics on what appears to be his bathroom mirror. In the first instance, Will's obsession is made clear, but it is a simple and straightforward performance of his obsession with math, and, perhaps the unreflective surface of the board on which he writes (possibly covering a window opening) hints at something blocked, cut off. The board is, at the very least, a surface, opaque, blank and unresponsive, revealing nothing but mathematics that is also opaque — readable, perhaps, by Will, but certainly not by any of his friends, from whom he is isolated by his mathematical genius.

In the revised version, Will's *tabula*, rather than being opaque, is reflective, if not transparent. Shot slightly from the left, over Will's shoulder, Will confronts himself in his mirror, and sees himself as a stranger. In an earlier film, Van Sant had already raised the issue of the danger of mirrors. In *Drugstore Cowboy*, Bob Hughes (Matt Dillon) comes home to find a broken mirror and freaks out. His rant catalogues a number of superstitions, which single out his fears of dogs, cats, and hats, but for him the most powerfully dangerous object is a mirror. Never, he urges, "never look at the back side of a mirror, because when you do, it will affect your future. Because you are looking at yourself backwards. And you are looking at your inner self and you don't recognize it because you are looking at yourself backwards." While Bob's theory invokes the Lewis Carroll-type mystery of the image behind the mirror, his fear of what mirrors can reveal is paralleled in Will's gazing at himself. Between the two images of Will, mathematical notation is interposed, a gateway and a focal point. In the elegant formulation of Bouquet and Lalanne (94), "Elle est son cerveau qui à la fois se matérialise et la clive. Le Théorème c'est son mystère. [It is his mind which at the same time is made manifest and splits in two. The Theorem reflects his mystery]." As Will stares at the mirror, he confronts the formulation of his divided self, his own mystery, and he joins forces with his future godfathers, Lambeau and Sean, to resolve the split between the bad Will and the good Will Hunting, to undo the cleaving of the Will. In this extraordinary, extradiegetic image, the split in Will is brilliantly made explicit, and math functions as both the focus of Will's dysfunction and the gateway through which he begins to recognize his problems and to solve them.

The solution involves two interactions and a photograph.[18] The two crucial interactions in the remainder of the film are between Will and Sean and between Will and Skylar. His interaction with Sean, while crucial to the plot, is fairly predictable and formulaic. Sean is the romantic (pseudo-)outsider, whose tragic tale of love pursued without hesitation or introspection, won with ease and enthusiasm, and lost to an untimely death, introduces Will to a history of heterosexual love and marriage that was entirely absent in his grim and cruel childhood. Sean gives Will a vision of family and fulfillment (illusory as that may be). The crucial "aha" moment[19] of classical Hollywood psychoanalysis occurs when Sean confronts a (nearly) broken Will about the latter's childhood abuse, and repeats, until Will believes him, "It's not your fault. It's not your fault." And with this miraculous breakthrough, all Will's problems are solved (at least, his problems with Skylar, which is all the diegesis cares about).[20]

Skylar, from the moment Will rescues her from the pushy preppy in the Harvard bar,

is destined to become Will's significant other. She is, in the traditional Hollywood mode, the rich girl in love with the poor boy, a disparity that, in films, is always resolved happily, although such a happy ending seems less often guaranteed in real life.[21] Of course, insofar as the tale of Will is a *conte*, it is to be expected that the hero will fall in love with a princess—in this updated version, a princess with an inheritance and a plan to go to medical school in California. Skylar represents an escape from and a rejection of everything that has defined Will so far, although she also has the winning ability to relate to Will on a basic level, finding the inner Southey in her British self. The script is at pains to portray her as a girl without baggage or pretensions. She can drink and tell a dirty story with the best of them, and has no trouble fitting in with Will's homosocial family.[22]

It is precisely her concern with and for family, however, that leads to another conflict that Will must confront. Living alone in his house, haunted by the absence of his parents, Will has constructed a substitute family consisting of Chuckie, Morgan, and another Southey, Billy. It is a family with which Van Sant, or at least his "heroes," are quite familiar.[23] From *Drugstore Cowboy* to *Last Days* (2005, inspired by the story of Kurt Cobain) and *Milk*, Van Sant's outsider heroes always seem to find an outsider family to provide some kind of comfort and support, although that support is often fragile, unreliable, and fraught. Will actually finds in his band of buddies some of the most reliable and caring friends of any in Van Sant's *oeuvre*, with the possible exception of the friends who dedicate themselves to the struggle led by Harvey Milk (although even there fractures and jealousies threaten the disruption of the "family"). Until the arrival of Skylar, Will seems quite content with his own group of friends. Although Skylar fits in with this group, she begins asking Will about his "real" family. It is her need to find Will's family (yet another quest to "solve" Will) that along with Sean's therapy hastens Will's breakdown/breakthrough. Not content with Will's homosocial family, the only one that has, in fact, nurtured and supported him, she keeps asking to meet his relatives. Ironically, to satisfy her need for a "real" family, Will invents a "fake" one. His invented family is such a success that Skylar is even more determined to meet them. In the inevitable confrontation, sparked by Skylar's request/demand that he join her in California, Will rejects her apparently "upper crust" family and her (imagined) mate, "some [rich] prick from Stanford that your parents will approve of." Skylar explains that she inherited her money (which is a "burden" to her, as it always seems to be for good-hearted rich folk in films), when her father died. (In the screenplay, Will comments, poignantly and unhelpfully, "At least you have a mother" [118].) In a rage, Will confesses that he is an orphan, revealing "I got fucking cigarettes put out on me when I was a little kid. That this isn't fucking surgery,," (gesturing to a scar on his torso), "that the motherfucker stabbed me."

To the script's moment of revelation, Van Sant adds his own. Will gives Skylar the photos from the police investigations of the abuse case in which he was involved. In part, Van Sant's preference for photos over skin reflects a kind of reticence about the body, especially when sex is involved, to which he has often admitted.[24] At the same time, the body that inspires reticence in the flesh encourages a certain scopic intensity in the photograph. Skylar, who, when first shown the photographs, looks, and then looks away from the body, in embarrassment for both herself and Will, is riveted by the pictures when she views them by herself. For Skylar, as for Van Sant himself, the picture is more powerful, more real, than the actuality. The photos, consisting of close-ups of bruised body parts—which become

separate objects, conforming to Van Sant's typical mode of filming the erotic body — give a power to Will's wounds that the mere echo of the wound on Will's actual body does not have. The photos also, of course, bear significant witness to the event in a way that even Will's twenty-year-old body cannot. The photos are contemporary with the wounds, and they are clearly wounds recently inflicted on a child. They are Will's repressed memories made visible.

In his two inserts, his visual interpolations, then, Van Sant creates an opposition between math and the body, between the sign and the symptom, Will's genius and Will's suffering. Sean's help ("It's not your fault") enables Will to accept Skylar's love and the rift is healed. Will is now one, on his way to join his love in California, and there is no longer a split between the Good Will and the Bad Will.[25] He is ready to abandon the house of the abandoning mother,[26] and get on his wobbly road to the happy ending.

But happy endings are not always guaranteed. While the diegesis certainly encourages us to expect a blissful reunion and a happily ever after for Will and Skylar, Van Sant's history and his interventions complicate that simple resolution. Insofar as the ghosts of Norman and Mrs. Bates hover around Will's memories and the house he abandons, it cannot be other than good that Will escapes that place. The final images of Will driving to California, however, remind us of the many fraught roads that Van Sant's heroes have traveled and may encourage us to recall that, apart from the haunted house, there are other things Will is leaving behind when he hits the road.

He, first of all, abandons his homosocial companions and his entire Southey, fiercely Irish identity, as he goes off not only to spend his life with a woman, but with, of all things, an *English* woman. (You can almost hear the bagpipes wail in horror at this betrayal.) Admittedly, Van Sant's boy bands are unstable; their comfort is temporary, situational, and fragile (as it would have to be, since their outsider lifestyles leave the groups open to constant disruption and dispersal). But, unlike the druggies and hustlers of Van Sant's earlier films, Will's Southeys have a stable, if impoverished, community, a proud history, and not inconsiderable influence. Thus, on one level, Will is indeed trading up, but he is also trading away community for (anticipated) love and money. It is a risky exchange. The weight of the Hollywood romance genre leading us to believe in love, we root for Will and his upwardly mobile choice; but, if we have paid attention to his surroundings, it is not so easy to decide that what he is heading towards is necessarily more valuable than what he is abandoning.[27] He has certainly made the right decision if we accept Hollywood's ideals and heteronormativity, but Van Sant's career has been an on-going critique of these very values. And, indeed, why does Skylar have to go to school in California in the first place? There are other schools besides Stanford; there are even a few right in Boston. While it would be difficult to confuse Palo Alto with Los Angeles, it is also difficult to escape the feeling that Skylar's and Will's destination has an unreal Hollywood quality to it, as if Will, awaking into Sean-and-Skylar-induced reality, chooses to embrace the Dream Factory.

There is a sense, then, that despite all the messages in the film that lead us to value Will's choice, it is just as easy to believe that rather than moving forward, he is, in fact, running away. He had a better chance of finding a career in Boston; Lambeau set up interviews for him and believed in his potential as an award-winning mathematical genius. Is Will running *to* Skylar, or *away* from the responsibilities that Lambeau's beliefs in his gifts have imposed on him? It is true, of course, that both of Will's battling godfathers are

attempting to reshape him in their own images, but is Sean's peculiar romanticism really more liberating than Lambeau's idea of destiny? Does Sean offer freedom or merely irresponsibility?

As he runs toward California and Skylar, towards a Hollywood ending and a conventional heterosexual relationship, Will is running towards an ending determined by Sean's therapy, but can we assume that the split between the Good Will and the Bad Will has been healed, that Will now sees himself as he is? That there is now only one Will in the mirror, and no longer any need for the math? It is not that clear that Will has healed his divided self; it is only clear that he has now repressed some of his traits. He represses his homosociality (and the possibility of homosexuality represented by Lambeau), his autonomy (since he will presumably depend on Skylar to support him), and his genius (since Skylar will presumably be the academic now). He has suppressed the Bad Will, his aggressive and combative Southey persona. But since math and his solitary study of it (and of other areas of learning, such as history, law, psychiatry, and art) were an essential part of Bad Will, becoming Good hetero, monogamous Will seems to involve repressing everything that made Will interesting in the first place. Embracing Sean's version of himself, then, may make him finally Good Will, but it does not necessarily make him Whole Will, or Undivided Will, or even, any longer, Interesting Will. What made Will bad is not necessarily incorporated into Good Will; it is simply repressed to make him Normal and Dull Will.

As he drives uncertainly Westward, among the many things he leaves behind are possible homosexual relationships (Will may not be gay but his sexuality is not yet limited by the constraints of monogamous, heterosexual marriage), his sense of identity, and his academic potential. Most of all, however, when he falls for Sean, he gives up Lambeau, and, in the curious dialectic of the film, the struggle between the two seems to be waged on the Math-Love axis. In the end, Will gives up math and has allowed his *mystère* to be solved by others. There is, in the end, very little of the Will that attracted us in the beginning. Rather than being made whole, he is, in fact, shattered. Like the metaphorical *Kindersurprise*, the search for the "inner" Will, the prize inside, has involved breaking the original Will.

As we last see him, driving west on a road that many of Van Sant's boys have traveled before, we see something between an uncertain beginning and a definite, if not happy, ending. The story of Bad Will, the math genius, is definitely over and it is not clear that Good Will actually has a story. The highway itself, as driven down by Mike Waters (River Phoenix in *My Own Private Idaho*), Gerry (Matt Damon in 2002's *Gerry*) and variants along the way,[28] is never an easy road in a Van Sant film. Whatever the diegesis may want us to believe, it is impossible to believe that a Van Sant hero on a highway stretching into an empty, endless distance is necessarily on the road to a happy ending. The scripted story of Will is a conventional *conte*. The story of Will as filmed by Van Sant is far more open-ended and complicated. The diegesis may present a happy ending, but Van Sant's images undercut that simple hope. The mystery of Will is not so easily solved. In the final image, then, it may not just be Matt Damon's inexperience as a driver that will make Will's final journey a little bit wobbly. Driving down an infinite road, without a home, without friends, without Lambeau, and without math, Will should now be truly anxious.

Notes

1. The casting of the relentlessly heterosexual Sean Penn as Harvey Milk highlights the issue of the sexuality of actors versus the sexuality of characters. Too often, the assumption is made that an actor playing a gay man must be gay. There is a certain naiveté behind this assumption that erases the obvious distinction between character and role, and such an assumption should be a non-starter in serious criticism. This absolute dictum, however, ignores the mileage that Douglas Sirk, for example, gets out of playing the real-life homosexuality of Rock Hudson versus the apparent heterosexuality of the characters he plays in *All That Heaven Allows* (1955) and *Written on the Wind* (1956). While the casting of Penn puts the lie to this ancient assumption, many of the younger actors in Van Sant's earlier works were not so lucky, in part, because they were young and desirable, and in part because they did not have the hetero credentials of having once been married to Madonna. The actors in *My Own Private Idaho* (1991) were particularly prone to such speculations. Rumors about the orgies at Van Sant's house in Portland and the degree to which Phoenix and Reeves may have gone to "research" their roles helped to fuel these speculations. (See, for example, the discussion of the making of *My Own Private Idaho* in Parish, 133–38.) Beyond the minor interest of Hollywood gossip, the uncertain sexuality of Van Sant's characters/actors is of some interest. In addition to the obvious sort of gender-bending that involves a straight actor (Penn) playing a gay character (Milk), Van Sant plays with gender in various ways, queering a plot or character in surprising and unsuspected ways. See, for example, the extraordinary shot of Vince Vaughn's expressive posterior (which has never looked better) ascending the stairs of Mother's house in *Psycho* (1998), or the relation between Sean Connery and Rob Brown in *Finding Forrester* (2000), of which it is reported both that Sean Connery asked Van Sant if he should play it more gay, and that Connery was furious at Van Sant for hinting to the press that the Forrester character was gay. Beyond this, one can only guess what Van Sant would have done had he completed his assignment as listed director of *Brokeback Mountain* (2005), or speculate that part of what makes Kidman's Suzanne Stone in *To Die For* (1995) both so compelling and peculiar is that she is performing a drag queen's notion of femininity, an almost Moebius strip version of gender-bending — a woman playing a "woman" playing a woman.

2. See the discussion of the early script and Damon and Affleck's efforts to see it picked up by a major studio in Parish, 226ff. and the elegant brief summary of the events in Bouquet and Lalanne, 91.

3. I take for granted that the published script is the work of Damon and Affleck and that Van Sant is responsible for anything that appears onscreen that is not in the text. In reality, the process and the assignment of responsibility for any scene or shot is considerably more complex, but I trust my rough approximation of the division of labor will serve for the purposes of this discussion.

4. Several scenes of the St. Patrick's Day Parade were in fact shot and are included in the bonus material of the DVD.

5. While this driving relationship between Will and Chuckie does have a role in the plot, it is also a kind of authorial in-joke making fun of the fact that Matt Damon did not drive at the time of filming, a fact that explains Will's somewhat shaky driving when he takes to the road to drive west at the end of the film. (See the *Good Will Hunting* screenplay, vi–vii.)

6. Van Sant also omits a scripted scene at this point, allowing him to transition his filming immediately from the house to the MIT campus. In doing so, Van Sant establishes Will as a double outsider, alienated from the MIT community because, as we soon see, of his janitorial job, and from the other Southeys because of his connection with academe.

7. Van Sant seems to take liberties in his definition of maguffin, but he may have in mind Hitchcock's remark in TV interviews that the maguffin is the object around which the plot revolves, but, as to what that object specifically is, he declared, "the audience don't care." In an interview conducted by François Truffaut, he defines the term (with a variant spelling) using a delightful and oft-quoted anecdote, which, as often with Hitchcock, may well be spurious:

> It might be a Scottish name, taken from a story about two men in a train. One man says, "What's that package up there in the baggage rack?"
>
> And the other answers "Oh, that's a MacGuffin." The first one asks, "What's a MacGuffin?"
>
> "Well," the other man says, "it's an apparatus for trapping lions in the Scottish Highlands."
>
> The first man says, "But there are no lions in the Scottish Highlands," and the other one answers "Well then, that's no MacGuffin!" So you see that a MacGuffin is actually nothing at all [Gottlieb 48, quoted from Truffaut's *Hitchcock*].

In a far more serious theoretical discussion of the term as a critical tool, Morris connects the term with "humanity's permanent delusion of taking the visible world to be real. Later in his career Hitchcock named this state of delusion the MacGuffin: a signifier universally believed in whose actual meaning is, on reflection, nonexistent" (Morris 28).

8. Jacques Lacan's *object petit a* represents an unattainable object of desire.

9. Hallway chalkboards seem to be a peculiar feature of Damon's imagined MIT. They solve the problem, however, of getting the mathematics in a place where Will is able to come across it without fortuitously breaking into Lambeau's classroom.

10. All future *Good Will Hunting* quotes are also from the film.

11. The mathematically-savvy reader might note that, technically, one "solves," rather than "proves," a mathematical system. Moreover, the mathematics that actually appears on the hallway chalkboard involves not Fourier analysis, but graph theory. This lack of attention to mathematical accuracy is perhaps due to Van Sant's perception of the film's mathematics as merely a macguffin.

12. I have in mind here Slavoi Zizek's clever and insightful discussion in *The Puppet and the Dwarf* of the *object petit a* and the *Kindersurprise*. The *Kindersurprise* is a hollow chocolate egg which holds a surprise toy inside — usually a cheap, trashy, and disappointing toy. Desiring the egg and expecting a treat, the child mangles the outside to seek for what is concealed inside, destroying the outer object in the process and discovering something that he usually does not actually want. The imagery suggests the childlike quality of Will, the naïveté of his search for self, and the less than pleasant discovery of what the alluring outside may reveal. Zizek points out that these eggs are illegal in Canada, undoubtedly because innocent children have discovered that the toys can choke or poison them (*Kindersurprise*, indeed!). The metaphor here becomes all too obvious in terms of the search of the "real" Will.

13. To be fair, grim as it is, the story is funny. Funny or not, however, it does introduce Will in the context of the camaraderie of a rough, if appealing, group of guys. They live in "a rough working-class Irish neighborhood, and these boys are its product" (Damon and Affleck, 2). Much as we may like these guys, they are intended to be "bad boys" (hence, probably, their appeal to Van Sant), and Will is as "bad" as any of them.

14. And, it bears repeating, that all of these responses kick in so immediately because of Matt Damon's natural charm and his skill in projecting it.

15. The film would have to be considerably more serious than it is to present a meaningful critique of psychoanalytic theory and practice. The theories and practices that Will attacks are not particularly profound. Nevertheless, Will does gain our sympathies as a victim (token as it may be) of the psychoanalytic system. Any notion that the film is a serious exposé of psychoanalytic practice soon wrecks itself on the rocks of Robin Williams. If apparently serious practitioners are incompetent, the solution is not to turn to the trivial talk-show level of social work practiced by Lambeau's friend, Sean, to whom Will is shortly to be turned over.

16. Even Van Sant's occasional "bad girls" pretty much reject the system. Ironically and deliciously, Nicole Kidman's Suzanne Stone (*To Die For*) in her dizzy and desperate love of the "system" and all it seems to offer her seriously undermines her own values and those of the system she thinks she loves.

17. And adds a certain piquancy to the fact that when Lambeau sets up the "audition" that will win him a prestigious academic post, he sends Chuckie in his place.

18. Not to belabor what may be an obvious point, but it may be worth stressing again, how important photography is to Van Sant's interest as a director and as a graduate of the Rhode Island School of Design. One need not be devoted to semiotics to notice how much weight is carried by the crucial pictures in a Van Sant film.

19. "Aha" moments range from the tines of a fork on a tablecloth that begins to bring forth a series of repressed memories in Hitchcock's *Spellbound* (1945) to the feel of water that sparks Helen Keller's initial use of language in *The Miracle Worker* (1962). From "Aha" to "Wawa," Hollywood's miraculous breakthroughs come with a bang (occasionally followed by a whimper).

20. Insofar as actual analysis is concerned, this is an entirely artificial and unbelievable moment, a contrived and purely Hollywood "breakthrough." On the other hand, it is a necessary moment to "suture" the diegesis and the theme. It is more important for us to believe that Will is healed than to necessarily believe in the healing itself. On the other hand, on the level of the *conte*, it is not always necessary to believe in the methods by which the hero slays the dragon, or to understand exactly how the heroine manages to spin straw into gold.

21. At least if we can believe that "real life" is accurately represented in such impeccable sources as "Judge Judy," "The People's Court," and "Judge Mathis," in which girls with money seem daily to be opting out of unhappy relationships with boys without it. The opposite gender configuration also occurs, the point above all being that the poor are poor for a reason; charity is a Christian virtue, not a capitalist one.

22. One of the weaknesses of the film is that Minnie Driver's Skylar joins so successfully in the camaraderie of Will's homosocial band of brothers that there is almost no erotic heat generated in her relation with Will, even (or, perhaps, especially) in the hectic scenes of lovemaking. This lack of intensity is particularly surprising in view of the fact that Matt Damon and Minnie Driver were reportedly "real-life"

lovers during the shooting of the film (Parish, 237; Parish, however, finds the relationship in the film to be far more successful than I do). We can easily see that Will and Skylar like each other, but they seem far more successful as chums than as lovers.

23. Van Sant himself seems to have had a reliably "regular" family, that on the surface at least was as close to the traditional 1950s "Leave It to Beaver" family as one can get without actually becoming embarrassing (See Parish, 14–17, for example, for basic details of Van Sant's early years, especially those spent in the hyperreal suburban community of Darien, CT.)

24. Which is why his sex scenes are so rarely sexy. Oddly, his first attempt to film a sex act in *Mala Noche* (1986) despite its reticences and odd close-ups that more often obscure rather than reveal the body part involved, may be the most successful of his experiments in eroticism. His later scenes may be bolder, franker, or subtler, but none are hotter than the steamy grapplings of Walt and Johnny.

25. Abandoning, perhaps, what less totalitarian therapies than those practiced by Sean and Hollywood, might have called the search for the "Good Enough" Will Hunting, which, of course, would not have been a good enough title for the film.

26. Again, the images of the house and the haunting mother recall Hitchcock's *Psycho* (1960). As the echoes of that film accumulate, it starts to become clear why Van Sant's next film was to be the otherwise inexplicable project of a shot-by-shot remake of the Hitchcock thriller. As Will seems more and more haunted by Norman, Van Sant may have undertaken the later project not only as a crash course in the techniques of the master, but as an exorcism of the troubled ghosts that haunt the interstices of the conventional and cheery *Good Will Hunting*.

27. One function of the character of Chuckie is to underline the positive value of this move. He is so certain that Will needs to move on, and we are so convinced that he has Will's best interests at heart, that it is difficult not to accept that Will's decision is for the best. (Sean's sappy life story about risk and spontaneity also encourages us to believe that Will has made the right decision.) There is no reason to assume, however, that Chuckie actually knows what is best for Will.

28. The most outrageous and comical variant is the view of Sean Connery barely managing to remain upright on his bike as he disappears down the mean streets in *Finding Forrester*.

Works Consulted

Affleck, Ben and Matt Damon. *Good Will Hunting: A Screenplay.* New York: Hyperion, 1997.

Bouquet, Stéphane and Jean-Marc Lalanne. *Gus Van Sant.* Paris: Édition Cahiers du Cinéma, 2009.

Drugstore Cowboy. Dir. Gus Van Sant. Perf. Matt Dillon, Kelly Lynch, James Le Gros. Avenue Pictures, 1989. Film.

Elephant. Dir. Gus Van Sant. Perf. Elias McConnell, Alan Frost, Eric Deulen. Fine Line Features, 2003. Film.

Finding Forrester. Dir. Gus Van Sant. Perf. Sean Connery, Rob Brown, F. Murray Abraham. Sony, 2000. Film.

Gerry. Dir. Gus Van Sant. Perf. Casey Affleck, Matt Damon, Ben Affleck. Miramax, 2002. Film.

Good Will Hunting. Dir. Gus Van Sant. Perf. Matt Damon, Robin Williams, Ben Affleck. Miramax, 1998. DVD.

Gottlieb, Sidney. "Early Hitchcock: The German Influence." *Framing Hitchcock: Selected Essays from* The Hitchcock Annual. Ed. Sidney Gottlieb and Christopher Brookhouse. Detroit: Wayne State University Press, 2002.

Mala Noche. Dir. Gus Van Sant. Perf. Tim Streeter, Doug Cooeyate, Ray Monge. Criterion Collection, 1985. Film.

Milk. Dir. Gus Van Sant. Perf. Sean Penn, Josh Brolin, Emile Hirsch, Diego Luna, James Franco. Focus Features, 2008. Film.

Morris, Christopher D. "The Allegory of Seeing in Hitchcock's Silent Films." *Film Criticism* 22.2 (Winter 1997–8): 27–50.

My Own Private Idaho. Dir. Gus Van Sant. Perf. River Phoenix, Keanu Reeves, James Russo. New Line Cinema 1991. Film.

Parish, James Robert. *Gus Van Sant: An Unauthorized Biography.* New York: Thunder's Mouth Press, 2001.

Psycho. Dir. Alfred Hitchcock. Perf. Anthony Perkins, Janet Leigh, Vera Miles. Universal, 1960. Film.

Psycho. Dir. Gus Van Sant. Perf. Vince Vaughn, Anne Heche, Julianne Moore. Universal, 1998. Film.

To Die For. Dir. Gus Van Sant. Perf. Nicole Kidman, Matt Damon, Joaquin Phoenix. Universal, 1995. Film.

Zizek, Slavoj. *The Puppet and the Dwarf: The Perverse Core of Christianity.* Cambridge, MA: MIT Press, 2003.

Thinking Outside the Box

Application Versus Discovery in Saw *and* Cube

JESSICA K. SKLAR

Perhaps I could best describe my experience of doing mathematics in terms of entering a dark mansion. One goes into the first room, and it's dark, completely dark. One stumbles around bumping into the furniture, and gradually, you learn where each piece of furniture is, and finally, after six months or so, you find the light switch. You turn it on, and suddenly, it's all illuminated. You can see exactly where you were.

— Andrew Wiles, *Nova*, "The Proof"

Introduction

Princeton mathematics professor Andrew Wiles's above description of performing pure research captures many of the key features of the endeavor: the disorientation, the failed attempts at familiarizing oneself with surrounding objects, the trouble of finding a path in the absence of light. It also describes a classic horror movie scene, if you replace the word "months" with "minutes" and append the phrase "in a room full of killer clowns." Truly, the goal of pure mathematicians and of many horror movie heroes and heroines is the same: to find illumination. What will avenge the ghost's murder? How do you prove Fermat's Last Theorem? What will help you escape from the surrealist nightmare of a lattice of murderous cubes?

On the other hand, we can consider applied mathematics. Applied mathematicians often start with an awareness of where they are: the lights are bright, they can see, or easily find, the appropriate tools for their needs, and they know how to use them. However, using these tools can be time-consuming, extremely challenging, and ultimately unsuccessful. Perhaps you know how to find the solution to a problem, but to do it would take three hundred years, given today's computing power. Perhaps you know you need to dig in someone's body for a key — but can you find the key in time?

In this paper, we consider the films *Saw* (2004) and *Cube* (1997) as allegories of mathematical research. Both films involve characters who mysteriously wake up in potentially deadly situations. The characters in *Saw*, like many applied mathematicians, are given very

explicit rules to follow. If they follow the rules, they will live; if they don't, they will die. The characters in *Cube*, on the other hand, are not explicitly given rules to follow, but must instead discover the rules governing their circumstances in order to stay alive; they must, as Wiles did in proving Fermat's Last Theorem, metaphorically fumble around in a dark room.

Applied Versus Pure Mathematics

In order to discuss *Saw* and *Cube* in the context of mathematical research, it is important that the reader have an understanding of the distinctions between applied and pure mathematics. Applied mathematics is the branch of mathematics concerned with using math to solve real-world problems. It plays an enormously important role in the fields of physics, engineering, economics, and chemistry, to name just a few. Applied mathematicians work as statisticians at marketing firms, actuaries at insurance companies, and cryptologists at the National Security Agency. They generally have specific tools and methods with which they work and as long as they use the appropriate techniques correctly, they are often (though certainly not always) guaranteed to get the results they require.[1] We will see that this type of research is allegorically played out in *Saw*. Pure mathematics, on the other hand, is generally not concerned with real-world application. A pure mathematician often starts by assuming a set of *axioms* (statements taken to be true) or properties of a mathematical object, and explores the mathematics to which these assumptions lead. Sometimes, however, a pure mathematician must, rather than assuming a set of truths, deduce, based on observation, the axioms governing a system. We find this process of discovery in *Cube*.

As examples: an applied mathematician's goal may be to set a price for selling hula hoops that will maximize profit, while a pure mathematician may ask what follows when you assume that given any line l and point P not on l in a mathematical universe, there are at least two distinct lines through P that do not intersect l.[2] In general, pure mathematicians have as goals both elegance and rigor. One might use a variation on Justice Potter Stewart's musings on pornography when describing mathematical elegance: it is hard to define, but one knows it when one sees it.[3] It is typically characterized by brevity, clarity, or cleverness of approach; one might more colloquially describe an elegant proof as "slick." Rigor consists of making sure all one's i's are dotted and t's are crossed; there should be no loopholes in one's arguments, no margin of error, no possibility of inaccuracy. Applied mathematicians, on the other hand, often do not share these goals. A solution to a real-world problem may be quite inelegant due to the problem's complexity, and while the work behind such solutions must itself be rigorous, practitioners of applied mathematics must often be satisfied with approximate, rather than exact, results: the solutions must simply (and sometimes quite literally) be "good enough for government work."

It should be noted that in many cases there is not a clear line between what is considered applied mathematics and what is considered pure. That said, for the purposes of this paper, we will consider applied and pure branches of mathematics in their most disparate manifestations: the former being concerned with using known techniques to solve real-world problems, and the latter being concerned with understanding systems that do not necessarily or obviously play a role in our day-to-day lives.

Saw: *Application and Amputation*

From the film's taglines ("Let the games begin!"; "Every piece has a puzzle"; "How do you solve a puzzle with pieces missing?") to its sadist's punning alias, Jigsaw, *Saw* and its marketing steep us in puzzle and game terminology (even the menu of the *Saw* DVD labels its "play" and "scenes" links as, respectively, "Play the Game" and "Pieces of the Puzzle"). Mathematics, puzzles, and games are in many ways closely linked. All involve set rules that must be followed in order to achieve a desired result. The rules may be that puzzle pieces must lock together and reveal a sensical picture; they may be that if you roll double sixes you may take another turn; they may be that you cannot divide a real number by 0, but can divide it by any other real number.

In *Saw*, terminally ill Jonathan Kramer (Tobin Bell), aka Jigsaw, ostensibly seeks to better people by forcing them to undergo challenges that are usually both painful and deadly. The challenges are designed to make their players stop taking their lives for granted. Dr. Gordon (Cary Elwes), a clinical and emotionally unavailable man, is to learn to appreciate the value of human life, as is Paul (Mike Butters), who has attempted suicide; Mark (Paul Gutrecht), a malingerer, is to learn to respect those who truly are ill; Amanda (Shawnee Smith), an addict, is to learn the dangers of drug abuse; and covert photographer Adam (Leigh Whannell) is to be punished for his voyeurism.[4]

Jigsaw frames these challenges as games, outlining for his victims goals, rules that must be followed, and consequences upon loss of the game.[5] The film begins with Dr. Gordon and Adam chained up in a bathroom. Clueless at first, they soon discover information provided to them on cassette tapes. On Dr. Gordon's tape, Jigsaw explains: "Your aim in this game is to kill Adam. You have until six on the clock to do it.... There are ways to win this hidden all around you.... If you do not kill Adam by six o'clock, then [your wife and daughter] will die.... Let the game begin."

The film focuses on Dr. Gordon's game, but also includes flashbacks to other sadistic games that Jigsaw has rigged. These games invariably have explicit goals and explicit rules. If Dr. Gordon doesn't kill Adam by six on the provided clock, his family will be murdered; if Amanda doesn't locate a key in a drugged man's stomach within one minute, a reverse bear-trap will tear her jaws apart; if Paul doesn't make his way through a razor-wire maze within two hours; he will starve in a permanently locked cage; and Mark has only a limited amount of time to unlock a safe (using a ludicrously long lock combination) that contains an antidote to the poison at work in his veins. Jigsaw communicates directly with his victims via cassette tapes and videos, and provides them with the material items they need to achieve their goals. Sometimes these items are directly given to the players and have obvious uses (e.g., a candle allowing Mark to see the safe combination written on the room's walls, a gun with which Dr. Gordon could kill Adam), while other times they are hidden or have uses that the players must discover for themselves. Dr. Gordon's course of action is not as clear as those of Paul, Mark, or Amanda. While he is provided with a gun, he cannot reach it while chained, and rather than being provided with an explicit method for removing his chain, he must first find a hacksaw using a cryptic hint from Jigsaw,[6] and then figure out how to use it: it won't cut through his chains, leading to one of the film's most memorable lines, "He doesn't want us to cut through our chains. He wants us to cut through our feet."

In these ways, the games in *Saw* mimic the practice of applied mathematics. As pre-

viously noted, applied mathematicians typically have explicit goals. Also, just as Jigsaw's victims have clear rules they must follow, applied mathematicians have clear parameters within which they must work: for example, subtraction of real numbers is not commutative (e.g., $3 - 5 \neq 5 - 3$), and in Euclidean geometry the area of a circle with radius r is always πr^2. Often, like Mark's candle, the tools applied mathematicians require are at their fingertips; but other times they must be sought out and, when discovered, applied correctly. Just as Dr. Gordon must consider multiple uses for his hacksaw, a statistician might need to try using several techniques in order to estimate a probability, achieving useless lower or upper bounds for the value along the way.

Saw beautifully demonstrates the necessity of checking one's hypotheses before using them to draw conclusions. While every step in your reasoning process may be correct, your conclusions may be wrong if your original assumptions are flawed. Such error can lead to tragedy in the real world. For example, in 1999, a $125 million Mars orbiter was lost due to a lack of necessary unit conversion: though they assumed that they were using a common system of measurement, NASA had used the metric system in its calculations while one of its collaborators, Lockheed Martin Astronautics, had used the imperial system.[7] Some second-semester calculus students fall into another "assumption" trap, concluding, using the Fundamental Theorem of Calculus, that the integral of the function $f(x) = 1/x^2$ from $x = -1$ to 1 evaluates to -2.[8] But this isn't possible: $f(x) = 1/x^2$ is never negative, so if the integral were computable using this theorem, it would equal the necessarily positive area that is simultaneously under $f(x)$'s curve and above the x-axis. The student's error was in assuming that $f(x) = 1/x^2$ is continuous on the interval $[-1, 1]$, which is *not* the case: specifically, the function has an infinite discontinuity at $x = 0$. Thus, one cannot use the Fundamental Theorem of Calculus to evaluate this integral.

Dr. Gordon makes the same type of error in *Saw*. As soon as they turn on the bathroom lights, Dr. Gordon and Adam see a man lying on the floor, with a shotgun in his hand and what appears to be a fatal head wound. Naturally, Dr. Gordon and Adam assume that the man is, like them, a victim. But throughout the film, Jigsaw has been creating his horror scenarios using proxies: Dr. Gordon and Adam are abducted by an unknown person wearing a boar mask, while Dr. Gordon's wife and daughter are taken hostage by Zep (Michael Emerson), an orderly at the hospital at which Jigsaw was a patient. When we later see Zep appear in the bathroom to kill Dr. Gordon, we, along with Dr. Gordon, assume that Zep is in fact Jigsaw. It is only after Adam kills Zep and finds another cassette tape in the latter's pocket that we discover Zep is merely one of Jigsaw's pawns. As Adam, open-mouthed, processes this information, we see, in perhaps the film's finest moment, the presumed dead body in the pool of blood slowly rise in the background: it has been Jigsaw, alive, all along. The viewer is left to wonder if perhaps the men might have been able to murder Jigsaw and somehow save themselves had they not made the tragic, unverified assumption that the body was a corpse. (It is interesting to note that Jigsaw never explicitly asserts that the prone man is dead, though he certainly implies it, stating on Dr. Gordon's cassette that "There's a man in the room with you. When there's that much poison in your blood the only thing left to do is shoot yourself.")

Finally, it is important to note that despite the clear parameters of Jigsaw's games, winning can be extremely difficult. The games require players to overcome panic,[9] perform physically challenging and painful tasks (Paul is deeply cut by razor wire, Mark must walk

on broken glass, Dr. Gordon must saw off his own foot), or go against their own senses of morality (Dr. Gordon and Amanda must murder men in order to win their games). The games often involve complicated mechanical devices, such as Amanda's reverse bear-trap, or take place in messy staged environments, such as the film's ubiquitous bathroom; some of the players (e.g., Dr. Gordon and Adam) may not be able to correctly sort through their item-heavy environments for the necessary tools, while others (Paul, Mark, Amanda) have few items, but must work with or within complicated systems (a maze of razor wire, a ridiculously long numeric code, and the human body, respectively).

Similarly, even with clear goals and the necessary mathematical tools, an applied mathematician may not be able to achieve her desired results. Her computations can be extremely complex and messy, like Jigsaw's devices (and, more generally, like *Saw*'s typical mise-en-scène), and the loss of a negative sign or an inappropriate rounding of numbers can lead to wildly incorrect results (a "loss" of a mathematical game), just as Mark's minor slip with a candle causes him to go up in flames. Successfully solving an applied math problem, even to a "good enough for government work" degree, requires precision in one's efforts despite being confronted with an extremely complicated system. However, this success often requires more care than creativity, more technical skill than inventiveness; one must follow known rules effectively, rather than deduce new rules to follow. The tools are at your fingertips; you just need to wield them correctly.

Cube: *Permutation Postulation*

The seven characters in *Cube*—henceforth known as *Cubists*—wake up, like Dr. Gordon and Adam, in a strange environment with no idea how they've gotten there. Unlike Jigsaw's victims, however, they are given no tools, no cassette tapes, no instructions. And their environment is not just unfamiliar, but truly *strange*. They find themselves in a lattice of cubic rooms; each side (including the floor and ceiling) of each room contains exactly one hatch leading to an adjacent room. In contrast to *Saw*'s filthy-yet-familiar mise-en-scène (who hasn't spent at least five minutes in a less-than-clean rest stop bathroom?), *Cube*'s sets are minimalist and abstract; the rooms' sides consist of monochromatic panels, decorated with seemingly meaningless black geometric shapes (perhaps in places implying spider-webs),[10] and the rooms are empty of any tools or props beyond those which the characters themselves have on them. We soon find out that while some rooms are safe, others contain deadly booby traps. Punctuating the lattice's soundscape are occasional grinding noises — sometimes far away from and sometimes close to the Cubists.

After a surrealist opening vignette in which a character we never get to know wakes up in the lattice and, in just a few minutes, wanders into a murderous trap, we see five of the remaining Cubists — Quentin (Maurice Dean Wint), Worth (David Hewlett), Leaven (Nicole de Boer), Rennes (Wayne Robson), and Holloway (Nicky Guadagni) — come upon each other in a white room.[11] None of the five are seriously hurt, though Worth has hit his head and Leaven breaks her reading glasses — losing a triangular piece of lens — while climbing into the room. The characters immediately ask themselves two major questions: "Why are we here?" and "How can we escape?" The first question is never answered in the film, though the Cubists offer varying theories about who emprisoned them — government, aliens,

a "rich psycho."[12] We focus here on the Cubists' attempts to answer the second question. Lacking recorded instructions, cryptic graffiti, and hidden props, *Cube*'s prisoners are left, like Wiles, to stumble around, desperately searching for a light switch. Rather than being given explicit rules to follow, they must discover the axioms that govern their universe.

The question of how they can escape can be broken down into several subquestions: is there an exit leading from the cube lattice to the outside world? If so, where is it? And how can they make their way to it, given that some of the rooms are equipped with fatal booby traps? Rennes, who has escaped from seven prisons, convinces the others to explore the lattice to search for an exit (says Rennes, "We won't solve jack shit sittin' still ... I'll move in a straight line 'til I get to the end"), so the question of how they can safely travel from room to room is urgently pressing. At first, they use a brute-force method of determining whether rooms are safe: Rennes, assuming that the traps are set off by motion detectors, uses one of his boots as a coal-mine canary, tossing it into rooms (while holding on to it by a length of laces) to see if it is set on fire, sliced to bits, or otherwise set upon. But it turns out that not all of the rooms use motion sensors to detect a human presence: Rennes, smelling a "dryness" in the air, declares that a later room — which his boot has entered and returned from unscathed — is equipped with "molecular-chemical" sensors that detect living beings. Not long after this he is killed when he enters a room that, despite passing his boot and sniff tests, squirts acid in his face. The remaining Cubists pull him back into the safety of their adjacent room, but it is too late; half of Rennes' face is missing. The others realize they must find a more rigorous way of determining the safety of a room.

This is analogous to situations that mathematicians often face. For instance, one does not prove that every circle of radius r has area $A = \pi r^2$ by taking each positive real number r and determining the area of a circle of that radius; as there are infinitely many possible values for r, this would be an impossible task for any human being. Rather, mathematicians build upon known truths (about geometry, calculus, etc.) to prove that this formula holds for all values of r without having to check it for each possible radial value.[13] Our Kafkaesque prisoners must find a similar rule that determines the safety — or lack thereof — of a given room. While it turns out that there are not infinitely many rooms in the lattice, so the problem is not one of a lack of time, the punishment for making an incorrect decision about any single room tends to be death, and it is clearly insufficient to rely on one's physical senses in making this determination. Rennes tells his peers, as he prepares to enter the acid room, "No more talkin' ... no more guessin' ... don't even think about nothing that's not right in front of ya." This might be reasonably good advice for most of Jigsaw's victims, but for the prisoners in *Cube*, this is exactly the wrong thing to do. They must think and reason about what they cannot see. They must abstract. So to what can they turn to find a foolproof method for identifying the booby-trapped rooms?

Math, of course.

Shortly before Rennes' death, something of note occurs: Leaven discovers that each room is assigned a number, engraved on brass plaques attached to its hatch frames. Each number consists of nine digits, grouped in threes; we'll call these three-digit groups *triples*. At the time, the group doesn't know what to make of this. After Rennes' death, however, Quentin, in a flash of insight, suggests that if whoever abducted them left Leaven her reading glasses, there must be a reason for it. He deduces, correctly, that Leaven studies math, and after examining the numbers of several rooms, Leaven concludes that if any of a room's

triples, considered as a three-digit number, is prime, then the room is booby-trapped. (It turns out that Leaven has been keeping tabs on room numbers all along; she tells them, "The incinerator thing was prime: 083. The molecular-chemical thingy had 137, the acid room had 149.")[14] Expanding on this, she postulates that a room is booby-trapped *if and only if* one of its triples is prime (she decides that a room marked 645 372 649 must be safe),[15] and the Cubists, taking this as an axiom, continue to safely explore for what a montage leads us to believe is a matter of hours, along the way encountering autistic Kazan (Andrew Miller). It seems that Leaven has discovered one of the invisible rules governing their prison's system.

And then, suddenly, Leaven's conjecture is proven to be incorrect. Quentin enters a room Leaven has determined to be safe, and narrowly escapes being sliced to bits by razor-wire. Leaven insists, "But [its] numbers aren't prime!" to which Quentin replies, "Then your number system failed!" Disproof by counterexample, at its finest. Leaven admits, "I guess the numbers are more complicated than I thought," countering the suggestion that the numbers are actually meaningless with, "No, it means they're more involved. They worked for us up 'til now, haven't they? I just need some more time with them." What they bumped into in the dark was not, in fact, a divan. Perhaps it was a settee, or a chaise longue? Without explicit rules handed out to them, the Cubists must resort to the scientific method; when a conjecture is proven wrong, they must refine it to one that more accurately describes their situation. But to do so, they need more data.

As Leaven, in classic prisoner fashion, scratches mathematics on the metal of a hatch with one of her buttons, Quentin antagonizes nihilistic Worth. In response to Quentin's insistence that they will escape from their prison, Worth shouts: "There is no way out of here!" He continues: "I designed the outer shell ... of this sarcophagus.... I was contracted to draw plans for a hollow shell. A cube." While Worth does not know anything about the lattice of smaller cubic rooms that the shell contains, or about the room numbers, he does have some crucial information that allows Leaven to make a breakthrough in her understanding of the numbers, and hence draw significant conclusions about the structure's design. Specifically, Worth tells them the dimensions of the shell, lets them know that it has one exterior door (which is sealed from the outside), and tells them there is a vacant "buffer" of about an inner room's width between the shell and any interior rooms.

From here on out, we will, like the film's characters, refer to the structure's lattice of interior rooms as the Cube. (Note that the full structure consists of three components: the Cube, the buffer, and the shell. The Cube does *not* include the buffer or the shell.) Further, we consider the characters to be on the *edge* of the Cube if they're in a room that is adjacent to the buffer. Leaven, pacing, determines each inner room's dimensions to be about 14 × 14 × 14 feet, and concludes that "the biggest that the Cube can be, then, is twenty-six rooms high, twenty-six rooms across, so 17,576 rooms."[16] And this is when Leaven has her next revelation: "Descartes! ... Cartesian coordinates — of course! — coded Cartesian coordinates. They're used in geometry to plot points on a three-dimensional graph.... These numbers are markers, a grid reference, like latitude and longitude on a map. The numbers tell us where we are inside the Cube."

Using her button, she demonstrates using the numbers of their current room:[17] "Ok, um, all we have to do is add the numbers together. *X*-coordinate is 19, *y* is ... twenty-six rooms, so that places us ... seven rooms from the edge."[18]

Interestingly, Leaven has not refined her earlier hypothesis; the group still cannot reliably determine whether or not a room is safe. Instead, Leaven has proposed a second hypothesis: that the numbers, in addition to providing information regarding a room's safety, identify its location within the Cube. This is common in the practice of pure mathematics; while stalled in one area, mathematicians can choose to look at the objects they're studying in other ways. Without a precise, well-defined goal (or, to put it another way, with many potential goals), pure mathematicians have a flexibility not necessarily available to other researchers. Leaven can, for the moment, focus on identifying where they're going, rather than how they will safely get there.

Quentin pushes them to move on, declaring that they'll "cut the risk with the numbers and the boot." How they determine which way to go is unclear to this viewer; perhaps Leaven has a sense of how the rooms' x, y, and z dimensions correspond to actual real-world directions, or perhaps the Cubists options are limited, due to booby traps. In any case, after a bit they obtain a new piece of information that confuses Leaven: "These coordinates: 14, 27, 14.... Well, they don't make sense. Assuming the Cube is twenty-six rooms across, there can't be a coordinate larger than 26. If this were right then we would be outside the Cube."

Unable for now to solve this puzzle, they continue on, and safely arrive in an edge room. But when they open the hatch leading to the buffer, they find — well, the buffer. There's no visible door to the outside world, and even were there one, they'd have no way to get to it across the buffer. Moreover, their current room is far from the ground level of the Cube, making their exploration of the buffer dangerous. While suspending Holloway in the chasm on a chain made of their clothes, they hear the Cube's grinding sound — this time very loud and close. They also feel it; their room shakes as if in an earthquake. Now Leaven has even more evidence to take into account in her hypotheses: there is a mechanical sound that varies in volume and environmental impact depending on your location in the Cube. However, she is distracted from her theorizing for the moment; when the room shakes, they nearly lose their grip on the clothing-chain, and Quentin — always hostile and now increasingly on the attack — takes the opportunity to allow Holloway to fall into the void.

Soon after, recognizing now that Quentin has let Holloway die, Worth and Leaven side together against him; in response, Quentin, wild-eyed, beats Worth and throws him into the room below, where he finds: Rennes' body. They despair that they've been going in circles. But when Worth opens the hatch that should lead to the acid room they instead find the buffer. And this time it is Worth who has an "aha" moment: "We haven't been moving in circles," he says, "The *rooms* have.... That explains the thunder and the shaking. We've been shifting the whole time." Leaven agrees, and now has enough information to refine her second hypothesis, the one allowing her to pinpoint their location in the Cube. She says, "The numbers are markers, points on a map, right? How do you map a point that keeps moving?" And Worth responds: "Permutations." Leaven explains:

> Permutations. A list of all the coordinates that the room passes through, like a map that tells you where the room starts, how many times it moves, and where it moves to.... I've only been looking at one point on the map, which is probably the starting position. All I saw was what the Cube looked like before it started to move.[19]

She continues:

LEAVEN: I know where the exit is.... You remember that room we passed through before, the one with a coordinate larger than twenty-six? That coordinate placed the room outside the Cube.

WORTH [in wonderment]: A bridge.

LEAVEN: Right. But only in its original position.... Look, the room starts off as a bridge, and then it, it moves its way through the maze, which is where we ran into it. But at some point it must return to its original position.

WORTH: So the bridge is only a bridge —

LEAVEN: For a short period of time. This thing is like a giant combination lock. When the rooms are in their starting position the lock is open, but when they move out of alignment the lock closes.

WORTH: With a structure this size it must take days for the rooms to complete a full cycle.

QUENTIN: So when does it open?

At this point, Leaven has what turns out to be a valid method of determining not only their current location in the lattice, but also, it seems, the location of the shell door and the time at which the bridge will be adjacent to it. (We are not told what this method is, and while we may applaud their creativity and ambition, one suspects that the filmmakers didn't actually have a legitimate method in mind. Rather, they finesse the situation by having Leaven mutter about original positions and subtraction while continuing her etching.) Using the numbers of their adjacent rooms as reference points (?), she impressively — if inexplicably — concludes: "X is 17, y is 25, and z is 14. Which means this room makes two more moves before returning to its original position." In addition, Leaven suddenly tells us that she has refined her first conjecture, as well. "Technically," she says, "I can identify the traps. At first I thought that they were identified by prime numbers, but they're not. They're identified by numbers that are the power of a prime." In other words: a room is safe if and only if none of its three triples is a power of a prime; equivalently, it's safe if and only if each of its triples has two or more distinct prime factors.

Pure mathematician Leaven's job is now done: she has observed the workings of the world around her, made conjectures about the rules governing its behavior, and refined those conjectures based upon gathering more information. Rather than following an (albeit puzzling) road map, as Jigsaw's victims do, Leaven — with Worth's help — has *created* a road map. She has found the light switch; all that remains is applying her theorems. But here our theorist hits a stumbling block: apparently, Leaven is unable to determine the number of distinct prime factors of three-digit numbers. She bemoans: "I'd have to calculate the number of factors in each set. Nobody in the whole world could do it mentally! Look at the numbers: 567, 898, 545. There's no way I can factor that. I can't even start on 567! It's astronomical!"[20]

Luckily, Kazan is there to save the day, spouting out the numbers of distinct factors of triples[21]; it turns out he is a mathematical savant. Using Kazan to test each room, they head to an edge location to wait for the bridge to appear next door. Worth, Leaven, and Kazan, having left Quentin behind, reach their desired edge room, seeing the vacant buffer space through one of the hatches. They wait; presently the rooms shift, and when they re-open the hatch, they see that a room has shifted in to fill the buffer space next to them. In this newly-arrived room, Leaven cuts her foot[22] on what turns out to be the shard from her broken eyeglass lens — they are in the white room in which they met at the beginning of the film!

Had they merely waited long enough in that room and peered out its hatches with sufficient frequency, they would have encountered the bridge. It is, similarly, not uncommon for a mathematician to perform numerous computations or write multi-page proofs only to discover that he has "proven" what he assumed to be true in the first place, or that the object he is studying doesn't exist in even a theoretical universe. Mathematicians often must return to their starting points, just as the Cubists do.

However, here our analogy fails. While mathematicians often make wonderful discoveries while traveling research paths that take them in circles or simply don't lead to achievement of their original goals,[23] the Cubists' meanderings lead them to savagery and death. Worth, Leaven, Kazan, and eventually Quentin all end up in the bridge room, but in the end, only Kazan is left alive: Quentin murders Leaven and inflicts a deadly wound on Worth before himself succumbing fatally to Worth's avenging wrath. It is not enough, the film suggests, to learn from one's mistakes; in order to be free, one's self must be annihilated. Only Kazan, the quintessential innocent, is able to exit the structure, walking out into a bright, blinding light. Only for our mathematical savant — free of the burden of superego — is there any illumination.

Notes

1. We are here discussing mathematicians who directly apply mathematics to practical problems, rather than those who develop techniques to be used in such applications. We also admit to oversimplifying here; certainly there are applied areas in which mathematicians must "fumble in the dark" to figure out which tools to use.

2. This is an assumption of hyperbolic geometry. This cannot happen in Euclidean geometry, the one which best models, on a microcosmic level, the world in which we live.

3. See Jacobellis v. Ohio.

4. Adam is technically a pawn in Dr. Gordon's game, rather than one of Jigsaw's players, but for all intents and purposes he is a player.

5. Note that these are single-competitor games (though often other people play game roles as props or foils); the competitors win if they are able to achieve their specified goals.

6. The phrase "Follow your heart," along with a heart painted on a toilet tank, leads Dr. Gordon to tell Adam to look in the tank, where two saws have been hidden.

7. See Cowen.

8. Since an antiderivative of the function $f(x) = 1/x^2$ is the function $F(x) = -1/x$, if the Fundamental Theorem of Calculus were applicable it would indeed follow that

$$\int_{-1}^{1} \frac{1}{x^2} \, dx = F(1) - F(-1) = -1 - 1 = -2.$$

9. In fact, it is often panic that dooms Jigsaw's victims: had he not panicked upon awaking under water, Adam might not have lost the key to his chain's lock down a bathtub drain.

10. Though the panels contain no words, the effect is that of graphomaniacal scribblings.

11. Cutely, the film's characters are all named after prisons.

12. The question is explored further in 2002's *Cube 2: Hypercube* and 2004's *Cube Zero*.

13. Numerous derivations of this formula can be found online.

14. This viewer wonders when she actually saw all these numbers; we certainly never see her look at them.

15. Poor mathematical knowledge — or poor judgment — on the part of the filmmakers is in evidence when it takes Leaven a full four seconds to determine that 645 is not prime.

16. These computations do not make sense to this viewer. Worth tells them that the dimensions of the Cube's outer shell are "434 feet square." Given that the units of this measurement are "feet squared" (rather than "feet cubed" or simply "feet"), we can conclude that Worth is describing either the area of a single side of the Cube, or the Cube's entire surface area. But neither of these possibilities would allow the Cube to contain even two 14 × 14 × 14 foot rooms, let alone over 17,000 of them! Perhaps what the

filmmakers meant was that each side of the Cube has dimensions 434 × 434 feet; taking into account the "buffer" space between the inner rooms and the Cube's shell, this would allow the Cube to contain at most 29^3 rooms. Then, assuming that the walls between the rooms have a certain thickness that plays into the measurements, Leaven's conclusion that the Cube can contain at most 26^3 rooms seems reasonable. (Interestingly, the French subtitles on the DVD translate "434 feet square" as "4000 mètres carrés," or 4000 meters squared, which is approximately 43055 feet squared; this is nothing close to either 434 or 434^2 feet squared.)

17. In an unfortunate continuity error, the room number we are shown is 517 478 565, while Leaven's subsequent mathematical etchings identify it as, rather, 649 928 856.

18. We can see from her etchings that the room's coordinates are 19, 19, 19; this, in fact, places them seven rooms from each of *three* edges.

19. For more information about mathematical permutations, see Wikipedia's entry on "Permutation" or consult almost any undergraduate-level abstract algebra textbook.

20. Leaven must have been very tired and traumatized by then, as it took this author less than eight seconds to factor 567 as $3^4 \times 7$.

21. The filmmakers may also have been very tired or traumatized by then, as Kazan is as often as not wrong in his calculations, though within the film's reality he is always correct.

22. Everyone by now is barefoot, their boots having played the roles of sacrificial testing lambs. The author does not know where their socks went; perhaps they became part of the clothing chain.

23. An excellent example of this is the work of the myriad mathematicians who unsuccessfully attempted to prove Fermat's Last Theorem. Some of the most significant advances in mathematics during the twentieth century arose from this work, despite the fact that the attempts were unsuccessful, and that the theorem itself is hardly important in the grand scheme of mathematics.

Works Consulted

Cowen, R. "Math error equals loss of Mars orbiter." *Science News* 156.15 (1999): 299.

Cube. Dir. Vincenzo Natali. Perf. Maurice Dean Wint, David Hewlett, Nicole de Boer. Cube Libre, 1999. DVD.

Jacobellis v. Ohio. No. 11. Supreme Ct. of the U.S. 22 June 1964.

"Permutation." *Wikipedia.* Wikimedia Foundation, 20 Jan. 2011. Web. 27 Jan. 2011.

"The Proof." *Nova.* PBS. WGBH, Boston. 28 Oct. 1997. Television.

Saw. Dir. James Wan. Perf. Cary Elwes, Leigh Whannell. Evolution Entertainment, 2004. DVD.

Tolstoy's Integration Metaphor
from *War and Peace*[1]

STEPHEN T. AHEARN

Introduction

> The movement of humanity, arising as it does from innumerable arbitrary human wills, is continuous. To understand the laws of this continuous movement is the aim of history.... Only by taking infinitesimally small units for observation (the differential of history, that is, the individual tendencies of men) and attaining to the art of integrating them (that is, finding the sum of these infinitesimals) can we hope to arrive at the laws of history.
>
> — Leo Tolstoy, *War and Peace*

In his great epic novel *War and Peace*, Leo Tolstoy employs some striking mathematical metaphors to illustrate his theory of history and to explain the naiveté and arrogance of placing the responsibility of history's direction on the shoulders of the leaders of armies and nations. These metaphors are unlike any other mathematical references I have seen in literature. They are not numerology,[2] nor has Tolstoy simply appropriated mathematical terms. These metaphors are rich and deep, requiring knowledge of some mathematics to fully comprehend their meaning. And they do what good metaphors should do: they enhance and clarify a reader's understanding of Tolstoy's theory.

In this essay I explore these mathematical metaphors that Tolstoy uses to describe his theory of history.[3] I focus on the mathematical ideas Tolstoy draws on to illustrate his theory, specifically integral calculus and the use of the discrete to stand for the continuous. At the end of the essay I discuss the origin of Tolstoy's mathematical metaphors. I do not attempt to critique the validity of Tolstoy's reading of history. Rather, I leave such critiques to the historians and literary scholars (see, for example, Isaiah Berlin, or Jeff Love's "Tolstoy's calculus"). Let me begin with an overview of the historical events about which Tolstoy is writing and a brief description of Tolstoy's theory.

The Historical Context

War and Peace is set in early nineteenth-century Europe during the throes of the Napoleonic Wars. Much of the novel concerns Napoleon Bonaparte's invasion of Russia in

1812. In late June of that year, Napoleon led the French army across the Nieman River and into Russia. In command of the Russian army after August 1812 was Field Marshall Mikhail Illarionovich Kutúzov. Napoleon's strategy was to engage the Russian army quickly and crush it. The Russian strategy, begun by Prince Barclay de Tolly and continued by Kutúzov, was to avoid major conflict and to retreat in advance of Napoleon's army, destroying crops and villages as the Russian army withdrew.

Barclay and Kutúzov were much criticized at the time for not engaging the French army more directly. Nonetheless the strategy succeeded. Napoleon captured the burning city of Moscow in early September, but the cost had been too great — his army had been drawn deep into Russia without adequate supplies and winter was approaching. Napoleon remained in Moscow for over a month, expecting the Russian leadership to capitulate. No surrender was forthcoming, however, and his army began a long retreat out of Russia, forced by Kutúzov to follow the devastated path he had taken on his way to Moscow. The invasion was a human disaster: of the approximately half-million French soldiers who invaded, fewer than 30,000 were alive and could still fight by the end of the campaign; the Russian army had lost some quarter of a million men.[4]

Tolstoy's Theory of History

As a Russian living in the mid-nineteenth century, Tolstoy despised Napoleon and the praise that had been heaped on him.[5] In *War and Peace*, Tolstoy sets out to denigrate Napoleon's place in history, espousing a view of the forces shaping the course of history that leaves no place for a grand Napoleon. National leaders, even the great leaders, do not control the outcome of the great events of history, Tolstoy argues. The ocean of individual actions that is history is too vast, too complicated, and too unpredictable for the actions of one or a few individuals to determine its course. Leaders might be able to identify a current in the ocean, thus appearing to be controlling the current, but in reality the current's direction is unaffected.

According to Tolstoy's theory, the national leaders of Europe in the early nineteenth century do not rally their people to fight for the greatness of their nations and for great causes; rather, Europe is already heading toward conflagration, with the leaders swept along. Napoleon is arrogant and naive for believing he controls the destiny of Europe. He and the French army are destined for defeat and ruination. Nothing Napoleon can do will change that reality.

In contrast, Kutúzov, says Tolstoy, understands that Napoleon's fate has already been determined. To give battle to the French will simply cause the unnecessary loss of Russian lives and accomplish nothing that is not already destined. Kutúzov is a Russian national hero for realizing this eventuality and for avoiding leading the Russian army to destruction.

In a similar fashion, Tolstoy believes historians have misrepresented history by focusing on a few individuals or a select sequence of events. Such an approach presents at best a vague shadow of historical reality. Moreover, the focus on historical causes is naive — causes are unknowable. "There is, and can be, no cause of an historical event except the one cause of all causes" (Tolstoy 1095). Tolstoy likens the focus on causes to declaring that the Earth is stationary and that the sun and the other planets move around it. Such a view does not

lend itself to an explanation of the laws of planetary motion. Similarly, he claims that historians' focus on causation blinds them to the laws of history.

> The discovery of these laws is only possible when we have quite abandoned the attempt to find the cause in the will of some one man, just as the discovery of the laws of the motion of the planets was possible only when men abandoned the conception of the fixity of the earth [1096].

Historians, urges Tolstoy, should seek to determine the laws that govern history, not the causes of historical events.

Using the Discrete to Stand for the Continuous

From Tolstoy's perspective the crux of historians' misconceptions about the nature of history and their failure to comprehend the complexity of history is an attempt to use the discontinuous (discrete) to stand for the continuous and an inability to comprehend continuity.

> Absolute continuity of motion is not comprehensible to the human mind. Laws of motion of any kind become comprehensible to man only when he examines arbitrarily selected elements of that motion; but at the same time, a large proportion of human error comes from the arbitrary division of continuous motion into discontinuous [discrete] elements [917].

Tolstoy illustrates this tendency by recalling Zeno of Elea's tale of Achilles and the tortoise, which Zeno intends to demonstrate that motion does not exist (see Aristotle's critique in his *Physica*, 239b). Achilles is ten times faster than the tortoise he is chasing. By the time Achilles has reached the tortoise's starting position, the tortoise has covered an additional one-tenth of that distance. When Achilles has covered that tenth, the tortoise has covered another one hundredth, and so on. The absurd conclusion is that Achilles can never overtake the tortoise, yet we know that he will.

The seeming paradox, says Tolstoy, arises from dividing motion into discrete elements, whereas motion is continuous. There is, in fact, no paradox and, Tolstoy reminds us, the problem is soluble:

> By adopting smaller and smaller elements of motion we only approach a solution of the problem, but never reach it. Only when we have admitted the conception of the infinitely small, and the resulting geometrical progression with a common ratio of one tenth, and have found the sum of this progression to infinity, do we reach a solution of the problem [917].

(Of course, the geometric series

$$\sum_{n=0}^{\infty} (1/10)^n$$

converges, so Achilles overtakes the tortoise after running a finite distance and thus within a finite amount of time.)

Likewise, Tolstoy explains, history is a continuous phenomenon. "The movement of humanity, arising as it does from innumerable arbitrary human wills, is continuous. To understand the laws of this continuous movement is the aim of history" (Tolstoy 918). But,

alas, historians have made the same mistake as the ancients did in contemplating the story of Achilles and the tortoise. Rather than treating the movement of humanity as continuous, historians take "arbitrary and disconnected units," approximating the continuous by the discrete.

Tolstoy sees historians employing two methods, both of which make this fatal mistake of using the discrete to stand for the continuous. The first method is to select a sequence of events — even though an event cannot have a beginning nor an end — from the continuous stream of history and to treat those events as representing the whole. The second method, and the one Tolstoy devotes much more energy to refuting, is to treat the actions of one person (e.g., Napoleon Bonaparte or Tsar Alexander) as equal to the sum of many individual wills.

These methods give only approximations of the continuous flow of human history and taking smaller units does not yield truth.

> Historical science in its endeavor to draw nearer to truth continually takes smaller and smaller units for examination. But however small the units it takes, we feel that to take any unit disconnected from others, or to assume a *beginning* of any phenomenon, or to say that the will of many men is expressed by the actions of any one historic personage, is in itself false [Tolstoy 918].

The result: historians have captured "perhaps only 0.001 per cent of the elements which actually constitute the real history of peoples" (Tolstoy quoted in Berlin 15).

Tolstoy's Integration Metaphor

In Tolstoy's view, the remedy for this failure of historians to deduce truth is the same as in the tale of Achilles and the tortoise. We must treat the movement of humanity as continuous (and turn to mathematics!):

> A modern branch of mathematics having achieved the art of dealing with the infinitely small can now yield solutions in other more complex problems of motion which used to appear insoluble.
>
> This modern branch of mathematics, unknown to the ancients, when dealing with problems of motion admits the conception of the infinitely small, and so conforms to the chief condition of motion (absolute continuity) and thereby corrects the inevitable error which the human mind cannot avoid when it deals with separate elements of motion instead of examining continuous motion.
>
> Only by taking infinitesimally small units for observation (the differential of history, that is, the individual tendencies of men) and attaining to the art of integrating them (that is, finding the sum of these infinitesimals) can we hope to arrive at the laws of history [918].

Thus, to understand the laws governing history, we must "integrate" the wills of all people. Once we are able to carry out this integration, the historical laws will be apparent.

This integration problem is quite difficult and Tolstoy gives no indication of how we might solve it. It is not even entirely clear what the variables are. I do not believe, however, that Tolstoy had any intention that we would solve it. Rather, the purpose of his metaphor is twofold: first, it succinctly summarizes his view of how the movement of humanity is determined. Second and most important, the metaphor illustrates the complexity of history and the infinitesimal nature of the influences on history's course.

In the second epilogue (only *War and Peace* can have two epilogues!), Tolstoy explains the importance of his metaphor: "Only by reducing this element of free will to the infinitesimal, that is, by regarding it as an infinitely small quantity, can we convince ourselves of the absolute inaccessibility of the causes, and then instead of seeking causes, history will take the discovery of laws as its problem" (1349).

Because the wills determining the direction of history are infinitely small in quantity and infinite in number, we human beings who cannot grasp such complexity will never determine causation. Historians' use of discrete events and personalities to explain the continuous flow of human history is doomed to failure. The search for historical causes is futile, and historians must instead seek the laws governing history.

Tolstoy is leading history down the road that he believes all sciences must take:

> All human sciences have traveled along that path. Arriving at infinitesimals, mathematics, the most exact of sciences, abandons the process of analysis and enters on the new process of the integration of unknown, infinitely small, quantities. Abandoning the conception of cause, mathematics seeks law, that is, the property common to all unknown, infinitely small, elements.
>
> [I]f history has for its object the study of the movement of the nations and of humanity and not the narration of episodes in the lives of individuals, it too, setting aside the conception of cause, should seek the laws common to all the inseparably interconnected infinitesimal elements of free will [1349].

Unfortunately, Tolstoy provides no substantive guidance on what these laws might be, nor does he suggest how one might search for them.[6] Tolstoy has shown us only the road he believes historians must take; he does not indicate what they might find there.

The Origins of the Integration Metaphor

During the nineteenth century calculus was given a rigorous foundation by the work of Cauchy, Riemann, Weierstrass, and others (see Chapter 11 in C. H. Edwards's *Historical Development*), finally answering George Berkeley's stinging critique of calculus in "The Analyst." Tolstoy wrote *War and Peace* between the summer of 1863 and the fall of 1869. However, there is no indication that Tolstoy was familiar with this revolution in mathematics. Tolstoy uses the language of Leibniz's infinitesimals, not the notions of limits and Riemann sums. Moreover, Tolstoy makes no mention of these mathematical issues in his notes, letters, or other drafts of the novel (Love, private communication). Instead, argues Boris Eikhenbaum, the idea of illustrating his historical philosophy with calculus was inspired by Tolstoy's friend Sergei Urusov, a mathematician and master chess player.[7]

Urusov had a profound faith in the power of mathematics, as is illustrated by the following extraordinary passage from one of his letters:

> To the question: "How is one to know whether a given people possesses genius, independence, and power; and where is enlightenment most advanced?" I answer: everything depends on the development of the exact sciences, especially of mathematics. The French republic was a most powerful state because Lagrange, Legendre, Laplace, and others were living then. Now France is not important because there are not mathematicians there. In Herschel's time, England was at the height of its powers and it is now at the same level because it has its Thompsons. Prussia has its Eulers and Jakobs. In Sweden there is Abel. [Russia has] Ostrogradsky, Chebyshev, Bunyakovsky, and Yurev [quoted in Eikhenbaum 213].

In his 1868 book *A Survey of the Campaigns of 1812 and 1813, Military-Mathematical Problems, and Concerning the Railroads*, Urusov draws on this faith in mathematics as he proposes a theory of history essentially identical to the theory Tolstoy describes in *War and Peace* (Eikhenbaum, 220–21). In particular, Urusov discusses the dichotomy between the continuous physical world and the discontinuous approximations the human mind uses to understand the world and suggests the use of integration to deduce moral-physical laws:

> Two conditions constitute the main obstacle to the discovery of moral-physical laws: first, the fact that in the physical world every interrelationship (function) is continuous, while man, as a primarily moral being, perceives all interrelations as disconnected; and second, the fact that very often, even in the majority of cases, social phenomena are reduced to disconnected functions, which we cannot deal with scientifically. Continuous functions can produce a sum (be integrated), but the elements which are integrated are unknown and inconceivable. Disconnected functions cannot be integrated, but they are known, conceivable elements. General truths, general laws, general rules are accessible to the human mind. This duality of functions is the best proof of the duality of nature and of the existence of the moral universe. Given these conditions, in order to eliminate difficulties in analysis, man has invented a way of combining the continuous and the discontinuous: the discontinuous elements are reduced and entered as a sum, or by changing the integration, we apply it to its elements without changing them at all [quoted in Eikhenbaum 220–21].

Here we see the germ of Tolstoy's mathematical metaphors.[8] From Urusov's observations about the continuous world and the discontinuous perception of the human mind, Tolstoy develops his stinging critique of historians. Moreover, Tolstoy pushes Urusov's ideas further to articulate clearly the idea of obtaining the laws of history by integrating the "differential of history," a concept that invokes enthusiastic praise from Urusov: "You understand how excited I was by your differential of history. If what you have found is valid, then the moral-physical laws will be in our hands" (quoted in Eikhenbaum 221).

Conclusion

It is striking how well-formulated and well-developed Tolstoy's metaphor is. Tolstoy builds layers of subtlety into the metaphor. He skillfully explains how a misconception about the appropriateness of substituting discrete events for the continuous movement of humanity leads to historians' failures. Remedying this misconception, Tolstoy lays the foundations for his metaphor: if we allow for the infinite, truth can be found. As my students often observe, Tolstoy is even careful to point out that history, too, is continuous, just as introductory calculus texts require the integrand of a definite integral to be continuous.[9] Having established the necessity for a different historical approach and meticulously developed the necessary prerequisites, Tolstoy calls on historians to find the laws of history by "integrating" the "differential of history." The result is a powerful, penetrating analogy.

Notes

1. This essay originally appeared in *The American Mathematical Monthly* 112.7 (2005): 631–38. I thank the editor(s) of the *Monthly* for permission to reprint it in its present, slightly revised, form. The essay is dedicated to the memory of John Mohan. I would like to thank Jeff Love for helpful correspondence regarding the origins of Tolstoy's integration metaphor and for bringing Tolstoy's friendship with Urusov to my attention. I would also like to thank Dan Flath, Karen Saxe, and Rachel Wood for reading drafts of this essay and for suggesting improvements.

2. Tolstoy does have Pierre, one of the main characters of *War and Peace*, engage in some amusing numerology. Seeking affirmation of his hatred of Napoleon, Pierre sees a biblical foreshadowing of Napoleon's evil: "Writing the words L'Empereur Napoleon in numbers, it appears that the sum of them is 666, and that Napoleon was therefore the beast foretold in the Apocalypse…" (Tolstoy 738).

3. Tolstoy also uses metaphors from mathematics and physics when he discusses military science. In those metaphors, as well, one can see the de-emphasizing of the importance of the commanders. See Vitányi for a catalogue of those metaphors.

4. For a more complete account of Napoleon's invasion of Russia, see Curtis Cate's *The War of the Two Emperors* or Eugene Tarlé's *Napoleon's Invasion of Russia, 1812*.

5. For a discussion of Napoleon's legacy in Russian culture see Molly Wesling's book *Napoleon in Russian Cultural Mythology*. The book begins, aptly, with a quotation from one of Tolstoy's letters.

6. Isaiah Berlin argues in his long essay *The Hedgehog and the Fox* that Tolstoy struggled with an inner conflict between his ability to see the flaw in any theory and his desire, never fulfilled, for a "single embracing vision" for the world. "Out of this violent conflict grew *War and Peace*" and the historical theory espoused therein, says Berlin (39–42).

7. Urusov published several works on mathematics and chess theory, including *Differential Equations* in 1863, *On the Integral Factor in Differential Equations* in 1865, and *On Solving the Problem of the Knight* in 1867.

8. The portion of *War and Peace* containing the mathematical metaphors was published after Urusov's book (Eikhenbaum 221).

9. I do not believe that this observation is ahistorical, nor are my students reading too much into Tolstoy's language. Prior to the work of Fourier in the beginning of the nineteenth century, there was no need to find the definite integrals of functions other than those defined by single analytical expressions. Thus putting restrictions on integrands was not necessary (Edwards 317). In fact, continuity as we understand it was not defined until the beginning of the nineteenth century by Bolzano and Cauchy (Edwards 308–09). However, if indeed Tolstoy is using Urusov's understanding of integration as a basis for his metaphor, then he *would* be careful to point out that the movement of humanity is continuous.

Works Consulted

Aristotle. *Physics. The Works of Aristotle*. Trans. R. P. Hardie and R. K. Gaye. Ed. W. D. Ross. Vol. 2. London: Oxford University Press, 1930.

Berkley, George. "The Analyst." *The Works of George Berkeley, Bishop of Cloyne*. Ed. A. A. Luce and T. E. Jessop. Vol. 4. London: Nelson, 1951. 63–102.

Berlin, Isaiah. *The Hedgehog and the Fox: An Essay on Tolstoy's View of History*. New York: Simon, 1953.

Cate, Curtis. *The War of the Two Emperors: The Duel between Napoleon and Alexander. Russia, 1812*. New York: Random, 1985.

Edwards, C. H., Jr. *The Historical Development of the Calculus*. New York: Springer-Verlag, 1979.

Eikhenbaum, Boris. *Tolstoy in the Sixties*. Trans. D. White. Ann Arbor: Ardis, 1982.

Love, Jeff. "Tolstoy's calculus of history." *Tolstoy Studies Journal* 13 (2001): 23–37.

Tarlé, Evgenii. *Napoleon's Invasion of Russia, 1812*. New York: Oxford University Press, 1942.

Tolstoy, Leo. *War and Peace*. Trans. Aylmer and Louise Maude. Ed. George Gibian. New York: Norton, 1966.

Vitányi, Paul. "Tolstoy's Mathematics in *War and Peace*." *Publications*. Centrum Wiskunde & Informatica, n.d. Web. 16 June 2010.

Wesling, Molly W. *Napoleon in Russian Cultural Mythology*. New York: Lang, 2001.

"We'll all change together"
Mathematics as Metaphor
in Greg Egan's Fiction

Neil Easterbrook

Science fiction or *speculative fiction* (SF) is that sort of literature which can contain paragraphs such as this: "'Are you free for lunch?' I asked. She hesitated; there was always work she could be doing. 'To discuss the Cauchy-Riemann equations?' I suggested" (Egan, "Singleton" 154).

We could imagine that other books — the fiction of Richard Powers or perhaps of Thomas Pynchon — might proffer such sentences, but generally such writers are either explicitly producing SF or have strong connections to the genre. For example, Neal Stephenson's *Cryptonomicon* and his *Baroque Cycle* (*Quicksilver*, *The Confusion*, and *The System of the World*) involve a good deal of mathematical logic, primarily concerning cryptography, and feature characters such as Gottfried Wilhelm Leibniz and Alan Turing. Neither the mathematics nor the names pop up often in most popular fiction.

SF is the consistent exception. Exceptional even among the exceptions is the Australian novelist Greg Egan, who after taking an academic degree in mathematics and working as a computer programmer has now published ten novels and six collections of stories.[1] With perhaps one exception, all are deeply devoted to serious engagements with the natural sciences, exploring burgeoning technologies such as nanotech or cybernetics, genetic or software engineering, or the realities of space travel limited to the speed of light. Known for writing extraordinarily imaginative and challenging fiction, Egan is also respected for staying close to the hard facts and cold equations, treating scientific development with an unrelentingly rigorous concern for detail, accuracy, and plausibility, even when the far-future setting requires elaborate speculative extrapolations of existing sciences. As the physicist and novelist Greg Benford admits, in speculative fiction "*The science does not have to be right to be useful*" (215). Yet Egan is perhaps as close to *getting things right* as any SF novelist has ever been. In his blog "Whatever," writer John Scalzi recommends Egan to fans of SF who like its "hard" part — that is, its focus on the hard, or natural, sciences — "diamond hard."

Only the complexity of Egan's scientific vision — many find his hard science hard to read — prevents him from achieving superstar status in the markets of modern genre fiction, since his innovative texts also feature exciting plots in wildly original, increasingly post-

Singularity[2] settings. One of the most appealing qualities of Egan's work is that he doesn't shy away from real science by descending into technobabble (as is generally the case in the "sci-fi" entertainments of Hollywood or television) or by ignoring scientific facts, such as inertia or the conservation of momentum. His characters are often mathematicians or mathematical physicists trying to achieve a conceptual breakthrough, and Egan takes us through the process of their reasoning, not so much to provide lessons on algebra or on the mechanics of curved spacetime as to produce, for readers, something of the cognitive beauty of science and the wondrous experience of discovery, both developed within all-too-human stories.

Or all-too-human *posthuman* stories.[3]

Throughout his work, Egan is deeply devoted to the evocative insights of mathematics and physics, beginning with the very first story he published, "The Infinite Assassin." Often the stories have less to do with human character or emotion than with the simple wonder of the universe we inhabit, or of an exotic mathematical speculation that Egan might narrativize. As he told Renai LeMay concerning his novel *Incandescence*:

> I'm interested in science as a subject in its own right, just as much as I'm interested in the effects of technology on the human condition. In many things I write the two will be combined, but even then it's important to try to describe the science accurately. In a novel such as *Incandescence*, though, the entire point is understanding the science, and it really doesn't bother me in the least that it's not an exploration of the human condition.

Egan's stories "Luminous" and "Dark Integers" (both featured in *Dark Integers and Other Stories*, 2008) involve the same characters in several scenes ranging across thirty years. In "Luminous," we are introduced to Bruno Costanzo and Alison Tierny, who will both go on to complete doctorates in mathematics. Bruno is initially a mathematical Platonist (19) and Alison a woman convinced of the "local truth" (38) of the contextual and empirical contingency of mathematics, what "Dark Integers" will call "Einstein locality" (113) or what Egan, in his introduction to *Dark Integers and Other Stories*, phrases as "the idea that the mathematics of ordinary numbers might be *malleable*" (7)—an idea counter to those of Bruno's rigid belief system. The two characters have heated debates, and on one occasion Alison proposes she try to prove, or Bruno try to disprove, the existence of such malleability. "Let me get this straight," Bruno says, "What you're talking about is taking ordinary arithmetic — no weird counter-intuitive axioms, just the stuff every ten-year-old *knows* is true — and proving that it's inconsistent, in a finite number of steps?" (21). They begin a search for this inconsistency or, as they call it, "defect," taking on "a project so wild and hip and unlikely to succeed that it made [the search for extraterrestrial intelligence] look like a staid blue-chip investment" (29).

Ten years later, having completed doctoral degrees, they manage to get thirty minutes on Luminous, a Chinese supercomputer so advanced that it is literally made of light. They run a program they have written, and Luminous shows that S implies not–S, and not–S implies S — statements that in our usual system of mathematical logic are patently false — because there exists another universe made up of non-standard arithmetic. Bruno and Alison conceptualize the rift between these differing mathematical universes using a spatial metaphor: they juxtapose "our side" (our universe of standard mathematics) and "their side" (a different universe of non-standard mathematics), separated by rules (which they call a "border") that they do not yet understand. The two sides are

incompatible systems of mathematics — both of which [are] *physically true*, in their respective domains. Any sequence of deductions which stayed entirely on one side of the defect ... would be free from contradiction. But any sequence which crossed the border would give rise to absurdities [31].

This is the defect for which they've been searching. But at the same time as they probe this border, mathematicians on the other side probe back, threatening utter catastrophe to both sides because of the possible reconfiguration of their universes: if the other side's mathematical rules pass into our physical universe, everything in our world will change, from the fortunes of the Chicago Cubs to the very structure of matter itself. And our mathematical rules similarly threaten the other side's way of being. Just at the right moment, the mathematicians manage to reestablish an equilibrium, forming an ad-hoc treaty or détente between universes (49): both sides agree to never inject (through a means Egan doesn't specify) the mathematics of one side into the other (or, as the far-sider Sam puts it, "jump the border" ["Dark Integers" 104]), thus preserving each universe from contradictions that would cause real-world catastrophes such as, on our side, multiple plane crashes and the collapse of the international stock markets. All this wild mathematical speculation is, it needs to be said, set among the trappings of genre SF: business espionage (by a company comically called "Industrial Algebra"), kidnapping, neurotoxins, chase scenes, innovative guns, and pending divorces.

Our noble "Knights of Arithmetic Inconsistency" (108) reappear in "Dark Integers," when the now ten-year-old treaty is unintentionally violated by Campbell, a young mathematician from our side, when his work leads to the discovery that "arithmetic wasn't merely inconsistent, it was *dynamic*. You could take its contradictions and slide them around like bumps in a carpet" (116). By analogy to the "dark matter" or "dark energy" hypothesized but not yet understood by physicists, Campbell calls far-side integers "dark integers" (118). Although "some mathematical/philosophical stuffed shirts ... spluttered with rage at the sheer impertinence and naivety of [his] hypothesis" (112), his discovery, which again probes the border between the two universes, causes the cold war status quo (49, 130) to turn hot.

Both of these stories are about scientific curiosity and reasoning rather than the human condition. The mathematics is not subordinated to the narrative; the narrative is *about* the math. *Incandescence* provides another startling manifestation of this set of priorities. Set about one million years into the future, this text weaves together two parallel stories, one of which deals with a group of pre-industrial posthumans who must rediscover the entirety of mathematical physics without the science of astronomy, since they are sealed within an asteroid orbiting near the accretion disc of a black hole. Half of the book is devoted to tracing the posthumans' fascinating experiments and calculations as they first form a theory of gravity and then work their way to the concepts of general relativity. Egan has written a good deal of non-fiction about the mathematics in his books, especially the mathematics of *Incandescence*. See, for example, "Orbits and Tidal Acceleration" (which does not use mathematical notation) and "Deriving the Simplest Geometry" (which does).[4] We might say that these fictions are entirely about growing curiosity and the attempt to understand complex empirical and theoretical problems.

However, even readers unfamiliar with mathematics or physics or uninterested in experiencing the crystalline joys of discovery can appreciate Egan's use of science as a metaphor to address essential and non-mathematical matters of the human condition. An excellent example is his 2002 novel *Schild's Ladder*,[5] which depicts a posthuman society living among

the stars some 20,000 years hence. Almost all of the novel's posthumans and *orthohumans*[6] fear change — and as we will see, it turns out their fears are, on some level, justified. The tale begins with physicist Cass attempting to discover, with absolute certainty, the ultimate constitution of material reality. Like the character Gisela in Egan's "The Planck Dive," Cass "want[s] to understand the universe at its deepest level, to touch the beauty and simplicity that [lies] beneath it all" ("Planck" 292). Cass' experimentation results in calamity: it accidentally seeds a new set of physical laws, forming what the novel's scientists dub the "novo-vacuum" — a "far-side" of space with physical properties that differ from those of our own universe (note the parallel with "Luminous"). Though it turns out that the novo-vacuum, unlike the "completely sterile" (189) vacuum of our normal interplanetary space, is extraordinarily fertile, its genesis has a terrible effect on our universe: wherever it contacts our space it reconfigures — and so destroys — everything it touches. With the novo-vacuum expanding at one-half the speed of light (211), two groups of scientists meet to investigate what can and should be done.

Now, posthumans are in principle immortal. Indeed, their biological engineering is such that bodies can be made to order and exchanged at will, and cybernetics has made it possible to digitize consciousness within a gadget called a "Qusp" (23),[7] so that even if a body experiences "local death" (145) the self can be restored from the latest backup (67). In this way, death becomes merely a memory gap, a sort of amnesia (40). Thus, the posthumans have ample time to study the new physical laws that Cass' work has created, though they feel a pressing urgency to understand them since many solar systems are being destroyed as the novo-vacuum continues to expand. Two groups of scientists — "Preservationists" and "Yielders" (53) — propose different solutions to the crisis. Preservationists want to destroy the novo-vacuum, or at least prevent it from coming into further contact with our universe; on the other hand, Yielders, acknowledging that they can retreat even as the novo-vacuum grows, want to explore the new space, seeking a "conceptual breakthrough" (193) that will allow them to discover new forms of life. The most prominent Yielder is Tchicaya, who comes to think that change is vital, is central to the human condition. While others fear change, he thinks change must be embraced; now four thousand years old, Tchicaya believes "if he didn't change, there was no point in living even one more century" (217).

He didn't always feel this way. A flashback finds Tchicaya on the eve of his ninth birthday, waking from troubled sleep. He confesses to his father that he has a common fear — "I don't want to get older" he says, "I don't want to change" (245). Not only is SF the literature of change,[8] but the changing self is at the heart of the human experience, in any setting of any time. What defines the self?[9] How is it that we change though time but remain the same? If we change, do we not lose our identity by becoming something else?

> Understanding identity means understanding those boundaries that inscribe and circumscribe the self. Yet there are four *different* boundary sets — philosophical (conceptual categories); psychological (personality, behavior, sexuality); physical (all matters concerning biology and the body, especially gender and race); and cultural (religion, politics, ideology, language). In turn, each set can be subdivided. For instance, philosophy considers identity as four discrete problems: *uniqueness* involves the distinction between the *I* that is *me* and the other *I* that is *you*; *endurance* questions how a (unique) self can be the same through time; *unity* investigates composition — how perceptions, thoughts, and bodies all meld into a single subject; and *essence* explores metaphysical substance (whether transcendental soul or merely bundles of effects produced by chemical exchanges between neurons) [Easterbrook 409].

Tchicaya's fear concerns *endurance*, which might also be called *continuity*: "*[H]ow will I know that I'm still me?*" (245). Or: "How will I know that I haven't turned into someone else?" (246).

To mollify the child's fears, Tchicaya's father introduces a simple geometrical model: Schild's ladder, a notion developed by the mathematical physicist Alfred Schild in a Princeton lecture of 1970 and a paper of 1972. In his list of "References" at the end of the novel, Egan says his source is Misner, Thorne, and Wheeler (342), who in their book *Gravitation* introduce the model to help explain the process of *parallel transport*— essentially, the transport of data along a curve. In Egan's novel, it provides a metaphor for the continuity of personal identity as it passes along time's arrow.

The father begins by drawing an arrow, and then asking the child how he might take this arrow along with him wherever he travels — in other words, how he might translate the arrow, i.e., reproduce the arrow in another location, preserving its direction and length. Tchicaya first responds that he'd use a compass or the stars to "reproduc[e] its compass bearing" (246). But when the father draws two arrows, both pointing north, on opposite sides of a globe, the son is convinced he must abandon this technique (247). The father then repeats the challenge: "This arrow is your only compass; there is nothing else to steer by" (247). He also forbids the use of any distance-measuring tool, such as a ruler or tape measure. The key to recreating the arrow, Tchicaya discovers, it to use a geometric construction. He and his father

> worked through the construction together, pinning down the details, making them precise. You could duplicate an arrow by drawing a line from its tip to the base you'd chosen for the second arrow, bisecting that line, then drawing a line from the base of the first arrow, passing through the midpoint and continuing on as far again. The far end of that second diagonal told you where the tip of the duplicate arrow would be [248].

How then, to repeat this trick on a globe, where the surface is curved? The key, as Tchicaya astutely observes, is to use *great circles*: that is, circles on the surface of the sphere which share their centers with that of the sphere (e.g., the Earth's equator). Repeatedly translating the arrow "using the parallelogram construction with the arcs of great circles for the diagonals" (249) produces a "lattice" containing multiple copies of the arrow. This lattice, the father explains, is called "Schild's ladder." He continues: "How do you carry something from here to there, to keep it the same? You move it step by step, keep-

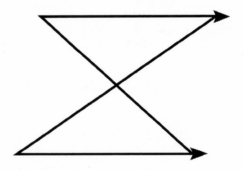

The translation of an arrow.

ing it in parallel in the only way that makes sense. You climb Schild's ladder" (249–50).

But the model has another, and perhaps more interesting, consequence as a metaphor of self: Tchicaya traces a different path across the globe, and this time the original and resulting arrows are not parallel. After Tchicaya asks what he did wrong, his father replies "Nothing.... This is what you should expect. There's always a way to carry the arrow forward, but it depends on the path you take" (251). Since the novel itself— not just a single section — is named after this model, a reasonable conjecture is that Egan intends the analogy to apply to all humanity, everywhere, and into the future.

Even readers who don't pause to reason things out can follow the geometric illustration: here we have a vivid mathematical metaphor of parallel transport, one that accounts for both continuity *and* change. Tchicaya's father concludes with some of the key thematic statements of the text: "You'll never stop changing" but "[t]here's nothing to be afraid of..." (251). This motif runs through the entire book — and, as is true in all great literature, "the same idea shows up in a thousand different guises" (249). Early on, the scientist whose experimentation with physics has such disastrous consequences remarks to herself that "[i]f she returned to Earth unchanged, it wouldn't be a triumph of integrity, it would be a kind of death" (29); later, we learn of a "Gaussian wave packet [that] can keep its shape in a harmonic oscillator potential" (172). Egan's scientific discussions metaphorically model the human experience: the text's central theme, derived from the aphoristic imperative "Only connect!" found in E. M. Forster's famous *Howards End*, is that humanity exists amid change, and that "this pattern of connections, repeated endlessly, [is] all there [is]" (3). Patterns of connection are vitally important to both the science and plot of *Schild's Ladder* (Egan, "Only Connect"). Remarking that "people had always found new ways to connect" (219), the novel's final third concerns Tchicaya's passage through the encroaching border of the novo-vacuum and discovery that the other side is teeming with life, is more vital by magnitudes than our lifeless interplanetary vacuum; and, in another of Egan's clever speculations, on the other side "Planck-scale biota" (187) or "vendeks" actually live, grow, and form complex societies, all on an incredibly small scale: the "organisms are a few hundred Planck lengths wide: about ten-to-the-minus-thirty-three meters" (187–88).

Of course, one danger of this sort of metaphoric modeling is that it might create category errors: anthropomorphism treats the natural and the inhuman as motivated agents, and while this is amusing, as in the case of *The Brave Little Toaster* or *The Little Red Caboose*, it also produces "earnest hypotheses that [are] just as likely to be wrong" (315). Even as a child, Tchicaya understands that "the arrow of his self" is "only a metaphor" (250). While there are clear parallels between *Schild's Ladder* and the stories "Luminous" and "Dark Integers," especially in their common depiction of two universes governed, respectively, by standard and non-standard arithmetic and physics (with the non-standard universe being the more dynamic and fertile of the two — so much so that in "Dark Integers," the far-siders take to calling our world "Sparseland" [103]), math is not used metaphorically in the stories, while in *Schild's Ladder* it plays both literal and figural roles.

Such use raises two questions, one for the novel and one for mathematics. The question for *Schild's Ladder* is that of the nature of the human condition. Egan uses a mathematical model not to dress up his work with specious pseudoscience trappings, but rather to provide a rigorous and precise understanding of the psychological development of individual selves, and of the sociological development of human collectives. This message of human solidarity, found despite post–Singularity changes, provides the central motif of the novel and a powerful theme. Egan takes Schild's ladder, used for modeling motion under the rule of general relativity, and explicitly applies it as a metaphor for the development of the human self and of the future of the human species, doing so largely as a means of deflecting or dismissing the deeply-seated fears most of us have about the prospect of a radical change that our species and our culture may soon experience. Egan's aesthetic principle is *parallax*— one thing viewed from several perspectives — so the novel's science echoes its imagery, its style resembles its content, and its plot resonates with its cognition. This analogical technique

identifies the profound role that mathematics plays in enabling Egan's themes and structuring his story; his structural parallax is in fact a formal demonstration of his theme of *connection*. Every level of the text intra-connects: theme connects to structure and structure connects to science, image connects to plot and plot connects to theme, all of this enabled by his metaphoric use of Schild's ladder.

A question concerning mathematics more generally is its metaphorical status, a question that turns out to be surprisingly vexed. A straightforward attempt to compare metaphor and mathematics[10] comes from the mathematical physicist Freeman Dyson, who in introducing the work of Yuri I. Manin writes that "mathematics as metaphor ... means that the deepest concepts in mathematics are those which link one world of ideas with another" (vii). This seems perfectly reasonable and reasonably unobjectionable. Dyson goes on to explain that specific sorts of mathematics not only result from metaphoric speculation, but themselves function metaphorically: "Coordinates, fluxions, symbolic logic and Riemann surfaces are all metaphors, extending the meanings of words from familiar to unfamiliar contexts." And he provides a description of Manin that applies equally well to Egan: "In both [physics and mathematics] he sees tantalizing glimpses of parallel concepts, symmetries linking the continuous with the discrete" (vii). One way to think of this simple line of argument is to conceptualize mathematics as using metaphor *metaphorically*, as a medium of substitution to compare, to link, and to speculate.

But there's perhaps another way that metaphor and mathematics are entwined — conceptualizing mathematics as *literally* metaphoric. It's beyond my brief— and more importantly, far beyond my ability — to offer an account of the foundations of mathematics,[11] but there is a rich secondary literature in the philosophy of science and cognitive science that seeks interesting correspondences between metaphor and mathematics. One place to start that investigation, which may initially sound as balmy as the research of Bruno and Alison, is with George Lakoff and Rafael Núñez's *Where Mathematics Comes From*. Núñez explains in the *Cambridge Companion to Metaphor and Thought* that "[t]he main point of [their] case study was to show that even the most abstract conceptual system we can think of, mathematics (!), is ultimately embodied in the nature of our bodies, language, and cognition" (356b). And for them, the foundation of cognition is ultimately metaphor.

The main point of *my* case study, however, was to show that even if Egan's fiction skirts the limits of the possible, extrapolating current technologies toward wild speculations on perhaps even wilder ideas, he provides an extraordinary example of an artist interested both in mathematics for its own sake and in using it metaphorically to explain important phenomena of the human condition. At one point in *Schild's Ladder*, a character remarks that in his culture, love is best expressed as an original theorem (130) — a charming detail about how human creativity might create human connection. While reading Egan's fiction can be hard going, and some readers find it cold or too overtly analytical, it's also possible to understand that same analytic rigor as serving a touchingly humane and deeply human function — to help us overcome our fear of change. Egan lovingly gifts his readers with the following theorem: "You'll never stop changing," says the father, but all human beings follow a similar path: "As long as we climb side by side, we'll all change together."

"It was only a metaphor. But it was a metaphor filled with hope."

Notes

1. Excellent overviews of Egan's career can be found in Blackford and in Murphy.

2. The term "Singularity" was coined by the computer scientist Vernor Vinge in a 1992 address to NASA engineers. Primarily, it denotes a moment of technological invention — such as the creation of artificial intelligence, effective nanomachines, or faster-than-light space travel — beyond which the status and development of human experience cannot be predicted. The futurologist Ray Kurzweil has written several books predicting such a moment, and along with the space entrepreneur Peter Diamandis, who administers the Ansari X Prize, has started the "Singularity University."

3. *Posthumans* are people who have been radically altered by technology, to the extent that they are no longer *Homo sapiens*.

4. Egan has also co-authored two academic papers on mathematical physics.

5. Unfortunately, *Schild's Ladder* has been out of print in the United States for some years. However, it remains available at very modest cost from major online sellers both as a used book and as an import.

6. This is Charles Stross' amusing term for unchanged *Homo sapiens* living amid posthumans. See *Accelerando* (335).

7. In SF, such ingenious but (given our current understanding) highly improbable or even impossible gadgets are *conceits*, a word that in literary study designates an elaborate metaphor that acts like a textual keystone; it may be far-fetched, but if we willingly suspend our disbelief, interesting results — both in plot and in theme — may follow.

8. "Science fiction" or "speculative fiction" has been notoriously difficult to define, primarily because the science and technology it engages is constantly in the processes of change, and so what is plausible or implausible, prescient extrapolation or pathetic pseudoscience, is always evolving. But most critics agree that in one or another fashion, *SF is literature focused on changes in the human condition brought about through developments in science and technology.* For discussions of this definition, alternative definitions, and the historical evolution of the genre, see Landon (especially 1–71) and Luckhurst.

9. A handy and short introduction to the philosophical, ideological, and psychological debates about subjectivity can be found in Hall. Atkins provides a very convenient collection of original philosophic source materials (with accessible commentary) from René Descartes to Catriona Mackenzie — the mid-seventeenth century to the recent present.

10. For an account that conceptualizes the similarity between mathematics and literature *metonymically* — as fundamentally the formal arrangement of elaborate patterns — see Cohen.

11. For a recent, readable, and very clever pop culture account of the foundations of mathematics from Frege and Hilbert to Gödel and Turing, see Doxiadis and Papadimtriou, whose graphic novel *Logicomix* traces arguments that would be sharply at odds with, say, those of Núñez or Tasić.

Works Consulted

Atkins, Kim, ed. *Self and Subjectivity*. Malden: Blackwell, 2005.

Baez, John C., J. Daniel Christensen, and Greg Egan. "Asymptotics of 10j Symbols." *ArXiv.org*. Cornell University Library, 4 Nov 2002. Web. 1 June 2010.

Benford, Greg. "Physics Through Science Fiction." *Reading Science Fiction*. Ed. James Gunn, Marleen S. Barr, and Mathew Candelaria. New York: Palgrave, 2009. 212–18.

Blackford, Russell. "Greg Egan." *A Companion to Science Fiction*. Ed. David Seed. Malden: Blackwell, 2005. 441–51.

Cohen, Joel E. "A Mindful Beauty: What Poetry and Applied Mathematics Have in Common." *The American Scholar.org*. The American Scholar, Autumn 2009. Web. 4 June 2010.

Doxiadis, Apostolos, and Christos H. Papadimtriou. *Logicomix*. New York: Bloomsbury, 2009.

Dyson, Freeman J. "Introduction." *Mathematics as Metaphor: Selected Essays of Yuri I. Manin*. By Yuri I. Manin. Providence: AMS, 2007. vii–xi.

Easterbrook, Neil. "Identity." *The Greenwood Encyclopedia of Science Fiction and Fantasy*. Ed. Gary Westfahl. Vol. 1. Westport: Greenwood, 2005. 409–11.

Egan, Greg. "Dark Integers." 2007. *Dark Integers and Other Stories*. Burton, MI: Subterranean, 2008. 103–48.

_____. *Incandescence*. San Francisco: Night Shade, 2008.

_____. "*Incandescence*: Deriving the Simplest Geometry." *Greg Egan's Homepage*. Greg Egan, 3 April 2009. Web. 10 July 2009.

_____. "The Infinite Assassin." 1991. *Axiomatic*. New York: HarperPrism, 1995. 1–16.

_____. Interview by Renai LeMay. "Greg Egan: The Big Interview." *Keeping the Door*. LeMay and Galt Media, 30 Oct. 2009. Web. 30 May 2010.

_____. "Introduction." *Dark Integers and Other Stories*. Burton, MI: Subterranean, 2008. 7–11.

_____. "Luminous." 1995. *Dark Integers and Other Stories*. Burton, MI: Subterranean, 2008. 13–49.

_____. "Only Connect." *Greg Egan's Homepage*. Greg Egan, 9 Aug 2000. Web. 15 Nov 2010.

_____. "*Incandescence*: Orbits and Tidal Acceleration." *Greg Egan's Homepage*. Greg Egan, 12 Jan 2008. Web. 26 May 2010.

_____. "The Planck Dive." *Luminous*. London: Orion, 1998. 290–327.

_____. *Schild's Ladder*. 2002. New York: Eos, 2004.

_____. "Singleton." 2002. *Crystal Nights and Other Stories*. Burton, MI: Subterranean, 2009. 133–85.

Hall, Donald E. *Subjectivity*. New York: Routledge, 2004.

Kheyfets, Arkady, Warner Miller, and Gregory A. Newton. "Schild's Ladder Parallel Transport Procedure for an Arbitrary Connection." *International Journal of Theoretical Physics* 39.12 (December 2000): 2891–98.

Lakoff, George, and Rafael Núñez. *Where Mathematics Comes From: How the Embodied Mind Brings Mathematics into Being*. New York: Basic, 2000.

Landon, Brooks. *Science Fiction After 1900: From the Steam Man to the Stars*. 1997. New York: Routledge, 2002.

Luckhurst, Roger. *Science Fiction*. Malden: Polity, 2005.

Misner, C. W., Kip Thorne, and J. A. Wheeler. *Gravitation*. 3rd ed. New York: Freeman, 1973.

Murphy, Graham J. "Greg Egan." *Fifty Key Figures in Science Fiction*. Ed. Mark Bould, et al. New York: Routledge, 2009. 76–81.

Núñez, Rafael. "Conceptual Metaphor, Human Cognition, and the Nature of Mathematics." *Cambridge Handbook to Metaphor and Thought*. Ed. Raymond W. Gibbs, Jr. New York: Cambridge University Press, 2008. 339–62.

Stross, Charles. *Accelerando*. New York: Ace, 2005.

Tasić, Vladimir. *Mathematics and the Roots of Postmodern Thought*. New York: Oxford University Press, 2001.

Vinge, Vernor. "Technological Singularity." *Whole Earth Review* Winter 1993: 81–88.

Truth by the Numbers

Mysticism and Madness in Darren Aronofsky's π

Laurie A. Finke *and* Martin B. Shichtman

The original shooting script for Darren Aronofsky's 1998 film π begins, like the film, with a voiceover. However, this script includes the following analogy, which is not included in the actual film. Aronofsky's protagonist, Max Cohen (Sean Gullette), intones portentously, "The alchemist awakes.... 'Turn lead into gold, Max, lead into gold.' Today, I find it." Max's analogy between his mathematical research on stock market fluctuations and the alchemist's goal of turning lead to gold, while never overtly mentioned in its final cut, structures the film's narrative and establishes (perhaps too obviously) its connections between mathematics, on the one hand, and magic, mysticism, and religion on the other. Aronofsky's fable about a Jewish prodigy intent on uncovering the mathematical secrets beneath the chaos of nature harkens back to Paul Wegener's 1920 silent horror film, *Der Golem*, in which Rabbi Loew (Albert Steinrück) must call upon magic and necromancy to discover the secret of life and so animate his clay monster to protect his community from the threat of anti–Semitic violence.[1] When, in a parody of the Genesis myth, the rabbi summons "the powers of darkness" in the form of the demon Astaroth in order to reveal the "magic word" that will bring the Golem (Paul Wegener) to life, we are given a glimpse of the mystical moment in which images, things, and words coincide, when "the word becomes flesh," a mythical moment of pure signification. In the film, the sacred word that Rabbi Loew must compel from a demon —*AEMAET*, the Hebrew word for "Truth"— is equated with the life-giving name of God. In π, Cohen ponders such a moment of pure signification when a string of 216 numbers — spewed out by his computer in a climactic burst — is believed to produce the letters forming the name of God, and unlocking the secrets of life, the universe, and everything. A numerical journey that begins as an exercise in stock-picking takes Cohen on a detour through Kabbalistic Judaism,[2] and leads him to imagine a point of absolute clarity, a visionary moment in which he finds himself Divinely chosen to understand that nothing is arbitrary, nothing coincidental, that meaning resides everywhere, if only we have the omniscience to discern it. But even as it holds out such a dream of realizing absolute presence, certainty, Truth, Aronofsky's film also takes it away, filling the audience with deconstructive doubt, realizing π's tagline: "There will be no order, only chaos."

This essay considers the implications of the film's quixotic search for absolute presence. At stake in the film is the fantasy that God or nature are fully present in numbers, that we understand our universe to be chaotic only because we lack the sufficient mathematical skill (or a sufficiently powerful computer) to enable us to see the "big picture." The film raises a number of fascinating questions about the relationships among mathematics, theology, and madness. Is the desire to describe nature — to comprehend the truth about nature — finally ontotheological? Does it necessarily lead to religious mysticism and numerology?[3] Or does it lead only to madness? The film suggests the possibility that logocentrism, the term the philosopher Jacques Derrida uses to describe the search for a truth that can ground reality and guarantee meaning, amounts either to religious mysticism or paranoid delusion. In the end, Max's belief that everything can be explained produces monstrosity, as Rabbi Loew does in creating his golem. But for Max, the mathematician, monstrosity takes the form of the ghost in the machine, the spectral (and thus absent) presence that hovers just out of reach.

The film's fantasy of full presence is undercut by the portrayal of its hero, Cohen, who is touched by genius, but also by paranoia. π struggles to create a convincing performance of mathematical brilliance. Sol Robeson (Mark Margolis), Max's mentor, calls him his "greatest pupil. Published at 16, Ph.D. at 20."[4] Marcy Dawson (Pamela Hart), a partner with the predictive strategy firm Lancet-Percy — a Wall Street company advertising "86% Accuracy ... (Only God is Perfect)" — tells Cohen, "I've studied your papers for years." Lenny Meyer (Ben Shenkman), a New York City Kabbalist searching for the name of God, tells him: "Your work's revolutionary, you know that? It's inspired the work that we do.... The only difference is we're not looking at the stock market.... We're searching for a pattern in the Torah." But the exact nature of Cohen's brilliance is never disclosed in the film. Why do so many people admire his work? What has he produced? Instead of clarifying this, Aronofsky provides Cohen with clichéd performances of mathematical genius. Cohen performs mathematical parlor tricks for a neighbor child, solving in his head complex multiplication and division problems more quickly than her handheld calculator. He offers simple — and simplistic — explanations of the golden ratio and the Fibonacci numbers.[5] For the movie's audience, Cohen's genius seems to be marked more by his obsessive character and his general emotional instability — signs that are associated with mathematical genius in films like Barry Levinson's *Rain Man* (1988), Gus Van Sant's *Good Will Hunting* (1997), and Ron Howard's *A Beautiful Mind* (2001) — than by anything even remotely resembling mathematical work. We might well wonder why paranoia so often marks cinematic representations of mathematicians. Jerry Aline Flieger argues that paranoia haunts postmodern narratives, the result of their rejection of the master narratives of the Enlightenment, including that of scientific rationality. Science fiction writers have long been interested in moments when scientific rationality shades over into paranoid delusions that construct a "fantasmatic persecutor who has arranged a system undermining the apparent Symbolic order, belying 'reality' as it appears to the rest of the world, but accounting for everything in it" (Flieger 90). What is the relationship of paranoia to systems of knowledge that purport to explain the world to us? Postmodern doubt calls into question as paranoid the belief Max expresses that numbers can accurately describe everything or that *every* collection of numbers must necessarily describe some kind of pattern, some thing in nature.[6]

However, we are not as interested in π's representation of the mathematician and his

madness as we are in what Elizabeth Klaver calls the "performance of mathematics." Like her, we are "concerned with the question of whether an abstract subject like mathematics can be represented in … performance genres" like film (6). In this essay we focus on the film's imbrications of mathematics and religion, science and theology, connections established in the film's subtitle, "Faith in Chaos," and realized through what Aronofsky calls his "hip hop" technique of sampling shots and then connecting them through repeated montages (see his commentary on the π DVD). The postmodern text, Flieger reminds us, "is iterative, driven by the compulsion to repeat, obsessed with citation and recursive narrative" (89). The Derridean concept of *différance*, which describes how signification is deferred along a chain of signifiers,[7] emerges from this shuffling of the paradigmatic relations among the shots, a deconstructive technique that consistently undermines, even more than Max's paranoia, the film's promise of mathematical truth.

Aronofsky establishes this narrative structure of iterative sequencing in two opening voiceovers.[8] In the first, the original script's alchemy metaphor has been replaced with an explanation of a childhood trauma; Max states:

> When I was a little kid, my mother told me not to stare into the sun. So once, when I was six, I did. The doctors didn't know if my eyes would ever heal…. Slowly, daylight crept in through the bandages and I could see, but something else had changed inside me. That day I had my first headache.

The anecdote, repeated at key moments in the film, provides a *point de capiton*,[9] or quilting point, that knits together the film's Hebraic and Hellenic theological strands, pointing us toward two cultural mythologies that parse both the origins and consequences of knowledge, including mathematical knowledge. Max's childhood curiosity points to the moment in Genesis when chaos is brought under the influence of the sign, when God delivers perfect signification, the Word(s) — *Logos* in the Greek Gospel of St. John — that both are God and impose His will on darkness and chaos:

> 1. In the beginning God created the heaven and the earth.
> 2. And the earth was without form, and void; and darkness was upon the face of the deep. And the Spirit of God moved upon the face of the waters.
> 3. And God said, Let there be light: and there was light.
> 4. And God saw the light, that it was good… [Gen. 1.1–4].

Max's story establishes that his relentless quest for knowledge, for which he is willing to endure any manner of suffering, is not motivated by the desire to know but rather created by the interdiction *not* to look, *not* to know. The interdiction links Max's narrative not only with Adam and Eve's first disobedience in Genesis, but also to the Greek myth of Icarus, a story referenced by Max's mentor Sol later in the film. Sol tells Max that he named his new fish "Icarus, after you, my renegade pupil. You fly too high, you'll get burnt," referring to the son of Daedalus who, as a result of ignoring his father's warnings, burned and crashed. Sol too has been burnt. Is it too obvious to note that Sol's name means "sun"? That he, in fact, has a sun tattooed on his hand? That he has searched for patterns in the digits of the number π for forty years, with only a stroke to show for it? Cohen's insatiable desire to see the truth behind the universe's source of light, which Sol articulates mythologically, points, we think, to the film's performance of mathematics as a branch of theology. "[L]ife isn't just mathematics, Max," Sol tells him, offering yet another interdiction that will fuel his curiosity.

Like Adam and Icarus, Max suffers, and suffers inordinately, in his frustrated quest for understanding of the deep mathematical structures that will allow him to glimpse Truth. The film's stylistic features — its soundscape, awkward handheld camera angles, subjective point of view, grainy black and white reversal film, and jump cuts — simulate for the audience the torture of Max's headaches. Max self-medicates with pills and injections, all the while longing for a mathematical Holy Grail that will remove the veil of signification. However, if defying the interdiction against knowing brings suffering, Max suggests it also brings knowledge (although we are never told what knowledge it affords). In one of the repetitions of his childhood trauma, Cohen describes his experience of enlightenment, a position of mystical transcendence:

> When I was a little kid, my mother told me not to stare into the sun. So once, when I was six, I did. At first the brightness was overwhelming but I had seen that before, I kept looking, forcing myself not to blink. And then the brightness began to dissolve. My pupils shrank to pinholes and *everything* came into focus. And for a moment I understood.

Such knowledge, if ever really achieved — and the film does much to cast doubt on Cohen's revelations — is short-lived, barely remembered. The ghostly glimpse of Truth slips away, leaving behind, along with headaches and pain that cannot be managed, only yearning for a subsequent revelation that will explain everything, that will realize the promise of full presence that is the dream of Western metaphysics. But can Cohen find, in a computer printout, "Truth," the name of God, or is he finally just paranoid? Incapable of comprehending what Cohen believes he has uncovered, are we even equipped to tell the difference? Like that of its intertext, *Der Golem*, π's logocentric desire is at every point blocked, undercut by the proliferation of signifiers and their specters with results that are both violent and unsettling.

In the film's second voiceover, through which Aronofsky completes the opening sequence (a sequence repeated at key points in the film), Max "restates" (the word is crucial) the set of assumptions that guides his mathematical research: "Restate my assumptions. One: Mathematics is the language of Nature. Two: Everything around us can be represented and understood through numbers. Three: If you graph the numbers of any system, patterns emerge. Therefore, there are patterns everywhere in nature." These are unexceptional axioms, easily accepted not only by practicing mathematicians, but by casual consumers of mass culture (presumably the film's audience). That Max sees mathematical patterns everywhere in nature — in the "cycling of disease epidemics, the wax and wane of caribou populations, sunspot cycles, the rise and fall of the Nile" — at this point in the film seems a fairly innocuous invocation of James Gleick's *Chaos: Making a New Science*, the 1987 book that chronicled for popular audiences the emergence of "chaos theory," the research paradigm that aims to identify the seemingly random patterns that characterize many natural phenomena.

Max organizes his thoughts loosely in the form of a mathematical proof. Notes Klaver, "The three assumptions of π act as axioms in a manner similar to the axioms of mathematics which are undemonstrated propositions" (10). Cohen's assumptions seem to echo Einstein's certitude about the mathematical orderliness of the universe ("I, at any rate, am convinced that *He* is not playing at dice"), but whereas Einstein offers caveats ("Quantum mechanics is certainly imposing. But an inner voice tells me that it is not yet the real thing. The theory says a lot, but does not really bring us any closer to the secret of the 'old one'"[10]), Max

expresses an assurance that God can be found in numbers, and that harnessing mathematical knowledge offers one a kind of omniscience — chaos is always brought under the control of the sign. In this belief, Max approaches the certainty of the mystic who "seeks to apprehend the intrinsic elements of God and His creation [that is, Einstein's "secrets of the old one"] even though they are beyond the grasp of the intellect."[11] Max comes to believe that, as written in the eighteenth-century Ba'al Shem Tov commentary on Genesis 6:17 (which might serve as an inspiration for *Der Golem*), "[o]ne must pronounce every syllable because in every letter there are worlds, souls, and divine presence. They ascend and unite with the Divine, where the letters connect to form each word and unite to bring together true unities in the Divine."[12]

The fact that Max posits a simple correspondence between mathematical notation and nature (between signifier and signified or sign and referent) as axiomatic suggests mathematics' fundamental logocentrism, a condition it shares with religion. Western philosophy, including both mathematics and religion, as Derrida argues, has been

> committed to the belief in some ultimate "word," presence, essence, truth or reality which will act as the foundation of all our thought, language and experience. It has yearned for the sign which will give meaning to all others — the transcendental signifier — and for the anchoring, unquestionable meaning to which all our signs can be seen to point (the "transcendental signified") [Eagleton 113].

God, nature, truth, and mathematics have all at various times been conceived as transcendental signifieds that lay the foundation for a metaphysics of presence purporting to grant individuals immediate access to meaning. Rightly or wrongly, Max seeks this metaphysics of presence through the science of mathematics; his assumptions articulate a quest for the deep structures that govern and give meaning to all of existence — in effect, the key to creation. In his critique of this metaphysics of presence, however, Derrida's analysis attempts to describe a "rupture" in the concept of structure itself ("Structure, Sign and Play" 247). Structure, Derrida remarks,

> has always been neutralized or reduced, and this by a process of giving it a center or of referring it to a point of presence, a fixed origin. The function of this center was not only to orient, balance, and organize the structure — one cannot in fact conceive of an unorganized structure — but above all to make sure that the organizing principle of the structure would limit what we might call the *play* of the structure ["Structure, Sign and Play" 247; emphasis in original].

This center "constitute[s] that very thing within a structure which governs the structure, while escaping structurality" (248). Derrida argues that the idea of a center that is "paradoxically, *within* the structure and *outside* it," a center that is not a center, a "coherence in contradiction," expresses "the force of a desire" to master anxiety by closing off the freeplay that the structure makes possible and creating a "reassuring certitude" (248). ("Play" in this context carries the meaning both of pleasurable activity and of freedom of movement.) Consider: in theology, God, the architect of Creation, who is both immanent in it and at the same time outside it; in literature, the author who limits the freeplay of meaning in the text and yet is not in it; in mathematics, π, the mathematical constant that expresses the ratio of a circle's circumference to its diameter, constitutive of the center while remaining transcendent, whose function in "centering" the Euclidean geometry of the circle cannot constrain the proliferation of its own digits.[13]

We might begin to describe how the film deconstructs Max's dream of absolute presence

and totality by teasing apart Max's choice of the word "restate" in articulating his assumptions. He suppresses the ambiguity in the word, which can mean both "repetition" and "revision." Each time Max "restates" his assumptions the audience is led to believe that he might be emending them; yet each time he repeats the same words unchanged. However, although the words are identical each time they are invoked, they are also different if only through the mere fact of being iterated in a different context. The word "restate" is locked, simultaneously, into two meanings that cannot be pulled apart. Its oppositional meanings hinge on the non-difference of repetition and revision. Aronofsky repeats this gesture in his shots. In the opening sequence, when Max reaches his conclusion ("Therefore, there are patterns everywhere in nature") Aronofsky cuts to a shot of a tree, the juxtaposition suggesting that nature will yield up its secrets to mathematics. Yet each time Aronofsky uses this shot in the film (which he does with some frequency), he varies the film speed, creating subtle differences in the audience's perception of the tree, reminding us that pictures of trees are not trees and that repetition always carries with it revision, as well as calling our attention to the non-difference of both iconic and linguistic signs.

The film explores the relationships among mathematical symbols (signifiers) and the concepts (signifieds) and natural world (referent) that notation is supposed to represent. To understand the film's performance of mathematics, we must unpack all of these key terms: *signifiers, signifieds, referents, representation.* Does mathematical notation work in the same way as linguistic signs (in which the connection between signifier and signified is arbitrary) or does it have a special relationship to that which it represents that linguistic signs do not (in C. S. Peirce's scheme, mathematical signs would then be iconic or indexical)?[14] If the latter is true, when does this special connection shade over from mathematics to numerology? The film needs to convince its audience that Max Cohen is a mathematical prodigy but still provide us with mathematical signifiers that even a non-mathematician can comprehend. This presents us with an opportunity to explore how mathematical notation signifies. Let us look at a simple scene. After visiting his mentor Sol, Max rides home on the subway.[15] His voiceover reiterates his belief in the power of mathematics not just to encode but to offer a privileged access to nature; however, his need to rely on notation to make his point belies the belief:

> Personal note. Sol died a little when he stopped research on π. It wasn't just the stroke. He stopped caring. How could he stop when he was so close to seeing π for what it really is? How could you stop believing that there is a pattern, an ordered shape behind those numbers, when you were so close? We see the simplicity of the circle, we see the maddening complexity of the endless string of numbers, 3.14 off into infinity....

The voiceover plays as the camera cuts to a shot of Max drawing on the stock market pages of a newspaper. He draws first a circle; then a point representing the circle's center; then a radius of the circle; and then the letters "*C*" (representing the circle's circumference) and "*A*" (representing the circle's area). Beneath the circle he writes the formulae for its area and circumference, easily remembered by almost everyone who has taken high school geometry: $A = \pi r^2$ and $C = 2\pi r$.[16] Finally, he begins writing out π's decimal representation: π = 3.14159.... In just this brief sequence, the concepts (or signifieds) of a circle's area and circumference slide along a chain of signifiers: the representation of a circle and its center and radius, the letters *r*, *A*, and *C*, the formulae $A = \pi r^2$ and $C = 2\pi r$ (including the Greek symbol π), and the number 3.141592 (a truncated version of π's decimal representation).

While Max's voiceover suggests that Sol was maddeningly close to finding a pattern in the sequence of π's digits, he simultaneously demonstrates how mathematical notation behaves like metonymy, the literary trope that describes the deferral of signification along a chain of signifiers (Presmeg 26)[17]: rather than simply pointing unproblematically to something in nature (a referent), these various signifiers — in the form of symbols, numbers, letters, diagrams, and graphs — combine in various paradigmatic and syntagmatic relationships[18] to create meaning that never quite coincides with nature, with things in the world. If Sol had proven there was a pattern in π's digits, would the function of π in mathematics really change all that much? Doesn't π work more or less well enough even if its meaning can't be fully deciphered? What seems to nag at Max is not that π doesn't describe nature or that it doesn't "work," but rather the disparity between "the simplicity of the circle" and "the maddening complexity of the endless string of numbers." It seems to offend his sensibilities that a number whose digits are seemingly chaotic should produce simplicity and elegance, since the goal of much science (and structuralism in the human sciences) is usually to show that what appears to be complex or chaotic can be reduced to simple and elegant underlying patterns. Even this brief sequence deconstructs any naive belief in a simple correspondence between mathematical notation and objects. "Deconstruction," observes Geoffrey Bennington, "does not have a place for language over here, a world over there to which it refers. Elements in the language refer to one another for their identity, and refer to nonlinguistic marks which refer in turn to their identity and difference" (quoted in Royle 7). The neuroscientist Terrence W. Deacon makes much the same point in *The Symbolic Species*: "The correspondence between words and objects is a secondary relationship, subordinate to a web of associative relationships of a quite different sort, which even allows us reference" to things that do not exist in nature (70).

While philosophers frequently describe mathematics' ability to endow the world with meaning, seeing in it, as Derrida notes "the exemplary model of scientificity" (Derrida, *Grammatology* 27), we might pause to consider whether or to what extent mathematicians make such claims. Bertrand Russell, in *Reflections on my Eightieth Birthday*, expresses an almost religious faith in the truth of mathematics: "I wanted certainty in the kind of way in which people want religious faith. I thought that certainty is more likely to be found in mathematics than elsewhere.... Mathematics is, I believe, the chief source of the belief in eternal and exact truth..." (quoted in Harris 967). Michael Harris, however, cites the philosopher of mathematics David Corfield to suggest that mathematics may be more performative than strictly mimetic; rather than pointing toward "eternal and exact truth," it is creative, generative. Corfield suggests that mathematicians may be less interested in questions like "How should we talk about mathematical truth? Do mathematical terms or statements refer? If so, what are the referents and how do we have access to them?" than in those such as "How does mathematical knowledge grow? What is mathematical progress? What makes some mathematical ideas (or theories) better than others? What is mathematical explanation?" (971). He goes on, "What mathematicians are largely looking for from each other's proofs are new concepts, techniques, and interpretations" rather than merely "the truth or correctness of propositions" (971).

The representation of mathematical notation throughout the film expresses the desire to discover the truth of nature and at the same time it falls back on metonymic relationships that defer both signification and reference. In his second meeting with the Hasidic Jew

Lenny, Max introduces another mathematical object which arises mysteriously in nature: the Fibonacci sequence. This sequence of numbers begins with the numbers 1, 1 (or sometimes with 0,1); each subsequent number in the sequence is then the sum of the previous two. (In other words, the Fibonacci sequence is the ordered list of numbers 1, 1, 2, 3, 5, 8, ...) Max links this sequence to Lenny's explanation of *gemetria*, a Kabbalistic system of numerology in which letters of the Hebrew alphabet are assigned numerical values.

> LENNY: The [Hebrew] word for the Garden of Eden, *Kadem*. Numerical translation: 144. Now the value of Tree of Knowledge, alright, in the garden, right, *Aat Ha Haim*, 233. 144, 233. Now you can take those numbers...
> MAX: The Fibonacci numbers ... you know, like the Fibonacci sequence? Fibonacci's, uh, an Italian mathematician in the thirteenth century. If you divide 144 into 233, the result approaches, um, theta ... the Greek symbol for the golden ratio [another important mathematical constant], the golden spiral.[19]

Once again, during this sequence both Lenny and Max are using writing, symbols, for their demonstrations, and once again the exchange sets off another metonymical chain of signifiers: Hebrew letters slide into numbers which correspond to the Fibonacci sequence, which leads to the golden ratio and the Greek letter θ, which in turn produces a golden spiral (a spiral whose growth factor is related to the golden ratio), which gives rise to a golden rectangle (a rectangle whose ratio of length to width is the golden ratio)—which can, for instance, be found, Max tells us, in the works of Leonardo da Vinci (who "penciled it into his masterpieces") as well as in nature.

The film thus presents us with two conceptions of mathematical notation that work at cross-purposes in the narrative. One stresses a profound, even mystic, connection between numbers and nature. "Pythagoras loved [the golden spiral] for he found it everywhere in nature: the nautilus shell, rams' horns, whirlpools, tornadoes, our fingerprints, our DNA, and even our Milky Way." Aronofsky frequently intercuts shots of the natural world (trees, galaxies, DNA strands, shells, waves on the shore) with shots of mathematical notation which, through juxtaposition (ironically another form of metonymy), suggest nature's conformity to mathematical principles. But in its proliferation of signifiers the film also deconstructs this belief, suggesting that meaning rests not in a simple one-to-one relationship between mathematical notation and nature, but in the complex relationships of *différance* among many signifiers.

The film's deconstruction of mathematical signification also illustrates Derrida's notion of the *supplément*,[20] suggesting the "dangerous supplementarity" of mathematical notation, in which the addition of something points to the lack at the center of what was thought to be complete in and of itself.

> What we have tried to show in following the connecting thread of the "dangerous supplement," is that ... there has never been anything but writing, there have never been anything but supplements and substitutional significations which could only arise in a chain of differential references. The "real" supervenes or is added only in taking meaning from a trace or an invocation of supplements [*un appel de supplement*]. And so on indefinitely, for we have read *in the text* that the absolute present, Nature, ... ha[s] always already escaped, ha[s] never existed; that what inaugurates meaning and language is writing as the disappearance of natural presence [*Grammatology* 158–59].

It is worth noting, however, that for Derrida reading Rousseau in *Grammatology* (144–57) the "dangerous supplement" refers *both* to writing (notation) and to auto-affection, masturbation;

that is, both are perverse additions which we want to believe leave untouched "normal" speech or sexuality (Nature), but which, because they substitute for speech or sexuality in the absence of an other, might well be necessary extensions (supplements) that finally supplant "normal" speech or sexuality (the other would be present even in absentia; Rousseau worries that unless children are prevented from masturbating, they might never marry).

This raises an interesting question. Is Max just "wanking off" in the film? What is he doing as he sits alone in his apartment, obsessively playing with his computer and listening to his neighbor and her boyfriend have intercourse? What is the relationship between auto-affection and Max's discovery of the 216-digit number? When confronted by the Hasidic Rabbi Cohen and his lot, Max says: "The number is nothing. It's the meaning, the syntax. It's what's between the numbers." Max's "revelation," his flash of insight into creation, then, is endlessly deferred by the film's proliferation of mathematical signifiers that continually supplement and so call into question the completeness of any revelation, any creation. Like writing, like auto-affection, artificial intelligence is a dangerous supplement.

We note that despite Cohen's insistence that "[e]verything around us can be represented and understood through numbers," he seems more interested in the numbers than in the "everything" they represent. Nevertheless, even as he believes that a passionless study of the signifier can perfectly explain the signified, Cohen offers himself up to a rhetoric indicating otherwise. His description of the workings of Wall Street, for instance, is filled with wonder and awe:

> So what about the stock market? The universe of numbers that represents the global economy, millions of human hands at work, billions of minds, a vast network screaming with life, an organism, a natural organism. My hypothesis is: within the stock market there is a pattern as well, right in front of me, hiding behind the numbers. Always has been.

He wants to know about the "life force" of the stock market, yet berates Wall Streeter Dawson for her interest in capital: "I'm not interested in your money! I'm looking for a way to understand our world. I don't deal with petty materialists like you!" What does Max mean when he identifies the stock market as "a vast network screaming with life, an organism, a natural organism"? For Max, the stock market is an event, a happening, the result of intentional human activity. However, as a network, the stock market seems an automaton, a machine (operated by human hands as if those hands were divorced from human bodies) based in iterability and inscription. The machine, according to Derrida, "is destined ... to reproduce impassively, imperceptibly, without organ or organicity, the received commands. In a state of anaesthesis, it would obey or command a calculable program without affect or auto-affection, like an indifferent automaton" ("Typewriter Ribbon" 73). Max is able to see in the stock market both "what is happening (we call that an event) and the calculable programming of an automatic repetition (we call that a machine)" ("Typewriter Ribbon" 72).[21] Max's goal is to discover "life" in that machine, and, in doing so, "in a single gesture" join

> the thinking of the event to the thinking of the machine.... For that, it would be necessary in the future (but there will be no future except on this condition) to think both the event and the machine as two compatible or even in-dissociable concepts. Today they appear to us to be antinomic ["Typewriter Ribbon" 72].

The concepts appear to us to be antinomic because they contrast the singular, living, organic and non-repeatable "event" with the machine — with repetition, inscription, the inorganic.

But like Rabbi Loew, Max, in imitation of God, has perhaps touched on the formula that brings life to inert matter.

As we noted earlier, Max Cohen's performance of mathematics seems to vacillate between savant trivia and intellectual hubris, between childish game and the belief that he, like Rabbi Loew of *Der Golem*, can imitate the paradigmatic act of creation. If Max Cohen's genius resides anywhere in π, however, it is in his creation of Euclid, a computer that brings him as close as he gets to the perfect signification of his fantasies. Named after the "Father of Geometry," Euclid is a disorderly *bricolage*[22] of dated machine parts that takes up most of Cohen's apartment:

> The room is knee-high in computer parts of all shapes and sizes. The walls are covered with circuit boards. Cables hang from the ceiling like vines in a Brazilian rain forest. They all seem to be wired together forming a monstrous homemade computer.
>
> This is EUCLID, Max's creation. The computer is alive with sounds and lights [original shooting script].

Aronofsky's description of the machine invokes the Golem: it is a "monstrous ... creation," "alive." Cohen has been living with this machine and living for it; its presence consumes him: "He cares for the machine as if it were his dream car" (original shooting script). In the retro chaos of his apartment — Max Cohen may possess the only rotary phone remaining in the entire city of New York — Euclid promises, though never quite delivers, silicon order, just as Max imagines mathematics promises, but never quite delivers, revelation of the underlying patterns of the world.

For one brief, shining moment, Euclid smoothes over this antinomy, springing to life, and producing a string of about two hundred numbers; it is never clear if this is really the 216-digit number that is being sought by nearly everyone in the film, or if it just some approximation of that number. Then Euclid short-circuits, leaving behind a printout, several perfect stock picks, and lots of greasy ooze. Confused — but somehow also aware that his machine has simultaneously achieved sensation and also run amok — Cohen destroys the evidence, tossing the printout in a park garbage can. He calls on his mentor, who tells him that "certain problems cause computers to get stuck in a particular loop; the loop leads to meltdown. But just before the crash, they become aware of their own structure; the computer has a sense of its own silicon nature and it prints out its ingredients." Cohen asks, incredulously, "The computer becomes conscious?" and Sol replies, "In some ways, I guess." The sudden spontaneity exhibited by the computer in its death throes weds the organic — perhaps indicated by the ooze that Euclid excretes, which Max examines with his microscope — and the machine, which produces an inscription: the enigmatic numeric string. This sequence of numbers is so imbued with potential meaning that it seems to realize Derrida's prediction that through the conjuncture of the singular event and mechanical repetition "one [will] have produced a new logic, an unheard of conceptual form." However, "against the background and at the horizon of our present possibilities, this new figure would resemble a monster" ("Typewriter Ribbon" 74).

It may not, however, be the suddenly self-aware machine, realizing life at the very moment of its demise, that is the monster here. Rather, monstrosity may reside somewhere in the awkwardness of such an uncertain relationship between organism and machine, in the possibility that the distinction between organism and machine no longer holds up. For even as the rabbi, the mathematician, the scientist, the artist, and, perhaps, the filmmaker

move towards the perfect logocentric gesture, imitating the paradigmatic moment of creation in speaking life into existence, making the word flesh, their efforts deconstruct. Instead of finding Truth, order, perfection, there is only chaos. In his epigraph to *Simulacra and Simulation*, Jean Baudrillard claims to quote Ecclesiastes: "The simulacrum is never that which conceals the truth — it is the truth which conceals that there is none. The simulacrum is true."[23] The horror of artificial intelligence is not that a machine takes on qualities of organisms, of the living, but that it calls life itself into question; it is a dangerous supplement to life itself. This is the horror that disturbs, for instance, Rick Deckard, the bounty hunter of Philip K. Dick's "Do Androids Dream of Electric Sheep," who in his encounters with "replicants," with the artificially intelligent, becomes less and less certain of his own humanity. Max Cohen has discovered, in Euclid's printout, not the answer to everything, but the truth of the simulacrum, the fact that he is on a hopeless quest doomed to end in failure and frustration. He cannot locate "absolute present, Nature" because such presence has "always already escaped," "never existed" (*Grammatology* 158–59).

Cohen desires to stabilize the sign, to find the patterns that give meaning to "the stock market ... [t]he universe of numbers that represents the global economy, millions of human hands at work, billions of minds...," to subordinate this "vast network screaming with life, an organism, a natural organism" to the authority of the machine in order to uncover the repetitions that suggest the machine-ness of the organism. What he gets instead is the organic nature of the machine, Euclid. Even as he encases Euclid's operating system in glass, even as he puts on a surgical mask when working on Euclid — to maintain, it would seem, an environment of purity, of sterility — ants contaminate the field. Is Euclid's demise the result of a power surge — as Cohen surmises, and which he attempts to address by equipping Euclid with a more powerful motherboard chip — or is it bugs, the real kind, crawling into, invading the system? Has Cohen missed the irony that Euclid's "life" comes into being only at its very moment of death, and that its output — the 200-some digit sequence, its "sense of its own silicon nature" — is incomplete? Lancet-Percy's attempt to profit from this number ends in failure, leading Marcy Dawson to complain to Cohen that "[y]ou gave us faulty information. Oh, you dangled the carrot, the right picks, but then you only gave us part of the code." Both Max and his shadowy pursuers want to believe that the full 216-digit version of the code, derived from Cohen's revived, amped-up machine and held in Cohen's memory, offers the key to stabilized signification. Max alternately claims "I've got it! I've *got* it! And I *understand* it. And I'm going to *see* it!"[24] and, dismissing Rabbi Cohen's life's work, "[i]t's just a number. I'm sure you've written down every 216-digit number, you've translated all of them. You've intoned them all. Haven't you? What's it gotten you? ... If you haven't understood it, it's because it's not *for* you."

In reconceiving the relationship between the event and the machine, Derrida wishes "to give up neither the event nor the machine, to subordinate neither one to the other, neither to reduce one to the other" ("Typewriter Ribbon" 74). He attempts to define a relation "in which the elements are internal to one another and yet remain heterogeneous. Derrida's famous term '*différance*' ... refers to this relation in which machine-like repeatability is internal to irreplaceable singularity and yet the two remain heterogeneous to one another" (Lawler). Throughout π, Max Cohen chases a number sequence which is apparently hidden away, forbidden. Aronofsky's film holds out the possibilities that such a number approaches perfection, mystically invoking the Divine, but constantly undercuts the assertion by sug-

gesting that the number may be utter gibberish. It appears that, at the end of Max Cohen's journey, there is only *différance*.

In the end, Max's creation is not like Wegener's Golem, a hulking clay monster run amok; rather, it is the ghost in the machine, the ghost that haunts all signification. The Golem's acts of uncontrolled violence point to the consequences of delving too deeply into the secrets of life, the secrets of God; they serve as a vulgar reminder for us to keep our intellectual and spiritual ambitions in check. *Der Golem* suggests that it is possible to imitate the paradigmatic act of creation, but a terribly high price must be paid for doing so. Aronofsky's π, on the other hand, offers up a very different kind of monstrosity, the monstrosity of the ghost, the trace of the human. Max Cohen is haunted by the possibility of meaning, of truth. He is haunted by ghosts of signification, present absences, and absent presences in much the same way that, as Nicholas Royle argues, deconstruction concerns itself with lost traces, with the revenant:

> Deconstruction is "just visiting"; it apparitions itself everywhere. Deconstruction is a sort of ghost-effect inscribing "things themselves." "The logic of spectrality," [Derrida] remarks, is "inseparable from the very motif ... of deconstruction" [Royle, 6; Derrida, *Specters of Marx* 29, 178].

Does Max Cohen suffer because he has seen "the universe's DNA" (as the original script suggests) or because he cannot, because the universe's DNA is not there to be seen, or is present only as ghostly trace? Cohen's contentment at the film's conclusion, a contentment created at least in part by his having taken a power drill to his skull,[25] may be the result of his acceptance of *différance* and his willingness to be unmoored within the freeplay of signs.

Notes

The authors would like to thank Hannah Markley and Jessica and Elizabeth Sklar for their perceptive comments on an earlier version of this essay.

1. The connection between π and *Der Golem* is suggested by Wallis.
2. Kabbalah is the body of teachings that make up the Jewish mystical tradition.
3. "Numerology" designates any system that posits a mystical or occult relationship between numbers and physical objects or living things. In the film, this is linked to Kabbalah.
4. Throughout the rest of this essay, all dialogue is taken from the actual film, rather than from the original shooting script, unless otherwise indicated.
5. Both the golden ratio and the Fibonacci numbers are mathematical concepts which are realized in the natural world. We discuss them later in this essay.
6. In a 2005 interview, the mathematician John Nash, subject of the 2001 biopic *A Beautiful Mind*, admitted that he cannot dissociate his genius from his madness, his schizophrenia:

> I can see there's a connection between not following normal thinking and doing creative thinking. I wouldn't have had good scientific ideas if I had thought more normally. One could be very successful in life and be very normal, but if you're Van Gogh or artists like that you may be a little off.

7. Derrida's neologism plays on the fact that in French, the verb "deferrer" means both "to defer" and "to differ." See "Différance," 7. For an eminently readable and witty introduction to Derrida see Royle, *Jacques Derrida*; on the relationship of postmodern thought to mathematics, see Tasic.
8. Aronofsky shared the film's writing credits with his leading man, Sean Gullette; the two work-shopped the voiceover narratives for months before shooting began.
9. Lacan's term for the point in any signifying chain or ideological field at which "the signifier stops the otherwise endless movement of the signification" and produces the necessary illusion of fixed meaning (*Ecrits* 303).
10. On the famous 1926 exchange between Albert Einstein and Max Born, see Gilder 99–100.
11. This definition of mysticism, and Jewish mysticism in particular, was offered by Rechnitzer.

12. The reference to the Ba'al Shem Tov commentary on Gen 6:17, as well as the translation of this commentary, were offered by Rechnitzer in a presentation at Eastern Michigan University. Such a belief in the power of mathematics to channel God is also expressed in some Christian sects. Consider the Baptist school in Texas whose description of a geometry course begins:

> Students will examine the nature of God as they progress in their understanding of mathematics. Students will understand the absolute consistency of mathematical principles and know that God was the inventor of that consistency. They will see God's nature revealed in the order and precision they review foundational concepts while being able to demonstrate geometric thinking and spatial reasoning [sic] [*ABC News*].

13. To be sure, transcendental numbers have a technical definition in mathematics ("real numbers that are not roots of any polynomial with integer coefficients" [Gowers et al. 71]), but, Derrida might argue, the mathematical signifier ("transcendental") carries the trace of its *différance* from the non-mathematical sign, the sense of being constitutive of structure, simultaneously within it and outside it. According to BBC News, as of January 2010, the value of π has been calculated to nearly 2.7 trillion digits without their sequence revealing any discernible pattern or structure (Palmer).

14. In the semiotics of Peirce, an iconic sign (a picture, for instance) takes its meaning from its resemblance to its referent. While linguistic signs are arbitrary, iconic signs are supposed to be "motivated" by that which they represent. Deacon, however argues that iconic signs are no less arbitrary than linguistic signs, 74–76.

15. To save money when making this film (its budget was around $60,000), Aronofsky filmed in the subways at night without a permit. The use of such techniques is commonly referred to as "guerrilla filmmaking."

16. The authors fondly remember the excruciatingly bad schoolyard pun: "πr^2 [pi are squared]?; no, pie are round," a pun that nicely demonstrates the operations of *différance*, since the pun works only because the traces (ghosts) of both "pie" and "roundness" for English speakers are both present and absent in the formula; the pun calls attention to the ways in which the linguistic signifiers are different from and yet defer the mathematical.

17. *Metonymy* is a figure of speech in which a thing is represented not by its own name, but by the name of something intimately associated with it. For instance, in the phrase "cradle to grave," the "cradle" and "grave" stand in for "birth" and "death" respectively. Metonymy describes the operations of *différance*.

18. In Saussurean linguistics, meaning never resides in an object or referent; rather, signs take their meaning from their differences from other signs. Those differences form paradigmatic relations (relations of substitution) or syntagmatic relations (relations of association). This sliding of meaning along a chain of associations and substitutions is what Derrida means by *différance*. A case in point: in mathematics, the capital letter is never used to represent the number π, even at the beginning of a sentence, because in mathematics the uppercase letter signifies something different from its lowercase counterpart. The meaning of the lowercase Greek letter derives as much from its difference from the uppercase letter as from its referent, 3.14159

19. This may be a mathematical error in the film. The golden ratio is usually represented by either phi (φ) or tau (τ), not theta (θ). Also, the fraction $^{233}/_{144}$ doesn't *approach* anything; it is a specific number (only a sequence of numbers can approach a value). Rather, it is an *approximation* of the golden ratio. We thank Jessica Sklar for pointing out these errors.

20. Like *différance*, *supplément* is a pun that can only be seen and not heard; in French it means both to supplement (add to) and to supplant (substitute for).

21. Derrida examines this intersection of event and machine as early as "Signature, Event, Context," which he concludes with a discussion of the signature. The signature is an "event" that authorizes the signer's intentions, yet ironically we routinely cash paychecks signed by a machine without interrogating the status of that signature.

22. Derrida discusses this term in "Structure, Sign, and Play...." The *bricoleur* is a "jack-of-all-trades, someone who potters about with odds-and-ends, who puts things together out of bits and pieces" (255).

23. This is a false Biblical reference — Baudrillard calls it a "Borges-like" fabrication — in essence simulating the Word of God. On Baudrillard's epigraph to *Simulacra and Simulation*, see Christianson 261.

24. We note here the deconstructive gap between the present tense (I understand it) and the future tense (I am going to see it).

25. When asked how he pulled off the final scene of Max drilling into his brain, Aronofsky simply replies, "Sean [Gullette] is a full-on method actor. We had an ambulance waiting" (π DVD commentary).

Works Consulted

Aronofsky, Darren. "Screenplay for π." *Internet Movie Script Database*. N.p.,1996. Web. 26 July 2010.

Baudrillard, Jean. *Simulacra and Simulation*. Trans. Sheila Faria Glaser. Ann Arbor: University of Michigan Press, 1994.

The Bible. Containing the Old and New Testaments [King James Version]. New York: Family Library, 1973.

Christianson, Eric S. *Ecclesiastes through the Centuries*. Hoboken: Blackwell, 2007.

Clark, Timothy. "Deconstruction and Technology." *Deconstructions: A User's Guide*. Ed. Nicholas Royle. New York: Palgrave, 2000. 238–57.

Deacon, Terrence W. *The Symbolic Species: The Co-Evolution of Language and the Brain*. New York: Norton, 1997.

Derrida, Jacques. "Différance." *Margins of Philosophy*. Trans. Alan Bass. Chicago: University of Chicago Press, 1982. 1–27.

_____. *Of Grammatology*. Trans. Gayatri Chakravorty Spivak. Baltimore: Johns Hopkins, 1976.

_____. *Specters of Marx: The State of the Debt, the Work of Mourning, and the New International*. Ed. and trans. Peggy Kamuf. London: Routledge, 1994.

_____. "Structure, Sign, and Play in the Discourse of the Human Sciences." Ed. Richard Macksey and Eugenio Donato. *The Structuralist Controversy: The Languages of Criticism and the Sciences of Man*. Baltimore: Johns Hopkins, 1972. 247–72.

_____. "Typewriter Ribbon: Limited Ink (2)." *Without Alibi*. Ed. and trans. Peggy Kamuf. Stanford: Stanford University Press, 2002. 71–160.

Eagleton, Terry. *Literary Theory: An Introduction*. Minneapolis: University of Minnesota Press, 1983.

Flieger, Jerry Aline. "Postmodern Perspective: The Paranoid Eye." *New Literary History* 28 (1997): 87–109.

Gilder, Louisa. *The Age of Entanglement: When Quantum Physics Was Reborn*. New York: Vintage, 2009.

Gleick, James. *Chaos: Making a New Science*. Viking: Penguin, 1987.

Der Golem: wie er in die Welt kam. Dir. Carl Boese and Paul Wegener. 1920. Kino Video, 2002. DVD.

Gowers, Timothy, June Barrow-Green, and Imre Leader. *The Princeton Companion to Mathematics*. Princeton: Princeton University Press, 2008.

Harris, Michael. "'Why Mathematics?' You Might Ask." *The Princeton Companion to Mathematics*. Ed. Gowers, et al. Princeton: Princeton University Press, 2008. 966–77.

"Interview with John Nash." *Schizophrenia Daily News Blog*. Schizophrenia.com, 10 April 2005. Web. 4 August 2010.

Klaver, Elizabeth. "Proof, π, and Happy Days: The Performance of Mathematics." *Journal of the Midwest MLA* 38 (2005): 5–22.

Lacan, Jacques. *Ecrits: A Selection*. Trans. Alan Sheridan. New York: Norton, 1977.

Lawler, Leonard. "Jacques Derrida." *Stanford Encyclopedia of Philosophy*. Stanford University Center for the Study of Language and Information, 22 November 2006. Web. 26 July 2010.

Norris, Christopher. *Derrida*. Cambridge, MA: Harvard University Press, 1987.

Palmer, Jason. "Pi Calculated to 'Record Number' of Digits." *BBC News*. BBC, 6 January 2010. Web. 27 July 2010.

Paulos, John Allen. "Gift From God or Work of Man: Mathematics, Religion and Evolution in School Curricula." *ABC News*. ABC News Internet Ventures, 2 September 2007. Web. 26 July, 2010.

π: *Faith in Chaos*. Dir. Darren Aronofsky. Perf. Sean Gullette. Lions Gate, 1999. DVD.

Presmeg, Norma C. "Metaphoric and Metonymic Signification in Mathematics." *Journal of Mathematical Behavior* 17 (1998): 25–32.

Rechnitzer, Haim. "To See God in His Beauty: Hebrew Poets and Mystical Union." Eastern Michigan University. March 22, 2010.Lecture.

Royle, Nicholas, ed. *Deconstructions: A User's Guide*. New York: Palgrave, 2000.

_____. *Jacques Derrida*. London: Routledge, 2003.

Smith, Robert. "Deconstruction and Film." Ed. Nicholas Royle. *Deconstructions: A User's Guide*." New York: Palgrave, 2000.119–36.

Tasić, Vladimir. *Mathematics and the Roots of Postmodern Thought*. Oxford: Oxford University Press, 2001.

Wallis, Frieder. "Analysis of 'Pi.'" *Darren Aronofsky Online*. Nick M. and Eric G., 21 Apr. 2001. Web. 2 Sept. 2010.

Flatland in Popular Culture

LILA MARZ HARPER

Introduction

Cultural historians, looking back from a post–World War II perspective, have privileged Einstein and the impact of quantum mechanics for creating a shift in perspective that changed the very nature of how we interpret our physical world and ushered in the nuclear age. However, in the 1880s–1920s there was an earlier revolution in perception, one that resonated with the general public and prepared the way for Modernism and the Einsteinian revolution, much as Robert Chambers' earlier *Vestiges of the Natural History of Creation* (1844), which had a popular following, prepared readers for Darwin's *Origin of Species* (1859). The careful work of Joan Richards and Linda Dalrymple Henderson has called attention to the cultural history of non–Euclidean geometry. As mathematicians debated whether mathematics could or should be divorced from the observable physical world and what it meant for mathematics to be an expression of creativity in addition to being a useful tool, the concept of worlds with non–Euclidean geometries, or with a number of dimensions differing from our measurable three, inspired popular fiction and much of what today is dismissed as pseudoscience, but which, based on the knowledge of the time, was just as likely or as possible as the existence of electricity.

An indication of the impact on popular culture of consideration of higher-dimensional spaces may be found by tracing the reception, retelling, and transformation of Edwin A. Abbott's 1884 *Flatland: A Romance of Many Dimensions.*[1] A gifted classicist, Abbott used Plato's cave simile from *The Republic* as the foundation of his novel as his characters, two-dimensional geometric shapes, grapple with and resist knowledge of third, and higher, dimensions. Abbott likely intended the work to serve the dual purpose of pedagogy, introducing to the public the concept of higher dimensions, and social satire, particularly of the limited and restrictive views of British society in regards to class and gender. However, almost immediately upon publication, *Flatland*, like Plato's cave, has been successively reimagined to reflect the impact of new technological and scientific advances on current culture, while at the same time readdressing issues of gender and class. With the coming of new technologies, each era has seen new reworkings of this late Victorian fantasy that had originally been influenced by reflections on Baconian science, non–Euclidean geometry and eugenics. Additionally, each new reimagining has attempted to address the social satire

and feminist concerns contained with this mathematical fantasy/dystopia. Long before its recognition by the academic community, *Flatland* had a popular cult appeal. At the turn of the century, in *An Episode of Flatland* (1907), Charles Hinton's characters mystically reached through the now debunked aether inspired by Theosophy and by early research into electricity. The Sputnik era brought about Dionys Burger's *Sphereland* (1965), which connected *Flatland* to Einstein's revolutionary concept of space; students in A. K. Dewdney's *The Planiverse* (1984) contact a two-dimensional world via a computer screen. Recently, Rudy Rucker used Silicon Valley as the location for his *Spaceland* (2002); and Steve Tomasula's 2002 *VAS: An Opera In Flatland* contemplates eugenics and the imposition of technology on the body. Noting the growing interest in this work outside the math classroom, this article explores some of these revisions, along with newer adaptations in role-playing games, and recent computer-generated productions of *Flatland*.

Victorian Developments in Geometry

Henderson has traced the idea of a world limited to two dimensions back to Immanuel Kant's reference to the possibility of other spaces in his 1769 "On the First Grounds of the Distinction of Regions of Space," which examined the differing orientations of the right and left hand in space (Henderson 17). This analogy of "handedness" was then used by August Möbius and later writers (Henderson 18). In 1781, Kant introduced the concept of objectivity in *Critique of Pure Reason* by examining how point of view determines the experience of space (A21/B35–A29/B45). This is a major theme of *Flatland*. As Henderson notes (18), the first written discussion of two-dimensional beings who are unaware of three dimensions appears to be in Gustav Theodor Fechner's 1846 essay, "Der Raum hat vier Dimensionen" ("Space Has Four Dimensions"). Making use of Plato's cave allegory, Fechner describes a "shadow man," pointing to the relationships between two-dimensional shadows and three-dimensional solids to reach the concept of a fourth dimension. Fechner also suggests that time is related to the fourth dimension, a concept that Abbott did not incorporate in his work, but that others, particularly Charles Howard Hinton and H. G. Wells, did.

In the 1870s–1880s, British mathematicians began to debate about whether or not higher-dimensional spaces should be considered within the field of geometry (Richards 56–57). Until then, the British practice of geometry was very much based on what could be directly measured. Writing in 1869, C. M. Ingleby held that perception was essential to the understanding of space; Hermann von Helmholtz agreed in 1876, writing:

> As all our means of sense-perception extend only to space of three dimensions, and a fourth is not merely a modification of what we have but something perfectly new, we find ourselves by reason of our bodily organization quite unable to represent a fourth dimension [quoted in Richards 57].

Samuel Roberts, president of the London Mathematical Society, felt a need to try to clarify terminology and wrote, in his "Remarks on Mathematical Terminology, and the Philosophic Bearing of Recent Mathematical Speculations Concerning the Realities of Space" (1882–83), that "It is admitted, on all hands, that we can form no conception whatever of a fourth geometrical dimension" (quoted in Richards 57) and, thus, that such speculations did not belong in the study of geometry. Richards notes that, in the context of these debates, Abbott's

Flatland is "a highly original and rare movement away from [a position] in which geometrical conception legislates against higher dimensionality" (57n65), since Abbott's story casts doubt on our conception of three dimensions and questions the separation of three-dimensional space from *n*-dimensional space (where *n* is an arbitrary positive integer).

As mathematicians debated the validity of considering *n*-dimensional spaces, these ideas filtered over to literature and the arts, even leading to religious and spiritual speculation as to whether a higher power could exist in some non-perceivable space. Henderson lists references to higher dimensions in the writings of such authors as Dostoevsky, P. G. Wodehouse, H. G. Wells, Oscar Wilde, Gertrude Stein, Joseph Conrad, Ford Madox Ford, and Marcel Proust. The idea of the fourth dimension also impacted the development of modern art, influencing Cubists, Futurists, Suprematists, Dadaists, and Constructivists from 1915 to the early 1930s. The concept was discussed by Apollinaire and Marcel Duchamp and is exhibited in such works as Kazimir Malevick's (1878–1935) *Painterly Realism: Boy with Knapsack—Color Masses in the Fourth Dimension* (1915), a painting consisting of a large black square above a smaller, tilting red square: what a boy with a knapsack might look like if the child were two-dimensional and observed from above.[2] The intriguing connections of higher dimensions, abstraction, and, eventually, spirituality, are apparent as late as Salvadore Dalí's 1954 *Corpus Hypercubus*, which features the body of Christ on an "unfolded" four-dimensional cube.

Most likely, Abbott was influenced by several articles directed to a general audience that followed German geologist Wolfgang Sartorius van Waltershausen's biography of Karl Friedrich Gauss, *Gauss zum Gedächtnis* (1856), a source for many stories about Gauss that were published after his death. According to Waltershausen, Gauss spoke of creatures that could understand only two dimensions, as a way of showing, by analogy, how we, in three dimensions, could understand the concept of four or more dimensions (Henderson 18). This illustration was expanded on by Hermann von Helmholtz in his article "On the Origin and Significance of Geometrical Axioms." Another important innovator in the study of higher-dimensional spaces was Bernhard Riemann, whose methodology, on a very profound and deep level, went against the traditional way of studying mathematics, which depended on distance measurement as a means of defining space in geometry and was still closely allied to Platonic idealism (Valente, "Triangulating" 252). Gradually, a series of British articles were published, attempting to explain Riemannian geometry and the idea of higher-dimensional spaces. J. J. Sylvester, President of the British Association for the Advancement of Science, focused on the topic of the need to reform the teaching of geometry in his 1869 Address, which was reprinted in the *Nature* essay, "A Plea for the Mathematician" (1869); he called for the removal of Euclid's *Elements* as the major mathematics textbook. Further presidential addresses by William Spottiswoode (1878) and Arthur Cayley (1883) continued to support research into higher-dimensional space (Valente, "Who" 130).

As mathematicians were developing geometries (such as what later became known as *spherical* and *hyperbolic geometries*) that did not conform to all of the axioms set out in Euclid's *Elements*, public debate about the teaching of geometry ensued. Underlying the debate's pragmatic implications (the advancement process used in government and military ranks was based on exams that required a detailed knowledge of the *Elements*) was a concern with social ones: Valente observes, "Questioning the primacy of Euclidean geometry directly threatened the notion of absolute truth and precipitated a paradigmatic dilemma as unset-

tling as any attending the dissemination of evolutionary theories" ("Triangulating" 251). As Valente notes, during the 1870s "the legitimacy of new geometric theorizing and the existence of higher dimensional space were soon conflated in the public's imagination" ("Who" 130): the idea of non–Euclidean geometry became entangled with the potential existence of a mysterious (and possibly spiritual) fourth dimension (discussed more in the next section). Valente suggests that some of this conflation can be traced to attempts by Hermann von Helmholtz and William Kingdon Clifford to popularize these novel geometries to those outside the mathematics community by using a "perceptual approach to geometry" rather than the rational Platonic approach ("Who" 130). Audiences were asked to compare their "limited" perception of a fourth dimension with the challenge two-dimensional beings would face in trying to comprehend a third dimension ("Who" 130).

Victorian Philosophical Conceptions of Higher Dimensions

While the existence of higher dimensions was first proposed by mathematicians, concepts of such dimensions were shaped and interpreted in the late nineteenth and early twentieth centuries by religious groups interested in the three intertwined and contentious areas of thought that might be broadly labeled as Liberal Christianity, Spiritualism, and Theosophy. Avoiding the modern tendency toward specialization, Abbott, a model progressive Victorian pedagogue, was simultaneously a Doctor of Letters, an Anglican minister, and a member of The Association for the Improvement of Geometrical Teaching; as part of the "Broad Church" movement, he attempted to reconcile science and Christianity. Along with many other Victorian-era Anglicans, he was heavily involved with a lifelong dispute with Catholicism and Cardinal Newman; in particular, Abbott was opposed to the use of miracles as the basis for religious belief. His historical religious novels *Pilochristus* (1878), *Onesimus: Memoirs of a Disciple of St. Paul* (1882), and *Silanus the Christian* (1906) reached out to readers who could not accept biblical accounts of miracles to make the case that mythological and religious beliefs that existed during the time of the New Testament, along with mistranslations, may have obscured the actual accounts of Christ's life.

Alfred T. Schofield's *Another World; or the Fourth Dimension,* a work that was heavily dependent on *Flatland*, was published in 1888. In opposition to Abbott's more pragmatic approach to the acceptance of biblical miracles, Schofield's Christian argument makes allusions to *Flatland* to explain the existence of God, a spirit world, and biblical miracles. While Schofield acknowledges his "deep indebtedness to the anonymous author of a small book, called Flatland, which I have used extensively throughout, and without which I am quite sure the public would never have been troubled with these remarks..." (218), Schofield's usage of Abbott's work goes well beyond fair use: several long passages are lifted directly from *Flatland*.

Schofield's book apparently sold well. At the time, when speculations over the existence of life after death were taken very seriously, Schofield received respectful attention from the scientific community. A reviewer in the *British Medical Journal* called the book a "lucid introduction to the study of a class of scientific romances" and linked it with Abbott's work (1343). The reviewer also noted that although the mathematics community was at first resistant to the idea of a fourth dimension, the concept was now receiving popular attention, and was "a very fair subject for inquiry" (1343).

It is likely that Abbott wrote *The Spirit on the Water: The Evolution of the Divine from the Human* (1897) in an attempt to repudiate Schofield's arguments. In it, he emphasizes the necessity of rejecting a faith based on miracles, and clarifies the distinction between understanding higher dimensions in mathematics and having religious beliefs. In the book's second chapter, he describes the view of a living Solid looking down on Flatland, seeing in each inhabitant's body "the pulses, the throbbing of the heart, the changes in the brain that accompany the processes of thought" (214). Abbott continues to explain that such a creature would be god-like, but "he would not be a God. He would be simply a solid being looking at flat beings, a creature of three dimensions contemplating creatures of two"; he may "perhaps be a wholly despicable creature, an escaped convict from the four-dimensional land" (215). In this way, Abbott discouraged readers from perceiving the fourth dimension as a spiritual realm.

While Schofield combined Christianity and Spiritualism in his writings, Spiritualism generally resisted Christian doctrine (just as Abbott resisted Spiritualism) and was critical of established religions (Valente, "Who" 127). Spiritualist groups were not looking for a mathematical mechanism that would explain life after death; still, the German physicist Johann C. F. Zöllner hypothesized that mathematics showed that there was a form of space beyond human perception where spirits could exist. While such mechanistic explanations for ghosts caught the attention of Spiritualists, not everyone followed the mathematical explanations and the absence of any notion of spiritual enlightenment in Zöllner's concepts hindered full acceptance of his theories by the spiritualist community.[3]

At the time that Abbott was developing his ideas, mathematics teacher Charles Howard Hinton described in his essay "A Plane World" an alternate two-dimensional world, which he later fleshed out in his 1907 novel *An Episode of Flatland: or How a Plane Folk Discovered the Third Dimension*. The novel's world, Astria, provides a more logically coherent vision of physical life in two dimensions than that provided by Abbott's world. In particular, Abbott had trouble explaining his Flatlanders' mobility and vision, as both Flatland and its inhabitants are embedded in the (horizontal) xy-plane, with no "up" or "down" direction in which to look or move. Hinton, on the other hand, embedded his world in what is usually thought of as the (vertical) xz- (or yz-) plane: Astria looks like a coin standing on its edge — an edge whose width is, technically, infinitesimally narrow. The world's inhabitants, roughly sketched as triangles with arms and eyes on one side, could move up and down along the edge of the coin, but not around each other.

Hinton also penned works that focused specifically on the fourth dimension. These works redirected popular understanding of higher dimensions into theosophical realms very much in opposition to Abbott's professional religious studies.[4] In the nineteenth and early-twentieth centuries, writers Madame Blavatsky and P. D. Ouspensky made the fourth dimension a central concept for Theosophy, a mystical and arcane belief system based on the idea that humanity is moving to a higher level of perfection and that all religious traditions contribute and lead to some greater truth. Theosophy's focus on a universal brotherhood and on comparative study of religion made it very popular during the late nineteenth century. Ouspensky, who was influenced by Blavatsky's works, saw in Hinton's writing on higher dimensions a way to synthesize religion, science, and mysticism. (Ouspensky references Hinton in his *Tertium Organum*, 54–72.)

And indeed, Hinton equated an understanding of the fourth dimension with heightened

Fig. 6.

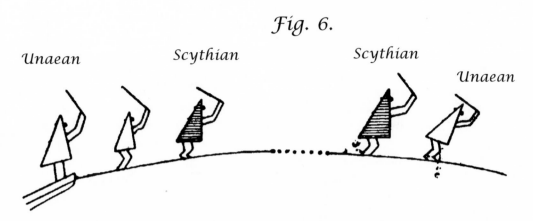

Astria and its warring inhabitants (Hinton, *Episode* 10).

enlightenment. In *An Episode of Flatland*, the comprehension of higher dimensions powers a kind of mystical heightening of consciousness. The narrator of the novel discovers that "by thinking certain thoughts, [he] can volitionally direct the activity of that real being, [his] soul. [He] can alter [his] weight. There is a power in everyone of doing this…. Our souls have this power" (116). Hinton concedes our difficulty in comprehending the fourth dimension, making use, like Abbott, of lower-dimensional analogies. In his essay "What Is the Fourth Dimension?" Hinton describes a creature confined in two dimensions, "some figure, such as a circle or rectangle … endowed with the power of perception" (3). He also imagines the perceptual limitations of a creature who is "confined to a single straight line" and considers "what might happen if a two-dimensional creature was taken into three-dimensional space," all ideas contained in Abbott's work. Unlike Abbott, however, Hinton hypothesized that our space actually contains "a slight hyperthickness in the direction of a fourth spatial dimension" and that, with training, it is possible to visualize four-dimensional space (Rucker, Introduction viii). Hinton appears to have been the first to describe and name the *tesseract* (the four-dimensional analog of a cube), and he marketed models of cardboard cubes to help people visualize the tesseract.[5]

Flatland

In *Flatland*, Abbott makes use of Plato's powerful and open-ended analogy of the cave and a limited perspective both to introduce its readers to *n*-dimensional geometry and to satirize the selective blindness of late Victorian society to women's intelligence and the arbitrariness and restrictiveness of the class order. Abbott's Flatland is a fogbound world embedded in the *xy*-plane; its inhabitants are geometric planar figures "scooting" on its surface.[6] Each male inhabitant is a polygon with three or more sides; his perceived moral and intellectual superiority is proportional to the number of sides he has and to the regularity of his shape (a polygon is *regular* if its angles are all equal in measure and its sides all equal in length). The entire culture is focused on their "Configuration," as any misstep in behavior could be passed on to the next generation in the form of physical irregularity. Each son has exactly one more side than his father: the narrator of *Flatland*, a square, has sons who are

pentagons, and two grandsons who are hexagons. Thus, the lower-class males are triangles, while Flatland's Priests have so many sides that they appear to be almost circular. All female inhabitants are lines; having no sides, they are at the bottom of Flatland's caste system. If an individual's shape is not completely regular, dangerous surgical intervention is used to maintain social conformity. Those in the highest caste regularly attempt to increase the number of sides of their newborns by breaking their delicate sides, even though most children do not survive the procedure. British book reviews of the time indicate that readers easily identified the satiric references to England's class structures and the Victorian treatment of women. The inhabitants of Flatland cannot actually see each other's shapes (for instance, a Flatlander will perceive a triangular countryman as a line, if he is approaching the triangle's edge, or a point, if he is approaching the triangle's corner), and instead depend on indirect modes of observation to determine those shapes, and thus each other's class positions. (While "feeling" is possible, it is considered poor manners.) In a complete reversal of standard gender representation, the aristocrats are egg-like vulnerable near-circles who are threatened by both the aforementioned phallic female lines and the sharply pointed isosceles triangles of the lower male classes.

The narrator of *Flatland* is named A Square (with no period—the A is an article, not an initial). He is a middle-class square lawyer; pompous and self-blinded in his commitment to the status quo, he is held in line by his hopes that his grandsons, hexagons, will elevate the family to the aristocracy. His views, however, begin to change when he has a dream of a world, Lineland, limited to one-dimension, whose inhabitants are points on a line. Square attempts to convince the inhabitants of his existence outside of their line space, only to give up in frustration. The next day, one of his grandsons asks him the geometric meaning of the third power of the number 3. After dismissing the question as nonsensical, Square then faces in his waking life an experience analogous to that of his dream. A three-dimensional sphere enters his planar world, appearing as a series of gradually widening and narrowing circles as he passes through, and Square finds he is no better able to comprehend the sphere than the Lineland inhabitants were to comprehend him. The Sphere explains that he comes every millennium to proclaim a new age and to bring a new awareness of space to Flatland, but has yet to be successful in his quest to disseminate geometric enlightenment. As the Square resists the idea of a third dimension, the Sphere touches him inside his stomach, tells him the contents of his safe, and displays knowledge of his dreams—all in an effort to persuade him that there are more than just two dimensions. Finally, the Sphere lifts Square out of his plane and shows him the third dimension. Through understanding the narrator's limitations and then the impact produced when the Square intellectually comprehends the existence of dimensions that he cannot directly perceive, the reader by analogy is directed toward an understanding of higher-dimensional space, answering those Victorian mathematicians who argued that it was not possible to conceive of n-dimensional space.

At least that was Headmaster Edwin A. Abbott's initial intention. As the novel's plot advances, though, it is apparent that more social and possibly mystical meanings lie beneath the surface. Eventually, Square attempts to instruct others in how to conceive of three dimensions, only to find that the rulers of his world have records of previous visits of the Sphere and were expecting his most recent visit. However, they have kept from the public any knowledge of these past visits. We also learn of past revolts, such as the Chromatic

Sedition, when color was discovered and then outlawed because it allowed irregular figures to appear as if they were regular and lower-class figures to appear to be of a higher class. We also learn of how women are kept in their place through the use of religion, limited education, and repeated calming lies. Eventually, just as Square is about to pass on his knowledge to his grandson, they hear an announcement that any discussion of other dimensions is made punishable by death and his grandson quickly refuses to acknowledge those speculations he had earlier entertained, fearing his grandfather has set a trap for him. By the end of the story, Square finds himself imprisoned, gradually losing his grasp of the vision he once had of three dimensions. He attempts to explain the concept to his brother and to those in power, but they demand that he show them the space that they cannot perceive — which, of course, he cannot do.

Additionally, Abbott's work alludes to the social and cultural context of 1880s London, a time of unusual heavy fogs, when scientists pondered the claims of mediums (such as Henry Slade, who purportedly untied knots and moved objects through walls via the fourth dimension) and women campaigned for the right to vote and attend university. It was also a time when Francis Galton was first expressing his eugenic ideas (coining the term "eugenics" in 1883) and held public fairs in London where people could be measured and learn how their reaction time and intelligence compared to that of others. In this sense, *Flatland*, with its focus on the importance of measurements, might be the first literary work to reflect on the implications of eugenics.

Flatland *Reimaginings*

Sphereland

Although Abbott's *Flatland* remained in print, speculations over n-dimensional geometries died down for a time. They were rekindled during the Sputnik era in the United States, as popular explanations attempted to elucidate Einstein's theory of relativity. Once *Flatland* went into public domain, Dover Publications brought out an inexpensive edition, which became one of the publisher's best sellers. In 1963, Barnes and Noble published an edition with an introduction by William Garnett, who connected Abbott with Lorentz, Larmor, and Whitehead, as well as to Einstein's theory of gravitation and the space-time continuum of his theory of relativity (vii–ix).

Dionys Burger, a secondary school physics teacher who had done quite a bit of popular science writing in Dutch, wrote a sequel, *Bol-land*, to *Flatland* in 1957. In 1965 it was translated into English as *Sphereland*, about the same time that *Flatland* was being introduced into junior high school mathematics classes (particularly in Southern California). In 1994, Barnes and Noble published the two works together in a single volume.

In *Sphereland*, Burger makes the first of several attempts to update Abbott's work, finding it "rather old-fashioned" (v). Burger notes that "[i]n Abbott's days the fourth dimension could only be imagined mathematically. Today, with the structure of our space the object of constant discussion, this dimension is of even more interest than it was in the nineteenth century" (vi). After a bland summary of *Flatland* which ignores much of its satirical impact (1–26), Burger images a more "enlightened" Flatland seventy years after the Square's adven-

tures and makes the Square's precocious grandson, a Hexagon, the book's narrator. In this world, the government of Flatland has raised a statue of the Square that is visited every year by a group of notables as penance for society's past discrimination. Women are now accepted as intelligent individuals capable of self-control; instead of having to warn others of their approach by wiggling their rears like Victorian bustles, they wear "shoes" on their sharp behinds (like buttons on fencing foils) to blunt their dangerous tips. Class distinctions have also been relaxed and Isosceles families demand to keep their Equilateral children, who were formerly removed from their care.

Unfortunately, the removal and tidying up of the dystopian elements of Abbott's world also removes his world's inherent logic, where geometric blindness parallels its social blindness. Where Burger does excel is in his reimagining of the physical world. Burger merges the visions of Abbott and Hinton, creating a world where the inhabitants gradually discover that their world is not really flat but curved; its two-dimensional beings are unknowingly living in a three-dimensional world. Like Hinton's Flatland, Sphereland lies in the xy-plane, but its inhabitants, rather than living on its surface, float about in its atmosphere. It consists of a series of concentric circles; in its center is a rocky core, surrounded by a ring of ocean. Outside of this ocean is a ring of tropical forests, then an inhabitable zone with a weak gravity field; this is where Sphereland's various cities and towns are located and where the inhabitants are "very light, and thus able to live in their planet's atmosphere" (Rucker, *The Fourth* 24). In his book *The Fourth Dimension: A Guided Tour of the Higher Universes* (1984), Rucker attempts to clarify Burger's model further by explaining, "It is as if people were able to live in clouds, clouds floating above tropical vegetation that is, in turn, floating on a sea that surrounds the planet's dense core" (24).

Since this is a sequel to *Flatland*, one expects that the Sphere will make a call on the Hexagon. Indeed, the Sphere does make his entrance after the Hexagon and his son have speculated on the potential physical reality of higher dimensions and on what an "over-cube" (a tesseract) would look like. The Sphere reveals somewhat sheepishly that he, in turn, has been visited by an "Over-Sphere," who performed the same sort of parlor tricks — such as removing objects from shut closets and touching the Sphere in the stomach — as the Sphere had performed for the Square. As an additional touch of higher-dimensional déjà vu, no one in the Sphere's world believes him, and he has come to Flatland to find a commiserator.

After the Sphere shows him some experiments, reversing the orientation of two-dimensional objects by flipping them around in three dimensions, the Hexagon, too, becomes convinced of the existence of a third dimension and thus becomes socially suspect. Finally, he discovers that the measures of the interior angles of large triangles used for surveying add up to more than 180 degrees. This means that the sides of the triangle must be curved and that their disk world is really a sphere with a three-dimensional curvature. The question now arises as to whether this information can be made public — whether this revelation will be accepted or denied by a society that has slowly acknowledged higher dimensions on a theoretical basis, but not considered their implications for the real world. This discussion leads to the analogous three-dimensional situation: can space be curved in a three-dimensional reality, and include an undetectable fourth-dimensional direction? With *Sphereland*, *Flatland* has been updated to be congruent with the Einsteinian age.

The Planiverse

With the coming of the Digital Age, people became interested in using computers to model two-dimensional worlds. In 1980, A. K. Dewdney asked himself, "Is a two-dimensional universe possible, at least in principle?" That is, could our laws of chemistry and physics operate in two dimensions as they do in three, and would life be possible in a two-dimensional world? Dewdney pursued his speculations, privately published a monograph entitled *Two-Dimensional Science and Technology*, and, as he explains in his article on his writing of *The Planiverse*, "in a fit of scientific irresponsibility" communicated with *Scientific American* columnist Martin Gardner, who publicized Dewdney's ideas in his July 1980 "Mathematical Games" column ("The Planiverse" 47). This was immediately followed by some two thousand requests for Dewdney's monograph, which quickly exhausted his supply (*Planiverse* 264). The publicity also resulted in proposals by many people, from universities all over the world, on the construction of a functioning limited-dimensional solar system. They considered such basic questions as whether atomic structures could form molecules and whether our known physical laws would hold in such a universe. These thought experiments were collected in *A Symposium on Two-Dimensional Science and Technology* (1981). Dewdney's subsequent 1984 novel *The Planiverse*[7] makes use of these discussions of how a two-dimensional world might work. It is apparent from the book's acknowledgements (263–67) that the articles' subjects of inquiry ranged from weather patterns to gears to DNA to pianos. Among the collection's contributors were Jef Raskin of Apple Computers, who designed a two-dimensional rocket plane, and Ta'akov Stein, who adapted Maxwell's equations to two dimensions; a periodic table for a two-dimensional universe was devised by Sergio Aragon of the Universidad del Valle de Guatemala, George Marx of Roland Eötvös University in Budapest, and Timothy Robinson of Christchurch, New Zealand. A subsequent collection, *The Second Symposium on Two-Dimensional Science and Technology*, was published in 1986. News outlets picked up on the topic and Dewdney found himself with a contract for a book project ("The Planiverse" 47–48).

His world was so believable that, much to Dewdney's concern, "many people believed the tale was factual" (Preface to the Millennium Edition xi). Dewdney's world is closer to Hinton's vision than to Abbott's. Like Hinton's Astria, Dewdney's world lies in a vertical slice of a three-dimensional universe. And like Burger, Dewdney attempts to describe a consistent, believable universe while using recent understandings of the basic principles of physics. Whereas neither Abbott nor Hinton attempted to flesh out, so to speak, the biology of their two-dimensional inhabitants, Dewdney provides his creatures with a detailed biology. The citizens of his world are not geometric shapes but bipeds with four arms (two on the right side and two on the left), and rather than facing one direction while traveling on the edge of a coin-shaped world (as Hinton's Astrians do), Dewdney's Flatlanders have flexible necks with eyes at the top, allowing vision to both the right and the left, as well as above (to keep a watch out for flying serpents). As in Hinton's world, the inhabitants can jump over or tunnel beneath structures, but cannot move horizontally around obstacles.

In *The Planiverse,* Dewdney introduces his readers to the character Yendred, and to his two-dimensional world, via a classroom's 1980s-era computer terminal. His fictional students have been working with a program called 2DWORLD, and designed a world called Astria (after the land in Hinton's *An Episode of Flatland*), populating it with "Ffennel-

Edwards Creatures" ("vaguely triangular" beings suggested by Hinton's work); but the program soon takes "on a life of its own" as new words not in the program's dictionary appear on the screen along with a different syntax (Dewdney, *Planiverse* 7). Eventually, a new world, Arde (from Ardaea, a planet that endangered Hinton's Astria) emerges (Dewdney, *Planiverse* 23).

The use of a computer terminal as a communications conduit gently eases the reader into the two-dimensional world, since a monitor's image is a projection and projections are almost two-dimensional: their depths are too small to be perceived by the human eye. By anchoring the narrative in our three-dimensional universe, it is possible to gradually puzzle out the physical laws of the two-dimensional universe without risking the reader's disorientation in an environment that continually opposes our preconceptions and learned assumptions about how reality works.

Dewdney uses three narrative perspectives. First, there is the Dewdney persona, a classroom teacher trying to keep the class' computer program secret while dealing with harassment from administrators over unauthorized use of computer time. He serves *in loco parentis* for his students, and adds a voice of maturity when explaining three-dimensional space to the unusually perceptive and intelligent two-dimensional Yendred. Second, we have the students' comments as they go from having difficulty accepting the reality of a two-dimensional world (tending to interact with Yendred as though he were a character in a video game), to identifying more and more with Yendred's search for knowledge and enlightenment, and, ultimately, accepting his true existence and learning that their own three dimensions might not make them as superior to him as they first assumed. The students' reactions give depth to the narration and make Yendred's world more believable.

Finally, there is Yendred himself, who, unlike the Square, is not an established member of his society, but barely an adult, leaving his family for the first time and undecided about his future. He is a quiet, patient, and intense individual who reaches levels of understanding beyond those of his three-dimensional spectators. In the end, he terminates communication with the computer and leaves with the mystic, Drabk, returning the students back to their original program, one which now seems meager and shallow, a haunting reminder of the detail and complexity of the Yendred's real two-dimensional world. The novel's plot has allegorical elements and, as Dewdney notes, the basics of a "Sufi story," as Yendred quests for knowledge (xi).

In the book's conclusion, outsiders enter the computer lab, demanding to know why there is unauthorized computer use. The students and their professor are left like Abbott's Square, with the memories of another world but with no means to revisit it, having to explain the unexplainable to a short-sighted bureaucracy. But here the tables are turned on Abbott's novel: it is the two-dimensional world that possesses higher understanding, on a spiritual, rather than a physical, level.

Role-Playing Games

Whereas Burger and Dewdney reconfigured the basic idea of Flatland for a more believable physical universe, recent versions of Flatland have focused on expanding the original text's social criticism (about the dangers of intolerance and narrow-mindedness) rather than on improving its physical mechanics. Marcus L. Rowland has, based on his LiveJournal dis-

cussion of *Flatland*, developed a role-playing game, *The Original Flatland Role Playing Game* (updated and expanded over the years 1993–2006), that involves a society that is very close to that of Abbott.[8] Social ranking is based, as in Abbott's world, on a polygonal inhabitant's number of sides, ranging from 1 for women, to 6 for members of the priesthood and the aristocracy. Individual characters, such as Professor Hex, a doctor with a hidden secret, and a criminal pentagon (cursed by Hex's surgical error to a life of irregularity) provide the opportunity for players to develop new plot lines in Abbott's world. It is notable that the manual of *The Original Flatland* harkens back to Abbott's original work in its use of archaic typeface and in its illustrative material.

Flatland: The Movie and Flatland: The Film

There have been a number of film adaptations of *Flatland*. Two such works, released in 2007, exploited new animation technology: *Flatland: The Movie*, a short animated production from Flat World Productions, and *Flatland: The Film*, a feature-length production from Flatland Productions.

The shorter Flat World version is designed for classroom use and its DVD includes an interview with geometer Thomas Banchoff of Brown University; the production's script is careful to direct the viewers back to Abbott's work, noting that although *Flatland* has been around a long time, its ideas still come across as fresh and original. The DVD also includes the text of Abbott's work. The film changes some of Abbott's world's features in order to create a more powerful cinematic impact; in particular, it removes Flatland's fog, allowing viewers a clear view of its inhabitants, and is in vivid color (Abbott's Flatland banned color after the Chromatic Sedition — his characters can only see things dimly). Other than that, the significant changes to the original plot involve the relations between men and women and the makeup of the protagonist's family. This Flatland is modeled more on modern American culture: its men and women work as equals in office cubicles. Class here is determined by shape, but not gender: there are no female lines. The narrator and his wife are both squares, raising a single hexagon granddaughter, Hex, while Abbott's Square's Victorian pentagon-shaped house held four sons, two orphan grandsons, a daughter, and four servants (scullion, footman, page, and butler). However, the unexplained mystery of the Square's orphan grandsons is echoed in the film's mystery of what happened to Hex's parents.

The shift in focus from a male square to a female hexagon, designated by a pink bow — the most common fashion accessory of all female cartoon animals since Disney's Minnie Mouse — reflects the producer's attempt to attract women to the fields of mathematics and computer science. Despite women's pioneering roles in these disciplines, general American culture still discourages women from entering math-oriented disciplines, reflecting a mindset apparently descended from Victorian-era beliefs in gendered intelligence.[9] The focus on Hex also continues the efforts (previously demonstrated in Burger's *Sphereland* and Ian Stewart's use of a great-great-granddaughter in his *Flatterland*[10]) to produce a *Flatland* adaptation that does not appear to be sexist. However, there are some problems with this version's treatment of gender. First, Abbott's social satire is weakened: the original *Flatland*'s pointed comments about women's limited sphere of movement and the two-faced manner of male communication — speaking of women one way while they are around and disparaging their intelligence in all-male environments — were specifically noted by nineteenth-century

reviewers as some of the most biting social commentary in the book. Second, the film's feminist approach of using a sympathetic female protagonist is undercut by its inclusion of a large, nasty, and domineering female Circle manager who oversees the workplace where Square and his brother work.

Although the novel's dystopian viewpoint, along with the rigidity of Flatland's caste system, the Circle's prior knowledge of the Sphere's visit, and the existence of the former's spies, transfer over to the film, in this version Hex has a means by which to convince her countrymen of the existence of higher dimensions. A three-dimensional rotating cube is contained in a mysterious, forbidden region, Area 33H (apparently inspired by America's notorious Area 51)[11]; those who can obtain access to this secured area can actually see the existence of three dimensions for themselves. In addition, in this world dissemination of information is apparently possible via a free press. So unlike the original *Flatland*, which ends with the Square unable to convince others of a third dimension's existence and imprisoned for what is essentially heresy, this film closes with the cheerful news that Hex is destined to proclaim a new age of understanding and bring in the new millennium.

To encourage further speculation by analogy, the film concludes with the Sphere, self-blinded here as in Abbott's work, murmuring, still disbelieving, about the ridiculous concept of four dimensions, while the film presents us with a three-dimensional view of a rotating tesseract. Banchoff helpfully expands upon this conclusion in his interview, as he explains how a four-dimensional figure might appear in a three-dimensional world.[12]

Ladd Ehlinger Jr.'s independent full-length feature *Flatland: The Film* is more radical in nature than its shorter cousin. The Ehlinger film takes place within Abbott's original timeline. In it, Flatland's geometric inhabitants display more biological detail than they did in the Flat World production: we can see a figure's brain and intestines, and even Square's dream activity, as the Sphere sees them. The figures have single eyes and mouths, along with barely-visible cilia along their sides that allow them tactile sensations. Their appearance seems inspired by that of amoebas. Additionally, the Sphere has arms, which he did not have in Abbott's work.

The adaptation opens promisingly enough with the Square giving his son a lesson in determining the shape of another Flatlander by sight rather than by touch, closely paralleling Abbott's plot. However, confusingly, this son is a hexagon while his brothers are pentagons; this breaks with the rigid generational hereditary of Abbott's class satire. Congruent with Abbott's work, however, the Square is a lawyer with cases and has a brother, B Square, who works in the ministry.

Ehlinger's film vividly mimics and expands upon a distressing aspect of Abbott's *Flatland*. Abbott's work describes with Renaissance medical terms how children are torturously manipulated in order to make them more regular (in the technical geometric sense). The film adds an episode in which the egomaniacal Circle Flatland president, with a crown on his head, hurries to the hospital as his newborn son's bones are broken in order to give the child's form more angles. The child does not survive and lies crumpled among a heap of other broken shapes about to be consigned to a fire. In this way, Ehlinger's film, like Abbott's work, roundly criticizes societal conformity (an aspect of *Flatland* generally ignored by more pedagogical productions).[13]

This version also adheres closely to Abbott's work in its depiction of Flatland gender discrimination. In it, women are represented as straight lines living in narrow, tightly-boxed

rooms. One woman is even shown committing suicide by eating herself in her prison cell. The women's voices are so high and piercing that they are barely audible in the film; the women do, however, continually give off their "peace-cry" and, in a particularly good scene that begins with an "I am Woman" proclamation, a war-cry is given by Square's wife before she attacks soldiers in order to allow her husband to escape their clutches. Ehlinger's film lacks the full impact of Abbott's critique of the social position of women, but it doesn't avoid the issue nor suggest through dismissal or omission that it is an unimportant element of Abbott's work.

Unfortunately, the elegant structure of Abbott's plot is muddled as Ehlinger attempts to conflate Abbott's history of the Chromatic Sedition with the entrance of the Sphere and the beginning of Flatland's fourth millennium. The film introduces "Chromatists," members of a rebellious political movement promoting the right of Flatlanders to color themselves, and we see an irregularly-shaped Chromatist, Senator Chromatistes, with painted outlines. The film's varying social tensions suggest a muddling of the Korean War with a bit of homophobia and red-baiting, as Senator Chromatistes' attempts at diplomatic relationships with the conservative north are purposefully undermined, in a McCarthy-era scenario, by Flatland's president. While the relationship between the Sphere and Flatland is mysterious in Abbott's telling, here it is merely confusing as the Sphere is a CEO at Messiah Inc., which apparently owns Flatland (a Spaceland no-fly zone). He brings A Square into his world and proceeds to simply set him on a desk, ignoring him, before forcing him to testify at a Spaceland Senate hearing. Yet, the point Abbott made in his *Spirit on the Water* comes through: other-dimensional superiority is not moral superiority and the Sphere is not worthy of worship just because he is a sphere. In a nice bureaucratic touch, A Square, struggling to survive, is mailed back to Flatland in an envelope with a clear address window through which we can see the poor, frightened Square peering out; the envelope is subsequently hit in the war's cross fire and falls through Flatland to the land's underside, where the Square loses his physical form and hears "Greetings A Square" from an unseen voice. This ending suggests both a visit from a fourth dimension and an existence after death, connecting the film with the turn-of-the-century tradition of Spiritualism and higher dimensions.

It is noteworthy that newer media, rather than radically revising *Flatland* (as Dewdney's *Planiverse* did) or rejecting Abbott's social critique as dated, choose instead to return to Abbott's work, finding its social commentary still very much relevant and an inspiration for further challenges to social conformity and intolerance: while the plot of *Flatland: The Film* diverges greatly from that of Abbott's original work, the picture retains a sense of outrage at stupidity and at enforced public conformity. Abbott saw, as a headmaster, the challenges his students faced living in a rigid social structure of late Victorian England, but could only speculate on the social implications of the new forms of scientific racism that were just being developed in the 1880s, and which would lead to practices of ethnic cleaning and genocide. The connections between Galton's measurements, which would establish a pseudoscientific concept of "normality," and the potential loss of personal liberty — that is, an awareness of the social dimension of Abbott's vision — is particularly apparent in recent retellings of *Flatland*.

Notes

1. There are many reprints of *Flatland*, but only a few which address the cultural and mathematical contexts of the work. Additionally, over the years, many printers' errors have made their way into *Flatland*

reprints. Versions edited by Rosemary Jann (Oxford University Press, 2006), Thomas Banchoff and William Lindgren (Cambridge University Press, 2009), Ian Stewart (Perseus, 2002), and myself (Broadview edition, 2009) are based on comparisons of different editions and attempt to place the work in a broader cultural context.

2. A chronology of specific references to higher dimensions in pre–World War I Paris is given in Henderson, 59–63.

3. See Valente, "'Who Will Explain the Explanation?': The Ambivalent Reception of Higher Dimensional Space in the British Spiritualist Press, 1875–1900," for a detailed discussion of the reception of the fourth dimension in British spiritualist publications.

4. Though Hinton's views tended toward the theosophical rather than the spiritualist, his publisher, Swann Sonnenschein, sensing the possibility of increased sales, added the subtitle *Ghosts Explained* to Hinton's pamphlet *What Is the Fourth Dimension?*, likely as an attempt to appeal to the spiritualist market (Rucker vii).

5. According to *The Oxford English Dictionary*, the term "tesseract" was coined by Hinton and first appeared in his 1888 book *A New Era of Thought*. His 1904 book, *The Fourth Dimension*, contains a color plate showing twelve colored cubes intended to help readers visualize how a tesseract might appear as it rotates in four dimensions, and the cover of the Oxford edition of *Flatland* is illustrated with Hinton's models. Scholars are still not completely sure how Hinton expected these shapes to be used, however, as his explanations are difficult to follow.

6. I use the term "scooting" here as the figures appear to move smoothly about in their plane, but just how they are moving while having no height is unclear.

7. In 2001, a new edition of Dewdney's *Planiverse* was issued.

8. Proceeds from the sale of the game go to Médecins Sans Frontières.

9. For discussions of the earlier roles of women in the study of mathematics see Abir-am and Outram's *Uneasy Careers and Intimate Lives: Women in Science, 1789–1979* (1987) and Schiebinger's *The Mind Has No Sex?: Women in the Origins of Modern Science* (1989).

10. Ian Stewart's *Flatterland: Like Flatland, Only More So* provides a lighthearted pedagogical guide to several topics in modern mathematics by working with ideas from *Flatland* and from the *Alice* books by Lewis Carroll (Charles Dodgson).

11. Area 51 is a secretive military base in southern Nevada used to test experimental aircraft. Conspiracy theorists believe it to be the location of an alien spacecraft whose presence is hidden by the U.S. government.

12. His explanation is very helpful, since my eleven-year-old daughter, who watched the film with me, couldn't make sense of the film's ending images of the rotating tesseract. While the movie was entertaining and colorful, as a child I understood (and was intrigued by) the Flatlanders' limits in perception after listening to Abbott's work read to me; my daughter, on the other hand, required additional explanation after viewing the film.

13. Steve Tomasula's experimental novel *VAS: An Opera in Flatland* also displays social criticism, making connections between forced sterilization in the United States and the criminalization and destruction of irregular shapes in Flatland, and pointing to a Supreme Court decision which "agreed with the inhabitants of Edwin Abbott's *Flatland* that the toleration of an Irregularity was incompatible with the sobriety of the State" (122).

Works Consulted

Abbott, Edwin A. *The Annotated* Flatland: *A Romance of Many Dimensions*. Ed. Ian Stewart. Cambridge, MA: Perseus, 2002.

_____. *Flatland*. Ed. Rosemary Jann. Oxford: Oxford University Press, 2006.

_____. *Flatland: A Romance of Many Dimensions*. Ed. Lila Marz Harper. Peterborough, ON: Broadview, 2009.

_____. *Flatland: An Edition with Notes and Commentary*. Ed. Thomas Banchoff and William F. Lindgren. Cambridge: Cambridge University Press; Washington, DC: Mathematical Association of America, 2010.

_____. *The Spirit on the Water: The Evolution of the Divine from the Human*. London: Macmillan, 1897. Excerpt in *Flatland: A Romance of Many Dimensions*. Ed. Lila Marz Harper. Peterborough, ON: Broadview, 2009. 214–16.

Abir-am, Pnina G., and Dorinda Outram, eds. *Uneasy Careers and Intimate Lives: Women in Science, 1789–1979*. New Brunswick: Rutgers University Press, 1987. Rev. of *Another World; or the Fourth Dimension*,

by A. T. Schofield. *The British Medical Journal* 2 (15 Dec. 1888): 1343. *BMJ Print Issue Archive*. Web. 22 Jan. 2010.

Burger, Dionys. *Sphereland: A Fantasy about Curved Spaces and an Expanding Universe*. Trans. Cornelie J. Rheinboldt. New York: Crowell, 1965.

Dewdney, A. K. *The Planiverse: Computer Contact with a Two-Dimensional World*. New York: Poseidon, 1984.

_____. "The Planiverse Project: Then and Now." *The Mathematical Intelligencer* 22.1 (2000): 46–51. JSTOR. Web. 3 March 2010.

_____. Preface to the Millennium Edition. *The Planiverse: Computer Contact with a Two-Dimensional World*. New York: Poseidon, 2001. ix–xi. *Google books*. Web. 3 Sept. 2010.

_____, and I. R. Lapidus, eds. *The Second Symposium on Two-Dimensional Science and Technology*. London, ON: Turing Omnibus, 1986.

Flatland: The Film. Dir. Ladd Ehlinger Jr. Perf. Ladd Ehlinger Jr. Flatland Productions, 2007. DVD.

Flatland: The Movie. Dir. Dano Johnson and Jeffrey Travis. Perf. Martin Sheen, Kristen Bell, and Michael York. Flat World Productions, 2007. DVD.

Garnett, William. Introduction. *Flatland: A Romance of Many Dimensions*. By Edwin A. Abbott. New York: Barnes and Noble, 1963. vii–x.

Henderson, Linda Dalrymple. *The Fourth Dimension and Non-Euclidean Geometry in Modern Art*. Princeton: Princeton University Press, 1983.

Hinton, Charles H. *An Episode of Flatland: Or How a Plane Folk Discovered the Third Dimension*. London: Swan Sonnenschein, 1907.

_____. *The Fourth Dimension*. Excerpts in *Speculations on the Fourth Dimension: Selected Writings of Charles H. Hinton*. Ed. Rudolf Rucker. New York: Dover, 1980. 120–41.

_____. "A Plane World." *Scientific Romances*. Vol. 1. London: Swan Sonnenschein, 1884. Rpt. in *Speculations on the Fourth Dimension: Selected Writings of Charles H. Hinton*. Ed. Rudolf Rucker. New York: Dover, 1980. 23–55.

_____. "What Is the Fourth Dimension?" *Scientific Romances*. Vol. 1. London: Swan Sonnenschein, 1884. Rpt. in *Speculations on the Fourth Dimension: Selected Writings of Charles H. Hinton*. Ed. Rudolf Rucker. New York: Dover, 1980. 1–22.

Kant, Immanuel. *Critique of Pure Reason*. Ed. Vasilis Politis. London: Dent, 1993.

Ouspensky, P. D. *Tertium Organum*. New York: Knopf, 1944.

Richards, Joan L. *Mathematical Visions: The Pursuit of Geometry in Victorian England*. Boston: Academic Press, 1988.

Rowland, Marcus L. *The Original Flatland Role Playing Game*. Self-published, 2006. Game.

Rucker, Rudy (as Rudolph Rucker). Introduction. *Speculations on the Fourth Dimension: Selected Writings of Charles H. Hinton*. New York: Dover, 1980. v–xix.

_____. *The Fourth Dimension: A Guided Tour of the Higher Universes*. Boston: Houghton, 1984.

_____. *Spaceland*. New York: Tor, 2002.

Schiebinger, Londa. *The Mind Has No Sex?: Women in the Origins of Modern Science*. Cambridge: Harvard University Press, 1989.

Schofield, A. T. *Another World; or the Fourth Dimension*. 3rd ed. London: Swan Sonnenschein,1905. Excerpt in *Flatland: A Romance of Many Dimensions*. Ed. Lila Marz Harper. Peterborough, ON: Broadview, 2009. 217–27.

Stewart, Ian. *Flatterland: Like Flatland, Only More So*. Cambridge, MA: Perseus, 2001.

Tomasula, Steve. *VAS: An Opera in Flatland*. Chicago: University of Chicago Press, 2002.

Valente, K. G. "Triangulating the Contributions of George Salmon to Victorian Disputes on Mathematics, Evolution, and Liberal Theology." *Nineteenth-Century Contexts* 31.3 (2009): 251–69. JSTOR. Web. 14 Oct. 2009.

_____. "'Who Will Explain the Explanation?': The Ambivalent Reception of Higher Dimensional Space in the British Spiritualist Press, 1875–1900." *Victorian Periodicals Review* 41.2 (2008): 124–49. JSTOR. Web. 14 Oct. 2009.

Discovering a Higher Plane
Dimensionality and Enlightenment in Flatland *and* Diaspora

Chris Pak

It may come as no surprise to the reader that mathematics often plays an important role in works of science fiction (SF). This role is sometimes straightforward, as in *Contact*, in which aliens communicate with humans using the "universal language" of mathematics. At other times, math plays a more metaphoric role; for instance, *1984*'s protagonist, Winston Smith, attempts (but fails) to combat his dystopian state's brainwashing with his insistence that two plus two equals four.

Geometry, in particular, can function in SF as a vehicle for interrogating the notion of physical reality and, consequently, the social structures built upon that understanding. In such narratives, geometry becomes a gateway to universes of other dimensional configurations. This tradition dates back to Edwin A. Abbott's entertaining 1884 novella *Flatland*, whose two-dimensional protagonist, A Square, experiences alien worlds of one and three (spatial) dimensions, leading him to reconsider some of his fundamental assumptions about reality and challenge his society's beliefs. Similar uses of mathematics appear in contemporary SF: for example, Greg Egan's 1997 novel *Diaspora* features virtual consciousnesses who practice mathematics as a form of truth-seeking. In order to escape from a universal catastrophe, they employ the insights of geometry to travel to alternate universes — ones that function according to physical laws differing from those of their universe of origin — in the hopes of finding an escape from the confines of their threatened universe.

How is the notion of other worlds and dimensions, a characteristic motif of SF, combined with mathematics in order to critique our fundamental assumptions about reality and society? How are these concepts employed by SF and what makes them so successful? In this essay, I compare *Flatland* and *Diaspora* to illustrate how these texts engage in a dialogue with representations of mathematics and the physical world and relate these insights to social worlds.

Mathematics and Science Fiction

In "Mathematical Themes in Science Fiction," Lila M. Harper summarizes the main trends in SF's exploration of mathematics, beginning, as I do, by considering Abbott's use

of geometry in *Flatland.* Harper discusses the difficulty of delimiting a genre called "Science Fiction" and notes the existence of many competing definitions, but suggests that SF "tends to be ... fiction which uses ideas, concepts, and gadgets from areas of study outside the general field of the humanities" (245). Having this view, Harper argues that "[i]n its best examples, science fiction is interdisciplinary in nature" (245). SF is especially dependent on the insights of mathematics as the latter provides a basis for many of the former's characteristic motifs, from computers and robots to space flight, hyperspace, and a range of other, sometimes abstract, scientific concepts. David N. Samuelson asserts that mathematics plays an integral role in SF on another level, explaining that SF's extrapolative mode, in which current scientific, philosophical and social understanding is extended into the future, "stems from an exercise in mathematical logic" (200).

Harper draws on the theories of mathematician Paul R. Halmos to argue that a limited understanding of mathematics has meant that its actual practice has been consistently misrepresented. In a 1968 *Scientific American* article entitled "Mathematics as a Creative Art," Halmos draws a distinction between "mathology" (pure mathematics) and "mathophysics" (applied mathematics). Harper argues that while the form's characteristic tropes would suggest that SF deals primarily with mathophysics, it in fact prefers "the more easily visualized or conceptualized aspects of mathology" (Harper 246). Harper highlights an old problem of mathematics in regard to its relationship to the real world when she notes that "Mathematics is both of this world and not of this world":

> [I]t is a creative subject, developed over thousands of years, playing with relationships of completely abstract ideas with no connection to the physical world. Yet ... we can use it to make predictions about the world we live in....
> This peculiar place of mathematics in our world underlines its use in science fiction. If the mathematics work, but the description does not match anything in the physical world about us, then perhaps somewhere, somehow, there is a physical reality which mirrors the concepts the mathematicians manipulate [246].

Mathematics, then, offers the SF writer a body of knowledge from which to draw in order to ground representations of other possible worlds. The writer may then endow these worlds — possibly born of mathology, rather than of our world's physical reality — with social structures that mimic or vary wildly from our own. While mathophysics holds up a mirror to our world, SF introduces us to other worlds that distort, and so throw into relief, aspects of the world in which we live. This distortion can be created through the presentation of a parallel world (as in *Flatland*), through the effect passages of time have on society (as in *Diaspora*, set in the far future), or through a combination or variant of these dislocations.

We now explore in detail how mathematics both inspires and is used to communicate social criticism in *Flatland* and in *Diaspora*.

Flatland: A Romance of Many Dimensions

Abbott's *Flatland* presents a universe which we can read as parallel to our own, but which operates as a hypothetical mathematically-based thought experiment, whose aim is to expand our conceptual boundaries. Published under the pseudonym A Square, *Flatland*

is divided into two parts, "This World" and "Other Worlds." The first part discusses Flatland itself, a spatially two-dimensional world (that is, a plane) inhabited by planar figures, such as triangles and squares. Social superiority is dictated by the number of sides possessed by each Flatlander, with near-circles occupying the upper echelons and taking the roles of priests, guardians of knowledge, and politicians. Women are lines and occupy the lowest social stratum, while triangles comprise the next social level, that of tradesmen and the military. Our narrator, A Square, is a mathematician who is in the third-lowest of Flatland's social tiers. At the beginning of the text, A Square's societal beliefs, and those of his family, conform to the dominant ones of his milieu: like his peers, he considers proportionality between the number of sides one has and one's social standing to be a matter of natural law. We are told of the events associated with the attempted institution of the "Universal Colour Bill," in which dispossessed Flatlanders, recognizing the "second Nature" of the newly-discovered use of color and its consequential effacement of "aristocratic distinctions," argued that "the Law should follow in the same path, and that henceforth all individuals and all classes should be recognized as absolutely equal and entitled to equal rights" (35). This attempted revolt is suppressed by a mixture of social manipulation and massacre and stands as an indication of the repressive social constraints in Flatland. Our narrator initially supports the suppression of these "ancient heresies which led men to waste energy and sympathy in the vain belief that conduct depends upon will, effort, training, encouragement, praise, or anything else but configuration" (46).

While the first part of the novella establishes the social norms and topological structure of Flatland, its second part confronts Flatlanders' beliefs with evidence of other possible worlds. A Square dreams of a world, Lineland, with only one spatial dimension; subsequently, he is visited by a Sphere from Spaceland, a world of three dimensions. Rounding off A Square's inter-dimensional excursions, he dreams that the Sphere takes him to Pointland, a world of no dimensions. A Square's attempts to explain to the inhabitants of Lineland and Pointland the existence of a two-dimensional world fail due to his inability to convey or experimentally prove the existence of these extra dimensions to creatures who are fettered by their experiential and social perception of their reality. His failed attempts are paralleled and inverted by an incident that occurs in Flatland's fifteenth chapter, in which his grandson suggests the existence of a three-dimensional object by extrapolating a geometric progression. A Square's conviction that his grandson is talking "nonsense" is analogous to the Pointland and Lineland inhabitants' failure to comprehend the existence of higher-order dimensionalities. As our narrator is subject to the same prejudices as the inhabitants of Lineland, the Sphere is forced to bring him into Spaceland to convince him of the existence of higher dimensions.

The 1884 preface to *Flatland*'s revised second edition, ostensibly written by the editor after conversations with A Square, features this lament: "*Alas, how strong a family likeness runs through blind and persecuting humanity in all Dimensions! Points, Lines, Squares, Cubes, Extra-Cubes — we are all liable to the same errors, all alike the Slaves of our respective Dimensional prejudices*" (xiii). The irony of his experiences in Spaceland is that, utterly convinced of the existence of three spatial dimensions, A Square attempts to employ an extension of the Sphere's own argument to convince the latter of the existence of a four-dimensional spatial world, only to fail because of the Sphere's own prejudices (88). This scene mirrors the previous one involving A Square and his grandson: again, we have a character who is

able to posit the existence of other dimensions by analogy to geometrical progression, but unable to convince his listener of his argument's validity. After his return to Flatland, A Square tries to convince his grandson that he himself was wrong to have dismissed his grandson's earlier suggestion of a third dimension, but his grandson puts a stop to the discussion, apparently in obeisance to a recent law forbidding discussion of the existence of other worlds on pain of imprisonment or death.

Flatland concludes with A Square being incarcerated for his heretical advocacy of the existence of other dimensions. His earlier request of the Sphere, "[c]an you not startle [the inhabitant of Pointland] out of its complacency? ... [R]eveal to it the narrow limitations of Pointland, and lead it up to something higher" (93) demonstrates his desire to enlighten his fellow Flatlanders. The ruling circles, however, are aware of this knowledge and suppress it in order to maintain their power. A Square is left simply to "hope that [his] memoirs, in some manner ... may find their way to the minds of humanity in Some Dimension, and may stir up a race of rebels who shall refuse to be confined to limited Dimensionality" (101).

Mathematics represents logical thought unfettered by prejudice and social limitations. Topology, with its exploration of other geometrical dimensionalities, is extended in the text from a physical representation of alternative realities to a metaphor for cognitive space. *Flatland* can be read in this context as an early expression of SF's "Sense of Wonder," a term that refers to a revelation — specifically, a conceptual breakthrough relating to a shift in paradigms of thought. The narrative dramatizes A Square's conceptual breakthrough from his limited vision of both his physical and social worlds to a sense of a wider universe populated by worlds containing alternative social configurations. Though the book ends with the Square's social downfall, the novella presents the positive view that the social stratification of Flatland, and of other worlds, is not "Nature" (and therefore subject to immutable laws), but rather open to the possibility of change by the actions of individuals and communities.

Diaspora

Diaspora engages in a dialogue with Abbott's *Flatland* and reworks many of its themes within the context of "hard SF" (that is, SF that emphasizes scientific detail and accuracy). As a computer programmer, Egan combines the language of computing and higher mathematics with many common tropes of SF, including genetic engineering, virtual consciousness, robots, space travel, wormholes, and parallel universes. Set in the far future, *Diaspora's* world is populated by three categories of *posthumans*.[1] First there are *citizens*, who are virtual consciousnesses — that is, computer programs modeled on the neural structure of organic human brains. Since citizens are analogical computer programs born of a mathematical conversion of DNA, they retain some human characteristics. Citizens "live" (or, more accurately, are stored) in communal groups known as *polises*; polises are essentially hard drives that contain the data comprising the community.

Set against these citizens are *fleshers* and *gleisners*. Of these, fleshers are the most similar to contemporary humans; however, the majority of fleshers make use of various degrees of genetic engineering to adapt themselves to different environments and to experience the physical world through different perceptual apparatuses. Finally, gleisners are human consciousnesses embodied in inorganic humanoid robots. An uneasy relationship exists between

these three groups, a dynamic that occupies the same structural role for the exploration of prejudice as the divisions between social strata in *Flatland*. Amongst and within these groups are a wide variety of belief systems, lifestyles, and approaches to the world based upon various modes of perception.

The novel focuses on the development and life of Yatima, a citizen of Konishi polis. The polis' citizens are able to manipulate virtual environments, or *scapes*, at will. They spatialize the sum of their mathematical knowledge as "Truth Mines" that any of them can explore. As programs, citizens are granted near immortality and are able to adjust the rate at which they experience time. This means that they have billions of subjective time units (known as *tau*) that span a potentially infinite length of objective time with which to engage in *Truth Mining* (that is, mathematical learning). Yatima could have all the mathematical knowledge that he desires downloaded instantaneously (that is, from a human perspective—the procedure would presumably occur over an unspecified period of tau) into his consciousness.[2] However, this is undesirable for several reasons, which bear implications for the way in which sentience based upon human evolution operates. Egan writes: "The only way to grasp a mathematical concept [is] to see it in a multitude of different contexts, think through dozens of specific examples, and find at least two or three metaphors to power intuitive speculations" (46). In fact, as the text seeks to demonstrate, this is the way in which any knowledge is truly understood.

The chapter called "Truth Mining," in which this quote appears, forms the background for Yatima's later exploration of other universes of multiple dimensions. Here, Yatima, still a young citizen, is exploring the properties of spatial curvature under the tutelage of the famous *miner* (scholar) Radiya by attempting to work with Euclidean geometry on a torus and a sphere. While doing so, he stumbles upon the Gauss-Bonnet Theorem (a famous real-world theorem in the area of differential geometry), discovering that "[u]nderstanding an idea meant entangling it so thoroughly with all the other symbols in your mind that it changed the way you thought about everything" (46). As a citizen able to define all the parameters of the scapes he inhabits, Yatima believes, contrary to the dominant doctrine of the citizens of the alternate Carter-Zimmerman (C-Z) polis, that "physics mean[s] nothing in the polises" (55) and that "only in the Mines [and therefore in mathematics] could he hope to discover the real invariants of identity and consciousness" (57).

Yatima's faith in mathematics is contrasted by his friend Inoshiro's preoccupation with the fleshers, a consequence of the latter's privileging of the physical world. Yatima believes that one's understanding of the universe is determined solely by one's mathematical proficiency, and he explores the physical world by studying computing processes and mathematics—he completely ignores the communities of embodied posthumans and their alternative ways of understanding the universe. However, Inoshiro, longing for an embodied existence and for sensation, convinces Yatima to join him in visiting one of these groups.

He takes Yatima to a flesher village of *bridgers* who work as translators connecting the diverse forms of genetically-engineered fleshers, or *exuberants*. Liana, one of these bridgers, tells them that, like citizens, "Most exuberants have tried [manifesting] ... constructive changes [to their consciousnesses]: developing new ways of mapping the physical world into their minds, and adding specialised neural structures to handle the new categories" (74). This passage highlights the fact that different consciousnesses experience the world in different ways; this can create barriers to communication between groups with radically different

perceptions of the physical world. Yatima's experience at the village helps him to recognize a world outside of the mathological world of the Truth Mines; he realizes that in order to truly understand the universe, he must explore the world outside of the Mines and interact with other types of posthumans.

When a massive cosmic event threatens the survival of all the fleshers on the planet, Yatima assists the villagers. The gleisners, however, predict that this catastrophe is but a prelude to a larger cosmic event — known as the "core blast" — that will endanger the whole of the universe and which, unlike the first event, threatens gleisners and citizens as well as fleshers. Yatima's experiences with the bridgers prompt him to contrast their reality with the scapes with which he is familiar; he realizes that the actual physical world "[can] only be manipulated, painstakingly, step by step — more like a mathematical proof than a scape" (113). In response to the physical and emotional devastation Yatima witnesses in the wake of the disaster he decides to join the citizens of C-Z polis on a diaspora into space, searching for a way in which to better control the physical world and prevent the predicted core blast.

Hence begins an exploration of other worlds that riffs upon A Square's travels in *Flatland*. Motivated by a sense of competition with the gleisners, who use traditional deep space travel to explore unknown regions of the universe, the C-Z citizens, joined by Yatima and his friends and mentors Blanca and Gabriel, attempt to develop travel via wormholes. This method of travel is based on the fictional *Kozuch Theory*, which is in turn built on the assumption of six spatial dimensions, and draws on the insights and language of quantum theory. "In Kozuch Theory, wormholes were everything" (156): "Chances were, every grain of sand, every drop of water on Earth contained gateways to each of the hundreds of billions of stars in the galaxy, and some that reached far beyond" (158). Kozuch theory suggests that these connections can be employed as wormholes to enable instantaneous interstellar travel. However, experimentation by C-Z citizens demonstrates that travel by wormhole takes the same amount of time as traditional space travel. In order to resolve this problem, and thereby "prove" their superiority over the gleisners, Blanca must posit the existence of twelve spatial dimensions. However, inverting Yatima's prejudices, the C-Z citizens' privileging of physical experience means that they are reluctant to accept knowledge that they do not see physically manifested. Kozuch theory already severely strains the C-Z citizens' doctrine of physicality, and Yatima is aware that "of course, no one in C-Z would believe a word of [Blanca's theory of twelve spatial dimensions]; it was abstractionism run riot" (193). The C-Z citizens' inability to use Kozuch Theory to efficiently time-travel reveals a gap in their understanding of the physical universe and drives them onward on their diasporic search for a more advanced civilization from which to learn. As a character, Paolo, in the novel states, "[they] need to understand what it means to inhabit the universe" (214), and it turns out that the key to that understanding is mathematics. (As we will later see, they eventually manage to adapt Kozuch theory to allow them to open traversable wormholes, though they lead not to other portions of their universe, but to distinct, alternate universes.)

C-Z citizens discover a form of life which forces them to dramatically re-evaluate their conceptual model of the universe. In the chapter "Wang's Carpets," explicit references to *Flatland* are made. On one planet, the travelers find "free-floating creatures living in the equatorial ocean depths" (206). It turns out that each of these creatures, called "carpets" by the travelers, is a single molecule, "a two-dimensional polymer weighing twenty-five

thousand tonnes" (224–25). Karpal, another member of the diaspora, observes that these creatures are *Wang tiles*, that is, "squares with various-shaped edges, which have to fit complementary shapes on adjacent squares" (226); in honor of this, he dubs them "Wang's Carpets." He then goes on to demonstrate how, when viewed from an outlook incorporating sixteen dimensions, each individual Wang's Carpet forms an independent organic Turing Machine — "an imaginary machine [conceptualized by Alan Turing] which move[s] back and forth along a limitless one-dimensional data tape, reading and writing symbols according to a given set of rules" (230). This discovery expands upon Blanca's earlier twelve-dimensional extravagance and is another "affront to Carter-Zimmerman's whole philosophy" (236). Moreover, continuing *Diaspora's* exploration of the boundaries between simulated and "real" life, Wang's Carpets simulate within themselves entire ecosystems; geared as C-Z citizens are toward physicality over the simulated scapes of the polises, the inexplicable existence of an organism that is structured like a computer and is able to simulate life confronts them with an existential dilemma. Because C-Z citizens are also simulations (as they are computer code inhabiting virtual spaces) but have prioritized the "natural," physical universe over a virtual one, they are shocked to discover that biological life would have been naturally selected for its ability to simulate life within its own structure. But Paolo is surprised at "how pragmatic even the most doctrinaire citizens turned out to be ... now that they were here, and stuck with the fact of it, people were finding ways to view it in a better light" (239). Optimistically, and in contrast to the suppression of knowledge in *Flatland*, the citizens of this posthuman future prove their adaptability in response to changing paradigms of reality.

 Diaspora is structured by escalating levels of discovery. It revisits the conceptual breakthrough dramatized in *Flatland* by pushing the characters' frontiers of knowledge beyond the bounds of the already strange future established by the text. The travelers' encounter with Wang's Carpets is succeeded by other encounters with varied life forms. They discover a beacon left by a supercivilization (that is, a civilization that is technologically and culturally superlatively superior to theirs), and its accompanying message tells them more about the predicted core blast, and of a nearby possible escape route. Blanca believes that this supercivilization's members, known to the travelers as "Transmuters," may have "[m]igrated ... [u]pwards" (278), via higher-dimensional travel, into a different universe, and left this beacon for other intelligent species to use in order to escape from the impending universal cataclysm. The orientation "upwards" resonates with A Square's recitation of the mantra "Upward, and yet not Northward" (Abbott 92) as he attempts to retain the memory of the third dimension of Spaceland; that statement is itself a mental construct similar in spirit to *1984's* mantra of "two plus two equals four." With the help of the Transmuters' message, the citizens are able to utilize their knowledge of Kozuch theory to travel, via wormholes, to other universes.

 The travelers escape to a different universe — one not threatened by the core blast. An exploration of topology (the mathematical study of spaces) ensues as Paolo explains to his father, Orlando, the meaning of "U-star," their name for this new universe:

> U is the ordinary universe, and the star is mathematical notation for its "dual space"[3] — that's a term used for all kinds of role-reversals. The universe and [U-Star] are both ten-dimensional ... but one has six small dimensions and four large, the other has six large and four small. So they're inside-out versions of each other [294].

Orlando initializes a subprogram that alters his perception so that he can view U-Star's five notable spatial dimensions (its other dimensions presumably consist of a temporal dimension, and four other dimensions that are too "small" to be perceived); but seeing it this way is disturbing, forcing him to confront the nature of his own limited (post)human identity. Unlike the simulated sixteen-dimensional world of Wang's Carpets, "[this universe] was no game; it was more real ... than his simulated flesh, more real, here and now, than the ruins of [his home bridger village]" (298). *Diaspora* again references *Flatland* in order to describe this dizzying reality: "[I]f he was like a Flatlander seeing the world beyond his plane, that plane had always been vertical, and his slit-vision had now spread sideways" (298).

While investigating Poincaré, one of the planets in this universe, the travelers obtain more information that helps them to track the Transmuters. They meet conscious aliens there and Orlando, once a flesher bridger, opts to make copies of himself and have each copy's consciousness progressively adjusted in order to bridge the gap between the citizens' perceptual systems and those of the alien inhabitants. The aliens of Poincaré are then able to tell the citizens that the Transmuters have jumped to yet another universe, this one of four dimensions. Once able to communicate with the aliens, Orlando opts to abandon the diaspora and offers his copies the choice of merging with him; all refuse but one, who decides to merge with him in order to act as a "reminder that you once embraced something larger than you thought you could" (328). Orlando's experience shows the impact to an individual's sense of identity that occurs when homocentric prejudices are confronted by the alienating effect of a conceptual breakthrough. In an echo of the negative responses to notions of higher dimensionalities in *Flatland*, Orlando is unable to endure more changes to his perception of reality and decides to return to Earth to seek sanctuary in the familiar. However, his clone, by choosing to merge with him, ensures that he will occasionally "dream in five dimensions" and so never forget that reality is larger than his limited perspective (328).

It turns out there is actually a series of embedded universes (each with its own set of physical laws) that have been yoked together to form what Egan dubs a "macrosphere" (this concept is based on contemporary ideas of quantum mechanics and string theory). The travelers visit seven universes in the macrosphere before they are finally able to confirm the details of the core blast. In the seventh universe, they meet a non-sentient AI, a "Contingency Handler" constructed by another supercivilization. It informs them that the Transmuters (and later, the gleisners) were in essence correct in the data extrapolation that led them to predict the catastrophe, even if their details were somewhat inaccurate — the core blast will in fact create new spacetime, a "mini Big Bang" (336). The Contingency Handler reveals that "[t]here are an infinite number of [universes in the macrosphere], an infinite number of extra dimensions. So every four-dimensional universe interacts with *an infinite number* of adjacent universes" (334). There are some six thousand advanced cultures in this universe, and the Contingency Handler encourages the travelers to "[b]ring your people through. They're welcome here. There's room enough for everyone" (337). This invitation contrasts with the division between the three groups of posthumanity at the beginning of the text and marks the end of the diaspora. As this universe is similar to their universe of origin and occupied by cultures desiring interaction, the travelers deem it appropriate as a new home, and most of them accept the Contingency Handler's offer to stay.

Yatima and Paolo, however, decide to form a new polis and continue the search for

the Transmuters. After many millennia and much physical exploration of the macrosphere, Yatima returns to his original studies. For Yatima, "[i]n the end, there was only mathematics": "To play out everything [he] was, to be complete, [he] had to find the invariants of consciousness: the parameters of his mind that had remained unchanged all the way from [newly-formed consciousness] to stranded explorer" (361).

The study of mathematics is Yatima's method of discovering what it means to possess a complete identity. It is a literalized metaphor for the search for truth, as Yatima's existence and his ability to interact with and understand reality is founded on mathematics. Most of the members of the diaspora were provided with a sense of purpose through their experience of community and interaction with individuals and groups, but here, too, the multiplicity of the co-existing and interacting dimensions that mathematics describe operate as metaphors for the plurality of cultures and of perspectives toward reality. *Diaspora* is a text that integrates higher mathematics with philosophical and social commentary to examine what it means to exist as an individual in a community.

Conclusion

Both *Flatland* and *Diaspora* explore mathematics as a system of knowledge whose study leads to truth: not a social truth limited by the prejudices of a particular community's belief system, but the fundamental truth of the universe and of reality. The discovery of this "fundamental" truth has repercussions in the way in which society is configured in each text. The new insight conditions or modifies each community's underlying beliefs (such as C-Z's doctrine of physicality); for readers, these texts not only dramatize inter-dimensional travel but also function as metaphorical gateways through which our contemporaneity is explored. SF offers a mode congenial to the incorporation of mathematics as a language of discovery and truth. It is a language represented as intimately concerned with not only physical, but also social, realities.

Notes

1. "Posthumans" is a term that loosely refers to entities who are evolved from contemporary humans, or whose race has actually replaced that of humans.

2. Yatima, like the other citizens and gleisners in *Diaspora*, is of neutral gender; in discussing such characters, Egan uses the pronouns *ve* (subject), *vis* (possessive determiner), and *ver* (object). For the sake of readability, I have chosen to use traditional male pronouns in this essay when discussing gender-neutral characters.

3. Mathematicians would notate this inversion as U*, and Egan uses that notation in the titles of chapters relating to this location.

Works Consulted

Abbott, Edwin A. *Flatland: A Romance of Many Dimensions*. Oxford: Blackwell, 1932.

Berkove, Lawrence I. "A Paradoxical American Appropriation of Flatland." *Extrapolation* 41.3 (2000): 266–71.

Bonyo, E. A. "Mathematics in Science Fiction: A Measure Zero." *Patterns of the Fantastic II*. Ed. Donald M. Hassler. Mercer Island, WA: Starmont, 1985. 39–44.

Egan, Greg. *Diaspora*. London: Millennium, 1997.

Eizykman, Boris. "Chance and Science Fiction: SF as Stochastic Fiction." *Science Fiction Studies* 10.29 (1983): 24–34.

Halmos, Paul R. "Mathematics as a Creative Art." *American Scientist* 56 (1968) : 375–89.

Harper, Lila M. "Mathematical Themes in Science Fiction." *Extrapolation* 27.3 (1986) : 245–69.

Orwell, George. *1984*. London: Penguin, 2000.

Potter, Gretchen. "Geometry and Science Fiction." *Mathematics in School* 5.2 (1976): 11–13.

Sagan, Carl. *Contact: A Novel*. London: Century, 1986.

Samuelson, David N. "Modes of Extrapolation: The Formulas of Hard SF." *Science Fiction Studies* 20.2 (1993): 191–240.

Warrick, Patricia S. "Quantum Reality in Recent Science Fiction." *Extrapolation* 28.4 (1987): 297–309.

Projective Geometry in Early Twentieth-Century Esotericism

From the Anthroposophical Society to the Thoth Tarot

Richard Kaczynski

Introduction

In the late nineteenth and early twentieth centuries, projective geometry was a dominant field of mathematics. Dealing with properties of objects that are preserved under certain types of transformations, it derived from earlier attempts to understand the mathematics behind perspective painting, whose canvases — presenting distorted but nevertheless recognizable shapes — appear to be three-dimensional. The field later broadened considerably to include other kinds of projections. Although projective geometry's star had faded by the 1930s, its concepts were subsequently embraced by followers of Austrian philosopher, scientist, and artist Rudolf Steiner, who saw in its heady concepts and abstractions a mathematical description of the metaphysical process underlying creation itself. Spearheading its revival were Olive Whicher and mathematician George von Kaufmann, who collaboratively provided non-technical treatments of the subject through their books and lectures. Their best-known student was artist Frieda Lady Harris, who incorporated elements of projective geometry into the Thoth Tarot deck, which she produced as artist executant under the direction of British occultist Aleister Crowley from 1938 to 1942. As one of the most popular decks in the world, the Thoth Tarot has exposed generations to images of projective geometry in a way that truly may be called "occult."

Projective Geometry in Mathematics

During the fifteenth century, artists turned to geometry for a solution to the problem of depicting three-dimensional objects on a two-dimensional canvas. Filippo Brunelleschi (1377–1446), Leone Battista Alberti (1404–72) and Piero della Francesca (c. 1420–92) were among the earliest and most influential artists to establish what is commonly known as *per-*

spective painting. By using lines of sight that intersect at a distant vanishing point, artists were able to paint objects as the eye saw them, creating the illusion of depth on a flat surface. This geometric technique was adopted by prominent Renaissance artists Leonardo da Vinci and Albrecht Dürer.

These artists' paintings represented geometric projections of three-dimensional objects onto canvas, much as we might regard a shadow, or an image in a photograph or on a movie screen today. Remarkably, although shapes thus rendered were distorted — circles became ellipses and squares trapezoids — they were nevertheless recognizable. Furthermore, the same object painted from different perspectives (and thus distorted differently) could be identified as the same object. This posed a question: What characteristics of a three-dimensional object are invariant — that is to say, are preserved — under projection? Theoretically, "whatever properties remain unaltered by the transformation are held to belong to the form, as it were, upon a deeper level; they are more fundamental than those that suffer alteration" when transformed through projection (Adams and Whicher, *Sun and Earth* 47).

Although scientists like Johannes Kepler, Isaac Newton, and Gottfried Leibniz flirted with projective concepts in the years to follow (Robbin; Kolmogorov and Yushkevich), the fundamental question remained largely unanswered until the nineteenth century — a time Bourbaki[1] called "the Golden Age of Geometry" (131). Gaspard Monge (1746–1818), inventor of modern technical drawing, inspired a new generation of geometers with his projective geometry lectures at the military academy in Mézières and at the Éccole Polytechnic in Paris. One of his students, Jean Victor Poncelet (1788–1867), published what is considered the first book on projective geometry, *Traité des propriétés projectives des figures* (*Treatise on the Projective Properties of Figures*); it was written in 1822 while the author was imprisoned in Saratov, Russia, following Napoleon's 1812 campaign. In 1845, another of Monge's students, Michel Chasles (1793–1880), rediscovered an overlooked mathematical study by French engineer-architect Gérard Desargues (1593–1662) and wrote a pair of treatises. Poncelet and Chasles, along with French and German mathematicians like Lazare Carnot, Charles Julien Brianchon, Joseph Diez Gergonne, August Ferdinand Möbius, Julius Plücker, and Jakob Steiner, worked out the theorems and axioms that launched projective geometry. According to Gindkin (2007), "From that time on, projectivity became the reigning method in geometry" (372).

In projective geometry, the dimensions of an object — as well as the ratios of an object's dimensions — were disregarded since these features change under different projections. Instead, the emphasis was on invariant properties like the *cross-ratio,* a ratio involving the distances between pairs of four points on a projective line (although based on measurements of distance, the resulting ratio is independent of any scale of measurement). By the mid-nineteenth century, two often-acrimonious schools of thought emerged within the area of projective geometry: *analytics* used geometric coordinates and complex numbers to perform algebraic analysis, while *synthetics* emphatically rejected these measurements as "ghosts" and "shadow-land in geometry" (Gindkin 373). The analytics countered that the cross-ratio of the synthetics also used metric concepts. Finally, Karl Georg Christian von Staudt (1798–1867) in *Geometrie der Lage* presented a truly non-metrical projective geometry (Robbin; Kolmogorov and Yushkevich).

In essence, projective geometry overturns conventional thinking about points and lines. In such geometry, points are not at uniquely determined coordinate positions, but rather

represent abstract locations, and parallel lines — which we usually think of as never cross-ing — intersect at what we can think of as a "point at infinity" (consider a perspective painting of train tracks that we interpret as parallel but that actually meet at a point). A central and intriguing feature of projective geometry is the principle of duality. As defined by Berlinghoff and Gouvêa, "any statement about points and lines that is true in projective geometry remains true if the words *point* and *line* are interchanged" (203). Or, as Robbins puts it, "Everything one can say about a point, one could instead say about a line, and vice versa" (53–54).[2] For example, as is the case in our usual (Euclidean) geometry, in projective geom-etry any two distinct points in space define a unique line. In projective geometry, the dual of this, therefore, is also true: any two lines intersect at exactly one point. Applied to more complex statements, the implications of duality become correspondingly more complex and profound.

Projective geometry became accessible to English audiences with the translation of seminal texts like Theodor Reye's *Lectures on the Geometry of Position* (1877) and Luigi Cre-mona's *Elements of Projective Geometry* (1885). George Bruce Halsted (1853–1922), a fourth-generation Princeton graduate, introduced non–Euclidean geometry to the United States through his original writings — such as *Synthetic Projective Geometry* (1896) — and through important translations of Bolyai, Lobachevski, Saccheri, and Poincaré. Before long, original English-language books on the subject began appearing, including works by Emch (1905), Matthews (1914), Dowling (1917), and Lehmer (1917). The best known of these is the two-volume set *Projective Geometry* (1910–18) by Oswald Veblen (1880–1960) and John Wesley Young (1879–1932). A lecturer at Princeton (1905–32), Veblen had previously published papers like "Finite Projective Geometries" (1906), "Collineations in a Finite Projective Geometry" (1907), and "Non-Desarguesian and Non-Pascalian Geometries" (1908); his later work on differential geometry would have important applications in relativity theory and atomic physics. He met Young after the latter became a preceptor at Princeton (1905), and together they developed simple but effective postulates that they developed in their text on general projective geometry.

Superseded by newer advances, projective geometry played a smaller role in mathematics after the 1910s (Torretti). It did not disappear, however: it remains influential in art (Nightin-gale), garden/landscape design (Phibbs), and computer graphics (Kirby).

Projective Geometry in Anthroposophy

In the 1930s, projective geometry found an unlikely champion in the Anthroposophical Society (AS). The website *anthroposophy.org* explains that the term "Anthroposophy" reflects the belief that "every human being (*anthropos*) has the inherent wisdom (*sophia*) to solve the riddles of existence and to transform both self and society." Thus, Anthroposophy is the practice of developing both the inner self and, consequently, the wider world. It postulates the existence of an objective spiritual world that the human intellect can apprehend by developing pure thought independent of sensory experience. Asserting that the precision and clarity of its investigations equals that of the physical sciences, Anthroposophy has characterized itself as a spiritual science.

Historical Background

Anthroposophy's founder, Rudolf Steiner (1861–1925), studied mathematics, physics, and philosophy at the Vienna Institute of Technology (*Technische Hochschule*) from 1879 to 1883, during which time an instructor recommended him for the position of scientific editor for Joseph Kürschner's new edition of the works of Johann Wolfgang von Goethe (1749–1832).[3] Steiner wrote introductions to and commentaries on four volumes of Goethe's scientific writings; he also wrote two volumes of his own on Goethe's philosophy: *The Theory of Knowledge Implicit in Goethe's World-Conception* (1886) and *Goethe's Conception of the World* (1897). In 1894, he wrote his main philosophical work, *The Philosophy of Freedom*. Consequently, the Goethe and Schiller Archives in Weimar, Germany, offered Steiner a position, which he held from 1890 to 1897. He also prepared, in 1896, a 227-page catalog of Friedrich Nietzsche's (1844–1900) library for the Nietzsche Archive in Naumburg.

In his travels, Steiner encountered a spiritual teacher, Robert Zimmermann (1824–98), who directed him to the works of transcendental idealist Johann Gottlieb Fichte (1762–1814); Steiner earned his doctorate in 1891 with a dissertation — later published as *Truth and Knowledge* — on Fichte's concept of the ego.[4] Steiner's subsequent esoteric writings attracted the attention of other spiritual leaders: after speaking regularly at meetings of the Berlin Theosophical Society (TS), he became its secretary general in 1902, and in 1907 organized a TS world conference in Munich. He also became involved in esoteric Freemasonry; although never formally initiated, he received a patent from Theodor Reuss (1855–1923) in 1906 to operate Mystica Æternita, a Berlin lodge of the Ancient and Primitive Rite of Memphis-Mizraim (Steiner, *Freemasonry*). These were both uneasy fits for Steiner: He preferred his own terminology to that of TS founder H. P. Blavatsky; he objected vocally when current TS leaders Annie Besant and C. W. Leadbeater announced in 1911 that the young Jiddu Krishnamurti (1895–1986) was the reincarnation of Christ; and Reuss' successor Aleister Crowley (of whom we will hear more later) quipped in later years that "Rudolf Steiner discovered what the secret of the IX° [grade in Reuss's group] did actually mean and took flight."[5]

These events set the stage for Steiner's founding of the AS in Cologne on December 23, 1912. He broke from the TS by 1913 and from Reuss — whose group was by then known as Ordo Templi Orientis or OTO — in 1914, taking with him many of his students. The AS thrived over the next eleven years, despite an act of arson on New Year's Eve, 1922, which destroyed the society's headquarters.[6] With 12,000 AS members in branches throughout fifteen countries, the groups united as the General Anthroposophical Society on Christmas, 1923, with a School of Spiritual Science at its core. Steiner died a little over a year later on March 30, 1925, leaving a legacy including some forty books and six thousand lectures, an AS that remains active to this day, and his successful Waldorf schools.[7]

Projective Geometry

Cambridge chemistry student George von Kaufmann (1894–1963) — the man who would marry Anthroposophy with projective geometry — was twenty-five years old when he first entered Steiner's circle. Born in Galicia (then part of Austria) to parents of German and British extraction, Kaufmann grew up tri-lingual.[8] A precocious child, he was educated

at Mill Hill School in London and won a chemistry scholarship to Christ's College, Cambridge, in 1912, becoming a lifetime member of the Chemical Society[9] in 1914 and earning his B.A. in 1915. Inspired by the mathematical and philosophical works of Alfred North Whitehead, Bertrand Russell, and G. H. Hardy,[10] he changed his curriculum to mathematics, studying non–Euclidean and projective geometry and earning his M.A. in 1918. On November 10, 1932, he was elected to the London Mathematical Society (Foster).

Kaufmann was a deeply spiritual person who hoped to bring spirituality into the, in his mind, too-materialistic field of science. When a Theosophist friend gave him Steiner's *An Outline of Occult Science* in 1914,[11] it was a perfect fit. Steiner's mix of social conscience and scientific rigor resonated deeply with Kaufmann; he joined the Emerson Group of the London AS in 1916 and, after World War I ended, met Steiner in Dornach, Switzerland, in 1919. Although Steiner validated Kaufmann's desire to apply projective geometry to spiritual solutions, he nevertheless directed Kaufmann to prioritize social issues over mathematics.

Kaufmann was already a pacifist. During the war, he had abandoned his post in a guard room and hid with friends; and he had been imprisoned twice as a conscientious objector.[12] Thus, Kaufmann, for the time being, readily set aside mathematics in favor of pacifism, working in Poland in the Friends' War Relief organization. He also devoted himself to interpreting and translating into English over 110 Steiner lectures, in addition to teaching his own classes on Anthroposophy.[13]

Some of Steiner's lectures and writings in the 1920s identified projective geometry as a potential first step toward scientific understanding of the profound spiritual aspects of creation. In a 1921 lecture, he remarked tantalizingly that projective geometry "will only give us a beginning, but it is a very, very good beginning" (Whicher, *George* 25). In *The Story of My Life,* penned between 1923 and 1925, Steiner elaborated by recalling his first encounter with projective geometry in school:

> It came over me that by means of such conceptions of the newer [projective] geometry one might form a conception of space, which otherwise remained fixed in vacuity. The straight line returning upon itself like a circle seemed to be a revelation. I left the lecture at which this had first passed before my mind as if a great load had fallen from me. A feeling of liberation came over me. Again, as in my early boyhood, something satisfying had come to me out of geometry [42].

In the duality principle, Steiner saw a profound polarity: just as a point and a plane could be interchanged, so did every object suggest its opposite. Even space itself suggested an opposite kind of space. Ordinary space concerned points, location, and distance, and conceptualized infinity as the imaginary ring of the horizon. By contrast, its opposite — which Steiner dubbed *Gegenraum* (counterspace) or *Sonnenhafter Raum* (sun-space) — concerned lines and intersections, and conceptualized infinity as the "star-point" or "infinite within." Steiner equated counterspace with the sun because he imagined it devoid of matter but filled with etheric force that radiated into regular space (*Raum*), filling it with vital energy. Thus, all life resulted from the interaction of space with counterspace.

Following Steiner's death, Kaufmann dedicated himself to integrating projective geometry with Anthroposophy. Encouraged by Dutch mathematician-*cum*-Anthroposophist Dr. Elisabeth Vreede, Kaufmann wrote "*Von dem aetherischen Raum*" (1933), the first article on space and counterspace from the standpoint of projective geometry; it was reprinted in English shortly thereafter as "Physical and Ethereal Spaces." He soon followed with *Space*

and Light of the Creation (1933) and *Strahlende Weltgestaltung* (*Synthetic Geometry in the Light of Spiritual Science*, 1934).

In 1935, Kaufmann's wife, Mary, gave a copy of *An Outline of Occult Science* to Olive Mary Whicher (1910–2006), a new visitor to the AS. Much like Kaufmann some twenty years earlier, Whicher was captivated by Steiner's writing and promptly joined the Society. She had no background in mathematics; but Kaufmann, using pictures rather than equations, explained projective geometry to her so well that she became his devoted assistant in bringing this subject matter to the masses. Their collaboration would span twenty-eight years.

With Whicher's help, Kaufmann taught classes on projective geometry at Rudolf Steiner House (RSH) on Park Road, London, in the mid–1930s.[14] His courses included "Geometry and Geometrical Drawing" (Thursdays, Spring Term, 1936), "Geometry and the Animal Kingdom" (Thursdays, Autumn Term, 1937) and "Practical Class in Geometric Drawing: The Lemniscate in Its Relation to Threefold Man" (Thursdays, Spring Term, 1938). His presentations to non-specialist audiences included various diagrams showing conic sections, lattices of intersecting lines, projections of the sight lines of various shapes, and depictions of lemniscates (figure-eight shaped curves).

During World War II, Kaufmann was forced to resign his military commission as a POW camp translator because of suspicions arising from his Germanic connections. He consequently took his mother's maiden name and began answering to George Adams. Around this time, he realized that projective geometry was manifested throughout the plant world. This stunning discovery verified not only Steiner's assertions but also those in Goethe's *Metamorphosis of Plants* (1863). Adams described how projective geometry and counterspace governed the morphogenetic field, or shape and growth of plant-life, in a series of works — *The Living Plant and the Science of Physical and Ethereal Spaces* (1949), *The Plant between Sun and Earth* (1952), *Die Pflanze in Raum in Gegenraum: Elemente einer neuen Morphologie* (1960), and *Pflanze, Sonne, Erde* (1963).

After a lifetime of promoting the AS, Adams died on March 30, 1963 — the thirty-eighth anniversary of Steiner's death. Whicher carried on their joint work of popularizing projective geometry, publishing *Projective*

Figure 1. George von Kaufmann (1894–1963), photographed in 1935 at Harrogate (Whicher, *George Adams: Interpreter of Rudolf Steiner*).

Geometry (1970, 1985) and *Sunspace* (1989). Another generation of Anthroposophists has since taken up the gauntlet, with new works by Lawrence Edwards (1985, 1992) and Nick Thomas (1999, 2008).

Projective Geometry in the Thoth Tarot

Historical Background

The best-known of Kaufmann and Whicher's students is arguably Frieda Lady Harris (1877–1962), artist executant of the popular Thoth Tarot. Marguerite Frieda Bloxam was born on August 13, 1877, at 8 George Street, Hanover Square, London,[15] and married Percy Harris, the son of family friends, in April, 1901.[16] Percy Harris' political career is well documented[17]: he began in politics in 1906 and remained active there for over forty years, including serving as chief Liberal whip from 1935 to 1945. When he became a baronet in 1932, his wife became "Lady Harris." She was a spiritual seeker, embracing at turns throughout her life the tenets of Christian Science, Co-Masonry,[18] Anthroposophy, Thelema (discussed below), and Hinduism. She was also politically motivated, participating in the women's suffrage movement (J. Harris).

When she began painting is unknown, but her husband proudly proclaimed:

Figure 2. Frieda Lady Harris (1877–1962) as a young artist (P. Harris, *Forty Years In and Out of Parliament*).

> My wife is an artist and a good one. She takes her art seriously, in fact works at her painting seven days a week and generally twelve hours out of the twenty-four. She has had an immense output of pictures [P. Harris 192].

Among her earliest works are four color illustrations for *Winchelsea: A Legend* (1926), dedicated to her mother, who had died that April. She adopted the pseudonym Jesus Chutney (J. Harris 32) to avoid any favoritism or prejudice associated with her title, and exhibited at the New English Art Club in 1929 (Johnson and Greutzner 107). By 1932, she exhibited under her own name at the Wertheim Gallery in Burlington Gardens, the London *Times* calling her paintings "original, generally pleasing in colour, and most welcome when they deal with everyday material."[19] In subsequent years, her art would appear in Leicester Galleries' April to May 1942 exhibition *Imaginative Art since the War*,[20] and she would design the set for the ballet *The Legend of the Taj Mahal* by Indian dance sensation Ram Gopal

(1917–2003), which debuted to rave reviews at the Edinburgh Festival in early September 1956.[21] Around 1958, Gallery Apollinaris selected ninety of her pieces for a show in November.[22] Harris also painted a set of tracing boards (graphic teaching aids) for her Co-Masonic Lodge and produced illustrations and dust wrappers for several works by Aleister Crowley.[23]

Harris' friend, William Holt (1897–1977), an artist himself (as well as a writer and news correspondent), offers a charming portrait of the artist:

> Like most artists, when painting she was careless about her dress, standing at her easel in a paint-stained blue linen smock. When entertaining guests she wore the most bizarre things. One afternoon she served tea wearing a voluminous dark-brown robe, with a length of thick, soft white rope around her neck. While clothing was rationed by coupons she managed by many stratagems and ingenious improvisation to make use of clothing which she bought in theatrical property shops, wearing ballet tights as stockings under her slacks. Once she threw a party wearing a Cossack officer's dress-tunic with gold braid and piping, a long black silk shirt, and embroidered shoes. The colours were always right, of course, and she was not afraid of something new and daring [173].

Aleister Crowley

Harris met Aleister Crowley (1875–1947) in 1937 through their mutual friend, Clifford Bax. The scion of a wealthy fundamentalist family, Crowley reached adulthood and predictably immersed himself in the things proscribed by his parents' faith: poetry, literature, sex, smoking, and alternative religions. A chance beer hall meeting while climbing in the Swiss Alps resulted in his introduction to the Order of the Golden Dawn, an influential secret society that counted many of Britain's intelligentsia amongst its members. Although Crowley's involvement with the group lasted only two years, his training in Kabbalah (Jewish mysticism) and ceremonial magic provided the foundation and friendships upon which he would build his own system of occultism. According to Crowley, the defining moment of his spiritual journey occurred while he was honeymooning in Cairo: under instructions from his wife (who was in a trance following a ritual demonstration), he performed a ceremony for the vernal equinox and a couple weeks later — on April 8, 9, and 10, 1904 — transcribed *The Book of the Law,* the sacred text of his philosophy, from the dictation of a spiritual presence. Its central exhortation — "Do what thou wilt shall be the whole of the Law" (I:40) — called on every individual to discover and do their True Will or purpose, rejecting all distractions that do not advance or sustain this goal. This philosophy was called Thelema after the Greek word for "will." To Crowley, its libertarian dogma of individualism and self-determination represented a new age for mankind, a clean break from the paternalism and constriction of the Victorian era.

The way to determine and do one's True Will was through the discipline he called *magick*, "the Science and Art of causing Change to occur in conformity with Will" (*Magick* xii). His was an empirical and pragmatic view of occultism, his encyclopedic knowledge and experience of Eastern and Western systems of magic and yoga tempered by his college grounding in skepticism, philosophy, and science.

Steiner and Crowley share some perspectives, though they arrived at different conclusions. Both studied philosophy, and Crowley frequently invokes Steiner's dissertation subject Fichte in his early writings (e.g., *Berashith: An Essay in Ontology* and *The Sword of Song*).

Indeed, in his commentary on "Do what thou wilt shall be the whole of the Law," Crowley wrote, "θελημα [Thelema] also means Will in the higher sense of Magical One-pointedness, and in the sense used by Schopenhauer and Fichte" ("Liber" 390). Much like Steiner, who called his approach "spiritual science" and emphasized the scientific study of unseen realms, Crowley coined the term "Scientific Illuminism" to describe his emphasis on skepticism, empiricism, and reproducibility. Also like Steiner, Crowley associated with Reuss, becoming the head of OTO after the latter's 1923 death.

Crowley's philosophy certainly parallels Steiner's view of projective geometry. This is not intended to suggest that Anthroposophy and Thelema are the same, but rather to acknowledge that, however different in external form, they share some fundamental ideas. For instance, central to Thelema are concepts of the infinite and the finite, the periphery and the point. These are exemplified by Nu (or Nuit), the Egyptian goddess whom *The Book of the Law* calls "infinite space and the infinite stars thereof" (I:22), and Hadit, the winged solar disk, the specific point, "the axle of the wheel" (II:7). In the second chapter of *The Book of the Law*, Hadit proclaims:

> 2. Come! all ye, and learn the secret that hath not yet been revealed. I, Hadit, am the complement of Nu, my bride. I am not extended, and Khabs [Egyptian for "light"] is the name of my House.
> 3. In the sphere I am everywhere the centre, as she, the circumference, is nowhere found.

These koan-like words suggest the duality (or polarity) principle of projective geometry ("I am the complement of Nu"), the vanishing point toward which lines extend ("I am not extended"), sun-space ("Khabs is the name of my House"), and Steiner's realization of infinity as "the straight line returning upon itself like a circle" ("she, the circumference, is nowhere found"). Additionally, Nuit says, "For I am divided for love's sake, for the chance of union. This is the creation of the world, that the pain of division is as nothing, and the joy of dissolution all" (I:29–30). The creation of the world through the interaction or union of the infinite circumference (Nuit) with the center point (Hadit) is a poetic version of Kaufmann's words: "Space itself, in which matter has its existence, is in reality the result of the polar interplay of centric and peripheral components" (Adams and Whicher, *Sun and Earth* 37).

To be clear, Crowley never referred to projective geometry. However, *The Book of the Law* attracted into its circle mathematicians and scientists who saw in its passages concepts from their disciplines (Kaczynski, *Perdurabo*). Norman Mudd (1889–1934) matriculated to Cambridge on a mathematics scholarship in 1907, a few years ahead of Kaufmann; he later became a mathematics lecturer at Grey College, Bloemfontein, from 1921 to 1923 and, like Kaufmann to that of Steiner, abandoned his academic career in service to the cause of his spiritual teacher (in this case, Crowley). Mudd's friend Edmund Hugo Saayman (1897–1971), a Rhodes Scholar who studied mathematics under G. H. Hardy and received his M.A. from Oxford in 1927, spent a summer with Crowley while a student in 1923. Finally, journalist and science popularizer John Wilson Navin Sullivan (1886–1937)—one of the few people in Britain who understood the theory of relativity well enough when it was first introduced to discuss it with Einstein (in German, no less) during the latter's visit to the University of London—saw mathematical theorems in *The Book of the Law*, and, though he had no interest in the occult, promised to write a précis that, alas, never materialized.

Significantly, Steiner and Crowley both associated the vital force in nature with the

sun. Steiner's *Gegenraum* or *Sonnenhafter Raum* was hyper-intellectualized as an objective spiritual realm accessible to pure thought. Conversely, Crowley — like many of his contemporaries and predecessors — believed that the solar, generative principle had expressed itself in human religions throughout history as fertility rituals and phallic cults. Thus Crowley, like Reuss before him, developed this thinking into a specialized praxis of sacred sexuality. Indeed, the symbol of the sun in astronomy is a circle (periphery) with a point in the center, a concise symbol of the polarity underlying sun-space and the creation of matter according to Anthroposophy. Crowley also saw it as a phallic symbol, and these themes were so central to his thinking that he adopted as a magical motto the much-misunderstood name "The Great Beast 666," whose number to Crowley was simply a traditional designation of the sun.[24]

The Thoth Tarot

By the time Crowley met Frieda Harris in 1937, he'd been a practicing occultist, writer and poet for nearly forty years, and had acquired a notorious reputation in England. None of this dissuaded the spiritually-curious Harris, who became Crowley's student and joined his magical societies.[25] Early in their association, Crowley suggested that Harris paint a set of tarot cards following the descriptions given by the Golden Dawn's "Book T" (a lightly edited version of which Crowley had published in 1912 as "A Description of the Cards of the Tarot"). They originally allotted six months for the job — allowing for "holidays and interruptions" — but it quickly became clear that the existing descriptions were inadequate. Harris proposed that Crowley design a new deck — informed by his accumulated decades of practice and insight into magic, philosophy, and science — for her to paint to his specifications. To sweeten the deal, she offered to pay him a stipend for the private instruction necessary for her to sufficiently understand magick in order to do justice to his designs. Thus began a collaboration that would span the years 1938 to 1943, resulting in the Thoth Tarot and its companion volume, *The Book of Thoth* (1944). Crowley was particular about the cards, and demanded revisions of many of the original versions. One or two iterations typically produced a satisfactory card, but in one instance — "The Magus" — Harris created at least seven versions.[26] The result of this collaboration was the first tarot deck to incorporate the Kabbalistic attributions of the Western esoteric tradition, augmented by Crowley's life-long researches into magic and science.

At this time, Harris' flat was near RSH, and, according to interviews with Whicher, she attended projective geometry lectures there around 1937 or 1938 (Hoffmann). Although RSH kept no attendance records for these lectures, the series Harris most likely attended was "Practical Class in Geometric Drawing." The course's term (Spring, 1938) coincides with her time spent working on the Tarot deck, and the course description reads:

> Geometry will be treated according to the modern method of Synthetic Geometry, which opens out the way to an understanding of the more cosmic forces in Nature, in harmony with Spiritual Science. No previous knowledge is presumed. Exercises in geometrical drawing will stimulate the imagination of form in movement.[27]

Whicher also tutored Harris privately at her studio, where Harris showed her how she was incorporating projective geometry into her artwork. (Harris reciprocated by advising Kaufmann and Whicher on the combined use of soft pastels and hard pencils in coloring their

Figure 3. A hexagon with sight lines projected to the horizon (upper left, from Whicher, *Projective Geometry* 54) is echoed in the projected sight lines of *The Hermit*'s lantern (upper right), and in the design of *The Hierophant*, pictured as drawn (lower left) and with superimposed hexagon added by the author (lower right). (Whicher image reproduced with permission from Rudolph Steiner Press. Thoth Tarot images reproduced with permission of Ordo Templi Orientis.)

Figure 4. A field of hexagons in a plane, with sight lines (upper left, from Whicher, *Projective Geometry* 55), compared to the field of diamond-shaped quadrilaterals appearing in a rejected draft of the card Justice (lower left), renamed to Adjustment in its final form (lower right) where the projective geometry still appears but in subdued form. (Whicher image reproduced with permission from Rudolph Steiner Press. Draft of *Justice* taken from the Freida Harris Papers, 1923–1964, accession 1969-0008R, and reproduced with the permission of the Special Collections Library, Pennsylvania State University. Thoth Tarot image reproduced with the permission of Ordo Templi Orientis.)

Figure 5. *Lemniscatory Space* by George Adams and Olive Whicher (top, from Whicher, *Sunspace* plate II), with cognate shapes appearing in an unfinished version of *The Aeon* (lower left, taken from the cover of a 1942 Thoth Tarot exhibition catalog) and the *Queen of Cups* (lower right). (Adams and Whicher image reproduced with permission from Rudolph Steiner Press. Thoth Tarot images reproduced with the permission of Ordo Templi Orientis.)

Figure 6. Projective net of cube and octahedron (upper left, from Adams and Whicher, *Sun and Earth* 77), inverted to highlight a similar structure in the *Queen of Swords* (lower left). Also, a logarithmic spiral (upper right, from Adams and Whicher, *Sun and Earth* 79) appears in *The Star*. (Adams and Whicher images reproduced with permission from Rudolph Steiner Press. Thoth Tarot images reproduced with the permission of Ordo Templi Orientis.)

plant pictures; see Hoffmann.) Harris' study of projective geometry is further illustrated by a posthumous auction catalog of her papers, which lists among them a selection of spiral designs and geometric models — "sketches, detailed pieces of geometry on Loxodromic/polar coordinate graph paper, and heavy cardboard guides for the drawing of the elaborate curves used in the Tarot pack drawings."[28] Years later, when preparing for her 1956 gallery show, Harris still referenced "Adams' book on geometry."[29]

The influence of projective geometry on Harris is obvious when one looks at the Thoth Tarot cards themselves. Although Crowley specified the major design elements for each card, he "left Lady Harris a comparatively free hand in respect of insignificant details."[30] She seized upon this freedom to express her artistic and esoteric interests. Harris was inspired by a large range of artistic influences; her depiction of "Adjustment" recalls the work of Aubrey Beardsley, while "The Tower" is rendered in Picasso's jarring and disjointed cubism. Elsewhere, she references surrealist, expressionist, symbolist, and art deco styles. As first noted by Hoffmann, projective geometry appears throughout, in both striking foreground images and subtle background textures and patterns. While not every card draws on Kaufmann's teachings, geometric designs and arrangements — both projective and Euclidean — are prevalent. As examples, Figures 3 through 6 juxtapose illustrations from Kaufmann and Whicher alongside selected tarot cards; note the similarities between the illustrations and the cards. From projective nets of quadrangles, cubes, and octahedrons (Figures 4 and 6) to lemniscatory processes (Figure 5) and logarithmic spirals (Figure 6), projective geometry appears frequently in the Thoth Tarot, sometimes subtly and sometimes stridently. The Thoth Tarot's tremendous popularity — I have suggested elsewhere ("Collaboration") that it is second only to the ubiquitous Rider-Waite deck — has introduced images and concepts from projective geometry to vast audiences who otherwise might never have considered non–Euclidean mathematics.

Conclusion

Higher math is, by its nature, an esoteric pursuit plumbed by a relatively small group of scholars and specialists. Projective geometry, after its nineteenth-century zenith, found a new incarnation in a different kind of esotericism: the world of mysticism and magic(k). Here, the concepts of duality and of shapes without measure are understood to demonstrate that scientific principles governed growth and beauty in nature; furthermore, these principles apparently exert their generative influence on the world from an ideal, creative space (or counterspace) that is knowable to the trained mind. While the specifics may remain obscure even to many of the faithful, their significance has been preserved in the seminal writings of Kaufmann and Whicher. And courtesy of the imaginative hand and eye of artist executant Frieda Lady Harris, projective geometry has also been disseminated surreptitiously in Aleister Crowley's immensely popular Thoth Tarot, whose beautiful and mysterious images beckon viewers to explore the depths of its secrets.

Notes

1. "Bourbaki" is actually the pseudonym of a group of twentieth-century mathematicians.
2. Adams and Whicher put it more poetically: "Wherever the point, there too the plane" (*Sun and Earth* 37).
3. Kürschner's (1853–1902) *Deutsche National-literatur* (Berlin, Stuttgart: W. Spemann) was the largest collection of German literature at the time, released in 222 volumes between 1882 and 1898. Steiner edited *Goethes Werke* in Volumes 33–36.
4. Both Fichte and Zimmermann had previously used the term "anthroposophy," and were no doubt inspirations for Steiner. See Erdmann, Volumes 3 and 161, and Zimmermann, *Anthroposophie*.
5. Crowley, Aleister. Letter to W. B. Crow. 16 July 1944. TS. New 24, Yorke Collection. Warburg Institute Archives, London. This implies that Steiner disassociated himself from the practice of sex magic.

Nevertheless, the Misraim Service of Steiner's "Cognitive Cultic Section" incorporated the rituals and lectures of Mystica Æternita.

6. These headquarters were designed by Steiner and originally completed in 1919. After the 1922 fire, they were rebuilt between 1923 and 1928.

7. For Steiner's life, see Bock; Lachman; and Lindenberg. For an academic analysis of spiritual science, see Hammer.

8. His mother, Kate Adams, was British. His father, George von Kaufmann, was an Australian born to German and British immigrants; he filed for divorce in 1897, retaining custody of his children and subsequently remarrying. See Divorce Court File 18632, item reference J77/610/18632, National Archives, UK.

9. "George von Kaufmann, Junr." was elected to the Chemical Society at its 3 Dec 1914 meeting (*Proceedings of the Chemical Society,* 11 Dec. 1914, 30(435): 290). See also *Proceedings of the Chemical Society,* 6 Dec 1914, 30(431): 173, where "a certificate was read for the first time in favour of Mr. George von Kaufmann, jun., Christ's College, Cambridge," and *Journal of the Chemical Society Abstracts* 1915, 108(2): 35 for a description of his article "The General Theory of Corresponding States," *Philos. Mag.,* 1915.

10. See Whitehead. Russell mentions Kaufmann in Griffin, 99. Coincidentally, Hardy also supervised Crowley's follower Eddie Saayman during the latter's mathematical studies at Cambridge in 1921 (Kaczynski, *Perdurabo*).

11. He likely read 1914's fourth edition; see Works Consulted.

12. For further biographical details, see Whicher, *George*; Kiersch.

13. See, e.g., "Spiritual Values in Education: Dr. Steiner's Lectures to Oxford Conference," *Manchester Guardian,* 21 Aug 1922, 10; "Anthroposophy in Manchester," *Manchester Guardian,* 4 Oct 1922; and "'Scientific Inquiry into Belief': University Lecture on Rudolf Steiner's Work," *Manchester Guardian,* 17 Jun 1926.

14. The 12 Nov. 1932 edition of London's *Times* mentions lectures of George Adams Kaufmann, M.A., on "The Spiritual Soul and the New Consciousness" on November 13, and on "The Spiritual Soul and the Descent into Matter" on November 20.

15. Birth certificate, GRO, UK.

16. The certified record of their wedding (GRO, UK) gives the date as April 2, but the date appears as April 1 in P. Harris 26–28.

17. See Milton and Ingham; P. Harris.

18. Co-Masonry is a form of Freemasonry which admits both men and women. In England, the term is virtually synonymous with Annie Besant's Order of Universal Co-Masonry in Great Britain and the British Dependencies, founded in 1902. The Order was closely tied to the TS, of which Annie Besant became head in 1908. For a Theosophical perspective on Co-Masonry, see Leadbeater. For a scholarly assessment of mixed Masonic lodges, see Heidle and Snoek.

19. "Art Exhibition: The Wertheim Gallery." *Times* [London], 9 Dec 1932: 12.

20. Ernest Brown and Phillips, Ltd.; "The Leicester Galleries: Imaginative Art since the War." *Times* [London], 30 Apr 1942: 6.

21. Harris, *Bump!* An auction catalog by Askin Books lists a 1 Jan 1954 letter from Ram Gopal to "My dear Frieda ji." Quotations of the *Daily Telegraph* and other ads come from advertisements for the London show, e.g., *Manchester Guardian* and *Times* for 15 Sep 1956; the London debut was reported in the *Manchester Guardian,* 8 Sep 1956, 3. For the London *Times* review, see "Festival Hall: 'The Legend of the Taj Mahal,'" *Times,* 18 Sep 1956, 3.

22. Harris, Frieda. Letter to William Holt. N.d. MS. HO:73/1. Holt Collection. West Yorkshire Archive Service, Calderdale, Halifax.

23. For more biographical information on Harris, see Kaczynski, "Crowley-Harris," and Hymenaeus Beta, "Brief," "Editor's."

24. In western occultism, the sun, moon, and planets are traditionally associated with single-digit numbers. The sun is 6, and other numbers linked to the sun are extensions of 6, such as $6^2 = 36$ and

$$\sum_{i=1}^{6^2} i = 1 + 2 + \cdots + 36 = 666.$$

Once, when defending himself in court against rumors of wickedness and asked to explain his identification with the Great Beast, Crowley answered, "It only means sunlight; 666 is the number of the sun. You can call me 'Little Sunshine'" (Kaczynski, *Perdurabo Outtakes* 39).

25. Crowley's 11 May 1938 diary entry says that "[Harris] agreed to affiliate to O.T.O. £10.10.0." "Affiliation" indicates that Crowley recognized her Masonic rank as equivalent to OTO's VII°—a high rank in its nine-grade system—and administratively conferred that degree upon her; in return, she paid the fee for that degree without taking the actual initiation.

26. Kaczynski, "Collaboration"; Hymenaeus Beta, "Editor's."

27. Archival copies of programs, quoted by Margaret Jonas, Consultant Librarian at RSH, in an April 22, 2009, email to the author.

28. Item description from an undated auction catalog by Askin Books that lists manuscripts and other possessions of Frieda Harris.

29. Harris, Frieda. Letter to William Holt. N.d. MS. HO:73/1. Holt Collection. West Yorkshire Archive Service, Calderdale, Halifax.

30. Society of Hidden Masters [Crowley, Aleister]. "An Open Letter to Alestair Crowley." 1942. MS. Aleister Crowley Papers 1911–44. Special Collections Research Center, Syracuse University Library, Syracuse.

Works Consulted

Adams, George (see also Kaufmann, George von), and Olive Whicher. *The Living Plant and the Science of Physical and Ethereal Spaces; A Study of the Metamorphosis of Plants in the Light of Modern Geometry and Morphology*. Clent, Eng.: Goethean Science Foundation, 1949.

_____. *Die Pflanze in Raum und Gegenraum: Elemente einer neuen Morphologie*. Stuttgart: Verlag Freies Geistesleben, 1960.

_____. *Pflanze, Sonne, Erde: 24 farbige Zeichnungen*. Stuttgart: Freies Geistesleben, 1963.

_____. *The Plant between Sun and Earth*. 1952. London: Rudolf Steiner, 1980.

Anthroposphy.org. Anthroposophical Society in America, n.d. Web. 5 Sept. 2010.

"Art Exhibition: The Wertheim Gallery." *Times* [London], 9 Dec 1932: 12.

Berlinghoff, William P., and Fernando Q. Gouvêa. *Math through the Ages: A Gentle History for Teachers and Others*. Farmington, ME: Oxton, 2002.

Bock, Emil. *The Life and Times of Rudolf Steiner*. 2 vols. Edinburgh: Floris, 2008–09.

Bourbaki, Nicolas. *Elements of the History of Mathematics*. Berlin: Springer, 1994.

Cremona, Luigi. *Elements of Projective Geometry*. Trans. Charles Leudesdorf. Oxford: Clarendon, 1885.

Crowley, Aleister. "An Article on the Qabalah [Liber 58]." Originally published as part of "The Temple of Solomon the King" in *The Equinox* I.5 (1911): 72–89.

_____ (as Abhavananda). *Berashith: An Essay in Ontology, with Some Remarks on Ceremonial Magic*. Paris: Privately published, 1903.

_____. *The Book of the Law: Liber Al Vel Legis: with a Facsimile of the Manuscript Received by Aleister and Rose Edith Crowley on April 8, 9, 10, 1904*. York Beach, ME: Weiser, 2004 [*The Equinox* I.10 (1913): 9–33].

_____. "A Description of the Cards of the Tarot with Their Attributions; Including a Method of Divination by Their Use." *The Equinox* I.8 (1912): 143–210.

_____. "Liber Legis: The Comment." *The Equinox* I.7 (1912): 387–400.

_____ (as The Master Therion). *Magick in Theory and Practice*. Paris: Lecram, 1929.

_____. *The Sword of Song, Called by Christians the Book of the Beast*. Benares, India: Society for the Propagation of Religious Truth, 1904.

_____ (as The Master Therion), and Frieda Harris. *The Book of Thoth; A Short Essay on the Tarot of the Egyptians, Being the Equinox, Volume III, No. V*. London: OTO, 1944.

Dowling, L. Wayland. *Projective Geometry*. New York: McGraw-Hill, 1917.

Edwards, Lawrence. *Projective Geometry: An Approach to the Secrets of Space from the Standpoint of Artistic and Imaginative Thought*. Phoenixville, PA: R. Steiner Institute, 1985.

_____. *The Vortex of Life: Nature's Patterns in Space and Time*. Edinburgh: Floris, 1992.

Emch, Arnold. *An Introduction to Projective Geometry and Its Applications: An Analytic and Synthetic Treatment*. New York: Wiley, 1905.

Erdmann, Johann Eduard. *A History of Philosophy*. Trans. Williston S. Hough. London: Swan Sonnenschein, 1980.

Ernest Brown and Phillips, Ltd. *Imaginative Art since the War: Catalogue of the Exhibition*. London: Ernest Brown and Phillips, Apr. 1942.

Foster, Janet (Archives and Records Management Consultant, London Mathematical Society). "LMS membership: George (Adams) von Kaufmann." Message to Richard Kaczynski. 7 June 2010. E-mail.

Gindikin, Simon. *Tales of Mathematicians and Physicists*. 2nd ed. New York: Springer, 2007.

Goethe, Rudolph, Emily M. Cox, and Maxwell T. Masters. *Goethe's Essay on the Metamorphosis of Plants*. London: Taylor, 1863.

Griffin, Nicholas. *The Selected Letters of Bertrand Russell: The Public Years, 1914–1970*. London: Routledge, 2001.

Halsted, George Bruce. *Synthetic Projective Geometry.* 4th ed. 1896. London: Chapman, 1906.

Hammer, Olav. *Claiming Knowledge: Strategies of Epistemology from Theosophy to the New Age.* Leiden, Netherlands: Brill, 2001.

Harris, Frieda. *Bump! into Heaven.* London: Mitre, 1958.

_____. *Winchelsea, a Legend.* London: Selwyn, 1926.

Harris, Jack. *Memoirs of a Century.* Wellington, NZ: Steele Roberts, 2007.

Harris, Percy. *Forty Years In and Out of Parliament.* London: Melrose, 1946.

Heidle, Alexandra, and Joannes Augustinus Maria Snoek. *Women's Agency and Rituals in Mixed and Female Masonic Orders.* Leiden: Brill, 2008.

Hoffmann, Claas. "Projective Synthetic Geometry in Lady Frieda Harris' Tarot Paintings and in A. Crowley's *Book of the Law.*" *Association for Tarot Studies Newsletter Archive* 15. Association for Tarot Studies and Jean-Michel David, Mar. 2004. Web. 5 Sept. 2010.

Holt, William. *I Still Haven't Unpacked.* London: Harrap, 1953.

Hymenaeus Beta. [William Breeze]. "A Brief History of the Thoth Tarot." *Magical Link* II.2 (Jul./Aug. 1988): 121–23.

_____. "Editor's Foreword." *The Thoth Tarot: A Descriptive Essay.* By Aleister Crowley and Frieda Harris. Ed. Hymenaeus Beta. In press.

Johnson, J., and A. Greutzner. *The Dictionary of British Artists 1880–1940.* Woodbridge, Eng.: Antique Collectors' Club, 1976.

Kaczynski, Richard. "The Crowley-Harris Thoth Tarot: Collaboration and Innovation." *Tarot in Culture.* Ed. Emily Auger. Victoria: Association for Tarot Studies, 2012.

_____. *Perdurabo: The Life of Aleister Crowley.* Rev. exp. ed. Berkeley: North Atlantic, 2010.

_____. *Perdurabo Outtakes.* Troy, MI: Blue Equinox Oasis, 2005.

Kaufmann, George von (see also Adams, George). "The General Theory of Corresponding States and the Thermodynamic State Equation." *Philosophical Magazine* 30.6 (1915): 146–62.

_____. *Space and the Light of the Creation: A New Essay in Cosmic Theory.* Self-published, 1933.

_____. *Strahlende Weltgestaltung: Synthetische Geometrie in geisteswissenschaftlicher Beleuchtung: Zugleich als Vorarbeit gedacht für eine geistgemässe mathematische Physik.* Dornach, Switzerland: Math.-astron. Sektion am Goetheanum, 1934.

_____. "*Von dem aetherischen Raum.*" *Natura* Feb/Mar 1933, 6(5/6). Rpt. in "Physical and Ethereal Spaces." *Anthroposophy* Michelmas/Christmas, 1933.

Kiersch, Johannes. *A History of the School of Spiritual Science: The First Class.* Forest Row, UK: Temple Lodge, 2006.

Kirby, Kevin G. "Beyond the Celestial Sphere: Oriented Projective Geometry and Computer Graphics." *Mathematics Magazine* 75.5 (Dec. 2002): 351–66.

Kolmogorov, A. N., and A. P. Yushkevich, eds. *Mathematics of the 19th Century: Vol. II: Geometry, Analytic Function Theory.* Basel, Switzerland: Birkhäuser Verlag, 1996.

Lachman, Gary. *Rudolf Steiner: An Introduction to His Life and Work.* New York: Penguin, 2007.

Leadbeater, C. W. *Glimpses of Masonic History.* Adyar, India: Theosophical Publishing, 1926.

Lehmer, Derrick Norman. *An Elementary Course in Synthetic Projective Geometry.* Boston: Ginn, 1917.

Lindenberg, Christoph. *Rudolf Steiner: eine Biographie.* 2 vols. Stuttgart: Freies Geistesleben, 1997.

Mathews, G. B. *Projective Geometry.* London: Longmans, 1914.

Milton, Frank, and Robert Ingham. "Harris, Sir Percy Alfred, First Baronet (1876–1952)." *Oxford Dictionary of National Biography.* Oxford: Oxford University Press, 2004.

Nightingale, Charles. "Projective Geometry in the Colour Drawings of H. P. Nightingale." *Leonardo* 6.3 (1973): 213–17.

Phibbs, John. "Projective Geometry." *Garden History* 34.1 (2006): 1–21.

Poncelet, J. V. *Traité des Propriétés Projectives des Figures.* Paris: Bachelier, 1822.

Reye, Theodor. *Lectures on the Geometry of Position.* Trans. Thomas F. Holgate. London: Macmillan, 1898. Trans. of *Geometrie der Lage.* 2nd ed. Hannover, Germany: Carl Rumpler, 1877.

Robbin, Tony. *Shadows of Reality: The Fourth Dimension in Relativity, Cubism, and Modern Thought.* New Haven: Yale University Press, 2006.

Staudt, K. G. C. von. *Geometrie der Lage.* Nürnberg, Germany: Bauer, 1847.

Steiner, Rudolph. *Freemasonry and Ritual Work: The Misraim Service.* Great Barrington, MA: SteinerBooks, 2007.

_____. *Goethes Weltanschauung [Goethe's Conception of the World].* Weimar, Germany: Felber, 1897.

_____. *Grundlinien einer Erkenntnistheorie der Goethischen Weltanschauung [The Theory of Knowledge Implicit in Goethe's World-Conception].* Berlin: Spemann, 1886.

_____. *An Outline of Occult Science.* 4th ed. London: Theosophical Publishing, 1914.

_____. *Die Philosophie der Freiheit, Grundzüge einer modernen Weltanschauung.* Berlin: Felber, 1894.

_____. *The Story of My Life.* London: Anthroposophical Publishing, 1928.

_____. *Truth and Knowledge: The Philosophy of Spiritual Activity: Fundamentals of a Modern View of the World: Results of Introspective Observations According to the Method of Natural Science.* Trans. Rita Stebbing, Samuel Hugo Bergman, Paul Marshall Allen. West Nyack, NY: Rudolf Steiner Publications, 1963.

Thomas, Nick C. *Science between Space and Counterspace: Exploring the Significance of Negative Space.* London: New Science, 1999.

_____. *Space and Counterspace: A New Science of Gravity, Time and Light.* Edinburgh: Floris, 2008.

Torretti, Roberto. "Nineteenth Century Geometry." *Stanford Encyclopedia of Philosophy.* Stanford University Center for the Study of Language and Information, 13 Jan. 2010. Web. 31 Mar. 2010.

Veblen, Oswald. "Collineations in a Finite Projective Geometry." *Transactions of the American Mathematical Society* 8.3 (1907): 366–68.

_____, and W. H. Bussey. "Finite Projective Geometries." *Transactions of the American Mathematical Society* 7.2 (1906): 241–59.

_____, and J. H. Maclagan-Wedderburn. "Non-Desarguesian and Non-Pascalian Geometries." *Transactions of the American Mathematical Society* 8.3 (1907): 379–88.

_____, and John Wesley Young. *Projective Geometry.* 2 vols. Boston: Ginn, 1910–18.

Whicher, Olive. *George Adams: Interpreter of Rudolf Steiner: His Life and a Selection of His Essays.* East Grinstead: Henry Goulden Ltd. for the Goethean Science Foundation, 1977.

_____. *Projective Geometry: Creative Polarities in Space and Time.* London: Steiner, 1985.

_____. *Sunspace: Science at a Threshold.* London: Steiner, 1989.

Whitehead, A. N. *A Treatise on Universal Algebra with Applications.* Cambridge, Eng.: Cambridge University Press, 1898.

Zimmerman, Robert. *Anthroposophie im Umriss: Entwurf eines Systems idealer Weltansicht auf realistischer Grundlage.* Vienna: W. Braumüller, 1882.

Appendices

A. Mathematics in Performance Media

We provide here a selection of films, television series/episodes, and plays — and, in the following appendix, novels, short stories, and poetry/short story collections — that contain mathematical content. Most of these works can be found in Alex Kasman's fine online *Mathematical Fiction* database (http://kasman.people.cofc.edu/MATHFICT). Our appendices are by no means comprehensive, nor is the mathematics in each entry necessarily substantial or even correct. We have simply chosen to include works that contain what we consider to be interesting representations of mathematics or mathematicians; indeed, we find some of these depictions intriguing precisely because they propagate common misconceptions about math and/or its practitioners.

Readers are encouraged to check out Kasman's database, and to propose any additions to it by sending an email to kasmana@cofc.edu.

All entries in this appendix are feature films, unless otherwise noted.

The Adjustment Bureau. Dir. George Nolfi, 2011.
Agora. Dir. Alejandro Amenábar, 2009.
Antonia's Line. Dir. Marleen Gorris, 1995.
Arcadia. Writ. Tom Stoppard, 1993. Play.
The Bank. Dir. Robert Connolly, 2001.
A Beautiful Mind. Dir. Ron Howard, 2001.
Breaking the Code. Writ. Hugh Whitemore, 1986. Play, made-for-television film (Dir. Herbert Wise, 1996).
Calculus (*Newton's Whores*). Writ. Carl Djerassi, 2003. Play.
Conceiving Ada. Dir. Lynn Hershman-Leeson, 1997.
Contact. Dir. Robert Zumeckis, 1997. (Also a novel.)
Copenhagen. Writ. Michael Frayn, 1998. Play.
Cube. Dir. Vincenzo Natali, 1997.
Cube 2: Hypercube. Dir. Andrzej Sekula, 2002.
Cube Zero. Dir. Ernie Barbarash, 2004. Straight-to-video film.
The Da Vinci Code. Dir. Ron Howard, 2006. (Also a novel.)
Death and the Compass. Dir. Alex Cox, 1992. (Also a short story.)
Death of a Neopolitan Mathematician. Dir. Mario Martone, 1992.
A Disappearing Number. Writ. Simon McBurney/Théâtre de Complicité, 2007. Play.
Doctor Who. "Logopolis" (1981) and "Castrovalva" (1982). Television series episodes.
Donald in Mathmagic Land. Dir. Hamilton S. Luske, 1959. Short film.
Enigma. Dir. Michael Apted, 2001. (Also a novel.)

Enigma Secret. Dir. Roman Wionczek, 1979.
Evariste Galois. Dir. Alexandre Astruc, 1965. Short film.
Fermat's Last Tango. Joanne Sydney Lessner and Joshua Rosenblum, 2000. Musical.
Fermat's Room. Dir. Luis Piedrahita and Rodrigo Sopeña, 2007.
Flatland: The Film. Dir. Ladd Ehlinger Jr., 2007. Straight-to-video film.
Flatland: The Movie. Dir. Dano Johnson and Jeffrey Travis, 2007. Short film.
Good Will Hunting. Dir. Gus Van Sant, 1997.
A Hill on the Dark Side of the Moon. Dir. Lennart Hjulström, 1983.
Hole in the Paper Sky. Dir. Bill Purple, 2008.
Ice on Fire. Dir. Umberto Marino, 2006.
An Invisible Sign. Dir. Marilyn Agrelo, 2010.
It's My Turn. Dir. Claudia Weill, 1980.
Jumpers. Writ. Tom Stoppard, 1972. Play.
Jurassic Park. Dir. Steven Spielberg, 1993. (Also a novel.)
Lambada. Dir. Joel Silberg, 1990.
The Last Casino. Dir. Pierre Gill, 2004. Made-for-television film.
The Last Enemy. Dir. Iain B. MacDonald, 2008. Television series.
Mean Girls. Dir. Mark Waters, 2004.
Mercury Rising. Dir. Harold Becker, 1998.
The Mirror Has Two Faces. Dir. Barbra Streisand, 1996.
Moebius. Dir. Gustavo Mosquero, 1996.
Moneyball. Dir. Bennett Miller, 2011.
The Mouse and His Child. Dir. Charles Swenson and Fred Wolf, 1977. (Also a novel.)
Mozart and the Whale. Dir. Petter Næss, 2005.
NUMB3RS. Creators Nicolas Falacci and Cheryl Heuton, 2005–2010. Television series.
The Oxford Murders. Dir. Álex de la Iglesia, 2008. (Also a novel.)
The Phantom Tollbooth. Dir. Chuck Jones, Abe Levitow, and David Monahan, 1970. (Also a novel.)
π. Dir. Darren Aronofsky, 1998.
The Professor and His Beloved Equation. Dir. Takashi Koizumi, 2006. (Also a novel, *The Housekeeper and the Professor.*)
Proof. Writ. David Auburn, 2000. Play, film (Dir. John Madden, 2005).
Rain Man. Dir. Barry Levinson, 1988.
She Wrote the Book. Dir. Charles Lamont, 1946.
Smilla's Sense of Snow. Dir. Bille August, 1997. (Also a novel.)
Sneakers. Dir. Phil Alden Robinson, 1992.
Solid Geometry. Dir. Denis Lawson, 2002. Made-for-television short film. (Also a short story.)
Stand and Deliver. Dir. Ramón Menendez, 1988.
Straw Dogs. Dir. Sam Peckinpah, 1971.
Summer Wars. Dir. Mamoru Hosada, 2009.
21. Dir. Robert Luketic, 2008.

B. Mathematics in Fiction and Poetry

All entries in this appendix are novels, unless otherwise noted.

The Algebraist. Iain M. Banks, 2004.
Alice's Adventures in Wonderland. Lewis Carroll [Charles Dodgson], 1865.
"And He Built a Crooked House." Robert A. Heinlein, 1941. Short story.
Beyond the Limit: The Dream of Sofya Kovalevskaya. Joan Spicci, 2002.
Big Numbers. Alan Moore and Bill Sienkiewicz, 1990. Comic book series.
The Blind Geometer. Kim Stanley Robinson, 1987.
The Boy Who Reversed Himself. William Sleator, 1986.

Brazzaville Beach. William Boyd, 1991.
A Certain Ambiguity: A Mathematical Novel. Gaurav Suri and Hartosh Singh Bal, 2007.
Continuums. Robert Carr, 2008.
Contact. Carl Sagan, 1985. (Also a film.)
Cryptonomicon. Neal Stephenson, 1998.
The Curious Incident of the Dog in the Night-time. Mark Haddon, 2003.
The Da Vinci Code. Dan Brown, 2003. (Also a film.)
"Dark Integers." Greg Egan, 2008. Short story.
Death and the Compass. Jorge Louis Borges, 1942. Short story. (Also a film.)
"The Devil and Simon Flagg." Arthur Porges, 1954. Short story.
Diaspora. Greg Egan, 1998.
The Difference Engine. William Gibson and Bruce Sterling, 1990.
Dirk Gently's Holistic Detective Agency. Douglas Adams, 1987.
"Division by Zero." Ted Chiang, 1991. Short story.
Do the Math: A Novel of the Inevitable. Philip Persinger, 2008.
"The Dreams in the Witch-House." H. P. Lovecraft, 1933. Short story.
"Drode's Equations." Richard Grant, 1981. Short story.
The End of Mr. Y. Scarlett Thomas, 2006.
Enigma. Robert Harris, 1995. (Also a film.)
An Episode of Flatland. Charles H. Hinton, 1907.
"The Exception." Alex Kasman, 2005. Short story.
Fantasia Mathematica: Being a Set of Stories, Together with a Group of Oddments and Diversions, All Drawn from the Universe of Mathematics. Ed. Clifton Fadiman, 1958. Short story collection.
Flatland: A Romance of Many Dimensions. Edwin A. Abbott, 1884. Novella. (Also multiple film versions.)
Flatterland: Like Flatland, Only More So. Ian Stewart, 2001.
The Girl Who Played with Fire . Stieg Larsson, 2006.
"Glory." Greg Egan, 2007. Short story.
Gravity's Rainbow. Thomas Pynchon, 1973.
Gulliver's Travels. Jonathan Swift, 1726.
The Hollow Man. Dan Simmons, 1993.
The Housekeeper and the Professor. Yoko Ogawa, 2003. (Also a film, *The Professor and His Beloved Equation*.)
In the Country of the Blind. Michael Flynn, 1990.
Incandescence. Greg Egan, 2008.
The Indian Clerk. David Leavitt, 2007.
"The Infinite Assassin." Greg Egan, 1991. Short story.
An Invisible Sign of My Own. Aimee Bender, 2001.
Jurassic Park. Michael Crichton, 1990. (Also a film.)
Leaning Towards Infinity. Sue Woolfe, 1996.
"The Living Equation." Nathan Schachner, 1934. Short story.
Logicomix. Apostolos Doxiadis and Christos Papadimitriou, 2009. Graphic novel.
"Luminous." Greg Egan, 1995. Short story.
A Madman Dreams of Turing Machines. Janna Levin, 2006.
The Mathematical Magpie: Being More Stories, Mainly Transcendental, Plus Subjects of Essays, Rhymes, Music, Anecdotes, Epigrams, and Other Prime Oddments and Diversions, Rational and Irrational, All Derived from the Infinite Domain of Mathematics. Ed. Clifton Fadiman, 1962. Short story collection.
Mathematicians in Love. Rudy Rucker, 2006.
"The Mathenauts." Norman Kagan, 1964. Short story.
Mefisto: A Novel. John Banville, 1986.
"Mimsy Were the Borogoves." Lewis Padgett [Hentry Kuttner and Catherine L. Moore], 1943. Short story.
The Mind-Body Problem. Rebecca Goldstein, 1983.
The Mouse and His Child. Russell Hoban, 1967. (Also a film.)
"No-Sided Professor." Martin Gardner, 1946. Short story.
The Number of the Beast. Robert A. Heinlein, 1980.

Nymphomation. Jeff Noon, 1997.
The Oxford Murders. Guillermo Martínez, 2003. (Also a film.)
The Phantom Tollbooth. Norton Juster, 1961. (Also a film.)
"The Planck Dive." Greg Egan, 1998. Short story.
The Planiverse: Computer Contact with a Two-Dimensional World. A. K. Dewdney, 1984.
Return from the Stars. Stanislaw Lem, 1961.
Sad Strains of a Gay Waltz. Irene Dische, 1994.
Schild's Ladder. Greg Egan, 2002.
Smilla's Sense of Snow. Peter Høeg, 1992. (Also a film.)
"Solid Geometry." Ian McEwan, 1975. Short story. (Also a made-for-television short film.)
Spaceland. Rudy Rucker, 2002.
Sphereland: A Fantasy About Curved Spaces and an Expanding Universe. Dionys Burger, 1965.
Starman Jones. Robert A. Heinlein, 1953.
Strange Attractors. William Sleator, 1990.
Strange Attractors: Poems of Love and Mathematics. Ed. Sarah Glaz and Joanne Growney, 2008. Poetry collection.
Strange Attractors. Rebecca Goldstein, 1993. Short story collection.
"A Subway Named Moebius." A. J. Deutsch, 1950. Short story.
Through the Looking-Glass, and What Alice Found There. Lewis Carroll [Charles Dodgson], 1871.
Tigor. Peter Stephan Jungk, 1991.
Time, Like an Ever-Rolling Stream. Judith Moffett, 1992.
"The Tolman Trick." Manil Suri, 2006. Short story.
"The Tower of Babylon." Ted Chiang, 1990. Novelette.
Turing (A Novel About Computation). Christos H. Papadimitriou, 2003.
Uncle Petros and Goldbach's Conjecture: A Novel of Mathematical Obsession. Apostolos Doxiadis, 2001.
"Unreasonable Effectiveness." Alex Kasman, 2003. Short story.
VAS: An Opera in Flatland. Steve Tomasula and Stephen Farrell, 2002. Hybrid image-text novel.
The Visiting Professor. Robert Littell, 1994.
"Wang's Carpets." Greg Egan, 1995. Short story.
We. Yevgeny Zamyatin, 1921.
The Wild Numbers. Philibert Schogt, 1998.
A Wrinkle in Time. Madeleine L'Engle, 1962.
xkcd: volume 0. Randall Monroe, 2009. Collection of webcomics.
The Years of Rice and Salt. Kim Stanley Robinson, 2002.
"Young Archimedes." Aldous Huxley, 1924. Short story.

About the Contributors

Gene **Abrams** is a professor of mathematics at the University of Colorado at Colorado Springs. His research expertise is in noncommutative ring theory and he is the author of more than three dozen research articles in that area. He was named as a University of Colorado systemwide President's Teaching Scholar in 1996, and was the Mathematical Association of America Rocky Mountain Section Teacher of the Year award recipient in 2002.

Stephen T. **Ahearn** is trained as a pure mathematician with a specialization in algebraic topology. In his own courses he used Tolstoy's writing to solidify his students' understanding of integration. After several years teaching he made the leap to non-academic mathematics where he works with data and creates models to solve practical problems. He lives in Reston, Virginia.

Sharon **Alker** is an associate professor of English at Whitman College. She specializes in the literature of the eighteenth century and has published articles on Tobias Smollett, Mary Brunton, Maria Edgeworth, Aphra Behn, Daniel Defoe, Margaret Cavendish and others. She has coedited two volumes of essays on the Scottish writers James Hogg and Robert Burns, and is writing a book on war in the early modern period.

William Goldbloom **Bloch** is a professor of mathematics at Wheaton College in Massachusetts. His doctoral work was done at the University of California, Berkeley, under Charles Pugh, and he held a postdoctoral appointment at the University of Texas at Austin. He is the author of *The Unimaginable Mathematics of Borges' Library of Babel* and a prime number of papers on subjects that have piqued his interest, including topology, dynamical systems, Zeno's paradoxes, and the literary works of Jorge Luis Borges.

Karen **Burnham** has a B.S. in physics from Northern Arizona University and a master's degree in electrical engineering from the University of Houston. She has worked in the aerospace industry since 1996, most recently for NASA in Houston, Texas. Her writing has appeared in the *New York Review of Science Fiction*, *Strange Horizons*, and *Salon Futura*. She is a member of both the Institute of Electrical and Electronics Engineers and the International Association for the Fantastic in the Arts.

Roberta **Davidson** is a professor of English literature at Whitman College. She has published numerous articles and book reviews in academic journals, and presented papers on medieval literature as well as Arthurian films and historical fiction. In addition to medieval literature, she also teaches Shakespeare, which led to her book *Macbeth for Murderers* (2005), about her experience teaching the plays of Shakespeare to maximum security inmates.

Michael D. C. **Drout** is a professor of English and chair of the English Department at Wheaton College in Norton, Massachusetts, where he teaches Old and Middle English, science fiction, and the works of J. R. R. Tolkien. He has published extensively on *Beowulf* and on the tenth-century Benedictine Reform. He is coeditor of the journal *Tolkien Studies*, and his books

include *How Tradition Works: A Meme-Based Cultural Poetics of the Anglo-Saxon Tenth Century*, *J. R. R. Tolkien Encyclopedia*, an edition of J. R. R. Tolkien's *Beowulf and the Critics*, and the soon-to-be-published *Tradition and Influence*, *The Tower and the Ruin*, and *Philology Reborn*.

Neil **Easterbrook** teaches literary theory and comparative literature at Texas Christian University, where he is a professor of English. He has published essays on William Gibson, Robert A. Heinlein, Neal Stephenson, Ethics and Alterity, feminisms, audio drama, and filmic adaptations of Philip K. Dick and has forthcoming pieces on Heidegger and Michael Crichton's *The Andromeda Strain*, iterations of the theme of panoptic surveillance, and the films *Battlefield Earth*, *Contact*, and *Sphere*. He received the 2009 Pioneer Award from the Science Fiction Research Association.

Kenneth **Faulkner** received his B.A. in English language and literature at the University of Michigan in Ann Arbor, and is a graduate student in English language and literature at Wayne State University in Detroit, where he serves as Theatre Management Program Specialist in the MFA Theatre Management Program.

Laurie A. **Finke** is a professor of women's and gender studies at Kenyon College. She is the coauthor (with Martin B. Shichtman) of *Cinematic Illuminations: The Middle Ages on Film* (2010) and *King Arthur and the Myth of History* (2004), and the author of *Feminist Theory, Women's Writing* (1992) and *Women's Writing in English: The Middle Ages* (1999). She is an editor of the *Norton Anthology of Theory and Criticism* and edited *Medieval Texts and Contemporary Readers* (1987) with Martin B. Shichtman. Her articles have appeared in numerous books and journals.

Kris **Green** is a professor in mathematical and computing sciences at St. John Fisher College in Rochester, New York. His Ph.D. is in applied mathematics from the University of Arizona, where his dissertation explored the gravitational consequences of macroscopic collections of particles moving faster-than-light. His current research relates to student learning in mathematics and science, particularly in problem solving and using technology.

Maura Varley **Gutiérrez** is interested in critical mathematics education and the intersections of gender and race at both the elementary classroom and preservice teacher levels. She completed her doctorate at the University of Arizona where she was a fellow with the Center for the Mathematics Education of Latinas/os (CEMELA). She is the director of teaching and learning at Elsie Whitlow Stokes Community Freedom Public Charter School in Washington, D.C.

Rodrigo Jorge **Gutiérrez** is a doctoral candidate in mathematics education at the University of Arizona, where he is a fellow with the Center for the Mathematics Education of Latinas/os (CEMELA). In addition to conducting research on the implementation of critical mathematics in an afterschool math club, he has taught courses for preservice and inservice teachers. His research interests lie in mathematics education for Latino/a students and teacher education.

Lila Marz **Harper** is a senior lecturer at Central Washington University, teaching in the English and computer science departments and in the Honors College, while serving as the university's thesis editor. She received her Ph.D. from the University of Oregon and is the author of *Solitary Travelers: Nineteenth-Century Women's Travel Narratives and the Scientific Vocation* (2001) and has recently edited an edition of Edwin Abbott's *Flatland* for Broadview Press.

Jeff **Hildebrand** is an assistant professor of mathematics at Georgia Gwinnett College in suburban Atlanta, where he has taken an active role in the development of their mathematics major and other new programs. He was introduced to both higher mathematics and baseball at an early age, and his interest in both has continued. He has published articles on Lie algebras, and baseball articles looking at scheduling issues and factors affecting attendance.

Donald L. **Hoffman** is a professor emeritus at Northeastern Illinois University in Chicago. Primarily a medievalist, he specializes in Arthurian literature. Through his varied work in the popular traditions in Arthurian film (most importantly in *King Arthur in Popular Culture*, which he

coedited with Elizabeth Sklar), he has extended his interest to other filmic narratives and written recently on Chahine's *Destiny* in Ramey and Pugh's *Race, Class, and Gender in "Medieval" Cinema*, and on Jack Cardiff in Kevin J. Harty's *The Vikings on Film*.

Richard **Kaczynski** is a researcher and historian of Western esoteric traditions and the author of *Perdurabo: The Life of Aleister Crowley* (2010) and *The Weiser Concise Guide to Aleister Crowley* (2009), among others. He recently contributed a paper on the Thoth Tarot to the anthology *Tarot in Culture* (2012), edited by Emily E. Auger. He received his Ph.D. in psychology from Wayne State University, and works as a biostatistician and research scientist with Yale University, the Northeast Program Evaluation Center, and the University of Detroit.

Alex **Kasman** is a professor of mathematics at the College of Charleston, South Carolina. After receiving a Ph.D. in mathematics from Boston University in 1995, he held postdoctoral positions at the University of Georgia, the Centre des Recherches Mathématiques, and the Mathematical Sciences Research Institute. In addition to his published fiction and literary analysis, he is the author of numerous research papers in math and physics journals and of a textbook on Soliton Theory.

Kathleen Coyne **Kelly** is a professor of English at Northeastern University. She has published in such journals as *Arthuriana, Exemplaria, Studies in Philology*, and *Year's Work in Studies in Medievalism*. She is coeditor (with Marina Leslie) of *Menacing Virgins: Representing Virginity in the Middle Ages and Renaissance,* coeditor (with Tison Pugh) of *Queer Movie Medievalisms*, and author of *A. S. Byatt* and *Performing Virginity and Testing Chastity in the Middle Ages*. She is writing a work on "Lost and Invented Ecologies" and is finishing the first volume of a cyberpunk trilogy.

Matthew **Lane** is a Ph.D. candidate in mathematics and the founder of *Math Goes Pop!*, a blog that explores the (surprisingly rich) interplay between mathematics and pop culture. His mathematical interests include analytic and probabilistic number theory; his non-mathematical interests include well-produced, serialized television drama. He lives in Los Angeles.

Kristine **Larsen** is a professor of physics and astronomy at Central Connecticut State University. Her scholarly work focuses on science and society, including gender and science and science and literature. She is the author of *Stephen Hawking: A Biography* and *Cosmology 101* and coeditor of *The Mythological Dimensions of Doctor Who*.

Jennifer Firkins **Nordstrom** is a professor of mathematics at Linfield College in McMinnville, Oregon. She has a Ph.D. in math from the University of Oregon. Although her primary research interests are in ring theory, she has an interest in many areas of mathematics. She has done research with undergraduates in graph theory and combinatorial game theory. She has an interest in economic game theory and teaches a game theory class for non-math students.

Chris **Pak** is a Ph.D. candidate at the University of Liverpool, where his specialty is science fiction narratives exploring the use of terraforming. He has published reviews and essays in several journals including *Foundation: The International Review of Science Fiction* and *Green Letters*, and has published articles in the collections *The Postnational Fantasy: Essays on Postcolonialism, Cosmopolitics and Science Fiction* and *Science Fiction and Computing: Essays on Interlinked Domains*. His website is www.chrispak.webs.com.

Kristin **Rowan** is an independent scholar who is fascinated by popular culture, from film and television to music and photography. She is the author of and contributor to numerous pop culture blogs online. While her educational background is in liberal arts, she works as a project manager in the field of information technology.

Martin B. **Shichtman** is the director of Jewish studies and a professor of English language and literature at Eastern Michigan University. With Laurie A. Finke, he has written *Cinematic Illuminations: The Middle Ages on Film* (2010) and *King Arthur and the Myth of History* (2004). He is coeditor, with James P. Carley, of *Culture and the King: The Social Implications of the Arthurian*

Legend (1994), and, with Laurie A. Finke, of *Medieval Texts and Contemporary Readers* (1987). He has also authored more than 20 articles.

Ksenija **Simic-Muller** has a Ph.D. in pure and applied logic from Carnegie Mellon University. At the University of Arizona she was a fellow at the Center for Mathematics Education of Latinos/as. An assistant professor at Pacific Lutheran University in Tacoma, Washington, where she teaches mathematics and mathematics education, and works with preservice teachers, she is primarily interested in issues of equity and social justice in mathematics education.

Jessica K. **Sklar** is an associate professor of mathematics at Pacific Lutheran University, and has published both on noncommutative ring theory and on recreational mathematics. She has team-taught a course in popular culture, and is the founder of *The Ideal Vacuum*, an ongoing mathematical art project. In 2011, she and coauthor Gene Abrams received a Mathematical Association of America Carl B. Allendoerfer Award for their article "The Graph Menagerie: Abstract Algebra and the Mad Veterinarian" (*Mathematics Magazine*, June 2010).

Elizabeth S. **Sklar** is a professor emerita at Wayne State University, where she specialized in Old and Middle English language and literature. She has published extensively in the fields of modern and medieval Arthurian legend, and has been active in the field of medievalism and popular culture, having served as area chair for Arthurian legend in the Popular Culture Association. Her publications on popular culture include a coedited book (with Donald L. Hoffman), *King Arthur in Popular Culture* (2002).

K. G. **Valente** holds a joint professorship in mathematics and interdisciplinary studies, and is also the director of Lesbian, Gay, Bisexual, Transgender, and Queer Studies at Colgate University. He has worked as an algebraist but now focuses his scholarly attention on the history of mathematics, science, and ideas. He has an ongoing project on Mary Everest Boole (1832–1916), part of which has appeared in the *British Journal of the History of Science*. He lives in both upstate New York and Manchester, England.

Douglas **Whittington** holds a B.S. in electrical engineering from the University of Missouri at Rolla and a Ph.D. in neurophysiology from MIT. He is the president of a small hardware and software consulting company, and is a fierce skeptic of pop science and technically-deficient science fiction.

Index

Numbers in **_bold italics_** indicate pages with photographs.

Abbott, Edwin A.: *Flatland: A Romance of Many Dimensions* 288–302, 304, 305–307, 310, 312

Abrams, M.H. 173

Achilles and the tortoise 260–261

Adams, Colin: "A Proof of God" 16–17

Adams, George 314, 317–320, *319*, 322–323, 326–329

adjacency matrix *see* network theory

AIDS 56–59, 68–69, 226

Aiyar, S. Narayana 128–130

Alan Turing: The Enigma 220, 221–223, 225–226

The Andromeda Strain 56, 61–63

Another World; or the Fourth Dimension 291–292

Anthroposophical Society 316–317

Anthroposophy 316–320, 322–323, 329; used by Fichte and Zimmerman 328

Anti-Oedipus 215

applied mathematics 11, 12, 13, 23, 64, 247–251, 305

Arcadia 11, 172, 173–182, 184, 185

Aronofsky, Darren: *⅔* (film) 274–286

Asimov, Isaac: *Foundations* series 13

Asperger's syndrome 202

Auburn, David: *Proof* 10, 172–173, 179–185

bargaining games 95–97

Baron-Cohen, Simon 202

baseball: expected winning percentages 120; and Markov chains 116; park factors 117; predictions in 118–120; probability in 114–118; sabermetrics 114–122; statistics in 114–118

Baseball Abstract 116, 117

Baseball Prospectus 118–120

Baudrillard, Jean 67, 284, 286

Beat the Dealer 149–150, 152

A Beautiful Mind (book) 210–214, 285

A Beautiful Mind (film) 203, 212–214, 218

The Big Bang Theory 6

Binary 28–30, 34, 209–210, 216, 238; in math 140, 141, 146; *see also* duality

The Black Death *see* Bubonic Plague

Blavatsky, H.P. 292, 317

Bletchley Park 222–223, 225, 227–228

Bloxam, Marguerite Frieda *see* Harris, Frieda Lady

Bonaparte, Napoleon: capture of Moscow 259; invasion of Russia 258–259; Tolstoy's view of 259, 264

The Book of the Law 321–322

The Book of Thoth 323

Breaking the Code 220, 226, 231

Bringing Down the House 152, 154

Brockmann, Dirk 58–60, 61, 65–66, 68, 69; *Where's George?* 58

Brunelleschi, Filippo 314–315

Bubonic Plague 57, 60–61, 68, 69; maps 64–65

Burger, Dionys: *Sphereland* 289, 295–297

Byron, Ada 179, 184

Byron, Lord George Gordon 173, 175, 176, 178, 179

calculus 128, 163–168, 170, 188, 196, 230, 250, 256, 258, 261–263

card counting: legality 162; simple point count system 149–151; team play 152–156; and violence 158–159

Cartesian coordinates *see* coordinates

chaos theory 12, 277

Chase, Alston: *Harvard and the Unabomber: The Education of an American Terrorist* 203–210, 217

Chicken (game) 94–95, 97–98

Children of Dune 15

Chutney, Jesus *see* Harris, Frieda Lady

codebreaking *see* cryptography

Co-Masonry *see* Freemasonry

computer graphics 45–46; use of matrices in 45

computer simulation 56–57, 58, 59, 62–63, 65, 67, 68

"Computing Machinery and Intelligence" 221, 223, 226, 227

constants 31–32

continuous 16, 103, 148, 250, 258, 260–264, 269–271; discontinuous 59

Cook, Earnshaw: *Percentage Baseball* 114

cooperative games *see* bargaining games

coordinates 30–31, 35, 37, 46, 62, 271, 315; Cartesian 253–255, 257; GPS 144–145

Corfield, David 280

crossword puzzles 123–131, *132–135*

Crowley, Aleister 314, 317, 321–328, 329; *The Book of Thoth* 323; Great Beast 323; and Rudolf Steiner 321–323

cruciverbalists 124, 125, 127–130, 131

Cruz, Omayra Zaragoza: *Popular Culture: A Reader* 6–7

cryptography 140–141, 222–223, 265

Cryptonomicon 16, 71–85, 265

Cube 247–248, 251–257

D&D see Dungeons & Dragons

"Dark Integers" 22, 266–267, 270

The Dark Knight 86, 92–93

Davenport, Clay 118, 120; Davenport Translations 118

The Day the Earth Stood Still 11

The Decidability Problem 220–222, 227–228, 230

deconstruction 280–281, 285
Deleuze, Gilles: *Anti-Oedipus* 215
Derrida, Jacques 275, 278, 280–
 285, 286
Devlin, Keith: *The Numbers
 Behind NUMB3RS: Solving
 Crime with Mathematics* 4
Dewdney, A.K.: *The Planiverse:
 Computer Contact with a Two-
 Dimensional World* 289, 297–
 298; *Two-Dimensional Science
 and Technology* 297
The Diamond Appraised 118
différance 276, 281, 284–285, 286
diffusion model *see* epidemiologi-
 cal models
Dische, Irene: *Sad Strains of a Gay
 Waltz* 18
discrete 103, 106, 201–202, 258,
 260–263, 271
disease *see* AIDS; Bubonic Plague;
 H1N1; Influenza Pandemic
 (1918); mental illness
*Dr. Strangelove, Or How I Learned
 to Stop Worrying and Love the
 Bomb* 57, 90–91
doomsday equation 37–39; *see also*
 Valenzetti Equation
"Drode's Equations" 20
Drugstore Cowboy 233, 235, 239,
 240
dual 310, 316
duality 37, 216, 263, 316, 318, 322,
 328
Dungeons & Dragons 99–102, 104,
 106, 109, 112

Egan, Greg: "Dark Integers" 22,
 266–267, 270; *Dark Integers and
 Other Stories* 266, 267, 270;
 Diaspora 15, 304, 305, 307–312;
 Glory 19–20; *Incandescence* 266,
 267; "Luminous" 22, 266–267,
 268, 270; *Schild's Ladder* 15, 20,
 267–271, 272
Einstein, Albert 13, 20–22, 177,
 199, 201–202, 215–216, 266,
 277–278, 285, 288–289, 295–
 296, 322
The End of Mr. Y 21–22
Enigma (book) 227–228, 231
Enigma (film) 228
Enigma machines 124, 222, 227
Entscheidungsproblem see The
 Decidability Problem
epidemiological models: diffusion
 58–60, 68; fractional diffusion
 58–61, 63, 65, 67–68; traveling
 wave 58, 59, 61, 65, 68
epidemiology: computational 58–
 59, 64; prediction in 59–60; in
 science fiction 55–68; *see also*
 epidemiological models
epiphany 173–174, 178–179, 181,
 185
An Episode of Flatland 289, 292–
 293
equilibrium point 94–95, 211, 216,

Escalante, Jaime 131, 163–170
"The Exception" 21
expected values *see* probability

fair division: 16, 71–84; cake-
 cutting algorithms 72–73; of
 indivisible goods 74–82;
 Knaster's Method of Sealed Bids
 71–72, 76–82
fairness: in division of goods 71–
 82; in role-playing games 109
Fechner, Gustav Theodor 289
female role models 187, 189, 195–
 197; *see also* McKellar, Danica
Fermat's Last Theorem 6, 20, 176,
 182, 185, 247, 248, 257
Fey, Tina: *Mean Girls* 187–195
Fibonacci sequence 141, 275, 281,
 285
Fichte, Johann Gottlieb 317, 321–
 322, 328
Finding Forrester 234, 243, 245
*Flatland: A Romance of Many
 Dimensions* 288–301, 304, 305–
 307, 309, 310, 312
Flatland: The Film 299, 300–301
Flatland: The Movie 299–300
Flieger, Jerry Aline 275–276
Flynn, Michael: *In the Country of
 the Blind* 13
Footloose 95
Formalism 220–221
Foundations series 13
Fourier series function 123–124,
 127, 129–130, 235, 264
fourth dimension *see* higher
 dimensions
*The Fourth Dimension: A Guided
 Tour of the Higher Universe* 296
fractional diffusion model *see* epi-
 demiological models
free will 230, 262; and predestina-
 tion 46–47
Freedom Club *see* Kaczynski,
 Theodore J.
Freemasonry 317; Co-Masonry
 320–321, 329
Freud, Sigmund 183; "The
 Uncanny" 172–173
Friend or Foe? 93–94

gambling: blackjack 149–158, 161;
 and mathematics 148–162; poker
 159–160
game theory 86–98, 211, 217; bar-
 gaining games 95–97; perfect
 knowledge in 87–92; predic0
 tions in 90–91, 97; strategy 87–
 89, 91; two-player competitive
 game 87
games of chance *see* gambling
geeks: female 142; and mundanes
 83–84; stereotypes 140, 141–142,
 145–146
gematria 39, 281
gender stereotypes 35–36, 172,
 175–177, 183–185, 188, 194–196,
 299–300, 301

geometry 128, 176, 199, 286, 291,
 304–305; analytic versus syn-
 thetic 315; differential 308;
 Euclidean 18, 250, 253, 256,
 278–279, 283, 290, 308; fractal
 11, 18, 175; higher-dimensional
 13, 289, 293; hyperbolic 256,
 290; projective 311–320, 323–
 328; Riemannian 15, 290; spheri-
 cal 269, 290; *see also*
 Non-Euclidean geometry
Germain, Sophie 182, 184–185;
 Germain prime 182
Glory 19–20
Gödel, Kurt 13, 14, 21, 199, 201,
 220, 230, 272; Gödel's Theorem
 10, 21
golden ratio 275, 281, 285, 286
golden rectangle 281
golden spiral 281
Der Golem 274, 277, 278, 283,
 285
Good Will Hunting 10, 233–245
Grant, Richard: "Drode's Equa-
 tions" 20
great circles 269
Grothendieck, Alexandre 200–
 201
Ground Zero Man 12
Guattari, Felix: *Anti-Oedipus* 215
Guins, Raiford: *Popular Culture: A
 Reader* 6–7

Halmos, Paul R.: "Mathematics as
 a Creative Art" 305
The Hangover 155–157, 160, 161
Hardy, G.H. 129, 227, 231, 318,
 322, 329
Harper, Lila M.: "Mathematical
 Themes in Science Fiction"
 304–305
Harris, Frieda Lady 314, **320**–321,
 323–328, 329, 330
Harris, Robert: *Enigma* (book)
 227–228, 231
*Harvard and the Unabomber: The
 Education of an American Terror-
 ist* 203–210
Henderson, Linda Dalrymple 288–
 290
Herbert, Frank: *Children of Dune*
 15
*The Hidden Game of Baseball: A
 Revolutionary Approach to Base-
 ball and Its Statistics* 116
higher dimensions 288, 290–294,
 296, 306–308, 310–311; fourth
 dimension 289, 290–293, 295,
 296; Victorian philosophy on
 291–293
Hinton, Charles: *An Episode of
 Flatland* 289, 292–**293**, 297;
 What Is the Fourth Dimension?
 293, 302
Hitchcock, Alfred: maguffins 243;
 Psycho (1960) 235, 245
The Hitchhiker's Guide to the Galaxy
 33

Hodges, Andrew: *Alan Turing: The Enigma* 220–223, 225–226
homosexuality 212, 219–230, 231, 243
H1N1 56, 60, 68
In the Country of the Blind 13
Incandescence 266, 267
Influenza Pandemic (1918) 57, 64

James, Bill 116–117, 119–120, 121; *Baseball Abstracts* 116, 117
Jazayerli, Rany 118–119
Johnson, Sally C. 207–208
Jungk, Peter Stephan: *Tigor* 17, 18

Kabbalah 39, 274, 275, 281, 285, 321, 323
Kaczynski, Theodore J. 202–210, 215–217; *Industrial Society and Its Future* 206; and the media 205–206, 214; mental state of 205–209
Kagan, Norman: "The Mathenauts" 16–17, 22
Kant, Immanuel 289
Kasman, Alex: "The Exception" 21; "On the Quantum Implications of Newton's Alchemy" 12; "Unreasonable Effectiveness" 12
Kingsbury, Donald: *Psychohistorical Crisis* 13, 14
Klaver, Elizabeth 276–277
Knaster, Bronisław 71, 76; *see also* Knaster's Method of Sealed Bids
Knaster's Method of Sealed Bids 71–72, 76–82; adjusted fair share 77; cash settlement 77; initial fair share 76; multi-player version 79–81; surplus 77

Latinos: and mathematics education 163–170; stereotypes of 164–169
law of large numbers 160
Leaning Towards Infinity 17–18
Leavitt, David: *The Man Who Knew Too Much: Alan Turing and the Invention of the Computer* 220, 226–227
Lem, Stanislaw: *Return from the Stars* 14–15
Lindsey, George: run expectations charts 115–116; sabermetrics 114–115, 121
linear algebra 44–54
linear weights: Batting Runs formula 116
Littell, Robert: *The Visiting Professor* 19
logocentrism 275, 278
Lorden, Gary: *The Numbers Behind NUMB3RS: Solving Crime with Mathematics* 4
Lost 27–43; DHARMA Initiative 28, 29, 38; gender stereotyping in 35–36; Hurley's numbers 32–34, 37–38, 40; Rousseau's maps 35; Valenzetti Equation 28, 38
luck 33–34, 101, 167

Ma, Jeff 152–154
madness *see* mental illness
magick 321, 323, 328
Mala Noche 233–234, 245
The Man Who Knew Too Much: Alan Turing and the Invention of the Computer 220, 226–227
maps 57–58, 61–65; of the bubonic plague 64–65
Markov chains 46, 48–49, 53, 121; transition matrices in 48–49, 53; transition probabilities in 48–49; and baseball 116
Martínez, Guillermo: *The Oxford Murders* 21
Master Therion *see* Crowley, Aleister
math phobia 27, 34–36
mathematical models: Monte Carlo simulations 119–120; related to role-playing games 99–113; *see also* epidemiological models
"Mathematical Themes in Science Fiction" 304–305
Mathematicians in Love 16
"Mathematics as a Creative Art" 305
mathematics education: banking concept 167; geometry 290; and Latinos 163–170; and role-playing games 106–112
"The Mathenauts" 16–17, 22
mathology *see* pure mathematics
mathophysics *see* applied mathematics
matrices 44–54, *45, 46, 51, 53*; in game theory 87–89, 91, 94, 98; in Markov chains 48
The Matrix trilogy 44–54, *48*; computer graphics in 45–46; and network theory 50–52
McKellar, Danica 192, 196
Mean Girls 187–195
measles (rubeola): "Polka-Dot Puss" 66–67; *The Sword in the Stone* 66–67
Mello, Michael: *The United States of America versus Theodore John Kaczynski: Ethics, Power and the Invention of the Unabomber* 205, 206, 207–208, 217
mental illness 181–183, 202; paranoia 275; paranoid schizophrenia 203, 212–215
Merrell, Patrick 127
meta-mathematics 14, 21–22, 23–24
metonymy 67, 280, 281, 286
Mezrich, Ben: *Bringing Down the House* 152–154
Milk 233–234, 240, 242–243
Moneyball 114, 120, 121
Monte Carlo simulations 119–120
morphogenesis 220, 223–224
Munroe, Randall: *xkcd* 137–146, *137–140, 142–144*
Murder by Numbers 93
Murray, Harold 204, 207, 208

My Own Private Idaho 233–235, 242–243
Mystery Men 89, 90

Napoleonic Wars 258–259
Nasar, Sylvia: *A Beautiful Mind* (book) 210–214
Nash, Alicia 212–213
Nash, John Forbes, Jr. 179, 202–203, 210–218; and the media 211–214; mental illness 212–214
Nash Equilibrium 211, 213, 217
National Council of Teachers of Mathematics 110, 165–166
nerds 36, 100, 130, 154, 187–192, 195–197, 211
Nettle, David 202
network theory 50–53; adjacency matrix in 50, *51*; in *The Matrix* trilogy 50–52
New York Times Sunday crossword puzzles 123–131
non–Euclidean geometry 288, 290–291; projective 311–320, 323–328; spherical 269, 290
Nova: "The Proof" (episode) 247
NUMB3RS 157–159, 161
The Numbers Behind NUMB3RS: Solving Crime with Mathematics 4
numerology 39–41, 264, 279–281, 285
"Nuremberg Joys" 12

Occam's Razor 105–106, 112
"On the Quantum Implications of Newton's Alchemy" 12
Order of the Golden Dawn 321, 323
Ordo Templi Orientis 317, 322, 329
The Original Flatland Role Playing Game 298–299
Outbreak 55, 56, 63, 64, 66, 67, 69
The Oxford Murders 21

Palmer, Pete: *The Hidden Game of Baseball: A Revolutionary Approach to Baseball and Its Statistics* 115–116
Panic in the Streets 56, 60, 62, 63
paranoia *see* mental illness
paranoid schizophrenia *see* mental illness
Peek, Kim 151; *see also Rain Man*
Percentage Baseball 114
Perelman, Grigori 3, 200–201
perfect knowledge: in game theory 87–92, 97
permutations 254
perspective painting 314–315, 316
π (film) 274–286
π (number) 19, 278, 279–280
The Planiverse: Computer Contact with a Two-Dimensional World 289, 297–298
Plato 145, 288, 293

Polaneczky, Al, Sr. 119
Popular Culture: A Reader 7
posthumans 266–269, 272, 307, 308, 312
predestination: and free will 46–47
predictions: in baseball 118–120; in epidemiology 59–60, 68; in fighting 49–50, 53; in game theory 90–91, 97; of human behavior 13
prime numbers: in *Cube* 253, 255; as factors 255; in fiction 21, 180, 182, 184
The Princess Bride 86, 90
principle of parsimony *see* Occam's Razor
The Prisoner's Dilemma 91–94, 97–98
probability 48; in baseball 114–118; Bayes' Theorem 120; expected values 107, 108, 112, 115; in role-playing games 101–105, 107–108
projective geometry 314–316; in Anthroposophy 316–320; in art 314–316, 323, *324–327*, 328; cross-ratio in 315; origins 315; principle of duality 316, 318, 322, 328; in the Thoth Tarot 323, *324–327*, 328
Proof 10, 172–173, 179–185
"A Proof of God" 16–17
Psycho (1960) 235, 245
Psycho (1998) 235, 243
Psychohistorical Crisis 13, 14
psychohistory 13, 14
pure mathematics 11, 19, 20, 248, 251–256, 305

queer theory 219–230, 231

race: and academic success 167
racism: in standardized testing 164, 168–169
Rain Man 150–152, 156, 160, 170
Ramanujan, Srinivasa 128–129
randomness 30, 101, 107–108, 112, 119, 145, 179, 277
Rebel Without a Cause 95
referents 279–280
Retrosheet 118
Return from the Stars 14–15
Return to Paradise 93
Reuss, Theodor 317, 322, 323
Revolution 110
Richards, Joan 288–290
Rickey, Branch 114–116, 121
Riemann, Bernhard 227, 262, 271, 290
Riemann Hypothesis 3, 10
Rock-Paper-Scissors 87
role-playing games 299; for learning mathematics 106–111; and mathematical modeling 103–106; probability in 101–105, 107–108; strategy in 107, 108; *see also Dungeons & Dragons*
rotations of objects 46, *47*

Royle, Nicholas 172–173, 285
Rucker, Rudy: *The Fourth Dimension: A Guided Tour of the Higher Universe* 296; *Mathematicians in Love* 16; *Spaceland* 289
Russell, Bertrand: 229, 280

sabermetrics 114–122
Sad Strains of a Gay Waltz 18
Samuelson, David N. 305
The Satan Bug 56, 61, 62, 69
Saw 247–251
Schild, Alfred 269, 270–271
Schild's Ladder 15, 267–269, 270–271, 272
Schofield, Alfred T.: *Another World; or the Fourth Dimension* 291–292
Schogt, Philibert: *The Wild Numbers* 19–20
science fiction 3–4, 9–11, 83–84, 85, 265–266, 272, 304–305, 307, 312; epidemiology in 55–68
sexism: in fictional mathematics 17–18, 23
Shaw, Bob: *Ground Zero Man* 12
Sheffield, Charles: *Nuremberg Joys* 12
Shortz, Will 127, 130, 131
signification 274, 276–277, 279, 280–285
singularity 265–266, 272, 284
Snow, C.P.: "The Two Cultures" 29
Snow Crash 83–84, 85
soliton theory 18–19
Sontag, Susan 55, 67
Spaceland 289, 301, 306, 310
Sphereland 289, 295–296
Spiritualism 291–292, 301, 317, 319, 323
spirituality 285, 290–292, 298, 302, 316–318, 320–323, 329
Stand and Deliver 5, 131, 163–170
standardized testing 164, 167, 168–169
Star Trek 3, 9, 10, 14, 15, 42, 108
statistics 41, 64, 104, 114–118, 170
Steiner, Rudolf 314, 317, 318, 319, 328–329; and Aleister Crowley 321–323
Stephenson, Neal 3, 5; *Cryptonomicon* 16, 71–85, 265
stereotypes: ethnic 164–169; of females 172, 175–177, 183–185, 188, 194–196; of mathematicians 130, 148–149, 151, 153–161, 187–191, 194, 198–217; *see also* geeks; nerds
Stoppard, Tom 10–11, 181; *Arcadia* 11, 172, 173–179, 185; *Enigma* (film) 228
strategy: card counting 149–159; in game theory 86–87, 91; during the Napoleonic Wars 259; in poker 159; in role-playing games 107, 108
superstition 27, 34, 41, 239
supplément 281
Survivor 86, 95–97

Suvin, Darko 55, 67
swine influenza *see* H1N1

tarot: Rider-Waite 328; Thoth 314, 320, 323–328, *324–327*
Teen Talk Barbie 188, 191
tesseracts 293, 300, 302
Thelema 320–322
Theosophical Society 317, 318
Theosophy 289, 291, 292
Thomas, Scarlett: *The End of Mr. Y* 21–22
Thorp, Edward O.: *Beat the Dealer* 149–150, 152, 161
Thoth Tarot *see* tarot
Tigor 17, 18
The Time Machine 13
time travel 13, 27, 30–32, 42, 109, 309
Tolstoy, Leo: differential of history 258, 261, 263; integration metaphor 261–263; theory of history 259–261; view of Napoleon Bonaparte 259, 264; *War and Peace* 258–264
Tomasula, Steve: *VAS: An Opera in Flatland* 289, 302
topology 20, 307, 310
transition matrices *see* Markov chains
transition probabilities *see* Markov chains
traveling wave model *see* epidemiological models
Turing, Alan 219–230, 310; arrest 224; *Computing Machinery and Intelligence* 221; cryptography 222–223; Decidability Problem 220–222, 227–228; homosexuality 219–230; statue 229; Turing machine 230, 310; Turing test 221, 228
21 152–155, 156, 158, 160
"The Two Cultures" 29
Two-Dimensional Science and Technology 297
2 Months, 2 Million 159–161

Unabomber *see* Kaczynski, Theodore J.
"The Uncanny" 172–173
The United States of America versus Theodore John Kaczynski: Ethics, Power and the Invention of the Unabomber 205, 217
"Unreasonable Effectiveness" (Kasman) 12
Urusov, Sergei 264; *A Survey of the Campaigns of 1812 and 1813, Military-Mathematical Problems, and Concerning Railroads* 263; Tolstoy inspired by 262
Uston, Ken 152, 161–162

Valenzetti Equation 28, 38; *see also* doomsday equation
Van Sant, Gus 233–245; *Drugstore Cowboy* 233–235, 239, 240;

Finding Forrester 234, 243, 245; *Good Will Hunting* 233–245; *Mala Noche* 233–234, 245; *Milk* 233–234, 240, 242, 243; *My Own Private Idaho* 233–235, 242–243; *Psycho* (1998) 235, 243
variable 20, 31–32, 42, 52, 102–103, 109, 112, 115, 261
VAS: An Opera in Flatland 289, 302
vector-based graphics 46
vectors 74–75, 85
The Visiting Professor 19
von Kaufmann, George *see* Adams, George

Wang tiles 310
Wang's Carpets 309–310, 311

War and Peace 258–264
Wegener, Paul: *Der Golem* 274, 277, 278, 283, 285
Wells, H.G. 289–290; *The Time Machine* 13
What Is the Fourth Dimension? 293, 302
Whicher, Olive 314, 319, 320, 323–328
Whitemore, Hugh: *Breaking the Code* 220, 226, 231
The Wild Numbers 19–20
Wiles, Andrew 6, 182, 185, 247–248
Wiseman, Rosalind: *Queen Bees & Wannabes* 187
Woolfe, Sue: *Leaning Towards Infinity* 17–18

Woolner, Keith 119
World of Warcraft 106, 108, 110
World War II: use of cryptography 72, 219, 222–223
The World's Greatest Blackjack Book 152, 155, 156
wormholes 307, 309–310
Wright, Craig: *The Diamond Appraised* 118

xkcd 137–146, ***137–140, 142–144***

Zeno of Elea: 127, 337; Achilles and the tortoise 260–261
Zimmerman, Robert 317, 328